The Pictorial
Encyclopedia
of Antiques

The Pictorial Encyclopedia of Antiques

by Jan Durdík
Dagmar Hejdová
Dagmar Hníková
Ludmila Kybalová
Miroslav Mudra
Dagmar Stará
Libuše Urešova

Introduction by
Frank Davis

Hamlyn

London. New York
Sydney. Toronto

Designed and produced by Artia for
THE HAMLYN PUBLISHING GROUP LIMITED
LONDON • NEW YORK • SYDNEY • TORONTO
Hamlyn House, Feltham, Middlesex, England

© Copyright Artia 1968
© Copyright this edition The Hamlyn Publishing Group Limited 1970
Second impression 1971
Third impression 1972
ISBN 0 600 03130 6

English translation from the German by
Babylon Translation Service, London

Printed in Czechoslovakia

CONTENTS

INTRODUCTION

I am one of those deplorable people who, consulting a dictionary or an encyclopedia about any subject on earth – the date when Gainsborough married, the exact meaning of existentialism, the chemical composition of Venetian glass – find it next to impossible to put the book down. One thing or another is certain to catch my eye, some unusual point of view, some minor revelation, even some theory with which I violently disagree. If I am not careful I am liable to forget why I opened the volume in the first place and, the world forgetting and the world forgot, spend the next hour browsing happily amid the accumulated learning of many generations and many countries. I suspect a grasshopper mind and a head disguised as a mere rag-bag of unrelated facts – but a bag full of numerous holes, for the odds are that half the facts I have so interestedly absorbed will have slipped out and been forgotten by the time I have remembered what it was I was so anxious to discover.

This book then is that sort of book, a massive accumulation of knowledge into which one dips at one's peril; it is to be consulted, to be treated seriously; its range is wide, its standard of scholarship high, its judgments (though not every reader will agree with every one of them) set down with moderation. I welcome it also in an English translation for another reason. It is good for us with our own inevitable prejudices, to see how the development of the applied arts appears in Middle-European eyes, for this is a volume written by Czechs whose country's art history is one of extreme interest. How curious, omitting all reference to politics or religion, and thinking only of the history of art and of the great collectors whose dedicated acquisitiveness has preserved so much of what is worthwhile from the past in spite of the destructiveness of the strange animal called Man – how very curious that in the middle of the 17th century, almost but not quite in the same

year, England and Bohemia each lost an incomparable collection. True, the circumstances were different, and the objects – thousands of them – were not destroyed but scattered; perhaps that was all to the good, for one can argue speciously enough, that the more fine things spread around the world instead of being all hoarded in one place, the more chance there is of Man civilising himself. It is the strangest of stories, for who could have foreseen, when the Emperor Rudolph II (who was forced to abdicate in 1612) was building up his vast collection, by all accounts the greatest ever assembled, that in less than half a century Prague would have become the prey of the Swedes under Königsmark. Inept monarchs have often proved enlightened patrons of the arts; Rudolph and Charles I of England are, in their several ways, notable examples.

Rudolph had been brought up at the court of his uncle, Philip II of Spain, and had more than his share of the Hapsburg passion for art. Mercifully free from Philip's gloomy religiosity, he shut himself up in the Hradschin Palace in Prague letting government go hang and spending his fortune on art, scientific investigations – both Tycho Brahe and Keppler were supported by him – and every conceivable extravagance: works by Dürer and Bosch, handsome and rare animals, handsome and not so rare women, learned men and charlatans. Before the close of that dreadful calamity, the Thirty Years War, in 1648, some of the finest things had been moved to Vienna, but many were left, the antiquities eventually ending up in Munich, while five boatloads of works of art were floated down the Elbe to become the personal property of Queen Christina of Sweden. When Königsmark occupied Prague a few months before the signing of the Peace of Westphalia, the contents of the palace were reserved for the Queen. It was a near thing, for Königsmark was afraid the treaty might be signed before he could send the booty home

to Stockholm. However, he got it away in November 1648. The catalogue prepared by the Frenchman Du Fresne during the next four years, listed nearly five hundred pictures, about one hundred statuettes in bronze, marble and alabaster, various manuscripts, clocks, precision instruments, jewels and 'a living lion'.

Fortunately for Stockholm Queen Christina had no use for Dutch or German paintings, only Italian, and so the hundred or more she left behind her, when she abdicated a little later, became the nucleus of today's Swedish National Gallery. Once again what was left of Rudolph's great accumulation started on a journey, this time to Rome, where it remained with Christina until her death in 1689. She had bought much else besides, but at least sixty-six paintings from Prague were among the two hundred and forty which, together with marbles, bronzes, coins and medals were sold by the nephew of her friend and executor, Cardinal Azzolini, to Prince Livio Odescalchi, while her library was bought by Cardinal Ottoboni, later Pope Alexander VIII, who gave it to the Vatican.

This was not the end of the story. The Odescalchi family lost money and in 1720 sold the paintings and drawings to Pierre Crozat, acting for the Regent of France, the Duc d'Orleans. The Regent paid Crozat by giving him the drawings; many of these were bought for the French Royal Collections in 1742, at the Crozat sale, and are now in the Louvre. The coins and medals were bought by Pope Pius VI in 1794 but were ceded to Napoleon by the Treaty of Tolentino and have since been in the Bibliothèque Nationale in Paris.

The contents of the Hradschin could hardly have been unpacked and sorted in Stockholm before King Charles stepped out of Inigo Jones' Banqueting Hall in Whitehall to his execution on January 30th, 1649, and yet another collection began its wander-

ings. Its chief glory was the fabulous accumulation of works of art belonging to the Gonzaga family, Dukes of Mantua, the greatest part of which was acquired in 1627, followed by Mantegna's *Triumphs* in 1629. The latter (now at Hampton Court) were saved from being sold by Cromwell himself. In addition there were the Raphael cartoons for the tapestries in the Vatican, bought on the advice of Rubens, classical antiquities obtained in the Levant by Sir Kenelm Digby, and a multitude of drawings, coins and medals – altogether as princely a collection as ever existed and of such quality that some of the greatest paintings in the Louvre and the Prado were acquired from it. The Mantua deal alone has been recognised as the greatest transaction of its kind until forty years ago Andrew Mellon acquired thirty-three paintings from the Hermitage at Leningrad. Several of these had once belonged first to the Gonzagas and then to Charles. The dispersal ended at last in 1653 and, though the Venetian Ambassador reported ridiculously cheap prices, the total for the pictures alone came to £118,080 10s 2d. How much that would be when translated into modern currency it is impossible to say, but in any case it was a forced sale and the Courts of Europe were duly grateful. The Spanish Ambassador bought so many paintings for Philip IV that eighteen mules were required to carry them from La Coruña to Madrid, and when the famous Cologne banker Evrard Jabach, acting on behalf of Cardinal Mazarin, returned from London, tradition has it that he entered Paris at the head of a train of wagons 'loaded with artistic conquests, like a Roman victor at the head of a triumphal procession'. He bought also for himself, mainly pictures and drawings, as well as *objets d'art*, tapestries and antiquities for Mazarin, while Queen Christina acquired a notable series of medals and jewels. The Archduke Leopold, Governor of the Netherlands and as voracious a collector as any before his time or

since, acquired many Venetian paintings for Vienna, and the dealers, acting either for themselves or for other grandees, acquired the remainder.

Fate, however, played a strange trick at the end of the 17th century. The old palace of Whitehall was destroyed by fire and its contents perished, among them seven hundred paintings some of which were certainly of great consequence, though they could not possibly have reached the standards of the collection of Charles I. How strange that art lovers on each side of the Atlantic should have to thank a sour-hearted, intolerant, victorious Parliament for having, for the worst of reasons, dispersed to safer keeping some of the world's finest works of art!

All this happened three hundred years ago, when only princes and grandees and a few – a very few – private individuals possessed either the taste, the knowledge or the resources, or (after a victorious war) the power to acquire those universally admired objects which we lump together casually as works of art. Since then, in spite of much destruction, whether by act of God or the malice of men, fine things have multiplied, knowledge has vastly increased, and the chance of seeing very great masterpieces and of actually owning a few lesser works, either by men of the past or by those of today, is the privilege of thousands who would at that time have been both illiterate and incapable of appreciation. Money in large quantities is still useful in acquiring exceptional rarities, but a good eye and a sound background of study provides just as much enjoyment, and that is where a compilation such as this, with its judicious commentary can be invaluable in keeping the collector on the right track and in providing a factual framework in which he can indulge his curiosity.

The real expansion of the market can scarcely be said to have begun until the 19th century, when new men who were not always quite sure who were their

great-grandparents dared to trespass upon what had been normally regarded as the preserve of the aristocracy, though, to be sure, representatives of the latter were not always remarkable for a sensitive approach. A typical story is that of Lord Palmerston who, shown the magnificent Soulages collection of Italian maiolica and asked to use his influence to have it bought for the nation, demanded 'What is the use of such rubbish to our manufacturers?' Another is of Alfred Tennyson who after expressing his approval of at least some of its works of art fled from Florence because he could not buy English tobacco. It is Elizabeth Rigby, later Lady Eastlake, wife of Charles Eastlake (an indifferent painter who resigned as President of the Royal Academy in 1855 to become Director of the National Gallery until his death ten years later), who with innocent snobbery tells us just how the climate is changing; between 1830 and 1840 she explains patronage is now shared and subsequently almost engrossed by a wealthy and intelligent class chiefly enriched by commerce and trade. The assumption that only third and fourth generation landowners can be expected to appreciate a Titian or an Italian bronze or a Greek vase is fatuously disarming. Such were Sir Robert Peel and – less well-known – John Sheep-shanks, whose considerable fortune came from Yorkshire cloth and who in 1857 gave his two hundred and thirty-three oils by contemporary British artists and two hundred and ninety-eight drawings to the South Kensington Museum, now the Victoria and Albert Museum. He was a nice, cosy, rather odd bachelor, too canny to indulge in Old Masters, for fakes abounded, but an enthusiast none the less for the paintings of his generation, just as was Charles I for Van Dyck. An even more quiet, attractive collector of that same generation was John Jones (1800-82) who had set up in business as tailor and army clothier at 6 Waterloo Place. He was able to retire

in 1850, though he continued to live over the shop until 1865, when he moved to the still existing building at 95 Piccadilly. He never married and he never kept a carriage, but he left the contents of his house to the South Kensington Museum and so achieved posthumous fame, though many who wander through the galleries where his French furniture, Sèvres porcelain and other 18th-century objects are so attractively displayed on the lower ground floor of that marvellous treasure house, probably ask themselves 'Who on earth was this Jones?' and do not wait for an answer. Again, he was a man with an eye – moreoever, a man of uncommon sensibility, for whereas most people of his generation were aware of the character and quality of French 18th-century craftsmanship, not so many, apart from Sir Charles Eastlake, the Prince Consort and a few persons of that sort, could see a great deal in the 15th-century Venetian Crivelli. Yet the 'Jones' Crivelli, a Virgin and Child, hung in the picture gallery away from the main part of the collection, can hold its own with any of its better known and much larger peers in the National Gallery. It was obviously bought by him, irrespective of the painter's name, for its decorative qualities. I wonder just where this essentially simple, unpretentious man hung it in his house; next to his sober, grey-silk portrait of Madame de Pompadour by Boucher (a most dignified rendering of a remarkable woman) or by a delicious, cheeky little picture of a young woman attributed to Drouais?

So much for two of the new men without the background of the Grand Tour thrown up by 19th-century England. A third was Ralph Bernal, the fortunate heir to a West Indian property, a Member of Parliament from 1818 until 1852, whose fabulous collection of works of art was sold at Christie's in 1855, the year after his death, in 4,294 lots for nearly £71,000 in a dispersal which occupied thirty-two days. He

was politically backward looking, for his only parliamentary speech of consequence, delivered in 1826, was an impassioned plea to delay the abolition of slavery. But however ultra-conservative his views on human beings, he was almost shockingly avant-garde as a collector. The connoisseur of a previous generation had passed a languid eye over paintings or classical (often bogus) sculptures or Greek vases. Such things were Art with a capital A. Porcelain, maiolica, Limoges enamels and similar objects were agreeable decorations especially pleasing to women, but hardly deserving of serious consideration. Bernal had other ideas: he bought what others thought trivial, and many of these objects are now accorded the respect they deserve. Perhaps the most famous of all his purchases was the object naïvely described in Christie's catalogue as 'King Lothair's Magic Crystal – A Highly Interesting Object' – and so it was, and is, though at the time its history and the circumstances of its miraculous survival were not known. The crystal is engraved with the story of Susannah and the Elders and with a Latin inscription 'Lothair King of the Franks ordered (this) to be made', presumably referring to Lothair II (855-869 A.D.). By 950 it belonged to the Abbey of Waulsort, near Dinant, on the Meuse. A local baron, Count Eilbert, had pledged it with a Canon of Rheims in exchange for a horse. It was essential for the Count to get it back because he had stolen it from his wife's jewel casket, but the Canon denied ever having received it. The Count, disliking having his honour called in question, promptly set fire to Rheims Cathedral. The quarrel spread. The Count waged war upon King Charles the Simple; the King won, took the Count prisoner, and gave the crystal to the Abbey. It remained there until the French Revolution when, with other relics, it disappeared. In the 1840s a fisherman hooked it up from the river, a dealer picked it up in a Belgian junk shop

for 12 francs, and Bernal bought it in Bond Street for £10. At his sale the British Museum, thanks to a special Treasury grant, acquired the crystal for what seemed then the phenomenal price of £267.

So much for three of the many men who, with no background of ancestral broadacres or of the Grand Tour, set the standard and the pace for today's enthusiast for the artefacts of past generations – exactly the men who would have appreciated the industry and learning which have gone to the compilation of this encyclopedia. One other dedicated pioneer in this kind of exploitation, a woman, must not be forgotten. In 1833 Lady Charlotte (1812-95), daughter of the 9th Earl of Lindsey, was 21. In the same year, at the house of Wyndham Lewis, whose widow in due course became Mrs Disraeli, she met the Welsh ironmaster, John Guest, aged 48, and promptly married him. An Earl's daughter had married an elderly dissenting tradesman! During the next ten years she produced thirteen children, helped in the management of her husband's business – she even had a room in the London office – was an indefatigable hostess, taught herself Welsh and was annoyed with the Government for fobbing off John Guest with a baronetcy instead of the peerage he deserved. In 1852 she became a widow, and three years later married her children's tutor, Charles Schreiber; this second marriage was as happy as the first, but as the children were grown up and there was no great ironworks to manage, she looked around for other interests. These she found in the pursuit of English porcelain and enamels, and her diaries during the remainder of a long life bear witness to her enthusiasm – incessant journeys here, there and everywhere, all over Europe. A typical entry at the age of 68 is 'Having walked nearly five hours, we at length took a cab'. She presented her huge collection to the Victoria and Albert Museum. Until her day few people on the

Continent, and fewer still in England, were interested in the early history of porcelain manufacture in Western Europe – it is due to her and to pioneers in other and related fields that the modern lover of art begins to realise what enormous possibilities of enjoyable activity are open to him; pleasures which were once reserved only for a few favoured individuals are now at the disposal of everyone with eyes in his head.

Where such collectors showed the way America soon followed and, to the subsequent annoyance of London, showed itself not merely possessed of greater resources but in many respects of greater understanding – for French Impressionists were being bought in the United States years before England had overcome its horror of these allegedly wild daubers. But the whole story of the rise of the great collectors across the Atlantic – Morgan, for instance, Bache, Frick, Andrew Mellon and now his son Paul Mellon and dozens of others is far too lengthy a matter to be debated here. The results are there for everyone to see in Mellon's gift to the nation, the National Gallery of Art at Washington, the Metropolitan Museum at New York, and elsewhere, while the enormously increased interest in all kinds of works of art is shown both by the publication of a book such as this, and by the extraordinary expansion of the art trade all over the world; it is not just that dealers are legion, but that auctions by Sotheby's and Christie's now take place as a matter of course in London, New York, Ottawa, Geneva, Florence, Tokyo – all this in addition to sales by less well-known firms. As far as one can look ahead there seems no reason for this interest to flag in the foreseeable future.

London, 1970 Frank Davis

FURNITURE

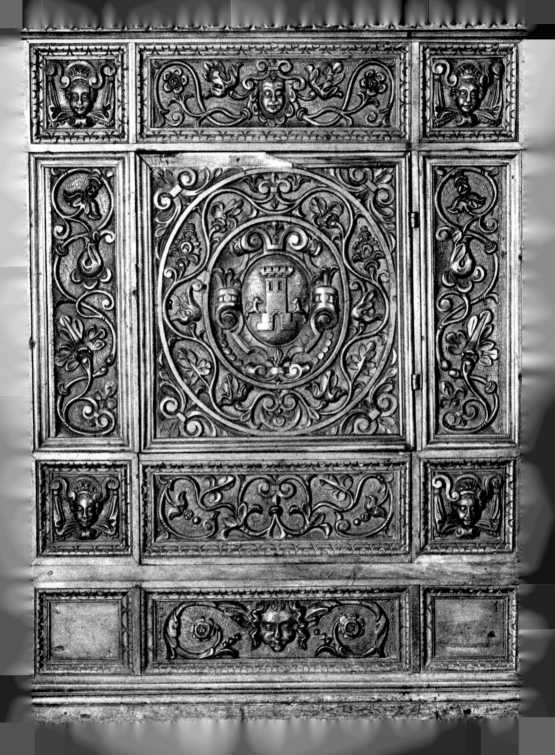

Furniture has served various purposes and
met several of man's basic needs. It has also,
with the passage of time, been transformed
into beautiful, elaborate, and valuable ar-
ticles, providing a brilliant setting for social
life. Today people collect antique furniture
for many reasons. There is modern man's
desire for beauty, his nostalgia for the past,
which perhaps makes things appear the
more beautiful simply because they are 'an-
tique' — and there is of course the element of
investment created by the very popularity of
beautiful things of the past. Whatever he col-
lects, whether dictated by his personal taste
or by fashion, he will be faced with a very
wide choice in terms of both artistic worth
and function; he will be able to select impos-
ing pieces of high-quality craftsmanship
with beautiful materials, severely practical
furniture, or small pretty pieces.

There is no doubt that originally the sole cri-
terion in furniture-making was that the ob-
ject should serve its purpose. Individual ar-
ticles were quite rudimentary, consisting of
an assemblage of unworked posts and
planks. Aesthetic preoccupations could
arise only after the two basic functions of
furniture — bearing (tables and chairs) and
containing (boxes, chests, etc.) — had become
established and their construction logically
determined. Then aesthetic feeling was
chiefly evident in the better organisation of
proportions. The plane was already in use in
ancient Egypt, where carpenters had discov-
ered how to join pieces of wood together.
They also used inlay and similar techniques.

The Greeks used the lathe for wood and the
Romans even worked metal with it. All these
techniques disappeared after the fall of the
Roman Empire, and had to be rediscovered.
The more refined finishes and decorations
were not seen again in the West until the
later Middle Ages. The combination of
basic pieces of furniture then gave rise to
new articles such as cupboards. The forms
of the individual parts became more com-
plex (facing, panelling, carving, piercing
and so on), and a great variety of surface
treatments developed (painting, carving,
veneering, intarsia, inlaying with metal and
stones, gilding, lacquering, staining, polish-
ing and studding with metal). The artistic
side of furniture-making, and, indeed, all
artistic output, was conditioned by the so-
cial system. Geographical situation, local
customs, materials available (construction
methods depended upon the specific quali-
ties of the various types of wood), technical
progress (tools, machines, chemical dis-
coveries) and the evolution of the great Eur-
opean styles, all influenced furniture-mak-
ing. The permutation of these factors pro-
duced widely different results. Accordingly,
furniture was either simple or complicated,
elegant and refined or unpretentious and
plain, showy and capricious, intimate and
comfortable, exclusive and luxurious, regal,
bourgeois or popular.

The development of furniture is inclined to
be repetitive, with several high peaks when
artistic cabinet-making could be compared
with the fine arts due to its high quality.

Historical Survey

Antiquity. Most works of art surviving from Antiquity testify to the wealth of design created in both arts and crafts. Not only the individual pieces of furniture which have come down to us, but paintings and fragmentary texts indicate that all the basic pieces of furniture, such as chairs, tables and chests, were already known. Furniture was sumptuously and richly ornamented, and the technique of inlaying with wood, metal, faience and precious stones was known. It was not until the 18th century that the same degree of technical competence was reached once more.

The pre-Greek cultures — those of ancient Egypt and Mesopotamia — produced stools, 3-legged foot-stools, chairs and tables with one to four legs (folding tables, games tables), beds (rare), luxurious chaises-longues and chests, and large and small cupboards. The usual materials for Egyptian luxury furniture, which was faced with precious metals and inlaid with ivory, faience and glass, comprised various woods, including ebony and cedar with ligaments of leather. Efforts to make furniture practical and comfortable as well as aesthetically pleasing did not become apparent until Greek times. Greek craftsmen not only produced chairs, tables and chests of various sizes, but also light movable beds and ladies' couches, the curving arms terminating in swans' heads, the legs with animal feet. They were decorated with friezes of acanthus leaves, metopes, meanders, egg-and-dart moulding and astragal. Metal first came into use in Etruscan and then in Roman times for the production of adaptable and sturdy furniture. Roman tables were usually round and had animal feet. For larger tables the Greeks and Romans used slabs of marble on magnificent carved supports in the form of chimeras or lions with acanthus leaves and relief-work on the top frieze, thus anticipating the console tables of the Baroque period. Bronze chairs, folding chairs and small tables have survived. Cupboards with shelves were also in use. Greco-Roman art as a whole was a great inspiration to European furniture-makers of the Renaissance and Neo-Classical periods.

The Early Middle Ages. The cataclysmic change in the economy of Western Europe which followed the passing of Roman rule radically changed the way of life, even for the very rich. The shortage of coinage and the redistribution of peoples during the early Middle Ages left huge areas unpopulated; Germany had but few centres of population, large parts of France were almost uninhabited. Even the largest towns only had a few thousand inhabitants. These conditions forced the large landowner who alone with the great prelates and a few merchants had the sophistication to demand good furniture to range ceaselessly through his lands. Chairs, tables and beds had to be made so that they were easily transportable and hence easily taken apart and reassembled. Chests and boxes were the most common articles of furniture. The most primitive form could serve as a receptacle, a stool, a chair or a work table. In the North, pine was the normal material, in the South, oak. The tools were usually axe and saw, with the occasional use of a plane. In the isolated Alpine villages this kind of medieval furniture was still being made in the 19th century. The ornamentation was often very rich, a combination of northern imagination with the art of the wood-carver. Vigorous interlaced foliage with animal heads and feet abounded (see, for example, the 9th-century Oseberg treasures). Where the techniques of Antiquity had been preserved, such as in the monasteries of central and southern Europe, they were used to advantage in furniture-making. The products of the St Gallen Monastery demonstrate this. Balusters in the backs of chairs, armchairs and benches were imaginatively turned, as in the Romanesque bench from Alpirsbach.

Fronts of box-type chests displayed the whole wealth of Romanesque design. They were chip carved with rows of blind arcades, pilasters, friezes, rosettes and pronounced cornices, and had iron locks and mounts which were as decorative as they were prac-

tical. The few examples of this furniture to survive the rigours of life in the early Middle Ages are now almost all in museums.

Gothic. At the beginning of the 12th century, chivalric ideas and a more refined social life began to appear. A general increase in the comforts of life led to a demand on the part of the nobility for more splendid interiors. Similar tendencies were evident in the development of the guilds in towns. The various crafts were strictly separated, and joiners and cabinet-makers left the carpenters' guild because they were concerned with the new trade of producing high-quality furniture.

Furniture was not seriously considered as a decorative art until the late Middle Ages. Pieces from this period already show an improvement in shape, technical construction and ornamentation, and can be picked up from time to time in the auction rooms. With the invention of the sawmill (Augsburg, early 14th century), the demand for light and elegant furniture could be met. Sawmill-cut planks made panel and frame work much easier to execute. Then the mechanised sawmill (Regensburg, early 16th century) made it possible to cut even thinner planks; these were used in intarsia, the inlaying of different-coloured woods into the body of a piece of furniture.

The chest became a show-piece, a symbol of the steadily increasing wealth of the bourgeoisie. In early Gothic times the entire front might be decorated with reliefs of heraldic beasts. Later the front would be treated as an architectural frame with graceful pediments, pinnacles, rosettes, finials which would be interspersed with individual figures or narrative scenes. The type of wood used dictated the ornament; in southern Germany, the Tyrol and Austria, pine was used for low-reliefs of leaf tendrils carved on a blue or red ground; good planeable hardwood in Scandinavia, northern Italy, England and Spain was suited to linen-fold decoration and X-fillings in different variations; in the Rhineland, furniture was ornamented with finely-carved foliage and garlands of flowers and fruit. Stylistic details in furniture, as in the other arts in the Middle Ages, varied from place to place.

From two chests standing one upon the other arose the second most important piece of furniture: the decorated cupboard.

It stood on a base, and the upper part was crowned with a cornice. The *Stollenschrank* (tallboy) — a forerunner of the sideboard — was made in Flanders. It consisted of a chest-shaped box standing on tall legs *(Stollen)* and fitted with doors in the front. There was a shelf at the base which, like the top surface, was used for displaying household plates.

Various types of table were also made. There were rectangular tables with crossed legs linked together by a footrail; round and octagonal tables with a central broad-based pillar leg; and long refectory-type tables supported by broad side pieces. Box tables, also known as *Rhône* tables, were made until the 18th century. Few new types of seat furniture were introduced. The elaborately turned or 'thrown' chair, three- and four-legged foot-stools and folding chairs remained in use. Throne-like armchairs with box seats were popular in the Netherlands and France. Benches became lighter and more pleasant to look at; one interesting type had an adjustable back. The most important item of furniture, however, was the bed. In southern Europe they stood on a platform, while in the North they were fitted with a canopy or half-canopy which was attached to the wall. In 16th-century France and in the Low Countries, beds formed an integral part of the panelled room.

Renaissance. The Renaissance had early repercussions on the visual arts, but a relatively slow impact upon furniture design.

Italy. The plain solid forms of late-Gothic furniture were enlivened in Renaissance Italy by fresh architectural elements such as an arcading of semicircular Roman arches, pillars or half-pillars. Decoration was inspired by Classical Antiquity and included egg-and-dart moulding, beading, dentils and rosettes. In contrast to earlier tendencies to conceal the construction work behind decorative panels, the structural framework and the beauty of the materials were now emphasised. We know from the paintings of several Tuscan artists that the character of the rooms in early Renaissance times was determined by the disposition and style of the furniture, the design of which was henceforth increasingly influenced by aesthetic considerations. Chests in particular were given prominent positions as show-pieces. They were still box-shaped, but they

were now constructed with panels and frames. In Siena the panels were of an uneven number; in Florence they were even. At first the panels were decorated merely with simple geometrical designs, but later human figures were used as corner caryatids and the panels were illustrated with scenes from mythology. One of the oldest methods of decoration was gilded stuccowork, which had long been executed in Siena and Lucca. In northern Italy, in Cremona and Milan, highly accomplished intarsia work was done. Geometrical patterns gave way to landscapes and architectural scenes, with an emphasised perspective, inspired by the works of Brunelleschi and Uccello. Later came arabesques based on vine tendrils. Early in the Renaissance, 'Certosina' work was used as a decoration for *cassone*. This consisted of an inlay of polygonal tesserae of wood, bone, metal and mother-of-pearl and was particularly popular in Lombardy and Venice.

Finally, chests developed into pure works of art with the decoration — carved, inlaid or painted — mainly on the front. At the peak of their popularity (1470-1510) chest panels were painted by such artists as Botticelli, Filippino Lippi, Pollajuolo and Piero di Cosimo. In the middle of the 16th century the first sarcophagus chests were produced, inspired by the finest Classical forms; Rome in particular was renowned for their manufacture. They rested on lions' feet and were decorated with mythological and other rich motifs. Masks, coats of arms, *putti* and cartouches were frequently used as elements in a rhythmic design.

A new type of chest was the *cassapanca*, which was used both as a chest and a seat and had a high back and sides. Italian prosperity meant more domestic goods and greater emphasis on furnishings, above all the cupboard. Already frequently found in sacristies and public buildings, it now appeared in the houses of the middle classes. Sideboards were built for the storage of plate and cutlery. They consisted of large or small two-door cupboards with a drawer beneath an adjustable flap. Surfaces were ornamental with carved rosettes, framed panels, pilasters, pillars and herms.

A few more modest two-storey cupboards stood in ante-chambers or lobbies. A particular need was met by cabinets with fall-fronts or extendable flaps which provided a flat writing surface. Chests of drawers were also made with two small drawers at the top and three larger ones beneath, as well as bookcases with lattice panels and simple bookshelves. The bed was designed to reflect the architectural concept of the room. It had a very high head and stood upon a raised platform. The base disappeared in about 1500, and during the High Renaissance it was given a more sumptuous appearance, with fluted and lavishly carved posts which supported a canopy. In the Baroque period the posts were transformed into caryatids.

The cult of Antiquity encouraged the production of tables based upon the marble and stone ones that had survived. Tables were made with two or three supports decorated with a fantastic combination of carved acanthus volutes, winged mythical creatures and caryatids. From the middle of the 16th century the stretcher between the supports was replaced by rows of columns or arcading. Drawers were inserted in the frieze under the table-top. In addition, octagonal and round tables were made on four, six or eight columns; and there were hutch tables (actually little cupboards) with doors and drawers beneath. In Tuscany a writing table was invented which remained virtually unchanged until the introduction of Neo-Classicism in the 18th century. Chairs, armchairs and footstools all demonstrate the great stress placed on comfort and elegance. The range of seat furniture was extended, and there were many provincial variations. In addition to the chair with baluster legs linked by stretchers, there was the Lombardy chair with carved or pierced horizontal panels, as well as the type of rounded armchair admired by Andrea del Sarto. Stools were provided with backs, and many had polygonal seats and an oval or cut-out back supported by carved cross pieces. Even the folding stool adapted from Antiquity was given a back. Seat furniture was covered with cloth or leather attached to the frame with brass studs and finished with fringes.

In France and the Low Countries it was customary to cover both the seat and the back of the chair with tapestry or woollen textiles.

During the Renaissance, domestic appointments included clothes stands, framed mirrors, bookshelves, and also brackets which were fixed to the walls to support busts and other items.

France was the first country outside Italy to come into contact with the Renaissance. From the beginning of the 15th century the French had been able to study the Italian Renaissance and the arts of Antiquity either directly, in Italy, or indirectly, through the work of Italian artists attached to the French royal and ducal courts. Nevertheless the position of Gothic art as the national art of France was not easily shaken.

The style associated with the court of Francis I therefore developed out of an amalgam of late Gothic styles of furniture and Renaissance elements; pilasters, Corinthian capitals, balusters, friezes and cornices. It was a mixed but very decorative style, original in both the choice and arrangement of motifs. Chests, dressers, sideboards and box seats all retained the characteristic Gothic verticality, but the ornamentation was new. It consisted of panels carved with arabesques and medallions framing profiled heads; it was French, lively and decorative. The chest for long remained a plank-made box on a plinth, the front surface of which was ornamented with rectangular panels covered with lozenge decoration. Dressers were used to store utensils, cutlery and valuables (in the box-shaped centre-piece above the middle drawer section), or as repositories for tableware. The upper part, supported by Gothic pillars, stood upon a lower section on which were placed wine coolers. Dresser corners were at first cut off diagonally; only later was the dresser made in a rectangular form mounted with pilasters and standing upon columnar legs. Chairs retained their box form, but were now distinguished by their raised armrests and were carved with classical motifs. The best quality furniture at this time was made in Touraine, Auvergne and Normandy, and also at Lyons and Liège. French Mannerist furniture was sumptuously decorated and harmonious in its proportions. Local craftsmen adapted the lessons of their Italian teachers to their own requirements and brought forth a new generation of original indigenous artists. In Franche-Comté, Burgundy, western Switzerland and northern Italy, furniture was covered with exuberant carved motifs — fantastic herms, caryatids and hybrid shapes. In the Île de France and Normandy, by contrast, stress was laid on logical and practical construction and upon harmonious proportions between the plain frame and the elegant, restrained but nevertheless decorative panels. Chests retained their rectilinear form but were supported at the corners with caryatids. The popular cupboard resting on slender legs was given a reduced top section, the panels being carved with the classical subjects, the seasons or the elements, all splendidly rendered, while further south the heavier cupboard composed of two parts of equal size *(meuble à deux corps)* continued to be made. Some fine sideboards were also made fitted either with a pair of cupboards or with a single central compartment with flanking wings or with a pull-down flap and interior compartments *(cabinet d'Allemagne)*. Among the most popular pieces of furniture were the dressers, those of Burgundy being notable for their superb carving.

The building of châteaux for the nobility in France reflected a taste for more civilised living conditions which was also evident in the outfitting of aristocratic interiors and the manufacture of seat furniture. The high-backed chair was typical. The panelled sides were replaced by arched armrests supported on turned balusters or with carved scrolls terminating in animal heads. Thus the cube-form was modified and shapes became more fluid. The back was no longer a solid piece, but an open framework with a central, carved splat. The seat, supported on columnar legs was decorated with a curved apron, richly carved. The legs terminated in lions' feet linked by a stretcher. Towards the end of the 16th century, chair-makers began to pay some attention to the shape of the human body — as had been done in Antiquity. The back was slightly tilted, the armrests, carved with scrolls or rams' heads, were arched, and the small turned columns upon which they rested were made ever more slender. In the 16th century the canopy bed, usually made on the Italian model, the corner posts being baluster-shaped or carved as caryatids, was prevalent in the noble houses and those of the rich bourgeoisie. Table design in France was based on Italian forms. Two carved consoles in the shape of chimeras or herms carry the table top. These supports themselves stand upon a moulded base linked by broad stretchers. Tables for the centre of the room had six, eight or nine feet. There were also lighter tables for daily use. The differences between the styles of Louis XIII and Louis XIV are so slight that it is often difficult to date an individual piece precisely.

Germany. It was not until 1500, that is, a hundred years after their creation, that Italian Renaissance designs began to be adopted in Germany. Their introduction was mainly due to the fact that the engravings of Dürer and Holbein and other masters were widely distributed. In the second quarter of the century, even the minor craftsmen were designing ornamental patterns based on Classical examples. The new style, however, affected only decoration, and did not alter basic shapes or their suitability to certain purposes. Furthermore, Italian designs were wholeheartedly adopted only for furniture made for the nobility; middle-class furniture retained Gothic elements until the late Baroque period. A certain originality persisted in German Renaissance ornament because it kept its regional characteristics (in contrast to France, where centralised production was introduced in the 16th century).

North Germany. Here the new style was very well received. Its adoption was primarily due to ornamental engraved designs produced by Heinrich Aldegrever. But in north Germany too, this purely ornamental period was of short duration. The main type of cupboard was the corner *Stollenschrank*, which resembled the French dresser. It was a large cupboard, the front of which retained its Gothic structure and was carved with profile heads and grotesques. The same range of decorations is to be found in the chests of the Rhineland-Westphalia region, which were long executed in the Gothic style; they were often decorated with linen-fold carving. Oak was mainly used for cupboards in the North, although in other areas the preference was for pine, larch and also ash, which remained in fashion until well into the 17th century. Rich carving was typical of the whole of north Germany. Detailed carvings of allegories, or of religious scenes, caryatids on rows of pilasters, scroll-work cartouches and festoons of fruit with moulded cornices were favoured. This type of cupboard was made in Schleswig-Holstein from the 17th century to the late Baroque period. Another typical north German piece is the taller and narrower corner cupboard.

The north German chests of the 16th and 17th centuries comprise a number of marked variations. The most restrained is the Lüneburg chest, made of planks and carried on tall legs. Then there is the Bremen chest, based on a simple cube. It differs from the Holstein chest, which rests on a box-shaped base but, like all contemporary chests, is heavily carved.

The Low Countries. Here joinery was strongly influenced by the styles of the neighbouring regions, particularly those of the wood-carving centres of Lübeck and Mecklenburg. While the Catholic provinces of Flanders were mainly influenced by France, the North (the United Provinces) went its own way. A taste for richly carved decorations characterised the second quarter of the 17th century. Both before and after this period, inlay work with various coloured woods, especially with ebony, was common even on carved pilasters, borders and beadings. The few surviving chests all have the same motifs. In the 16th century and throughout the 17th century, there were households that contained an *Überbauschrank* with a shallow top section and a prominent cornice. Outside the Netherlands these were especially popular in Cologne on the Rhine. The most beautiful examples there were made decorated with rich oak carvings or with marquetry depicting vases of flowers, vine trails, birds, arabesques and cartouches.

South Germany. Here too, marquetry was much appreciated. The ornamentation of the High Renaissance as well as the new architectural vocabulary penetrated to southern Germany via Augsburg. It was there in the 17th century that special skills in marquetry were developed which made use of local woods (poplar, maple, birch, cherry) and exotic woods (ebony, kingwood).
Holbein, Burgkmair and others prepared the designs. The basic lines of cupboards disappeared beneath the strongly architectural treatment and ornamental detail. Cupboards were mainly of the two-storey type, the horizontal lines accentuated by plinths, central sections and cornices. They were carved with vine tendrils, grotesques, triglyphs, metope friezes, dentils and egg-and-dart mouldings. The ornamental designs of the architect and sculptor Peter Flötner were extremely influential. In Nuremberg, where he lived during the first half of the 16th century, a particular type of chest was made on strictly architectural lines. Another variation on the architec-

tural theme is represented by the Ulm cupboard where particular emphasis was laid on carved pilasters. So obsessed were the German cabinet-makers with architectural detail that one popular form of cupboard was actually called a 'façade cupboard'. However, the highly ornamental effects of Cologne marquetry were still popular, as was veneering with the much admired Hungarian maple. Side by side with the balanced plain surfaces, a more dynamic form appeared with a jutting base and prominent cornice. The panels became taller and thinner, thus heralding the larger two-door cupboards which became such characteristic German pieces in the 17th and 18th centuries.

The preference for architectural decoration and marquetry was carried over to the south German linen presses and the large wide sideboards and ample chests which were a Swiss speciality.

South German chests always had a base with drawers; the lids had cross members and were decorated with inlay work. Normally the front of a Tyrol chest had two supports, but three and four or even five legs were not unknown. The flat surfaces were either ornamented with inlay work or the wood-grain was deliberately displayed. A great deal of walnut was still used in the South. In the course of time such chests were only to be found in peasant households.

Unlike cupboards, seats and tables have seldom survived. Many forms were known in the German Gothic and Italian Renaissance periods. The simplest type, the 'peasant chair', with a four-cornered seat, slanting legs and a richly carved back, was adopted from Italy and made well into the 18th century.

Another chair in common use had square-section rear legs extended upwards to form part of the back. Richly carved stretchers were used to strengthen the legs. Folding chairs were still in vogue, particularly in Switzerland, as well as X-frame chairs with leather seats and backs. In about 1600, the old turning-lathe technique was used to produce a new kind of Dutch armchair, the legs of which were either baluster-shaped, or simple turned columns which came into fashion during the 17th century.

Obvious Gothic influences can be seen in the south German hutch table, which originated in France and persisted until late Baroque times. It had no carving on its supports. Somewhat more elegant were the polygonal or round tables with a single central support, either open or of closed-box form, which was replaced in the second half of the 16th century by balusters. In northern Germany, side by side with the Dutch table, a similar but longer type was being produced, which was supported by vase-shaped legs linked together by a stretcher.

Beds which were not placed against a wall were of the canopy type and fitted either with curtains or short lambrequins. Late Renaissance furniture was extremely solid. Costly materials were used, and furniture therefore became increasingly expensive. The surfaces were loaded with complicated detail; paint and stain were used as well as a combination of domestic and exotic woods.

Baroque. It is extremely difficult to determine with any accuracy the precise point at which the Renaissance gave way to the Baroque period, particularly with regard to furniture design. This is because the two styles merged imperceptibly one into the other, and because the basic characteristics of the Baroque style only became apparent at its peak in the second half of the 17th century. Its significance lies in the Baroque artist's rejection of the rational approach of the Renaissance, in the splendid shapes he emphasised so dramatically with light and shade effects, and in the overall impression of dynamism thus created. In furniture construction the grand line took precedence over details of form and ornamentation. Polished surfaces reflected light and shade, and wood was inlaid with tortoiseshell, ivory, pewter and semi-precious stones. Plinths, cornices and pediments assumed a serpentine silhouette, while the supports were scroll shaped. The ornamentation, borrowed from engravings, assumed a particular form and was known as auricular work, as well as broad-leaved acanthus foliage.

France. At a time when the whole of Europe — except one or two parts of the Netherlands and England — was dominated by the exuberant style of the Italian Baroque, French artists adhered to the moderation of Classicism. The strengthening of the monarchy under Louis XIV, and the lavish patronage dispensed by the king, ensured that all the major productions of French art

should be in 'Louis XIV style'. Not surprisingly, French court furniture also developed an independent national style.

In 1677 the Manufacture Royale des Meubles de la Couronne was opened, and designers and craftsmen flocked to the royal workshops. Cabinet-making was raised to the status of an art. In furniture design the whole appearance of the room was considered as well as the construction and decoration of indivudual pieces. During the Renaissance a change had been made from easily transportable to more stable furniture. Now it was designed to harmonise with the decoration of the room as a whole.

The new furniture styles required materials hitherto unused. Instead of walnut, exotic woods came into their own. Ebony, already popular in the reign of Louis XIII, and particularly in Antwerp, was used for contrast in inlay designs, as for example in the furniture at Montargis. But the real genius of the period was André Charles Boulle, an artist at the court of Louis XIV. At first he used naturalistic designs in the Dutch style for his inlay work (vases of tulips, jasmin and roses). Later he replaced these with the grotesques and arabesques inspired by the engraved designs of Marot and Bérain. The designs for which he became famous made use of inlays of tortoiseshell, pewter and brass (tortoiseshell into light pewter and vice versa). He thus created a glittering and appropriate substitute for the marquetry which had been so popular in the 1660s and 1670s.

The bed was the major item of furniture, and the scene of the morning ceremony known as the levée. It retained its closed cubic form, with four columns and contrasting inner and outer curtains. The bed-chamber adjoined the salons which became increasingly famous for elaborate court entertainments and ceremonies. Magnificent cabinets were the principal item of furniture in the salon. They were fitted with interior drawers and stood upon a base which, in Boulle-type designs, was still separate, but which in time developed into an integral part of the cabinet. Chests had been banished to the village (except for small jewellery chests) and were replaced by commodes. These first appeared in France in 1700 as chests of drawers descending almost to floor level. Boulle changed their appearance by raising them on small legs. Another style was the table-commode on taller

legs and inlaid with pewter or tortoiseshell. The tops of the legs were decorated with bronze masks, the drawers, which were also veneered and inlaid, were fitted with gilt-bronze mounts. New types of table were also devised. Baluster legs now seemed too heavy, and were replaced by scrolled legs. Tables for ordinary use were also decorated with metal mounts, as were writing tables (bureaux plats), which had wide, shallow drawers. According to need, dressing-tables blending with the architecture, as well as smaller tables for lamps and other minor articles, were installed in the appropriate room. Chairs and armchairs were made in the most varied shapes. Quite the most sought after were armchairs with turned legs, which were later developed into baluster legs covered with ornamentation and connected with elaborately carved stretchers (either H-shaped or crossed). These were replaced by scrolled legs. The arched armrests were upholstered and the back rests became higher. They too were upholstered and curved or bowed at the top. English influence led to the adoption of the upholstered armchair, which later broadened to become a sofa. (This, in its turn, had been influenced by the English day-bed — a long seat with slanting sides and eight or more short legs linked by stretchers). It formed part of the drawing-room furniture, which included armchairs, chairs, stools and sofas. Cupboards were more or less confined to the middle-class homes. A new piece of furniture — still a luxury — was the bookcase.

Germany and Austria. In Germany, Baroque ideas were applied with great originality. They were expressed on the one hand in dynamic furniture design, and on the other in lively and exuberant carving and inlay work.

From the 1660s the small spindle-shaped column and heavy acanthus foliage were replaced by auricular ornament. From the beginning of the 18th century, marquetry was no longer limited to chequered designs, diamonds and scrolls, but carried representations of figures.

Polished walnut was used increasingly and when this wood was used in parquetry the natural figuring was displayed to the utmost advantage. (In parquetry, the contrasting veneers were cut in geometrical shapes to

form a repeating square or lozenge-shaped pattern.) German furniture was very varied. In addition to that based on Renaissance traditions, a new, more refined and elegant style which owed a lot to foreign influence flourished in palaces, castles and country residences. North Germany depended upon Dutch imports until the reign of Frederick I of Prussia, when late Roman Baroque became the dominant style. After Frederick's death Dresden under the patronage of Augustus the Strong became the chief centre of German culture. The courts of the Bavarian princes were under French influence. They exhibited a taste for lighter tables in the Boulle manner as well as heavy console tables with baluster legs of the Italian type. The mounts also reflected the works of Boulle and Marot. Augsburg ebony cabinets were truly splendid affairs, inlaid with wood, ivory, and semi-precious stones known as *pietres dures*. The increasing intensity of Baroque decoration was particularly evident in the cupboards. A radical change took place in the basic shape of pad-footed cupboards. At first they were fitted with four doors, but these were later reduced to two. The fronts were cut off diagonally at the sides, and were decorated with turned columns or pilasters and surmounted by heavy cornices. Northern Germany, from Danzig to Hamburg, and Holland formed a separate cultural region in which local variations appeared. Hamburg occupied a leading position and in the years1660-80 Hamburg craftsmen were already making four-door cupboards rather similar to Dutch Renaissance ones. Between 1680 and 1720, an enormous two-door *Schapp* or cupboard was produced at Hamburg with a straight cornice, façade of pilasters and decorated surfaces.

The Lübeck type differed basically in its curved pediment. The effect of the Danzig cupboard, with its broken pediment, was altogether quieter; its rectangular panels carried mythological scenes. Westphalian and Holstein cupboards still carried a good deal of figurative carving, even during the Baroque period. In Holland the *Kussenkast,* which was similar to the *Schapp,* appeared. Dutch influence on naturalistic flower marquetry of coloured woods and ivory persisted throughout the 18th century. In addition to these showy cupboards, there were simple uncarved ones made of painted ash.

The Ulm cupboard is a dynamic interpretation of the Renaissance cupboard. Augsburg cupboards were small and sometimes overloaded with decoration. Among the most beautiful — and from the end of the 17th century also the most popular — was the Frankfurt *Wellenschrank*, with its serpentine front of highly polished walnut veneer.

In time, carving was abandoned, and the large unbroken surfaces of the fronts created a monumental effect. In the North, as in Augsburg, the cabinet was among the chief pieces of furniture. In Danzig it was a small one- or two-storeyed version of the *Schapp*, while in Hamburg the front of the cabinet was filled with acanthus scrolls. Also worth mentioning is the *Cheb* cabinet, with its figurative reliefs in coloured woods. Writing-cabinets and writing-tables with drawers and a flap were in use in the middle-class houses.

In everyday use were armchairs with plaited leather seats, baluster, scroll or turned legs (which were also used for tables), heavy sides and high back rests decorated with carved strapwork and acanthus leaves. The large surfaces of canopy beds, with their turned posts and animated carved figures, provided plenty of scope for marquetry and carving. Canopied beds rapidly declined in popularity.

The 18th Century *France (Régence and Rococo).* The death of Louis XIV was followed by a period of light-hearted elegance. The Parisian salons replaced Versailles as the social and the artistic centres; and the luxury, arts and manners of the capital soon set the fashion for the whole of Europe. The many purposes to which rooms were put — there were living-rooms, dressing-rooms, studies, boudoirs, bedrooms and libraries as well as reception rooms and servants' rooms — dramatically extended the demand for varied types of furniture.

During the regency of the duke of Orleans, rectilinear furniture still appeared in the interiors designed by such men as J.A. Gabriel, François Blondel, Robert de Cotte and G. Boffrand. A basic change took place only in the 1740s, when decoration became lighter and more elegant as curves and serpentine forms replaced the heavier angles.

The very great skills required in furniture manufacture, the costly woods worked with consummate craftsmanship, and the cast-

ing of bronze mounts in which the metal was chased with all the delicacy of a goldsmith, led to a high degree of specialisation. This was facilitated by the quality of the market, by good taste and by the large general demand. From 1743 furniture-makers, apart from the royal ébénistes, were required to sign every single piece they made with a stamp. Even so, it is still often very difficult to ascertain the true maker, as the ébénistes, who were also distributors and merchants, often signed everything that passed through their hands. A network of sub-contractors, who supplied wood, frames, drawers, mounts and marquetry, also contributed to standardisation. A very wide variety of seats were made, with serpentine outlines that in no way enhanced their comfort. Very popular were gilded carvings with shells and cartouches originated in Italy, the symmetrical arrangement of the carving being relieved by free compositions of flowers and ribbons. From 1740 the fully-developed *rocaille* ornamentation had appeared — whence the name Rococo, which was given to this whole style. The furniture was luxuriously upholstered in satin and brocade, velvet and silk damask from Lyons, Genoa and Peking, or with tapestry from the Aubusson factory, or with *petit point* embroidery to designs by Charles Eisen. Cane chairs also came into vogue. A completely new type of seat furniture included the small upholstered sofa with closed sides known as a *bergère*, as well as a *bergère à jour*, which resembled the wing chair of today. A *fauteuil de bureau* was placed in front of the writing-desk, while a dressing-table had its *fauteuil de toilette*. Day-beds, which in France were called *chaises longues,* were made in various styles. Those with open fronts were designated *turquoises,* but were referred to as *veilleuses* when the armrests were upholstered. Sofas had S-shaped broad arched sides, while *canapés* had open sides. The *marquise* was a short half-sofa with arched cut out sides; an ottoman had semicircular sides. Tables too were very varied. The corners were softened by the application of gilt-bronze mounts, sometimes in the shape of female figures *(espagnolettes).* Purely ornamental tables were made, displacing the heavier console tables. Folding games tables with a built-in chess board, and round *guéridon* occasional tables were placed in the salon. In ladies' bedrooms were dress-

ing-tables *(tables de toilette,* later *poudreuses)* and various night tables *(tables de nuit* and *tables de lit),* as well as ladies' writing-tables *(bonheurs du jour).* The writing-table in the gentleman's study was a heavier piece of furniture *(bureau)* of rosewood, kingwood or some other exotic wood. Some preferred the flat *bureau plat,* which was replaced in about 1750 by the roll-top desk. The dining room usually contained a large table with several small serving tables. From the beginning of the Rococo period, cupboards were dispensed with, except in the country and in middle-class houses.

However, low cupboards with two doors in front *(meuble d'entre deux),* linen chiffoniers and double-doored bookcases were still used.

Chests no longer appeared in the salons, but were replaced by the commode with a corner cupboard *en suite.* The commodes were much lighter than they had been in the Louis XIV period. The front assumed a gently undulating double curve. The drawers and corners were decorated with gilt-bronze mounts. The finest examples were made by Charles Cressent who was famous for his costly veneers and sumptuous mounts. As the Rococo rose to its height, outlines became more complicated. The marquetry designs and the mounts were designed with a pronounced asymmetry. The apron curved deeply towards the centre. Practically every major Rococo furniture designer — Bernard van Risenburgh, F. Oeben, Abraham Roentgen, J. H. Riesener, J.F. Leleu, M. Carlin, Nicolas Pineau and J.P. Latz — made such commodes. The exotic tendencies of the Rococo period were reflected in the great enthusiasm for lacquer. During the golden age of Rococo, France replaced Holland as the main importer and imitator of Japanese and Chinese lacquers. In this period the Martin brothers were the main producers of lacquer *à la Chinois,* producing charming landscapes with figures.

By the middle of the century, beds had taken on more elegant and delicate shapes. A series of whimsical forms were constructed and named, according to the type of canopy, *lit à l'allemande, à la chinoise, à l'anglaise, à la française,* and *à l'italienne.*

Germany and Austria (pre-Rococo and Rococo). German furniture design was in-

fluenced by both political and geographical factors. The capitals of German states, Dresden, Berlin, Munich, Vienna, followed French court styles. Styles in the French Rhineland differed from those in the Dutch Rhineland and the Aachen-Liège regions. In the North, Dutch and English styles were preferred. Master craftsmen produced their own identifiable variations, but German cabinet-makers frequently worked to detailed instructions from their clients. The copying of French styles was not only limited to certain regions, but was also regulated by the tastes of the copier. The enormous popularity of ribbon-work on all pieces of furniture, and particularly on secretaires, lasted until the middle of the 18th century. Secretaires assumed a serpentine form with curved corners and legs. They were veneered with marquetry of ebony and other contrasting coloured woods. Of similar construction and generally popular was the small, handy Frankfurt cupboard.

In the North, French-style three-to-five drawer commodes were not veneered. In the South they were given a deeper form, with walnut-veneered straight sides and simpler metal mounts. The richest examples in the French style, which are of great beauty, are only found in royal palaces (for example, the work of M. Kambli and M. Schindler at Potsdam). The ordinary commode, excellently carved, was made in natural oak and walnut for a middle-class clientele, notably in the Aachen-Liège region, where show-cases and tall, narrow china cupboards for displaying dinner services and bracket clocks were also produced. Writing tables, also copied from France, were modified and made narrower and lower. In north-western Germany, glass cupboards were made in the Dutch style. Dutch influence was also clearly seen in court lacquer furniture, outstanding examples of which were produced in Dresden, Berlin and Mannheim. Lacquered and veneered seat furniture was manufactured, but pieces made of stained solid oak or walnut were more usual. Lime and beech were usually white or stained a yellowish colour, while court furniture was gilded. Centres specialising in the production of luxury furniture in both Germany and Austria employed outstanding mastercraftsmen. Joseph Effner, an architect working in Munich from 1725, was influenced by both Cressent and Boulle. However, he made greater use of figurative and naturalistic elements. In contrast to Effner's symmetry, his successor, F. Cuvilliés the Elder, introduced asymmetrical *rocaille*, angel heads and flowers combined into the most charming Rococo ornamentation. The exceptionally sensual and exuberant *Friderizianische Rococo* (after Frederick the Great of Prussia) originated at Potsdam. J.M. and J.C. Hoppenhaupt were among those who created a free-flowing yet controlled asymmetrical *rocaille* combined with naturalistic bird and animal motifs. Among the attractive styles of this time, painted folk-type furniture must be mentioned; its colour and gaiety, added to *rocaille* motifs, secured its popularity until the middle of the 19th century.

France (Louis XVI style). Growing numbers of artists and scholars were visiting Italy and Greece by the mid 18th century. Their essays and lectures familiarised the public with the arts of Antiquity, for which the excavations at Pompeii and Herculaneum created a vogue. At the same time, the creed of a return to simplicity and nature was being formulated. These tendencies were more speedily integrated into furniture design than into the other arts. Thus certain Classical designs such as bead and egg-and-dart mouldings, dentils, triglyphs, herms, caryatids, rams' heads, bulls' and lions' masks, entwined ribbons, scrolls, garlands and rosettes came back into fashion. Everything was small, delicate and elegant. Carving and decorations in bronze were replaced by delicately coloured veneers. From the 1780s, inlays of Sèvres porcelain, Oriental lacquer, miniatures and *verre églomisé*, as well as upholstery featuring bouquets of flowers, came to be considered signs of a cultivated taste. Seat furniture was not only beautiful but also comfortable. From the 1770s, chairs had oval or elliptical backs with pierced cresting. Armchairs and easy chairs remained the basic types. The twisted three-seated sofa known as a *confidante* was a novelty. *Bergères* and sofas usually had straight sides. Console tables rested on a single fluted pillar, though they were later made with four legs linked by cross-stretchers, at the centre of which stood a lyre or urn. As beds were no longer placed in alcoves. each side was richly decorated. Other beds were fashioned *à la greque, à la dauphine* and so

on. Bourgeois furniture remained conservative. Double-doored cupboards (the best came from Brittany and Normandy) were still made, along with low double-doored china cupboards, ladies' writing-tables, work tables (tricoteuses), dining tables (tables de déjeuner) and flower tables. The roll top desk was new. Commodes were smooth and rectangular, usually standing on tapering legs.

J.H. Riesener's furniture was the most beautiful. It was decorated with fruit, vases and flower marquetry, with magnificent bronze mounts representing allegorical figures. In the early 1780s, Riesener's work became more sober while losing much of its magnificence. He now used geometrical marquetry in preference to floral designs. His commodes and secretaires, box-shaped with rounded corners, were made with immense care. Many of the outstanding ébénistes working for the French court were Germans. They included Adam Weisweiler, J.F. Schwerdtfeger and, above all, Abraham and David Roentgen, who supplied all the European courts. One of David Roentgen's specialities was furniture with secret mechanisms and marquetry motifs taken from paintings by Januarius Zick. Roentgen lived in Paris for a few years, between 1775 and 1780, and his best work was done there, generally in light wood with bronze decorations. Georges Jacob was, with Riesener, the leading furniture designer of the Neo-Classical period in France. He was an accomplished woodcarver, producing elegant mahogany chairs with beautiful pierced splats decorated with a lyre, a wheatsheaf or a basket. He was the first to use solid mahogany, a fashion he adopted from England. From 1789 another German, J.G. Benemann, came to the fore. His specialities were massive rectilinear china cabinets with imposing bronze decorations carved by P.P. Thomire.

Neo-Classicism, Empire, Biedermeier. *England.* Until the 18th century, English furniture-makers took not only their shapes but also their ornamentation from Europe, although they usually preferred the styles emphasising an elegant simplicity. The history of English furniture can be divided into three periods, according to the wood used. The oak period extended to Stuart times, when French luxury furniture was imported, as was the more sober — and therefore in a sense more nearly English — furniture from the Netherlands. With the William and Mary style (1689-1702), England began to produce its own designs. This was the beginning of the walnut period. English craftsmen modified the Dutch chair, giving it a higher back, pierced and decorated with scrolled motifs. Light cane-work replaced the upholstery. Chairs were also extended into benches with sides and backs called settees, into small sofas known as love-seats, and into double backless stools. Production of these multiple seats was continued until the 18th century. In the 1690s, floral marquetry became popular, and Dutch techniques and decorations were adopted, depicting tulips, birds and flowers. The bureau cabinet was an important piece of furniture. This was a chest of drawers with a writing top placed on turned legs surmounted with a cabinet. From 1680 to 1720 Dutch-style marquetry and lacquer-work were very popular, and remained so for many years. The most important piece of furniture was the high or low chest of drawers. In Queen Anne's reign the broad arched cabriole leg came into fashion; late in the reign, from about 1710, the claw and ball foot (in which animal claws clasp a ball) also appeared. The Windsor chair, by contrast, was extremely plain. Thomas Chippendale, who made much of his furniture in mahogany, began to influence English furniture design decisively in 1754. He integrated aspects of French and Far Eastern art into his own work, which also included traces of English Gothic; for example, late Gothic elements are combined with Rococo shells. Among his designs are small tripod tables on arched legs, reading tables, card tables, writing desks, beautiful library bookcases with barred doors and scrolled pediments, glazed china cabinets and break-front cabinets (that is, with a projecting centre section). His commodes were in the serpentine French style. Chippendale lavished painstaking care on his chairs, made with lightly carved, straight suare-section legs based on Chinese and Gothic models. His creative imagination was given full play in the decoration of the splats, which were fretted and arched with a pattern of ribbon-work or of knots or scrolls, flowers or foliage.

With the Neo-Classicism of Robert Adam we

reach another stage of decorative art in which the more austere and purely Classical decorations are employed. The fronts of his semicircular commodes were ornamented with delicate marquetry and paintings (heads, pillars, vases or trophies, on oval fields surrounded by garlands of laurel leaves and ribbons). His table-friezes were decorated with palmettes, meanders and rosettes; the tops were painted with figures, ornamented with ormolu or carved motifs, or finely inlaid with simple geometrical designs. The works of George Hepplewhite and Thomas Sheraton are variations of Adam's style. They made several types of cupboard in which they discarded carving in favour of bringing out the natural grain of the wood. Both made designs for side tables, writing-tables with cylindrical tops, dressing-tables and night tables. Like Adam, they did beautiful work on chair-backs. Hepplewhite carved his oval frames with festoons of husks and with the Prince of Wales's feathers. He also made fan, heart and shield shaped frames. Sheraton simplified the chair still further, choosing square or rectangular backs with vertical fillings. He also reintroduced cane seats, which had been out of fashion for some thirty years.

Remarkable changes in the English decorative style took place in the Regency period. Furniture has sweeping 'Greek' curves and scrolls and is richly carved and gilt. 'Trafalgar' chairs with outward-curving legs and carved back rests became popular. Dining-tables had rounded ends and a simple pedestal support and the attractive sofa-table was introduced. Towards 1812 the art of brass inlay in the manner of Boulle was reintroduced for bandings and friezes.

France. The French Empire style was a development of the Louis XVI style, a new style based upon admiration of ancient Greece and employing motifs taken from Classical art. The age was rich in gifted and creative artists, among them the great architects who more or less created the Empire style, Charles Percier and Pierre Fontaine. They sought inspiration from the newly discovered buildings of Antiquity, adopting the proportions of Classical interiors. They covered their walls in brilliantly coloured silks or with tapestries. These new artistic conceptions, with their accent on the heroic and romantic, gave rise to a splendid and majestic art of sober luxury which was expressed in smooth, admirable proportions, and strictly symmetrical design both in the furniture itself and in its disposition within the room. Beautifully carved decorations, the most outstanding of which came from Thomire's workshops, were made of polished or matt bronze, and featured palmettes, egg-and-dart moulding, acanthus foliage, wreaths of laurel, lions, Egyptian caryatids, sphinxes, swans, vases and dolphins. Equally important were the columns, pilasters and cornices. Every piece of Empire furniture was based with extraordinary consistency on the same general conception, and there is a striking family likeness between all the objects made in this style. The major ébénistes of the first twenty years of this period were Georges Jacob and his successor Jacob-Desmalter. The most remarkable pieces were the beds, usually without canopies. A favourite was the boat-shaped bed. Next to the bed went a night table with a decorated front. Tables for all purposes were richly ornamented; four-legged writing-tables and writing-tables with side cupboards or with a tambour front were widely used. A new type of secretaire with a fall-front became popular; simple commodes had either two doors or drawers. Ordinary tables, following Classical patterns, were mainly round, though some were octagonal. Console tables were supported by a carved figure, sometimes with a mirror back. Washstands had a shelf for the jug; the bowl was supported by swans. Dressing-tables had mirrors attached to the drawer. Quite new were the adjustable mirrors on a stand, known as *Psychés* or cheval glasses and found in bed- or dressing rooms. All types of seat furniture were characterised by heavy construction, the front feet being at first round pads but later voluted. To complete the furnishing were small work-tables, flower tables and multi-shelved *étagères* with fretted fronts. And then piano cases followed the design of the rest of the furniture.

Germany. At first Germany was reluctant to accept the Neo-Classical style and Rococo forms continued there for much longer than elsewhere. The new style was first expressed only in terms of ornament, bead mouldings, garlands and festoons, being used in carving and inlay work. Although German taste may

not always have been impeccable, the technique was outstanding. Furniture from the Aachen-Liège region remained very much under French influence, whereas local craft traditions held sway in Lübeck and along the north coast, where the heavy white furniture was beautiful and simple in the best Danish and Swedish manner. Cupboards were Classically ornamented. German furniture also came increasingly under English influence: in Hamburg and Berlin particularly, growing numbers of English chairs were to be seen in broad-cut veneer made from imported mahogany, which superseded such local woods as pine, walnut, cherry and pear. Even the Biedermeier style of the 1820s which will be discussed later showed English characteristics, sharing with the Queen Anne style a love of fine grained surfaces and subtle lines. Biedermeier work-tables, writing-tables, tallboys and, later on, glass cabinets and bookcases possessed this refined simplicity. As far as luxury furniture was concerned, France still led the way, partly thanks to David Roentgen, whose still-lifes of flowers, birds and animals were famous. They were much appreciated in Germany, where both *chinoiserie* and the Dutch imaginative allegorical style eventually caught on. The demand for this type of luxury furniture was mainly confined to the courts of the ruling families, and particularly those of the Confederation of the Rhine, formed under the aegis of Napoleon. German society was differently constituted from that of France; in particular, the German middle-class was nowhere near as prosperous as the French bourgeoisie, and their houses were therefore modestly furnished. And, too, the Baroque and Rococo tradition was still very much alive in Germany. The influence of English interior decoration was clearly visible in the North and Baltic Sea towns. In Berlin, too, Karl Friedrich Schinkel, who admired the English Neo-Classical school, was producing Classical designs. Leo von Klenze in Munich was nearer to the French styles. The gentle decorative Vienna style united comfort with a cultivated taste.

The architect Leo von Klenze also designed furniture and interiors, influenced by the style of the French Empire but also by Greek and Italian Renaissance decoration. His furniture was simple, light and comfortable.

The Biedermeier period was restricted to Germany, Austria and Switzerland from 1815 to 1848 and particularly Vienna. It was a reaction against the formality of the Empire style and grew out of bourgeois furniture fashions around 1800. It was typified by broad, flowing lines, circles and ovals, by gentle curved surfaces, by comfortable chair backs and rounded corners. The desire for comfort led to the manufacture of broad divans and sofas. Whole suites were made of these, plus matching tables and chairs, and prominently displayed. Three-part Sheraton-style cupboards were favoured, and bookcases too were three-part, in the English fashion. China, clothes and linen cupboards had smooth surfaces, only the corners being supported by pilasters. Secretaires were still in demand; they varied from province to province, being fitted with either a superstructure or a pediment reminiscent of a Gothic cathedral façade. The interior was fitted with small pillars, mirrors, drawers and secret compartments. The whole was decorated with painting or coloured veneers. Favourite woods were ash, cherry, birch, pear and mahogany. Homes overflowed with such smaller pieces as work- and flower-tables, wastepaper baskets, multiple-storeyed étagères for porcelain and books. Bronze mounts were in limited use and confined to handles and corner mounts, employing small lyres, horns of plenty and swans. Upholstery was in rep or richly coloured rose-flowered cretonne. Wallpaper was either plain or patterned with flowers and tendrils.

Eclecticism. Biedermeier was the last creative effort of the 19th century. Retrospective tendencies, already present in Neo-Classicism, had become marked in the first half of the century as Neo-Gothic styles developed from Romanticism. These were replaced in Germany and Austria by the 'second Rococo' period from 1840 to 1860. This was followed by the Neo-Renaissance of the 1880s with its typical heavy sideboards. It was towards the end of the century that the style associated with the Austrian painter Makart, with its overloaded decoration and over-full interiors, gave way to decor in the 'Oriental' manner, expressed in such articles as carpets, divans, mother-of-pearl tables and vases. In France, the Second Empire smothered memories of the heroic Napoleonic age in a mass of draper-

ies and large upholstered pieces of furniture. This was ostentation at its worst, hopefully attempting to disguise a lack of creative spirit; it was also the trademark of the new rich who had made their money out of commerce and industry. The Industrial Revolution affected furniture production even more directly, leading to the mass-production of inexpensive but impersonal goods of all sorts and bringing about the decline of handicrafts. A contributory factor, nonetheless, was the artistic uncertainty of craftsmen and handicraft schools. During this period of general eclecticism, in which artists and craftsmen borrowed freely from all periods and all countries, Michael Thonet was the only furniture-maker to come up with an original idea. About 1830 he discovered a method of bending laminated woods and birch rods in steam from which he made light, fanciful furniture.

Art Nouveau. Towards the end of the century, there was a reaction against the pompous plagiarism of established art and the mass-production of ugly furnishings. Critics and writers, poets and painters, architects and illustrators, championed simple and above all functional art, logical construction and conscientious craftsmanship. Although independent groups with roughly the same idea appeared almost simultaneously in England, France, Germany and Scotland, Munich was in fact the first. It was there that Georg Hirth, a publisher, founded a magazine called *Die Jugend* (Youth) from which the new style took its name in Germany, *Jugendstil*. In England, John Ruskin was a powerful influence on the new movement looking back to the craftsmanship of the Middle Ages. The Scottish architects went their own individual way, with Charles Rennie Mackintosh at their head. Vienna was an important centre of the new movement, known as the Sezession; a firm of that name was set up in 1897 under the management of G. Klimt and J.M. Olbrich. Local stylistic features originated here such as mother-of-pearl and ivory inlays and plaques with motifs taken from east European art. In France, Art Nouveau possessed certain Rococo tendencies, and here furniture was characterised by sinuous curves and romantic plant forms.

Advice to Collectors

The growth of antique-collecting has brought with it a widespread international trade in fakes. The only protection against this is the painstaking study of all aspects of antique furniture — shapes, decoration, artistic standards, materials and the technical quality of the workmanship — and, of course, reliance upon expert advice. Faking is now done with very great skill. However, fakes are usually made of cheaper materials treated to counterfeit more expensive woods. Thus we find pear, apple or fir stained with sulphates and chloride as imitation ebony; beech or lime dyed with aniline to represent walnut; and walnut or oak coloured with bichromate to simulate rosewood. Fakers have a wealth of technical aids at their disposal. One of their less harmful activities is the repair of damage caused by woodworm or poor workmanship. Of a more serious nature are so-called restorations and the making good of missing drawers, doors, legs, plinths, etc. But these can always be recognised because modern tools leave unmistakable traces (regular grooves and so on). The practice of making two or three antiques out of one original by manufacturing additional parts can be recognised by the differences in wood graining. The drawer dovetails — the older ones had more pronounced shaping — are just as revealing of the fake as the rebate on the corners. Other signs are a smooth back and planed interior, veneer that is too thin (under 2 mm), new locks, machine-made screws, added beading or carving (noticeable from its sharp edges), galvanised yellow bronze mounts or new, carelessly finished castings of old parts or superimposed inlay. Fakers are of course experts at manufacturing woodworm holes or using new wood from a worm-infested store. They are also able, by means of mechanical rubbing, to age a piece of furniture until it has the appearance of, for example, a Rococo chair or a French writing-table dating from 1750-80. The French excel at this. Fakers also make *cassapanca* out of old chests, and complete cupboards out of a pair of old doors. Excellent copies of japanned furniture can be detected if they lack the appropriate wooden nails. Wood surfaces which have been subjected to fierce mechanical 'wearing' are sprayed with cellulose polish which has a hard gloss and a greenish shimmer. Fake signatures, both burnt-in and impressed, excite suspicion by their prominent positions. Fake peasant cupboards with 17th- or 18th-century façades have strickingly smooth sides. The alert collector can see all this from an examination of the piece. It is this which leads him to the genuine antique.

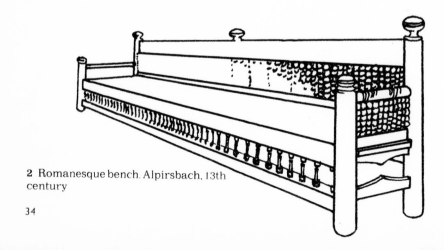

2 Romanesque bench. Alpirsbach, 13th century

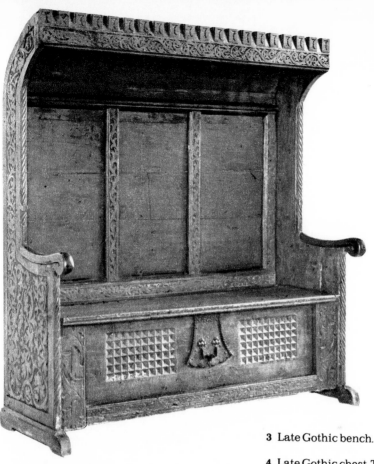

3 Late Gothic bench. Switzerland, *c.* 1500

4 Late Gothic chest. Tyrol, *c.* 1500

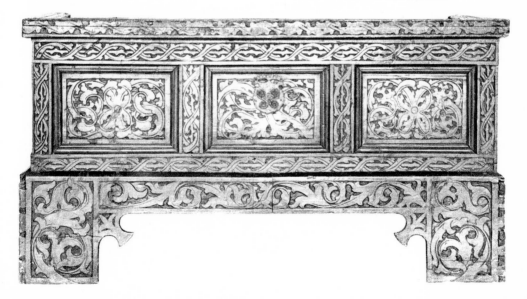

5

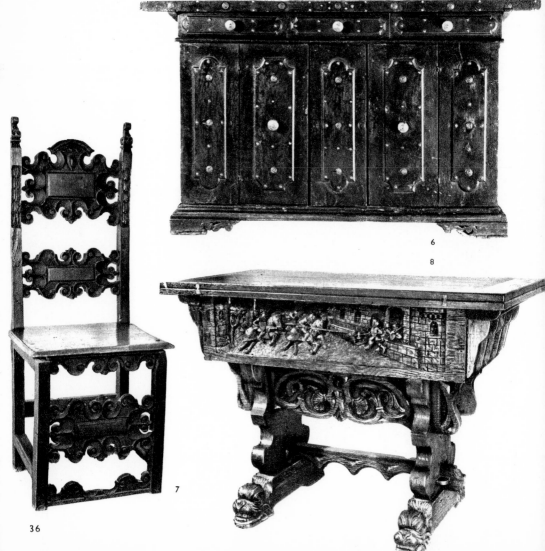

6

8

7

36

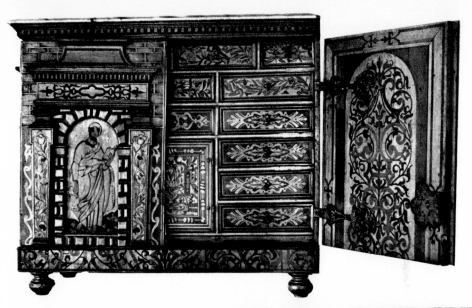

9

5 *Cassone* (wedding chest).
Lombardy, *c.* 1465
6 Renaissance sideboard. Siena,
second half of 16th century
7 Renaissance chair. Lombardy,
end of 16th century
8 Renaissance hutch table, carved.
Northern Germany, after 1600
9 Renaissance cabinet, inlaid.
Bohemia, *c.* 1600
10 Renaissance X-chair. Italy,
16th-17th century
11 Cupboard with relief
medallions; Renaissance.
Westphalia, *c.* 1550, copy

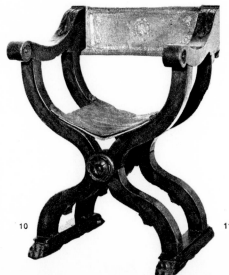

10

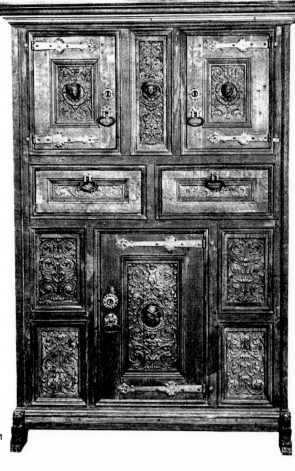

11

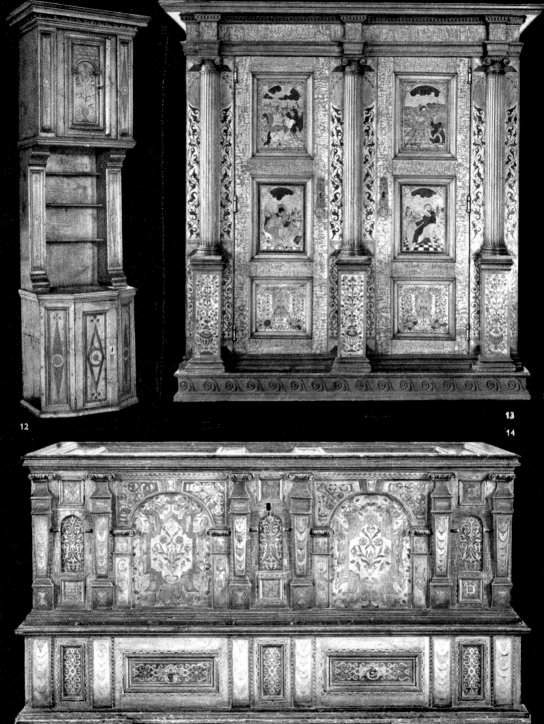

12

13

14

12 Renaissance washstand, inlaid. Cologne, second half of 16th century

13 Renaissance cupboard with inlays on religious themes. Nuremberg, *c.* 1560

14 Renaissance chest, inlaid. Switzerland, *c.* 1600

15 Two-storeyed cupboard; Renaissance. Swabia, beginning of 17th century. Copy

16 Rare example of an oak wainscot chair. New York, *c.* 1680-1700

17 Renaissance secretaire (vargueño), encrusted; Spain, second half of the 16th century

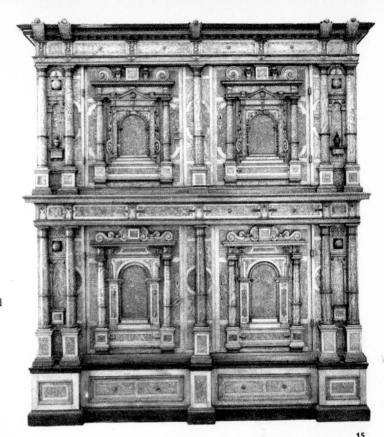

15

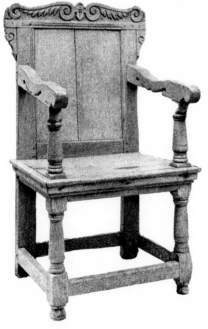

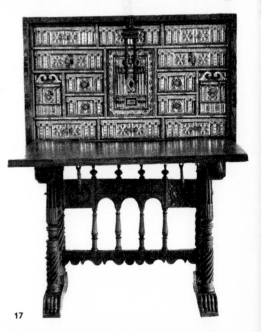

16 17

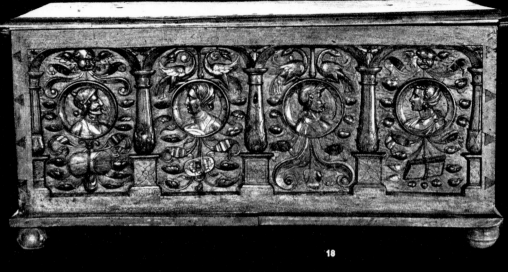

18

19

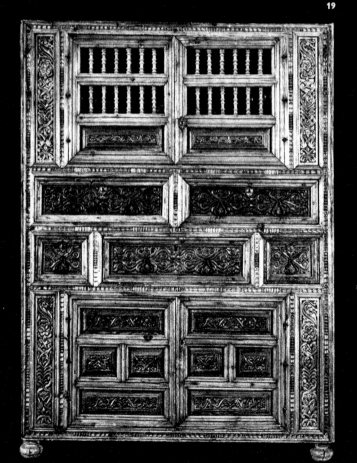

18 Renaissance chest with
medallions. France, first
half of the 16th century
19 Carved Renaissance
document cupboard,
England, second half of the
16th century. Copy
20 Rosewood card table
made in New York City,
c. 1850-5
21 Commode, Boulle style.
France, late 17th century

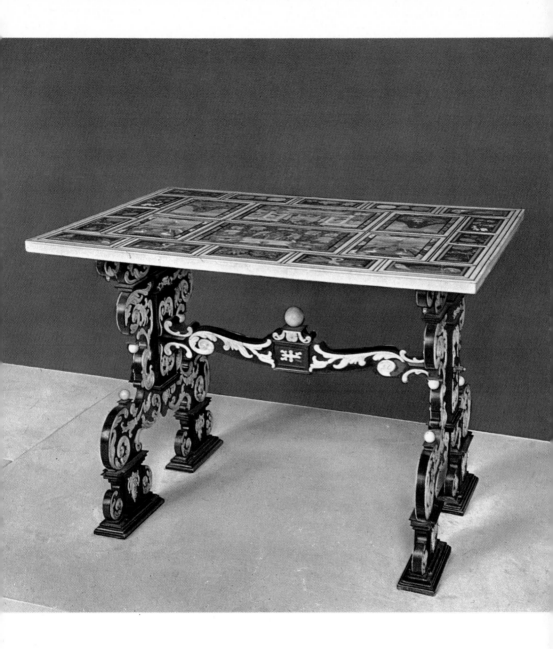

I Table inlaid with marble; early Baroque.
Prague, first half of 17th century

II Black japanned jewel cabinet,
chinoiserie. England or Holland, second half
of 18th century

▶

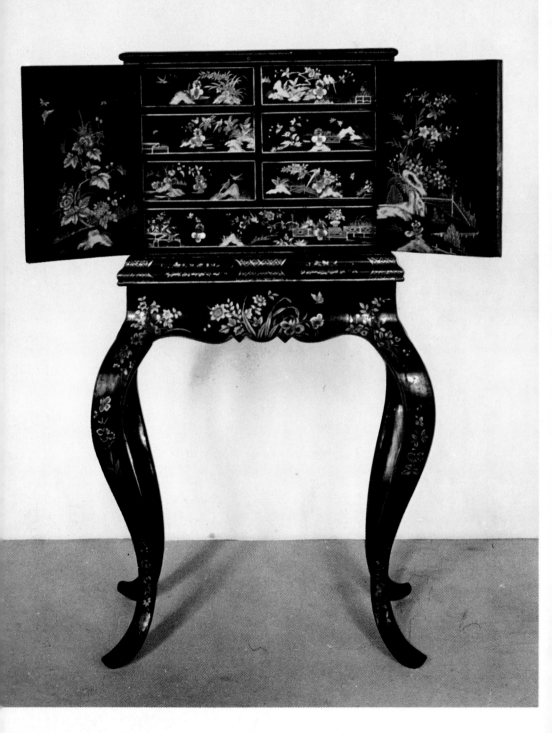

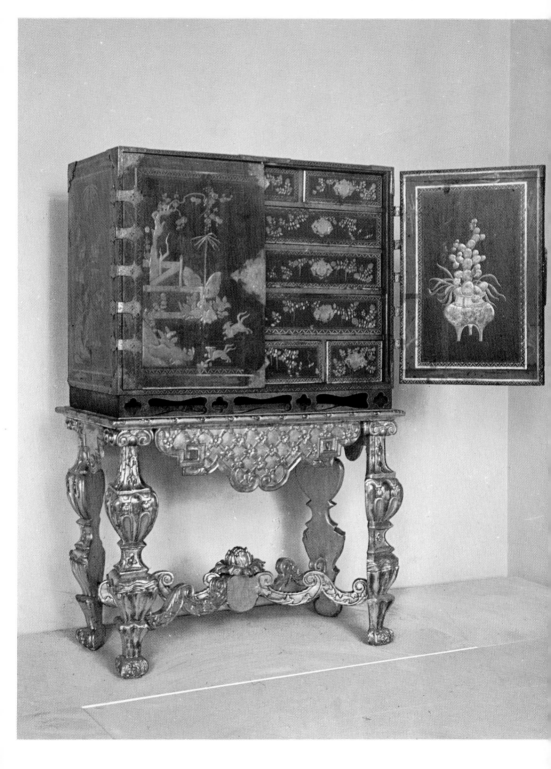

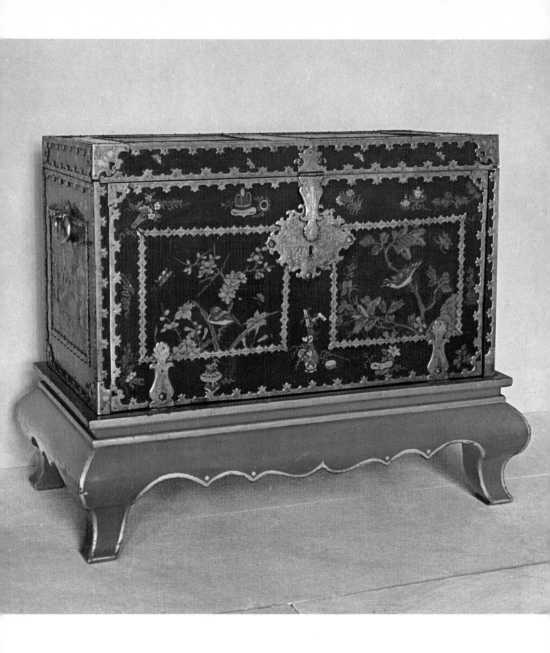

III Black japanned cabinet, *chinoiserie*.
England, first half of 18th century

IV Black japanned chest, *chinoiserie*.
England, second half of 18th century

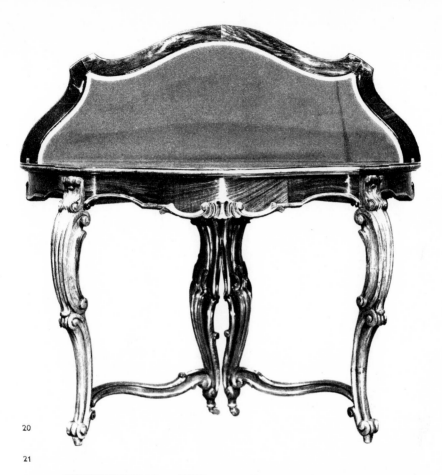

20

21

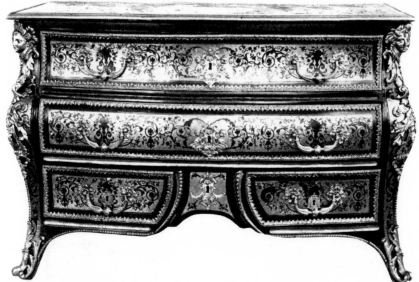

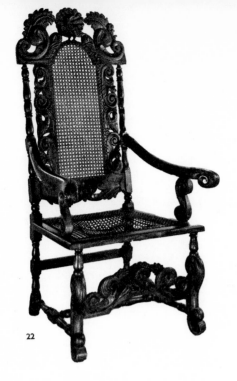

22

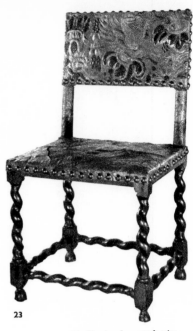

23

22 Carved armchair;
early Baroque. Germany,
17th century
23 Chair; early Baroque.
Germany, middle of the
17th century

24

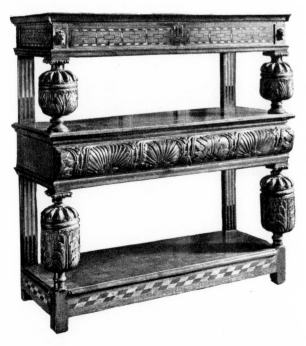

25

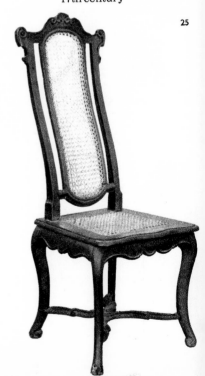

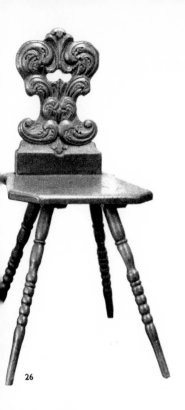

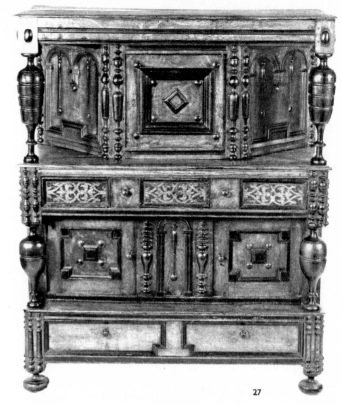

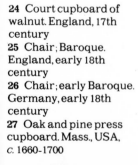

24 Court cupboard of
walnut. England, 17th
century
25 Chair; Baroque.
England, early 18th
century
26 Chair; early Baroque.
Germany, early 18th
century
27 Oak and pine press
cupboard. Mass., USA,
c. 1660-1700

28 Tabouret; early
Baroque. Bohemia, last
quarter 17th century
29 Chair with floral
intarsia; Baroque.
Holland, second half 18th
century

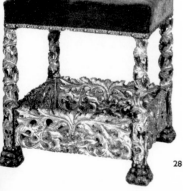

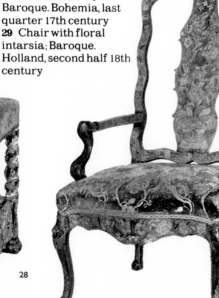

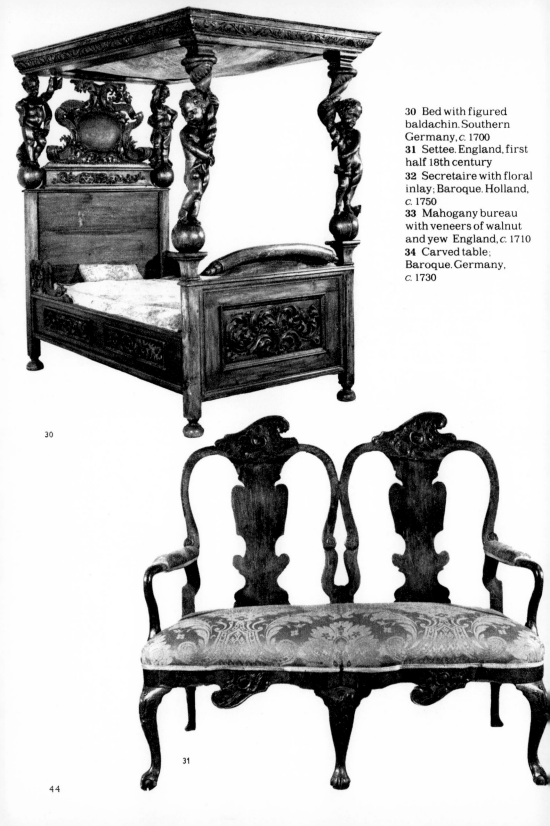

30 Bed with figured baldachin. Southern Germany, *c.* 1700
31 Settee. England, first half 18th century
32 Secretaire with floral inlay; Baroque. Holland, *c.* 1750
33 Mahogany bureau with veneers of walnut and yew. England, *c.* 1710
34 Carved table; Baroque. Germany, *c.* 1730

30

31

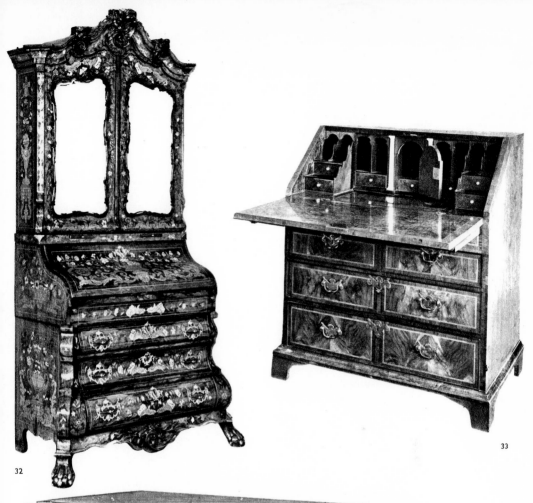

32

33

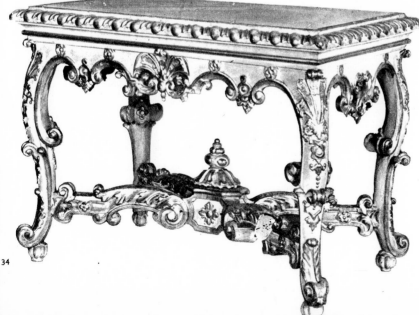

34

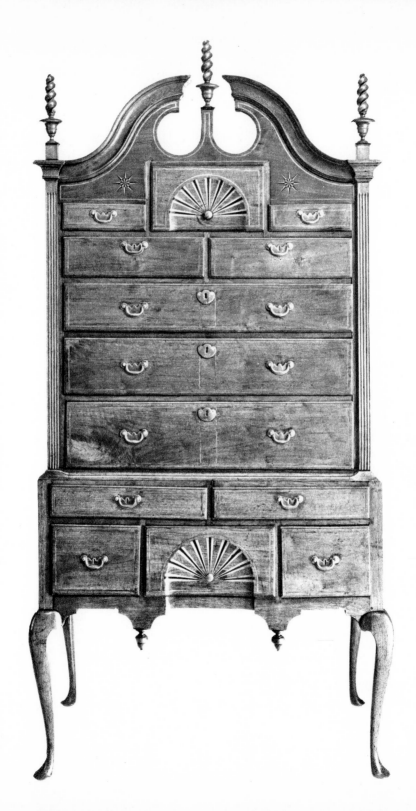

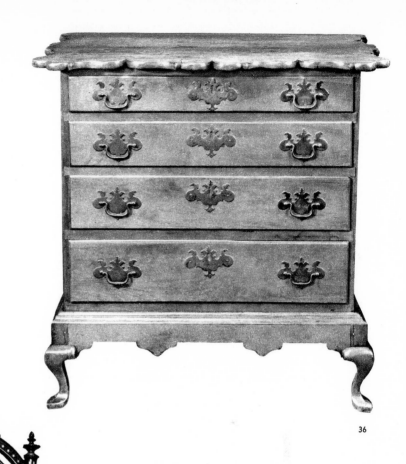

36

35 High chest of drawers. USA,
c. 1725-40
36 Chest of drawers; Connecticut
River Valley (?) U.S.A., *c.* 1750
37 Ebonised mahogany armchair
with gilt decoration. New York, USA,
c. 1875

37

47

38 Lamp console with figure;
Baroque. Austria, first half of 18th
century
39 Sofa, carved and gilt beechwood,
made by the firm of Gillow, England,
c. 1805
40 Etagère; Rococo revival. Bohemia,
c. 1850

38

39

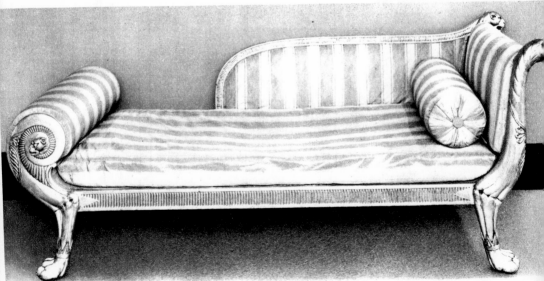

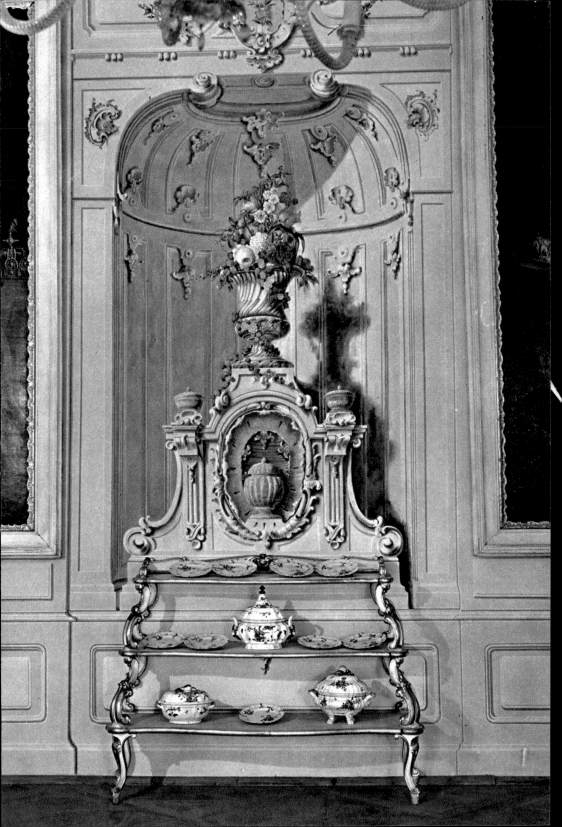

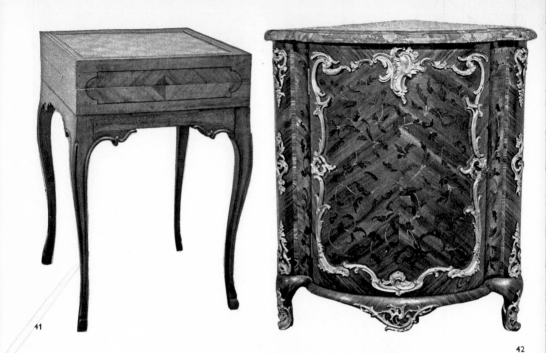

41

42

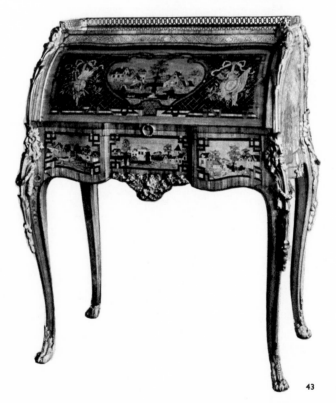

43

41 Games table, inlaid; Rococo. Bohemia, *c.* 1750

42 Corner cupboard (encoignure); Rococo. France, 1740-50.

43 Writing-table with coloured inlay; David Roentgen. 1770-80

44 Commode, inlaid in Robert Adam style. Late 18th century

45 Secretaire inlaid with Sèvres porcelain plaques. Adam Weisweiler, *c.* 1780

46 Drop-front secretaire. David Roentgen, *c.* 1770

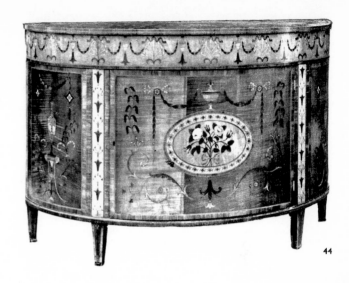

44

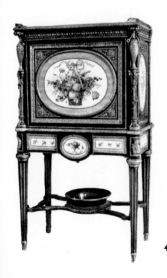

45

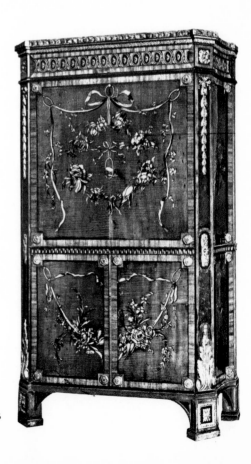

46

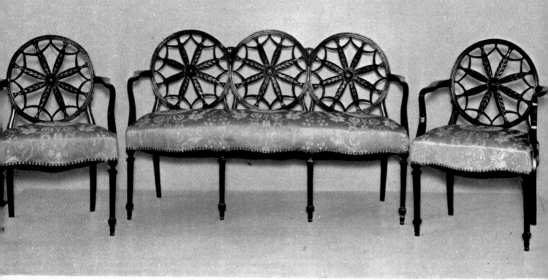

47 Settee and armchair suite, Hepplewhite style. England, late 18th century
48 Commode with marquetry; Neo-Classical. Italy, c. 1790

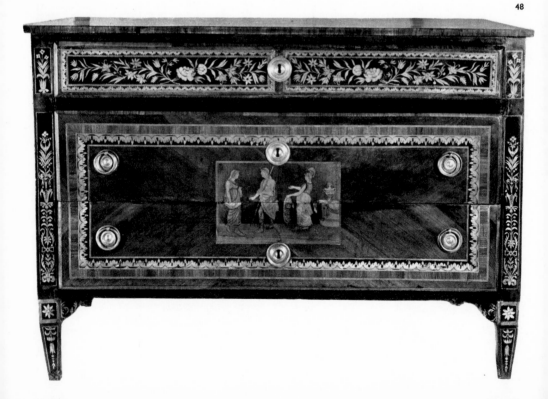

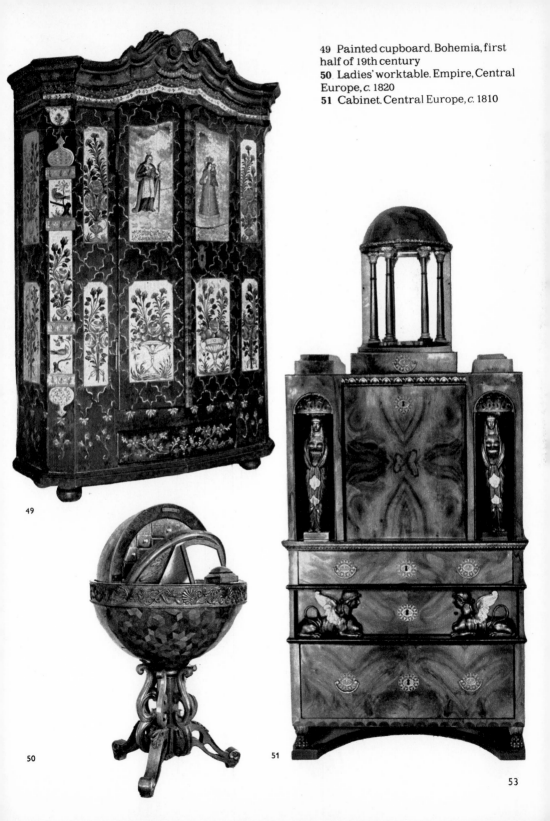

49 Painted cupboard. Bohemia, first
half of 19th century
50 Ladies' worktable. Empire, Central
Europe, c. 1820
51 Cabinet. Central Europe, c. 1810

49

50 51

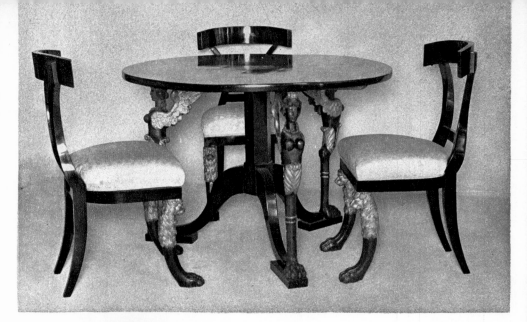

52

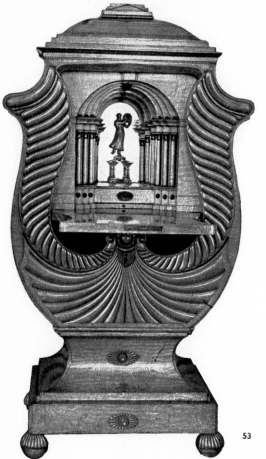

52 Table and chairs; Empire. Central Europe, *c.* 1810
53 Ferdinand V Cabinet; Biedermeier. Vienna *c.* 1830
54 Table; late Empire. Bohemia, *c.* 1830
55 a - d Four chairs; late Empire. Bohemia, *c.* 1830-40
56 Table and upholstered suite; late Rococo. Bohemia, *c.* 1850

53

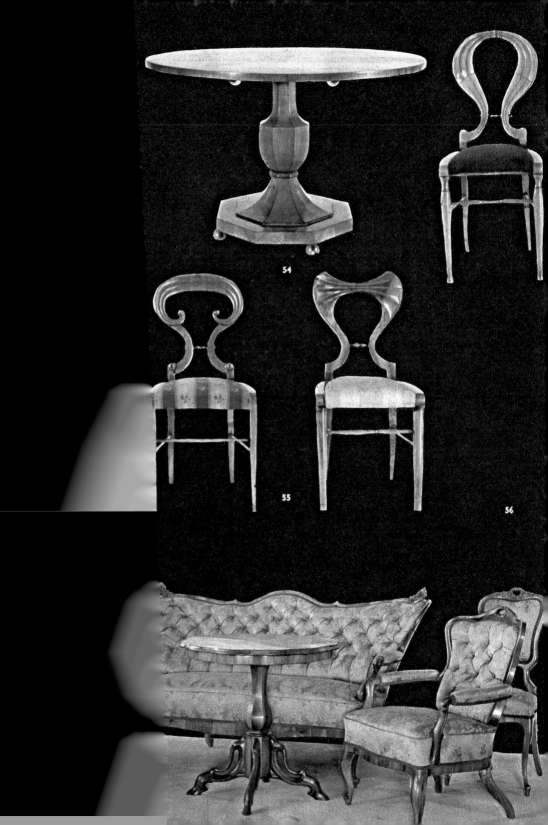

54

55

56

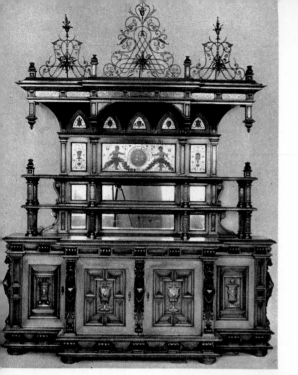

57 Sideboard, Renaissance revival style.
J. Koula, Bohemia, 1886
58 Cupboard, Art Nouveau. L. Majorelle.
France, c. 1900

57

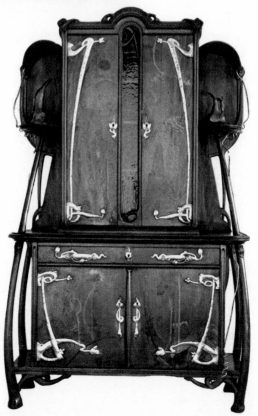

58

TAPESTRY

Tapestry is known by various names derived either from its place of origin (Arras, Gobelins) or from its type (hanging, Berlin wool work). However, none of these descriptions is precise, and they change according to time and place. Le Corbusier introduced a new term — *muralnomad* — at the first Biennale International de la Tapisserie at Lausanne in 1962. This term embraces the two basic qualities of a tapestry — that it can be hung and that it is easily transportable. Mural = wall decoration + Nomad = movable.

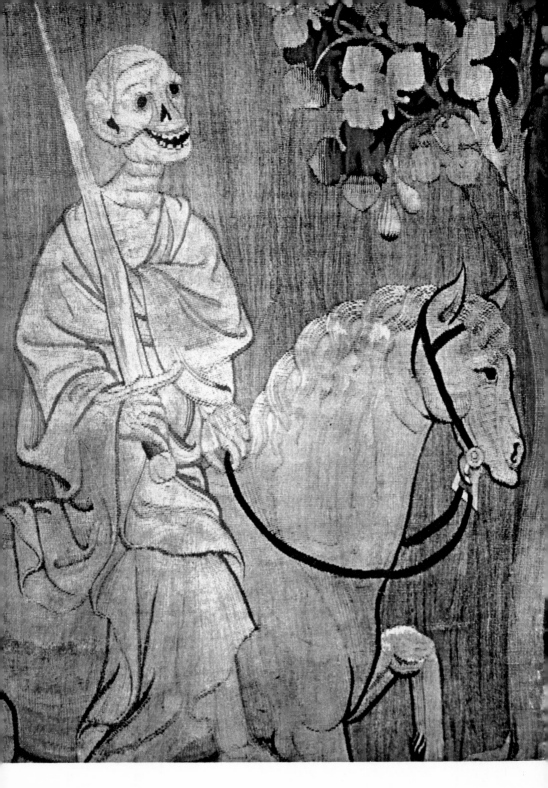

Manufacture

Tapestry weaving, which has been known since ancient times, is such a simple process that it can be carried out on the most primitive looms. All that is required is a frame upon which the warp threads are stretched. The classical French techniques involve weaving coloured weft threads back and forth sufficiently closely together to cover the warp ends completely. Each coloured wool thread is wound round a separate bobbin which, after use, is left hanging on the back of the work until it is required again. Should this be not too far from the original spot, it can be used without cutting the thread. In other tapestries there are frequent variations in the technique used. For example, the tapestry can be worked sideways if this is more convenient; or the weft can cover two or three threads at a time instead of the normal one. In other cases, knots, loops or embroidery are combined with the basic weaving technique; even painting is used. Tapestry weavers use either a vertical loom (high warp) or a horizontal loom (low warp). The warp ends are stretched between two cylinders, the completed part of the tapestry usually being rolled over on to the bottom one. To facilitate work on high warp looms, the even-numbered warp ends are separated from the odd ones by a rod. Each odd end is grasped by a heddle or cord which is attached to a heddle rod or stave so that the weaver can easily draw the weft towards him. The low-warp loom is similarly arranged, but the warp ends are attached to shafts controlled by pedals.

In high-warp weaving the designer's cartoon is used as a guide to which the weaver refers after he has traced the main lines of the design on to the warp. But in low-warp weaving the cartoon is placed beneath the warp. The tapestry worker stands behind the loom, on the wrong side of the tapestry and although he uses a mirror to watch his progress he does not see the completed tapestry until the work is removed from the loom. In France the classical Gobelins upright loom is always used. A number of contemporary artists not only make their own designs, but also weave the tapestries themselves. That being so, a finished cartoon is seldom prepared, and the artists use high-warp looms in order to be able to observe the work in progress.

The thread is almost always of wool, although cotton or linen are frequently used for the warp. However, in the past, when tapestries were often replicas of paintings, silk was the usual medium because its fineness permitted the reproduction of minute details. Where gold or silver was required, the silk thread was intertwined with the metal thread. In the past, threads were coloured with vegetable dyes from which the great variety of tones and shades required by designs were obtained. Only a limited number of colours were employed in Gothic tapestries, but hundreds of shades were often needed for Baroque replicas of paintings.

Tapestries are made from cartoons; the job of the cartoonist is to reproduce every line and detail with sufficient clarity for the weaver to be able to work from it. The weaver's job is to select the best shades and hatchings for the given design. He should, in short, professionally interpret the cartoon and not slavishly copy it in textile terms.

The number of warp ends per inch is not necessarily an indication of quality. Wool tapestries have an average of 12 to the inch and silk 20-30 or more according to the thickness of the thread. Recently tapestries have been made using very much thicker threads. However, wear and quality depend above all upon correct warp tension and the coverage afforded by the weft, as well as upon the regularity of the work and the quality of the materials. Subtle colour gradations from dark to light are achieved by using a great many different threads of very slightly varying colour density. In Gothic tapestries the transition was clearly visible because of the small number of colours available, but by the Baroque period the existence of a large number of shades made for more convincingly naturalistic effects. Slits occur when two colours which are not interwoven meet over a large area but they can later be sewn together.

Historical Survey

Tapestry weaving is among the most elementary and certainly among the oldest methods of producing textiles. A linen cover decorated with woven lotus blossoms and scarabs (Egyptian Museum, Cairo) was found in the tomb of Pharaoh Thutmose IV; it dates back to 1400 BC. The Hermitage Museum, Leningrad, has a Greek tapestry from the 4th century BC with a similarly woven design based on ducks; it was recovered from a tomb at Kerch in the Crimea. Similar materials, patterned with figurative and ornamental designs, formed part of Coptic clothing from the 4th to the 10th centuries. Of these, however, only fragments remain. They rarely indicate exactly how these textiles were used, but when they do, it is quite clear that their function was very different from that of later tapestries. Their true history begins in Germany.

Romanesque period. *Germany.* The earliest existing tapestries, such as the wall hanging in St Gereon's Church in Cologne, are not the large compositions we associate with later tapestries. They rather crudely reproduce Byzantine silk weaving patterns common in the 9th and 10th centuries; the technique is still poor, the colours and dyeing primitive and the warp loose. They were probably made along the Rhine valley in the 11th century. The wall hangings in Halberstadt Cathedral, however, are true tapestries, with motifs taken from Romanesque frescoes (the Angel, Apostle and Charlemagne tapestries). At this time — the 12th and early 13th centuries — a few examples of a provincial character were also made by weavers in the Scandinavian countries.

Gothic. *France.* After its beginning in Germany, the development of tapestry-making appears to have been interrupted, for no known examples have come down to us from early Gothic times. It was not until the early 14th century that the high-warp weavers' corporation was established in Paris. Under its auspices, carpets, wall hangings, curtains, throne canopies, altar cloths and so on were produced for the next fifty years. Tapestry techniques were certainly used for some of these; others were reputed to be some kind of silk or embroidery. But the true French tapestry technique was not perfected until the time of Charles V; he and his family became the powerful patrons of the industry. The commonest themes were scenes from the Old and New Testaments, scenes from tales of chivalry, hunting scenes and symbolic representations of the months of the year. It was at this period that the merchant *tapissiers* came to the fore, the best known being Nicolas and Colin Bataille and Jacques Dourdin. Nicolas, who was active about 1400, was responsible for the first outstanding series. This was ordered by Charles V's brother, the Duke of Anjou, and depicted the Apocalypse. Destined for Angers Cathedral, it consisted of ninety scenes and measured 150 metres in length. Here tapestry already displays all its distinctive characteristics: a pure weft face and a monumental figurative style employed in a series of tableaux taken from wall and easel pictures as well as miniatures.

Churches and cathedrals apart, tapestries were at this time to be found only in royal dwellings. Here they insulated the stone walls of the interior from both noise and cold, and divided the rooms into smaller apartments. They were similarly used in churches, either as wall hangings or stretched between the pillars along the nave. Here pictures based on religious themes, often in series, served the faithful as a tapestry version of the frescoes which constituted the 'bible of the people'.

The Netherlands. During the last quarter of the 14th century, workshops were set up in the frontier region of northern France and Burgundy in close association with the Paris workshops. The most important was in Arras, where Philip the Bold was its patron. The themes treated were now expanded to include medieval history. The courts of France and Burgundy favoured hunting and courtly love scenes; some of the most famous are

now in the Cluny Museum in Paris. The mutual emulation of French and Flemish tapestry weavers stimulated the production of fine works, and the art of tapestry-making was also influenced by such leading painters as Jan van Eyck and the Limburg brothers.

Towards the middle of the 15th century, Arras was superseded by Tournai, where a flourishing school of artists had a beneficial effect on tapestry design. Pasquier Grenier's beautiful work for Philip the Good dates from this period. He introduced a note of lively realism into the rather strict ceremonial style which was favoured; this style was particularly decorative in its treatment of the drapery of clothing. An individual Flemish style strongly influenced by the painting of Hugo van der Goes grew up in Brussels. The principal patrons were the Emperor Maximilian of Austria (son-in-law of Charles the Bold of Burgundy) and Philip the Fair. The main producer was Pieter van Aelst.

Germany. It seems that it was not until the end of the 14th century that tapestry-making was resumed in Germany. By contrast with French and Netherlandish work, German tapestry-making remained a domestic art, mainly done by the wives and daughters of the bourgeoisie or by nuns in cloisters. The secular themes of German tapestries were suggested by the love poetry of this age of pageant and chivalry: the *wilde Männer* (rustic) tapestries and the *Minne* (love) tapestries. They were chiefly made of wool, were rather small in size, and were used either as altar frontals or choir stall dossals, or as curtains for domestic use. They were made in various places. From Nuremberg, for example, came rather crudely executed tapestries inspired by woodcut techniques and based upon cartoons by Pleydenwurff and Wolgemut. The Bamberg tapestries, with their Biblical themes including the gifts of the Wise Men, were probably made by the nuns at the Dominican Convent of the Holy Sepulchre. These tapestries are particularly interesting in that they are the first to carry a German mark. In Basle, Lucerne and the Aargau, epic sagas and erotic themes were largely used, inspired by the painter Konrad Witz and his school; in Strasbourg, legends of the saints were popular, again in a style reminiscent of woodcuts.

Late Gothic. *France.* In the second half of the 14th century, following the outbreak of the Hundred Years' War with England, the development of French tapestry production was suddenly interrupted. New centres arose in Tours and Touraine, but tapestry weaving was not to flourish again in Paris until the middle of the 16th century. The Tours workshop specialised in long dossals for choir stalls depicting a sequence of subjects very much in the style of Pasquier Grenier. Figurative scenes were enclosed in late Gothic architectural frames with considerable background detail and with rich floral foregrounds. Similar ecclesiastical tapestries were produced until the middle of the 16th century. A charming explanation of the origin of the typical Touraine tapestry has it that the flower decoration (known as *à fleurette* or *millefleurs*) is connected with a Corpus Christi festival still celebrated in France today. The streets through which the procession passed were decorated with hangings upon which real flowers were sewn. This was translated into tapestry by means of a black background upon which hundreds of tiny stylised flowers were strewn. This floral ornamentation was used as a background for such subjects as a chamber concert or hunting scene. The famous series of tapestries known as *The Lady with the Unicorn* (Cluny Museum) was also made here. The detail includes not only flowers but also the lavish court dresses of decorative patterned materials.

In the Loire area a great number of large tapestries were made at Felletin and Aubusson, but the delicate flower ornamentation eventually declined into a lifeless formal pattern which survived as a local handicraft in cushion covers and curtains.

Renaissance. *France.* In 1539, Francis I invited a colony of Flemish weavers to Fontainebleau to decorate his palace with tapestries. They were supervised by the architect Philibert de l'Orme, who used designs by Giovanni da Udine, Bachiacca, Bronzino and others. Following the style developed by Jacques Androuet Ducerceau, new motifs involving herms, cartouches and masks were introduced.

Under Henry II, Paris again became the court capital. A new period in French tapestry-making began — of which the details are still not entirely clear. The oldest

workshops were attached to an orphanage, the Hôpital de la Trinité, where children were trained in tapestry-making. Production continued there until the mid 17th century. Early in the century, Henri IV founded a workshop in the Louvre. In 1601, he invited two Flemings to Paris. They were François de la Planche (or van der Planken) from Oudenaarde and Marc de Comans of Brussels. He set them up in the Faubourg St Marcel, on the banks of the small River Bièvre, where they were accorded considerable royal privileges. Another workshop was opened in the Faubourg St Germain, where Raffael de la Planche, on of François' sons, worked. All workshops were influenced by the academic Renaissance school of painting represented by Vouet, Poussin, Corneille and Philippe de Champagne. Their designs consisted mainly of illustrations of stories from the Old and New Testaments and from Classical mythology. These were realistic figure compositions in Renaissance style against a landscape background. The borders were purely decorative, comprising scrolls, ribbon work, cartouches, masks, trophies and medallions in endless permutations. Craftsmen evidently found no difficulty in keeping pace with the artistic developments; technical ability was at its height and the colour range very wide indeed.

Flanders. The prosperity of the court at Brussels in the early 16th century under the regent, Margaret, resulted in a like prosperity in the Brussels workshops, the output of which was almost at a factory level. The most impressive and creative personality was Master Philip, who designed more than a hundred tapestries. They were based on Old or New Testament stories or else were flower tapestries in the tradition of the Touraine *verdures*. They were extremely decorative and complex compositions of figures dressed in sumptuous clothing, the folds of which were particularly emphasised; the faces were expressively rendered. Master Philip's individual style was copied until it became stereotyped and conventional. Flemish late-Gothic styles and early Italian Renaissance arabesques were combined in extraordinary fashion with acanthus foliage, volutes, masks, sirens and *putti*. The painters Hugo van der Goes, Gerard David and Quentin Massys all influenced figure composition in

tapestry design. In 1528 the Brussels authorities ordered the city's tapestry weavers to mark their products with two Bs flanking a small red shield. Regulations governing the quality of the weave were laid down. Copying a tapestry by another craftsman was forbidden, and cartoon copyrights were recognised, though these provisions were later completely disregarded. The painting in of details, particularly faces, was also banned (another regulation that went by the board within the next hundred years).

One of the leading Brussels tapestry weavers, Pieter van Aelst, was commissioned by Pope Leo X to reproduce in tapestry the story of the apostles from Raphael's cartoons. Upon completion of the work (the seven tapestries were 16 ft. 3 in. high and had a total length of 136 ft. 6 in.), van Aelst was appointed papal tapestry maker, a position he continued to hold under Clement VII. He nevertheless continued to work in his national style until the 1530s, adopting only a few Renaissance characteristics. Bernard van Orley, court painter to Margaret of Austria, was responsible for the weaving. After the pope's commission, the next in significance and importance was that given by the Emperor Charles V to Wilhelm Pannemaker, son and successor to Pieter Pannemaker, for a record of his journey to Tunis. According to the contract, Pannemaker ordered silk from Granada, while the emperor himself obtained the necessary gold thread. Pannemaker used nineteen different colours, each in three to five shades.

Techniques were continuously refined in order to reproduce contemporary paintings as exactly as possible. At this period Pieter Coecke van Aelst was working in Brussels. He and Orley were the dominating personalities in the Brussels carpet manufactory between 1530 and 1550. An increasingly important role was played by the cartoonist, upon whose work the weavers largely depended. Figure composition gradually came under the influence of the Italian Renaissance, but borders varied little. Bunches of flowers and piles of fruit, medallions framed in laurel leaves and birds on black backgrounds frequently appear; the shading on the leaves is always done in much the same way. These borders are directly related to late Gothic *verdures*, which they interpret more richly, graphically and delicately.

Foliage carpets with coats of arms were the speciality of Oudenaarde and Mechelen. Between 1540 and 1550, Italian Renaissance styles replaced Oudenaarde local styles in the borders as well. The result was a fashion for ornamental grotesques with herms and masks as well as figures in aedicules. Van Aelst is reputed to have used these motifs in woodcut designs for the title-pages of books before adapting them to tapestry borders. The fashion for grotesques became such that purely ornamental carpets were frequently made. The revolt of the Netherlands against Habsburg — and Spanish — rule led to the decay of the Brussels workshops. Output during the last quarter of the 16th century showed a considerable decline in artistic quality. On the one hand, rhetorical ideas were expressed through the use of figures of a Michelangelesque monumentality, while on the other, a superficially decorative element crept into the composition in an unhappy combination of delicately draped clothing and strange ornamentation. Conventionally treated compositions representing Old Testament, allegorical and mythological stories were repeated. Copyrights were infringed and the Brussels merchants kept a stock of cartoons which they re-used as often as they could find customers for them; the Scipio legend was in particular demand. Matters improved in the last decade of the 16th century under the regency of Alexander Farnese, and again under the Archduke Albrecht of Austria in the early decades of the 17th century. A whole series of important workshops were fully occupied, including those of Jean François van den Hecke, founder and doyen of the guild, Philippe de Macht, Gaspard Leyniers and Henry Reydams.

Germany. The stylistic development of German tapestry-making was uneven. While a series of scenes from the passion of Christ, based on Dürer's woodcuts and Schongauer's engraving, were being produced in Strasbourg around 1600, in southern Germany, and notably in Nuremberg and Augsburg, tapestries in a pure Renaissance style were already being made by Flemish weavers in the middle of the 16th century. Quite a number of commissions were sent directly to Brussels, such as *The Conversion of St Paul*, the cartoon for which was prepared in Nuremberg after a drawing by Hans Baldung Grien, and genealogical tapestries and cycles on historical themes ordered by Charles V and others. There was a steady emigration of Flemish weavers to Germany, at first to Nuremberg but later to Frankenthal, the Stuttgart court and Munich. Among the most important was Seeger Bombeck, who produced tapestries to designs by such local artists as Hans Crell and Veit Thieme for Leipzig town hall, for Weimar and for the Thuringian courts. Bombeck's most important work is a Reformation tapestry dating from about 1550 and based upon themes from Hans Sachs's lyrics. The figure compositions greatly resemble Cranach's works, while border motifs were copied from other Brussels tapestries. Another Flemish weaver, Peter Heymanns, settled in Stettin, where he worked in the Bombeck style and where in 1551 he produced the Croy tapestry (Greifswald University). In Lower Saxony a work was produced that is known as the Rochlitz Marriage Tapestry; it tells the story of the Schmalkaldic War. The figures were designed by Aldegrever, and are clad in rich clothes in the then popular Spanish fashion. Local tapestry-making in Lower Germany did not really flourish until the late 16th century. At this time whole colonies of Flemish weavers fled from Spanish rule to northern Germany; but after some years in Germany they began to abandon their indigenous manner and to adopt German styles. Thus small tapestries remained typical of Germany, particularly in Westphalia, Lower Saxony, Mecklenburg and Schleswig-Holstein. These were mainly rectangular cloths and cushion covers; for centuries they remained an important form of country folk-art.

Baroque. *France.* In 1662, the *Manufacture Royale des Meubles de la Couronne* was set up. A whole series of small workshops was concentrated within the state-organised manufactory, in order to meet the growing demand for tapestries without being obliged to fall back upon the assistance of the Flemish workshops. Weavers were not the only employees: the Manufacture Royale comprised all the skilled craftsmen required to furnish and equip the French palaces — carpenters, silversmiths, bronze-casters, and so on. This manufactory was situated on the little River Bièvre in the Faubourg St Marcel, where the Gobelins family had had their dye

works since the 15th century. The building was bought by the king, and the name Gobelins was applied to the tapestry products of the royal workshops. From the time of Jean Jans, the first master weaver to settle there, sixty-seven high-warp looms were in use at the Gobelins. The first artistic director was the painter and decorator Charles Le Brun, a man of universal talents and great organising ability, who produced not only paintings and cartoons but also architectural drawings and schemes for interior decoration.

Tapestry now underwent a radical change. The cartoon became of overriding importance; it was usually a work of art in its own right, and exact reproduction was essential. In style Le Brun turned to the Italian Renaissance, to Raphael and Pietro da Cortona, but in figure composition he favoured Rubens. In line with Baroque practice, several painters worked on a single cartoon, dividing up the various tasks between them. Tapestry became an inseparable part of interior design, forming supplementary partitions. No longer hung loosely from the wall, it was stretched within a frame and occupied a specific place, rather like wallpaper. Frequently a whole room would be hung with tapestry so that, in addition to large individual works, extra pieces would be required to go over doors (sopraportes) and between windows (entre-fenêtres). A very fine weave was used in order that cartoons could be exactly reproduced. The most suitable material was fine silk and gold thread. The number of colours and shades was increased enormously. No longer were single examples made of cartoons and tapestries. Boucher's very popular cartoons, for example, were repeated until the end of the 18th century, during which time they underwent several stylistic changes. Biblical themes went out of fashion almost completely and were replaced by myth, history and allegory. The compositions were enlivened by a number of decorative devices which in turn became themes for whole tapestries; columns and pillars, birds and fruit, all against landscape backgrounds with distant horizons. After the magnificent Le Brun period there followed a decline. This was the natural outcome of economic difficulties and the academic eclecticism of Le Brun's successors. However, a number of great tapestry cycles were produced during the last years of Louis XIV's reign, the Twelve Months grotesques, *Portières des dieux,* (after Audran). Italian grotesques gradually gave way to beading and egg-and-dart borders, and to shell and cartouche motifs. The beginning of the Regency was marked by a decline in Classical and religious themes in favour of gayer subjects, such as pastoral scenes in the style of Watteau, Lancret and Boucher. Charles Coypel and his son were responsible for translating the greater part of these works into tapestry. Under Louis XV, subjects became more exotic to include such titles as *The Arrival of the Turkish Ambassador, The Indies,* and so on. In 1748 there was quite a serious disagreement between the artist Jean Baptiste Oudry, designer of the *Royal Hunt* series and director of the Gobelins, and the weavers. Oudry complained that the weavers insisted on using their own colours and in this and other technical ways departed from the cartoon, whereas the beauty of the tapestry depended upon absolute fidelity. In Boucher's time as artistic director, when tapestry-making reached its zenith, Neilson was among the best weavers. He so perfected dyeing techniques that it was possible to achieve a high degree of realism in shading with both wool and silk. Boucher's last work, *Portraits of the Gods in Medallions,* was woven by Neilson and already displays Neo-Classical influences, particularly in the frame section, in the damask-like background and in the ribbons from which the medallions hang. In the pre-Revolutionary period, Jacques-Louis David's designs in graphic linear style were used at the Gobelins. Decorative qualities were abandoned in favour of a naturalistic style. During the Revolution new times were reflected in new themes and examples of the love of freedom were portrayed. Economic difficulties continued because the noble clientele had disappeared, and Napoleon's attempts to resuscitate the industry were unsuccesful. In addition to scenes from the life of the emperor and the imperial family, a series on the life of Marie de Médicis from sketches by Rubens as well as copies of Raphael's cartoons were also made in the early 19th century. From the mid 19th century, further progress was made in the dyeing process under the directorship of Lacordaire, the first historian of the old Gobelins works. Chevreuil discovered the ten chromatic circles which govern the scientific deter-

mination of all colours and shades. Under the Paris Commune in 1871 the Gobelins was partly destroyed, along with its stock of valuable tapestries.

Colbert also took over and unified workshops in Beauvais and Aubusson, as well as some older and smaller workshops. Beauvais was made a royal manufactory in 1664, and worked exclusively for the court. Its first director was Philippe Béhagle of Oudenaarde, who himself signed a number of works. The second director was Jean-Baptiste Oudry, who provided upholstery designs and lamp and stove covers as well as tapestries based on the fables of La Fontaine. The work was almost exclusively in silk, and great attention was paid to shading in order to try to reproduce the high reflective qualities of paintings. The greatest successes were with tapestries designed by Boucher: *Loves of the Gods (Amours des dieux)*, his pastoral scenes, the story of Psyche, and illustrations of Molière's comedies. Typical of this period are the extraordinary representations of the court of the Grand Mogul, complete with semi-Chinese, semi-Gothic baldachins. Under Louis XVI a number of purely ornamental works were produced, usually with a floral design, and primarily intended as upholstery for the royal furniture. During the 1730s, furniture at the Tuileries and at St-Cloud had been upholstered with tapestries with Classical scenes, made at Beauvais. Such designs were repeated right up until the 19th century so that it is very difficult to date works from this period. From the early 18th century, tapestries are frequently marked 'Beauvais' and with the name of the director.

In Aubusson too, tapestry-making traditions go back to the 15th century. The *Manufacture Royale d'Aubusson* was set up in 1665 with the amalgamation of the local workshops. The leading personality here was Jean Joseph Dumont, who prepared original cartoons as well as a number based upon the works of Lancret, La Hyre, Gillot, Watteau and Boucher. Thus in the years 1730-70 numerous tapestries were produced with pastoral themes, *chinoiseries*, garden parties, tea parties and so on. In contrast to Beauvais, Aubusson worked for less wealthy and aristocratic clients. Its products were therefore of poorer quality, and were usually made of wool rather than silk; their sentimentality also reflected

bourgeois tastes. In the 18th century, tapestries appeared with narrow garlands of flowers, then *verdures,* and later upholstery in the Empire style of Percier and Fontaine, as well as floor carpets.

Tapestries were also made in a number of smaller and less important workshops, such as those at Valenciennes, Douai, Tournai, Arras and Nancy.

Flanders. The style of tapestries in Brussels in the early 17th century was completely revolutionised by the work of Rubens who wished to restore to tapestry design a monumental character. The first series in the new style, the *History of Decius Mus,* was produced in 1618 in the workshops of Jan Raes and Frans van den Hecke. Rubens's unmistakable technique in rendering figure subjects was always faithfully preserved — the impressive brushwork, the sharply contrasting colours, tones and shades, and the expressive surface quality. Only on the borders is a powerful architectural composition retained, with forceful, sometimes twisting columns supporting richly moulded pediments. Auricular work, cartouches, garlands of fruit and draperies borne by *putti* complete the architectonic framework. Rubens often produced quick oil sketches rather than cartoons on the basis of which whole series of tapestries were made — *The Story of Constantine the Great* (a twelve-part cycle), *The Life of Achilles, The Thriumph of the Church and Religion,* and others. Through the work of his pupils, Joost van Egmont, Jan Bockhorst, Jordaens, Jan Snellinck and Jan van den Hoecke, the output of the Rubens school soon became the common property of all the workshops. His successor was David Teniers, who was appointed court painter in 1647.

During the last three decades of the 17th century, Parisian influences were felt in Brussels. As well as the indigenous Flemish style of Rubens and Teniers, the style of Le Brun and Mignard made itself felt; of particular importance was their treatment of mythological, allegorical and historical themes, such as the cycles on the lives of Caesar, Cleopatra, Cyrus and Alexander, as well as such subjects as Apollo and the Muses, Diana and her nymphs, etc. The Flemish style was most effective in genre paintings, landscapes and battle scenes. Whole series, often based on drawings by van der Meulen,

depicted contemporary military actions. They were mainly undertaken in the Josse de Vos and van der Borght workshops, although the van den Hecke and Leyniers families also worked on them. Demand began to fall off about the middle of the 18th century. Society was no longer solely interested in tapestries; a preference for painted and printed wallpapers accompanied the advent of Neo-Classicism. Several workshops closed down, and by the end of the Seven Years War only the Borght workshop remained. It too finally closed down with the death of the last remaining member of the family, Jacques Borght, in 1794.

Verdures had been produced in Oudenaarde since the 16th century. In 1539 twelve hundred weavers were already at work there. Less common than *verdures* were figure compositions such as the *Nine Deeds of Hercules* (c. 1600). In the first half of the 17th century, tapestries were made in the late Renaissance style, with narrow borders of bunches of flowers, and trees with straight trunks, tiny leaves and rounded tops; water birds and herons filled the foreground. These were taken from Flemish landscape paintings and pictures by Roelant Savery, Brueghel and others. During the second half of the 17th century, the style of *verdures* changed under the influence of Rubens and Teniers. The climax came about 1700. The composition of the *verdures* becomes dramatically alive; the graceful trees with their many branches have been drawn to the sides of the composition, leaving the centre free. The middle and distant planes show a typical pleasure garden with avenues of gnarled trees leading to grottos and fountains, shrubberies, summer-houses and pavilions. The foreground abounds with flowers, small ornamental lakes and waterfalls, animals and birds. Picturesque foliage, and the realistically treated light and shade, are faithfully interpreted in the tapestry. The borders resemble those of the Brussels tapestries.

Tapestries were made at Antwerp from the beginning of the 16th century, when the town was in fact the centre of the Netherlands tapestry market. Simon Bouwen's and Balthasar Bosman's workshops were busy here from the end of the 17th century. In 1688 tapestry workshops were founded at Lille (already part of France) under the management of the Brussels weavers.

Netherlands. In the 16th century, workshops were set up in what is now the Netherlands which, like those in Germany, were staffed by Flemish workers who had fled North from Spanish oppression. Joost Lanckeert and Hendrick van Vairleir were among those who worked in Delft. The most successful was Franz Spierinck, who was active about 1593, and whose workshop produced mainly for the court.

Germany. Interest in tapestries increased in Germany towards the end of the 17th century. The nobility, like the nobility of France and Italy, used them to decorate their palaces and castles. The increased demand was, however, largely met from French and Flemish sources through agents and the larger trading houses. Attempts to open local workshops were helped by the arrival of weavers from the Netherlands and, particularly after the revocation of the Edict of Nantes in 1685, from France.

The oldest workshop was founded in Berlin by Pierre Mercier, who came from Aubusson. He produced *The Warlike Deeds of the Great Elector* after a design by the Dutch artist Langeveld. Mercier moved to Dresden in 1714. Another Frenchman from Aubusson, Jean Barraband, managed the Prussian manufactory from 1699 until his death in 1725. He made whole series of tapestries based on Jean Bérain's grotesques. Under the subsequent management of Charles de Vigne and his successors, copies of Beauvais tapestries remained fashionable. Mercier worked in the manufactory founded by Augustus the Strong in 1714 at Dresden; on his death he was succeeded by another Frenchman, Jacques Nermot. During the building of the castle at Würzburg, a tapestry workshop was opened where two Frenchmen, Andreas Pirot and Andreas Thomas, were employed.

A workshop was founded in Munich in 1718 by Max Emanuel, and managed by French weavers, who made tapestries from cartoons by the court painter Christian Winck and by Johann Georg Winter. During the Baroque period, German tapestry production was completely under French influence. The majority of weavers were French, and local skills were insufficient to permit the development of even a joint industry.

Italy. The Italian nobility also copied the French. They bought tapestries from the Ne-

therlands but also set up their own manufactories in Mantua, Ferrara, Perugia, Milan, Florence, Todi, Correggio, Siena, Rome and Venice. Ferrara was one of the oldest workshops, and was already famous in the mid 15th century. Work was usually to designs by Giulio Romano and Battista Dossi.

In Florence, Cosimo I founded a tapestry works in which Flemish, French and Italian weavers worked. Bernardino Pocetti, a decorator, developed Florentine grotesques, which were featured on tapestries until the middle of the 17th century. A large number were made to designs by the Fleming Giovanni della Strada, called Stradanus, for the Palazzo Vecchio. They are distinguished by their cold monumentality and rhetoric, by their mighty perspectives, bright colours and harsh lines. The manufactory was closed on the death of the last of the Medici family in 1737.

Since the middle of the 17th century, Rome too had been an important tapestry centre; French and Flemish weavers worked there. It was in this city that the famous cycle *From the Life of Pope Urban VIII* was made, as well as various tapestries on religious themes for the Vatican and other Roman palaces. The workshop was closed down in 1738 and removed to Turin and Naples.

There was never a characteristically Italian tapestry style. For the most part, murals and easel paintings were copied. It must also be remembered that in the warm climate of Italy, tapestries did not have a functional use as insulating wall hangings (as was the case in Germany, Flanders and France). They were almost exclusively decorative, whether used for religious or secular purposes. Hanging from balconies, they transformed street scenes on festive occasions, a fact that largely accounts for the exuberance and the somewhat extreme colours of Italian tapestries.

England. The first important English tapestry works was founded in 1619 by James I at Mortlake (then just outside London). The works produced were completely under the influence of the Italian Renaissance, the most famous being the *Acts of the Apostles* from the original Raphael cartoons. A number of tapestries on historic themes were made to designs by Van Dyck, and under James II a series of royal portraits were completed. Tapestries were ordered from the Netherlands during the reign of William of Orange and Mary.

Denmark and Sweden. Although weaving traditions in Scandinavia have always been very strong, there was no great development of tapestry-making. Since local production was minimal, completed works were ordered from the Netherlands. There were well known works in Stockholm, where French weavers were active during the building of the castle, and later, until 1794, in the manufactory. In the Småland and Scania regions small cushions, curtains and covers were made in the local traditional style.

Spain. Since Flanders and Spain had the same ruler — a Habsburg — from the early 16th century, Spain received the best Netherlands tapestries. An attempt by Spaniards in the middle of the 17th century to set up their own workshops, as recorded in Velázquez's painting *The Spinners,* was unsuccessful. It was not until the 18th century that Jacob van der Goten of Antwerp opened a tapestry works in Madrid, where his family carried on business until 1835. To start with they worked to designs by Teniers and Wouwermans, and they only turned to Spanish originals — mainly by Goya — in the last three decades of the 18th century. Some forty-five tapestries were made to his cartoons on rustic subjects such as country festivals, games and dances. On the whole the weavers were faithful to his style, and although a hint of Neo-Classicism can be detected, the tapestries are very lively and decorative.

Russia. In 1716 Peter the Great engaged a number of French weavers, including some members of the Béhagle family, to found a manufactory at St Petersburg Production continued until the middle of the 19th century, always with French and Flemish weavers. French tapestries were copied, or cartoons were prepared from paintings. A whole series of portraits of the Tsar's family were also made.

19th and 20th Centuries. The failure of the tapestry industry in the 19th century was the outcome of various economic and political events. Tastes had changed and the new bourgeoisie did not want enormous tapestries to decorate the interior of their houses. Even so, and particularly in France,

great efforts were made in the middle of the 19th century to revive the industry. There was a movement to revive Renaissance styles, although the more commercial firms still continued to turn out imitations of 18th-century designs. In the early 20th century, faithful reproductions were made at Aubusson of paintings by Rouault, Matisse, Picasso and other contemporary painters. It was only when Lurçat became active that a new tapestry style was introduced, characterised by flat areas of colour, a limited range of colours and simple techniques; it was obviously related to the approach and methods of medieval tapestries. Production was stimulated in other European countries, and today a number of painters weave their own tapestries, thus eliminating both the need for a cartoon and specially trained weavers.

Although French artists today construct their tapestries according to traditional methods (H. Georges Adam, M. Matégot, J. Picart le Doux and others), completely new techniques are being developed in countries which do not have these traditions, especially Poland (M. Abakanowicz, J. Owidzka, A. Sledziewska), Czechoslovakia (A. Kybal, J. Vohánka, B. Mrázek) and Canada (K. Sadowska). These artists often work in novel materials (linen, thick wool, hemp), and deliberately depart from purity of style, employing knots, embroidery, irregular weaves and new formats. The object is to get as far away as possible from any hint of factory production and to concentrate upon designing the work directly on the loom.

Advice to Collectors

In the course of the last two hundred years many great collections have been dispersed. Great families no longer live as a rule in the palaces for which the tapestries were made and many fine examples have found their way into museums. Even in the most luxurious houses it is unusual today for there to be room for tapestries. For this reason, modern collectors tend to look for the smaller items, which are therefore comparatively more expensive than large tapestries. An *antependium* of German origin, dating back to the 15th century and measuring approximately three feet square (97 × 104 cm.), fetched £ 13,000 whereas a Brussels tapestry of the 17th century measuring roughly 11 × 15 feet (345 × 496 cm.) was valued at only £ 18,000.

The collector hardly needs to worry about fakes, since production costs, including the very tricky job of dyeing the materials, are prohibitively expensive. Tapestries frequently have borders missing because they have been cut off after being damaged, or in order to suggest that they are rarer than is actually the case. Jacquard or embroidered tapestries are so simple to distinguish from the real thing that they can hardly be called fakes.

Tapestries can be repaired very successfully, but the work must be done by a specialist workshop which can accurately dye threads to match. There have been examples of careful restoration in which the colours were not fast, so that after a few years the colours faded and the repairs became visible as a series of patches. A collector buying a tapestry can easily detect repairs and judge for himself whether the work is a reconstruction or a restoration. It is also important to notice whether significant parts have been repaired, such as figures or faces, or whether only the background or decoration have been touched. The restored portions can be recognised by the regular weave, by the warp, and by the freshness of the colours.

A valuable tapestry should never stand in direct light and never be exposed to the sun, since this speeds fading and is harmful to the materials. The ideal way to hang a tapestry is loosely against the wall or in some other way that ensures that the warp does not have to bear the whole weight. It can be supported from the back by a frame, by bindings or by a canvas lining.

The first signed tapestries originated in Brussels during the Renaissance. Since then master weavers have woven their initials into the work. Later the name was included along with the name of the manufactory and sometimes the name of the designer.

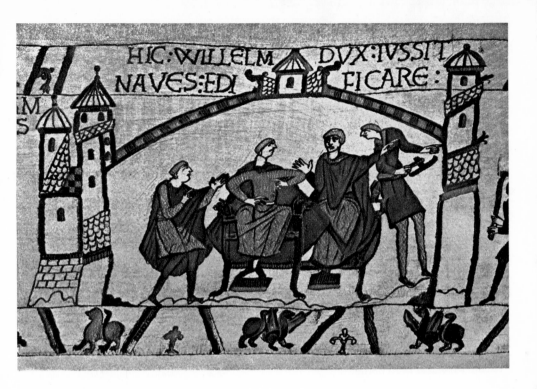

HIC·WILLELM DUX·IVSSIT
NAVES·EDI FICARE·

60 Two scenes from the Bayeux tapestry.
France, 11th century

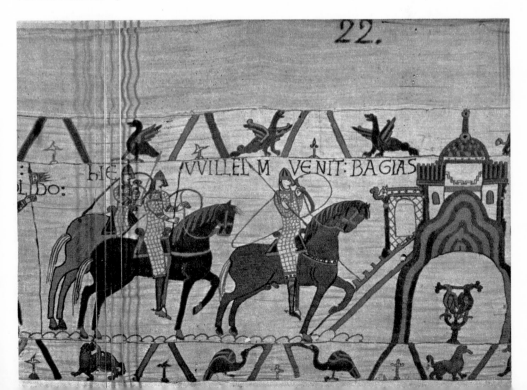

22.

·DO· HIE WILLELM VENIT·BAGIAS

61

62

61 SS Thomas and Matthew. Convent near Basle, end of 15th century
62 Deer-hunting; fragment. Germany (Alsace?), end of 15th century
63 *Gifts of the Three Wise Men.* S. Germany, probably French workshop, end of 15th century

64 *Verdure with animals.* Holland, *c.* 1540-50
65 *The Apocalypse of St John;* detail: *Angels Singing Moses' Song.* Nicolas Bataille, 14th century

63

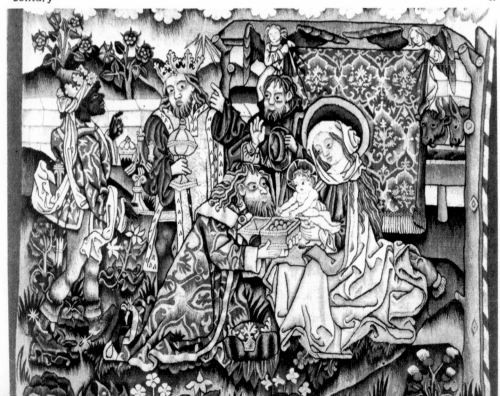

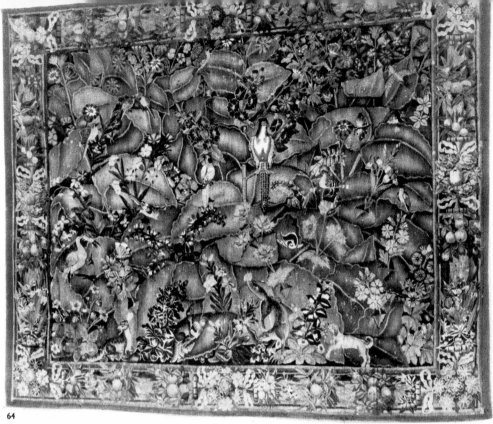

64

65

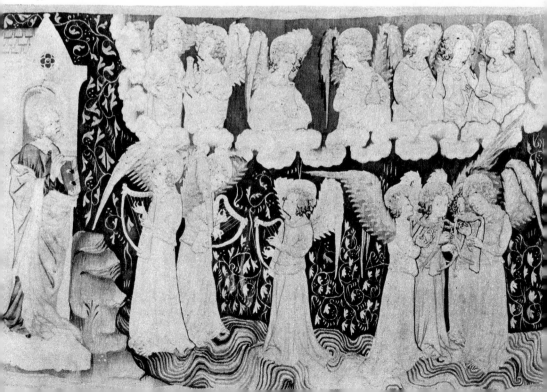

66 Youth feeding pigeons and strewing pigs with roses; detail. France (Touraine?), late 15th or early 16th century
67 *Lady with a Unicorn*. Loire workshops, 16th century
68 *Concert.* Loire workshops, 16th century
69 *The Life of St Remigius; Battle of Tolbiac and Conversion and Baptism of Clovis.* Chamennois, 1531

66

67

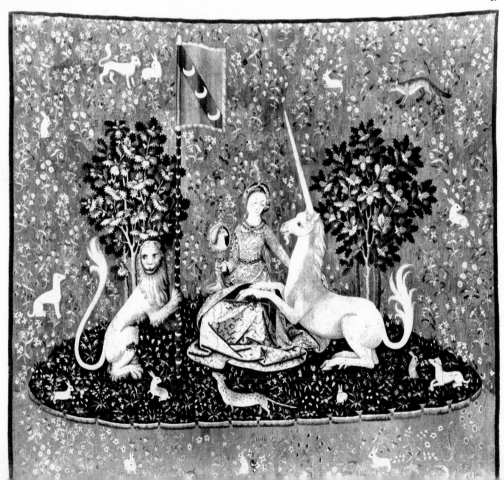

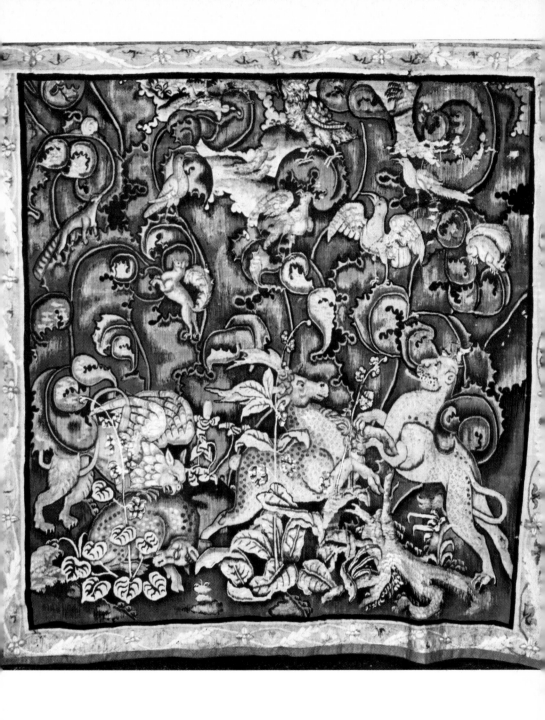

V *The Fight of the Fabulous Beasts*. France, late 15th century

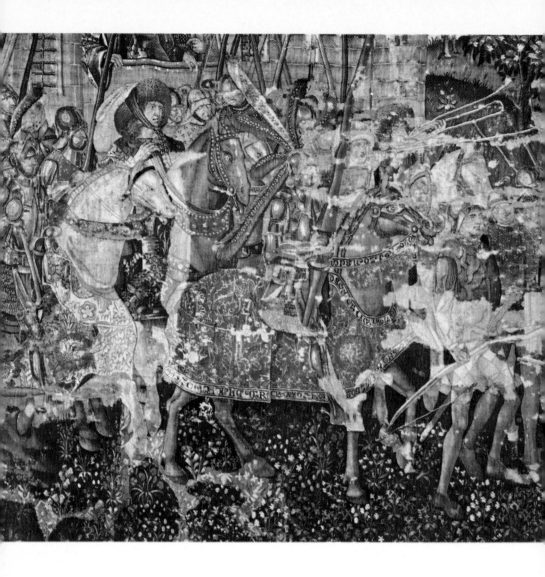

VI Battle scene. France, late 15th century

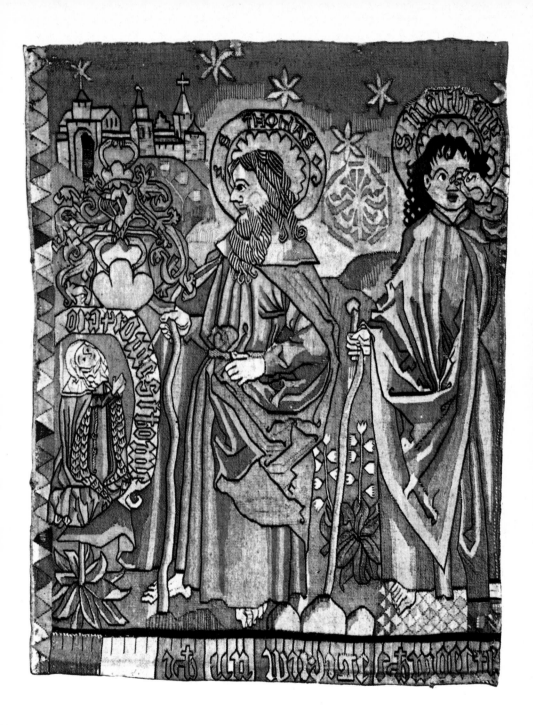

VII SS Thomas and Matthew; fragment. Basle (Convent), late 15th century

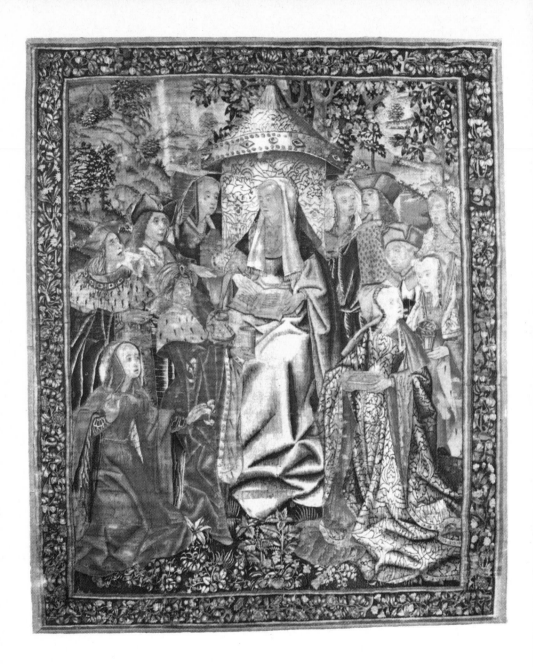

VIII *Wisdom* from a series on the *Virtues*. Flanders (Brussels), late 15th century

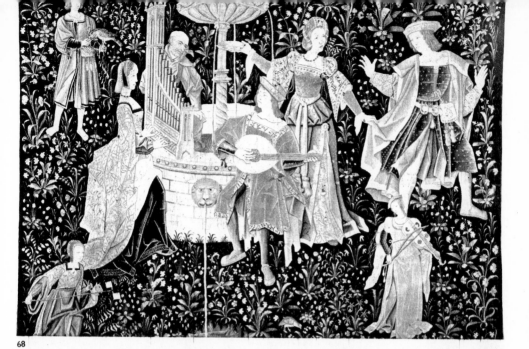

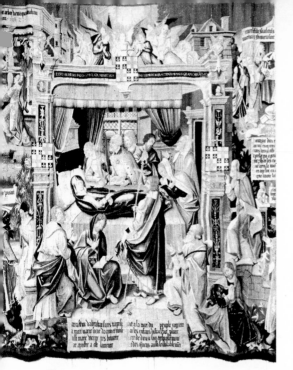

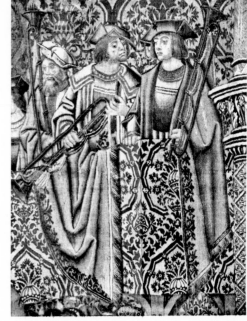

70

71

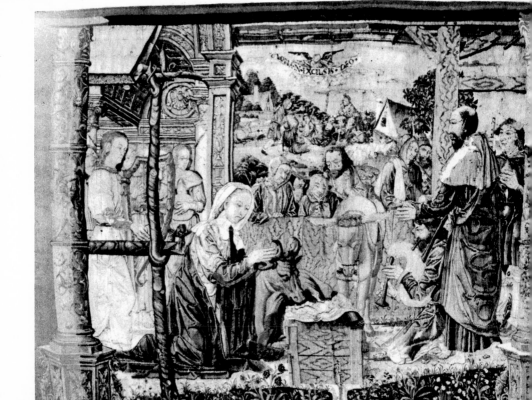

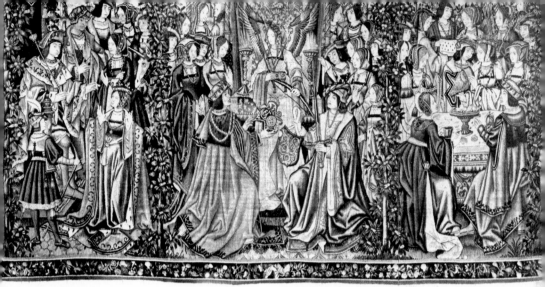

72

70 *The Life and Death of the Virgin Mary.* France, 1530
71 *The Marriage of Beatrice*, from the series on the Knights of the Swan (?). Brussels, early 16th century

72 Tapestry (subject unclear). Brussels, *c.* 1530
73 *The gifts of the Shepherds and Three Wise Men* from *the Life of Mary.* France, early 16th century

73

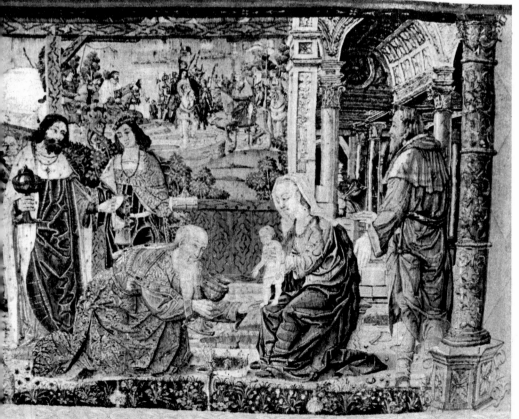

74 *Medea Helping the Argonauts* from the series *the Story of Jason;* detail, Early 16th century

75 *Handing over the Army Insignia* from the cycle on Decius Mus. From a cartoon by Rubens dated 1618 and signed G. van der Streken, 1618

76 *Judith Displays the Head of Holofernes.* Flanders, *c.* 1600

77 *The Transformation of the Heliades into Trees.* 17th century

74

75

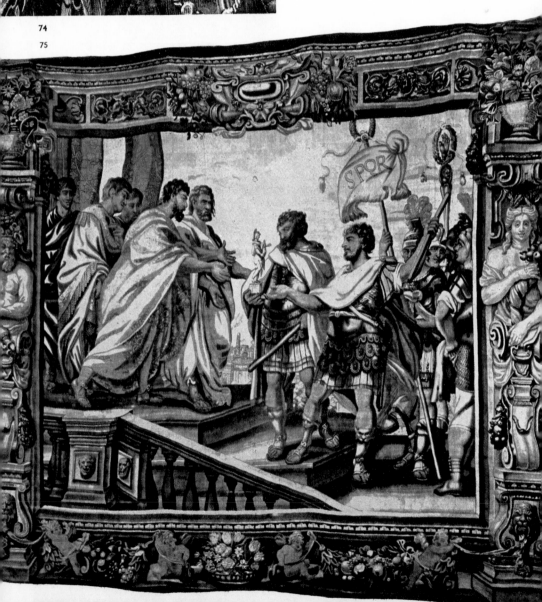

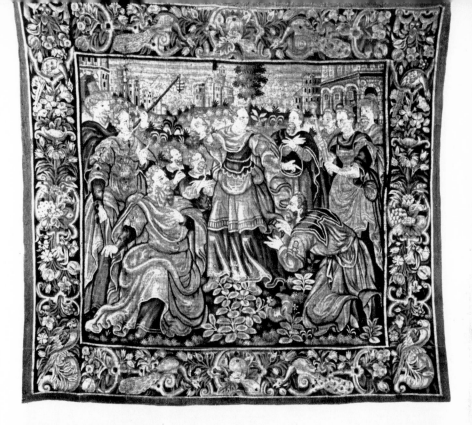

76

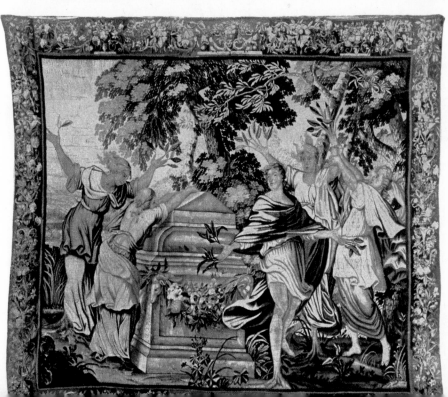

77

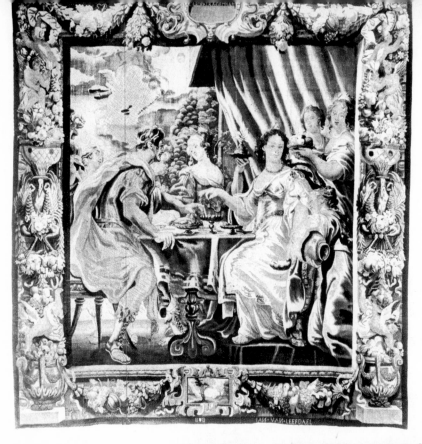

78 *The Feast of Anthony and Cleopatra.* Jan van Leefdael, late 17th century

79 Fontainebleau tapestry: *Struggle of the Centaurs and Lapiths.* After decoration in the Galerie des Réformés François I by Rosso Fiorentino and Primaticio, 16th century

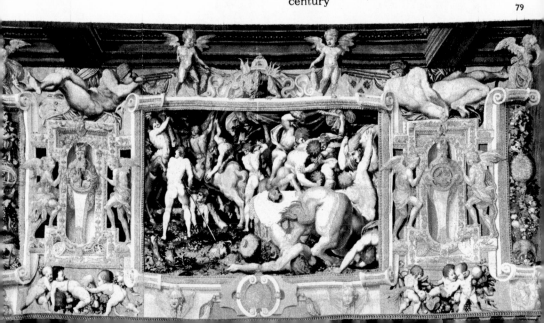

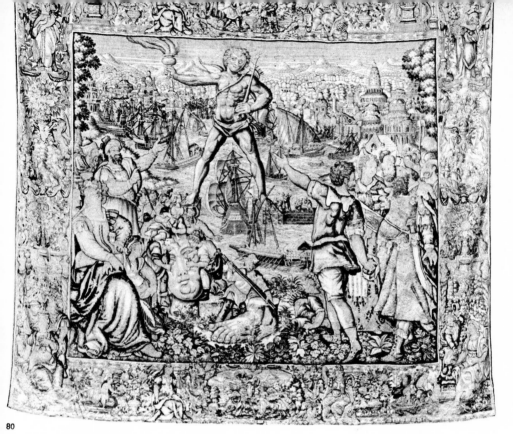

80

80 *The Wonders of the World: Colossus of Rhodes.* Early 17th century
81 *Maximilian's Hunts.* After van Orley. Paris, Gobelins

81

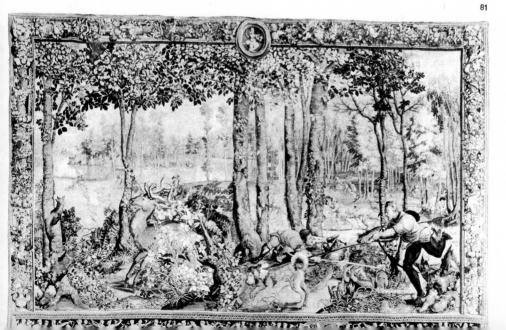

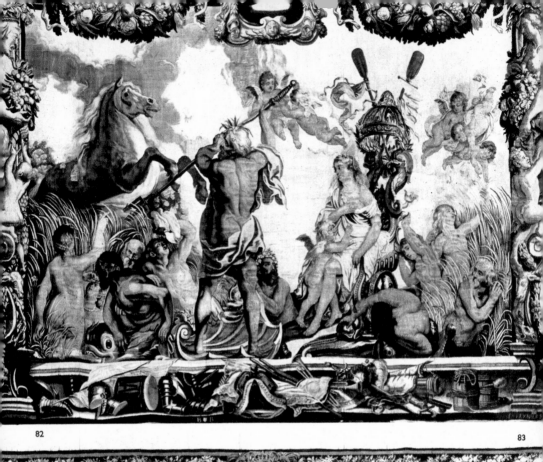

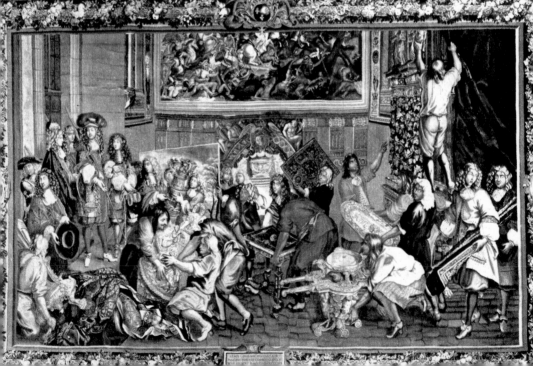

IX *The Annunciation* from the series of legends on the Virgin Mary of Sablon. Brussels, 1518-9. (Detail). Cartoon probably by Bernard van Orly

X *The Marriage of Maestra* from the series *The Story of Maestra*. Brussels, early 16th century

82 *The Creation of the Horse by Neptune* from the cycle *The Riding-School.* After Jordaens, signed by B. E. Leyniers, *c.* 1645
83 The King Visits the Gobelins. 17th century
84 *The Adventures of Don Quixote: Don Quixote and Dorothea.* Beauvais
85 *Water* from the cycle *The Four Elements.* Le Brun

84

85

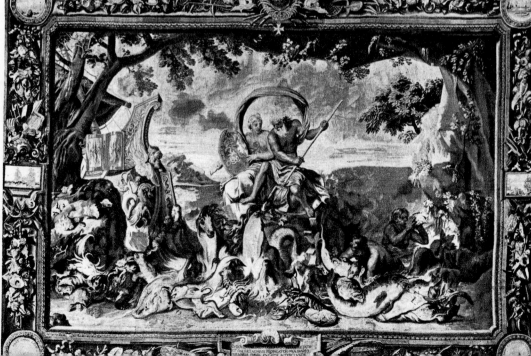

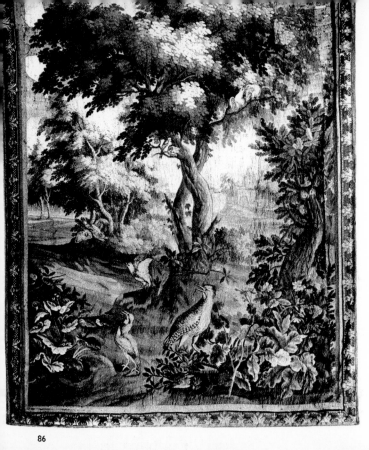

86

87

86 *Verdure.* Brussels,
17th - 18th century
87 *Shepherd's Idyll.*
Aubusson, 18th century
88 Landscape with
figures. Early 18th
century
89 *Gods of Antiquity.*
Brussels, 18th century

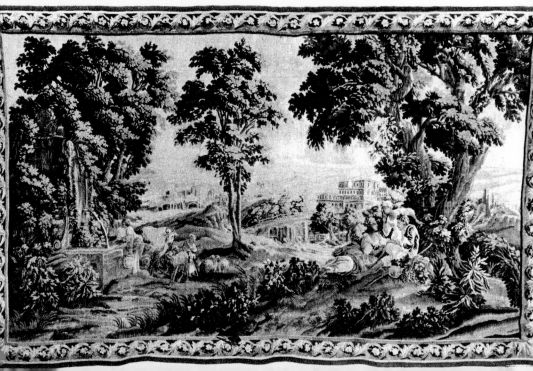

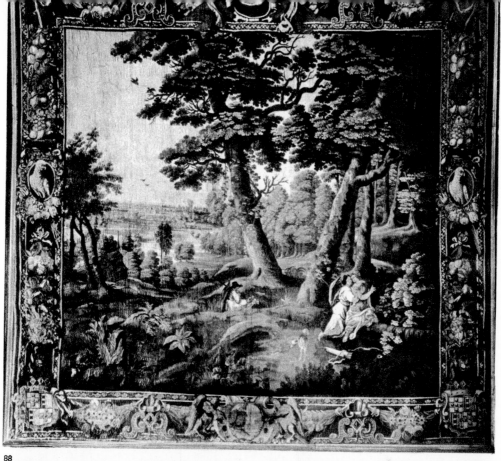

88

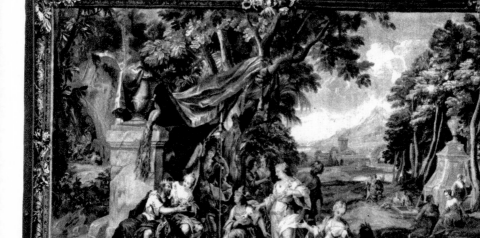

89

90

90 *Minerva leaves Telemachus* from the series *The Adventures of Telemachus*. Jodokus de Vos *c.* 1710
91 *Blind Man's Buff* from the series *Country Amusements*. Aubusson, after a cartoon by F. Casanova, *c.* 1750
92 *Sacrifice to Hermes*. J. Bérain
93 Grotesque. Lamalgrange, 1773

91

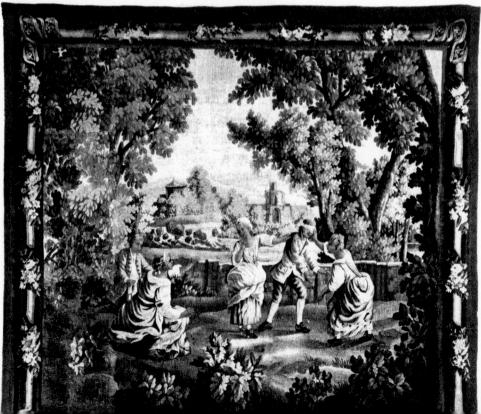

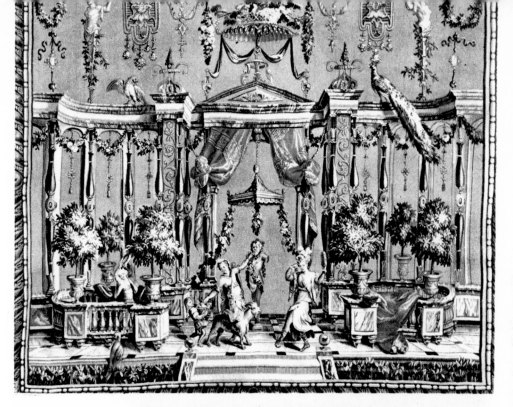

92

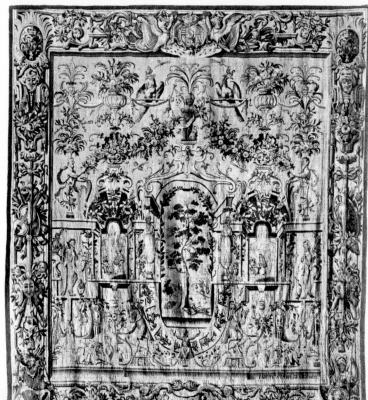

93

94

95

94 Young musician,
chair-cover. Beauvais
95 Armchair
upholstered in tapestry.
1750-75

CARPETS

Carpets can be woven or knotted in wool or silk. They can be of one or more colours, and can be decorated with a simple or complex pattern or a figurative design. In Europe they are used for warmth or as floor decorations; in the East they have been, and to some extent still are, an essential feature of life, being used to construct tents or for lying or sitting on. Five times a day the Moslem prays upon a carpet. In some places, carpets still serve as saddles on horses' backs, are presented by the bride to the bridegroom, and accompany their owners to the grave. The nomenclature of carpets is unsystematic: sometimes the name is taken from the town or region from which the carpets originate, sometimes from the name of the place where they are collected or sold.

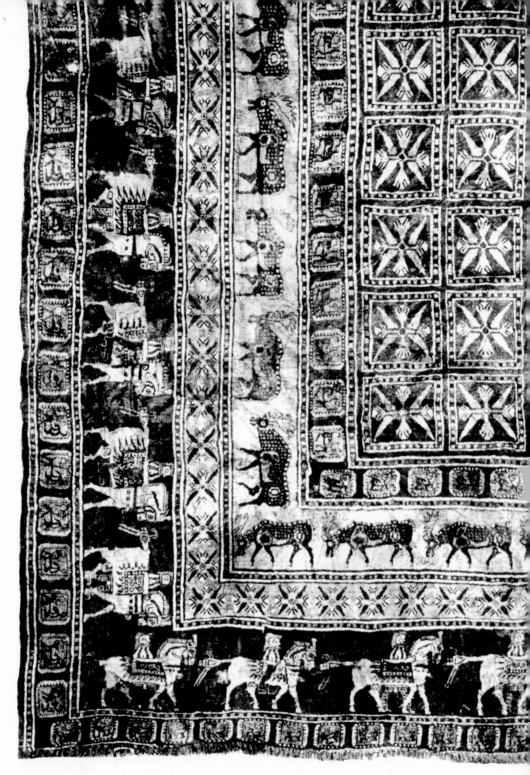

Manufacture

Materials. Wool, hair, cotton, silk, linen,
hemp and jute are used in various combina-
tions and proportions as raw materials for
carpets in both Asia and Europe. The wool
and hair is gathered from sheep, camels and
goats, and ranges in quality from short and
coarse to long, fine and shiny. Everything de-
pends upon where the sheep is reared, the
part of its body from which the wool is taken,
and upon the way in which the material is
prepared. Processes from combing to spin-
ning are already being mechanised. Wool is
principally used for the pile, only a few no-
mad products being entirely of wool. In these
the natural range of wool colours is often
used, ranging from white to yellow and
brown and grey to black. Cotton is a cheap
and firm material which the nomads used to
spin by hand; today it is spun in workshops
and factories throughout Asia. It is used for
both warp and weft of the carpet ground to
prevent puckering. Silk is the most ancient
and luxurious material used; it has a high
gloss and its fineness makes it possible to
put the knots very close together. Pure all-
silk carpets were made in the royal Persian
workshops in the 15th and 16th centuries, but
later use of the material was normally re-
stricted to the pile. Linen, hemp and jute,
which were already used in the distant past,
are today sometimes used for both warp and
weft, particularly by the nomads.

Dyeing. As with all other hand processes in
carpet manufacture, hand dyeing, whether
of imported or local dyes, disappeared in the
mid 19th century. The use of chemical dyes
was also spreading across Asia during this
period. A Persian law banning the importa-
tion of chemical dyes was of no effect; neith-
er was a regulation prohibiting production
in any factory using such dyes, although the
penalty for infringement was that the dyer's
right hand should be cut off. The law was sel-
dom enforced, and chemical dyes were in
general use after World War I. Inferior ani-
line dyes, which were discovered by the
English chemist Sir William Henry Perkin
in 1856, led to a decline in the colours of
Oriental carpets. Since then a whole range

of high-quality synthetic dyes have been
discovered and are today in general use.
Vegetable dyes, however, have certain quali-
ties for which modern industrial products
cannot provide substitutes. Vegetable-dyed
fabrics lose some of their original colour,
but in an agreeable manner which softens
the tones. Vegetable dyes can also be pro-
duced with variations in intensity, so that
even when the colours are bright they are
subtly tempered and need not be crude.
There are a number of sources, both vegeta-
ble and animal, from which natural dyes can
be obtained; here only the most common can
be mentioned. Red is taken from female
Cocus cacti insects, known as cochineal or
kermes in the trade, which are found in Cen-
tral America and the Canary Islands; they
contain carmine red. A dark purplish red
comes from the madder plant *(Rubia tinct-
orum)*, found in southern Europe. Blue is
usually made from the tropical plant indigo,
from woad and from various types of foliage
and extracts of oak bark. Yellow comes from
roucou *(Bixa orellane)*, zedoary *(Curcuma
rotunda)* or saffron *(Crocus sativus)*. For
green, the buckthorn *(Rhamnus chloro-
phorus)* and safflower *(Carthamus tinct-
orus)* plants are used. Black is used rarely
and in small amounts; it is obtained from
oak-apples or saltpetre, from vinegar or
pomegranate skins, from tartar or from
substances containing iron oxide which,
however, eats into the wool, as a result of
which in old carpets it is often the black
parts which have decayed.
Dye recipes were the closely guarded secrets
of workshops or tribes, and like all trade
processes were handed down from genera-
tion to generation. As with the raw material,
dyes are greatly affected by the climate and
soil in which the dye plants have grown.
The quality of the wool also influences dye
colour, which can vary quite considerably
despite identical dyeing processes. The yarn
is first rinsed in hot water to remove dirt and
grease; sometimes a little soap is used. It will
then be soaked for twelve hours or more in
the dye-bath and is then dried in the sun. In
workshops the dye batches are quite large,

but nomads can only manage a small quantity at a time. Thus quite considerable tone variations are found within a single carpet, particularly if the ground is made up of a single colour.

Patterns. The design of nomad and folk products does not depend on the use of a previously prepared pattern. Motifs are created out of the stock of individual designs, even of complete carpet patterns, which the weaver carries in his head. But in the workshops producing luxury carpets, prepared patterns are always used. Sketches produced by calligraphers or miniaturists are transposed on to a chart on very fine squared paper where each square represents a knot. These may be in colour or in black and white (when each of the colours selected for the carpet is represented by a number). Where several weavers are working simultaneously on a carpet, the chart can be cut into strips so that each weaver may have the design for his part in front of him. In the past, instead of a chart, a *salim* would continuously recite the design and direct the work of all the weavers.

The loom. For centuries now the technique of knotting carpets has remained unchanged. The only difference is that nomads use primitive looms while workshops have more advanced ones. The nomad's loom consists of two horizontal beams held steady by pegs driven into the ground; the warp threads are stretched between the beams. Such a simple horizontal loom is easily transported from place to place, as is of course essential to the nomads. It is relatively narrow, which explains the narrow, rectangular shape of nomad rugs.

The usual vertical loom found in workshops consists of two revolving beams connected by two vertical posts. The completed work is rolled on to the lower beam - the cloth beam - from the top beam, which holds the warp. More primitive vertical looms lack revolving beams, and the weavers are therefore obliged to raise their seats to keep pace with the work. A vertical loom of this type does, however, permit them to see the finished work in its entirety. The warp threads are evenly spaced and stretched to an equal tension; they are usually of raw, undyed material. When a weaver begins a new carpet, he does not generally start knotting straight

away but works about an inch of *kelim*, a plain flat-woven border, going over the outside warp threads a few times to ensure a firm edge. The knots are made from skeins which the weaver usually keeps on the top beam of his loom. After each row of knots, two or three rows of weft threads are inserted which are firmly forced down with an iron or wood beating-comb so that the carpet has the desired degree of density and firmness. Caucasian rugs are not usually knotted exclusively by hand: a special kind of knife with a hooked tip is used first to knot the pile and then to cut it from the skein. This makes the work much faster. Today it is difficult to estimate the number of knots that a worker can tie in a day, but it probably varies between six and ten thousand, although an experienced workshop weaver can reach fourteen thousand. Two types of knot are used, the Ghiordes and the Senneh. In the Near East and the Caucasus, the Ghiordes knot is used almost exclusively, while in Persia both are used. The completed carpet is clipped so that the pile is of a regular length; thus about one to two and a half inches of wool are lost. In China only the ground is clipped, leaving the pattern to stand out in relief. When the carpet is finished, it is washed or merely sprayed with water, brushed, stretched and dried.

In the Near East, the knots are not always worked regularly row by row but in patches following the pattern, so that the design is not worked vertically on the warp, but diagonally. This method can be detected on examining the back, where small openings can be seen. Some older carpets, particularly intended as protection against the cold, had a large number of threads about an inch in length worked into the back. In addition to knotted pile carpets, flat-woven *kelims* are produced in the Near East. These are reversible and thinner, and are primarily used as door-curtains and blankets. *Kelims* are made on looms similar to those used for knotted carpets, except that for a flat-weave carpet the weaver proceeds as for tapestry, beating the weft so close together that the warp is completely covered. The cloth mosaic carpet is also occasionally made in the Orient; it consists of coloured pieces of cloth sewn on to a carpet ground.

Nomad regions also produce felt carpets; in Iran, the Middle East and India they are made of sheeps'wool or goat or camel hair.

Historical Survey

Asia. In the Old Testament (Exodus, Chap. 26) instructions are given for the weaving of draperies for the tabernacle. The oldest known carpets date from 500 BC and were discovered in the Altai region a few years ago. They are unique: other, widely dispersed finds are all much later products. Written evidence of a highly developed carpet industry in Persia and the Near East dates back to the 3rd century. The first preserved carpets or fragments of carpets are of the late medieval period.

The legendary carpet of King Khosrau I was made for the royal palace at the Sassanian capital of Ctesiphon; it has survived only in copies. Its division into a central portion containing two medallions, its cut-off corners and series of borders constitute what has become a classic design. This basic type was made in Asia for centuries, repeated in simple or complex variations. It was only towards the end of the 19th century that regional and tribal characteristics in fabric, technique and design began to disappear. Then collectors bought up all the old carpets they could find - which merely encouraged craftsmen to make carpets more quickly and less carefully. Soon the last remaining craftsmen will disappear.

The great majority of Oriental carpets are an integral part of Islamic culture. The Arabs brought no style of their own to the countries they converted to Islam, but, in carpet design as in the other arts, absorbed Egyptian and Classical elements alike, and the Persian along with the Byzantine; with the passage of time, disparate features were unified into an Islamic style. Designs became complex abstract compositions in which there was no place for emotion or sentiment, and in which every motif originally taken from nature took a pre-ordained place. Plants were either imaginatively stylised or used heraldically; only occasionally can they be distinguished botanically. The individual motifs are composed of two-dimensional shapes, and the resultant pattern fills the whole field; rarely is an area left undecorated.

The pictorial reproduction of human beings or animals was forbidden over most of the Islamic world for centuries, although the Koran itself makes no explicit ban. The Arabs have no personified gods and did not feel the need to cover the walls of their mosques with didactic pictures; and indeed, the Islamic religion is very simple by comparison with Christianity. The ban on pictorial representation of human beings was not always strictly enforced; in some regions and periods people are realistically portrayed, as on Persian luxury carpets, or, by contrast, very stylised, as on Caucasian rugs. Symbolism nonetheless played an increasingly important part in Oriental carpet designs. It was this that underlay their whole conception; each colour and every single motif, whether of geometrical, animal or plant origin, had its symbolic meaning. The very workmanship is bound up with the symbolic content of the religion: occasional faults in the carpet do not arise from the inattention of the weaver, but from his humility — Allah alone is infallible.

Persia, today called Iran, is the classic home of the Oriental carpet, and also probably its place of origin. The designs, particularly those of the luxury carpets produced in the Shah's workshops, were imaginatively stylised; the technique was unusually accurate, and only the best wools and silks were used. The oldest luxury carpets were woven in about 1250, between the Mongolian dynasties of Genghis Khan and Tamerlane.

Among the most famous luxury carpets are *medallion carpets*, with a classic centralised composition including the use of plants; *flower carpets* with spiralling tendrils and palmettes; and *polonaise carpets*, usually dating from the 17th century. Polonaise carpets were rare, and were usually given as presents; they were probably made in workshops at Yezd or Kashan. The traditional pattern with a central star, a field with stepped sides and borders is composed of tendrils, Saracen trifoliates, flowers and arabesques or alternating line patterns. Gold or silver threads were also used.

Only a few examples of *hunting carpets* survive. They show fighting animals of the most diverse kinds - phoenixes, dragons, lions, tigers and so on.

Animal carpets produced between the 15th and 17th centuries are of the classic design and feature cloud bands, phoenixes, dragons, bats and lightning. They were apparently made during the Sassanian period in the royal workshops at Herat, Tabriz and Isfahan.

Herat carpets were made in the city of that name from the end of the 16th to the beginning of the 18th century. The field is regularly and closely covered with the Herati pattern of floral and geometrical designs. They are to be found in mosques as well as in Europe, where they have appeared in the paintings of such artists as Rubens and Van Dyck.

Vase carpets are long and narrow, with a vase as their central theme, linked by a whole network of tendrils to various flower and palmette motifs; they were made during the Safavid period, probably in southern Persia and perhaps in the city of Kirman.

The number of these antique carpets is very small, and all the surviving examples are now in museums. Collectors can, however, acquire the so-called new Persian rugs, most of which date from the 18th, 19th or even 20th centuries.

New Persian carpets. Afshari (sometimes known in the trade as Saidabad or Sirdshan) carpets are made by nomadic or semi-nomadic tribes inhabiting the region between Shiraz and Kirman. They originally wandered between the Euphrates and the Tigris, but during the rule of Shah Abbas they migrated to Persia. The carpets are made with cotton and wool, and the Ghiordes and occasionally the Senneh knot is used. The size of Afshari carpets is 1.20 × 1.80 m. Colour: varied, ground red or blue, often white or cream, all in pastel shades. The field is filled with lozenges with stylised flowers, delicate tendrils, barbers' poles, and *Mir-i-bota* patterns rather similar to Caucasian motifs.

Bijar carpets are made by the Kurds, both nomads and semi-nomads, in the workshops of Ardelan province (now Kurdistan) in northern Iran. Both warp and weft are of cotton; the pile is of wool or camel hair. The Ghiordes and Senneh knots are at a density of approximately 7 to 2 per square cm. The

sizes are 1.50 × 2.40 m., 2.20 × 3 m., 2.50 × 3.50 m., 3 x 4.50 m. and 6 x 4 m. The colours are red, blue, yellow, ivory, the natural colour of camel hair, black and dark blue. The central field is filled with an arabesque, and has stepped corners, stylised flowers, trees, birds, animals and human beings. The borders frequently contain Herati motifs, rosettes and tendrils.

Joshegan carpets were produced mainly in the 18th and early 19th centuries in central Iran, north of Isfahan. The warp is made of cotton and the weft of cotton or wool; the pile is of wool. The Senneh knots are at a density of 8 to 15 per square cm. The size varies from rugs up to large carpets 7 m. long. The basic colours were blue, red and beige. The brilliantly coloured design was similar to Tabriz and Kashan - a diamond lattice with stylised flowers or tendrils. Sometimes the centre is a lozenge medallion and the borders are composed of flower and Shah Abbas motifs.

Feraghan. These carpets were produced - for the European market - in the Feraghan region of central Iran, east of Hamadan, from 1880 to 1914. Warp and weft are of cotton, the pile of camel hair or wool. The Senneh knots are at a density of 7 to 20 per square cm. The sizes are 2 × 3 m. to 6 × 10 m., 2.40 × 2 m. and 7 × 3.50 m. The colours are dark and restrained; all the usual Oriental carpet colours - beige, blue, red - are used, none being given a marked preference. These carpets were originally made with a typical Herati pattern, but during the height of the export trade, antique luxury carpets with large medallions and stepped corners were copied. The Feraghan carpet can be recognised by the thick cotton warp, which can be seen from the back. The borders contain flowers, leaves, tendrils and arabesques.

Hamadan rugs are made in roughly two thousand villages surrounding the central Iranian town of Hamadan. The warp is of cotton, the weft of wool and the pile of wool or camel hair. The Ghiordes knots are at a density of 5 to 12 per square cm. The sizes are 2.50 × 3.50 m., 5.50 × 5 m. and 1.10 × 1.40 m. (a small rug). The colours are blue, red, occasionally green, and the natural colour of camel hair; the borders are yellow. Patterns are very varied, often with an astragal medallion in the centre, human and animal motifs primitively stylised. The composition of the middle field is divided by a central medallion and stepped corners.

Herat. These carpets are manufactured in eastern Iran. The warp is of cotton, the weft and pile of wool. The Ghiordes knots are at a density of 18 to 25 per square cm. The overwhelmingly predominant colours are Turkey red and dark blue. The pattern is usually the classic and regularly placed Herati pattern in the central field and borders, or, more rarely, *Mir-i-bota*. The borders carry rosettes and lotus blossoms.

Isfahan. In the city of Isfahan, where Shah Abbás founded the famous workshops, modern production follows classic patterns. The warp is made of cotton and the weft and pile of wool. The Senneh knots are at a density of 20 to 50 per square cm. In size they are mainly rugs 1.20 × 2 m. and 2.50 x 3.80 m. The basic colours are red, beige or light blue; the pattern is multi-coloured. The basic design is of intertwining tendrils, with or without medallions, lotus blossoms, animal motifs and inscriptions; in the borders, whose patterns occasionally invade the inner field, Shah Abbás patterns are used.

Yoraghan. This is the name given to Heris rugs. The material is cotton and wool. The Ghiordes knots are at a low density of 3 per square cm. The sizes are 1.20 × 2 m. up to 8 × 8 m. The basic colour of the central field is dark blue to black, more rarely ivory or copper. The Yoraghan carpet has a large central medallion and stepped corners. The ground is covered with tendrils, leaves, flowers and palmettes; all are geometrically stylised.

Kashan. The city of Kashan, which lies between Teheran and Isfahan, is, despite a long break, a production centre in which old traditions are not forgotten. The warp is of cotton and the weft of cotton or wool; the pile is wool or silk. The Ghiordes and Senneh knots are at a density of 30 to 50 per square cm. in wool carpets and 40 to 80 in silk. The sizes are 2 × 3 m., 2.50 × 3.50 m., 3 × 4 m., and 3.50 × 4.50 m. The basic colours are red, blue and ivory; the pattern is multi-coloured. The middle field is divided by medallions and corner patterns. Patterns are based on lotus blossoms, columns, Herati and vase motifs. In Persia these carpets were not put on the floor but used as hangings.

Khorassan. These carpets are produced in Khorassan province. The material is cotton or wool. The Senneh knots are at a density of 6 to 25 per square cm. The sizes are 90 cm. × 1.50 m., 1.20 × 1.80 m., 2 × 3.50 m. and 2.50 × 5 m. The central field is red, often with a blue-pink element or dark blue shot with green. It has a central design with stepped corners decorated with naturalistic bird and animal patterns and a wide border. Modern production includes poor quality carpets, sparsely and irregularly knotted, produced in the city of Khaiz, as well as a group of carpets of much better quality produced in Birjand.

Kirman. The city of Kirman (now Kerman), in the province of the same name, has an old carpet-making tradition. Carpets produced in the neighbouring towns of Yezd and Raver are known as Kirman-Yezd and Kirman-Raver. The warp is of cotton, and the weft of cotton or wool, the pile of wool. The Senneh knots are at a density of 25 to 40 per square cm. The sizes are 1.20 × 1.90 m., 2 × 3 m., 3 × 2 m., 3.50 × 5 m. and 70 × 170 cm. The basic colours are pastel shades: cream, green, blue, dark red or multi-coloured. The central field has a medallion in the middle with stepped corners, richly decorated with flower designs, tendrils, rosettes, or stylised roses, sometimes an all-over palmette design is used. Animal and figure designs were used in the 19th century. The Kirman-Raver appealed to European tastes and exhibits French Baroque influences. The borders show flowers, tendrils, the tree of life, lotus blossoms, palmettes, meanders and rosettes.

Saruck. Produced in the town of Saruck, south-west of Tehran. The material of these carpets is wool or cotton. The Senneh knots are at a density of 20 to 40 per square cm. The sizes of the rugs and runners are 2.20 to 5 m., 1.20 × 1.80 m. and 4 × 6 m. The basic colours are blue, red, and sometimes cream. The pattern is similar to the Kirman or Kashan, with a central medallion, stepped corners, and tendrils or several medallions dispersed over the whole field. Herati patterns appear in the field and border. The Saruck is among the most beautiful of Persian carpets.

Senneh. Production is in the environs of the town of Senneh (now Sanandaj) in Kurdistan province. The material for the warp is cotton, for the weft, wool; the pile is wool or silk. The Senneh knots are at a density of 25 to 50 per square cm. The sizes are 1.20 - 1.80 m. and 2.40 m. at the most. The basic colours are blue, red, sapphire, pink, yellow or white. The whole carpet is covered with a small pattern of flames, Herati motifs and palmettes.

Seraband. The town of Seraband lies in western Iran, in the Saravan mountains.

The warp of the Seraband carpet is cotton, the weft and pile are wool. The knots are at a density of 15 to 30 per square cm. The sizes are 2 × 3.50 m., 2.50 × 4 m. and 3.40 × 5.20 m. The basic colours are red, blue and cream. The all-over design is in *Mir-i-bota* with tulips facing alternately left and right, and with a broad triple border of tendrils and arabesques.

Shiraz. Carpets have been made from 1890 by nomadic tribes in the Kashkai region. The town of Shiraz is the collecting point for the Fars region. Warp is of cotton or goat-hair, weft of goat-hair and the pile of wool. The knots are at a density of 6 to 10 per square cm. The sizes are 70 × 120 cm., 1.10 × 1.60 m., 1.50 × 2.90 m., 2 × 3 m., 2.50 × 3.50 m., 3 × 4 m. and larger. The colour contrasts are sometimes harsh, with red, blue and occasionally cream. The central field is usually composed of lozenges, often stepped with borders of undulating tendrils and stylised animals and plants.

Tabriz. The town of Tabriz in the province of Azerbaijan is a centre both of production and collection for the surrounding areas (Heriz, Sarab and Karadja). Tabriz carpets are made of wool, cotton and occasionally silk. The Ghiordes and Senneh knots are at a density of 20 to 40 per square cm. The sizes vary greatly - 2 × 3 m., 2.50 × 3.50 m., 3 × 4 m., 4 × 5 m., 8 × 12 m., and the silk 1.20 × 1.80 m., 2 × 3 m. and 2.50 × 3.50 m. The basic colours are cream, red or blue. The central medallion is surrounded by smaller medallions, blossoming tendrils and hunting patterns. The borders are of Herati patterns, lotus blossoms with tendrils, frequently copies of antique luxury carpets.

The Near East. Carpets originating in this area are sometimes referred to as Anatolian or Turkish. The oldest surviving examples date from the 14th century. These carpets are characterised by austere designs in which many of the patterns reveal their Byzantine and Sassanian ancestry, particularly the circle pattern and the coats of arms with animals; they also include the decorative Arabic Kufic script. In the high Middle Ages the most beautiful carpets in the world were made in Ikonia (Konya). Near Eastern carpets appear in many 14th-century Italian paintings. More recently their patterns have been influenced by Persian designs.

As in Persia, luxury carpets were also made for the nobility and the court; they were probably manufactured in the workshops around Brussa and Constantinople. They were made of wool and silk, were softer than Persian carpets, and were used as door hangings and coverlets. Syrian carpets were large and decorated in the Persian style, with medallions supplemented by narcissi, hyacinths and tulips. *Damascus* carpets were in all probability merely collected in that city for export. They can often be seen in 16th-century Venetian pictures. The patterns are either geometrical or reminiscent of Damascus or Rhodes porcelain. Typical *Chintaman* carpets regularly repeat a single motif. *Ouchaks*, in which the medallion designs show strong Persion influence, are often to be found in European palaces. *Holbein* rugs acquired their name from the family of painters, who often reproduced them in their pictures. Their design is composed of angular tendrils, arabesques, Kufic script, plaiting, plant motifs and cloud bands. *Transylvanian* carpets were exported to European churches. Their patterns are similar to the Ouchak with, typically, a vase-like *ampulla* as the central motif.

New Near-Eastern carpets. Bergamo. This town lies to the north of Smyrna (Izmir). The carpets are made by nomads in western and southern Anatolia. Both warp and weft are of wool, sometimes of goat-hair, and the pile of softer wool. The Ghiordes knots are at a density of 8 to 12 per square cm. Bergamo carpets are almost quadrate - with dimensions of 80 × 110 cm. and 2 × 3 m. The basic colours are almost always blue and cherry red, sometimes light green; the patterns are yellow, orange and often ivory. The motifs recall Turkoman rugs with squares, stars and lozenges.

Ghiordes carpets are made in northern Turkey, in the town of Ghiordes (now Gördes) to the north of Izmir. Warps are of cotton or wool, wefts and pile of wool. The Ghiordes knots, short and thick, have a density of 30 to 50 per square cm. The older examples, very finely knotted, are among the best Turkish carpets; the quality of the new ones is not so high. The sizes are 1.30 × 2.20 m. and 1.10 × 1.60 m. The basic colours are red and, more rarely, blue or green. Ghiordes carpets are mainly prayer rugs with a design of two columns, and usually a lamp hanging from the

tip of a *Mihrab*, or else a flower or vase of flowers. They have triple borders, and the central band is decorated with Herati patterns and the outer ones with blossoms.

Hereke. In the town of Hereke in northwestern Turkey there was, before World War I, a large Ottoman factory, the artistic director of which was a Frenchman. The material used was silk and wool. The Ghiordes knots are at a density of 20 to 40 per square cm. Up to World War I they were of very good quality, the silk very delicate, the wool coarser. The material and knotting was of very good quality. The sizes were 2 × 3 m. up to 5 × 8 m. The basic colours were usually white or beige. The pattern underwent numerous changes, from copies of luxurious Persian prayer and medallion carpets with landscapes, animals and humans, to relief-carpets with clipped pile in the style of Louis XV and XVI. About 1900, Art Nouveau styles were introduced, and Sultan Abdul Hamid II had some of the rooms in his Constantinople palace decorated with Art Nouveau carpets.

Kula carpets are produced in central Turkey. Warps are of wool or cotton, wefts of wool or goat-hair, piles of wool. The Ghiordes knots are at a density of 8 to 15 per square cm. Older examples are of very good wool but relatively soft. The size is 1.15 × 1.80 m. The basic colours are red, blue or (more rarely) cream; the pattern is multicoloured. The centre is a stepped, framed lozenge medallion, and the borders often feature the alligator motif or large stylised flowers. Most of the carpets produced at Kula are prayer rugs.

Ladik is today an unimportant town in central Turkey, but it was formerly renowned for its prayer rugs. The warps were of wool or cotton, the wefts and piles of wool. The Ghiordes knots are at a density of 10 to 20 per square cm. The older examples are of very high and the more recent ones of medium quality. The sizes are 1 × 1.80 m. and 1.40 × 2 m. The basic colours are red or blue, yellow, cream and green. The central field is decorated with tulips and usually surrounded by one broad and several narrow borders. Pomegranate motifs and stylised trees often appear.

Melas. This town, today known as Milâs, lies south of Izmir, not far from the Mediterranean coast, and is the collection centre for carpets from western Turkey. The warp is of cotton, wool or goat-hair, and the weft and pile of wool. The Ghiordes knots are at a density of 6 to 10 per square cm. The size is 90 × 140 cm. The basic colours are copper, light red, blue or green; the borders are light golden yellow, dark blue, yellow, brown and (rarely) green. The oldest extant examples date from 1750. The pattern is similar to the Caucasian, with stripes, zig-zags and often a large central medallion. The border consists of three stripes, the central one having a floral pattern. Prayer rugs have a design of a plain *Mihrab*.

Mohair. These carpets are called after mohair wool, which has been produced in the province of Aidin (Aydin) since 1895. The goats which provide the wool are mainly bred in the provinces of Angora (Ankara) and Konya. The material is goat-hair, with Ghiordes knots. The sizes are 2.50 × 3.50 m. and 3 × 4 m. The basic colours are mainly pink, light blue, dark red and dark blue. Mohair carpets have no characteristic pattern but draw upon the generally known Near Eastern designs.

Panderma (now Bandirma). The carpets are produced in northern Turkey; the town itself lies on the Sea of Marmora. The warps are of cotton, the wefts cotton or sometimes a cotton-silk mixture. The knot density is 15 to 20 per square cm. Large numbers are manufactured; the quality is not especially good, and they are more suitable as wall hangings than as carpets. The size is 2.50 × 3.50 m. or smaller, the basic colour blue, red or ivory. As many as twelve colours are used in the pattern. The pattern repeats the usual prayer rug motifs, particularly those from Persia and Kula.

Smyrna (now Izmir). Although carpets have never been produced in the city itself, it has always been an important trading centre. Wool was bought and spun here, and carpets came here from the province of Aydin for export to Europe and America. Here too orders were taken for the manufacture of carpets to European taste; they were popular from the Biedermeier to the *fin de siècle* periods. The warps of Smyrna carpets were of cotton, and the wefts and piles of wool. The Ghiordes and Senneh knots, with piles from 1 to 2 cm. long, are at a density of 2 to 5 per square cm. - that is, rather sparse. The size is 2-6 m. wide and 3-12 m. long. Colour and design are very varied, both being determined by the particular order. Persian-type medal-

lions and large blossoms in green, red or blue are used.

Ouchak. These carpets are made in the western Turkish town of Ouchak (now Ushak). The warps are of cotton, wefts of wool or goat-hair, the piles of wool. The Ghiordes knots are at a density of 4 to 10 per square cm. The sizes are 90 × 130 cm. and 4 × 5 m. The older rugs were made in only three colours - dark green, dark blue and dark red - but since 1750 they have been multi-coloured. The pattern still tends to follow traditional Ouchak style.

Yürük rugs were made in the eastern Turkish-Iranian border region; today they are made only by a few nomads. Warps are of goat-hair or wool, wefts of goat-hair, the piles of wool. The Ghiordes knots are at a density of 6 to 10 per square cm., tightly knotted with a pile up to 2 cm. long. The sizes of runners and small rugs are 80 × 130 cm., 1.20 × 1.90 m. and 1.10 × 2.50 m. The basic colours are red, green or blue, with a white or cream design. The pattern is of Caucasian type, with large lozenges on a ground with a stepped margin enclosing small lozenges.

The Middle East. This term is used here to denote the part of Asia where rivers do not flow into the open sea but into the Caspian Sea, the Sea of Aral or Lake Baikal. We distinguish between carpets from Russian west Turkestan, Chinese east Turkestan, Afghanistan and Baluchistan. In these areas, carpets are made exclusively by nomads whose craft traditions go back to the 13th century. Under the rule of Tamerlane (1387-1405), who conquered the Persians, Mongolian motifs began to appear in Persian art. Carpets produced in this area were the last to come under European influence since they were made in isolated places which were separated from other cultures by steppes and mountain ranges.

The Kirghiz and Turkomans, who live in western Turkestan, produce the most beautiful carpets made in this region. The weavers are principally women, who also make bags, saddle cloths and door hangings. The Turkoman tents, known as *kibitkas,* are round huts with wooden frames completely covered with carpets. All nomad carpets are made of wool or goat or camel-hair. They used to be very small but are now made according to European taste.

Beshir carpets are produced by nomads along the Amu Dar'ya river in the neighbourhood of Beshir, about 125 miles from Bokhara. The warps are of cotton, wool or jute and the wefts of wool or goat-hair; the pile is of wool. The Senneh knots are at a density of 8 to 18 per square cm. The sizes are 1.40 × 4 m. and 2 × 5 m.; smaller prayer rugs and small woven bags known as *chouvals* are also produced. The basic colours are red and yellow, with some blue and green. Small geometrical patterns, stars, diamonds, S-lines, cloud bands, rosettes and leaves are used; the central field is divided into several small fields.

Tekke-Turkoman. These are made in the Ashabad (now Ashkabad) and Merv (Mary) regions by a large semi-nomadic tribe which roams as far as the northern steppes of Iran. The rugs are mostly woven by women from wool on a jute warp. The Senneh knots are at a density of 30 to 50 per square cm. The sizes are now determined by European demand, but were earlier 1.60 × 2.80 m. and 80 × 110 cm.; they now go up to 4 × 5 m. The basic colour is red ranging from shades of mahogany hue through crimson to violet. The designs are nearly always regularly distributed octagons with tarantula patterns or stylised stars or hooks. This type of carpet has been widely sold in Europe. The borders have stars, lozenges and geometrical plant patterns.

Yomud. These rugs come from the large region encompassed by northern Iran, the Caspian Sea, Uzbekistan and Afghanistan, and are made by the nomadic Yomuds. They use wool mixed with other kinds of animal hair. The Senneh knots are at a density of 20 per square cm. The size is 3 × 2 m., and the colour is mainly red, in the whole range from light red to purple, with some white. The design is almost entirely composed of little patterns which cover the whole field in horizontal or vertical rows. The borders often include stylised ornamental bird (eagle) patterns, leaves and stylised trees.

Bokhara. Carpets marketed under this name are all made by Tekke-Turkoman nomads; Bokhara is no more than a collecting and trade centre for the finished products. Warps are of jute, wefts of wool; the pile is wool and sometimes silk. The Senneh knots are at a density of 25 to 45 per square cm. The size varies between rugs and 3.40 m. long carpets. The basic colours are red (of various shades, including a lovely crimson), white

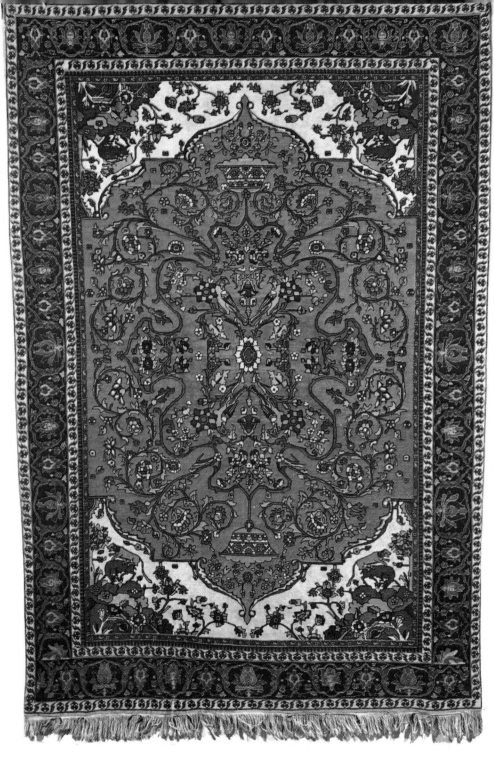

XI Persian carpet. Herat, early 19th century

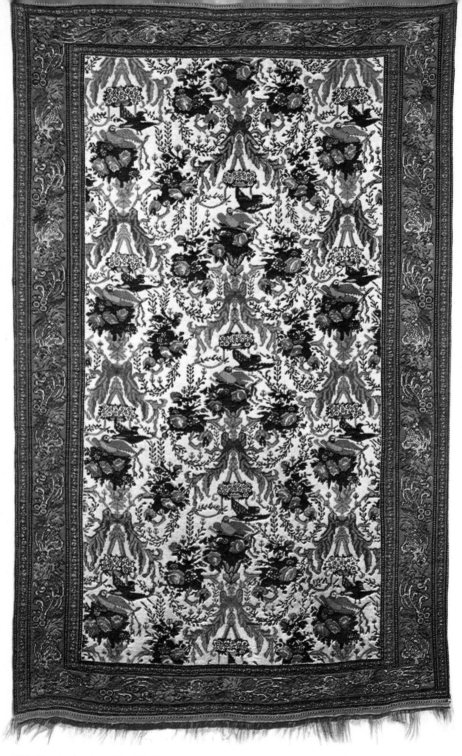

XII Persian carpet. Kashkai, early 19th century

and brown. The pattern on the field is composed of repeated *guls* in rows, and the border of stars or *guls*. These carpets are mainly made by Chinese in east Turkestan, but also by Tataro-Manchus, Kalmucks and Kirghiz. Although carpets have been made in this region for a very long time, they did not come on to the international market in any quantity until 1900, and then only under the names of Samarkand or Arghan. It is somewhat difficult to draw up rules for the identification of carpets named only after collecting centres. They are usually of austere geometrical design, and made of high-grade glossy wool which is frequently mixed with silk, gold and silver threads

Chotan. This town lies on the important caravan route from India to Kaschgar. The material of the carpets produced is mainly silk, with wool in the warp as well as in the weft and pile. The Ghiordes knots and Senneh knots are at a density of 3 to 5 per square cm. The sizes are 90-110 cm. × 1.50-2.50 m. and 1.30-2 m. × 2.50-4 m. The colour is striking and deep; the basic colours are pink, brick-red, dark blue, white and golden yellow. Chinese motifs appear in the pattern - blossoming branches, vases of flowers, meanders, naturalistic bats and butterflies, trees of life and whole landscapes. Round medallions (lucky rings) on a flat ground are often used, as are Chintamani and swastikas. Borders are mainly meanders and large rosettes.

Samarkand. This is the collecting centre for carpets made in the region between Chotan and Kaschgar. The warp is made of wool or cotton, and the weft and pile of wool. The Senneh knots are at a density of 6 to 8 per square cm. Rugs or runners are up to 4 m. in size. The basic colours are yellow (of all shades), blue, pink or violet. The field contains three medallions, or there is an all-over design of regularly repeated motifs. The borders are usually of meanders.

Afghanistan. Here carpets are made by Turkmenese nomads who roam across the whole region. Carpets used to be made of silk and were generally large, measuring up to 4 × 5 m. They aroused the interest of European and American collectors, and pressure of demand caused a diminution of quality. More recently, wool and goat-hair have been used. There is a very great difference between washed and unwashed carpets; only the washed are sold in Europe. Patterns are mainly geometrical and restrained; designs of repeated *guls* are frequently used with barbers' poles in the borders, or zig-zag patterns, hour-glasses, rows of octagons and the elephant-foot design. Typical colours are red with touches of copper, dark blue or brown. In the trade these carpets are known as old Afghan, modern Afghan, Ennessi and Kabul.

Baluchistan. The production of these is by ten nomad tribes, in the Khorassan region. The work of the various tribes can be differentiated by the patterns used, whereas the colours are usually the same (brown and white). Baluchistan carpets, like those of Afghanistan, remained quite unknown in Europe for a long time. *Baluchi* rugs were produced by Baluchi nomads using wool, animal hair and sometimes jute. Their colours were primarily red and brown; geometrical designs were composed of very stylised flowers which were usually arranged in diagonal rows across the inner field. *Fergana* rugs were also produced by nomads from wool, mainly in red and a dark chestnut brown. The designs are rather coarse versions of Turkestan and Baluchistan carpets.

Caucasus. In this region, bordering on the Black and Caspian Seas, inhabitants of diverse origins are concentrated into a small area. In general, all the carpets produced stem from nomad traditions, using highly stylised geometrical designs which appear either simple or primitive by comparison with those of other regions. Their plainness is determined by the nomadic way of life, whose limited technical possibilities have resulted in narrower carpets, a more modest range of colours and less dense knotting than is the case elsewhere.

Among the older examples is a group of *dragon* carpets dating from the 15th-17th centuries. They were formerly thought to be Armenian or Mongolian works, and it is only recently that their connection with Scythian culture has been established. Typical designs include confronted heraldic animals, and fighting dragons and phoenixes of mythical significance. The narrow borders are filled with serpentine tendrils.

Baku. These carpets were made on the shores of the Caspian Sea, in the village of Amer-Adjan, near the town of Baku. They are made of wool, camel-hair and cotton. The Ghiordes knots are at a density of 25 per square cm. The size ranges from 1.50 × 1.80 m. to 2 × 4 m. The colours are dull and patchy, as if faded by the sun: light green, various shades of blue, light yellow with a ground of dark blue and black. The centre is composed of a star-shaped medallion, quarters of which fill the four corners. The border is of three stripes; patterns are geometrical, using stylised human and animal forms.

Daghestan rugs are made on the western shores of the Caspian in the north Caucasus. Asians call them Lesgistan rugs, after the Lesghi tribe of shepherds who live in the Daghestan districts of the region to the north of Kuba. They are particularly hardwearing. Cotton is used for the warp, and cotton or wool for the weft; the pile is wool. The wool is often natural white or brown. The Ghiordes knots are at a density of 13 to 20 or 8 to 14 per square cm. The sizes are 80 × 140 cm., 1 × 1.70 m., 1.15 × 2.80 m.; the largest are 3.50 m. long. The colour is preponderantly white, sometimes blue or red. The central field and borders are patterned with rows of quadrate motifs in vertical or horizontal rows. Trefoil, wine-glass and barbers'-pole motifs often appear in the borders, as well as stylised blossoms and arrows. Sometimes a stylised eagle's head and geometrical motifs with stepped margins are used.

Derbent. Carpets produced by the peoples inhabiting the mountainous region beyond the west coast of the Caspian Sea are merely sold in Derbent. Warps are of cotton, wefts of wool or cotton, piles of wool. The wool is from sheep, but undyed goat-hair is sometimes used for the weft. The Ghiordes knots are at a density of 8.5 to 12 per square cm. The wool is fine, glossy and short. A hard-wearing carpet. Its size is 1.40 × 2.50 m. and 1.70 × 3.50 m. The basic colour is dark blue or (infrequently) red; motifs are in yellow, green and white, and the borders have a white ground. There are usually up to three medallions in the central field, while the borders mainly feature stars, quadrates, arrow-heads and triangles.

Karabagh carpets come from the southern Caucasus or from the northern fringes of the Kurdish steppes. Warps are cotton, wefts

and pile are wool; the wool is coarse and short-haired. The Ghiordes knots are at a density of 8 to 15 per square cm. The size ranges from 70 × 90 cm. to 1.10 × 1.40 m. The characteristic colour is cochineal red, and, more rarely, blue. The design shows strong Persian influence and is geometrical with gentle, rounded motifs. The central field has two or three medallions with stylised blossoms and animals. These carpets are sometimes mistaken for Kazak.

Kazak. These are made by Kazaks, Circassians, Armenians and Kurds in the central Caucasus, most of them nomads. Warps are of cotton or wool, wefts and piles of wool. Goat-hair is sometimes found in the warp and camel-hair in the pile. Natural white and brown wool is often used. The Ghiordes knots are at a density of 13 to 20 (8 to 18) per square cm. The sizes range from 0.9 × 1.3 m. to 1.60 × 2.20 m., 0.7 × 1.00 m., the largest being 3.50 m. long. The basic colours are mainly red, brown, very occasionally ivory; patterns in green, yellow, sometimes pink and brown; borders in ivory and cream. The patterns are severely geometrical, with a medallion (octagon, star, Greek cross) in the centre of the design, which is filled with stylised plants or animals (camels, mythical beasts, birds). The borders are composed of five bands using wine-glass, crab, barbers'-pole, zigzag, S-line and star motifs.

Kuba. Carpets from the southern Caucasus are stored in the town of Kuba on the Caspian Sea, halfway between Derbent and Baku. The majority of the inhabitants are concerned in carpet production. The warp is of cotton or wool, and the weft and pile of wool. The Ghiordes knots are at a density of 10 to 15 per square cm. Kuba carpets are considered the best quality Caucasian carpets. The size ranges from small runners to carpets 3 m. long. The basic colours are dark red or blue, and sometimes beige. The design is geometrical and the borders made up of two or three bands with S-motifs.

Lesgistan. A carpet from the western Caucasus, along the eastern coast of the Black Sea. Warps are of cotton or wool, the wefts and the pile of wool. The Ghiordes knots are at a density of 10 to 15 per square cm. The sizes are 1 × 1.40 m. and 1.40 × 3.50 m. The basic colours are a light brilliant blue, red or beige. The pattern shows Oriental influences in the number of stylised and geometrical motifs, the most important of which are

stars, quadrates with stepped frames, hooks and rosettes.

Shirvan (old). These carpets were made to the south-west of Koba (now Kobeh) in the Shirvan district. Large numbers were produced. Warps were of cotton or wool, wefts and piles of wool. The Ghiordes knots are at a density of 8 to 20 per square cm. The sizes are 80 × 125 cm. and 1.20 × 1.80 m. The colour is very harmonious, with grounds of blue, ivory or red, and designs in yellow, pink and light blue, with ivory in the borders. The patterns are of lozenges, octagons, S-lines and borders of three to five bands with wine-glass, scorpion, star and sometimes ram's horn motifs.

Shirvan (new). These are produced by state monopolies, and every trace of individuality is lacking in them. Warp, weft and pile are of coarse wool. The Ghiordes knots are at a density of 9 to 20 per square cm. The sizes are 70 × 90 cm. and 1.10 × 1.70 m., the largest being 3.50 m. long. The colouring is generally lacking in harmony, shades are brownish, cherry-violet, blueish, yellowish and dirty white. The field is often patterned with three diagonally-placed quadrates covered with small geometrical designs. Borders are wide, often with wine-glass motifs.

Chichi. The Chuchense tribe is located on the northwest border of Daghestan, in part of the Terek region. Chichi rugs are made of fine short-haired wool. The Ghiordes knots are at a density of 14 per square cm. The size is 1 × 1.40 m., the colours are ivory, red and brownish orange, with a dull blue in the field. The inner field is covered with small geometrical patterns of spirals or mosaic-type flower motifs sometimes arranged in rows. The borders are made up of between three and six bands with rosettes.

Armenia and Kurdistan. The art of weaving has been known in Armenia since the year 700. Persian, and later Turkish, influence was felt on the arts, including carpet-making. The Kurdistan weavers were exclusively nomads whose methods and designs were traditional. At the close of the last century many carpets were exported from here, under the name Yürük, to Europe. Today this name is used to describe carpets made by Kurdish tribes; they use wool and dark goat-hair with Ghiordes knots at a density of 6 to 14 per square cm. The colouring is copper, grass-green, dark blue, bright yel-

low and pure white. Motifs are of a simple geometrical type, often in diagonal stripes with star or cross patterns arranged in the centre. They are like Caucasian carpets.

By far the best known of the Armenian carpets is the *Sivas*, named after the town on the river Kizil Irmak where they are stockpiled. They are made by nomads and semi-nomads, and also in workshops; the material is wool and the colours are bright, sometimes gaudy; patterns are based on those of the Persian luxury carpets.

China. Although Europe experienced several bouts of intense interest in things Chinese, including the 18th-century fashion for *chinoiserie*, Chinese carpets were hardly known until about 1900. It was only after 1920 that any large quantity appeared on the market, particularly in America. Probably the oldest date back to the 10th century, when luxury carpets were manufactured whose designs were suited to the silk used. Designs were later adapted from other applied arts. The field was composed of religious symbols connected with Buddhism and Taoism. During the Ming dynasty, carpets were made entirely of silk, and it was at this period that the practice of clipping the pile around the pattern was introduced so that the latter would stand out. During the K'ang H'si reign, a number of naturalistic forms (plants and landscapes) were included among design motifs; during the Ch'ien Lung reign, symbols of knowledge, music and ethics were introduced - written scrolls, the lyre, vases and fans. At this time, too, designs were enriched with motifs from Persian and Indian carpets. The colouring of Chinese carpets is light, the grounds being usually blue, light green, yellow or pink. The oldest carpets are not large, 2 × 3 m. at the most, while the more recent are 3 × 4 m. and larger. From 1910, carpets under the name *chinois* appeared on the European and American markets; they catered to western tastes in form and design, but the quality was still good and the deep pile was still clipped around the pattern.

Pakistan. Carpet-making in Lahore and Karachi has been influenced by Persian, Turkmenian and Caucasian work. These towns reached their peak after World War II, when Moslem weavers left India to settle in West Pakistan.

India. During the reign of the Mughal Emperor Akbar, Persian artisans were invited to the court of Lahore, and it was at this time that Indian carpets began to be produced. They were, from the beginning, so strongly under Persian influence, particularly that of the Herat and Kirman types, that the frequently used term 'Indo-Persian carpet' was coined. The pattern, however, was always more naturalistic than in Persian carpets, and never filled the whole available space; large areas of the ground were left plain, giving an effect of tranquillity. The very best quality Kashmir wool or, more rarely, silk was used. Exporting to Europe began in about 1850. The mass production of recent years has led to a certain decline in individuality and technical quality.

Japan. Production did not begin in Japan until the 17th century. Japanese carpets were never for export, but were destined solely for the wealthiest Japanese. They were made of hemp, cotton or (rarely) wool. The weave was slack and the design followed European or Chinese patterns. A very few examples appeared on the European market between 1895 and 1910.

African carpets can be divided into two groups: those of Arab and those of Berber manufacture. The Arab carpets exhibit strong Persian influence in their designs; although simple motifs are used, such as tresses, volutes, meanders, spirals and formalised tendrils, they always have a tendency to curved and rounded shapes. Berber carpets use lozenge and triangle motifs with stepped, broken frames in strictly parallel vertical lines. They lack the delicacy and gloss of Persian carpets, even when they are of good quality. They have never been intended for export and rarely appear on the market.
Recently, commercial copies have been made of rare old carpets, as has happened in Asia.

Europe. *Uses*. In Asia carpets were an essential part of the daily life of the nomads, and were necessary to every home. In the Middle Ages in Europe, their use was restricted to church and court. They were hung upon the walls of cathedrals on holy days or laid before the altar at which the priest celebrated mass, separating the believers from the altar in much the same way as in secular society they separated king from courtiers. At the Bourbon court, no-one was allowed to step upon the carpet unless invited to do so by the monarch. When Louis XIII was no more than a seven-year-old prince, he made sure that his guest, the Turkish ambassador, did not set foot on the carpet. His royal majesty also announced which symbol of sovereignty was to be incorporated into the carpet; as this changed in the course of history, some carpets were therefore destroyed. From 13th-century documents we learn that not only were Oriental carpets given as presents in Europe, but also those made by carpet weavers in the Parisian guild known as the *Tapissiers sarrazinois,* who had settled in France from Spain. At the same time Caucasian carpets appeared in Spain, and it was not long before imitations were being made in both countries.

European folk carpets. The production of handicraft carpets has never been anywhere near so widespread or important as in Asia, although certain analogies exist between the two. The main production centres are Scandinavia, the Balkans and Poland. European folk carpets are made in the same way as Oriental carpets, and there is also a certain similarity in the motifs. The fact that the tree of life of ancient Babylon or the lotus-blossom figure appears on these carpets is an indication of their long history. The knotted carpets are, however, considerably thinner than their Oriental counterparts, with anything from ten to twenty rows of weft between each row of knots. Thus instead of a close, even pile, there is a softer weave with a long, loose pile for use not only on the floor but also on beds, chests and tables.

In *Poland* only 'Kelims' are produced, woven in tapestry technique. The pattern, in other words, is formed only by the coloured weft, closely woven and entirely covering the warp. The design is based upon both Eastern and Western patterns; in the early 13th century the preference was for geometrical motifs, whereas in the 17th century, Persian and Caucasian influences led to the introduction of Oriental plant motifs which became submerged by naturalistic designs during the Baroque period.

Balkan carpets from Walachia, Serbia, Bessarabia and Bokowina are very similar

to Polish carpets. Plant designs represent local vegetation and there are simplified stylised figures treated in flat colours.

Scandinavia remained free of all influences. The persistent influence of Nordic designs, with their angular geometrical shapes, is clearly visible. The Old Norse *Eddas* tell how Gudrun wove a carpet for Thor. Some of the Norse and later pieces are very small, and are decorated with figure patterns or sometimes with epic motifs; they are more like covers or cushions than carpets. Quite the most interesting are the Finnish *rya* carpets (a name derived from *ruh*, meaning 'shaggy'). The oldest examples, which were not very thick, were made and then distributed among the villagers. They developed stylistically from simple geometrical patterns to complicated compositions of such motifs as tulips, the tree of life, or two hearts, motifs also to be found in Oriental carpets. However, there is no over-all design filling up the whole field; rather single, slightly stylised and enlarged motifs are placed on a single-colour ground. As these *rya* carpets formed an important part of a bride's dowry, they were often decorated with two hearts as a symbol of mutual love, or with a representation of Christ upon the cross with the engaged couple who entrust themselves to his care. Finnish *ryas* have been influenced by the great European styles, and as a result, naturalistic plant motifs appeared in the original simple forms.

Italy. Here the traditions of folk carpets go back a very long time. Even today they are still made in isolated parts of Calabria and Sicily. Cypriot and Turkish slaves brought a knowledge of weaving with them to Italy; hence the strong Oriental flavour freely mixed with a local Renaissance heritage. A distinctive trait is the combination of flat weaving and tufted knotting.

Carpets from European workshops. France. In 1605 a workshop was opened in the Louvre, where Pierre Dupont, an illustrator of religious books, designed carpets in the *façon de Turquie*. The circumstances in which the workshop was set up alone indicate that the products were destined solely for the king. A second workshop was founded in 1624 in the Paris suburb of Chaillot; today it houses the Musée des Artistes vivants.

The building was formerly used as a soap-works - from which is taken the name of all carpets made there: *savonneries*. The new works prospered; the weavers were orphans, the cheapest labour of all. Apart from carpets, *paravents*, bed-covers, chair-covers and sets of textiles for the decoration of a whole room were made there. In 1672 the Savonnerie was merged with Dupont's workshop. Production was at its zenith during the reign of Louis XIV, when 92 carpets were made for the king alone; then economic conditions obliged the workshops to extend their clientele, hitherto confined to the king and the great nobles. Yet this did not lead to expansion since the workshops suffered from the competition of Aubusson, where *savonneries* had been manufactured since 1742 under the personal supervision of the king: he directed production and provided designs free of charge, produced by his court painter. In Felletin too, the production of *savonneries* began in 1786. The English and Spanish imitated Oriental carpets or inserted the coats of arms of their rulers in completed carpets. The French, however, disliked Oriental decor which they considered 'grossier' and 'malfaçonné'. This attitude is understandable, in that the French considered the carpet an integral part of the interior decoration which must harmonise with the moulding on the ceiling as well as with the furniture. The two-dimensional design was replaced by the illusion of three dimensions; ornamental stylisation was replaced by naturalistic garlands, trophies, shells, masks, cornucopias and acanthus foliage. During Charles Le Brun's management, complex allegorical carpets were made for the Apollo Gallery in the Louvre. Soon carpets were to be made floridly depicting entire scenes, allegories and myths as well as landscapes with wide views. Subjects such as La Fontaine's fables and the series on New India were also used. During the Empire period too, when figural themes disappeared, illusionistic effects were still sought: there is a story that on one occasion Louis Philippe walked around a carpet rather than damage what he thought was a hunting trophy in the middle of the floor.

Italy. The French example was followed in 1710 by the opening of a workshop in Rome under the management of Pietro Ferloni

and with the support of Pope Clement XI. In *Spain* too, a royal workshop was set up in Madrid.

England. It was England that provided the first real challenge to the French. In the 18th century a former Capuchin monk named Norbert von Lothringen, who called himself Peter Parisot, founded workshops first in Paddington and then in Fulham. He soon attracted workers from the French tapestry workshops and from the Savonnerie, until the French government felt compelled to threaten would-be *émigrés* with the death penalty. However, Parisot went bankrupt in 1753. His manufactory was bought up by a wealthy Swiss coffin-maker of Basle named Claude Passavant, who transferred it to Exeter. He succeeded in creating the first truly modern manufactory of which he was the fully independent proprietor. English carpets again became a serious threat to the French market, and one which was this time met by the imposition of customs duties.

Recent times. In the 17th century France and Flanders had already produced a plush fabric known as moquette, which was used in bourgeois homes as a floor covering, as upholstery and for table-cloths. At first Oriental patterns were used, but after the rise of the *savonneries*, their designs were used. From 1839, moquette was woven on the new Jacquard machines which had been designed specifically to weave figured fabrics. As with Oriental carpets, machine production resulted in an initial decline in technical standards and artistic achievement.

Cheap and speedy production necessitated immediate efforts to find designs suited to a new way of life and modern production methods. Historic designs were continually being copied without any creative initiative. But during the latter half of the 19th century, the work of William Morris, who sought new forms for all the applied arts, altered the appearance of carpets. Art Nouveau was a further step forward which encouraged a new interest in handicrafts and in industrial design. But there was no real change until the creation of the Bauhaus, which became a centre of modern creative handicrafts and had a very pronounced effect on carpets, stressing simple two-dimensional patterns suitable to the chosen technique. At present both handicraft and mechanical production exist side by side; carpets of the most diverse materials are made in which a balance is sought between materials used, methods employed and intended use. There is also, of course, no lack of copies of old Oriental and European design. On the other hand, there are designers working to produce carpets - of a limited colour range, with simple two-dimensional designs or merely of an interesting texture - which they regard as relevant to contemporary art.

Advice to Collectors

On collecting Oriental carpets. From the last decades of the 19th century, exhibitions of Oriental art have been held all over Europe: the Persian pavilion at the World Exhibition in Vienna (1873), the Oriental Carpet Exhibition in Vienna (1881), the Exhibition of Moslem Art in Munich (1910), etc. For some time dealers easily met the increased demand for Oriental carpets. At first they went from house to house buying all available carpets in easily accessible areas as well as in the main production and trading centres; later they were obliged to go further afield. Prices were low, since in many of the poor countries of Asia criteria of value were different from those of the West. But demand rose faster than supply. Agents bought not only carpets in good condition but also those which had been damaged and repaired. The collecting mania, largely instigated and perpetuated by traders, led to the introduction of mass production with the harmful effects already indicated. An article intended for personal use, an essential part of the day-to-day life of the producer, became a product of workshop or home-industry which was intended only for the market.

Today the prices of carpets increase with the rising standard of living in the East, and also as a result of the rising cost of hand-made products all over the world. Following World War II, London, Hamburg, Zürich and Stockholm became the main centres for trade in Oriental carpets; for Russian and Caucasian carpets the main centre is Leningrad.

The most practical method of buying is to go to a well established and well known dealer, though some prefer the more hazardous - and certainly more exciting - method of going to an auction; the one thing not to do is to buy from a pedlar or take a chance in the hope of acquiring a bargain. The entire carpet must be looked at, with and against the pile, in a good light, so that the condition of the whole can be judged. With any two carpets, even from the same region, there will be great differences in the quality of the materials, in the method of weaving and in the colouring. The density and fineness of the pile can be judged from the number of knots per square centimetre. The regularity of the knotting can be seen by parting the pile until the weft is visible. Where carpets have been chemically bleached, the colour of the knot is brighter than the pile (see below). Bleached pile is sometimes scorched, in which case the depth of the pile will be variable. A carpet pile burnt by acid has damaged weft threads. A much trodden one has often lost its original shape, particularly if the knotting is rather sparse. A twisted warp can be detected by running the palm of the hand lightly over the pile, when the damaged wool will be heard to crackle and will split. A good quality carpet does not retain an impression on the pile even when the greatest possible pressure is applied to it. The best test is to grind your heel sharply into the pile with your whole weight on it. The resilient pile of a good quality carpet will immediately spring back into place, whereas, for example, a coarse Smyrna carpet will retain the imprint. It is as well also to examine closely the underside of the carpet in order to judge the quality, density and regularity of the weave and perhaps to detect repairs. A carpet with a brittle pile is past its prime. This can be established by rubbing two sections of the pile together; if it is brittle, there will be an audible crackle.

Antique carpets are naturally more expensive than modern ones, although they are usually damaged, with edges giving way and the pile worn and thin. Such a carpet must be treated rather like a damaged old master, and restored by an expert. Missing portions can be reknotted, while the edges can be backed by solid material or the whole thing even lined; new fringes can be added. Such a carpet is not to be placed upon the floor but hung upon the wall. It should be attached to a pole in such a way as to distribute the weight evenly.

Copies - fakes - modern imitations. For many years it was the custom both in the East and in Europe to reproduce the traditional patterns of Oriental carpets. There was no intent to defraud the purchaser but

merely to produce modern examples, usually superior in materials and workmanship, of older designs that were no longer generally available. This skill was naturally exploited by the unscrupulous, who were often successful in their attempts to pass off new copies as originals. One of the oldest extant is the copy of a Tabriz which was very highly valued in Europe. Often, too, new carpets were subsequently 'aged' without the knowledge of their manufacturers.

From 1900, 'antique' carpets known as Pandermas began to appear on the market, especially in the hands of pedlars. The name itself was misleading, as it refers to a town on the south bank of the Sea of Marmora where no ancient carpets remained intact. The 'Pandermas' were good copies of antique Persian and Near Eastern designs, made of silk and wool plus the very discriminating use of gold and silver threads. The shades used matched the antique patterns, there were deliberate mistakes, and deliberately made holes and rents were repaired. They all measured 1.20 × 2 m. The quality of these carpets was so good that even experienced dealers were taken in. It was only by chemically dating the wool that they were revealed as fakes. Merely by handling a carpet it is possible to get a fairly reliable idea of its age: the wool of antique carpets is more elastic and not so excessively dry as the wool of modern carpets. A freshly completed Oriental carpet usually has very intense colouring. In the manufacture of fakes, this must be toned down so as to appear dulled with age. This bleaching or fading process takes many forms but always results in a loss of quality, since the material is inevitably harmed. Sometimes the carpet is only exposed to very strong sunlight and the surface re-washed, but it is usually bleached by some chemical means - calcium chloride, oxalic acid or even lemon juice. An application of acid must be followed by alkali to neutralise it or the wool will be completely destroyed. Rubbing in coffee grounds also gives an aged appearance; while a certain patina is achieved by burying the carpet in the ground. Still another method is to dampen the carpet surface with spirits and set it on fire. Only the tips of the pile will be burnt, and the whole colour range is softened. Or again, a spirit lamp is applied to both surfaces of the carpet, and the burnt black part is then brushed off. Practically all these methods of carpet-fading were first used in Europe and then exported to the East, where they are quite common. The opposite kind of deception involves reviving old carpets which have lost their colour with water colours just before the sale; but this kind of treatment is very easy to detect.

When a good carpet is to be used in the home, it should be cared for in the ordinary way. It should be spread upon a level floor and not have very heavy furniture placed upon it. Dust should be removed not more than once a week, with either a vacuum cleaner or a soft brush. Heavy beating can loosen the knots and should only be used in exceptional cases.

If a carpet is to remain unused for any considerable period of time, it should be rolled round a straight pole with the pile facing inwards and paper or material placed between the layers. Then it should be well covered and placed in a well ventilated spot. Moths are best kept away by preventive means such as DDT for example; each spot or stain should be carefully cleaned with one of the modern carpetcleaning preparations, although of course the most satisfactory method is to have each carpet chemically cleaned so that any insect eggs present will be killed.

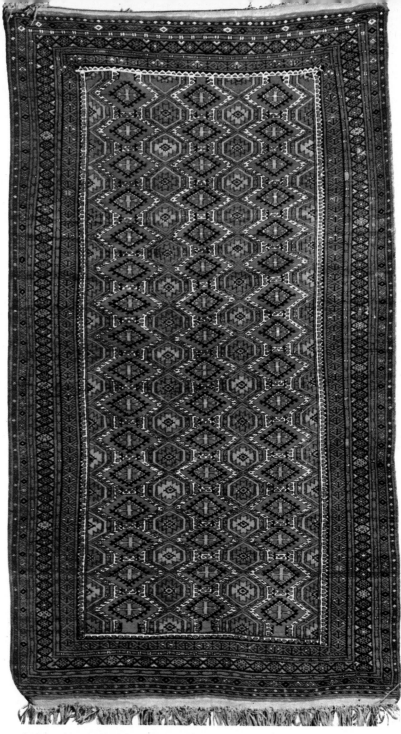

XIII Persian carpet. Safawi, first half of the 19th century

XIV Persian carpet, Ferraghan, first half of the 19th century

▶

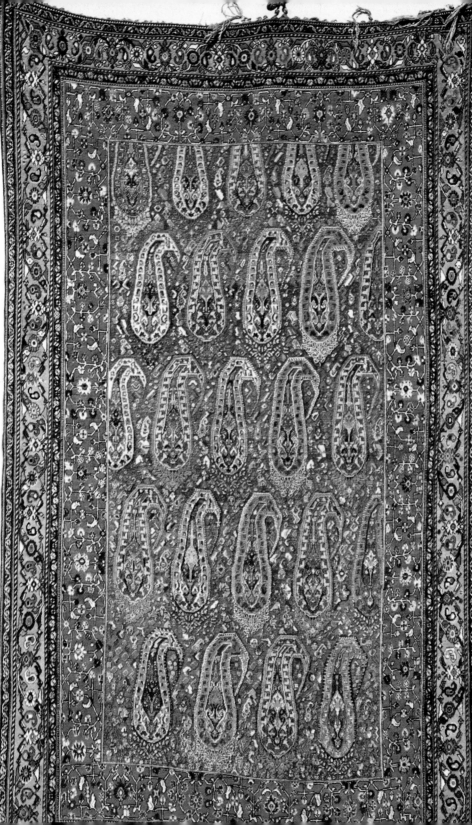

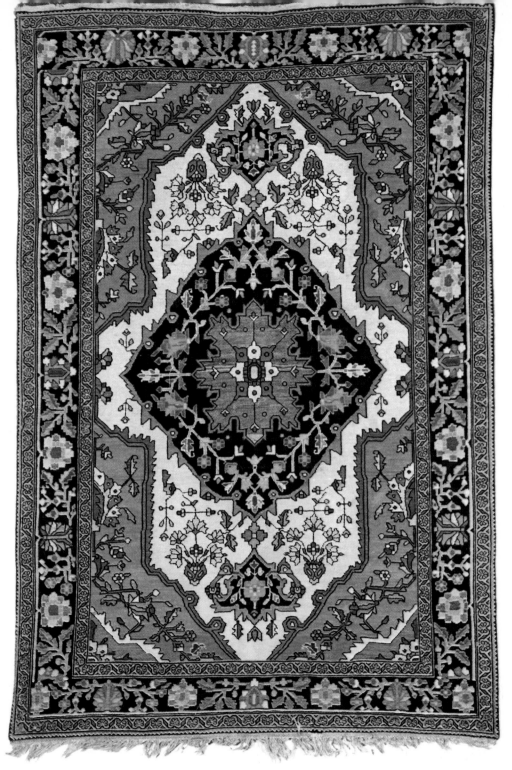

XV Persian carpet. Bijar, middle of the 19th century

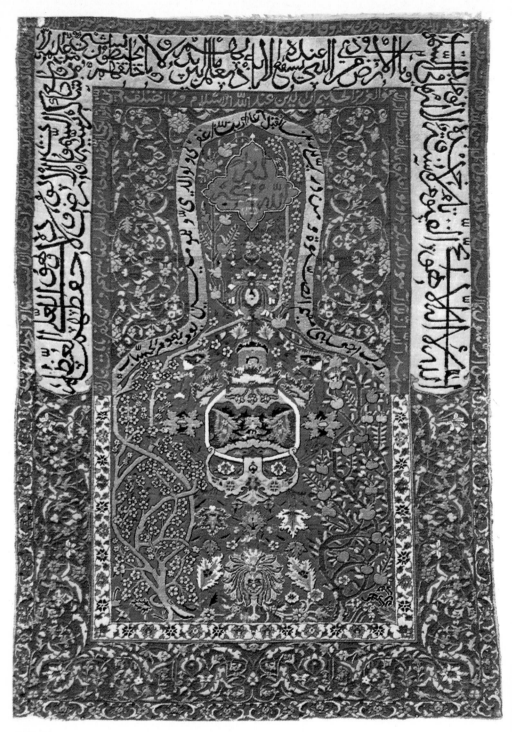

XVI Persian carpet. Saruck, early 19th century

Senneh and Ghiordes Knots

Senneh knots have the pile thread
twisted round one warp

Ghiordes knots have the pile thread
twisted round two warps

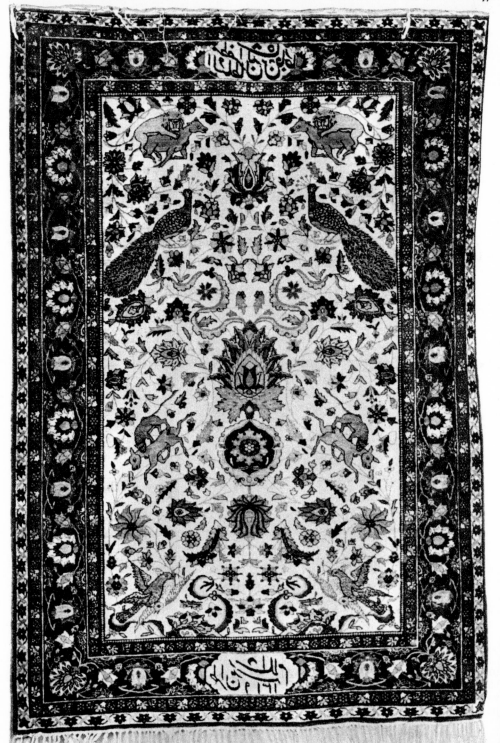

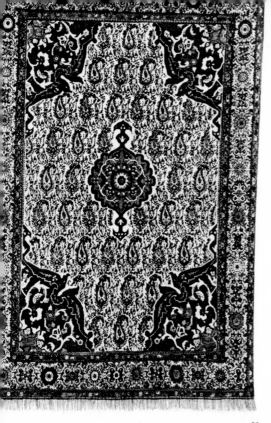

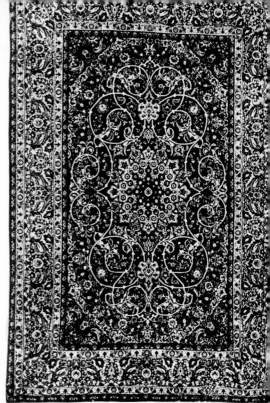

99
100

98

97 Persian carpet. Tehran
98 Persian carpet. Saruck
99 Persian carpet. Isfahan
100 Persian carpet. Tabriz

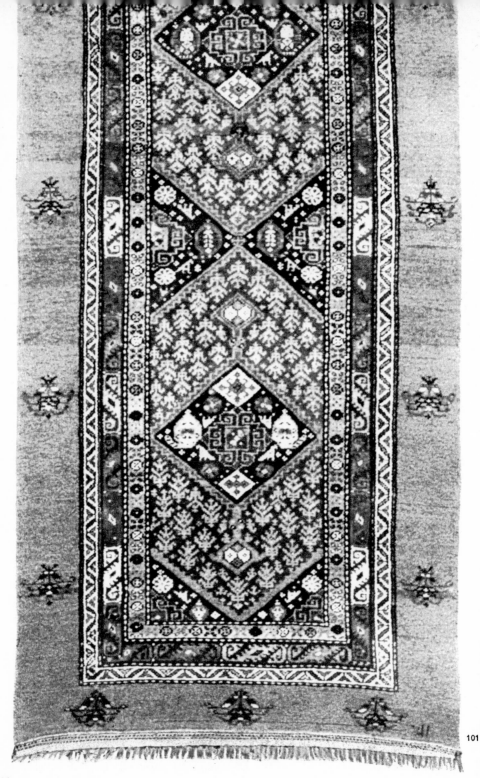

102

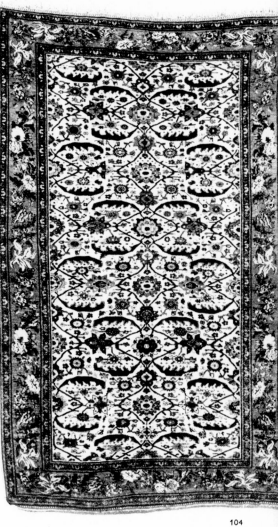

103

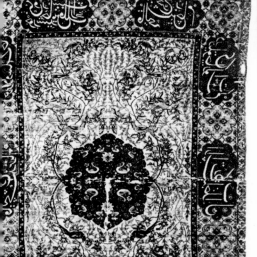

104

101 Persian carpet. Hamadan
102 Persian carpet. Shiraz
103 Persian carpet. Safawi
104 Persian carpet. Bijar

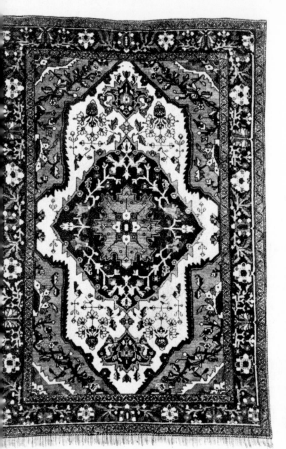

105

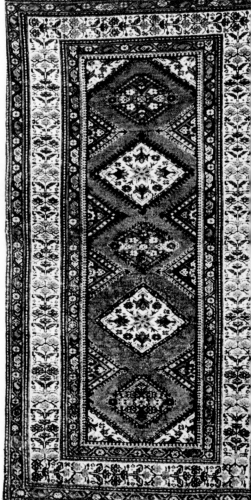

106

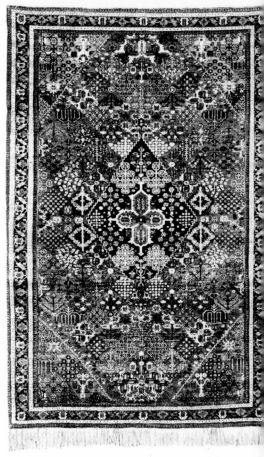

107

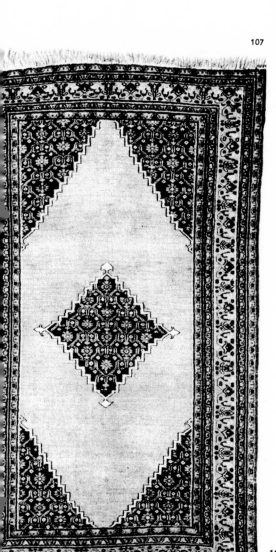

108

105 Persian carpet. Ferraghan
106 Persian carpet. Ferraghan
107 Persian carpet. Khorassan
108 Persian carpet. Isfahan

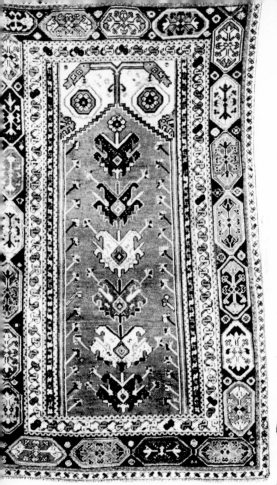

109

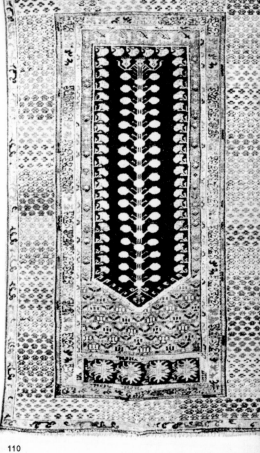

110
111

109 Near Eastern carpet
110 Near Eastern carpet
111 Near Eastern carpet

112

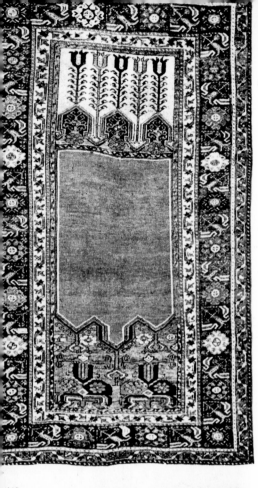

112

112 Near Eastern carpet
113 Near Eastern carpet
114 Near Eastern carpet

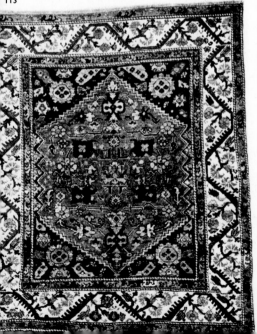

113

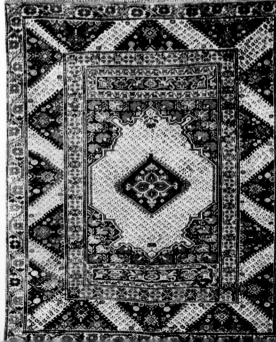

114

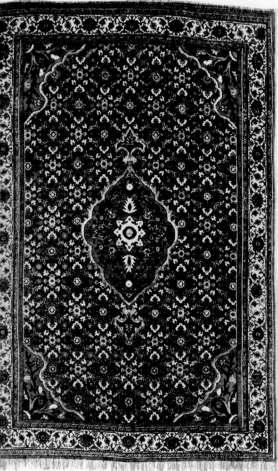

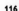

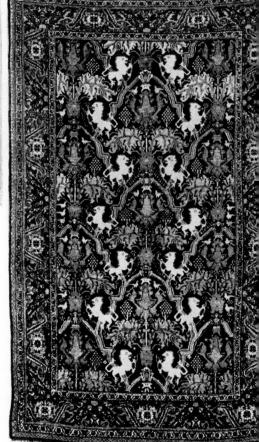

115

115 Kurdistan carpet. Bijar
116 Kurdistan carpet

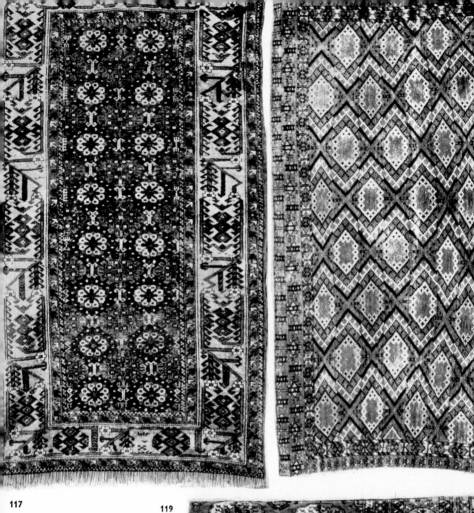

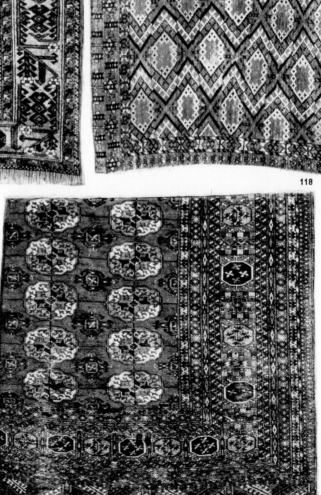

117 Baluchistan carpet. Bashir
118 Baluchistan carpet. Bashir
119 Turkestan carpet. Bokhara

117

118

119

121

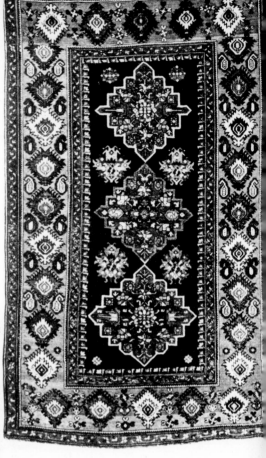

120

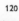

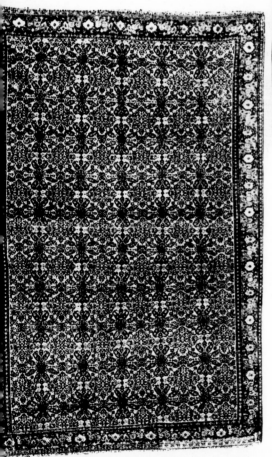

120 Kurdistan carpet. Senneh
121 Caucasian carpet. Kuba
122 Caucasian carpet. Shirvan

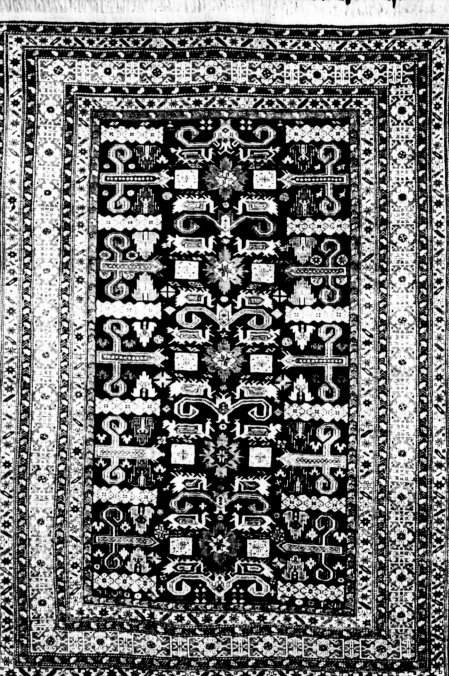

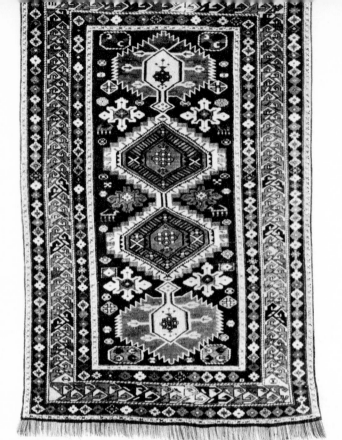

123

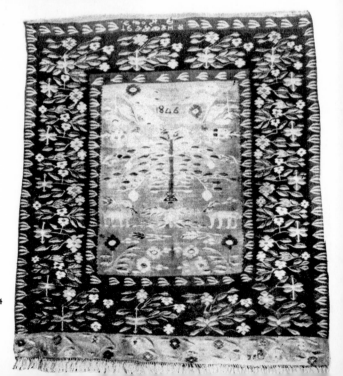

123 Caucasian carpet. Derbent
124 Rumanian peasant carpet

124

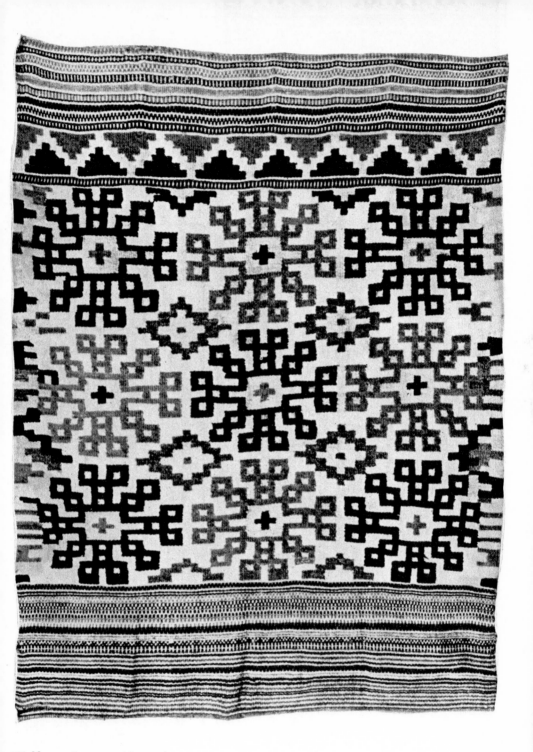

125 Norwegian peasant carpet

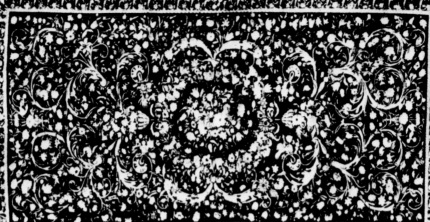

126

127

126 French carpet. Louis
XVI period
127 Carpet designed by
M. Erps. Made in the
Research Department of
the Weimar Bauhaus,
1923

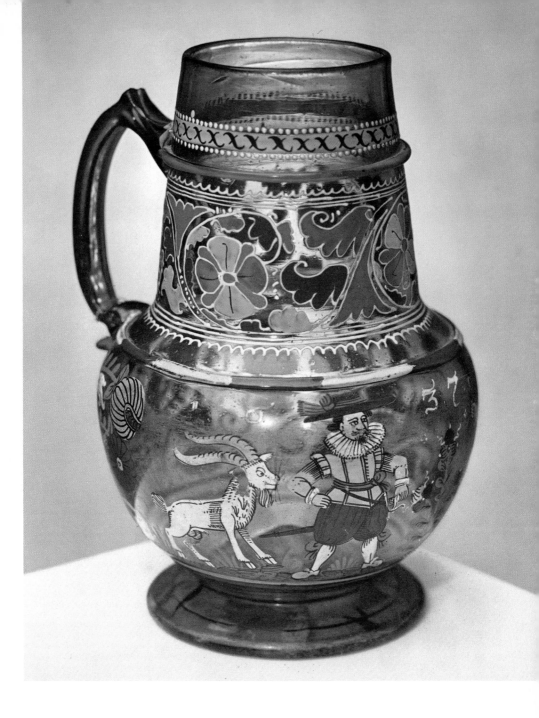

XVII Enamelled jug. Bohemia, 1637

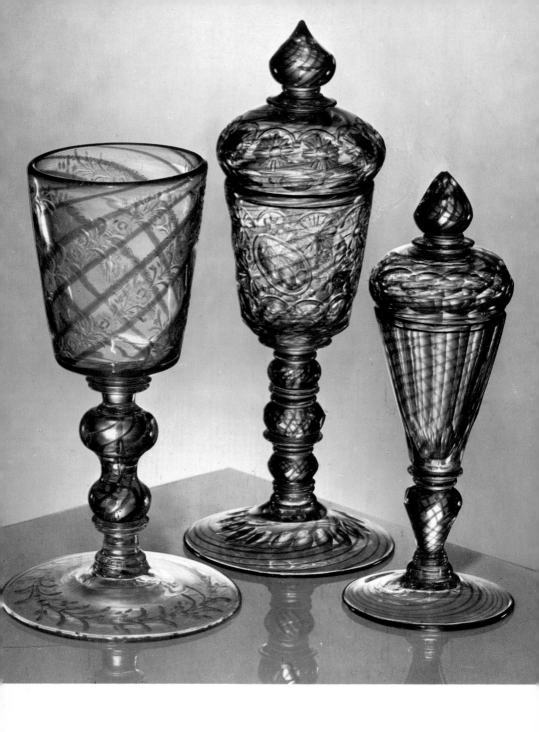

XVIII Cut and engraved glasses with trailed-on ruby spirals. Bohemia, first half of 18th century

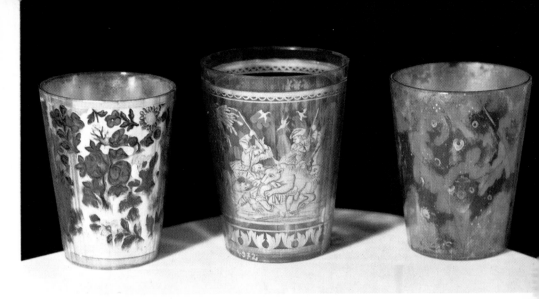

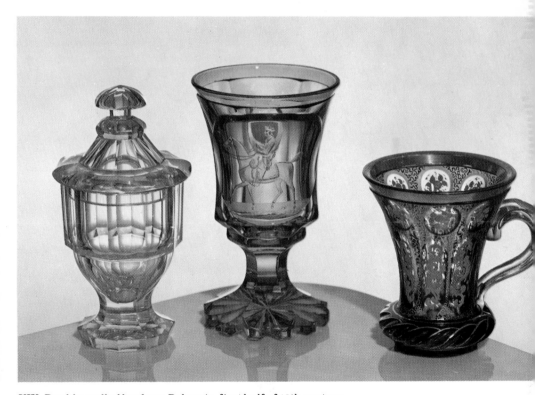

XIX Double-walled beakers. Bohemia, first half of 18th century

XX Coloured and stained glasses. Bohemia, 1830-40

XXI Lithyalin tableware. Bohemia, about 1840

XXII Cut glass with ruby glaze. Bohemia, 1840-50

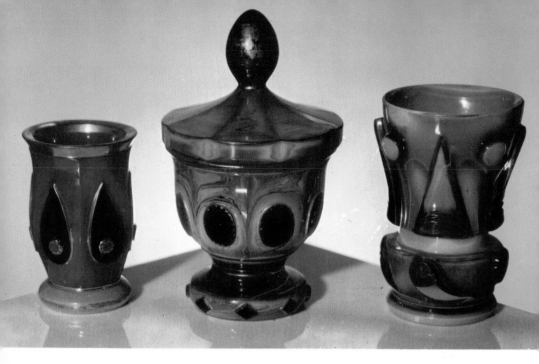

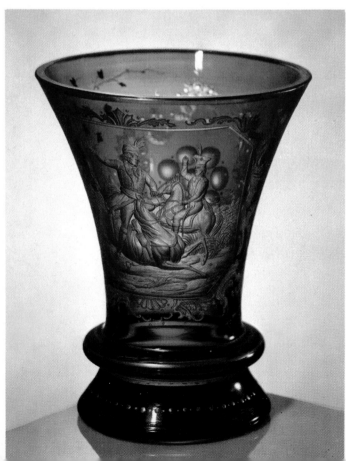

GLASS

For us, glass is such a commonplace article that we hardly appreciate its qualities or its complicated nature; we look upon it simply as a hard substance. But for the glass-maker it is the outcome of a highly complicated chemical process, whereby it is endowed with a living form that can be moulded in obedience to his wishes. For the chemist, glass is just a supercooled liquid, the high viscosity of which gives it the character of a solid substance, for which reason it cannot be classed among the materials with a stable state of aggregation. Since, however, glass quickly becomes rigid, there is no danger of crystallisation, which might impair its transparency and reduce its mechanical stability. Its transparency and refractive quality are precisely the factors that make it possible to produce works of art in glass; and in this respect no other material can rival it.

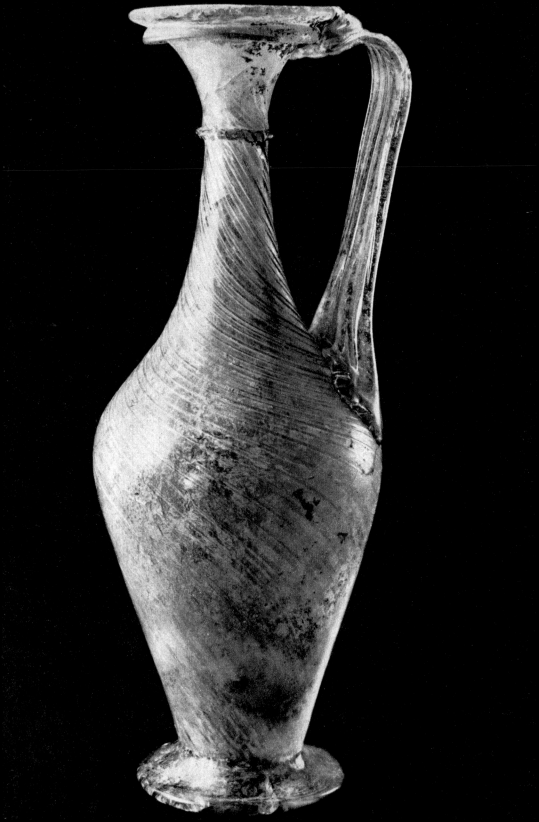

128 Jug of light-green glass. Syria, 2nd century

Manufacture

Characteristics and composition. Glass is made by fusing quartz with various metal oxides. It contains particles of glass (quartz, boric oxide), alkaline fluxes (sodium or potassium oxide) and stabilisers (calcium or lead oxide), which make the silicates insoluble. The proportions of the various components have been established on the basis of centuries of experience.

There are three principal kinds of glass:
Soda-lime glass . . . $(1\,Na_2O : 1\,CaO : 6\,SiO_2)$;
Potash-lime glass. . . $(1\,K_2O : 1\,CaO : 6\,SiO_2)$;
Potash-lead glass . . . $(1\,K_2O : 1\,PbO : 6\,SiO_2)$.
The chief component (70-75 %) is silica (SiO_2). This is obtained from vitreous sand which has the right grain and is free from all impurities. The Venetian glass-makers used pure river sand from the Po, or even imported sand from Istria. The Bohemians used sand obtained from pure quartz.

The second component is calcium oxide (CaO), which makes the glass chemically resistant and constant, and also enhances its brilliance. Calcium oxide is added to the mixture in the form of limestone (calcium carbonate), which changes to the oxide in the furnace. The ancient Egyptians obtained it from fragments of sea-shells, and during the Middle Ages it was obtained from the ashes of wood or of certain marine plants, because the use of limestone as a raw material was then unknown. The 17th-century Bohemian glass-makers were the first to add 'chalk', as limestone was then called.

Other components are alkaline fluxes such as sodium oxide (Na_2O) and potassium oxide (K_2O) which make it possible to melt the glass and manipulate it. The proportion is normally 15-17 %. The fluxes are added in the form of soda ash (Na_2CO_3) or potash (K_2CO_3) and when heated they quickly decompose into oxides. Soda ash was originally obtained by leaching the ashes of marine plants, but in inland districts potash was used, because it could be obtained by alkalising the ashes of beechwood or bracken.

Soda-glass is easy to melt; it is soft and therefore easy to manipulate. Moreover, it is pure and clear.

Potash-glass, on the other hand, is less fusible, hard and less malleable, but it is also very brilliant. As potash was formerly obtained direct from ashes which also contained a considerable amount of iron, potash-glass had a greenish colour, and to decolorise it the 16th-century glass-makers began using brownstone. As the raw material for this type of glass came from the forests, it was called forest glass *(Waldglass).* Nearly half a ton of wood fuel was needed to make one pound of potash.

Lead-glass is made by using lead oxide instead of calcium oxide. It is softer and easier to melt, but heavier. A distinguishing feature of lead-glass is its greater brilliance and high refractive index; it breaks up rays of light into the colours of the rainbow and enables splendid effects to be obtained from the play of light.

Coloured glass. The glass 'metal' obtained after fusion of the usual raw materials is colourless except for a slightly yellowish or bluish-green tint due to the presence of certain mineral elements. To give it a definite colour, metal oxides are added to the mass before or during fusion. Compounds of iron make the glass bluish-green, yellowish or reddish brown; manganese oxide makes it yellow or brown to violet; chromium oxide, grass-green; uranium oxide, yellowish-green (uranium glass); cobalt oxide, blue (cobalt glass); nickel oxide, violet to greyish-brown; antimony oxide or sodium sulphide, yellow. The most beautiful effect of all, however, is obtained by using colloidal silver, which makes the glass copper-oxide red (copper ruby, as distinct from golden ruby, produced by adding colloidal gold). Bone-glass is made by adding bone-ash; milk-glass by adding a mixture of felspar and fluorspar. If the mass is very slightly diluted with the additives used for making bone- or milk-glass, the result is opal glass.

Production methods. Glass has been produced for the last four thousand years, and it was probably discovered by chance in Egypt.

Glass furnaces of the medieval type, made of stones and clay, were used down to the end of the 18th century, but in the 17th century - and especially in England - glass-makers were already using coal owing to the lack of wood-fuel. The sulphur dioxide given off by coal in the furnace, however, tended to colour the glass yellow, and for this reason the English began using kilns for the fusion process. This made the process of melting the glass more difficult and longer, but by the end of the 18th century the use of coal for heating became general, though it brought with it a demand for a softer type of raw material.

The glass-maker's most important tool is the blow-pipe, a hollow metal rod from 3 to 4 feet long, covered with wood for a third of its length and with a brass mouthpiece at the end. The craftsman uses the pipe to take the molten glass out of the furnace, blows it in a mould and shapes it. For the shaping he needs other instruments - metal shears with which to cut away the gathering and attach it to the pipe; a long, pincer-shaped metal rod to pull the gathering out, shape it, form the various decorations, etc.; a chopper with which to detach the blown product from the pipe; and a wooden spoon or bobbin-shaped rolling-pin to reduce the gathering to the desired form. The glass shaped by the craftsman with these tools (the core) is then placed in a mould made of wood or iron. When the finished product is detached from the pipe, there remains a piece of glass, known as the cap or deposit, which has to be ground away.

A somewhat different process is press-moulding. The gathering, still glowing, is pressed with tongs into a mould containing a metal core (formerly wood) and then subjected to pressure until it assumes the desired shape. Pressure-moulded glass has stronger walls and is found mainly in utility wares, though the process has also been used for the production of artistic glass, for example the works which the ateliers Gallé and Lalique have made famous.

Shaping and decoration of glass. The glass produced at the furnace sites was often embellished or decorated on the spot. But in other cases the decoration was executed elsewhere, the glass being painted, stained, scratched or stippled with a diamond-point, engraved, cut, etched or sand-blasted.

The various techniques of glass-decoration serve different purposes. Some are purely ornamental (enamelling, iridising); others are merely subordinate factors in other techniques (cased and stained glass); others again are in themselves effective and artistic (diamond-point engraving, intaglio and cutting). Collectors should be familiar with all these techniques, since they are frequently characteristic of certain periods and styles. Before considering the history of glass, we must therefore discuss in somewhat greater detail the actual process of manufacture.

Hüttenglass. This is the term used by the Germans to denote glass made by the oldest process, the decorations being executed and the wares given their final form on the furnace site where they were produced. The shape of the object was determined during blowing, either by moving the pipe about, or else by placing the gathering in a mould. The surface decoration could also be done with the pipe, by covering the still warm metal with another hot gathering of glass of the same or a different colour, which was applied so that it remained flush with the surface or stood out in relief.

For thousands of years this was the normal way of making glass. It was used with results of the greatest excellence in ancient Rome and during the Middle Ages, and even today it is the truest and most practical expression of the glass-maker's art, since it offers the widest range of possibilities.

An important means of decoration used at the furnace site was *spun glass,* made by winding threads of glass of the same or a different colour round a glass core in the form of thick spirals. Another process used at the furnaces was the melting-on of drops, knops and 'tears'. Also among the oldest techniques evolved by glass-workers, and certainly among their finest achievements, were the lace-glass and the *millefiori* ('thousand flowers') type of decoration, and they were basic features of Murano glass in its heyday during the 16th century. In *lace-glass,* inaccurately called filigrane glass, thin white threads of opalescent glass were assembled to form a hollow cylinder; the interior of the cylinder was then filled with a glowing core and the threads were melted on to the surface. The glass-maker then pulled the whole contents of the cylinder lengthwise, and in so doing could produce an infinite variety of

patterns according to how he manipulated the metal. Another way of making lace-glass was to lay the threads on a marble bed, over which the glass core was then rolled, so that the threads adhered to it. Glass vessels with melted-on white or polychrome patterns (either lace-glass or rolled-on threads) were known as *vasi a ritorti*. A similar process was used in decorating vessels with casings of combed threads, a technique already found on Egyptian *balsamaria*. A white thread was wound spirally round the glowing glass bubble, and patterns representing birds' feathers or fern-leaves were then formed by combing. In Spain this type of decoration was particularly popular.

Reticulated glass (also known as *reticella* glass) could be made in a similar way, melted-on white, and later ruby-red, threads being made to intersect; for this, two glass bubbles were needed which were turned in opposite directions. This technique was only invented in the 17th century in Venice.

The *millefiori* technique was one of the most effective types of decoration: little glass discs with patterns of multi-coloured flowers on them were melted on to the surface of the vessel. The name of this technique dates from the Renaissance, and the finest pieces were made in Venice, but it was already known to the Egyptians, who used it for inlaid mosaic work.

Aventurine was another very effective type of decoration, frequently used by 17th-century Venetian and Bohemian glass-makers, by the latter mainly for the stems of glass cups and the handles of lids. The effect of gold-spangling which it produced was achieved by adding oxidised copper and forge-scales to the mixture. When melted these produced golden-yellow copper crystals.

Ice-glass (frosted glass, crackle-glass or *craquelé*) was made by a process already known in the 16th century, especially in Venice. The hot glass was plunged into water, whereupon a network of irregular cracks (*craquelure*) appeared on the surface and the glass became opaque. To remove the sharp edges of these cracks the glass was subsequently re-heated and blown again.

The last technique used on furnace-manipulated glass was only a preliminary stage in a more complex process. This was multi-layer or *cased glass*, the coating or casing sometimes being applied to the inside of the vessel. This was a very delicate process, requiring great skill on the part of even experienced glass-makers. The blown glass was dipped into one or more gatherings of coloured glass or the casing was applied to the inside. The layers of colour were then cut through, ground or etched away, and in this way interesting patterns could be formed. A similar technique was known to the Romans, and it survived until the 19th century in European and Chinese glass-factories. A similar effect was achieved by staining the surface of the glass with a transparent coloured film, a technique used by medieval makers of stained-glass windows for churches.

Painting. At a more advanced stage the decoration of glass was executed separately, away from the furnace site where the glass was fused, manipulated and shaped. Workshops were set up in which artistic decorations were added in a number of ways. Painting was among the earliest secondary methods of decoration usually applied away from the furnaces. For this there were various techniques - painting by the cold process, with fired-on colours and by applying metals (chiefly gold and silver leaf) to the surface of the glass.

Painting by *the cold process* was done with non-transparent oil or lacquer colours which were not fired. It reached its maximum development in Venice during the 16th century. Classic examples are the large dishes with portraits or reproductions of contemporary works by Venetian painters. The colours were applied to the inside of the vessel, so that the painter had to work in reverse. First the highlights were inserted, and then the shadows. This technique was usually combined with gilding. Hollow-ware was also painted, but on the surface in the normal way. Decorations of this kind were frequently used in Central Europe during the 16th and 17th centuries, though painting in unfired colours has the disadvantage that it is liable to be rubbed off in the course of time.

Enamelled glass. Painting could be executed in a similar way by using fired-on colours.

The 'enamel' was really glass that could be easily fused and fired on at a comparatively low temperature. It is usual to draw a distinction between thick opaque enamels, flat colours and transparent enamels.

Opaque enamel conceals almost completely the character of the glass.

Flat colours were produced by using a basic flux, which remained clear and transparent after firing and retained its own colour. Such colours could be made either opaque or transparent, according to how the mixture was diluted and the brushwork applied. They are called flat colours because they were applied in the form of a thin film. They were fired-on in a muffle-kiln at a temperature of between 450 and 550°C., at which the colour was thick and brilliant.

Transparent enamelling was a very similar technique. The colours, however, did not conceal the glass but remained transparent, so that after firing the wares looked as if they were made of transparent coloured glass. This technique was used by medieval makers of window-glass, and it reached a high artistic level in Swiss windows of the 16th and 17th centuries. At the end of the 18th century the Dresden glass and porcelain-painter Samuel Mohn produced cylindrical commemorative glasses decorated with transparent enamel. His son, Gottlob Samuel Mohn, and Anton Kothgasser used the transparent-enamel technique in Vienna.

Painting on glass is a very complicated matter because the colours used are liable to change during firing. In the 15th century, under the influence of Oriental painting on glass, the Venetians produced painted hollow-ware. In the 16th and 17th centuries painting became a favourite form of decoration on Central European furnace-manipulated glass. The tradition survived until the 18th century on glassware intended for middle-class households - on cups and beakers with Rococo figure-scenes - as well as on milk-glass; and it survived until the first half of the 19th century on peasant glassware.

Black enamel was used by Johann Schaper in Germany in the 17th century, and by Daniel and Ignaz Preissler in Silesia and Bohemia during the 18th, as a special type of decoration for hollow glass.

Decorations with metals, especially with gold, was known even in ancient times. The gilding was done by the cold process - by applying gold-leaf to the glass. Outstanding examples are the *fondi d'oro*, the gilded bottoms of flat dishes and beakers, dating from the 3rd to the 5th centuries, which have been found in the Roman catacombs in early Christian tombs. Roman glass-makers engraved Christian symbols or religious scenes on the gold leaf applied to the undersides of the bases, and these were then covered with another layer of glass. The same technique is found on little gilded tablets made in the East, where they were used for mosaic-work. In a theoretical work dating from the late 10th or early 11th century AD, Theophilus calls this technique *opus musivum* (mosaic work), and from this it can be deduced that the term 'mosaic technique' is derived from the use of gold and glass in mosaics.

The technique of decorating glass with gold leaf placed between the walls of two glass vessels, one of which was inserted into the other, was known to the Romans, and was revived in the second half of the 17th century by the technician Johann Kunckel. Certain beakers decorated with monochrome gold or silver leaf, together with others on which stains or marbling are applied in imitation of precious minerals, are specifically attributed to Kunckel. Production of these 'gold sandwich' glasses, which the Germans call *Zwischengoldgläser,* was concentrated mainly in Bohemia during the second half of the 18th century. All kinds of subjects were used in the decorations, depending on the purpose for which the wares were intended. Some of the beakers and covered goblets were show-pieces or souvenirs, but many carry references to secular and ecclesiastical dignitaries - secular and hagiographical motifs which prove that they must have been intended for pilgrimage centres and monasteries in Bohemia. The majority, however, were decorated with scenes of life on the big country estates, hunting scenes being the most frequent. The heraldic and figure subjects were usually accompanied by elaborate ornaments in the form of plants, generally in the early Baroque style, which was already considered old-fashioned. Such glasses were often advertisements for the Bohemian glass industry rather than souvenirs of the original giver.

A simplified form of the gold-sandwich technique can be seen in double-walled vessels on which gold leaf decoration is limited to a medallion embedded in a recess in the outer wall which has been ground out of the surface. This technique was used by Bohemian glass factories during the 18th century, culminating at the end of the century in the *Mildner glass*. The surfaces of other glasses were simply painted with gold oxide, a less difficult and cheaper method, dating from the Rococo and Neo-Classical periods, which was frequently used by glasshouses in the Riesengebirge. These same glasshouses also produced combinations of engraving and gilding, as did the Harrachov factory, and decoration of this kind is characteristic of glass made during the Neo-Classical period at the end of the 18th century. In 19th-century peasant glass - pictures of saints, crucifixes, etc. - gilding and silvering on the inside of glasses survived for a long time.

Similar to the decoration of glass by covering it with metal overlays are the *lustre painting* and *iridising* processes. In these, thin films of metal were applied to the glass, producing a glittering mother-of-pearl effect. Iridising was done at the furnace on the still-glowing glass, whereas lustre was painted on cold glass. The former is thus a furnace technique, while the latter belongs to the realm of painting.

Iridising was done with a mixture of tin chloride and barium nitrate, which made the glass glitter like mother-of-pearl. Depending on their composition, these mixtures were colourless, golden-red or a pinkish-red very like ruby. The mixtures were sprayed on to the glass.

Lustres were obtained from resins of heavy metals, applied to the glass with a brush and then fired in a muffle-furnace like enamel colours. Very charming iridescent glasses were produced by the American artist Louis Tiffany.

Stained glass. By staining is meant the colouring of glass with metals, the stains then being fired on in a muffle-furnace. Only two metals are suitable for making these coatings - silver, which gives a yellow stain, and copper, which gives a red or black stain. (The red has to be fired three times, the black twice.) Stains are similar to transparent enamels, but they form a component part of the glass, do not stand out like reliefs and leave no traces of brushwork. Owing to the thinness of the coating, stained glass looks very like ordinary coloured glass, and even more like cased glass. The stain could be etched, engraved or cut with a diamond-point, and it could also be freely painted. In 1830 the Bohemian glass-painter Friedrich Egermann of Nový Bor used a yellow stain on hollow glasses, and in 1832 he introduced red stains.

Scratching and stippling of glass. The technique of *diamond-point cutting* or scratching on glass entails scratching deep lines on the surface of the glass with a diamond, which is fixed in a holder and used like a pencil. This was an invention of the Venetian glass-makers, its delicacy and gracefulness being in harmony with the appearance of the thin-walled Murano glasses. It was a simple technique and soon spread to Central Europe, where workshops for the cutting of glass were established either on the furnace sites or in large cities like Prague, Vienna and Nuremberg. The best diamond-point glass was made during the 17th century at Hall in the Tyrol, at Nuremberg and in Antwerp. With a diamond point the craftsmen could execute ornamental decorations, grotesques and armorial bearings or else elaborate details of previously engraved glass, a technique which was especially used at Nuremberg during the 17th century.

In the 18th century, *stippled glass* appeared in Holland. The artist fixed his diamond point in a holder resembling a hammer, the design being formed by hammering dots of varying sizes into the surface of the glass, a technique not unlike that used for mezzotints. The technique of stippling was practised in particular by two well-known artists, Frans Greenwood and David Wolff.

Engraved glass. Glass, like crystal and precious stones, can be engraved in two ways, by using the intaglio technique - the basic, classical method - or else by engraving reliefs and removing the surrounding ground (cameo-relief). The two techniques were frequently combined. The engraver cut into the surface of the glass with a little copper wheel, set on a fast-revolving axle, the cutting medium being emery powder mixed with oil. The engravings were then either left in the rough or polished. A few engraved beakers (Hedwig glasses) have survived

from medieval times, after which the technique of glass-engraving disappeared for several centuries. It was only revived in the late 16th century, when it was used by the cutters of crystal and gems. Outstanding among these was Caspar Lehmann, glass-engraver at the court of Rudolph II.

It was only in the late 17th century, when a robust chalk-glass began to be used in Bohemia, that engraving on glass was widely practised. The technique spread from Bohemia to Silesia, where work of outstanding quality was produced, especially cameos. Later the technique spread to the rest of Germany, and the discovery of chalk-glass acted as an incentive to the production of engraved glass at Nuremberg, at first by pupils of Caspar Lehmann working on thin-walled glass.

Cut glass. Originally glass was cut (or ground) for purely technical reasons, since this was a way of removing unwanted particles of glass from vessels blown on the pipe. Two kinds of cutting can be distinguished - polished cutting on straight surfaces and round cutting on curved surfaces (rims, bases). The cutting was done on heavy cutting-wheels revolving horizontally on a perpendicular axle in a wooden trough full of water. The wheels were made of iron, copper, steel or sandstone, and those for polishing of wood or cork.

Among the earliest methods were the cutting and grinding away of surfaces, in other words faceting. At a later stage, especially in early Baroque times, round or olive-shaped depressions were cut out. In the 17th century the introduction of lead-glass in England brought with it a new type of decoration, the cutting up of the surface into diamonds and lozenges, and in the 18th century the cutting of semi-cylindrical forms. These two meth-

ods were often combined, and they are characteristic of glasses produced during the 'Biedermeier' period in Germany.

Etching on glass. In 1771 the Swedish apothecary and chemist Scheele discovered hydrofluoric acid; this makes glass shine and its vapour produces faint etchings. As in graphic etching, the surface of the glass was covered with a layer consisting chiefly of asphalt, through which a picture could be scratched with a metal needle. When dipped in a bath of acid the parts thus engraved are etched on to the surface of the glass. On glass consisting of more than one layer, patterns in several colours could be etched, either flush with the surface or in depth. The leading artist in this field at the end of the 19th century was the Frenchman Emile Gallé.

Sand-blasting. In the sand-blast process a stream of sharp-edged grains of sand is directed on to the glass in such a way as to form patterns. The technique is relatively new, and was used for the first time by Benjamin Tilghman in Philadelphia in 1870.

Encrusted glass and firing-on of pastes. This is a special side-line among the techniques of glass production. Reliefs of white clay or biscuit porcelain are melted on to the still soft gathering, and if the craftsman wishes to produce the effect of silver or gold, he then covers the reliefs with a coating of colourless or yellow glass. The metallic gleam is caused by the layer of air between the reliefs and the wall of the glass. In the first half of the 19th century this type of decoration was very popular all over Europe. Pastes with the portraits of well known people were melted on to the glass. The technique was the result of collaboration between French potters and glass-makers.

Historical Survey

Antiquity. *Egypt.* It is impossible to say where glass was first made, but we know for certain that in the 3rd millennium BC the Egyptians were acquainted with the use of glass for making glazes, with which they covered objects and vessels made of clay or stone. The earliest finds consisted of trinkets - beads and amulets - made of a non-transparent coloured paste. From the 15th and 14th centuries BC some dark-coloured glass hollow-ware has survived, most of it decorated with threads of a lighter colour. The earliest surviving example is the cup of Thutmose III, dating from about 1500 BC and now in Munich; it is made of turquoise opaline glass and decorated with blue, yellow and white threads in the shape of a lotus-bud. The objects most frequently found are little flasks for salves, the *Balsamaria*. The most important glasshouses were in Alexandria, whence glass was exported to all parts of the known world.

The Near East. About the year 1000 BC, the manufacture of glass spread to other countries, though it was some time before the Egyptian techniques were adopted. Glass was used mainly for making large objects - plaques or high reliefs - which were cast in hollow moulds of wood or iron. It was not until the 7th century BC that the technique of shaping glass round a core of sand again came into use, and this was perfected between the 6th and the 2nd century BC. In this period a number of small glass vessels were produced, the forms being derived from those of Greek ceramics; they were decorated with combed or zigzag patterns. About the same time, new techniques were introduced - glass mosaics and *millefiori* patterns in bright colours.

During the last decades before the birth of Christ, notable changes were introduced into the manufacture of glass after the invention of the glass-maker's blowpipe at Sidon in Syria. At that time Sidon was the most important centre of glass production, and the new technique made it possible to produce the first transparent thin-walled vessels in a great variety of shapes.

Glass in Antiquity. During the first two centuries AD, Syrian glass-makers produced vessels blown in moulds - phials, bowls and alembics - often decorated with trailed-on threads and sometimes with fired-on ornaments resembling Egyptian reliefs. In the same period Palestine also produced fine glass, and during the 1st century AD glasshouses were established in Italy as well as in Roman Spain, Gaul and Britain. Of these, the glasshouses in Gaul and on the banks of the Rhine became important in the 2nd and 3rd centuries. New forms of glass for everyday use were produced, and even glass urns, which soon replaced similar wares made of pottery or metal. Together with these we find sumptuously decorated vessels, *millefiori* and *fondi d'oro* patterns, as well as *vasa diatreta* (cage-cups). The most celebrated showpiece is the 'Portland vase', now in the British Museum, which dates from the 3rd century. Trinkets - and in particular necklaces - were also made of glass, and these were exported in large quantities.

Eastern glass. With the disintegration of the Roman Empire, the centre of glass-making shifted back from the West to the East; the Byzantine Empire became the biggest producer of glass. Once again new forms and new techniques were evolved, especially in the making of mosaics and engraved or cut-glass flasks, jugs and beakers. Among these were Hedwig glasses with animal motifs engraved in relief.

After the Arab conquest of the Near East, painting in enamel colours and gold was introduced. Aleppo and Damascus became the chief centres of production. The best articles, produced between the 12th and 15th centuries, were lamps, jugs, bowls, flasks and beakers, made of coloured glass and enriched with paintings in bright colours and with gilt arabesques.

In the 15th century, Persia became the most important centre for the production of Islamic glass. Many examples of Persian glass dating from the 16th-18th centuries have been preserved. Most of these are jugs of blue or green glass, shaped like big-bellied

flasks, with narrow necks, handles and long spouts, and with nipped-on decorations.

Medieval and modern European glass. The production of glass continued in northern and central Europe. During the early Middle Ages the favoured decorations included threads wound round vessels and various kinds of fluting and melted-in ornaments. Novelties were the German *Nuppen-* and *Rüsselbecher* (claw- and trunk-beakers), while little medicine bottles were also produced. Nearly all these products were made of green glass, and from the technical point of view they were far from perfect.

The 9th century witnessed a general decline in the production of glass. Early Christian culture banned the use of glazes, restricted the practice of placing glass vessels in tombs, and in general regarded the making of glass as a pagan activity; Pope Leo IV even forbade the use of hollow glass for liturgical purposes. However, Bishop Isidore of Seville, in his etymological works, quoted Pliny's treatise on glass-making, and the bishop of Mainz, Hrabanus Maurus, included Pliny's account in his encyclopaedia. The most important medieval work on the arts is the *Schedula Diversarum Artium* by a monk named Theophilus, who probably lived in the Rhineland in the late 10th or early 11th century. In his chapter on glass he gave an account of Classical and Eastern recipes and legends, and provided precise instructions on the making of hollow glass.

Venetian glass. The pioneers of Venetian glass-making were the Benedictines of Venice, who from about the beginning of the 11th century specialised in the production of glass flasks. After the Latin conquest of Constantinople in 1204, Venetian glass-makers became concerned with the production of glass mosaics, and about the middle of the century, glass trinkets and fine hollow-ware made their appearance. Shortly afterwards, the manufacture of glass was officially organised as a monopoly of the Venetian Republic and, since the presence of glass furnaces in the centre of the city was believed to constitute a danger, they were moved shortly before 1300 to the island of Murano. From the same period comes our first information about the export of Venetian glass, its use for windows in building and the production of optical glass for spectacles.

The production of glass coloured with bone-ash was followed in the late 14th and early 15th centuries by that of the threaded and network *(reticella)* glass. The Venetians were also acquainted with the process of colouring glass with gold, cobalt and copper, and the use of fired-on decorations. This form of decoration is typical of 15th-century Venetian glass, while in the 16th century the decorations most frequently used were abstract and botanical patterns on thin-walled glasses, the patterns being nipped on while the glass was still hot. In addition to clear, coloured and bone-ash glass, the Venetians also produced semi-opaque glass, ice and millefiori glass, and small carvings executed on the furnace sites. The chemical processes used in the manufacture of glass were State secrets, and from the end of the 13th century the betrayal of these secrets to foreign undertakings was severely punished.

Despite this, from the beginning of the 16th century numerous Venetian glass-makers obtained employment in foreign countries, where they helped to produce imitations of Venetian glass. In the newly established glasshouses of France, Spain and the Netherlands, such accurate imitations were produced à la façon de Venise that it is often difficult to say whether a particular object was made in Venice or elsewhere. Generally, however, the metal used for such imitations is not so fine, pure and thin as in the Murano originals. In Germany and Bohemia too, 'Venetian glasshouses' were established, but in most cases they soon ceased production. In France a new period opened with the arrival of emigrants from Italy, who endeavoured to produce very pure, transparent glass. In the Netherlands the glasshouses produced flute-shaped wine-glasses on low feet with scratched decorations, as well as the typical winged beakers, the wings of which were designed to look like a double-headed eagle. It is, however, quite possible that some of these wares, on which diamond-cutting was combined with enamelling executed on goblets by the cold process, may have been produced in Germany, and especially in the Rhineland. The same can be said of the Italianate goblets produced at Hall in the Tyrol. The Spaniards produced furnace-manipulated glass à la façon de Venise with trailed-on threads and nipped-on cobalt decorations. Typical products were two kinds of wine-jugs - big-bellied objects with han-

dles or conical ones with long straight spouts.

German and Bohemian potash-glass. During the 13th and 14th centuries, glasshouses were established in the thickly-wooded areas of the Böhmerwald on the Bavarian frontier, the Thüringer Wald and the Fichtelgebirge, as well as on either side of the Riesengebirge. These produced 'forest-glass' (*Waldglass*) which, owing to the presence of iron and chemical substances in the sand, was usually green. New shapes were developed, most of them designed for particular purposes. These glasshouses produced articles for everyday use, such as inkpots and cylindrical jars for apothecaries and alchemists, and above all glass beakers, which at the beginning were their chief products. These were decorated with trailed-on threads, knops, and sometimes curious patterns in relief. In the 14th and 15th centuries these beakers were still small, but during the 16th larger types were produced. The most common were mould-blown; the *Maigelein,* which were cylindrical beakers with vertical fluting; and larger tankards with trailed-on threads *(Passgläser)* or beakers in the shape of cabbage-stems (sometimes called cabbage-stem glasses or, in German, (*Krautstrunks*), as well as beakers with cavities for the fingers (thumb-glasses). In Bohemia during the 14th and 15th centuries, the most characteristic types were tall, slender glasses on small feet, the whole surface being decorated with trailed-on knops. Towards the end of the 15th century a new type of drinking-vessel was introduced, the *Roemer,* which was very popular in the Rhineland. A peculiar type of late-medieval bottle was the *Kuttrolf* or *Angster,* an onion- or dewlap-shaped bottle with several intertwined necks joined in a wide mouth. There were also late medieval bottles, jugs and other vessels, often in fanciful shapes, representing animals, parts of the body, etc.

Information on glasshouses and the manufacture of glass can be found in two important works: *De Re Metallica* (1556) by Georg Agricola and *Sarepta oder Bergpostille* (in which see the fifteenth 'sermon' on glassmaking) by Johann Mathesius, printed at Nuremberg in 1562.

Enamelled glass. The use of paintings in enamel on glass was brought about in part by a demand for central European ware comparable with Italian Renaissance products. The shapes of the vessels manufactured were different, since in central Europe the usual beverage was beer, whereas in Italy it was wine. From the middle of the 16th century, production in central Europe consisted mainly of beer glasses, like the *Willkomm* (greetings-glass) and *Humpen* (bumpers). At first these were conical, but subsequently they were invariably made in a cylindrical shape, with low feet. The addition of painted decorations made them look like products of the Italian Renaissance, and the painting also served to conceal flaws and impurities in the potash forest-glass. Other kinds of tankards were produced with handles and often with lids. The great age of enamelling was the first half of the 17th century, when the appearance of the glass was improved by adding decolourising agents to the mixture, and in particular brownstone.

Very original are the armorial beakers, on which the owner's coats of arms were painted, often accompanied by a monogram and the date. To a second group belong the imperial-eagle bumpers *(Reichsadlerhumpen),* large glasses bearing the arms of the German Empire and of all the imperial lands (variants of a woodcut by Nickel Nerlich printed at Leipzig in 1570). Originally the eagle had a crucifix on its breast, but in the 17th century this was replaced by the imperial orb. To the same group belong the elector glasses *(Kurfürstenhumpen),* showing the emperor on his throne and the seven imperial electors. A variant of this theme, showing the emperor and the electors on horseback, was produced down to the end of the 17th century. Ochsenkopf or Fichtelgebirge glasses form a separate group, decorated with painted views of the wooded Ochsenkopf hills, in which four rivers — Saale, Eger, Main and Naab — have their sources. Other subjects found on painted glasses of the Renaissance and Baroque periods are allegories, episodes from the Old and New Testaments or from fables, and sometimes genre subjects.

Although enamelled glass originated in Venice, for two and a half centuries it was the characteristic form of good-quality glass in central Europe. In the second half of the 17th century it could be found in the houses of prosperous burghers and artisans, and in the final stages of its development it became a form of peasant art, pro-

duced by small craftsmen; while in the form of milk-glass it became a substitute for porcelain. Over the years, new shapes were invented and the composition of the raw material was changed in accordance with new ideas. In addition to greetings-glasses, large numbers of beer jugs, four or six-sided bottles and tankards were produced; later, in the 18th century, there were popular types of spirit flasks, small beakers, goblets and decanters for wine and spirits and so on.

It is difficult to identify the place of manufacture of these wares. Glass-workers continually moved from one glasshouse to another, and the same materials were used in different places, with the result that local characteristics did not remain stable. It is, however, possible to divide the various types into groups which have certain common characteristics. For example, Bohemian glass has a smoky topaz colour, while Hessian glass is pale-green; Saxon enamelled glasses are straight and slender, whereas in Bohemia broader shapes were preferred and sometimes even big-bellied glasses. Beakers with the imperial eagle or the emperor on his throne surrounded by the electors are typical products of Bohemian glass-houses - the earliest types were made at Chřibska u Děčina - while glasses showing the electors with the emperor on horseback come from glasshouses in Upper Franconia and Hessen. Ochsenkopf glasses also come from Upper Franconia.

Together with enamelling in several colours, we also find, though more rarely, glasses enamelled in monochrome white or blue, and also black. The *Schwarzlot* (black-enamel) glasses form a separate group. During the 17th century many well known artists devoted themselves to this type of painting, which was derived from cabinet-painting, and this was especially the case in Nuremberg. The most celebrated of these artists was Johann Schaper, after whom the whole group of *Schwarzlot* glasses in the manner of fired-on wash paintings are called Schaper glasses. Schaper lived in Nuremberg from 1655 to 1670, and it was there that he painted beakers with three ball feet, his subjects usually being landscapes. He frequently signed his works with his full name, but on occasion he used only a monogram accompanied by the date. Schaper glasses by other hands, with genre subjects and battle scenes, sieges and

the storming of cities, dancers from the Italian *Commedia dell'Arte* and landscapes, have survived in large numbers. None of them, however, can bear comparison with Schaper's own delicate and tender works.

After 1700 *Schwarzlot* painting on glass was revitalised by independent decorators. On gold-rimmed glasses it was practised by Daniel Preissler in Breslau and by his son Ignaz Preissler, who from 1710 to 1740 lived on the estate of Count Kolowrat at Kunštát in eastern Bohemia. The style of this sort of painting is in many ways akin to that found on Meissen porcelain produced under the direction of Johann Höroldt, or on products of the Vienna factory during the second phase of du Paquier's management. The predominant motifs were either allegorical, or contemporary scroll-and-strapwork patterns, or bands containing Chinese figures and birds.

Glass painted with transparent enamels. In the late 18th century another type of decoration on hollow glass was introduced by the Dresden porcelain-painter Samuel Mohn: painting with transparent enamels. His presentation cups decorated with portraits, allegories, landscapes or acrostics were usually signed simply 'Mohn fecit', whereas the works of his son Gottlob Samuel are signed 'G. Mohn in Wien'. In Vienna, to which he moved in 1811, Gottlob Mohn painted views on beakers which soon became very popular. This type of decoration was later continued by Anton Kothgasser, who was employed by the Viennese porcelain factory. Kothgasser produced bell-shaped glasses on low, serrated feet; sometimes he signed them with his full name, but more often only with his monogram - a very small one placed between the serrations of the engraved foot. Kothgasser's works were also in demand as souvenirs or gifts, and the decorations on them - allegories, mythological scenes, bunches of flowers, pansies, forget-me-nots, immortelles and shamrock, with appropriate inscriptions - were in harmony with the purpose for which the wares were intended. In about 1875 his beakers decorated with playing-cards achieved great popularity.

Since these glasses were much sought after by collectors, they have often been imitated. Such imitations, however, are easily recognisable on account of the more primitive

technique and the ingenuous compositions, for Kothgasser's skill was unrivalled in works of this kind.

German and Bohemian potash-lime glass (engraved glass). In southern Germany the ancient Roman technique of engraving on glass was revived at the end of the 16th century. The direct incentive was provided by the vogue for cut rock-crystal wares, which spread from northern Italy to the other side of the Alps, mainly through Milan. As, however, adequate supplies of rock-crystal were lacking, and the material was also dear, the technique of rock crystal cutting was applied to glass. The outstanding figure in this field was Caspar Lehmann, engraver of crystal at the court of Emperor Rudolph II. Until recently Lehmann was wrongly described as the inventor of engraving on glass. He arrived in Prague some time before 1601, and in 1609 the emperor granted him the exclusive privilege of engraving glass.

One of his masterpieces, bearing his signature, is known as the 'Lehmann cup' and is now in the Museum of Arts and Crafts in Prague; it is decorated with allegories of the Virtues after a print from an engraving by Egidius Sadeler. The Victoria and Albert Museum in London possesses a rectangular pane of glass engraved by Lehmann, showing Perseus and Andromeda. Other panes, with portraits of Duke Rudolph of Saxony (now in Vienna) and Emperor Rudolph II (Prague) and the Judgment of Paris (Vienna, private collection), are also attributed to Lehmann. He employed several assistants, outstanding among whom after 1618, was Georg Schwanhardt, who moved to Nuremberg after Lehmann's death and was there granted an imperial privilege for engraving on glass; he used this technique mainly on tall goblets of the Venetian type. Among other artists who became active in Nuremberg as glass-engravers were Schwanhardt's sons Georg the Younger and Heinrich, who specialised in views of towns, animals and flowers, Hans W. Schmidt (battle scenes) and Hermann Schwinger (landscapes, genre subjects surrounded by wreaths). Despite the competition of Venetian glass, Paul Eder, Georg Killinger and Christian Dorsch began using Bohemian potash-lime glass, known as Bohemian crystal. With this the Nuremberg glass-

engraver W. Mäuerl achieved notable success.

The discovery of potash-lime glass, which was very pure, clear and brilliant (hence 'Bohemian crystal') and has a high refractive index, was the prelude to further developments in the engraving of glass, for which the thin-walled Venetian glass was far too fragile. The discovery was made contemporaneously (1670-80) in three glasshouses in northern and southern Bohemia. It was at once widely exploited: instead of enamelled forest-glass, which was henceforth used mainly in middle-class households, Bohemian crystal was used for making beakers, goblets, decanters and flasks, all decorated with engravings. At first, Bohemian crystal wares tended to be imitations of the shapes and nipped-on decorations of Venetian glass, though with a sparing use of engraved decorations - this being in harmony with Counter-Reformation artistic trends. On account of its Italianate perfection, the new material was soon able to compete with Venetian glass, as is proved by the success achieved in exporting it by a number of merchants, among them Johann J. Kreybich of Kamenický Šenov and Fr. Kittel of Polevsko; after 1675 Bohemian glass was exported not only to other European countries, but also overseas. In particular, Bohemian glassware with engraved decorations became known all over the world. These decorations included armorial bearings, figure compositions, allegories, mythological scenes, pictures of saints, etc., enclosed in frameworks of elaborate scroll-and-strapwork ornaments clearly revealing the influence of the French artist Jean Bérain. The Bohemian glass-makers created new forms of faceted beakers and baluster goblets which were in harmony with the luxurious taste of the Baroque period, and thanks to Giuseppe Briati, Bohemian glass even began to influence the production of Venetian glass. The leading noble families vied with one another in producing glass - the Kinsky and Kaunitz families in northern Bohemia, the Harrachs in the Riesengebirge, the Eggenbergs and Buquoys in southern Bohemia. As well as hollow glass, the Bohemian factories also produced lustred glass in Bohemian crystal (in the area of Kamenický Šenov, after about 1710) and mirrors (mainly at Sloup and in the Böhmerwald). After 1705 glass beads and composite glass (imitations of

precious stones) were produced in the neighbourhood of Trutnov, and in 1742 Johann W. Riedl began to manufacture glass trinkets at Polubný, thereby giving a stimulus to the production of artificial jewellery made from glass, which was later concentrated at Jablonec n. Nisou.

The expansion of Bohemian glass-production as a result of the discovery of potash-lime glass was soon followed by expansion in Silesia, especially in the glasshouses owned by Count Schaffgotsch. Of particular importance was the Hermsdorf factory, thanks to the activities of an engraver named Friedrich Winter, who from 1690 produced a number of 'friendship beakers', as well as goblets, all decorated in cameo-relief. Equally noteworthy for delicate engraving are the wares made by the glasshouse at Warmbrunn (now Cieplice Slaskie Zdroj, Poland) and the Lobkowitz factories at Wiesau. Thistle-shaped bowls are a distinctive feature of Silesian glasses, and the quality of the engravings is superior to that of the Bohemian products, though the latter were made of better glass. A famous 18th-century Silesian engraver of glass was Christian Gottfried Schneider.

In the mid-18th century the Bohemian and Silesian glass-industries began to decline. The growth of European porcelain factories, the development of lead-glass, and changes in taste all had an unfavourable effect on the development of the glass industry. Plain beakers were produced instead of sumptuous goblets, engraved figure scenes were replaced by Baroque cartouches and monograms, and painted decorations took the place of engravings. In brief, forms and decorations became simpler in an attempt to adapt to new circumstances.

Another way in which Bohemian glassmakers tried to overcome their difficulties was the introduction of milk-glass, the primary purpose being to offset the growing competition of porcelain. Drinking-vessels, flasks, vases, etc. made of white glass were produced at Harrachov (Bohemia) from the 1760s to the middle of the 19th century. In colour, shape and enamelling these milk-glass wares closely resembled porcelain, and they were, moreover, considerably cheaper.

The introduction of potash-lime glass also had an influence on the development of the German glass industry, not only in Nuremberg, where the growing influence of Bohe-mian glass began to make itself felt towards the end of the 17th century, but also in the glasshouses controlled by the electors of Brandenburg and Saxony.

A prime factor in the production of glass at the Brandenburg factories in Berlin and Potsdam, and later (after 1736) at Zechlin, was the presence of Martin Winter, the brother of the Helmsdorf glass-engraver, who was able to draw on the experience he had gained in Silesia in the production of crystal glass and in engraving. Martin Winter, who introduced the technique of cameo-relief (though the results he achieved do not bear comparison with his brother's works), was summoned to Potsdam by the glass expert and alchemist Johann Kunckel, author of the *Ars Vitraria Experimentalis*. Kunckel had made a study of the composition of glass-metal, and he is credited with the rediscovery of the method of making ruby glass by adding gold chloride, and with the invention of *Zwischengoldgläser*. Other leading artists working with Winter in Brandenburg before and after 1700 were the monogrammist H. I. and Gottfried Spiller, the latter specialising in the engraving of mythological subjects and, in particular, of groups of children. There was a vogue for massive and heavy forms, and the bowls, lids and feet of glasses were decorated with sharp-pointed leaves in relief. After 1720 the glass-engraver Elias Rosbach showed a preference for lighter forms. Zechlin glass, with its gilded portrait-medallions trailed on to the surface is marred by the rather stiff execution. After the annexation of Silesia in 1740, when the region became part of Prussia (the elector of Brandenburg was called king of Prussia from 1701) it became the chief centre of glass production.

The techniques used in the production of Bohemian crystal soon spread further north via Nuremberg, and especially to Hesse, where the art of glass-engraving was practised by Franz Gondelach at Kassel; some of his signed works are now in the Mühsam Collection. On the basis of these, other works have been attributed to Gondelach, a gifted artist who generally used cameo-relief. Characteristic Hessian shapes are the goblets with conical stems, in which bubbles were pricked out. In the middle of the 17th century the glass-engraver Johann Heinrich Balthasar was active in Brunswick. He is chiefly known for his decorations on gob-

lets with feet vaguely resembling bells.

An important place in the history of 18th-century German glass must also be assigned to the Thuringian glasshouses, which produced goblets with bell-shaped bowls and ribbed quadrangular feet. Well known glass-engravers in this region were Samuel Schwartz, who produced mat and polished engravings (for example the Altenberg goblet, *c.*1720), and his pupil G. E. Kunckel, who worked until about the middle of the century for the court at Gotha. The shape and type of decoration of Thuringian glass had an influence on the wares produced by the glasshouses of the Russian tsars.

Saxony. The electors of Saxony also encouraged the glass industry. From the beginning, Saxon glass developed along lines parallel with those of Bohemian glass; but it also produced certain specific forms, for example horizontal bands of faceting running obliquely across the underside of the bowl and on the shafts of the foot, gilt reliefs applied to the surfaces of glasses (similar to Saxon enamelwork), and gilded intaglios. The arrangement of the decorations was also different, for example the broad friezes on the upper rims of bowls. The leading glass-engraver in Saxony was Johann Christoph Kiessling, who produced numerous hunting scenes and was active in Dresden during the second quarter of the 18th century.

Gold-sandwich glasses (Zwischengoldgläser). During the golden age of Baroque, the Bohemian glass factories used other types of decoration besides engraving. In about 1725 they produced a new type - gold-sandwich glasses - though it should be noted that this technique was known to the ancient Romans, and Kunckel had studied the problem towards the end of the 17th century. The same pictorial or ornamental motifs that we find on contemporary engraved glass were repeated on gold or silver leaf, often embellished with a coloured stain, and the leaf was then inserted between two glasses in the manner described earlier. Technical curiosities are certain small beakers and goblets with dice embedded between the walls of goblet bowls, or in the lower portions of beakers.

Later in the 18th century the technique of double-walled glass was simplified. The glasses were only partly double-walled, usually the upper and lower edges, and into a ground-out bed on the outer wall a medallion on gold-leaf was inserted. The best known artists who used this process were Johann Sigismund Menzel, who worked at Warmbrunn (Cieplice Slaskie Zdroj) in Silesia, and Johann Mildner of Gutenbrunn in Austria.

In the glasses Menzel produced between 1786 and 1803, a gold silhouette on a black ground was usually inserted inside the thickness of the wall with, on the back, an engraved view of Warmbrunn or some other place. Menzel's pupil Mildner, who signed and dated most of his works, painted a great variety of objects on the inlaid medallions: monograms, portraits, silhouettes, figures of saints, coats of arms, landscapes, views of buildings, etc. The views were usually engraved on silver leaf and covered with red lacquer. The upper and lower edges of beakers were often decorated with double walled rings.

Lead-glass (English crystal). In the middle of the 18th century a new feature appeared in European lead-glass production: lead-lime glass. When Neo-Classicism became the dominant style, the simple constructional lines of heavy lead-glass found favour, partly because the metal was brilliant and absolutely clear, and partly because when the surface was cut to a diamond-pattern, a striking rainbow effect was produced by the rays of light reflected from the numerous angles.

In Holland, where engraved glass had never been particularly popular and the tradition of scratching designs with a diamond point had been preserved, lead-glass was very popular. From about 1750 a whole group of wares appeared which were made of a hard glass stippled with a diamond point. This group consisted mainly of massive goblets with balustered, cylindrical or faceted feet, and many of them were imported direct from England. The funnel or bell-shaped bowls were stippled with grouped and graded dots. This technique was developed by Frans Greenwood and above all by David Wolff (dated works between 1784 and 1796). In style the works of these two artists are very different - Greenwood's work was more monumental than Wolff's, which is distinguished by the extremely delicate stippling. The goblets they produced were

designed to commemorate festive celebrations or were congratulatory pieces. Wolff's glasses are seldom found in collections, and most of those that survive are still in Holland.

The 19th century. Bohemian crystal found a formidable competitor in the cut lead-glass produced in England during the Neo-Classical period, since its simple lines and the beauty of the metal were very much to the Neo-Classical taste. The Bohemians soon mastered the English technique, but the quality of the potash-lime glass they used could not reproduce the optical effect of cutting on lead-crystal. Cutting was therefore used only to produce shapes and as a subordinate process in engraving. The choice of subjects was influenced by two contemporary tastes: Classical Antiquity and sincerity carried to the point of sentimentality. The chief products were commemorative and presentation glasses, goblets and vases decorated with symbolical emblems, religious motifs, symbols of friendship or love, views of towns and especially of watering-places, romantic landscapes, reproductions of pictures by famous artists, and also busts of high artistic quality. New workshops for the cutting of decorations were established - at Kamenický Senov, Karlovy Vary, Nový Bor, etc. - and some of these were under the direction of outstanding artists like Dominik Biman and Karl Pfohl. In the long run, however, it was not cut-glass or a combination of cutting and engraving, but *cased* and stained glass that re-established the worldwide reputation of Bohemian glass.

In 1822, inspired by Wedgwood's black basalt stoneware, Count Georg Buquoy, owner of the glasshouse at Nové Hrady in southern Bohemia, and Friedrich Egermann, a technician working at Nový Bor, began producing a black glass called *hyalith,* usually decorated with *chinoiseries* in gold. Their chief wares were coffee services, decanters, dishes and vases. A little later, Egermann invented another type of opaque glass which he called *lithyalin.* He produced mainly imitations of precious stone, especially agates and jaspers, and these - like the stones themselves - were decorated solely with large cut patterns. Another discovery of Egermann s was a golden-yellow stain which he used on beakers and goblets; but his most important contribution was a process, in which copper was used, whereby cheap imitations of ruby glass made with gold could be produced.

In the category of chemically-coloured glasses we must also include genuine ruby glass, as well as cobalt, turquoise, chrysoprase, uranium and alabaster glass, either smooth or cut, but always decorated with symbolical flowers painted in gold or various colours. Highly original were the *Annagelb* and *Annagrün* - yellowish and greenish opalescent glasses produced by the Riedl factory at Polubný on the slopes of the Riesengebirge and named after Riedl's wife Anna.

In 1804 Bohemian glass-makers began to use different coloured stains - thin coatings of coloured glass applied to the outer wall of pure glass. One of the reasons for this development was the demand for cheapness and variety in shapes and colours. This also contributed to the evolution of a new type - the *Mehrschichtenglas* (multi-layer or cameo-glass), a technique which no foreign glass-house succeeded in imitating. The principle of using several layers came originally from China. The glass core was covered with one or more layers of opaque glass of a different colour, which could be cut through, making all kinds of effects possible. Very popular was the addition of a layer of milk-glass, which was then cut through to form flower-patterns painted in enamel colours. In the 1850s this type of glass enabled the Bohemian producers to obtain numerous orders from abroad.

About 1820 there was a vogue in Bohemia for glasses decorated with trailed porcelain or gypsum pastes, for the most part bearing portraits of well known people. Painting in transparent colours in the manner of Mohn or Kothgasser was also used. From 1830 glass-factories in Bohemia, and in Belgium, produced cheap, mechanically made and decorated pressed glass; on such glass few decorations were used - usually figure or ornamental motifs which were superficial imitations of the technique of cut-glass.

The mechanisation of production in the second half of the 19th century, which resulted in the appearance of mass-produced articles and an increased consumption of glass, was a prelude to an artistic decline. There were a few exceptions, among them progressive Viennese producers and artists like Ludwig Lobmeyr, who ran a glass factory at Kamenický Senov, encouraged the neo-

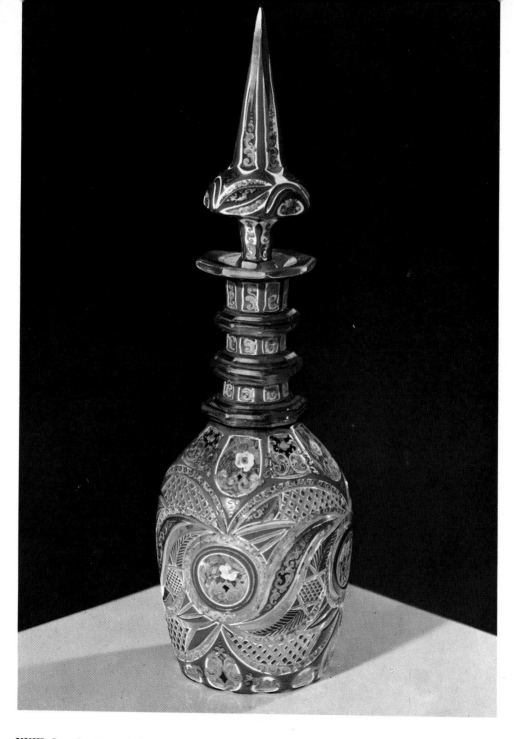

XXIII Carafe of cased glass, cut and painted. Bohemia, mid-19th century

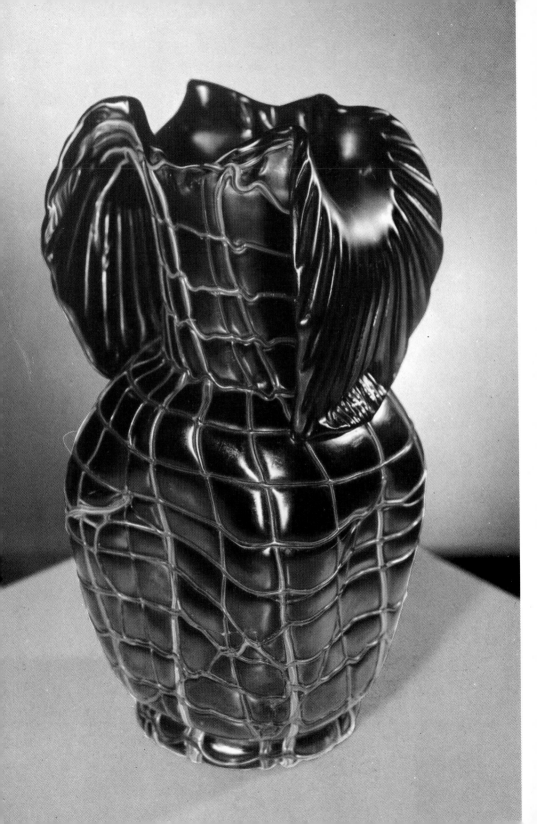

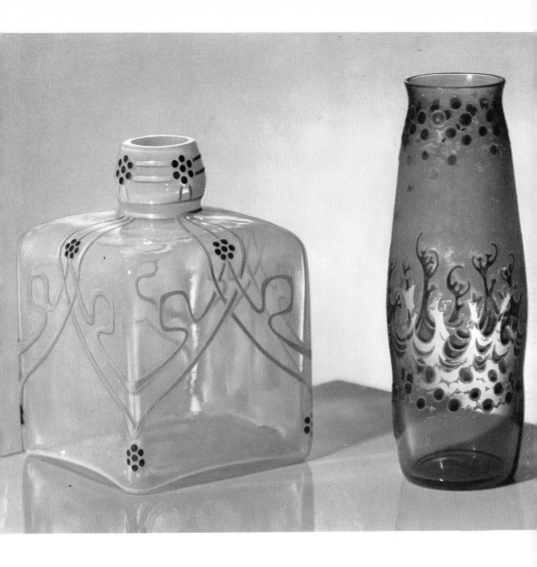

XXIV Vase of green glass. Josef Velík, Košťany (Bohemia), 1910-4

XXV Vases of opaline and cased glass. School of Glass Decoration, Kamenický Šenov, about 1900

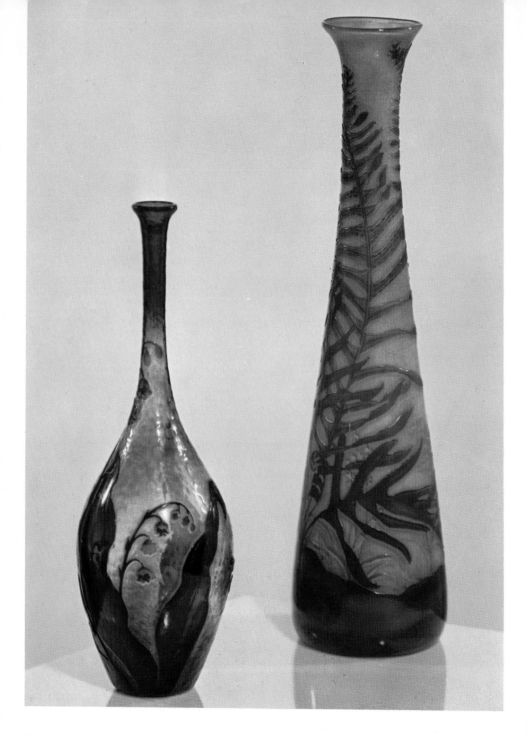

XXVI Vases of cased glass. Nancy, Atelier Daum and Atelier Gallé, about 1900

Renaissance style and did his best to stem the rising tide of tastelessness. Examples of Oriental, late-Renaissance and Baroque glass in museums and private collections were studied and copied, and factories began to produce wares designed by artists. New and simpler forms were thus created, due consideration being given to the purpose for which the wares were intended and the nature of the materials. But before ideas of this kind could be adopted by glass factories in other countries, they had to contend with a new decorative style known as Art Nouveau. In the production of glass Emile Gallé and the Daums' workshop achieved an expressiveness based on the old tradition of cameo-glass, especially as seen on Chinese snuff bottles. In America Louis Tiffany drew inspiration from antique and Oriental glass with its metallic, iridescent glitter, and by combining this with the enchanting colours of the metal, he achieved striking effects in asymmetrical and unconventional forms. Tiffany soon found imitators in Europe, among them the Lütz glass factory at Klasterni Mlýn in Bohemia. In France René Lalique influenced the development of modern artistic glass with his opalescent wares, the effectiveness of which is due mainly to the quality of the decorations in high relief.

Glass jewellery. The origins of the production of glass beads and pastes go back to the early days of glass-making in ancient Egypt. In the days of the Roman Empire, the glasshouses in Alexandria supplied the rest of the known world with glass beads and necklaces. These were made in various colours, and decorated with trailed threads in brighter shades. From Byzantium and the Roman colonies the art of bead-making spread to other European countries, and especially to Venice, which in the 11th century was the chief centre of the industry. The *Arte del perlaio* made a valuable contribution to the revenues of the Venetian Republic, which were derived in the main from exports. Both hollow and solid beads were made, and later on cut beads which were smoothed in rotating drums; pastes pressed on with pincers were likewise used. During the Renaissance period the *millefiori* technique was also used in the production of beads and necklaces.
In Germany the manufacture of beads be-

gan at Nuremberg in the 16th century, in the Fichtelgebirge during the 17th century, and shortly afterwards in Thuringia and at Potsdam. Solid beads were the chief product in the Fichtelgebirge, and blown hollow beads in Thuringia (Lauscha and district). In France production began at the end of the 17th century, and French beads soon became famous. In Bohemia, where glass imitations of precious stones were produced as early as the 14th century, the production of beads and jewellery was revived in the early 18th century, the chief centres being the Iser and Riesengebirge. This branch of the glass industry became known as 'Jablonec bijouterie', after the place where the most important factories were situated, and the term is used to denote all small articles made of glass. The next most important centre was Trutnov, where imitations of precious stones were produced from 1710, and later blown-glass and enamelled beads, made mainly by independent artisans working at home.
From the end of the 18th century there were not only bead-makers in Thuringia and Bohemia but also artists who modelled animals, insects, fruit and complete gardens in blown glass.

Glass windows and painting on glass. Although the use of glass for windows was known to the Romans, medieval glassmakers never managed to produce large transparent panes of glass. They confined themselves to the production of smaller panes made up of pieces of glass of different colours joined together by strips of lead. The first patterns, borrowed from the textile industry, were geometrical, but later on figure scenes were produced, mainly episodes from the Old and New Testaments. At first the choice of colours was limited; the glass-makers found a solution in the use of stains, with which they could produce glass of different colours, the outlines being drawn in black enamel containing copper.
The original home of coloured window glass and painting on glass was France. The earliest information we possess concerns some painted windows in the monastery of St Rémy, commissioned by Bishop Adalbert of Rheims. The golden age of French glass windows was the 13th century, when the huge windows of the cathedrals made complicat-

ed figure scenes a necessity. In the 15th century the range of colours was enlarged by the addition of yellow, and in the 16th so many colours were available that the colouring of glass at the furnace sites virtually ceased. During the Renaissance the demand for naturalistic subjects led to the production of 'cabinet-paintings', the artist painting the entire scene in colours which were then fired. Prominent in this activity were the Swiss makers of glass windows, who produced small panes containing figures and heraldic motifs, which were then assembled to form large windows consisting of circular, light-coloured panes. In the 17th century round panes were replaced by hexagonal ones, and rectangular panes were made at the same time. In this process a glass cylinder was cut longitudinally and the glass was then 'stretched'.

The painting of pictures on glass originated in the East, and the earliest European examples are found on the backs of panes which were subsequently inserted into the walls of important reliquaries. Later on, painted glass was used for fillings on caskets and on pieces of furniture. During the 15th century the Venetians began producing free-standing paintings on glass, a genre that was further developed in the 17th century, when the subjects of contemporary prints (landscapes, battle scenes, genre pictures, etc.) were reproduced on glass. This type of painting on glass reached its highest points in the late 18th and early 19th centuries, especially with the peasant pictures painted on glass and intended for devotional purposes.

Advice to Collectors

Imitations and copies of glassware. The period of the imitation of historical styles, and in particular the neo-Renaissance, culminated round about 1860 in the manufacture of pseudo-historical furniture and imitations of Renaissance enamelled glass - lidded vases, tankards, dishes - which became a speciality of the Harrachov glasshouse at Neuwelt. Together with such imitations, the production of actual forgeries of Renaissance enamelled beakers gradually began. At a first glance it is difficult to distinguish such forgeries from the genuine articles, this being especially true of the imperial-eagle tankards produced by a number of Bohemian and German factories between 1870 and 1880. Apart from the composition of the glass, however, the weakest point in these forgeries is the incorrect palaeography of the inscriptions, and in particular the incorrect forms of the figures in dates. Even famous connoisseurs and collectors like Lanner have forgeries of this kind in their collections. In about 1870 forgeries of Oriental enamelled glasses began to appear, these having been copied from the pattern-books of Ludwig Lobmeyr in Vienna and of Fr. Schmoranz at Kamenický Šenov. About the same time, Lobmeyr began producing pseudo-Baroque and pseudo-Renaissance glass-

es, which were masterly imitations with figure and ornamental decorations, engraved with an accuracy surpassing that of the Baroque engravers themselves. A follower of the Lobmeyr tradition was his nephew Stefan Rath, who was in charge of the factory at Kamenický Šenov from 1919. Admiration of 18th-century engraved glass led to the production of copies of original works, thus carrying on the traditions of engraved glass, which had survived the crises in the glass industry, especially in northern Bohemia. Copies of Lehmann's goblets were made, as well as a whole series of beakers and goblets after Baroque originals preserved in the industrial museums in Vienna and Prague. These copies came mainly from a factory owned by one of Lobmeyr's relatives — the Meyers Neffe factory at Adolfshütte in the Böhmerwald — and its wares were signed with the monogram MN. Both the glass and the engraving were of outstanding quality. The deliberate aim of such copies was to provide collectors of fine glass with substitutes for original works which were almost or entirely unobtainable.

Besides such copies, there are also deliberate forgeries of engraved Baroque glassware. Lured by the prospect of quick profits,

some engravers produce 'originals' which can hardly be distinguished from the genuine products. The antique dealers supply them with undecorated, or only partly decorated, Oriental glasses, on which they engrave patterns copied from genuine Baroque or Rococo specimens, and these are then offered for sale as authentic 17th- or 18th-century glasses. Encouraged by the vogue for collecting glass, modern factories also produce imitations of glass from the Empire period, especially of cased glasses decorated with little paintings in enamel. Such imitations can, however, be easily recognised owing to the absolute purity of the glass and the fact that the decorations show no signs of wear. Consequently, even a layman can see that they cannot possibly be 19th-century works.

Preservation of glass. Glass must be protected from the effects of damp, sudden changes of temperature and strong sunlight. Whenever possible, the specimens should be kept in suitable glass-cases. If a glass is accidentally damaged, the owner should never try to stick it together himself, but should consult an expert or, better still, a restorer from one of the museums of applied arts.

Diseases of glass. Very often opaque glass looks as if the surface is covered with very thin threads of metal. This is a purely physical phenomenon: the ingredients of the metal were not in the proper proportions and, in particular, the silica and the alkalis have not combined as they should have done. Under the influence of damp the excess of alkali comes to the surface, with the result that thin scales are formed which after a time peel off. Since the cause of this disease, known as crizzling, is an excess of potash or soda in the metal, which turns the glass into a watery silicate, there is no cure. The unsightly appearance due to prolonged decay can be remedied only by placing the specimen - provided it is not painted - in a bath of water containing 5% nitric acid and then covering the surface with a layer of pure metacryl. This strengthens the surface, especially if it is already in an advanced state of decay after the thin scales have flaked away. The types of glass most frequently affected by this disease are 16th- and 17th-century German and Bohemian wares.

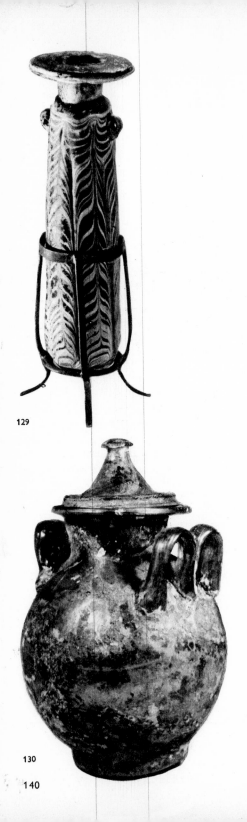

129

129 Balsamarium of coloured opaque glass
with trailed combed threads. Egypt, 4th-3rd
century BC
130 Roman cinerary urn. 1st century AD
131 Cage-cup. Cologne or Rhineland, early
4th century
132 Claw-beaker. Rhineland, 5th or 7th
century
133 Chalice. Venice, 16th century
134 Bucket of ice-glass. Venice, end of 16th
century
135 Jug with coats of arms, painted by the
cold process, of the Ebner von Eschenbach
and Führer von Heimendorf families of
Nuremberg. Venice, second half of 16th
century

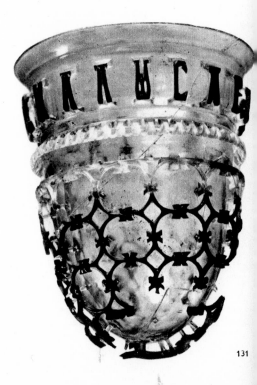

130

131

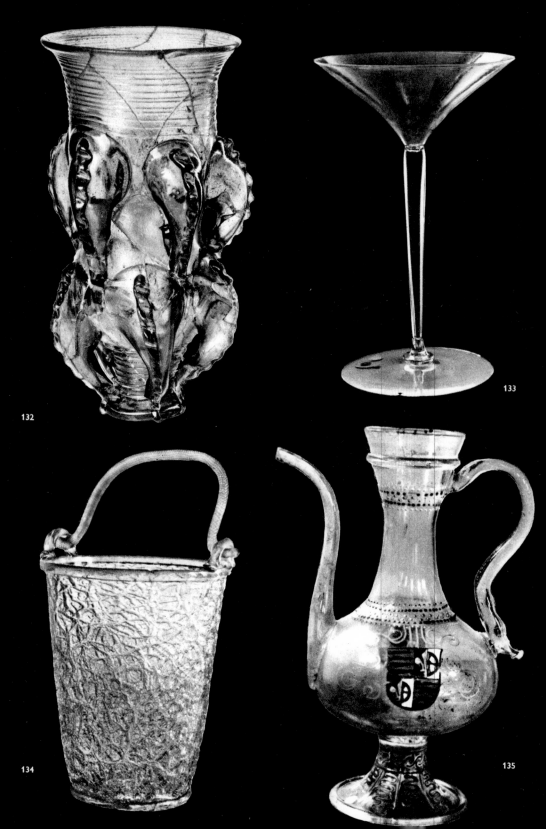

132

133

134

135

136

136 Plate of milk-glass with view of SS
Giovanni e Paolo in Venice; painting in
sepia enamel after an engraving by Antonio
Visentini. Venice, second quarter of 18th
century
137 Bowl of reticular glass. Venice, 16th-17th
century

138 Bowl of agate-glass. Venice, 17th
century
139 Winged glass with diamond-point
engraving. Holland or Germany, 1672
140 Jug (cantir). Spain, 17th century
141 Pole-glass. Germany, 16th-17th century
142 Cabbage-stalk glass. Germany, c. 1500
143 *Kuttrolf*. Germany, 17th century

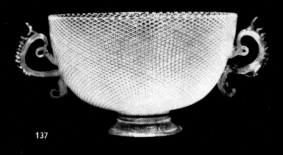

137

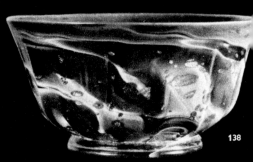

138

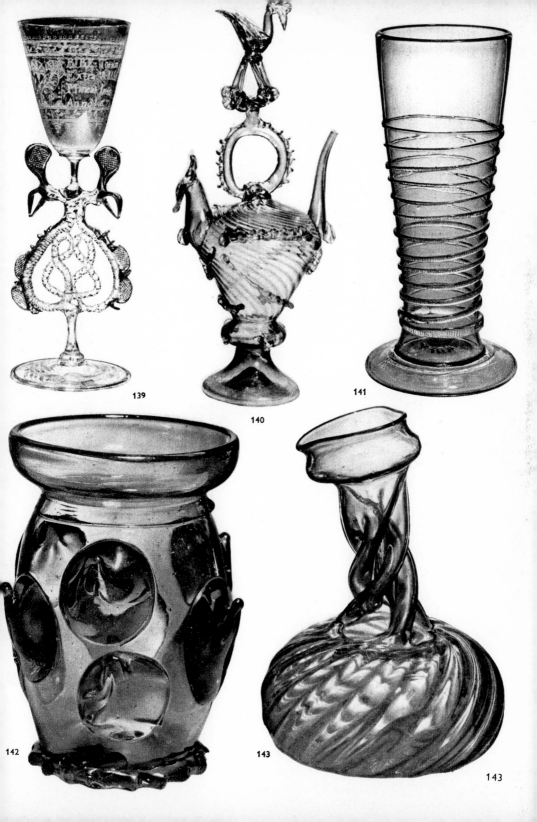

139

140

141

142

143

143

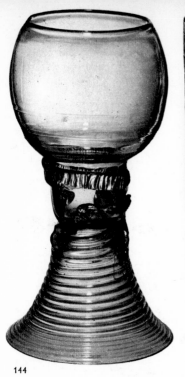

144

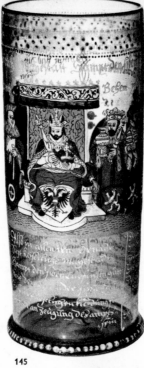

145

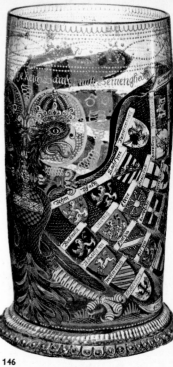

146

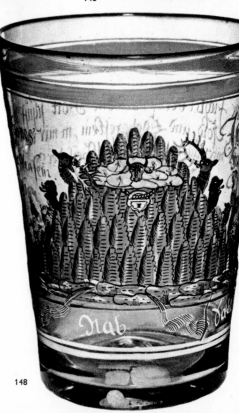

147 148

144 Römer. Germany or Holland, 17th century

145 Electors' bumper, showing the Emperor Rudolph II with the seven electors. Northern Bohemia, 1593

146 Imperial-eagle bumper. Bohemia, 1650

147 Beaker with armorial bearings of the Gerlach and Schlitter families. Bohemia, 1584

148 Ochsenkopf glass. Bischofsgrün im Fichtelgebirge, 1711

149 Beaker on three ball feet, painted in black enamel by Johann Schaper. Nuremberg, 1666

150 Covered goblet and two decanters, painted in black enamel and gold. Ignaz Preissler, Kunštat (Bohemia), 1725-30

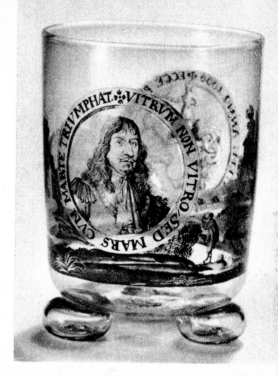

150

149

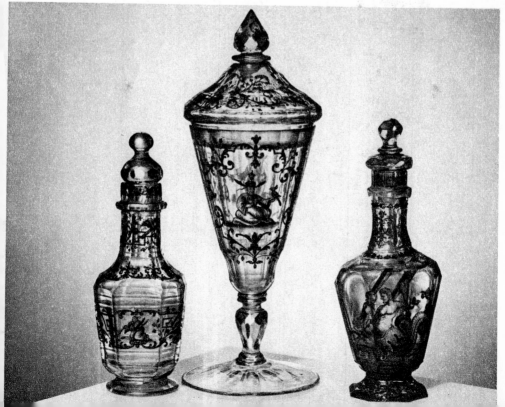

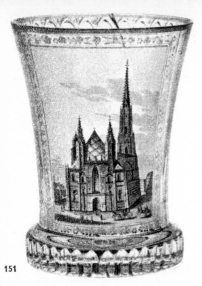

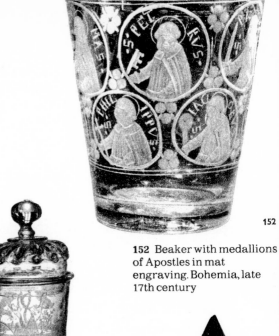

151

152

151 Encrusted beaker with view of St Stephen's, Vienna. Anton Kothgasser, Vienna, 1820-30

152 Beaker with medallions of Apostles in mat engraving. Bohemia, late 17th century

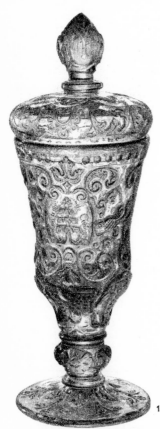

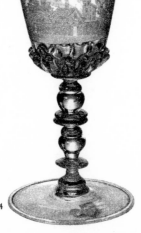

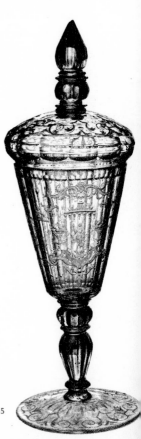

153 154

155

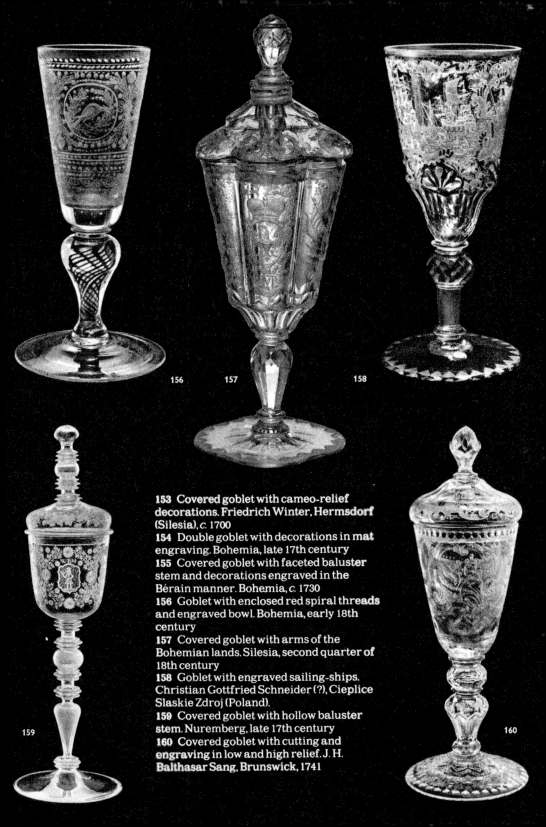

156 157 158

153 Covered goblet with cameo-relief
decorations. Friedrich Winter, Hermsdorf
(Silesia), c. 1700
154 Double goblet with decorations in mat
engraving. Bohemia, late 17th century
155 Covered goblet with faceted baluster
stem and decorations engraved in the
Bérain manner. Bohemia, c. 1730
156 Goblet with enclosed red spiral threads
and engraved bowl. Bohemia, early 18th
century
157 Covered goblet with arms of the
Bohemian lands. Silesia, second quarter of
18th century
158 Goblet with engraved sailing-ships.
Christian Gottfried Schneider (?), Cieplice
Slaskie Zdroj (Poland).
159 Covered goblet with hollow baluster
stem. Nuremberg, late 17th century
160 Covered goblet with cutting and
engraving in low and high relief. J. H.
Balthasar Sang, Brunswick, 1741

159 160

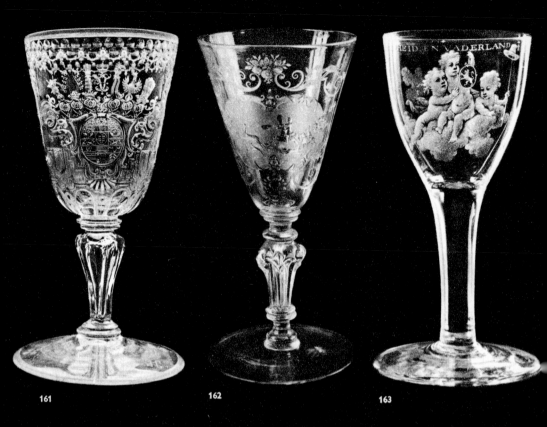

161 162 163

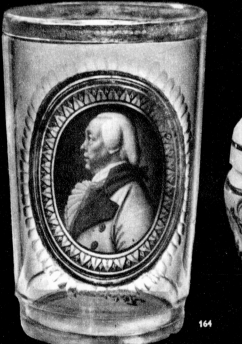

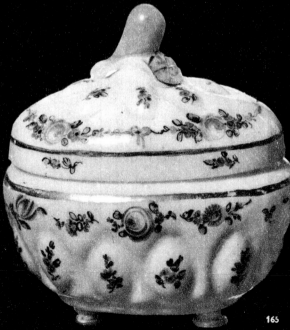

164

165

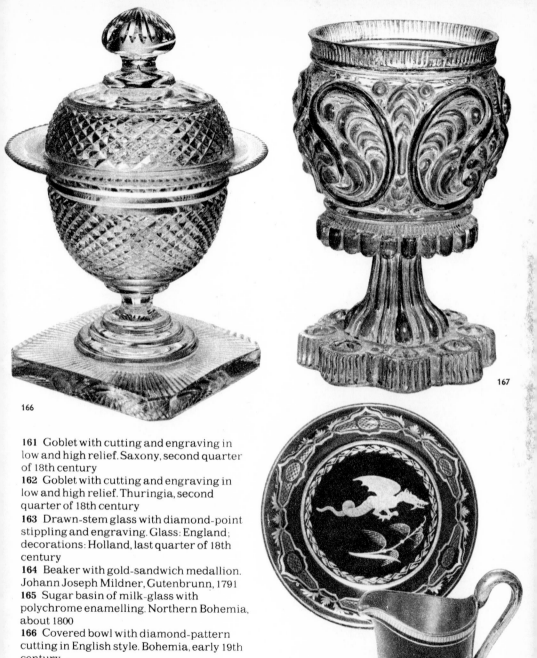

166

167

168

161 Goblet with cutting and engraving in low and high relief. Saxony, second quarter of 18th century

162 Goblet with cutting and engraving in low and high relief. Thuringia, second quarter of 18th century

163 Drawn-stem glass with diamond-point stippling and engraving. Glass: England; decorations: Holland, last quarter of 18th century

164 Beaker with gold-sandwich medallion. Johann Joseph Mildner, Gutenbrunn, 1791

165 Sugar basin of milk-glass with polychrome enamelling. Northern Bohemia, about 1800

166 Covered bowl with diamond-pattern cutting in English style. Bohemia, early 19th century

167 Goblet of pressed glass with decorations etched in pink and blue. Bohemia, third quarter 19th century

168 Hyalith tableware with painting in gold. Bouquoy glassworks, Southern Bohemia, 1820-30

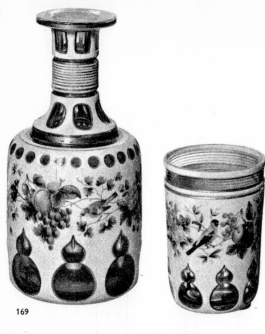

169 Carafe and beaker of ruby glass with milk-glass casing, cutting and coloured enamelling. Bohemia, *c.* 1840
170 Vase of bluish-green lustre-glass. Lütz Witwe, Klášterni Mlýn (Bohemia), *c.* 1900
171 Vase of opaline glass. René Lalique, France, *c.* 1920

169

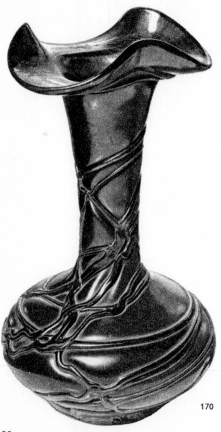

170

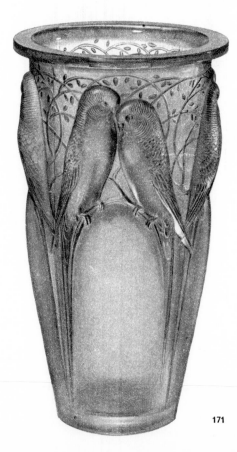

171

POTTERY

The production of pottery was one of man's earliest achievements because it supplied one of his most vital needs. Originally, the form of ceramic products was determined exclusively by the use to which they were put, as was the case with other crafts. Eventually however, pottery became an important branch of artistic activity, and craftsmen strove to achieve ever more sophisticated effects.

The term 'ceramics' comes from the Greek word for potter's earth, from which the Greek term *keramos* (= pottery) is also derived. By ceramics, therefore, we mean products in which the principal raw material is clay (and sometimes kaolin as well), mixed with felspar, quartz or lime. After mixing, these substances were worked up to form a paste, which was than shaped, either with the hand or on a potter's wheel, and afterwards fired.

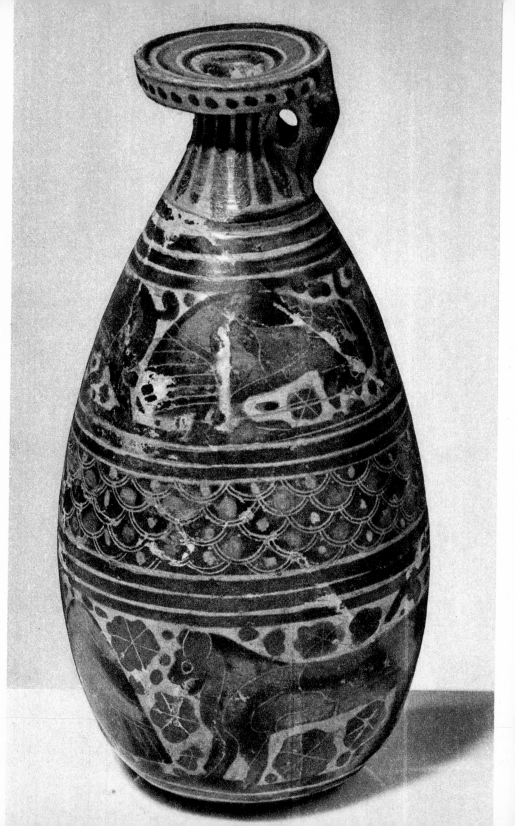

172 Alabastron decorated with animals and scaled patterns in three friezes; Orientalising style. Corinth, first quarter of 6th century BC

Manufacture

Various types of ceramics can be distinguished, according to their composition, the quality of the raw material and the temperature at which they were fired. As production processes were improved, these types gradually emerged, and examples of most of them have survived. The earliest type was pottery with a natural coloured and porous body. To this category belong typical utilitarian articles and also others which were embellished in a variety of ways — by stamping and engraving (for example, *bucchero*), or by the addition of a thin outer coating (Greek ceramics and Roman *terra sigillata*), of a coloured salt-glaze (medieval pottery), or of lead glazes (Renaissance 'Hafner' ware). Towards the end of the 14th century, *maiolica* made its appearance in Europe. This was made of porous, ferruginous or calcareous clay, or else of white earthenware or stove-tile clay, covered with two glazes — one of them non-transparent and containing tin, and the other a transparent, glossy lead-glaze. The decorations were applied to the raw glaze, before the product was fired at a temperature of about 1000° C. The chemical composition of the colours used for painting was the same as that of the glazes. Among the more important components were metal oxides, which are resistant to high temperatures (the hard-fired or high-temperature colours — blue, green, yellow and violet). It was not until the 18th century that muffle or low-temperature colours were used. These were applied to the glaze after firing, and excellent results were obtained with them, especially on porcelain.

In the 16th century the production of stoneware was developed in Germany. In this the very thick body was white (as at Siegburg) or coloured (as at Raeren), and consisted of clay mixed with felspar, quartz, fireclay and other materials. Since stoneware is fired at a temperature of 1200 to 1280° C., it is very hard and almost non-porous. In Holland, potters began to produce red stoneware based on Chinese models, very similar to Böttger stoneware, while a very special kind of stoneware was later manufactured by Josiah Wedgwood in England. The production of fine earthenware developed rapidly in England during the first half of 18th century; it had a white, porous body, covered with a white glaze. According to the thickness of the body, it can be divided into soft-paste earthenware with a high lime content and hard-paste earthenware containing no lime. In composition and the thickness of the body, hard-past earthenware is often similar to stoneware and porcelain.

Originally pottery was shaped with the hand. The invention of the potter's wheel in the 3rd century BC represented a great step forward, since it enabled the potter to produce vessels with much thinner walls. For many types of articles (for example, plates), moulds were used to ensure that the shapes were regular.

Historical Survey

Unlike other materials — glass, wood, metals, textiles — pottery is not subject to deterioration when exposed to the atmosphere, and consequently examples have survived dating from all periods.

Antiquity. As early as the 7th century BC, pottery occupied an important place in Greek art. In it the craftsman's skill and artistic inspiration were combined to produce consummate works of art. This was the result of sophisticated working methods coupled with an innate feeling for art. It found expression in the adaptation of the shape to the purpose and the choice of decorations. The products were destined for numerous purposes — there were showpieces as well as articles for ritual or everyday use — and the purpose also had an influence on the quality. The masterpieces of Greek vase painting are practically the only works of Greek painting that have survived; the quantity of more commonplace pieces that has survived, especially from later periods, demonstrates that the ordinary customer was also well catered for.

Greek pottery was made from a very fine-grained paste, the surface being covered with a thin slip. The decorations were painted on with what is called lustre, a colour made from clay which, as a result of the chemical changes that occured during firing, acquired a black gloss. The various periods of Greek pottery can be distinguished by studying the style of painting.

The culture of the ancient Greeks had its roots in two great civilisations of the 2nd millennium BC, centred on the island of Crete and at Mycenae on the mainland. Both produced pottery of a high technical and artistic standard. Between the 10th and the 8th centuries, knowledge of the culture of Mycenae enabled the Greeks to evolve a style that already contained the germs of Classical art. From the type of decoration this is known as Geometric (also called the Dipylon style, after the quarter of Athens where the most important pieces were found). Regularity of shape was achieved by arranging geometrical motifs rhythmically and in bands, interspersed with subjects taken from nature and even human figures.

The establishment of Greek colonies on the islands and in Asia Minor (Ionia) led to the adoption of new models and new ideas borrowed from the cultures of Egypt and Mesopotamia. During the period of what is called the Orientalising style (mid-7th to early 6th century BC). Eastern compositional schemes together with zoomorphic and botanical motifs, were used on painted vases; the chief centres were in Corinth and other localities occupied by the Greeks. In Attica, from the beginning of the 6th century BC, black-figure vases were produced — ceramic vases with painting in lustre and incised decoration. In these, we find indigenous subjects — scenes arranged in bands, such as the exploits of the Homeric heroes, Hercules or the gods. Various new shapes of vessel were introduced. We also know the names of some of the designers and artists, since potters and painters were in the habit of signing their products. From the same period come a number of small painted votive pieces. Towards the end of the 6th century BC there was a change in decorative treatment; the surfaces of vessels were covered completely with black, only the outlines of the figures were picked out and the details were later inserted with a fine brush. The development of red-figure vases already belongs to the Classical period of Greek art. To the same period belong the white scent-bottles called *lekythoi*, which were covered with a white slip and then painted in red or black, for the most part as a token of homage to the dead. Wares of this kind were produced in the workshop of Attica from the middle of the 5th century BC.

In the ceramic sculpture of the 4th century BC the solemn themes of the previous period were replaced by graceful smaller works, such as statuettes of women and girls. These are called Tanagra figures, after the place where some of the most important pieces were found, but they were also produced in the Greek colonies in Italy and Asia Minor,

and on the island of Rhodes. After Tanagra, the best known centre was Myrina in Asia Minor. In the 4th century BC the centre of artistic activity shifted from the cities of the Greek motherland, which had lost much of their economic power, to the Greek colonies in Apulia, Campania and Lucania, and to southern Russia (Kerch in the Crimea). In these areas potters continued to work in the red-figure style, but they chose very different subjects. In southern Russia attempts to achieve dramatic groupings of scenes from local legends and a wider range of colours often resulted in the smooth surfaces of vessels being transformed into painted reliefs. In southern Italy, on the other hand, a taste for sumptuousness resulted in the creation of rather mannered works. Examples are the 'theatre-subject' vases from Apulia, on which the whole surface is covered with groups arranged round a central panel. The original native products — the black pottery of the Etruscans, with their smooth surfaces and raised or stippled decorations, often influenced by the ornamentation of metal articles — reveal skilful craftsmanship. The Etruscan wheel-made ware, known as *bucchero*, has a characteristic highly polished body achieved by fumigation. The finest examples date from the 7th century and continued into the 6th. The mould-made *bucchero*, featuring human or animal heads were still being made in the 5th century. From the 3rd century BC vessels were decorated with stylised patterns on a black ground. The bright colours (white, yellow and red), the little patterns and the delicate forms, more and more influenced by metalwork, won great popularity for Gnathia ware, named after the place where the largest number of such pieces has been found. Meanwhile Rome was creating an empire and developing and exporting a culture that was a Greco-Roman hybrid. In the first century BC a completely new kind of pottery was produced — red ware with slips and gleaming surfaces. As many of these works bear the potter's seal, they are known as *terra sigillata*. Usually they were decorated with reliefs impressed on the models. Pottery of this kind was also produced at Arezzo in Tuscany, as well as in other parts of the empire, for example in Gaul and on the island of Samos. A large number of pottery lamps cast from moulds have survived, mainly from the Imperial period.

The Middle Ages. It was not until the Romanesque period that pottery production — which, like other crafts, had declined after the collapse of the Roman Empire — began to revive. From the artistic point of view, pottery intended for everyday use was for a long time of very mediocre quality, though from the 14th century attempts were made to master the problem of decorating the surface effectively. An example of such attempts is the use of Gothic letters arranged to form patterns in a band; but such works have a documentary rather than artistic value. Far more important in this respect were the 'architectural' pieces, which became widespread in Europe as early as the 11th century. From monasteries and churches, tiles have survived which date from the 12th century and are already decorated with figures and ornamental motifs in relief, sometimes with monochrome glazes. In the 15th century the quantity and number of types of pottery increased, while the products themselves became more artistic. Stove-tiles decorated with reliefs were produced from the end of the 14th century; in their decoration — ornaments, religious subjects, legends or scenes from everyday life — the imagination of peasant potters found ample scope. From the end of the 15th to the middle of the 16th century, green glazing became more frequent in central Europe, and in the 16th century we even find vessels of a late-Gothic type with coloured tin- or lead-glazes.

The Renaissance. Southern Europe received an impetus for the production of fine pottery from the East. Islamic potters had made great progress both technically and from the aesthetic point of view. The simplest of their methods was to cover the porous body with a non-transparent coating of clay, which served as a ground on which decorations could be scratched (*sgraffito*). Before firing, this was covered with another thin and transparent coating, usually colourless, of easily fusible glossy lead-glaze. This technique is known as *mezzamaiolica*, and during the 14th century it was introduced into southern Europe by Islamic Persia and Turkey. By the end of the 15th century it was extensively used in northern and central Italy, especially in the workshops of Padua, Bologna, Perugia and Città di Castello.

A higher standard was reached by the more exacting and artistically more advanced maiolica with glossy, non-transparent tin- and lead-glazes and decorations in hard-fired colours. Maiolica, too, was first introduced into Europe by Arab traders, the Mediterranean seaports playing an important role. The word 'maiolica' was derived from the name of the island of Majorca, one of the chief centres for the export of Hispano-Moresque pottery to Italy.

Italy. Here there was widespread production of maiolica by the middle of the 15th century. The Florentine sculptor Luca della Robbia used this medium for large reliefs, which he decorated with paint as well as with coloured glazes. The products of his workshop were unique, for down to the last quarter of the 15th century Italian maiolica was completely under the influence of Hispano-Moresque pottery, from which it borrowed not only the forms, but also the types of decoration. Technically speaking, however, the Italian version did not reach the level of its models until gold lustre, so characteristic of Hispano-Moresque pottery, was used in Italy as well.

1470-1500. In the last quarter of the 15th century a reaction to the imitation of foreign models set in, and attempts were made to evolve a new artistic formula. Early Renaissance elements — pomegranate patterns, rosettes, acanthus leaves and palmettes, arabesques, figures of men and women in contemporary costume — were gradually supplanting the traditional Gothic forms of foliage with stylised leaves, inscriptions in Gothic minuscules and leaf ornaments. As these motifs were very accurately rendered, the name 'strict style' was applied to this period. The chief centre was Faenza.

1500-1550. In the early 16th century maiolica production became an integral part of Renaissance art. Both the forms and function underwent a change. In the 15th century, when pottery was intended mainly for everyday use, the chief products were drug pots, or *albarelli,* and other domestic pots and jugs. In the 16th century, by contrast, pottery became an indispensable luxury in the houses of patricians. Flat tableware — that is, plates and dishes — could be more effectively decorated than other vessels, and were produced in great quantities. A change of function also led to a number of technical improvements. Great attention was paid to careful preparation of the paste and to shaping, with the result that the vessels assumed more refined and elegant proportions. The quality of the glazes was also improved, not only with regard to the non-transparent tin-glaze which served as a ground for painted decorations, but also by using an external, colourless and transparent lead-glaze which after firing gave brilliance to the surfaces of vessels. Coloured tin-glazes were also used — light blue *(smaltino)* and dark blue *(turchino).*

The aim of the craftsman was to achieve a greater refinement of colouring and at the same time to extend the range of subjects. Decorations of such high quality were produced that they became known as the 'fine style'. This development reached its zenith in the second quarter of the 16th century, and its main trends were as follows:

1. As regards decoration, the innumerable variants of the grotesque motifs popular during the Renaissance became the common property of all workshops. The town of Castel Durante became particularly famous for the originality of the quaint groups of human figures and animals produced, symmetrically placed in panels distributed over the whole surface. Following the same style, Faenza developed a delicate type of decoration consisting mainly of botanical motifs such as palmettes and acanthus tendrils terminating in masks or of dolphins, festoons, wreaths and vases, these being usually executed in blue on a two-coloured ground. About 1525 this taste for grotesques reached its zenith with the products of the Pirotti family, on which the *a berrettino* technique was used. In this the glaze was light blue instead of white, and drawings were made on a ground painted dark blue, the two shades of blue making an effective contrast. A particularly large number of grotesque motifs were designed in the Medici workshop at Cafaggiolo.

In addition to grotesques, some workshops employed foliage (*a foglie*) and floral (*a fiori*) ornaments, which were sometimes described as *alla porcellana,* because the craftsmen drew their inspiration from Chinese porcelain imported into Europe. *Alla porcellana* consisted of tendrils painted over a white or light-blue glaze. In the mid-16th century a high standard of quality was achieved

in producing such forms in Venice, and in the second half of the century similar forms were still being produced there, though polychrome decorations were preferred to monochrome and the little flowers were replaced by vigorously rendered acanthus leaves. The most important Venetian potteries were directed by Master Domenico and Master Ludovico.

The products of Deruta in Umbria can be distinguished from this general trend by their rather conservative style. From a technical point of view the outstanding features are the use of cooler, generally bluish-yellow tones and golden lustre on surfaces only rarely covered with lead-glaze. Archaic motifs were in the main preferred. Particularly noteworthy are the paintings on flat plates, showing earnest maidens in contemporary costume.

2. Figure painting. From the beginning of the 16th century the grotesques on the rims of plates produced in the above-mentioned centres were combined with figure paintings in the well. This period is rightly condered the heyday of Italian maiolica, for the painting was executed with the utmost care, often in several layers of light tones. In the second quarter of the century, the period of the 'fine style', preference was given to figure scenes, the subjects being either mythological or historical, or else genre pictures which were distributed over the whole of the surface to the extinction of any extraneous ornament. The best pieces were produced in workshops at Castel Durante and Urbino, and in the development of this kind of maiolica an outstanding painter named Niccolo Pellipario, who worked in Castel Durante, played a leading part. He also produced pieces for the workshop of his son Guido Durantino (named after Castel Durante), who later opened a factory in Urbino and was given the nickname of Fontana. Niccolo had a particular influence on painters of the Urbino school, some of whom were employed in Fontana's workshop (Francesco Xanto Avelli, Orazio Fontana), while others, like Francesco Durantino, were active elsewhere. The Urbino work is characterised by the exceptional beauty of the painting, accuracy in the drawing of forms and a subtlety of style. It spread during the 1530s to Venice, Pesaro, Gubbio and Faenza, where one of the best figure-painters, Baldassare Manara, lived.

1550-1620. In reaction against the Urbino style of painting, and as an expression of admiration for Chinese porcelain, which was imported through Venice to every part of Italy, the production of white maiolica became widespread in the third quarter of the 16th century. Faenza took the lead. Decoration was limited to sketchily executed drawings of *putti*, busts, or schematically conceived foliage, executed in blue and yellow in the style created by Virgiliotto Calamelli and his follower Giovanni Bettisi (*stile compendiario*).

About 1600 there was a slackening of demand, and production was confined mainly to the export of white maiolica. During the first half of the 17th century a new centre of production was created at Montelupo in Tuscany. In the products of this centre stylisation was carried to the point of caricature, and there was a preference for bright colours and sharply observed genre scenes.

Later periods. In some centres there was a revival after the middle of the 17th century, when the production of maiolica was adapted to Baroque taste. In this Venice took the lead, producing wares which were similar in style to those of the neighbouring towns of Bassano and Angarano. The vessels produced in these towns had very thin walls and were covered with a pure, glossy grey glaze. The painted decorations were executed in flat tones of rather insipid colours, in most cases manganese. Pottery also began to be produced in a few Ligurian towns — at Savona, Albissola and Genoa. This, however, did not occur until the main centres of production had shifted to the countries north of the Alps.

France. For a long time. tin-glazes were to be found in France only on pottery imported from Italy; lead-glazes were used exclusively on wares produced outside the Italian sphere of influence. Such glazes can be seen on two famous types of French Renaissance pottery — on St-Porchaire ware and on pieces designed by Bernard Palissy.

St-Porchaire ware, of which about sixty examples have survived, used to be misleadingly known as 'Henri II' ware, and has been attributed to a number of craftsmen. Nowadays it is generally believed that the surviving pieces were produced between 1525 and 1560, that is, before the reign of Henri II. In the history of ceramics they are a unique

phenomenon, without parentage or successors. The forms and technique of decoration, reminiscent of *niello* work, suggest that they may have been the invention of a goldsmith. St-Porchaire pottery was made of a fine-grained, almost white paste; most of the pieces have very thin walls and are covered with a transparent, ivory-toned lead-glaze. The decorations were impressed with stamps, and the depressions thus formed were filled with black, reddish or brown clay. Three phases of development can be distinguished. 1. Simple forms derived from metalwork, with rather heavy decorations. 2. Architectural forms decorated with lively grotesque figures. These intricate, inlaid decorations were enriched by the use of reddish or yellow ochre clay, also used for reliefs. 3. The decadent period, characterised by extravagant forms, with inlaid or relief decorations, often carelessly applied; the reliefs include natural forms, apparently imitated from Palissy.

Bernard Palissy was a typical product of the Renaissance and had a considerable influence on more than one of the arts and sciences. Originally a student of natural history, and later a glass-painter, it was at Saintes, between 1540 and 1550, that he began to make exhaustive experiments in the use of glazes for pottery. After fifteen years' hard work he succeeded in firing several enamel colours simultaneously. From then on he devoted homself to the making of pottery with glazes of mingled colours. His own works, mostly large dishes with naturalistic plants and animals, executed with great feeling for sculpture, reveal at the same time a scientific mind. Palissy's importance lies in the fact that he knew how to form a harmonious whole out of these elements drawn from nature, the effect of which was heightened still further by the glazes. His work, moreover, had a great influence on his contemporaries.

When Palissy went to Paris in the 1560s, he abandoned his naturalistic style and began using arabesques for decorative purposes. In this he was following in the footsteps of some of his contemporaries working with other materials; for example, he made a plate imitating a work by the tin-caster François Briot. After the massacre of St Bartholomew, Palissy, a Huguenot, was imprisoned; he died in the Bastille de Bucy in 1590. He has been imitated by numerous potters

— most successfully in the 19th century by Alfred Corplet of Paris.

The production of maiolica began rather late in France. In the 16th century there were only isolated attempts to use tin-glazes, and little progress was made before the Baroque period. North of the Alps tin-glazed earthenware is usually referred to, not as maiolica, but as faience after the famous Faenza ware in France, as Fayence in Germany, and as delftware in England. The technique was used mainly in the manufacture of tiles, and early references to it mention the name of Masseot Abaquesne. The first experiments were made at the instigation of Italian potters who emigrated to France at the beginning of the 16th century (for example Girolamo della Robbia, a member of the famous Florentine family), followed in the second half of the century by numerous others. In 1556 Sebastiano Griffo of Genoa and Domenico Tardessir of Faenza opened a maiolica factory at Lyons. The products of such Italian factories were decorated in the Urbino style, but original features can be discerned in the colouring and details. In the 1580s other factories were founded in Nantes, Nimes and Nevers, but even at that time the use of tin-glazes had not spread to native-born potters.

Germany. In the 16th century the situation in Germany was much the same as in France. Only in southern Germany were maiolica wares produced, and in style they were so like Swiss maiolica that it is often difficult to distinguish between the two. Plates and drug pots were produced in imitation of Italian maiolica, but these, though historically interesting, have little artistic value. The exceptions are some jugs in the form of owls; there are numerous imitations of these.

In addition to the far from perfect imitation of Italian maiolica, two types can be distinguished in German Renaissance pottery: Hafner ware, which developed from the traditional medieval styles; and stoneware, which was Germany's greatest contribution to pottery.

Hafner ware. By Hafner ware we mean pottery covered with coloured glazes. Most of the pieces produced in this way were stove-tiles, which in the countries to the north of the Alps were manufactured from the 13th century. In the 14th century they were decorated with reliefs; in the 15th they were cov-

ered with a green glaze; and after 1500 yellow or brown or sometimes white glazes were applied. In the 16th century the manufacture of glazed tiles was already widespread, the chief centres being Nuremberg in Germany, Salzburg in Austria, and Winterthur in Switzerland. The Swiss tiles were flat and decorated only with paintings in bright colours, but German tiles were covered with reliefs and coloured glazes without any painted decorations. Biblical, mythological, allegorical and historical subjects were based on contemporary woodcuts and engravings. During the Renaissance the coloured glazes acquired a greater subtlety.

A number of 16th-century pieces produced by the same technique, but made only on special occasions, are highly esteemed. With their rich colours and unusual ornamental or figure decorations in relief, they are most effective. Leading figures in the production of Hafner ware were Oswald Reinhard and Paul Preuning in Nuremberg, Melchior Lott and Adam Vogt in Augsburg, and the Pfau, Erhart and Graaf families, which were active in Winterthur (Switzerland) down to the 18th century.

Stoneware. The manufacture of stoneware began in the Rhineland during the first half of the 16th century. High temperatures were required for firing, and this necessitated large quantities of wood, which were unobtainable in the Mediterranean area. Stoneware was made of raw materials of the best quality, and after firing at a high temperature was so non-porous that glazes were unnecessary. Despite this, glazes were used, but owing to the high firing temperature they had to have special qualities. Those most commonly used were salt-glazes produced by sprinkling common salt into the kiln during the firing. The sodium in the salt combined with the aluminium oxide and silicates in the clay, forming a thin hard coating on the surfaces. Stoneware was decorated with ornaments which were impressed on the model before firing. Later on, engravings were made on the paste, or else patterns were impressed by means of wooden stamps. The shapes of the pieces were the result of original designs, each made for one of the centres of production. Even today it is not quite certain whether the first stoneware was produced in Cologne, Frechen or Siegburg. The necessary conditions were present in all three towns, and in each the

tradition of pottery manufacture goes back to the Middle Ages.

Cologne-Frechen. It is difficult to distinguish between the products of these two towns, because in both a number of factories used the same materials and the same style. The paste is grey, with light-brown or yellowish glazes. Here a whole range of shapes were developed. Particularly noteworthy are *Sturzbecher* (tumblers); *Trichterkannen*, with funnel-shaped mouths; round-bellied jugs with low necks; 'greybeards' (*Bartmannskruge*, pear-shaped jugs with the face of a bearded man on the shoulder); jugs with spouts; and the small tankards known as *Pinten* and the large, tapering ones called *Schnellen*. On the bellies of Frechen 'greybeards' we usually find a band with an inscription, sometimes accompanied by the date. The most important factory was Eigelstein's in Cologne, which later moved to Frechen.

Siegburg. The chief characteristic of Siegburg pottery is the excellent quality of the paste, which remained white, or at the most became a very light grey, after firing. For this reason brown or reddish glazes were used only rarely in Siegburg, and normally a thin salt-glaze was considered sufficient. During the 16th century, certain forms typical of Siegburg were evolved, such as the tapering tankards called *Schnellen* and spouted jugs. Down to the middle of the 16th century, pieces decorated with reliefs were produced. Figure subjects were reproduced on bands, as well as medallions or armorial bearings, often accompanied by the potter's initials and the date. Dates are found most frequently on pieces produced between 1560 and 1610. Among the modellers whose names are known are F. Trac, Anno Knütgen and Knütgen's relatives, Peter, Christian and Hans Hilgers.

Raeren. In contrast to Siegburg, Raeren produced stoneware which, from the earliest period, had only a brown glaze. Raeren ware did not acquire an individual character until Jan Emens, the greatest master of Rhenish stoneware production, became active (1566-94). One of his pupils was Engel Kran. The only contemporary who could compete with Emens was Baldem Mennicken (active 1575-94), who was Emens' equal as regards form, but inferior to him in the execution of relief decorations. Emens produced a type of jug with a broad, cylindrical band which bal-

anced the curves of the vessel and formed a natural ground for figure compositions. In the 1580s he began to follow the example of the Westerwald and omit the brown glaze, either leaving the body without any glaze at all or else covering it with a blue glaze. It is therefore difficult to distinguish such works from those produced in the Westerwald.

Westerwald. Stoneware was produced at several places in the Westerwald. After 1590 master-potters from Salzburg and Raeren settled there, and it is only from this time that Westerwald ware was of any aesthetic importance. A typical product was grey stoneware with a blue glaze (the 'blue ware'), which from the 17th century was often replaced by a special manganese glaze. The shapes of drinking-vessels and jugs did not differ greatly from those of Raeren and Siegburg, but decorations in relief were used only sparingly. Preference was given to impressed or incised ornamentation, which made the grey colour of the body stand out better against the blue background of the glazing. In the 17th century, figure compositions were more and more frequently discarded in favour of ornamental patterns, and at the same time the traditional shapes were replaced by new ones.

Kreussen. Pottery was also produced in other parts of Germany during the Renaissance. In Bavaria the town of Kreussen, where Hafner ware had originally been produced, became famous. In Kreussen the stoneware acquired a reddish tone after firing, and was covered with a brown glaze. The chief products were large squat tankards and, after 1640, polygonal flasks. Two groups can be distinguished, though the periods in which they were produced overlap. In the first the decorations were applied in liquid clay, in the manner of Rhenish stoneware, and the whole of the surface was brown. In the second they were painted in enamel colours (blue, red, yellow, white, green and sometimes gold). The oldest brown tankard bears the date 1614; the earliest painted one dates from 1618. The main period of development was the 17th century, when the decorations consisted of Biblical, heraldic and similar subjects which were arranged in bands and often dated.

The pottery produced in Saxony is often very similar to Kreussen ware, and it is difficult to distinguish between the two.

Moravia-Slovakia. The production of faience in Moravia, towards the end of the 16th century, had its roots in the Reformation. The Moravian nobility acted as the protectors of Protestant sects, among them the Anabaptists, who had begun to settle in southern Moravia from 1526; they were refugees from Switzerland, Germany, Tyrol, Holland and Italy. Many were craftsmen, and some had mastered crafts hitherto unknown in Moravia. They lived together in communities known as *Haushaben*, and through a corruption of the word their products became known as *Habaner* ware. Their faience, which they probably learned how to make from Italian craftsmen who emigrated to Moravia between 1560 and 1566, became famous. In any case, it is known for certain that by 1594 the manufacture of faience had become a local industry and had reached a high stage of development in every respect.

The earliest types of vessels clearly reveal the influence of Faenza, while the round jugs and small tankards were inspired by Rhemish stoneware. After the 1590s, light-blue glazes were used as well as white and later dark-blue. The austere principles of the sect, formulated in 1612, were for many decades a determining factor in the decoration. The representation of living creatures was forbidden, so the potters had to be content with flowers, distributed over the surface singly or in bands or bunches. Plain, uniform hard-fired colours were used for the decorations, but never orange. A noteworthy addition consisted of simple geometrical motifs, usually accompanied by the date or the initials of the patron who had commissioned the work.

In 1622 the Habaner were compelled to move to southern Slovakia. Not until 1665, after two members of the sect had visited Holland, did the influence of Delft faience make itself felt in their ware. From Delft the Habaner borrowed the blue-and-white colouring and a new series of subjects which, however, were adapted to the ideas of the peasant potters. A highly original variant is to be found in a group of products dating from about 1700, when the Habaner were no longer bound by the strict rules of their sect, and could give free rein to their imagination. The objects produced at this time were covered with a blue marbled glaze in which the lighter portions were embellished with painted

plant motifs, birds, buildings, etc., giving the whole a dreamy effect.

Baroque. From the 17th century, the centre of gravity of faience production shifted north of the Alps. In the production of faience, Holland, Germany and France were most important, while in that of stoneware, and later fine earthenware, England assumed the leading role. The first European porcelain, production of which began at Meissen in the early years of the 18th century, will be discussed in the next chapter.

Holland. The production of faience began in Holland during the late 16th century, when Protestant refugees from the south took refuge there. Among them were faience-workers from Antwerp, where faience workshaps had been established in the early years of the 16th century. A number of pieces dating from before 1600 indicate that the use of tin-glazes must have been introduced by Italian immigrants. From the beginning of the 17th century the manufacture of faience was concentrated almost exclusively in Delft: the town was favourably placed with a harbour and essential supplies of clay in the neighbourhood. In 1557 the Portuguese established warehouses on the island of Macao, near Canton, and the export of Eastern porcelain to Europe began; European demand soon increased rapidly. In 1605 the trade passed into the hands of the Dutch, and the Netherlands East India Company (which had been founded in 1602) began to import porcelain. Its popularity naturally influenced the artistic forms of Dutch faience. In the first half of the 17th century the decorations on Ming porcelain were directly imitated — not only the patterns, but also the execution in blue on a white ground. Such imitations, however, were rather undistinguished and showed little sign of imagination. More extensive than the production of faience vessels at this time was the manufacture of wall-tiles, concentrated mainly in Haarlem, Rotterdam and Amsterdam.

Delft. The importation of porcelain began to fall off, and by 1640 it had definitely ceased. The Dutch had managed to obtain a monopoly for the importation of porcelain from Japan, but the quantities delivered did not suffice to meet the demand. The Delft potters took advantage of this situation, and began to produce much better imitations of Far Eastern porcelain than they had hitherto done. Between 1640 and 1660 a number of factories were opened in Delft, and their high quality faience was so successful that they were able to compete successfully with the porcelain imported from Japan. This was due to the enterprise shown by the Delft manufacturers, their adaptability in meeting the requirements of their customers, and the skill and technical knowledge of their craftsmen. To these factors must be added the relationship between Delft and the chief centres of Dutch painting, and the models provided by Chinese and Japanese porcelain.

As regards technique, the Delft manufacturers reached such a high standard in the production of thin-walled pieces, in glazing and painting, that at a first glance Delft could easily be mistaken for porcelain. The hard-fired colours were enriched by the use of red and the painting technique improved by combining hard-fired colours with muffle-colours. It was only in the designing of shapes that Delft failed to produce any novelties; these were normally copied from those of authentic pieces imported from the Far East. Very few original models were produced, and artistic skill was concentrated on the ornamentation of the surface. The Delft faience-makers had an infinite number of decorative patterns at their disposal, drawn from both native and foreign sources, and the outcome of this situation was the emergence of two different artistic trends — one indigenous and the other Oriental.

In the third quarter of the 17th century the indigenous trends still predominated. They found expression in figure compositions reflecting the everyday life of the Dutch in their cities and in the sea, in landscapes, interiors, naval battles, episodes from the Old and New Testaments and, more rarely, in mythological episodes. These were painted exclusively in blue, and in their execution they are closely akin to contemporary Dutch panel-paintings. Among the best pieces of this period are those of the painter Frederik van Frijtom, active in Delft from 1658 to 1673.

Oriental decorations were employed in this period, and about 1760 they became the main artistic inspiration of Delft faience. The attempt to imitate Chinese porcelain resulted in the production of pieces which, from the

aesthetic point of view, were admirable. It is customary to name as creators of the Delft style of decoration Albrecht Cornelis de Keizer (signature AK) and his sons-in-law Jacobus and Adriaen Pijnacker, together with Wouter van Eenhoorn and his sons Samuel and Lambertus. Their works are imaginative variants of Chinese and Japanese porcelain decoration, and their models — for it cannot be denied that they had models — were transformed into charming paintings which achieved novel effects because they were executed on a softer material. The decorative motifs consisted of flowers, sprays, birds and foliage forming a harmonious whole, of gardens full of flowers with human figures and birds, or of *lambrequins* with ornaments. As regards ornamentation it is often difficult to identify the real source, for European patterns frequently reached China and then returned to Europe after being modified to conform to Chinese taste.

Polychrome decoration was used as well as blue, and at first this was painted only in hard-fired colours, enriched towards the end of the 17th century by the use of red. From the beginning of the 18th century, Chinese *famille verte* and Japanese 'Imari' wares were copied, though again Dutch craftsmen created new compositions based on these models, compositions in which all kinds of patterns were combined in picturesque confusion. Effects of light and shade were emphasised by the introduction of fluting on vases and other vessels. Later on in the 18th century, muffle-colours were used more and more, especially in imitations of *famille rose*, with which the Delft makers of painted faience reached the zenith of their achievement between 1725 and 1735. A third polychrome technique used in Delft was a combination of underglaze and overglaze painting after Japanese models.

Towards the end of the 17th century, control of the shops (previously in the hands of artists) was taken over by merchants. However, thanks to the strength of tradition and the forceful personalities of certain masters, the artistic quality of the ware was unaffected. During the 18th century the decoration of Delft remained true to its traditions. It is true that certain new Baroque forms were produced, among them 'finger-vases' and tall, many-tiered pyramid-shaped vases for hyacinths. Also of Delft origin are the ves-

sels in the shape of slippers, animals or birdcages. At the same time, however, wooden models were made in Holland and exported to the Far East, where they were used as models for porcelain vessels. The expansion of trade with China during the 18th century, the fall in the price of Chinese porcelain, the competition of Meissen and later of other German factories, and lastly the appearance on the market of a new kind of porous ware made in England (fine earthenware), led in the second half of the century to a noticeable decline in the artistic quality of Delft faience, which also returned once more to European decorative motifs.

Most of the pieces produced in Delft carry factory marks; the most reliable list of these was compiled by F.W. Hudig. 18th-century Delft ware sometimes carries no marks, or they are for the most part unidentifiable.

Red stoneware. Closely connected with the novel features to be found in Delft ware was the use of a new material, red stoneware, for making teapots. This was an imitation of Chinese practice, for the Chinese served tea in stoneware pots instead of using porcelain vessels. These stoneware pots arrived in Europe together with porcelain, and it seems probable that this kind of pottery was first imitated in Holland about 1670, for it is often mentioned in inventories dating from 1678 and later years. One of the men who manufactured it was Lambertus Cleffius, whose workshop was taken over by Lambertus van Eenhoorn in 1691. Another was Ary de Milde, in partnership with Samuel van Eenhoorn, in the late 17th century. It was Ary de Milde who came closest to the Chinese models in the material he used and in the appearance of his products. These are the hardest of all, and have a smooth break; from which it may be concluded that during firing the same process took place as with porcelain, a process which made the end-product harder, non-porous and heat-resistant. The surfaces of these teapots were polished, the decorations in most cases being limited to Chinese-style reliefs of flowering sprays and dragons, though some pieces were painted with enamel colours. In the more elaborate decorations, Bohemian garnets were sometimes inserted among the flowers. Delft red stoneware provided the impetus for manufacture of similar wares in England and at Meissen.

France. The example of Holland was soon followed in France. Here there was a tendency to substitute large-scale production, using rationalised working methods, for pure craft work. In the later 17th century, factories were set up which in the 18th century took over almost the whole of the production of faience. As, however, it was a question not of using machines but of organising the work in a better way, the wares retained their individuality. In France the production of faience was helped by the melting down of silverware, which was twice ordered by Louis XIV at crises during his long wars. The most important result from our point of view was that faience tableware began to be substituted for articles made of precious metals.

In French Baroque faience, it is important to distinguish between two groups which can be differentiated by the technique of decoration used. In the first group, which predominated until the middle of the 18th century, the Dutch and Italian techniques of painting in hard-fired colours on unfired glazes were followed. The chief centres of this trend were Nevers, Rouen and Moustiers. In the second group, which emerged later, the painting was done in muffle-colours on glazes that had already been fired. This method, which made many more nuances possible, had been introduced into France via Strasbourg, and was extensively used at Marseilles and Lille. But although the French borrowed technical and artistic ideas, in the matter of decoration they had ideas of their own.

At *Nevers* where there was a long tradition of pottery-making, no characteristic style was developed. In the 17th century, good results were obtained by following the Urbino style, and later the Nevers potters borrowed subjects from Delft, imitating the manner of Rouen and Moustiers. In the later 17th century the most important innovation in Nevers faience was the *bleu persan* used for 'Persian decoration', consisting of flowers and birds in white and yellow over a deep blue glaze.

At Rouen, faience had been produced since the 16th century and good results achieved for the first time in Europe in the production of soft-paste porcelain. Towards the end of the 17th century a new kind of decoration made its appearance in Rouen, the chief motifs being *lambrequins,* or hangings of drapery and leafy tendrils. These two funda-

mental patterns and a number of others were extended with innumerable variations in compositions which never repeated themselves, yet at the same time paid great attention to symmetry and a radial arrangement, for which reason this style is called the *style rayonnant.* This was the predominant style in Rouen from about 1700 to 1730 or 1740, and it had a great influence on French faience in Paris, St-Cloud, Lille, Marseilles and other centres. About 1750, by way of reaction against monochrome and symmetrical decoration, polychrome patterns in hard-fired colours were used in Rouen, the *décor à la corne,* the name deriving from the invariable presence of a cornucopia with flowers emerging from it amid a cloud of insects and birds. It is interesting to note that, quite apart from the fundamental element of asymmetry, this later Rouen style was not in any way influenced by the Rococo style, in which respect Sinceny also imitated Rouen.

Another important centre as regards creative ideas was Moustiers, where two factories, directed respectively by Pierre Clérissy and Joseph Olerys, successively led the way. In the late 17th century Clérissy introduced decorations painted in blue; Italian inspiration is clearly visible in the beautiful scenes adorning plates and dishes, while the delicate ornaments on the rims of plates reveal the influence of Rouen. Equal skill in painting was used in another, original and often imitated style of decoration, which before 1720 developed into the Bérain style, derived from the paintings of Jean Bérain and his son. In Moustiers this type of decoration was used for about twenty years, but between 1735 and 1740 it was replaced by a new style of polychrome painting introduced by Joseph Olerys after his return from Alcora (Spain) in about 1738. This coincided with the beginning of the vogue for brown, yellow, green and purplish-red, often combined with blue, which were taken from Spanish models. Almost contemporary (1740-50) was the *décor à la guirlande,* with patterns of garlands round the rims of plates, and dishes and mythological scenes in the centre. As very similar wares were produced at Alcora, it is often difficult to distinguish between the products of the two centres. Both the 'Bérain' and the 'Olerys' styles were imitated by a number of workshops, not only in the south of France, but also further north,

at Clermont-Ferrand, Limoges and Bordeaux.

In the development of later French faience of the Rococo period, the products of Strasbourg played a decisive role. At Strasbourg, as in Germany, muffle-colours were used for painting faience, just as they were in the production of porcelain. This new method of painting was used not only on the later and not always satisfactory ware produced at Rouen and Moustiers, but also by other factories, which contrived to produce novel artistic results by this method. It was at Marseilles that the most original and best French faience with muffle-colour decorations was manufactured. In 1756 a school of faience painting was founded there, one of its fundamental principles being to avoid the well-known paths, and to draw inspiration from nature. The result was an unusually vivid type of painting and a wider range of colours, among which pink and a brilliant red predominate. Quite apart from the type of decoration, the influence of Strasbourg made itself felt in a greater variety of shapes with plastic Rococo motifs. A particularly celebrated Marseilles factory was that of the Veuve Perrin. In addition to Marseilles, prominent centres of faience-painting in muffle-colours were Niderviller, Lille, Lunéville, St-Amand-les-Eaux and Rennes.

Germany and Central Europe. In Germany, as in France, the 'Mercantilist' economies of contemporary states, stressing the development of manufactures at home and the undesirability of imports, contributed to the development of faience manufacture. Most of the factories which were founded in the German states were protected from foreign competition by 'privileges' granted by the ruling princes. Further encouragement was given by the increased demand for tableware, created by the popularity of Chinese porcelain. For some time after the opening of the first European porcelain factory at Meissen, porcelain remained a luxury that most people could not afford. This stimulated interest in faience, which was cheaper and in 18th-century Germany became a substitute for porcelain, just as in France it had taken the place of table silver. The number of factories multiplied, and in the 18th century there were eighty in Germany, scattered all over the country from the Alps to the Baltic and from the Rhine to beyond the Oder. All

the same, their products have, by comparison with those of other countries, a relatively uniform character, mainly because faience painters frequently moved about the country from one factory to another.

From both the technical and the artistic points of view, German faience of the late 17th century was imitative of the products of the Dutch factories, with which it was in competition. In the course of time, changes in form and decoration were gradually introduced, ranging from Baroque through the various types of Rococo to a sober Neo-Classicism. After 1720 the tendency was to depart more and more from Chinese models and monochrome, turning instead to European patterns in hard-fired polychrome colours. In Germany, as in other countries, muffle-colours were introduced after the mid-18th century, together with a type of decoration resembling that used on European porcelain.

The oldest and most productive faience factory in Germany was established at Hanau in 1661 by two Dutchmen, Daniel Behagle and his brother-in-law Jacob van de Walle. Schematic Chinese motifs, landscapes and Oriental flowers were the principal decorative features on Hanau ware, which for a long time was often mistaken for genuine Delft, like the products of the equally important factory at Frankfurt am Main (founded in 1666). In fact, owing to its technical and artistic qualities Frankfurt faience could compete with Delft even in Holland. But in Frankfurt, towards the end of the 17th century, in addition to decorations painted in blue, definitely Baroque patterns were used — flowers and conversation-pieces or mythological scenes — painted in manganese colours. Early Berlin faience was likewise influenced by Delft, particularly noteworthy being the large ribbed vases with Chinese decorations in blue or in hard-fired colours; yellow was also used, though this was not the case in Delft. Factories at Potsdam, Brunswick, Zerbst and other smaller centres followed the same methods.

Among the best pottery produced in the later 17th century are the works of the *Hausmaler,* independent decorators who worked at home; they painted on both faience and glass. The best known of them was Johann Schaper, active in Nuremberg from about 1660. Also important were his successors, Johann Ludwig Faber, Hermann

Benckert and the monogrammist J.C. These *Hausmaler* used black enamel, but after 1680 polychrome painting, delicately executed, was characteristic of the work of Abraham Helmhack and the masters known only by their monograms: M.S., W.R. and J.H., who also worked in Nuremberg. Later representatives of this trend, in the second quarter of the 18th century, were Bartholomäus Seuter in Augsburg and Adam Friedrich Löwenfinck in Bayreuth, Höchst and Fulda. In the second decade of the 18th century there was a tendency to try to escape from the pervading influence of Delft faience and Oriental porcelain, and an independent Baroque style began to take shape. The period between 1715 and 1740 witnessed the production of the best faience, made by two factories in southern Germany, at Nuremberg and Bayreuth. The Nuremberg factory (founded in 1712) continued to produce blue ware, but it also turned out other pieces painted with hardfired colours, which were beginning to be more popular, though these had only very minor points of resemblance to the earlier works produced by *Hausmaler.* One of the outstanding features of this kind of ware is the utilisation of the whole surface for painting, the most typical patterns being webs of foliage and bands, elder leaves, Rouen lambrequins, ornamental borders, cartouches containing still-lifes of fruit, landscapes, Biblical scenes, etc. Similar subjects were also used at the Bayreuth factory (founded in 1719), where the painting was done in light blues. They differ from those of Nuremberg ware in that the polychrome decorations must be attributed to the influence of Bayreuth *Hausmaler,* in particular Adam Löwenfinck and Joseph Philipp Dannhofer. The third factory in order of importance in southern Germany was at Ansbach (founded in 1709). In the course of the 18th century it developed a refined Baroque style with arabesques and decorative bands, and after 1720 Rouen patterns were also used. About the same time, the influence of Chinese *famille verte* porcelain was being felt, and at Ansbach this was reflected in faience-decorations revealing an admirable feeling for colour.

After 1740 the influence of porcelain, above all that of Meissen, became ever stronger in the technique of painting and the choice of decorative motifs. Undoubtedly Löwenfinck

played no small part in introducing the use of muffle-colours. Originally he had been employed at Meissen, where Höroldt brought this type of painting to a high standard during the 1720s. After he had mastered this technique, Löwenfinck moved via Bayreuth, Ansbach and Fulda to Höchst, where, in 1746, he opened a faience factory of his own. His influence was felt in all these factories, even after his departure; and the same is true of the Strasbourg factory's branch at Haguenau, which he managed from 1750 to 1754. Echoes of the decorations on Viennese porcelain can be detected on certain delicately executed pieces produced by the factory at Küberberg (founded in 1745).

During the later 18th century, Strasbourg faience was of fundamental importance. Although the city was on French soil, the character of its products clearly derives from German faience. The Strasbourg factory was founded in 1721 by Charles François Hannong and Johann Heinrich Wachenfeld, the latter having previously worked at Ansbach and Kassel. During the first twenty years of its existence, blue decorations, mostly borrowed from Rouen, were mainly used, and it was not until about 1740 that these were replaced by polychrome decorations in hard-fired colours. Significant artistic development began only in the mid 18th century, when muffle-colours and new decorative motifs were introduced, and in this development Löwenfinck and his brothers Christian Wilhelm amd Karl Heinrich played a considerable part. In producing lively paintings in delicate muffle-colours, the Strasbourg factory achieved notable results and became a model for many other factories. No less important than the variety of colours and decorative motifs were the innumerable new ideas as regards form. The handles of vessels were shaped like fruits or figures, while the vessel itself was adorned with reliefs in the form of fruit, foliage and vegetables. Lastly, the Strasbourg factory continued in its efforts to compete with porcelain, and produced faience figures which, although the modelling is somewhat clumsy, can bear comparison with those made of porcelain.

After the middle of the 18th century the Strasbourg style of faience painting spread throughout France and Germany, though its influence was not everywhere the same. It was particularly strong in northern Germa-

ny (the Baltic and North Sea areas), which, unencumbered by traditions, was receptive to influences from outside. Faience factories were not established in these areas until the second half of the century, in other words during the Rococo period. Characteristic of all such factories were the shapes, on which a wealth of relief decorations stood out effectively. These were supplemented by paintings inspired by those on porcelain; but such paintings played only a subordinate role. Only in a few cases was the main stress on painting, for example at Kiel (founed in 1763). The Strasbourg style had been brought to Kiel by the arcanist J.S.F. Tännich, and from there it spread to Schleswig, Stockelsdorf, Eckernforde, Stralsund and Marienberg, and further east to Königsberg. The Strasbourg style owed its rapid diffusion chiefly to the modeller and arcanist Johann Buchwald and his son-in-law, the painter Abraham Leihamer, who worked in the various factories we have mentioned and to some extent left their imprint on the products of them all. One of the most important centres from which this influence spread throughout central Europe was the factory at Holice in Bohemia, founded in 1743. Nicolas Germain, a native of Lorraine, introduced the Strasbourg principles of modelling at Holice; Dominik Cumy of Durlach added *chinoiseries* to the available range of painted motifs; and J.J. Buchwald, who spent a short time in Holice before he went to northern Germany, introduced some new decorations after the Strasbourg manner. These influences were mingled with others derived from the copying of decorations on porcelain, especially of those on Vienna and Meissen wares.

A curious anachronism in the early years of production at Holice was the use of painted decorations modelled on those of early Baroque pottery from Castelli (Italy). Between 1760 and 1770, in addition to tableware decorated only with painting, pieces were produced with high relief decorations, as well as vessels in the form of animals, birds and even human beings. After 1786, like factories in other parts of Europe, Holice began to produce fine earthenware in the English style, which gradually supplanted faience. In its heyday, however, Holice had a direct influence on the factory at Proszków (Silesia), which in 1783 was moved to Hranice in Mo-

ravia, as well as on the subsequent production of pottery in Schleswig-Holstein and at Tata (Hungary).

Among the smaller producers of faience, the Thuringian factories are important. Dorotheenthal and Atbessingen produced pieces in the Baroque style, with blue or polychrome painting in hard-fired colours, of a quality equal to that of Nuremberg and Bayreuth ware. Another important Thuringian centre for the production of simper wares was Erfurt, the most typical being cylindrical tankards, the grounds of which were often sprinkled with manganese.

Red ceramics. The red Böttger stoneware was often imitated. At Ansbach a 'brown porcelain' factory was opened, but essentially this ware was made from a reddish-brown paste with a dark-brown glaze, the decorations consisting of reliefs or painting in fired-on gold and silver. At Bayreuth, imitations of Böttger stoneware were made in the form of 'brown ware', which was a reddish earthenware covered with a dark-red glaze, while the decorations consisted of a combination of *chinoiseries* in silver or gold and strapwork.

Identification of the place of origin. The place of origin of faience pieces can be established from the factory marks, which were usually executed in hard-fired colours (cobalt, manganese or black). Lists of these marks can be found in a number of specialised works, which are given in the bibliography. It does not follow that every mark is a factory mark, for many of them are the signatures of painters or 'repairers', while others merely indicate the size. If a piece bears no marks, we must try to identify it from the kind of material used, the shape and the type of decoration. This is often very difficult, and in such cases one must be content with a regional classification, since many of the commoner wares have no more individual characteristics.

England. The development of ceramics in England was on more or less independent lines. England played the leading role in launching a new kind of pottery: white or cream-coloured earthenware. The necessary pre-condition was a slow but steady technical progress in which the outstanding figure was Josiah Wedgwood. The production of English pottery was concentrated mainly in Staffordshire.

Toft ware and Delft ware. Pottery was already centuries old in England when, in the 17th century, a new type of peasant ware began to be made. Red clay was used, covered with a lead-glaze, with painted decorations on slips of various colours. The most interesting examples were the Toft wares, named after a Staffordshire family of potters.

In England there were materials suitable for the production of faience and Rhenish stoneware, and in the second half of the 17th century, English manufacturers began to exploit them. Nevertheless, English faience, whether it was made in Lambeth, Liverpool or Bristol, could not compete with the Delft models even when it was sold under the name of Delft ware: the material was too hard and the glazes were of poor quality. The future of English pottery did not lie in the production of faience or peasant pottery.

Stoneware and fine earthenware. In 1671 John Dwight was granted a patent for the manufacture of pottery, and his factory subsequently produced a number of stoneware busts covered with salt-glazes. Stoneware of this kind, which had a very light, whitish-grey body, often transparent, is generally considered to have been the starting-point of a development which eventually led to the production of fine earthenware. Like Dwight, the Elers brothers used a salt-glaze on light-coloured stoneware which, on account of its relative hardness and light colour, enjoyed great popularity, with the result that many Staffordshire potteries began to produce it. John Philip and David Elers were two Dutchmen who settled in Staffordshire in 1688, and in addition to stoneware they produced two other types of pottery which proved to be of importance for later developments. Their red stoneware, doubtless inspired by a close study of the Delft ware produced by Lambertus van Eenhoorn and Ary de Milde, can best be compared with Böttger stoneware, though it is lighter in colour and was not cast in a mould but thrown on a potter's wheel. The other new type was their black stoneware, which was in some respects a precursor of Wedgwood's basalt ware.

In 1720 a further contribution to the development of light-coloured stoneware was made by John Astbury who, by adding flint to the clay, produced a hard, white body. Instead of salt-glaze, he used a yellowish lead-glaze, and so his products can already be described as 'cream-coloured'. Astbury followed the style of the Elers' work closely. He used applied or stamped reliefs, which were often imperfectly executed. Astbury's near-white earthenware soon found imitators everywhere, and production of it continued until 1780 in Staffordshire. After that its place was taken by another, finer ware, the 'cream-coloured' ware associated with the name of Josiah Wedgwood.

Wedgwood was a good organiser who also possessed the necessary technical knowledge and had artistic ambitions. From childhood he had worked in his father's factory, and later, in partnership with Thomas Alders, he learned how to produce all kinds of Staffordshire pottery. Accordingly, when he entered the business of Thomas Whieldon in 1754, he was already an expert. He then devoted himself mainly to experimenting with coloured glazes. In 1759 he set up his own factory at Burslem, where he produced every type of Staffordshire pottery. A great influence was his friendship with Thomas Bentley, who in 1768 became his partner. Together they opened a new factory which bore the name 'Etruria' (1780). Both were well-educated men, and shared the enthusiasm of their contemporaries for the art of Antiquity and the Neo-Classical style to which this enthusiasm had given birth. All this was expressed in the forms, subjects and style of decoration of Wedgwood pottery. Under the direction of Wedgwood and his partner — technically gifted, experienced men with a feeling for art — several new types of pottery were produced. The importance of Wedgwood's work lies chiefly in the fact that he perfected Astbury's invention — fine earthenware — and, by producing it on a large scale made it available to the public at large. Starting with the manufacture of Staffordshire salt-glaze pottery and Astbury's lead-glaze light-coloured earthenware, in 1759 Wedgwood began producing a technically improved, pale-yellow earthenware covered with a tin-glaze, which was known at first as 'cream ware' but was later generally called 'Queen's ware'. About 1780 Wedgwood succeeded in improving the quality still further by adding larger quantities of kaolin and flint to the paste, thus making it white. The practical advantages of this fine earthenware were such that it found a ready market not only

in England but also on the Continent, where in the 19th century it became one of the most sought after products. Wedgwood also tried to improve stoneware and, following the example of the Elers brothers, who had produced black and red stoneware in Staffordshire, he set himself to improve the composition of the raw material. His 'basalt ware' was unusually hard, fine-grained and of exceptionally good quality, so much so that it was capable of being polished on the lapidary's wheel. After very slight rubbing of the surface it took a dull gloss. The properties of this basalt ware were such that modelling was easy, and it was consequently used not only for decorative pieces such as vases, but also for portrait busts, tablets, medallions and intaglios. Basalt ware was suitable for *de luxe* articles, but red stoneware of similar composition — *rosso antico* — was used mainly for more commonplace wares — jugs, pots, coffee and tea services, etc.

After his red and black stoneware, the buff ware known as 'cane-colour' and his other types of pottery, Wedgwood's most famous product was his jasper ware, a stoneware produced by adding barium sulphate to the paste. This was so hard that the surface could be polished, but at the same time it was soft enough to permit of the paste being coloured right through with metal oxides. Originally it was produced in white, blue and green, but after 1775 seven colours could be used — dark blue, light blue or lavender, sage-green, olive-green, pinkish lilac, black (a black distinct from that of basalt ware) and, more rarely, yellow. Monochrome pieces were decorated with reliefs in a different colour, usually white. Jasper ware was used for tableware and for all sorts of small articles, such as buttons, earrings, chains and shoe-buckles; in the form of plaques it was also used for the decoration of furniture. Wedgwood described as his best work a replica of the famous Portland vase, made between 1786 and 1790. Jasper ware proved so popular that it is still being manufactured today.

The 19th century. During the last quarter of the 18th century, fine earthenware began to dominate the market previously reserved for faience, and also largely replaced the more expensive porcelain in the middle-class home. On the Continent of Europe ef-

forts were made to equal the standard of English cream-coloured ware, but these were often unsuccessful because raw materials of the same quality as those to be found in Staffordshire were not widely available. Nevertheless, some factories succeeded in imitating not only the materials but also the forms, with the result that the collector is often surprised to come across 'Wedgwood ware' bearing the factory mark of a 'Wedgwood factory' on the Continent.

This expansion of the manufacture of fine earthenware coincided with a reaction against all superfluous ornamentation and a desire to display the qualities of the material. The mass-production of earthenware lasted as long as porcelain was within the reach of only the wealthy. When porcelain too was mass-produced, its practical advantages were such that is dominated the world market despite the fact that the fall in its price had only been achieved at the expense of a decline in quality. Fine earthenware was no longer able to compete; as an artistic product its heyday therefore lasted only from 1780 to 1830.

It was quite natural that in the beginning the forms of fine earthenware should be imitated from works in other materials. In France the earliest fine earthenware clearly reveals the influence of French table-silver, which since 1760 had been decorated with Baroque, Rococo and Neo-Classical motifs. It was soon realised, however, that these forms were not suitable for fine earthenware, and simpler, more sober and fluid forms were evolved, borrowed from English pewter vessels. The English were chary of using Rococo motifs, and when they did use them it was only for decorating the rims of plates. They devised a very popular pattern, the 'feather-edge', which was taken up by the Continental factories and used in many places in the first few decades of the 19th century. The real fine earthenware style, which was imitated on the Continent as well as in England was invented by Wedgwood and based on Neo-Classical ideas. The principle of allowing the material to speak for itself and emphasise the beauty of the form, set the standard for the production of fine earthenware in its heyday. This explains why the relief decorations are always restrained, and designed to stress the formal qualities of the ware. A very charming method of

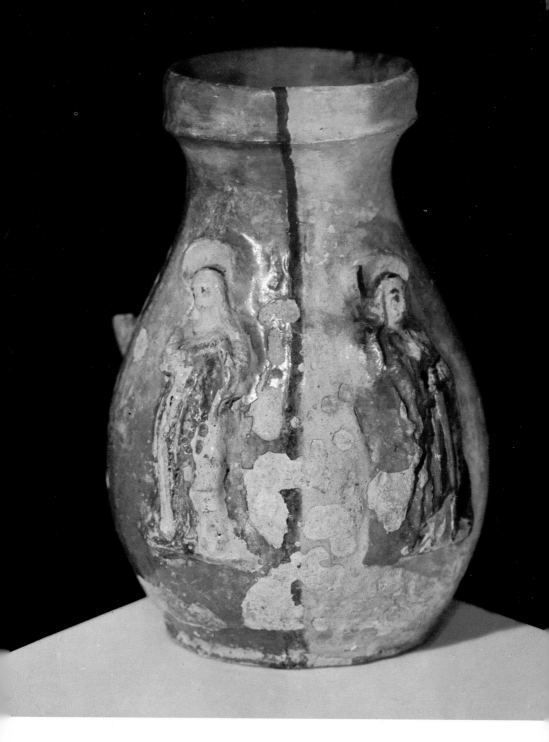

XXVII Jar with relief figures of SS Catherine, Barbara and Elizabeth; faience with coloured glazes. Kutná Hora, Bohemia, 16th century

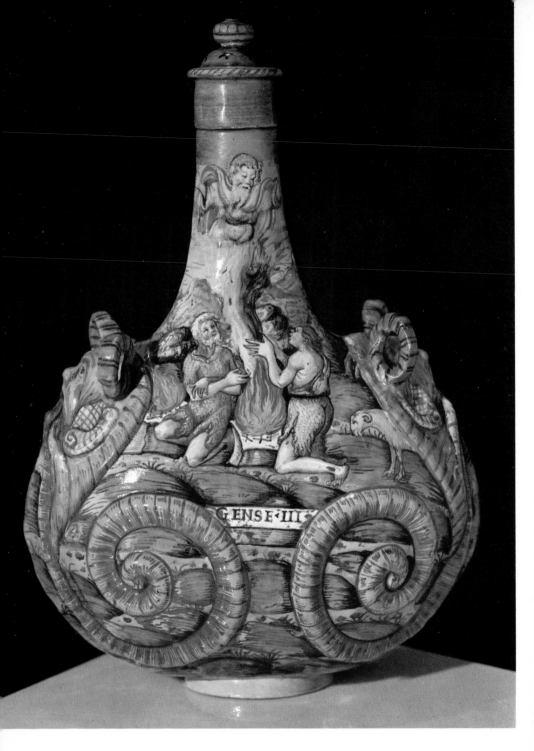

XXVIII Pilgrim bottle with Cain and Abel; maiolica, painted in hard-fired colours. Urbino, *c.* 1550

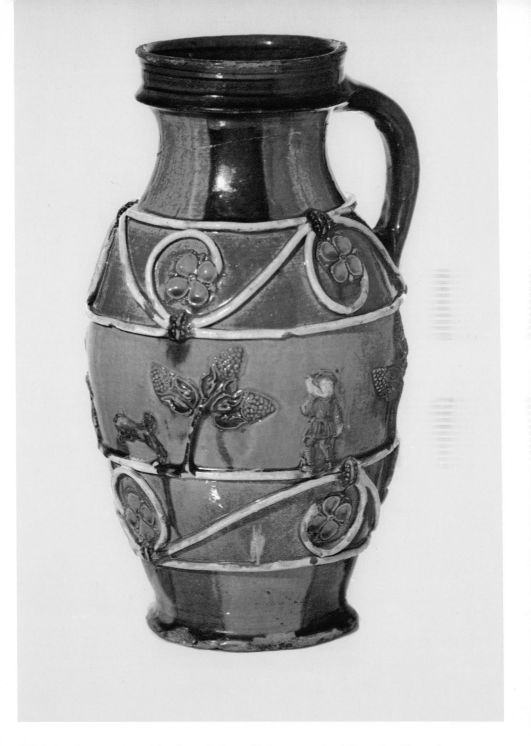

XXIX Earthenware jug with coloured glazes, Hafner ware. Paul Preuning, Nuremberg, *c.* 1550

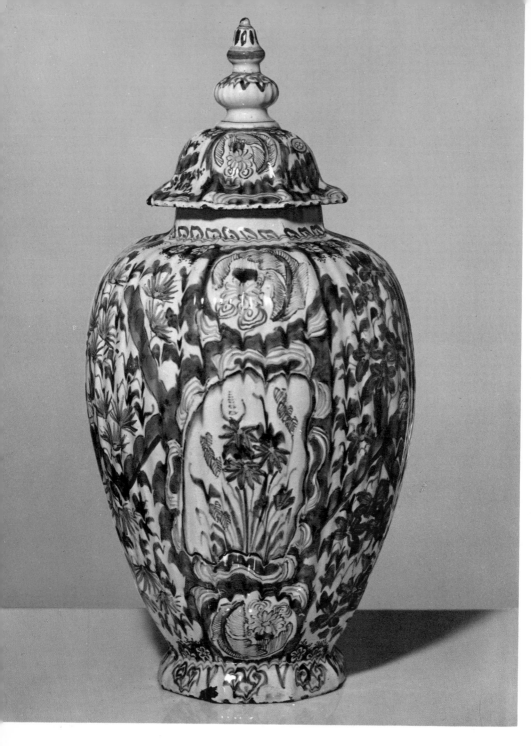

XXX Fluted vase with cover, *cachemire* ware; faience with Far Eastern decorations in hard-fired colours. Delft, after 1700

decoration was the pierced pattern, applied with a metal stamp, the artistic effect of light and shade being provided by the quality of the material. Decorations of this kind were used in earthenware factories all over Europe — in England, France, Germany, Bohemia.

Painted decorations were much inferior to the more usual relief or pierced ornamentation. The best painted works were produced in Bohemia, at Prague and Teinitz, but they were only imitations of Viennese porcelain of the Sorgenthal period. Apart from individual painted pieces of this kind there are the vast majority of painted wares, which are of a simplicity that makes it appropriate to classify them as peasant pottery. In the early days of Wedgwood's Queen's ware, painting was replaced in England by the cheaper process of transfer-printing, which was also more suitable for mass-production, and this process was used throughout the period of fine-earthenware production.

The coloured glazes introduced in England during the 18th century (marbling, Columbine-glazes) influenced a few Continental factories around 1800. The use of lustre began in France at the same time, and became particularly common during the second quarter of the 19th century. It represented, however, a reaction against the original principles of fine eathenware decoration, and marked the beginning of a decline; about the middle of the century it also resulted in preference being given to materials such as terralyte, hydrolyte and siderolite. This occured at a time when porcelain had become far cheaper and could thus compete with fine earthenware.

The poverty of stylistic invention, which degenerated into 'historicism', and the decline in the quality of industrial products, led to attempts in France to revive the craft of pottery. The result achieved by the French potters Avisseau, Ziegler and Deck were a prelude to the creative works of the next generation, as represented by Chaplet, Cazin, Dalpayrat, Carriés and Delaherche These artists improved the technical processes used by thir predecessors and after they had become acquainted with Far Eastern art at the Paris exhibition in 1878, found their own vein of artistic expression. The search for new ideas coincided with changes in all branches of art and with a widely felt desire to get away from the historical styles. The leading practitioners of a new style, known in England and France as Art Nouveau and in Germany as Jugendstil, included architects, painters and graphic artists, but the chief credit for the diffusion of these ideas in the applied arts must be given to the Belgian Henri van de Velde, who was a theoretician as well as an artist.

In pottery, France took the lead. It is to the efforts of French artists that we owe the greater attention paid in recent times to craftsmen's methods, and to the revival of old pottery techniques and their adaptation to meet modern requirements. Thanks to this development, pottery again became a living art, and found points of contact with other arts. In particular, Auguste Delaherche, Jean Charles Cazin, Etienne Moreau-Nélaton and the chemist Alexandre Bigot devoted themselves with enthusiasm to pottery. André Matthey, in collaboration with other leading artists, made the greatest step forward, when he persuaded the best artists of his time — Bonnard, Derain, Maillol, Signac, to produce decorations for pottery.

The English art potteries of the period are of great interest, catering as they did for the intellectual side of the public who had reacted against the soulless technique of the big factories. The Arts and Crafts movement led by William Morris was responsible for the emergence of artist potters such as William de Morgan, a close associate of Morris's, who produced earthenware in pure shapes painted in lustre colours or in rich blues and greens.

Soon, however, other European countries began to vie with France and England. In Denmark, T. Bindesbøll and the group led by J.F. Willumsen had a considerable influence on the production of pottery; in Germany, the versatile artist Max Läuger, Adalbert Niemeyer and Ernst Barlach; in Vienna, M. Powolny, J. Hoffman, Dagobert Peche and O. Prutscher, who worked in close collaboration with the *Wiener Werkstätte* (founded in 1903) and in 1905 together set up the *Wiener Keramik*. At the same time the products of the technical school of ceramics at Teplice reached a very high level, as did the wares produced by C. Kloucek and Anna Boudová, who, however, obviously drew their inspiration directly from France. In Hungary the factory at Pecs attracted outstanding artists under Vilmos Zsolnay.

Advice to Collectors

Identification of pottery. On faience and fine earthenware there is usually a factory mark on the base from which the place of origin and the period can be deduced. On faience these marks were usually applied in hard-fired colours (blue, manganese or black); on other types of ware they were either stamped on or impressed. It should, however, be noted that these are not always factory marks, but often — especially in the case of faience — the signatures of the painter, thrower or 'repairer'. For this reason it is important to examine not only the mark but also the type of execution, the shape, the colours of the glazes and — last but not least — the style of decoration. An accurate classification of pottery is possible only after many years of experience, and even then the possibility of errors cannot be excluded.

Imitations and forgeries. The great demand for old pottery encouraged the making of imitations and forgeries. In the former there was no fraudulent intention; the makers of such pieces were merely meeting the requirements of the purchasers, whose taste, especially during the latter half of the 19th century, was strongly influenced by the tendency to follow traditional styles. In particular, Westerwald stoneware was imitated on a very large scale. Such imitations, however, can be recognised at a first glance as works of the 19th century.

Far more difficult to detect are forgeries, in which deliberate deception of the purchaser was the aim; but here too it should be noted that there are various types of forgeries. In some cases they were meant to conceal repairs and in these, especially in pieces restored in the old-fashioned way, the touching-up or repainting may extend far beyond the repaired or added portion and even cover parts of the original painting. Overpainting of this kind can be easily removed. In other cases a fragment of pottery has been so skilfully 'completed' to form a whole piece, and then repainted, that it looks just like a well preserved authentic article. To justify a high price for wares of inferior quality, manufacturers' marks are often added subsequently, this being easy to do but hard to detect.

The most dangerous of all are those forgeries in which genuine unpainted faience, the body of which awakens no suspicions, is subsequently painted. In the case of modern forgeries, made by someone possessing the necessary knowledge of style and technique it is extremely difficult to prove that they are fakes.

Preservation and restoration. Like porcelain, glass and other works made of brittle materials, all pottery should be kept in a safe place and protected from dust. The best way of washing it is to use a plastic bowl, or to lay a soft cloth on the bottom of a wash-basin, in order to avoid damaging the article. The repairing of damaged pottery should always be entrusted to an expert.

173 Black-figure amphora with quadriga. Attica, *c.* 520 BC
174 Red-figure amphora. Attica, 'Painter of the Boston Phial', *c.* 440 BC
175 Standing Tanagra figure, 4th century BC
176 *Lekythos with the Mysteries.* Apulia, 4th century BC

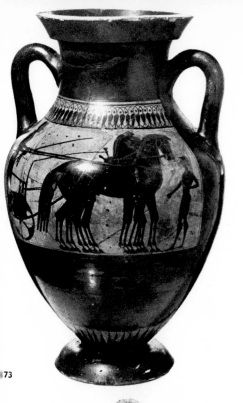

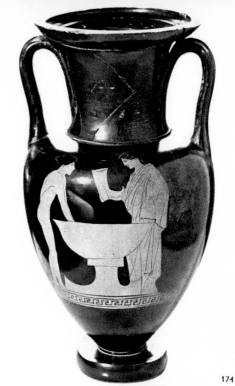

173

174

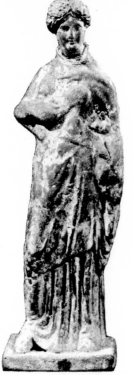

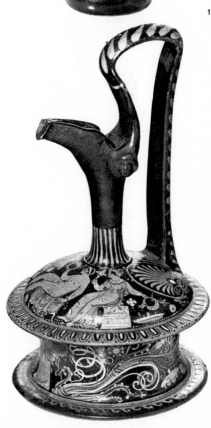

175

176

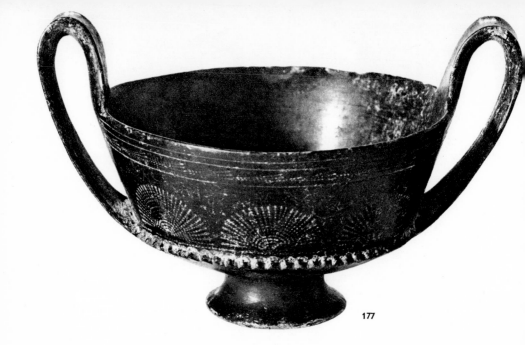

177

178

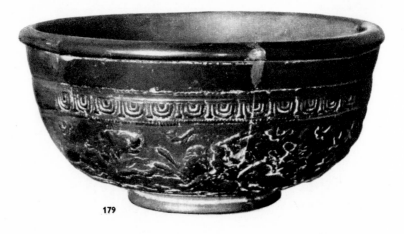

179

172

180

177 Kylix in *bucchero nero* with stippled decorations. Etruria, 6th century BC
178 Romanesque clay tiles. Bohemia, 12th century
179 Dish of *terra sigillata*. First century BC
180 Stove-tile of clay. Bohemia, 15th century

181 Dish with bust; *messamaiolica* with *sgraffito* decorations. Perugia or Città di Castello, 1500-20
182 Dish with female figure; maiolica with blue and yellow lustre. Deruta, *c.*1520

181

182

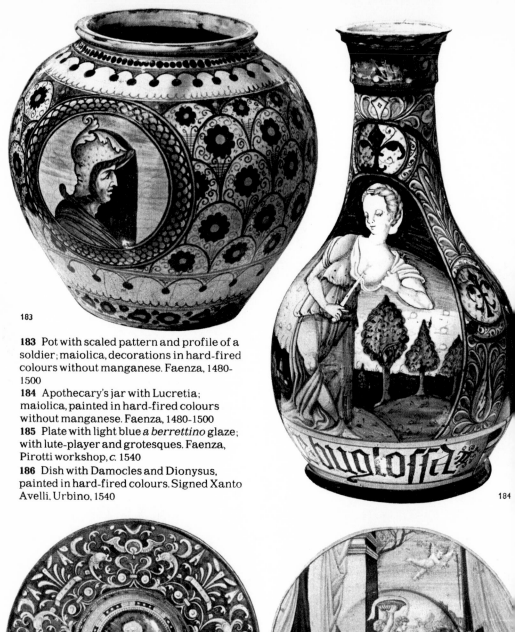

183 Pot with scaled pattern and profile of a soldier; maiolica, decorations in hard-fired colours without manganese. Faenza, 1480-1500

184 Apothecary's jar with Lucretia; maiolica, painted in hard-fired colours without manganese. Faenza, 1480-1500

185 Plate with light blue *a berrettino* glaze; with lute-player and grotesques. Faenza, Pirotti workshop, *c.* 1540

186 Dish with Damocles and Dionysus, painted in hard-fired colours. Signed Xanto Avelli, Urbino, 1540

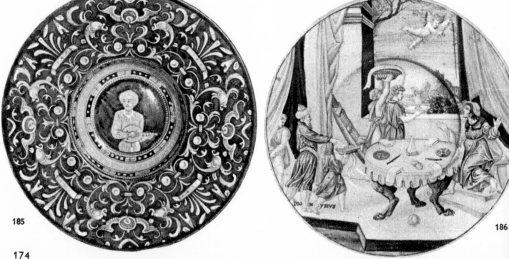

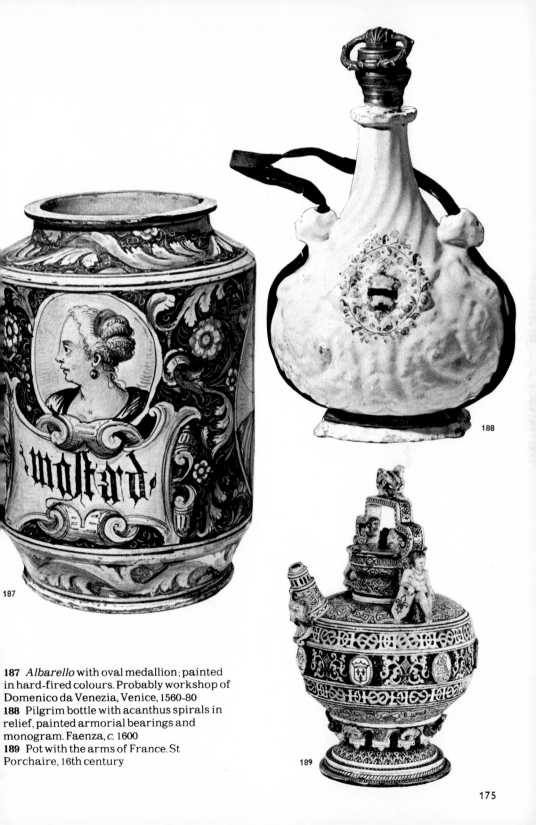

187 *Albarello* with oval medallion; painted in hard-fired colours. Probably workshop of Domenico da Venezia, Venice, 1560-80
188 Pilgrim bottle with acanthus spirals in relief, painted armorial bearings and monogram. Faenza, c. 1600
189 Pot with the arms of France. St Porchaire, 16th century

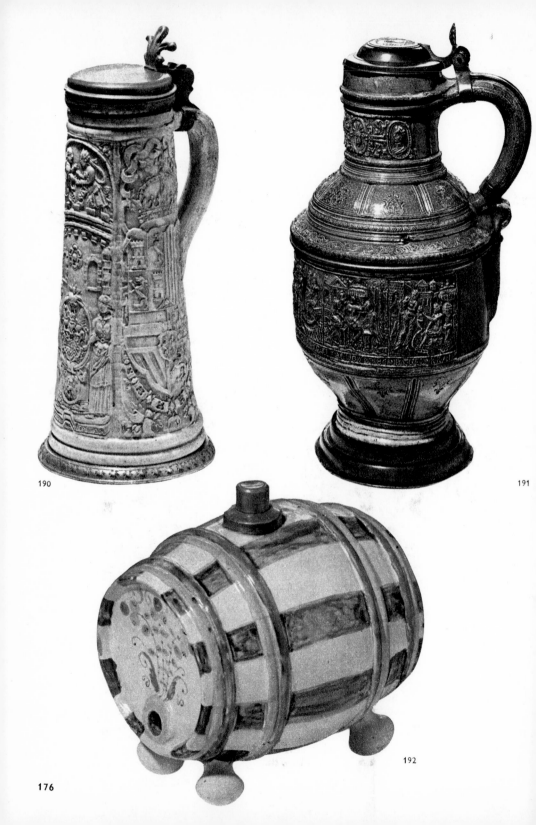

190

191

192

176

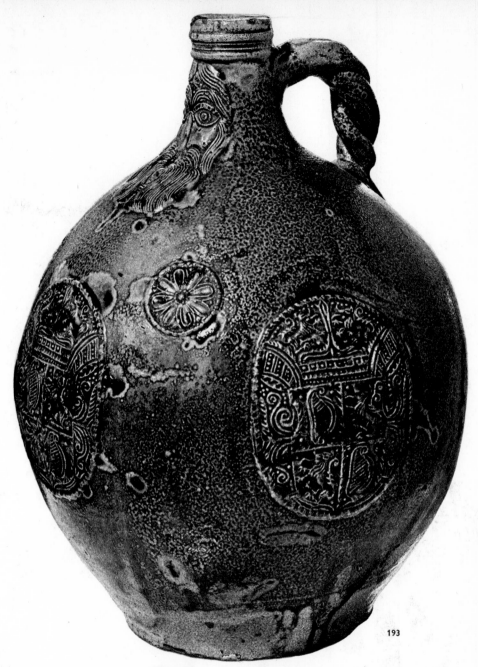

193

190 Tapering tankard with arms of King
Philip II of Spain and figures of Justice,
Mercy, Peace and Truth; Siegburg
stoneware. Signed HH (Hans Hilgers), 1572
191 Brown-glazed jug with story of Susanna
and the Elders, after Gotzius. Raeren
stoneware, Engel Kran, 1584

192 Barrel, painted in hard-fired colours;
faience. Habaner ware, Moravia, 1611
193 'Greybeard' with armorial bearings;
stoneware with brown and blue glazes.
Frechen, c. 1590

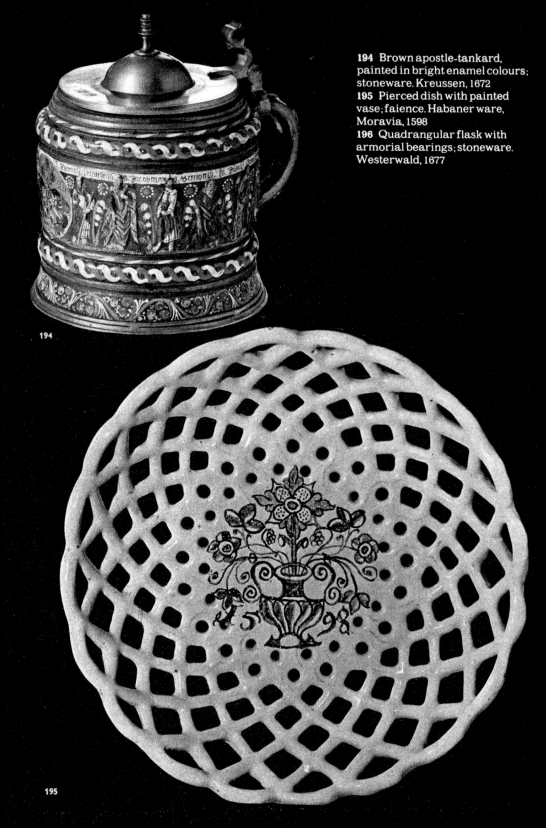

194 Brown apostle-tankard, painted in bright enamel colours; stoneware. Kreussen, 1672
195 Pierced dish with painted vase; faience. Habaner ware, Moravia, 1598
196 Quadrangular flask with armorial bearings; stoneware. Westerwald, 1677

194

195

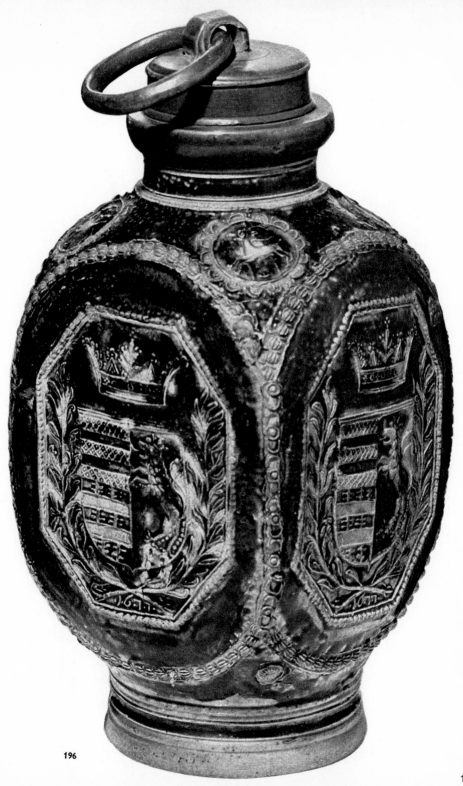

196

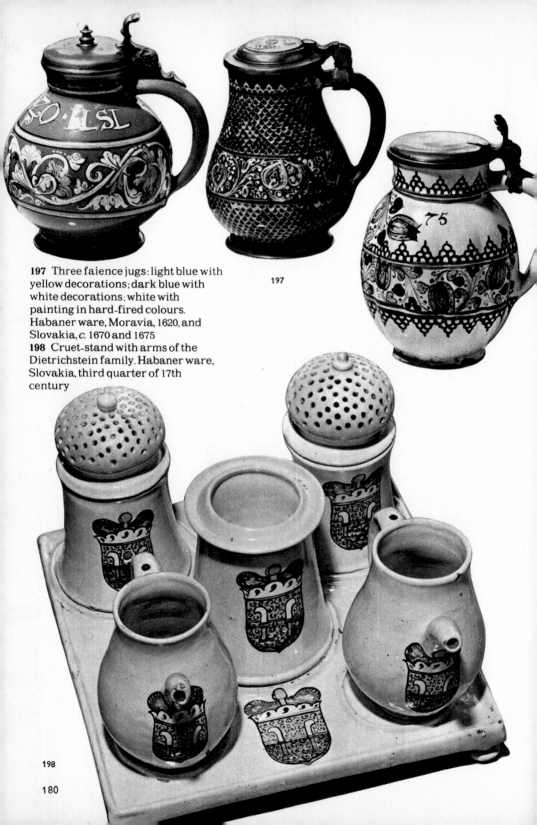

197 Three faience jugs: light blue with yellow decorations; dark blue with white decorations; white with painting in hard-fired colours. Habaner ware, Moravia, 1620, and Slovakia, c. 1670 and 1675

197

198 Cruet-stand with arms of the Dietrichstein family. Habaner ware, Slovakia, third quarter of 17th century

198

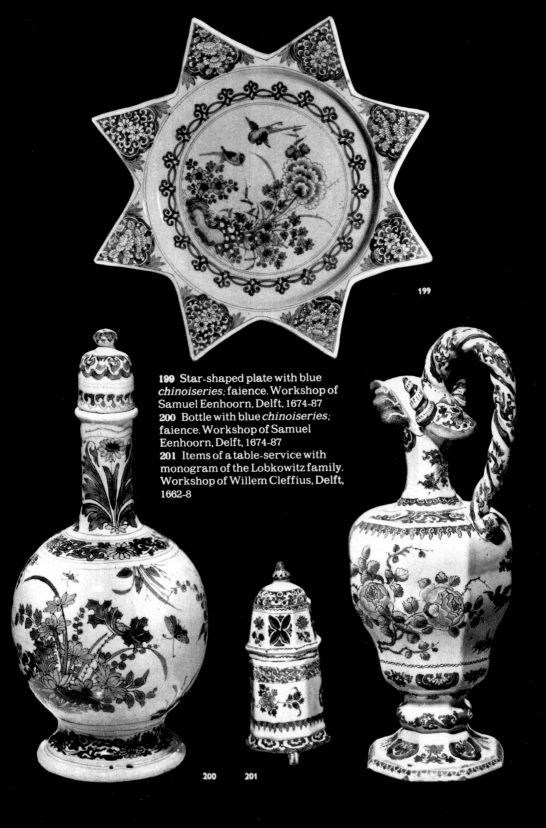

199 Star-shaped plate with blue *chinoiseries*; faience. Workshop of Samuel Eenhoorn, Delft, 1674-87
200 Bottle with blue *chinoiseries*; faience. Workshop of Samuel Eenhoorn, Delft, 1674-87
201 Items of a table-service with monogram of the Lobkowitz family. Workshop of Willem Cleffius, Delft, 1662-8

199

200 201

202

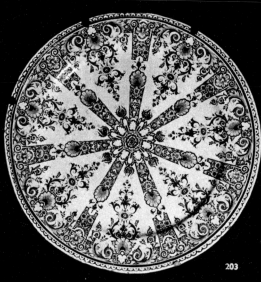

203

202 Dish with blue tea-tree decoration;
faience. Workshop of Hugo van Brouwer,
Delft, 1775-88
203 Faience dish with blue, *style rayonnant*
decorations. Rouen, 1720-40
204 Oval dish with *à la corne* decorations in
hard-fired colours. Rouen, *c.* 1750

205 Plate decorated with garlands and a
mythological scene; faience, painted in
hard-fired colours. Moustiers, *c.* 1750
206 Red stoneware teapot with dragon in
relief. Ary de Milde, Delft, late 17th century
207 Flower pot with blue 'Bérain'
decorations; faience. Moustiers, *c.* 1720

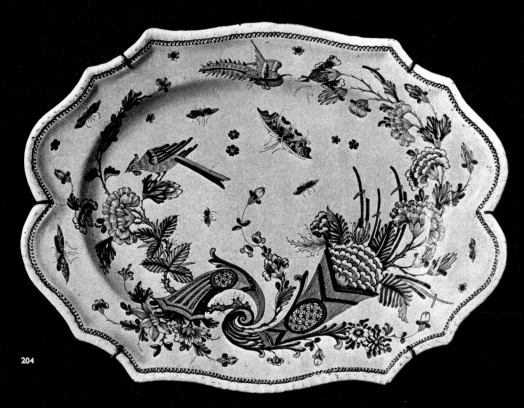

204

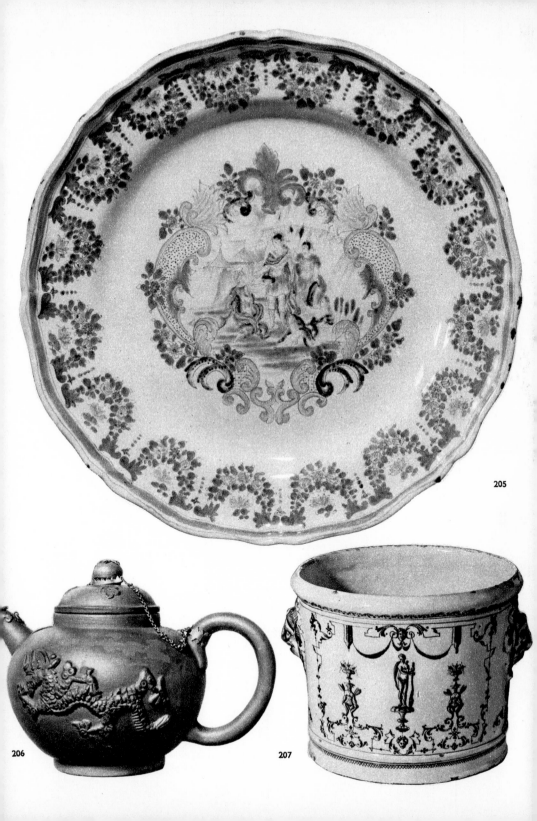

205

206 207

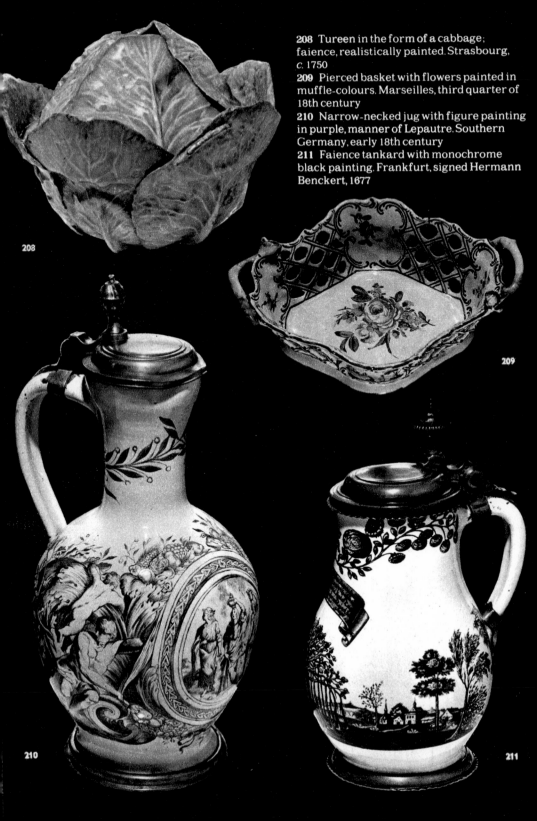

208 Tureen in the form of a cabbage; faience, realistically painted. Strasbourg, *c.* 1750

209 Pierced basket with flowers painted in muffle-colours. Marseilles, third quarter of 18th century

210 Narrow-necked jug with figure painting in purple, manner of Lepautre. Southern Germany, early 18th century

211 Faience tankard with monochrome black painting. Frankfurt, signed Hermann Benckert, 1677

208

209

210

211

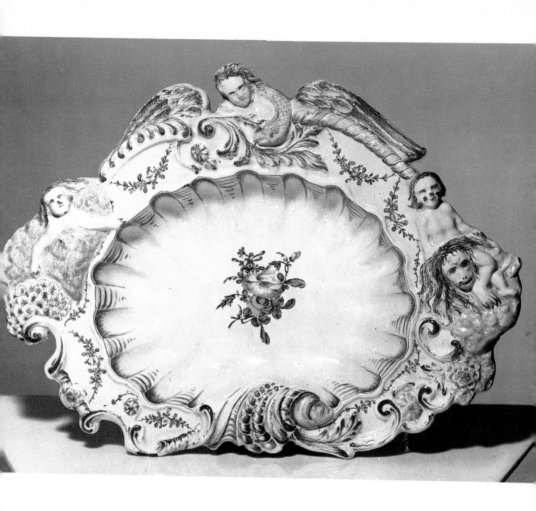

XXXI Wash-basin with polychrome decorations. Münden, *c.* 1760

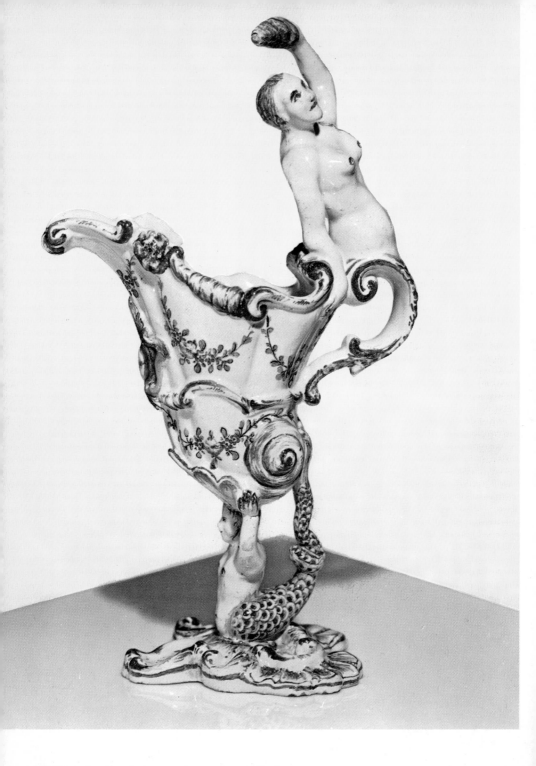

XXXII Jug with polychrome decorations. Münden, *c.* 1760

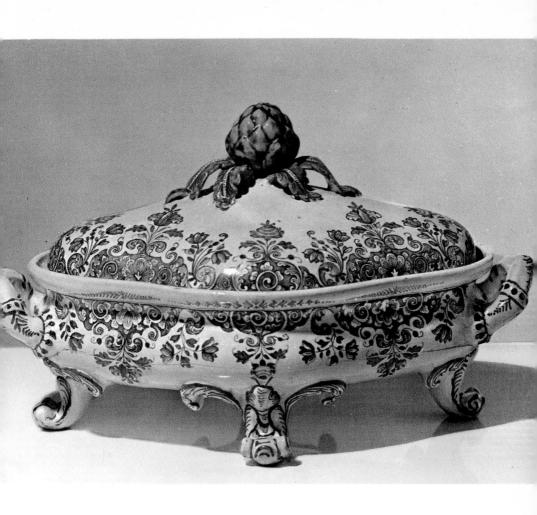

XXXIII Tureen with blue under-glaze decorations. Strasbourg, *c* 1730

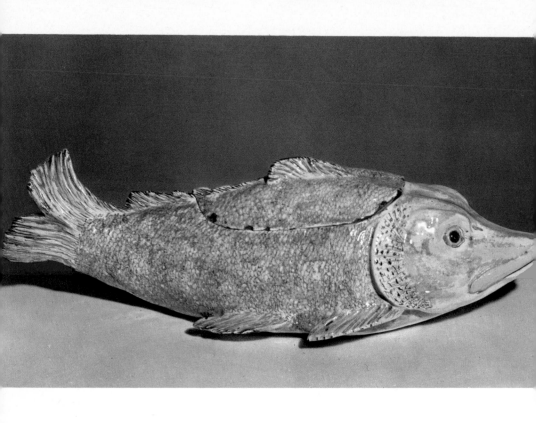

XXXIV Pastry-mould in the shape of a fish; faience, painted in high-fired colours. Holice, *c.* 1750

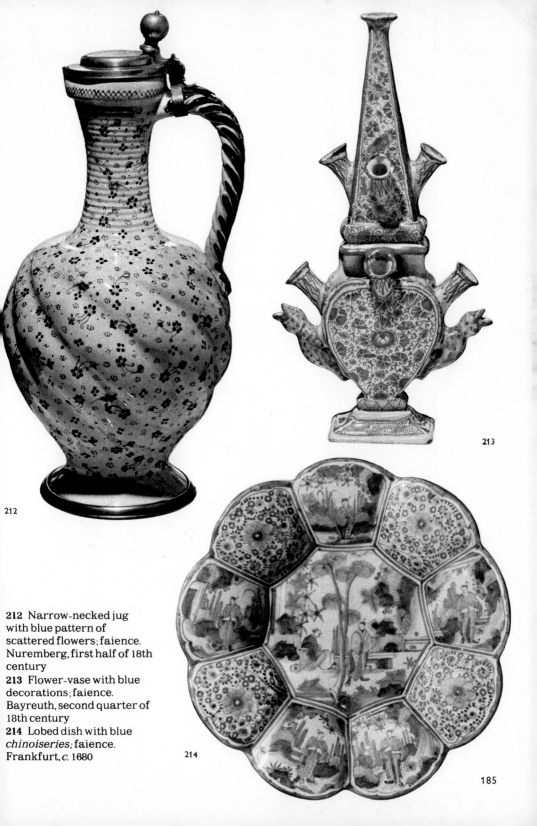

212 Narrow-necked jug
with blue pattern of
scattered flowers; faience.
Nuremberg, first half of 18th
century
213 Flower-vase with blue
decorations; faience.
Bayreuth, second quarter of
18th century
214 Lobed dish with blue
chinoiseries; faience.
Frankfurt, *c.* 1680

212

213

214

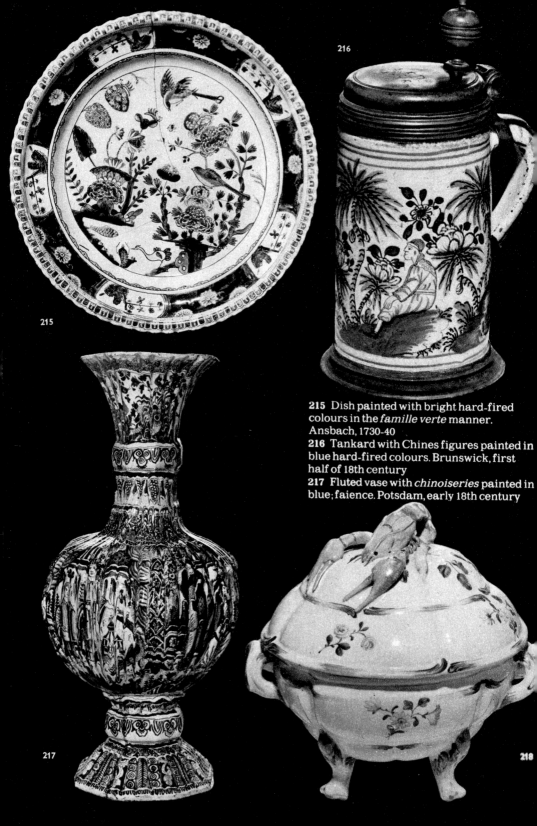

215

216

217

215 Dish painted with bright hard-fired colours in the *famille verte* manner. Ansbach, 1730-40

216 Tankard with Chines figures painted in blue hard-fired colours. Brunswick, first half of 18th century

217 Fluted vase with *chinoiseries* painted in blue; faience. Potsdam, early 18th century

218

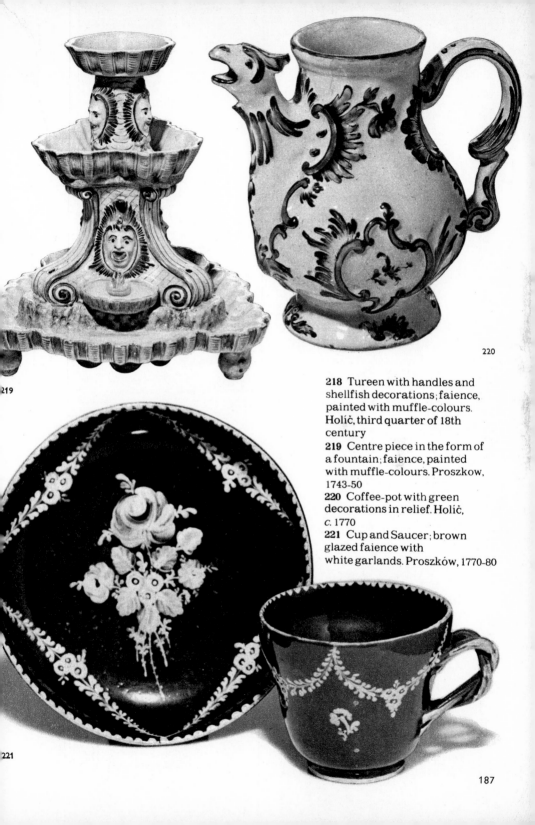

218 Tureen with handles and shellfish decorations; faience, painted with muffle-colours. Holíč, third quarter of 18th century

219 Centre piece in the form of a fountain; faience, painted with muffle-colours. Proszkow, 1743-50

220 Coffee-pot with green decorations in relief. Holíč, *c.* 1770

221 Cup and Saucer; brown glazed faience with white garlands. Proszków, 1770-80

219

220

221

224

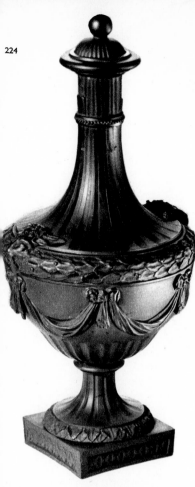

225

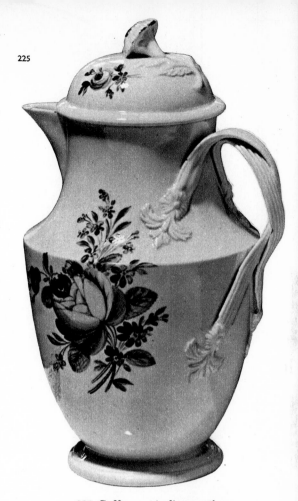

222 Red stoneware plate with painted slip; Toft ware. Staffordshire, *c.* 1660
223 Busts of John Locke and Isaac Newton, after models by J. M. Rysbreck. Wedgwood, 1777-80
224 Black basalt vase. Wedgwood, 1770-80

225 Coffee-pot in fine earthenware with roses. Teinitz, end of 18th century
226 Covered box in light blue jasper ware. Wedgwood, *c.* 1785

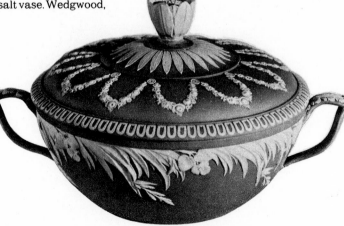

226

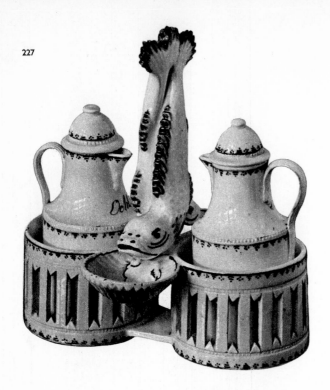

227 Cruet-stand in fine earthenware. First quarter of 19th century
228 Tureen and dish; fine earthenware with allegorical scenes transfer-printed in black. Creil, end of 18th century

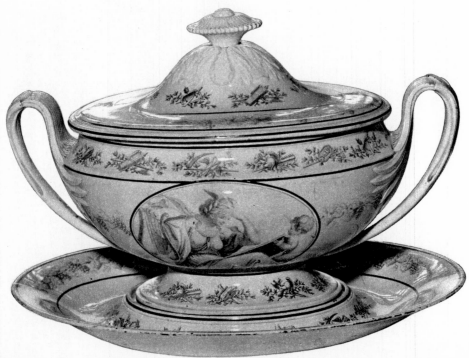

228

PORCELAIN

Porcelain, the finest of all ceramics, has its own peculiar characteristics — its absolute whiteness, not only on the surface but also on the areas exposed by a break, and its transparency at those places where the body is thin. It consists of a mixture of clays which form the body and of a translucent glaze which covers them. If a twice-fired porcelain paste is left unglazed — a normal practice in some porcelain factories when making figures, medallions and sometimes even tableware — we call it biscuit porcelain.

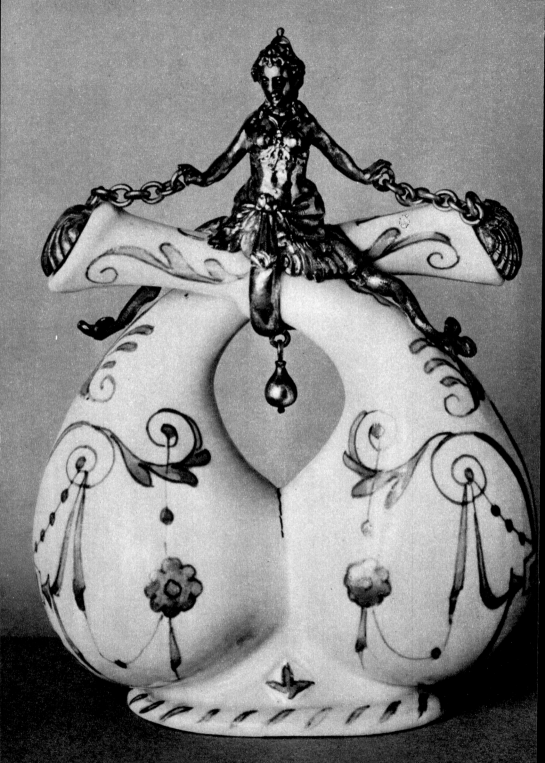

Manufacture

Kinds of porcelain. We distinguish between hard-paste and soft-paste porcelain, according to the composition of the porcelain paste and of the glaze. Bone china is a special type halfway between the two.

Hard-paste porcelain is made of two main substances: china clay (pure clay — a greasy and very plastic material very difficult to fuse) and felspar (generally combined with white mica and comparatively easy to fuse). Quartz or sand is also added but the properties of the porcelain depend on the ratio of china clay to felspar — that is, the more china clay the paste contains the less easily it fuses and the harder it is. The mixture is ground, kneaded, washed and then dried to give a plastic dough which can be either poured into moulds or turned on a potter's wheel. Once shaped, the pieces are fired twice, first at $600\text{-}800^0$ C. and then — after glazing — at $1300\text{-}1500^0$ C. As the glaze is made of the same substances as the body — although in different proportions — it fuses with the body, cannot be scraped off and will not flake off. Hard-paste porcelain is distinguished by its hardness, its great resistance to heat and acids, its impermeability, its transparency, the shell-like appearance of the surface of a break and, finally, by the clear, bell-like sound it gives if it is tapped. Although long known in the Far East, it was discovered in Europe by Johann Friedrich Böttger at Meissen in 1708.

Soft-paste porcelain, also known as artificial or frit porcelain, consists chiefly of a mixture of vitreous substances, a frit which contains sand or flint, saltpetre, sea salt, soda, alum and pounded alabaster. The mixture is allowed to fuse for a certain length of time and marl, which contains gypsum and clay, is then added. We thus have a fused, vitreous substance mixed with clay which is then ground and filtered until it is plastic. The pieces modelled from it are fired at $1100\text{-}1500°$ C., and allowed to dry and become porous. The glaze is mainly glass, which fuses easily and which is rich in lead oxide and also contains sand, soda, potash and lime. Glazed pieces are given a second firing at $1050\text{-}1100°$ C. to make the glaze merge with the body. Soft-paste porcelain is more translucent than hard-paste porcelain, and of a softer, sometimes almost creamy white. It is not as resistant to heat, and when it is broken the break is straight. Its unglazed surface has a granular appearance. Soft-paste porcelain was discovered in Florence in the 16th century (Medici porcelain) and most of the earlier European porcelain was of this kind, including the beautiful and very highly-prized products of old Sèvres.

Bone china is a compromise between hard-paste porcelain and soft-paste porcelain. It was discovered in England and was first made there in about 1750. It contains not only china clay and felspar but also calcium phosphate from bone ash, which makes it easier to fuse. It is fired at $1100\text{-}1500^0$ C. The result is a hard-paste porcelain softened by the addition of bone ash. The glaze is basically the same as for soft-paste porcelain but, in addition to lead oxide, also contains borax to make it merge better with the body. When a certain firing temperature is reached, the glaze fuses and marries firmly with the body. Its peculiar properties place bone china halfway between hard-paste and soft-paste porcelain in quality. It wears better and is harder and less permeable than soft-paste porcelain but has the same soft type of glaze. It is whiter than soft-paste but less white than hard-paste porcelain. It was used for the first time by Thomas Frye at Bow in 1748.

Decoration. Broadly speaking, there are two ways of decorating porcelain — relief decoration and colouring. Relief decoration is produced in the actual body of the piece by engraving, perforation or the addition of a raised pattern. Sometimes the piece and its relief work are modelled together in the same mould; sometimes the relief or certain portions of the decoration (flowers, buds, leaves, figures — used as handles, etc.), are modelled separately and then attached to the piece. Colours can be applied either over or under the glaze. When they are put under the glaze metallic oxides, which can withstand high temperatures, are applied direct and then fired with the glaze.

Historical Survey

The Orient. The Chinese discovered how to make hard-paste porcelain in about the 6th century AD, but they guarded their secret very carefully. Chinese porcelain attained an extremely high standard, particularly in the 15th and 16th centuries. At this time plenty of Chinese pieces were reaching Europe, thanks to the activities of Portuguese sailors. The Chinese used cobalt and colcothar as colours because they stand very high temperatures, and they perfected the use of enamels in the 17th century. In about 1700 green was the colour most used, and pieces made at this time came to be known as *famille verte*. Similarly the term *famille rose* was used to describe a later type in which the main colour was pink. Like the products themselves, the various stages in the history of Chinese porcelain are named after the dynasty ruling at the time.

The Japanese began to make porcelain in about 1500, and the Dutch helped to make it known in Europe in the 17th and 18th centuries by bringing it from the port of Arita in the province of Hizen. This porcelain was called Imari ware, after the port from which most of the products were shipped. The body of Japanese porcelain is inferior in quality to that of Chinese, but the decoration is much richer and more diverse. The Japanese used the same colours as the Chinese but also decorated their porcelain with gold.

Medici porcelain. In 1575 the Tuscan prince Francesco I de' Medici had a soft-paste porcelain factory built in the famous Boboli Gardens in Florence. The properties of Medici porcelain place it somewhere between hard-paste and soft-paste porcelain. It was transparent, thanks to white clay from Vicenza, but as its colour was yellowish the Italians used a white glaze already developed for the manufacture of maiolica. About 50 authentic pieces are still in existence, plates, dishes, bottles, pilgrims' flasks, vases, wash-basins and jugs. They are decorated with stylised flowers in the manner of Persian ceramic decorations, or with dwarfs and grotesques with birds and masks taken from contemporary Italian pottery. Cobalt blue, sometimes combined with lilac blue and manganese oxide, was used for decoration. The factory continued working until the first quarter of the 17th century. Medici porcelain bore the mark 'F' and above it, in blue, the cupola of Florence Cathedral.

Medici porcelain was only one of several episodes in the early history of porcelain. It was followed by further experiments in England (Dr Dwight and Francis Place, both in the second half of the 17th century) and in France (Rouen, St-Cloud), encouraged by large imports of porcelain from the Far East from the beginning of the 17th century; but no positive results were obtained until the 18th century.

Germany and Austria. *Meissen*. In 1700 the problem of how to manufacture white, translucent porcelain remained unsolved, and the chemical composition of hard-paste porcelain was still unknown. Towards the end of the 17th century the physicist and mathematician Ehrenfried Walter, Count of Tschirnhausen, carried out extensive geological researches in Saxony in the hope of finding raw materials which would give some solid basis to the duchy's economy. At the same time he was considering building glassworks, and wanted to find fireproof material for the crucibles. In the course of his experiments he used clay from Colditz which later became one of the chief constituents of Meissen porcelain. It is evident from his reports on journeys he made to Holland that he was aware of the difference between hard-paste — that is, true porcelain — and soft-paste. He began to interest himself in the problem of the composition of hard-paste porcelain, and continued his experiments with some positive results. In 1704 he was entrusted with the supervision of the young Johann Friedrich Böttger, whom Augustus of Saxony was holding prisoner at Meissen. This collaboration between the old, experienced scientist and the gifted young man led to the mystery of the true composition of hard-paste porcelain being solved. During his studies in Berlin, Johann Fried-

rich Böttger had begun to devote all his time to experiments in alchemy, for which he became well known. When Frederick I, King of Prussia, heard about him, he decided to make use of Böttger for his own purposes. Böttger, however, wanted to continue his experiments and his research and — fearing for his freedom — fled to Wittenberg in 1701. Here, however, he found himself within the sphere of influence of Augustus the Strong, Elector of Saxony and King of Poland, who had him brought to Dresden and kept under observation, intending that Böttger should work for him and make gold. But Böttger made good use of his association with Tschirnhausen. Spurred on by the threats of the impatient Augustus, who was eager for results, he suggested setting up a factory to make hard stoneware, and in 1707 the necessary means to do this were placed at his disposal. The factory was founded in 1708 to make ceramic products like the hard, smooth stoneware of Ary de Milde in Holland. Clay from Plauen was used for this kind of pottery. It had an iron oxide content, turned reddish-brown when fired, and became so hard that the piece could be further worked by grinding, cutting, and so on.

The two collaborators also tried to make hard-paste porcelain, but Tschirnhausen did not live to see the success of these experiments, for he died in October 1708 and it was not until March 1709 that Böttger at last achieved complete union between body and glaze by using the same materials for both. After the discovery had been checked and approved by a commission, the first European factory making hard-paste porcelain began work on the Albrechtsburg at Meissen in January 1710.

Böttger managed the factory until his death in 1719, when Johann Gregor Höroldt was made artistic director. Under him painting became the main element of decoration. From 1727 the sculptor Johann Gottlieb Kirchner worked under Höroldt, becoming *Modellmeister* in 1730. In 1733 Johann Joachim Kändler took his place, and it was his work in porcelain sculpture that made European porcelain an independent art. From 1774 the factory was managed by Camillo Marcolini, under whom there were considerable economic difficulties. Production gradually declined, and in the 19th century the factory's products were of less artistic merit.

Böttger's period (1710-19). Stoneware and porcelain were produced at the same time. The same shapes, generally copied from Chinese sources, were used for both, and as far as porcelain was concerned only the tall bell-shaped beakers were new. The hardness of the stoneware made a number of decorative techniques possible: motifs from Chinese and antique ornamentation were modelled in moulds as reliefs, Bérain ornamentation and Baroque leaf and strapwork were cut and polished (a technique taken over from glass-making), and *chinoiseries* were painted in gold and silver (which had already oxidised). The hard stoneware body could also be ground to give a shiny surface. The porcelain too was decorated with ornamentation made in moulds, or with naturalistic plant decoration which was modelled and applied by hand. Few painted pieces were made at this time, and those that were painted were done in gold and silver only. It is believed that it was Böttger who discovered a pinkish-violet 'mother-of-pearl glaze'. The figures made during these years were of no artistic value.

The period of Höroldt and Kändler (1720-c.1745). Höroldt introduced muffle colours at Meissen. They require only a low fusing temperature and give a wide range of colours. In 1722 red, violet, brown, yellowish-green and greyish-green, yellow and light blue were used, and in 1725 fired gilding.

Until 1735 tableware shapes were taken from Far Eastern patterns, and porcelain painting also drew its inspiration from this source. Pierces were decorated with 'India flowers', a term which includes motifs representing bamboos, chrysanthemums, peonies, pine trees, fantastic birds and dragons. A.F. Löwenfinck's style was also derived from Far Eastern decoration. He was a distinguished painter who worked at Meissen round about the year 1730. Between 1725 and 1735 groups of pseudo-Chinese figures and landscapes — known as *chinoiseries* — were painted, in imitation of engravings which had been published in Germany and the Netherlands since the end of the 17th century. Höroldt and his colleagues adapted these motifs, and at first reproduced them in gold silhouette only, but from 1726 onwards they were painted in several colours. At the same time Höroldt successfully made *Fondporzellan* — porcelain with a single ground colour (yellow, turquoise or blue) in which panels

were left blank for polychrome paintings. This method, inspired as it was by Oriental art, was followed closely after 1735. Both the composition and style of the painted panels were maintained, landscapes (particularly coastal scenes) being the most popular subjects. In the 1740s, however, groups depicting scenes of gallantry became fashionable, inspired by the Dutch landscape painters Rugendas, Wouwermann and van de Velde, and by the French painter, Watteau. These paintings either covered the whole surface of the piece or, like the *chinoiseries,* were framed in gilded arabesques. Of the landscape painters who were active around 1740, J.G. Hintze was particularly distinguished, whilst J.B. Borrmann, who worked at Meissen until about the middle of the century, became well known for his scenes from Watteau. Up to 1740, underglaze blue was not used for technical reasons. The famous 'onion pattern' and the 'immortelle pattern' were produced in about 1740 and survived in the younger porcelain factories for a long time. But it was only in painting that there was much change; the shapes of the pieces were still copied from Oriental patterns. This situation remained unaltered until J.G. Kirchner and, particularly, J.J. Kändler came to Meissen and gave porcelain paste what it had lacked until then – a peculiarly European style in the Baroque taste.

During the first few years under Höroldt's direction, G. Frietzsche worked at Meissen and produced figures which were not of very high quality. From 1727 onwards Johann Gottlieb Kirchner was employed there and was made *Modellmeister* in 1730. He was a gifted sculptor from the circle which had formed around Pöppelmann. As early as 1727-29 he made some clock cases and a hanging fountain in the shape of a shell borne by Atlas. Augustus the Strong himself encouraged a broader, more creative approach to porcelain manufacture by his desire to have lifesize porcelain figures of animals for his 'Japanese Palace'. This task was given to Kirchner, who modelled a number of large figures between 1730 and 1733. In 1733, however, he was dismissed, and it was left to his successor Johann Joachim Kändler to finish the work. Kändler made a further series of large animals, but the extravagant plans for the 'Japanese Palace' collapsed soon after the death of Augustus.

Kändler then turned his attention to smaller figures and to designing tableware. His most important work of this sort is the service made for Count Alexander Josef Sulkowsky between 1735 and 1737, and the 'Swan service' (1737-41) made for the Saxon minister Count Heinrich Brühl, who directed the Meissen factory after the death of Augustus the Strong. It was also Kändler who introduced basketwork in low relief as a decoration for plates. This took different forms and is often named after the original customers: 'Old Brandenstein', 'New Brandenstein', 'Gotzkowsky's raised flowers' and the 'Dulong relief pattern'. Although the first of these was produced in the 1730s, they were still being made in the second half of the 18th century. Another very good modeller, J.F. Eberlein, was working with Kändler in 1735. He helped with the modelling of large animals and himself made a number of mythological figures.

The Rococo period (c.1745-74). Between 1740 and 1750 the motifs used in porcelain painting changed. Decoration was chiefly limited to realistic representations of flowers, known as 'German flowers', with sprigs, fruit, birds and insects. Originally, engravings were copied from books (for example the illustrations of Schmidthammer and J.D. Preissler), but copying was soon abandoned and painting became freer and more natural. During the rest of the century some small porcelain pieces were made at Meissen and decorated with particularly fine painting.

In about 1740 Kändler was made head of the modelling shop, in which more than 50 modellers worked. His colleagues were all excellent artists and helped to make his work successful. Besides Eberlein there was P. Reinicke, who worked at Meissen from 1743 until 1768 (many of his figures are mistaken for Kändler's work), and F.E. Meyer, an artist with a marked Rococo style who later went to Berlin, but who worked at Meissen from 1748 until 1761. A great variety of subjects is to be found in the porcelain figures made from the 1740s. There are allegorical and mythological figures, cavaliers and ladies in crinolines, characters from the Commedia dell' Arte, craftsmen, peasants and traders, soldiers and huntsmen, shepherds and shepherdesses.

In the 1760s the sculptor Michel Victor Acier

introduced Neo-Classical ideas from France, and even Kändler — until then the leading creative personality at Meissen — was put in the shade. In spite of his great age, Kändler skilfully adapted himself to the new style. His very last work, in collaboration with Acier, was a service for Catherine II in the new style. He died in 1775, shortly after it was finished.

The Marcolini period (1774-1814). From the 1780s tableware shapes became simpler and more austere under the influence of Classical art, and were also decorated differently. From about 1782 the entire surface of a plate — except for the medallions left blank for painting — was covered with a blue colour, called *bleu-de-roi*, in the style of Sèvres. *Veduta* painting, symbolical subjects or miniature portraits were executed in several colours or sometimes in grey only — *en grisaille*. One of the best known painters of this period was J.G. Löhnig.

In the Marcolini period, Meissen porcelain lost its lead over other European porcelain factories — in fact, patterns from Vienna and Sèvres were even used at Meissen. At the end of the 18th century pieces were made at Meissen in the Sèvres style from unglazed porcelain (biscuit), but the Meissen biscuit, granular, bluish and chilly in appearance, never achieved the quality of the Sèvres original. G. Jüchtzer and J.G. Matthäi, both talented modellers, worked mostly with this material and left behind them a few good pieces modelled in the Neo-Classical style, based on Greco-Roman models and contemporary pictures.

The famous and creative epoch of Meissen porcelain manufacture ended definitively with the Napoleonic Wars. The 19th-century products are not nearly as good as those which were made when Höroldt was competing with Kändler, who set the pace in porcelain painting and modelling. 18th-century shapes were often reproduced in the 19th century.

Marks. Porcelain made in Böttger's time bears no mark. Between 1720 and 1725 imitations of Chinese inscriptions or drawings are often found. After 1725 the marks were in underglaze blue and were an outline drawing of the caduceus or the letters KPM (Königliche Porzellanmanufaktur — Royal Porcelain Factory) or MPM (Meissner Porzellanmanufaktur — Meissen Porcelain Factory). Large pieces in the Chinese and Japanese style made between 1725 and 1730 bear the letters AR (Augustus Rex), as do products manufactured for the court in subsequent years. From 1720 two crossed swords (from the arms of Saxony) were used, and it is this mark which, with some alterations, has remained the traditional sign of Meissen porcelain. On porcelain made between 1763 and 1774 there is a dot between the two sword handles (hence this is known as the dot period), and on porcelain made in Marcolini's time, from 1774 to 1814, a star. From 1814 to 1820, Roman numerals appeared below the swords to indicate the date. On biscuit figures in the Classical style the mark is impressed or painted in blue and the swords are within a triangle. The mark was sometimes scored across with one or more lines to indicate the poor quality and condition of the piece on leaving the factory. It is not quite clear how the system worked, but if the mark is struck through at the point where the two swords cross it means that the piece left the factory undecorated and was probably not painted until later. This method of marking was not, however, used for porcelain sculpture, and here the origin has to be determined from the colours and the way in which they are applied.

Vienna. The Viennese factory was founded in 1718 by the Dutchman Claudius Innocentius du Paquier. He was helped by Samuel Stölzel, an arcanist (that is, one who knew the secret of porcelain manufacture) and by the painter and gilder Christoph Konrad Hunger, both of whom had originally worked at Meissen. In 1720, however, Stölzel went back to Meissen, and Hunger went on to Venice. The factory remained the property of du Paquier until 1755, when he sold it to the state. Now that it was financially secure and had a staff of competent workers, the factory began to flourish, but its development was interrupted by the Seven Years War, and at the end of the war it had to deal with an economic crisis. The manager of the factory was Konrad Sorgenthal, and it is due to him that Vienna's reputation eventually surpassed that of Meissen. The factory declined in importance in the 19th century, and in 1864 it was closed down on orders from the Austrian Council of State.

The du Paquier period (1718-44). During this period Viennese craftsmen were restricted to making and painting tableware. From the

very first, the shape and decoration of Vienna ware were *sui generis*, and remarkable results were achieved during the first few decades. The shapes of the vessels were quite independent of Meissen, including, for example bell-shaped cups with two handles, sometimes fluted, teapots and coffeepots with spouts rising from moulded masks and handles in spiral shapes, bowls, plates, terrines, dishes, tea caddies and so on. Even painted decoration was free from the influence of Meissen, and during this period can be roughly classified into four groups. From 1720-30 polychrome *chinoiseries* were predominant, usually covering the whole surface. The drawing and motifs are expressive and often inspired by Japanese Imari porcelain. Iron-red was often used, and also the purple so typical of Vienna. European flowers began to appear as early as 1725. The painting was more an exercise in drawing than it was at Meissen, and fewer colours were used. From 1730-40 the motifs owed less and less to the Far East and were more in line with the Baroque sensibilities of the time — polychrome leaf and strapwork, basketwork, shells, flowers, fruit, baskets, and also landscapes in cartouches. As a contrast to this group there was a similar kind of decoration which was painted in one colour (black, purple or silver) after the fashion of engravings, and finished in gold. Jakob Helchis was particularly successful in this style. He and J.P. Dannhofer were two of the best painters and worked in the factory, unlike the independent painters (*Hausmaler*) in Vienna who worked at home, such as Bottengruber and his pupil Wolfsburg. Porcelain of this period was not marked, and it is often difficult to decide what was done in the factory and what outside.

The pre-Sorgenthal period (1744-84). New shapes, new motifs and new colours were developed, all in the Rococo style of the period. From the 1750s Viennese porcelain shapes did not differ much from those made in other German porcelain factories — the pear-shaped pots, semi-spherical terrines with handles in the form of fruit or figures, and so on. They were usually ornamented in relief with *rocaille*, basketwork and other Rococo ornamentation. The chief painters of this period were C.D. Busch, J.G. Klinger, who worked in Vienna for thirty years, J. Daffinger, A. Anreiter and J.S. Fischer. Later there was P.E. Schindler, to whom is attribut-

ed some fine painting done between 1750 and 1760 in the style of Watteau, Rugendas and Teniers. It was not until the 1740s that porcelain sculpture was executed at Vienna. From the very beginning it had a character of its own, and, whether the subjects were allegorical and mythological or scenes taken from life, they had the same grace and liveliness of movement. A typical feature of Viennese figures is their small heads with fine laughing mouths. Also typical are the choice of colours, ranging through red and brown, with black, gold and clear lilac, green and yellow. Johann Joseph Niedermayer, who was made *Modellmeister* in 1747, helped to give Viennese porcelain sculpture an outstanding reputation. He worked in the porcelain factory until 1784. There were also a number of modellers working there from 1760 to 1770 who marked their work with impressed initials. The most important were L. Dannhauser, J. Dangel, J.U. Mohr, D. Pollion, A. Payer and J. Gwandtner.

The Sorgenthal period (1784-1805). Production of dinner, coffee and tea services in the style of Sèvres greatly increased. There was an improvement in both the financial and the artistic direction. Painting became particularly important, and much was done to improve the colours. The chemist J. Leithner (Leithner blue) made a special contribution. The ground colours remained lilac and cinammon red, the painting being often done in grey (*en grisaille*). Tableware increasingly tended to be covered all over with coloured glaze, ornamentation or paintings copied from pictures by famous artists in the Vienna galleries. None of the other factories employed such well-known painters at this time. J. Anreiter, M.M. Daffinger, an excellent miniature painter, and K.A. Kothgasser, who also painted glass independently, worked in the Vienna factory. After Niedermayer's death, his assistant Anton Grassi was made *Modellmeister*. Under Grassi, Viennese porcelain sculpture became Neo-Classical, just as Meissen had done when Acier arrived. Grassi's urban and rural subjects have the freshness of everyday life. In the 1790s, shortly before his death, he also made groups and portrait busts in biscuit in the style of Sèvres. Grassi's pupil Elias Hütter, who took his place, continued along the same lines, favouring the academicism represented by the Empire.

Marks. From 1744 to 1749 the mark was a

shield with two bars across it (from the Austrian coat of arms), impressed; such marks were known as wood marks. From 1749 to 1770 the same mark was used, often asymmetrical, in underglaze blue. From 1770 the shield was smaller and more symmetrical but still blue. From 1827 a regular, impressed mark was used. From 1783 the year of manufacture was given. Up to 1800 only the last two figures were given (83 = 1783), from 1800 onwards the last three figures (803 = 1803). The figures showed the year of manufacture but not when the piece was decorated. Painted numerals were sometimes used as well as impressed ones, and indicated the painter.

Independent painters. As in the case of glass, independent painters of porcelain who worked at home existed from the second quarter of the 18th century. These *Hausmaler* worked mainly on direct orders, and although many of them were of little account, others had extraordinary artistic ability. It was difficult for them to get hold of porcelain (particularly in the initial stages of European manufacture, when care was taken that no undecorated porcelain left the factory) and for this reason they often also worked on the more easily obtainable imported Oriental porcelain, which was frequently already painted with cobalt under the glaze. J. Aufenwerth worked in Augsburg, and some of the pieces made by him are signed IAW. Ignaz Bottengruber worked in Breslau and later (from 1720 to 1736) in Vienna, as did his pupil K.F. Wolfsburg from 1727 to 1748. Ignaz Preissler worked in the 1720s and 1730s in Kunštát in Bohemia, and F.F. Mayer, one of the last independent painters of note, worked in Přisečnice from 1745 to 1770. In the 1720s and 1730s J.K.W. Anreiter and later also his son Anton worked as independent painters in Vienna and then in Italy: both signed some of their work. There were also some independent painters working in Holland. In the 1760s, however, the number of independent painters began to drop, and they finally disappeared altogether.

Höchst. A factory was founded at Höchst in 1746 by two financiers and the porcelain painter A.F. Löwenfinck, who had come from Meissen. Johann Benckgraff managed the factory after Löwenfinck, but its unsatisfactory financial position did not improve when the elector of Hesse made it the property of the state in 1778 and re-organised it. Towards the end of the century it was approching bankrupty, and it finally closed down in 1796, after the French occupation.

The shape and decoration of the tableware were influenced by Meissen, particularly in the initial stages, but the purple shades used in painting at Höchst are typical of the Rococo period.

The figures — made by a number of good modellers — are much more original and more interesting in style. Simon Feilner was a modeller at Höchst from 1750 to 1753, when he went to Fürstenberg with Benckgraff; he made pastoral groups, groups of comedians and other genre scenes. Lorenz Russinger worked at the factory from 1758 to 1765; he later went to Fulda. Johann Peter Melchior then took his place as *Modellmeister*, continuing his work until 1779. He modelled mythological figures and also small works to which he gave an air of animation and reality. This is particularly evident in his figures of children, although it is also conveyed in his portrait work and his medallion reliefs.

Marks. Until 1763 the mark was a wheel with six spokes, from the electoral coat of arms, painted in red or gold over the glaze or impressed; from 1763 it was painted in underglaze blue. Between 1765 and 1775 the electoral crown was often shown above the wheel.

Berlin. The Wegely factory (1751-57). The first Berlin factory was founded in 1751 by a merchant, Wilhelm Kaspar Wegely, who managed to attract workers from Höchst. He entrusted the artistic side of the work to the modeller E.H. Reichard and a miniature painter from Meissen, I.J. Clauce. The factory was forced to close down a year after the outbreak of the Seven Years War (1757). The porcelain paste from which the oldest products of this factory were made was of incorrect composition, and although the body was white, because china clay from Saxony was used, there were flaws on the surface. The material was too hard and the colour decoration difficult to execute. The shapes of the tableware were clumsy, the relief decoration rather coarse, and the whole lacked the elegance of the Rococo style. Most of the painting was of flowers in blues or purples — colours which are much more a feature of the Berlin than of the Meissen palette. 'German flowers' were painted in bright colours.

The Gotzkowsky factory. At the suggestion

of Frederick the Great, Johann Ernst Gotzkowsky, a merchant, founded a new factory in 1761. He employed some of the Wegely personnel and also the Meissen modeller F.E. Meyer and the painters K.W. Böhme, K.J.C. Klipfel and J.E. Borrmann. J.G. Grieninger was made manager. In 1765 the newly organised factory was sold to the state. At this time no Saxon china clay could be obtained, and clay from Passau was used, together with Silesian china clay, which gave a fine, creamy-white porcelain.

In the 1760s the factory turned to the manufacture of tableware decorated with relief ornamentation and painting. The painters were of such an inventive turn of mind that they very rarely drew on foreign designs. Their innovations included the types of decoration known as *Reliefzierat*, in which Rococo ribs divided the surface into several areas which were filled with painting, and *Neu-Zierat*, in which Rococo ornamentation was spread over the whole surface. *Antikenzierat*, in which the edges were pierced in a basketwork style, was also often used. A characteristic of Berlin porcelain painting is the use of a single colour, often emphasised only by complementary gold painting. Apart from flower decoration in orange, carmine or brown, the vessels were often decorated with scenes from engravings by Boucher, and the rims with small flowers or scale patterns, known as mosaic decoration. Services ordered by the king in 1765 and 1767 for the New Palace at Potsdam, for Breslau Castle in 1767-8 and for Sans Souci in 1769, were made in this style. It was not until 1780 that copies of Meissen pieces appeared in Berlin, decorated with the 'New Brandenstein' and 'New Osier' relief designs. In 1784 a service was made on which *bleu-mourant* was used for the first time: this was a very light matt blue, the king's favourite colour.

The porcelain figures made at the Berlin factory are not nearly as good as those from Meissen, although F.E. Meyer, working in the Rococo style, did raise the level of the work. He also made models for tableware for the New Palace at Potsdam and for figures to go with the tableware (personifications of the elements and the seasons). Wilhelm Christian Meyer followed his brother to Berlin in 1766. Little of the Rococo style is to be found in his work, which inclined very much towards academic Classicism.

In the 1780s the shapes of the tableware made in Berlin became simpler, as they did in all other porcelain factories, but they were still painted in one dominant colour, either iron-red with gold, or pink with grey. This cool harmony of colours was particularly characteristic of the Berlin factory.

Marks. The Wegely factory used a W in underglaze blue and the Gotzkowsky factory from 1757 to 1763 a blue G in underglaze or painted in enamel over the glaze. From 1763 to 1837 the Royal Prussian Porcelain factory used a number of variants of the sceptre in underglaze blue to which, from 1837 to 1844, were added the blue letters KPM below the sceptre. From 1844 to 1870 the blue letters KPM were used with a Prussian eagle impressed above. From 1870 the sceptre appears again with a central line across it.

Fürstenberg. This factory was founded by Duke Charles I of Brunswick. Although earlier attempts had been made, manufacture did not begin until 1753, when the arcanist Benckgraff from Höchst, the painter Zechinger and the modeller Feilner were persuaded to join the factory.

From the artistic point of view, Fürstenberg tableware was heavily influenced by Meissen, although it did have some traits of its own. In the 1750s and 1760s the tableware was decorated with rich reliefs to cover faults in the porcelain paste. Painted decoration executed in choice colours was always the most distinguished aspect of Fürstenberg porcelain. From 1765 to 1770 large porcelain plates were ornamented with paintings so that they resembled pictures.

S. Feilner made a series of figures from the Commedia dell'Arte, tradesmen and peasant groups, mythological scenes and so on. Feilner came from Höchst and worked in Fürstenberg until 1770. In subsequent decades, under the direction of the *Modellmeister* J.C. Rombrich, Fürstenberg employed C.G. Schubert and A.K. Luplau. They had no inventive ability and worked from Meissen models or from engravings. The Frenchman Desoches also tended to rely on reproductions, although his figures and groups — often made in biscuit — are very graceful.

From 1795 another Frenchman, Louis Victor Gerverot, managed the factory. He introduced the French Empire style, which found expression in the shapes of the tableware, in its gold decoration on a black or blue ground

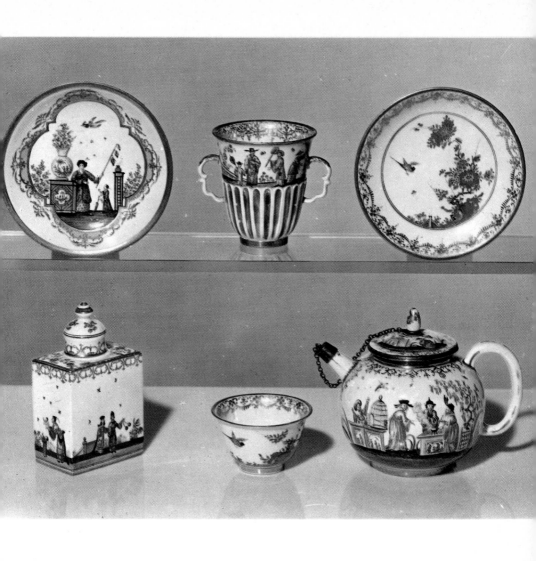

XXXV Porcelain tableware with painted *chinoiseries* and 'India flowers'. Meissen, Höroldt period

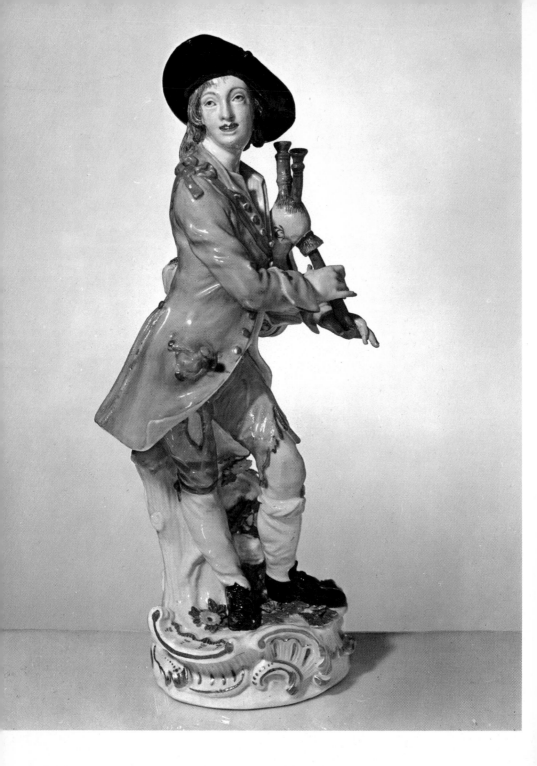

XXXVI Bagpiper: painted porcelain figure. Model by J. J. Kändler, Meissen, *c.* 1750

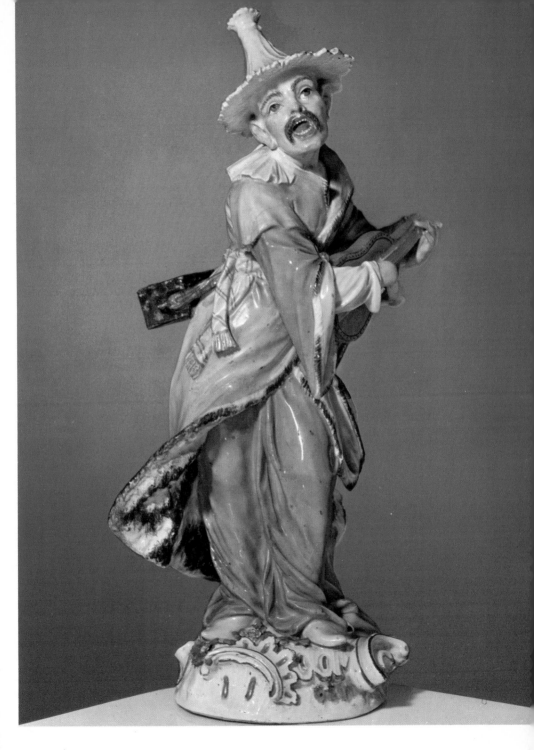

XXXVII Malabar figure with musical instrument: painted porcelain figure after a model by F. F. Mayer, Meissen, *c.* 1755

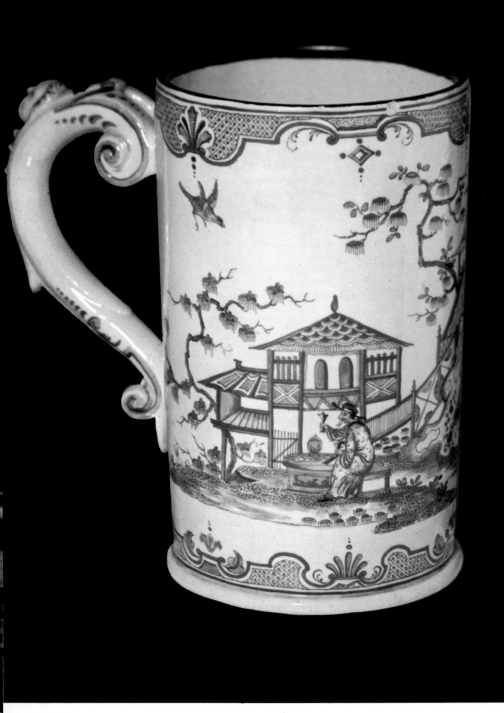

XXXVIII Tankard with painted *chinoiseries*. Vienna, du Paquier period, *c.* 1725

(*bleu-de-roi*), and in particular in porcelain sculpture, mainly portraits in biscuit.

Marks. The mark used was a written F in underglaze blue. At the beginning of the 19th century the impressed outline of a horse was used on busts.

Frankenthal. In 1755 the Elector Palatine Carl Theodor gave Paul Hannong permission to found a factory. Hannong's son Charles François managed it, and in 1759, when Charles François died, his younger brother Joseph Adam took it over. In 1762 the elector bought the factory. In 1795 he leased it to the brothers van Recum, but in 1800 it was closed down. From 1755 to 1761 Johann W. Lanz was working as *Modellmeister*, and a very high artistic standard was reached. Lanz introduced realism into his work, making rural figures and groups copied from French engravings. Johann Friedrich Lück was working in Frankenthal at the same time (1758-65). After Lanz, Konrad Link became *Modellmeister*; his porcelain sculpture (busts, portraits and dancers) was extremely skilful. Karl Gottlieb Lück, the brother of Johann Friedrich Lück, took Link's place in 1766. From 1779 to 1793 the famous J.P. Melchior worked as *Modellmeister*, introducing the first Neo-Classical elements before his departure for Nymphenburg. Of the later modellers, Adam Clair, a pupil of Melchior, followed his master to Nymphenburg in 1799.

Marks. From 1756 to 1762 the marks were PH (Paul Hannong) or PHF (Paul Hannong Frankenthal), impressed; from 1756 to 1759 a lion rampant in underglaze blue; from 1759 to 1762 intertwined initials JAH (J.A. Hannong). From 1762 the monogram of the elector, CT (Carl Theodor), was used, with the crown in underglaze blue. From 1770 to 1788 abbreviated year numbers were also impressed. From 1795 the letters VR (van Recum) appear.

Nymphenburg. Franz Ignaz Niedermayer founded a factory in 1747 in Neudeck, a suburb of Munich. He had little success with his experiments, and a turning point was reached only in 1753, when the Viennese arcanist Josef Jakob Ringler came to Neudeck. The factory passed into state ownership and moved to Nymphenburg in 1761. From 1862 it was again privately owned.

The painted tableware made at Nymphen-

burg was entirely eclipsed by the porcelain sculpture. From 1754 Franz Anton Bustelli worked in Neudeck and subsequently in Nymphenburg as *Modellmeister*, and he remained faithful to the firm until his death. It was he who made all the tender, supple figures, groups of ladies with cavaliers and figures from the Commedia dell' Arte for which the Nymphenburg factory became famous, as well as figures of *putti* and Chinese musicians. Bustelli was one of the best European modellers of the Rococo period. He knew his material and understood how to give it life and meaning. Some of his figures were left white, others were gilded or painted, but the painting was always in tune with the modelling.

After Bustelli's death, Dominik Auliček, a Czech who had been trained in Bohemia as a sculptor, took his place. He became Bustelli's successor in 1763 after travelling in Europe to study works of art, and he held this position until 1797. In contrast to Bustelli's, Auliček's sculpture inclines towards the tranquillity and dignity of Neo-Classicism. Apart from antique gods and some large mythological groups, he also made models for twenty-five hunting scenes, evidently inspired by the engravings of Riedinger, who was then very popular. Most of his work in the Nymphenburg factory was done between 1763 and 1772. Auliček was replaced by the *Modellmeister* J.P. Melchior, who remained at Nymphenburg until his retirement in 1822. He made a number of portrait busts and allegorical groups in biscuit, which was a popular material from the end of the 18th century.

Marks. The oldest work from Neudeck is marked with a hexagram in underglaze blue accompanied by various letters. At the same time a chequered shield from the Bavarian coat of arms was also impressed and was subsequently used in various sizes by the Nymphenburg factory. Bustelli marked some of his work with the impressed letters FB.

Ludwigsburg. The factory, founded in 1756, was taken over in 1758 as a state concern by Duke Carl Eugen of Württemberg. A year later he asked Josef Jakob Ringler, who had worked as an arcanist in Höchst, Strasbourg, Neudeck-Nymphenburg and Vienna, to be manager at Ludwigsburg. The most favourable conditions for development occur-

red during the years 1760-67, when the duke moved for a time to Ludwigsburg, but afterwards the artistic standard of the products declined, and in 1824 the factory was closed down.

Ludwigsburg was particularly noted for its porcelain sculpture. Its most famous modellers, apart from Jean Louis, were Beyer and Lejeune. Johann Christian Beyer was in the service of the Dukes of Württemberg from 1759 to 1767. During his travels in Europe he had visited Rome, where he studied the art of Antiquity and was converted to Neo-Classicism. He was one of the first to introduce this style in Germany in the 1760s. He made a number of figures in contemporary costumes, and also allegorical figures and figures representing various national types. His pupil J. Weinmüller worked at Ludwigsburg at the same time, as did P.F. Lejeune, who had been called to Stuttgart in 1753 as court sculptor, and who remained in the service of the duke until 1778.

Marks. From 1758 to 1793 several variants of two intertwined Cs were used, sometimes with a crown painted in underglaze blue. From 1793 to 1795 there was an L below the crown (Prince Ludwig); from 1806 to 1810 FR below the crown (Fridericus Rex); from 1816 to 1824 WR (Wilhelmus Rex), generally in gold. In the last quarter of the 18th century and at the beginning of the 19th century, the antlers from the Württemberg coat of arms were often used, sometimes tripled, as a variant with intertwined Cs.

Other German porcelain factories. Of the smaller, less important German factories, Ansbach, Fulda and Kloster Veilsdorf deserve to be mentioned. A factory was founded at *Ansbach* in 1759 and moved to Bruckberg three years later. Up to 1777 it made tableware with Rococo decoration and porcelain sculpture, including a number of fine Turkish, Tartar and Indian figures, as well as groups of lovers in leafy settings. The factory continued under private ownership until 1860.

Marks. The marks used were a written A in underglaze blue and sometimes, on figures, the Ansbach coat of arms (a roof with three fishes). Sometimes the figures are not marked.

The *Fulda* porcelain factory, founded in 1763, was in production until 1790. Its tableware can be recognised by its painted decoration done in one colour, either purple or reddish-brown. The best works were figures modelled by L. Russinger, who had previously worked in Höchst. Arched bases with supple Rococo decoration are characteristic of his figures.

Marks. From 1763 to 1788 a single or double F was used below the crown in underglaze blue. From 1765 to 1780 the cross from the Fulda coat of arms was also used in various forms.

Kloster Veilsdorf is the only porcelain factory in Thuringia which can be included among the leading German factories. It was founded in 1760 and belonged from 1797 to 1822 to Greiner. The flower decoration and landscape paintings of the tableware made in about 1770 can be compared in quality with similar products from the Berlin factory. The firm also made good porcelain figures, and many of those made in about 1780 are attributed to the modeller Franz Kott.

Marks. The intertwined letters CV in underglaze blue.

There were other smaller Thuringian porcelain factories in Gotha (founded in 1757), Volkstedt (founded in 1760), Wallendorf (founded in 1763), Limbach (founded in 1772), Ilmenau (founded in 1777) and Gera (founded in 1779).

France. *Rouen.* The oldest French factory was founded here in 1763 by Louis Poterat. It produced a soft-paste porcelain of which a few pieces still exist. They are mostly decorated in blue, but other colours (green, red) were sometimes used. The colour was applied to the glaze before firing. No Chinese motifs were used, the ornamentation being of the type normal at that time for faience from Rouen and other French potteries (see the chapter on pottery). The body of Rouen porcelain had a somewhat greenish shimmer and the glaze looked as though it was not of a very vitreous character. The ware carried no mark.

St-Cloud. Permission to manufacture soft-paste porcelain was granted to the family of Pierre Chicaneau by letters patent dated 1702. Pierre Chicaneau had discovered how to make soft-paste porcelain in 1679, and the family kept the secret for a long time. The factory produced a wide range of products.

Its tableware was copied in shape and decoration from Chinese examples. The decoration took the form of reliefs shaped in moulds, depicting flowers, prunus buds, sprigs and rosettes. Some objects with this sort of decoration were also painted in underglaze blue. Generally speaking, workers at St-Cloud tried to make faithful copies of Far Eastern porcelain. Other colours as well as blue were used on the glaze, including turquoise, yellow, iron-red and green. The porcelain was of a creamy colour and the glaze pure. The factory was closed down in 1764.

Marks. The oldest St-Cloud porcelain is very rare and was marked with St C in underglaze blue. In about 1696 a sun in underglaze blue was used, and from *c*.1722 the mark was SC with a cross above it and the letter T below. Many pieces of soft-paste porcelain similar to the St-Cloud pieces exist, but they probably come from other factories which were greatly influenced by the St-Cloud products. These were the factories in Lille, founded in 1711, and Chantilly, which was in production from 1725 until 1789. Both adopted the style of Meissen and, later in the 18th century, Sèvres.

Mennecy-Villeroy. The factory was originally founded in Paris by François Barbin in 1734, then moved to Mennecy in 1748, and finally, in 1773, to Bourg-la-Reine. At first tableware was decorated with paintings of Meissen flower motifs over the glaze. Mennecy, like other French factories, was chiefly concerned with the imitation of Chinese porcelain. Some pieces are reminiscent of St-Cloud, and when Sèvres became the leading factory in France, its products also served as models for Mennecy, as can be seen from the choice of motifs (birds, flowers, figures in landscapes, and so on). After 1751 figures were also modelled in biscuit. Some figures made at the factory have survived, and a series of groups of children after Boucher, made about 1760, particularly deserve to be mentioned. The others are by no means aesthetically irreproachable, but have a graceful simplicity. The porcelain had a dark ivory-coloured lustre and the glaze had some imperfections.

Marks. At first the mark was DV (de Villeroy). From 1773 it was BR (Bourg-la-Reine).

Vincennes-Sèvres. In 1745 a porcelain factory was founded at Vincennes, directed by a syndicate headed by Orry de Fulvy. De Fulvy succeeded in obtaining not only the necessary permission but also the financial support of the king, who in 1753 himself became a partner in the firm. From that time the name 'Manufacture Royale de Porcelaine de France' was used. When Fulvy died, the talented chemist Jean Hellot took his place and the painting and gilding workshops were directed by Bachelier, who became the true creator of French porcelain. The porcelain made in Vincennes and later in Sèvres was of the soft-paste variety.

More tableware was produced than anything else, and the shapes were designed by the court goldsmith, Duplessis, who was the factory's artistic director. They are often reminiscent of metal tableware, and in the softer material are strange rather than beautiful. In decoration the main emphasis is placed on the ground colour. The most famous and most important ground colour was the strong underglaze blue — *bleu-de-roi* — which was discovered in 1749 by J. Hellot. From 1752 sky-blue is typical of Vincennes. Panels were left blank for polychrome paintings of flowers, birds, figures and landscapes. The most interesting features of the porcelain sculpture of Vincennes were the flowers realistically rendered and painted in naturalistic colours. They were used for a great variety of decorative purposes.

In 1756 the factory was moved from Vincennes to Sèvres, where the manufacture of soft-paste porcelain was continued. Real hard-paste porcelain was not made until 1769, when a china clay deposit was discovered in Limoges. But soft-paste porcelain continued to be made until 1800, when the factory was entirely re-organised; it then made only hard-paste porcelain. The entire Vincennes personnel moved with the factory to Sèvres. In 1759 the king assumed sole financial responsibility, paying off the other partners. Bachelier was made artistic director of the firm, Étienne Falconet manager of porcelain figure production, and Duplessis manager of the other modelling shops.

Dinner, coffee, tea and chocolate services were made, tea caddies and tobacco boxes, dishes, centrepieces and fruit baskets, jewel cases and sewing boxes, washing utensils, inkwells, clock cases, vases and candlesticks. Production at Sèvres carried on directly from Vincennes, the only difference being

that the decoration and colour range at Sèvres was richer and more ornate. Apart from the ground colours already mentioned, there was a beautiful pure pink ground called 'Pompadour pink' (*Rose Pompadour*), doubtless discovered by Hellot, for no pieces like this were made after his death (1766). The effect created by these remarkable ground colours was heightened by gilding and polychrome painting in the blank panels. An apparently inexhaustible number of gilded motifs was produced. One of the most popular decorations was *œil-de-perdrix*, green or blue dots with small gold dots on a white ground; and finely-gilded latticework or circlets of gilded flowers were also much in demand. The gilding was sometimes raised, sometimes smoothed down with agate so that several gradations of colour were produced. In the blank panels were polychrome paintings of flowers, birds, figure groups, pastoral scenes, scenes of gallantry, views of harbours, mythological subjects and martial characters. The landscapes were sometimes in one colour — *en camaïeu* (cameo painting). All these subjects had already been used at Vincennes, but practice, experience and the collaboration of talented professional painters gave a greater refinement and delicacy to Sèvres ware. Until about 1770 the tableware was decorated with painting in the pure Rococo style, but after this date the Neo-Classical style gradually took over. This style dominated all the arts in France during the reign of Louis XVI, and eventually spread all over Europe.

Figures. Soft-paste porcelain is used to make figures because it is easy to model. Production at Sèvres was almost exclusively restricted to biscuit (introduced in 1751 by Bachelier) for porcelain sculpture because, with its semi-matt, finely granular surface, it was reminiscent of Classical statuary. Besides genre and mythological groups there were also portrait medallions and busts made by sculptors of considerable merit, such as Étienne Falconet, to whom is attributed the graceful biscuit statue of Mme de Pompadour as the goddess of friendship. Jean-Claude Thomas Duplessis also worked at Sèvres, as did Bachelier and former pupils of Falconet. In 1771 Simon Boizot and his pupil Le Riche joined them. The figures were based on original groups or portraits by Pig-

alle, Pajou and Bouchardon, and later by Boizot, Caffieri and Clodion, who worked independently, simply supplying the factory with models. There were many other painters and model-makers whose names are to be found in publications dealing with the Sèvres factory.

The French Revolution was not a favourable period for the factory, although production did not stop. In 1800 the manager, Brogniart, re-organised production, and the factory went over entirely to the making of hard-paste porcelain. This ended the creative life of Sèvres: it is only its soft-paste porcelain that is worth collecting.

During Napoleon's time, however, Sèvres set the fashion for European porcelain manufacture. Meissen and (to an even greater extent) Vienna soon succumbed to the new Empire style. Tableware was reduced to simple shapes and the decorators drew widely on Pompeian designs and the frescoes of Raphael. Heads and figures were shown like cameos in small, square, oval or polygonal patterns with intertwined shoots of acanthus leaves, cartouches, cornucopias and various other symbols. Ornamentation, particularly where done in gold, was always executed with great accuracy. This style lasted longer at Sèvres than at other factories, and eventually became nothing more than a mannerism.

Marks. From 1745 to 1753 there were no marks. From 1753 two intertwined Ls turned towards each other were used; pieces intended for the king sometimes had lilies drawn above the letters. From 1753 a letter indicating the year was placed between the two Ls — A for 1753, B for 1754, and so on; once the alphabet had been used up, the letters (from 1777) were doubled — AA for 1778, etc. From 1793 to 1800 no year is given, the mark for this period being RF Sèvres (RF = République Française), and also the intertwined initials R.F. Hard-paste porcelain dating from 1769-93 usually had the king's crown above the two Ls. In the 19th century the marks were generally impressed writing, such as 'M. N le Sèvres', 'M. Imp le de Sèvres' and 'Manufacture Impériale Sèvres'.

Italy. *Venice.* Hard-paste porcelain was made in Italy by J.C. Hunger, who came to Venice for a short time in 1720 from Vienna.

He was made manager of the factory which was founded by the brothers Vezzi, who were wealthy goldsmiths. Production ceased after the death of Francesco Vezzi in 1740.

Fourteen years later, Geminiano Cozzi founded a new factory which manufactured soft-paste porcelain. It was financially succesful and continued working until 1812.

In the Vezzi factory, tableware was made from very good porcelain decorated with modelled or impressed ornamentation, pierced work and painting. The painting was in underglaze blue or in enamels on the glaze. Iron-red became popular later on. Figures were made as well as tableware. In the Cozzi factory the situation was much the same, although the Rococo style was already giving way to Neo-Classicism and Neo-Classical motifs gradually superseded *chinoiserie*.

Marks. Vezzi porcelain was not marked from 1720 to 1725. From 1725 to 1740 it carried a V or VENEZIA in red or blue. Cozzi porcelain has an anchor in red, blue or gold. The letter C may also have been used.

Ginori-Doccia. The factory was built in 1735 by Marquis Carlo Ginori on his property at Doccia. In 1737 he engaged the chemist J. Karl Wendelin Anreiter (Carl Wandhelein), who brought some of his fellow-workers with him from Vienna. The Ginori family remained partners when the direction passed to the Richard company of Milan. Hard-paste porcelain was made in the Meissen and Viennese styles, but from Italian raw materials. At the beginning of the 19th century the Ginori family bought a lot of moulds from Capodimonte and felt themselves entitled to put the Capodimonte mark on the reproductions they made with them. Doccia ware passed through several stylistic phases, all from recognisable sources. Some subjects were taken directly from Chinese porcelain, others from the various European porcelain factories, but Ginori porcelain was given an individuality of its own by the new ornamental variations introduced. Tableware made between 1735 and 1765 in Rococo shapes was often not painted at all, or it was painted in underglaze blue and eventually also in various colours over the glaze. From 1765 shapes and decorations are in the Neo-Classical style, and from 1780 Pompeian and Etruscan motifs are used in the style of Capodimonte.

Marks. The mark most often used was a six-pointed star or a star with 8 or 12 points, usually in red. The mark in the form of a star of David was in gold. Reproductions in the style of Capodimonte have the mark N with a crown (see Capodimonte).

Capodimonte - Naples. This factory was founded in 1743 by King Charles III and housed in the palace at Capodimonte near Naples, where it remained until Charles became king of Spain in 1759. He then moved the most capable workers and all the models and moulds to Madrid, where he created a new factory at Buen Retiro. In 1771 Ferdinand IV started the Capodimonte factory up again. At first it was housed in the Villa Reale in Portici, but two years later it was moved back to Naples. Hard-paste porcelain and biscuit were then made for the first time in addition to soft-paste porcelain. This factory was closed in 1821. Tableware and figures were manufactured in both kinds of porcelain. The rich relief decoration with figures as motifs is regarded as typical of the tableware of Capodimonte, although it was not the only kind of decoration used there. All sorts of different pieces were made, at first in the Rococo and later in the Neo-Classical style. Unfortunately there are very few of these pieces left, and many vessels with relief decoration in the form of figures are forgeries.

Marks. For Capodimonte the mark used was the fleur-de-lis, impressed or in blue underglaze (also used at Buen Retiro with a double C). Later an N was used, generally below the crown in blue underglaze and in a few exceptional cases also in red. For Portici the marks were RF or FRF. Figures from Capodimonte bear no mark.

Apart from the factories mentioned there were other Italian porcelain factories at Nove (1761/2-1855) and Vinovo (1776-1820).

England. *Bow.* The Bow factory was probably founded in about 1745 by Edward Heylyn and Thomas Frye, and by the end of the first ten years was making large quantities of china. Frye worked as manager until 1759. Three years after that, Weatherby, one of his partners, died, and in 1763 the last of the three owners, Crowther, who was in a difficult financial situation, sold the factory to William Duesbury from Derby. In 1755 Duesbury moved it from Bow to Derby, where he made china to which he added bone ash. It is diffi-

cult to identify the products made before 1750, which were poor quality pieces. The shapes of Bow wares made between 1750 and 1760 show the great influence of Meissen and Chinese porcelain. The Meissen shapes were also imitated in figures which, in spite of their unfinished appearance, have a certain grace. In about 1760 high, four-legged bases for figures with Rococo relief decoration in shades of carmine red came into fashion, and they make it easier to identify Bow work. In painting, a wonderful harmony was achieved with 'German flowers' combined with the Kakiemon pattern and Chinese flower motifs. Later on the work was merely imitative, although the occasional use of vived colours was a positive contribution.

Marks. At first the marks were indeterminate. From about 1760-65 pieces were marked with an anchor and a dagger in red. The craftsman's own sign was often placed below the factory mark.

Chelsea. This factory probably existed as early as 1745, and in about 1759 the name N. Sprimont from Liège is associated with its management. The owner was Everard Fawkener, and after his death Sprimont took over the factory, selling it in 1769 to James Cox, who a year afterwards sold it to W. Duesbury and J. Heath from Derby. Soft-paste porcelain was made at first, then hard-paste and in the final years porcelain mixed with bone ash (bone china). The products were very varied, as were the sources of inspiration on which the craftsmen drew. They borrowed from the Orient the shapes and decoration of the Kakiemon and Imari styles; they copied the shapes, painted decoration and figures made at Meissen; and from Sèvres they took tableware shapes decorated with ground colours of blue, turquoise, pea-green or sea-green, red, yellow and carmine, with popular paintings after Boucher and Watteau in the blank panels.

Marks. The mark used was an oval medallion with an anchor in low relief. Later on the anchor was painted in red or reddish-brown, and less often in blue or gold.

Worcester. In 1751 the Worcester manufactory was formed with Dr John Wall at its head. In 1783 the firm was bought by Thomas Flight and his sons Joseph and John. In 1793 Martin Barr became a partner, and later on so did his son. When the last of the Flights died, the factory was left entirely in the

hands of the Barrs. Robert Chamberlain, who had worked at the factory since it was founded in 1751, left in 1783; he and his son founded their own factory and soon became competitors of the Flights. Both factories produced the same type of goods. In 1840 they combined to form the Worcester Royal Porcelain Company.

Wall and his partners were aware of the faults in the china made in other English factories, and realised that this was why people preferred Chinese goods. They therefore tried to make a harder body, and at the same time to imitate Chinese porcelain in shape and decoration so that their products could stand up against imported ones — in which they were successful. For a long time they produced little besides tableware. After 1768, when painters from Chelsea came to work in the factory, larger, more ornate decorative pieces were also made. The decoration often took the form of impressed reliefs, and the painting imitated Chinese porcelain very closely and successfully. The painters from Chelsea had a great deal of experience in painting ground colours, which they successfully combined with coloured motifs in the blank panels. From 1757 black, blue, purple and red moulded decoration appeared. At the end of the 18th century, Neo-Classical figures from drawings by Angelica Kauffmann, Cosway and Bartolozzi were used to decorate tableware. In the first quarter of the 19th century — as in Vienna — the whole surface of the vessels was covered with excellent painting.

Marks. At the Wall factory the mark used before 1783 was a written W or a half-moon or a fretted square, a stylisation of the Chinese sign, generally in underglaze blue. At this time imitations of Chinese marks, the Meissen swords and the Sèvres L were also used. After 1783 the half-moon was again sometimes used, accompanied by the name 'Flight'. From 1792 to 1807 'Flight and Barr' with a crown impressed or in underglaze blue and also in red over the glaze was used. The Chamberlain factory used 'Chamberlain's' and 'Chamberlain's Worcester', at first written and later impressed.

Derby. Founded in the early 1750s by W. Duesbury, the factory was already a flourishing concern by 1756 with financial support from J. Heath. In 1770 Duesbury bought the Chelsea factory, which continued in operation until 1784 when it was closed

down. A similar fate overtook Bow which Duesbury bought in 1776 and closed down immediately, removing the moulds to Derby. After Duesbury's death in 1796 the firm remained in the hands of the family until 1811, at which time it was being run by Michael Kean, who had married Duesbury's widow. Kean sold it to Robert Bloor in 1811 and in 1848 it was closed down. Comparatively little is known about the factory before 1770. Small figures were made as well as tableware and other useful pieces. After the Chelsea factory had been taken over, the range of products made at Chelsea under Sprimont was also made in Derby. Japanese Imari motifs were used a great deal, and from 1786 to 1795 the flower painting and other decorative motifs were of high quality. Biscuit figures and fine portrait medallions were also made.

Marks. Until 1782 the well-known D below the crown appeared. During the Chelsea-Derby period an anchor with the D was used. After 1782 crossed batons and six dots with the crown and the D were used. From 1811 'Bloor, Derby' appeared, usually impressed. Forged Meissen and Sèvres marks also appear in underglaze blue.

Denmark. After much fruitless effort the secret of hard-paste porcelain was discovered in Copenhagen in 1773. The factory came under state ownership in 1779, and from that time artistic standards rose. Painters and workers came from Meissen, and A.K. Luplau of Fürstenberg was employed as a modeller.

Although the influence of Meissen was evident, as one might expect, the predominant influence was French. Glazed and biscuit figures were made in large quantities, copied from Falconet, Boucher and Acier, and also large, decorative vases, clock cases, mirror frames and tableware. Flower motifs, garlands, wreaths and medallions with heads *en grisaille* were painted on the pieces. Particularly popular was the blue decoration known as the 'immortelle' pattern, which had been designed in Meissen in 1740. Copenhagen is one of the few factories which achieved a high artistic standard after 1800. Towards the end of the 19th century, under the direction of Arnold Emil Krog, Copenhagen ware was made in an 'Eastern' style to profit from interest in Oriental art.

Marks. Three wavy blue lines were used.

Russia. *St Petersburg*. The factory at St Petersburg was founded in 1744 by the Empress Elizabeth, who brought J.C. Hunger to St Petersburg from Sweden. Hunger had already helped to found the factories in Vienna and Venice, but he was unsuccessful in Russia and was dismissed in 1748. Dimitri Vinogradov then managed the factory from 1748 to 1751, when very good porcelain was made. He was succeeded by the director of the Russian Mint, Schlatter, and later by J.C. Müller, who came from Saxony.

Until about 1760 only small pieces, mainly in the style of Meissen, were made. In the reign of Catherine the Great (1762-96) many changes were made in personnel and Catherine imported foreign modellers who improved artistic standards. The current admiration for French culture also found expression, and the influence of Sèvres can be seen in the shapes and fine decoration of the splendid tableware. François Dominique Rachette made porcelain figures in St Petersburg from c.1780 and fully developed the Neo-Classical style. Russian traditions were still evident here and there during Catherine's reign, but they vanished entirely during the reign of Paul I (1796-1801) and the pieces assumed a marked French character. Artistic standards declined briefly, then flowered again under Alexander I (1801-25). By the third quarter of the 19th century, St Petersburg porcelain had ceased to be of any artistic value.

Marks. The initials of the current ruler appear in Cyrillic lettering.

Gardner-Verbilki. The private porcelain factory of the Englishman Francis Gardner, founded in Verbilki, near Moscow, in 1754, rivalled the Imperial factory in the quality of its products. In 1780 it moved to Tver, and in 1891 passed into the ownership of F.S. Kusnezov. The factory made a large number of pieces, mostly tableware, and also worked for the court. The pieces were painted chiefly in greyish-green or apple-green, sometimes combined with red and sometimes with bright yellow.

Marks. The name 'GARDNER' appears in Roman or Cyrillic letters (ГАРДНЕР) or sometimes only the initials 'G' or 'Г'. In the 19th century St George on horseback with the Russian Imperial eagle impressed above is also used. Products of older date are often not marked.

Of the other Russian porcelain factories, those worthy of mention are Korzes in Volhynia (founded in 1780), where Merault, a painter from Sèvres, worked; and the Popov factory founded in Gorbunov, near Moscow, in 1801.

The 19th century. Pieces made in the 19th century are generally not worth collecting, as the artistic standard of porcelain declined. Some porcelain factories founded in the late 18th and early 19th century were fairly successful because they had no traditions behind them and had to rely on their own discoveries in line with contemporary taste.

At this time a number of porcelain factories in Bohemia became well known for their good products. Workers from Thuringia were employed in some of them. The factories in Slavkov (founded in 1791) and Březová (founded in 1803) were particularly well known in the second quarter of the 19th century for their fine porcelain painting. Loket (founded in 1815), Klášterec (founded in 1793) and Stará Role (founded in 1813) were famous for their tableware fashioned in the style of the second Rococo period, and Prague ware (from 1837) became known for porcelain sculpture. But in the second half of the 19th century Bohemian porcelain also suffered of banal pieces of a utilitarian character.

Theoretical and practical experiments aimed at raising the level of craftsmanship in Europe led at the turn of the century to a study of Japanese and Chinese ceramic wares, and to experiments in new manufacturing techniques. It was largely due to the progressive tendencies of the Art Nouveau style that these techniques were applied, and this is particularly true of the porcelain factories in Sèvres, Berlin and Copenhagen. The designs of the theoretician and architect Henri van de Velde greatly influenced the non-traditional kind of porcelain modelling. New shapes were produced, some simple, some almost bizarre, and new ways of decorating them were sought. Arnold Emil Krog, the artistic director of the Copenhagen porcelain factory, introduced underglaze painting in soft blue, grey, green and pink, and renewed the reputation of Copenhagen porcelain.

Advice to Collectors

Imitations. In the 19th and 20th centuries the eager demand for their work forced many porcelain factories to produce new versions of old 18th-century shapes. These factories had no intention of misleading the public or of marketing these imitations as if they were old pieces, and they can easily be recognised by their marks.

Intentional forgeries produced outside the original factory are much more difficult to spot. Forgeries of Sèvres pieces are the most frequently found, and particular attention should be paid to them. There are cases where hard-paste porcelain pieces bear a mark from the soft-paste period, etc. Owing to shortage of space it is not possible to deal at length with all the aspects of forgery. It should, however, be emphasised once again that the porcelain paste, the mark and the kind of decoration should all be closely studied and must correspond to one another. But years of experience are needed to do this — experience which can only be gained in close contact with the material: books can only impart a limited ability to recognise forgeries. The products most often forged were those most highly prized on the antique market — that is, porcelain from Sèvres and Meissen, and also pieces from Nymphenburg, Fürstenberg, Höchst, Ludwigsburg, St-Cloud, Chantilly, Capodimonte and Chelsea.

Preservation and restoration of porcelain pieces. It is advisable to move the pieces as little as possible, and they should therefore be kept behind glass, which protects them from dust and damage without spoiling their aesthetic effect. If, despite the care taken, a piece is damaged, a qualified restorer should be found to repair it. Some experience is needed in sticking porcelain together, particularly if it is tableware, as the fragments tend to shift about when being stuck. If it is not possible to entrust the repairs to an expert, a quickly drying and easily soluble adhesive must be used, which can be removed easily and without trace from the area of the break should the fragments be stuck together badly.

230

230 Flask in Böttger stoneware with incised decoration. Meissen, 1710-20
231 Vase with modelled sprig decoration, Böttger porcelain. Meissen, 1713-20
232 Vase with painted 'India flowers' Meissen, *c.* 1725

231

232

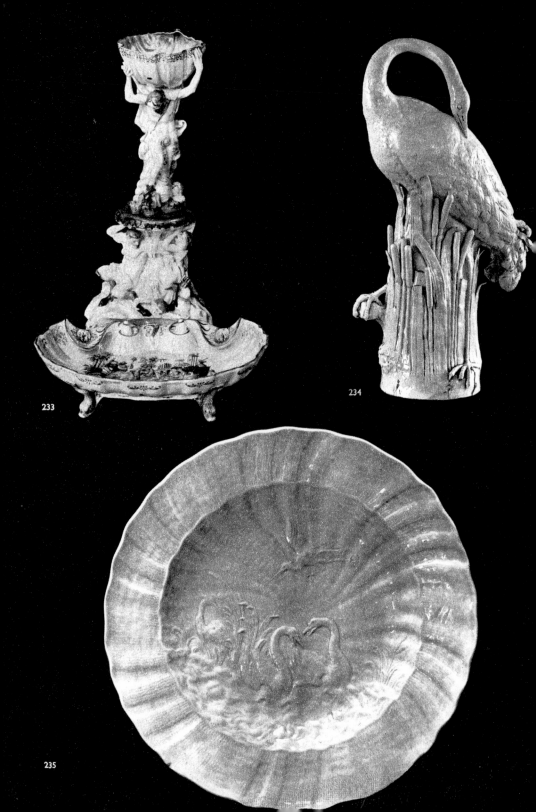

233

234

235

233 Table fountain with figure of Neptune. Model by J. G. Kirchner, Meissen, 1736
234 Crane in white porcelain. Model by J. J. Kändler, Meissen, 1736
235 Plate from the Swan Service. After the model by J. J. Kändler, Meissen, 1737-41
236 Mercury and Venus: figures with polychrome decoration. Model by J.F. Eberlein, Meissen, 1741
237 Figures from the series 'Cris de Paris'. After the model by M. V. Acier, Meissen, 1765-70

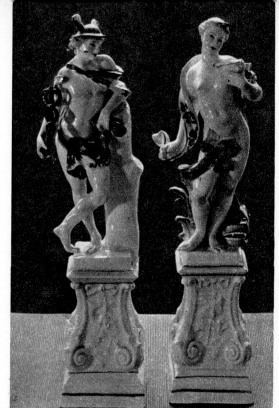

236

237

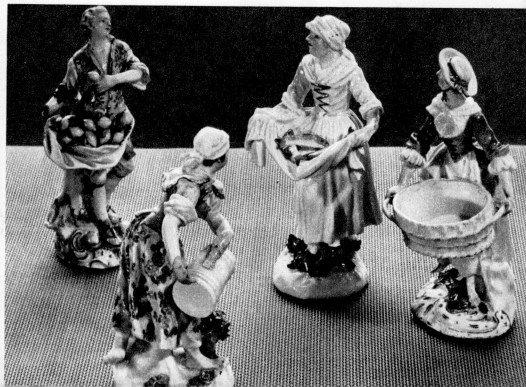

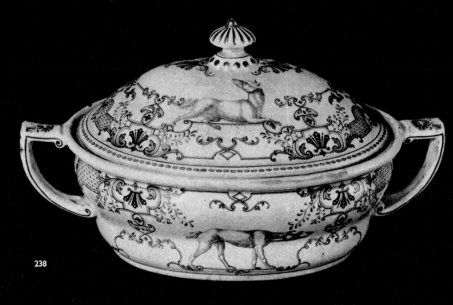

238

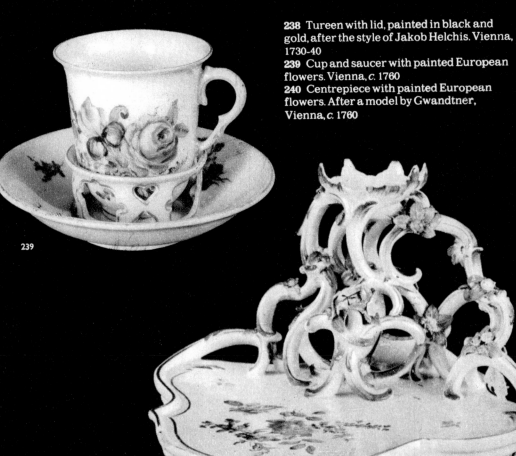

239

240

238 Tureen with lid, painted in black and gold, after the style of Jakob Helchis. Vienna, 1730-40
239 Cup and saucer with painted European flowers. Vienna, c. 1760
240 Centrepiece with painted European flowers. After a model by Gwandtner, Vienna, c. 1760

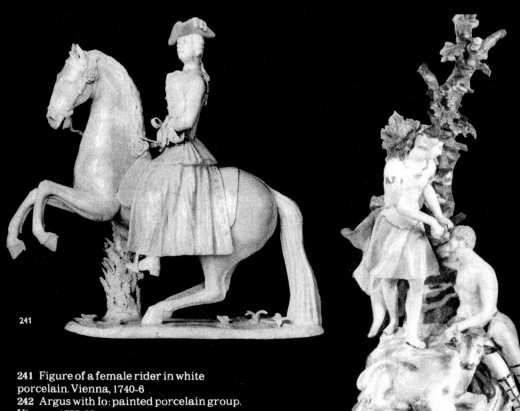

241

242

241 Figure of a female rider in white porcelain. Vienna, 1740-6
242 Argus with Io: painted porcelain group. Vienna, 1750-60
243 Covered bowl with green mosaic decoration and polychrome flowers. Vienna, *c.* 1780

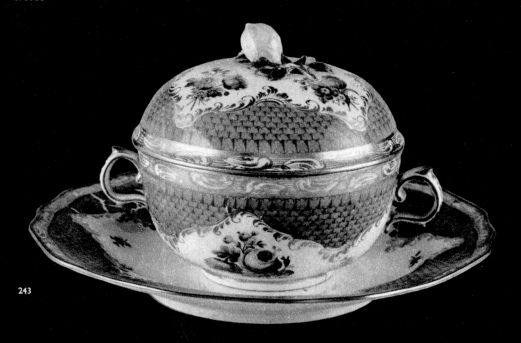

243

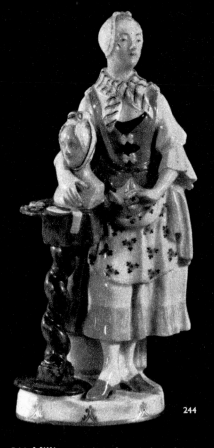

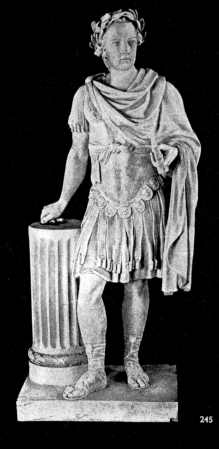

244

245

244 Milliner: painted porcelain figure.
Model by D. Pollion, Vienna, *c.* 1760
245 The Emperor Joseph II: biscuit figure.
After Heinrich Függer, porcelain model by
A. Grassi, Vienna, 1789

246 Cooler with biscuit medallions and
painted flowers. Vienna, *c.* 1780

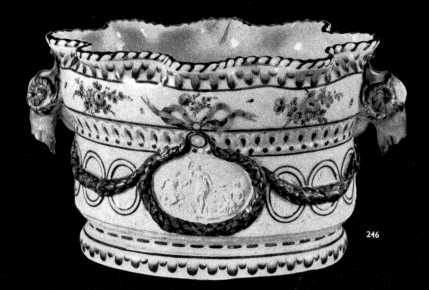

246

247

247 Plate with painting after Rubens.
Vienna, after 1811
248 Teapot, cup and saucer with
chinoiseries. Painted in black and gold by
I. Preissler, Kunštát in Bohemia, *c.* 1730

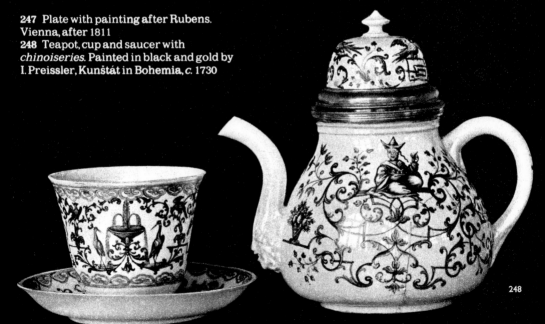

248

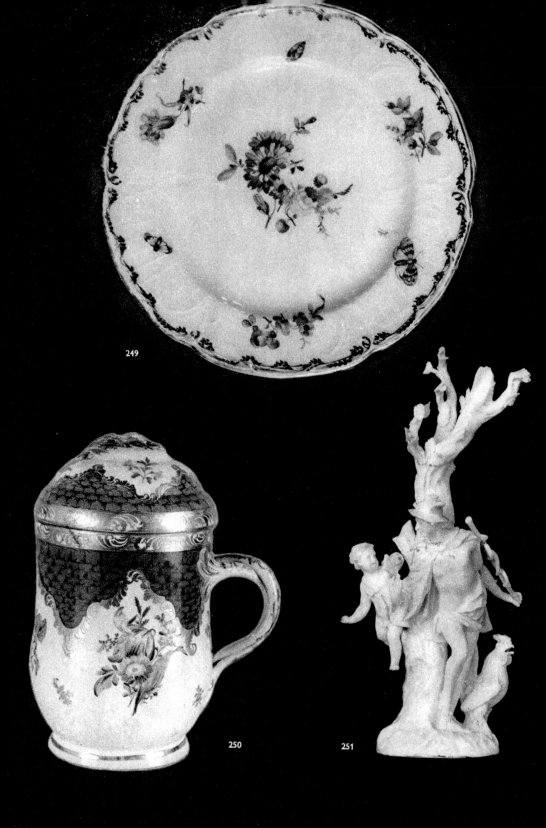

249

250 251

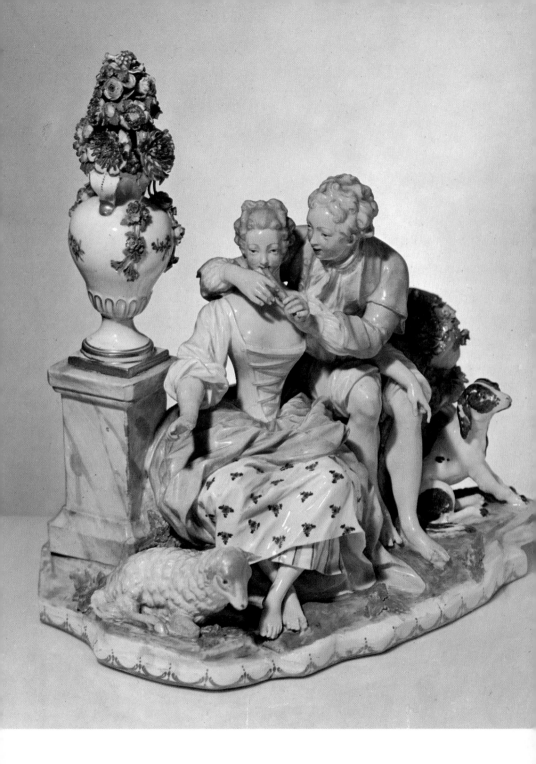

XXXIX Pastoral scene: painted porcelain group. Model by Dionys Pollion, Vienna, *c.* 1760

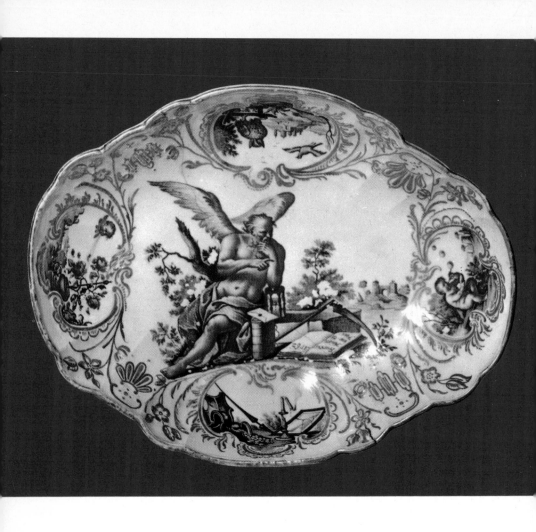

XL Dish with painted figure of Chronos. F. F. Mayer, Přísečnice in Bohemia, 1769

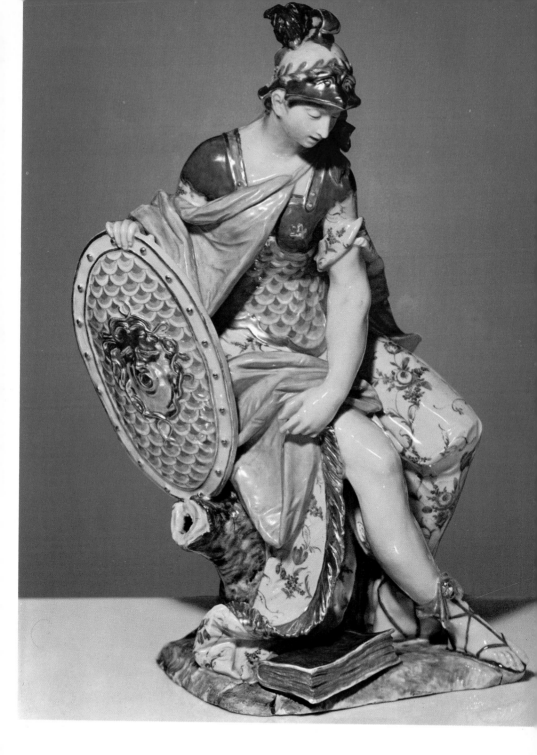

XLI Minerva: painted porcelain figure. Model by D. Auliček, Nymphenburg, 1763-7

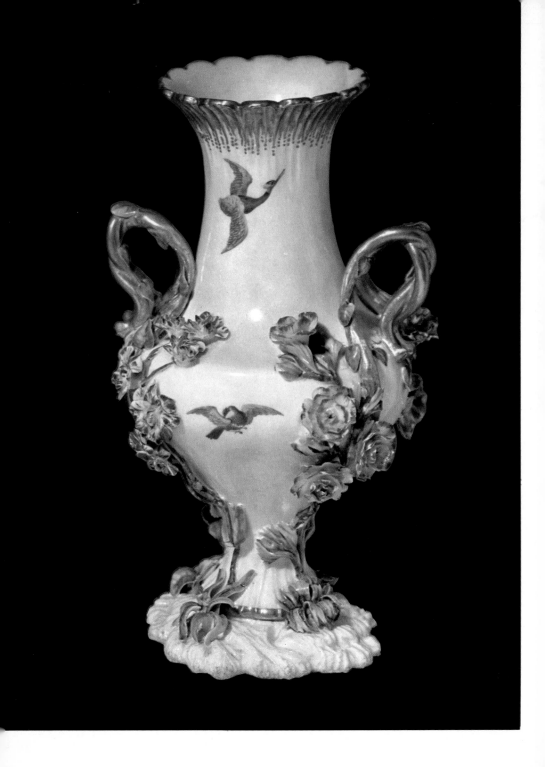

XLII Vase in soft-paste porcelain with painted flowers. Vincennes, *c.* 1750

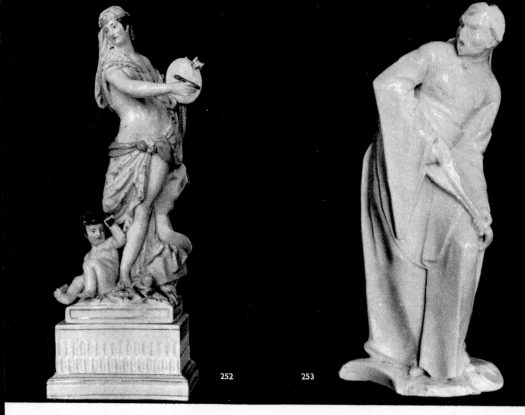

252

253

249 Plate with relief decoration and painted flowers. Gotzkowsky factory, Berlin, 1765-70
250 Tankard with purple mosaic decoration and polychrome flowers. Wegely factory, Berlin c. 1755
251 Mercury with Cupid: white porcelain group. Model by F. E. Meyer, Berlin, 1761-3

252 Allegory of Sculpture from the series of allegories belonging to the breakfast service made for Catherine II. W. C. Meyer, Berlin, 1770-2
253 Chinaman with lute: figure in white-glazed porcelain. Model by F. A. Bustelli, Nymphenburg, 1755-60
254 Wild boar fighting with dogs: clay model for a porcelain group. D. Auliček, Nymphenburg, c. 1765

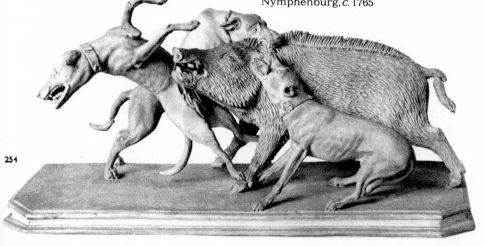

254

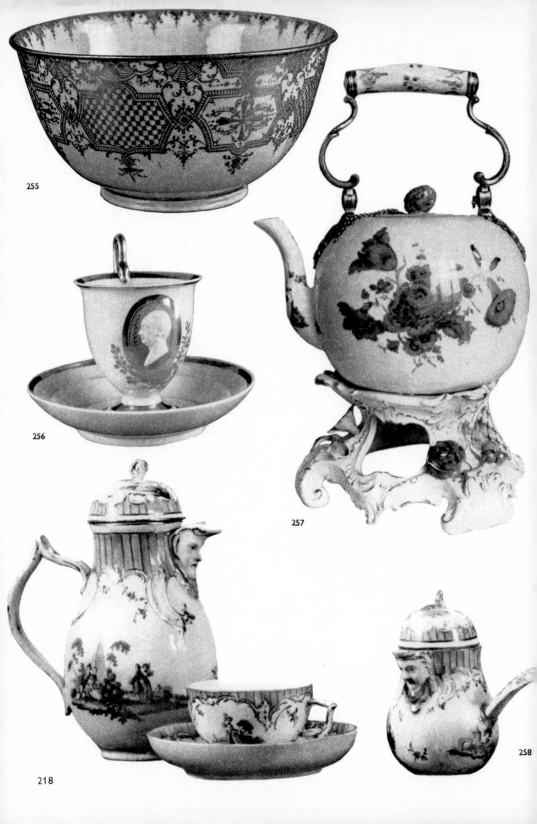

255

256

257

218

258

259

255 Bowl with gold decoration, Fürstenberg, c. 1760
256 Cup and saucer with biscuit portrait of King Joseph I of Bavaria. Adam Clair, after a model by J. P. Melchior, Nymphenburg, c. 1810
257 Teapot with stand. Decorated with modelled flowers and green painting. Fürstenberg. c. 1760-5

258 Part of a coffee service with relief decoration and painted pastoral scenes. Fürstenberg, c. 1760-5
259 Painted porcelain plate. Fürstenberg, c. 1770
260 Dish with lid and plate with 'Osier' decoration and violet landscape painting. Höchst, c. 1760

260

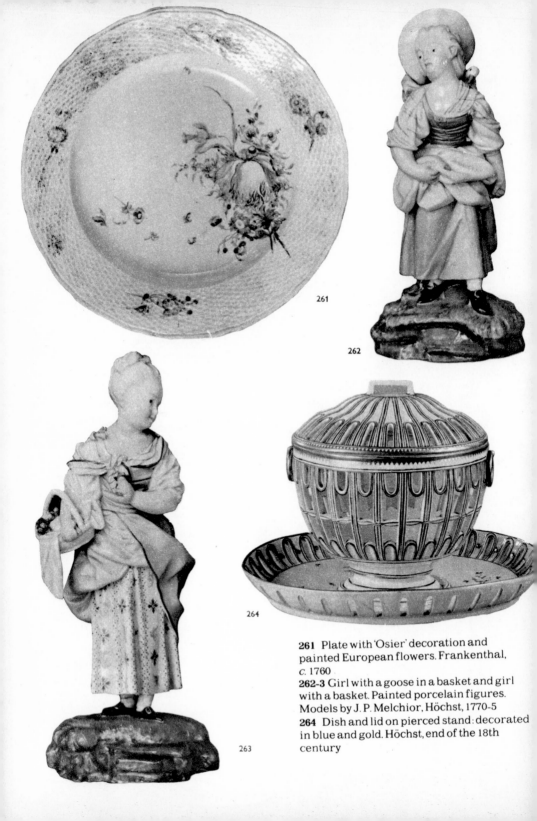

261 Plate with 'Osier' decoration and painted European flowers. Frankenthal, c. 1760.

262-3 Girl with a goose in a basket and girl with a basket. Painted porcelain figures. Models by J. P. Melchior, Höchst, 1770-5

264 Dish and lid on pierced stand: decorated in blue and gold. Höchst, end of the 18th century

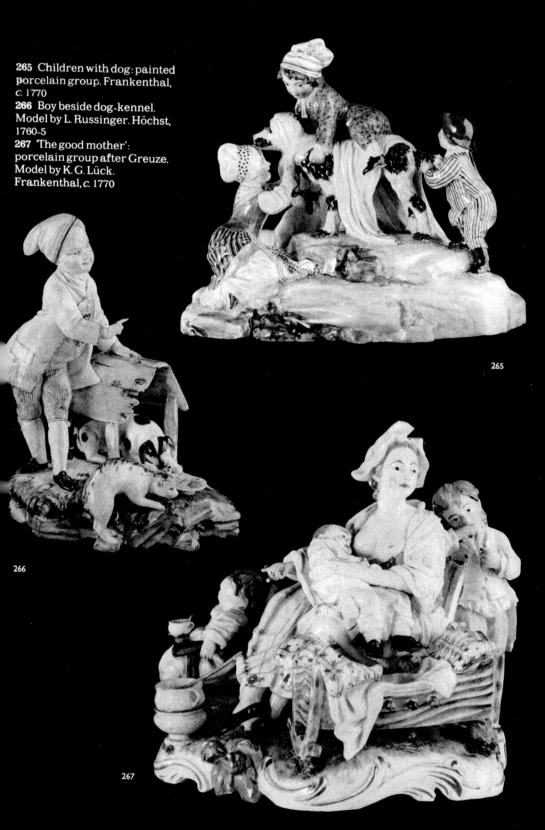

265 Children with dog: painted porcelain group. Frankenthal, *c.* 1770
266 Boy beside dog-kennel. Model by L. Russinger. Höchst, 1760-5
267 'The good mother': porcelain group after Greuze. Model by K. G. Lück. Frankenthal, *c.* 1770

265

266

267

268 Tureen with 'Osier' decoration and
painted landscape. Ludwigsburg, 1760-70
269 The Horn of Plenty: painted porcelain
figure after the model by J.C. Beyer.
Ludwigsburg, 1762-7
270 Solitaire with painted birds.
Ludwigsburg, 1770-80

269

270

268

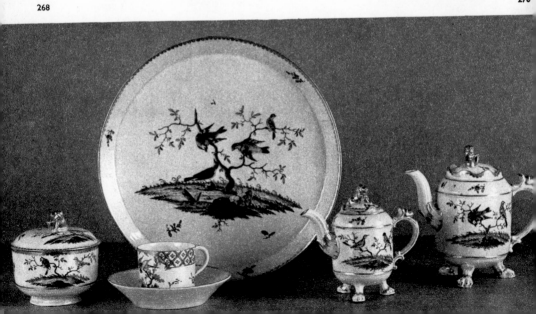

271 272

271 Allegory of Winter: painted porcelain
group. Ludwigsburg, c. 1775
272 'A rest on cut hay': painted porcelain
group. Ludwigsburg, c. 1780
273 Vase in soft-paste porcelain with blue
decoration. St-Cloud, beginning of the 18th
century
274 Covered pot of soft-paste porcelain
with blue decoration. Probably Rouen,
beginning of the 18th century

273

274

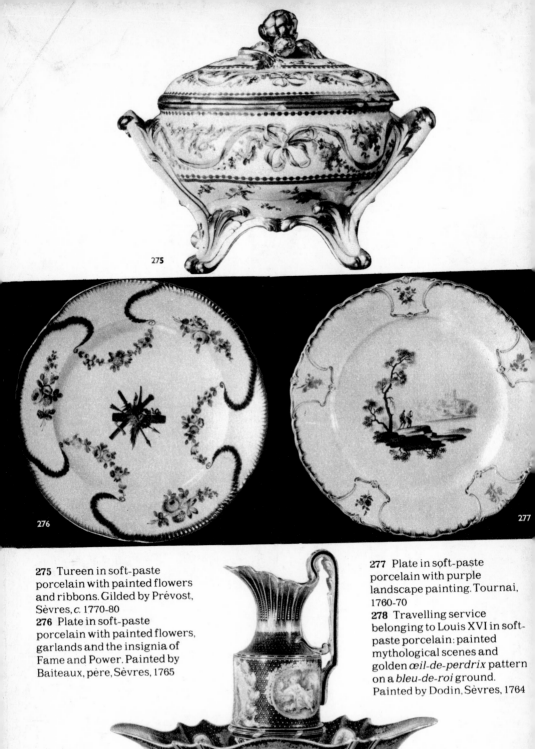

275 Tureen in soft-paste porcelain with painted flowers and ribbons. Gilded by Prévost, Sèvres, c. 1770-80

276 Plate in soft-paste porcelain with painted flowers, garlands and the insignia of Fame and Power. Painted by Baiteaux, père, Sèvres, 1765

277 Plate in soft-paste porcelain with purple landscape painting. Tournai, 1760-70

278 Travelling service belonging to Louis XVI in soft-paste porcelain: painted mythological scenes and golden *œil-de-perdrix* pattern on a *bleu-de-roi* ground. Painted by Dodin, Sèvres, 1764

279

279 Cup and saucer in soft-paste porcelain: painted birds in panels on a bleu-de-roi ground. Sèvres, 1765
280 Plate in soft-paste porcelain, painted in the Kakiemon style. Chantilly, third quarter of the 18th century
281 Cup and saucer with relief sprigs. White porcelain. Capodimonte, 1740-1750
282 Bust of the Dauphin in white biscuit. Sèvres, 1793

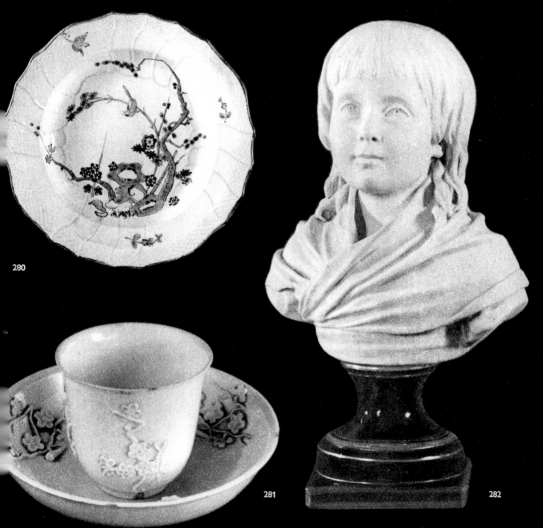

280

281

282

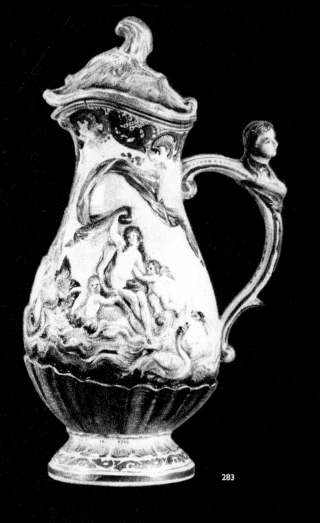

283

283 Jug in soft-paste porcelain with painted relief figures. Capodimonte, 1750-9

284 Plate with painted Watteau scenes in relief cartouches. Chelsea, 1750-60

285 Plate in the Imari style. Worcester, Wall period, c. 1770

286 Psyche: white biscuit figure. Copenhagen, first quarter of the 18th century

287 Vase and cover with dark blue ground and exotic birds painted in panels. Worcester, c. 1770-5

288 Tea-warmer with painted landscape. Pirkenhammer (Březová) c. 1830

289 Tureen with painted flowers. St. Petersburg, end of the 18th century

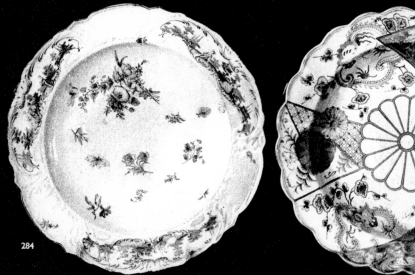

284

285

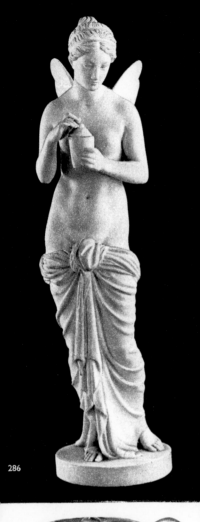

286

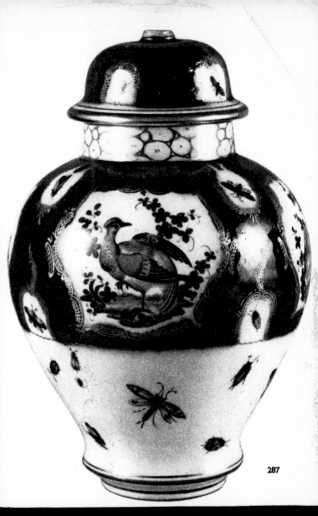

287

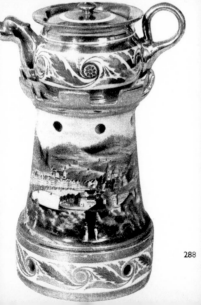

288

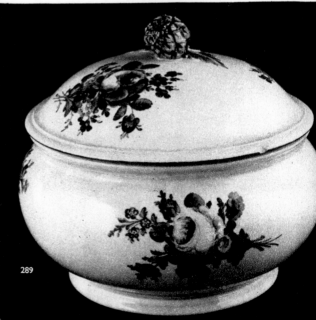

289

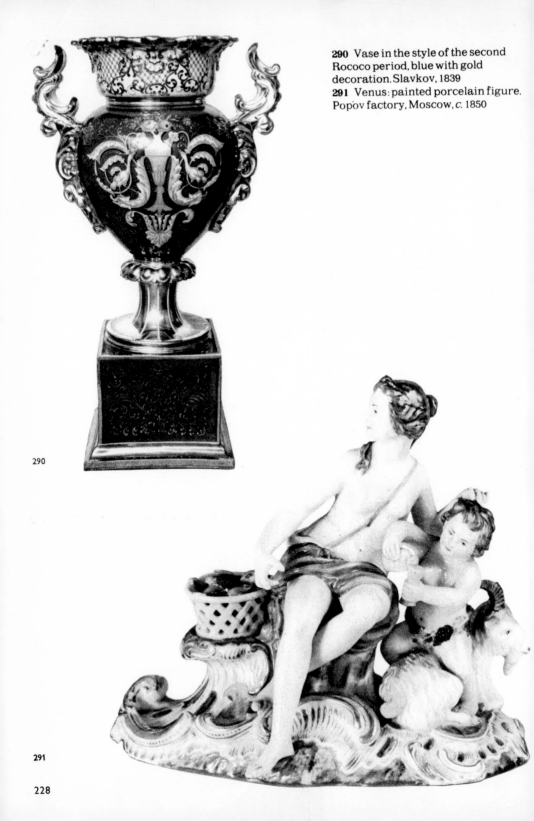

290 Vase in the style of the second
Rococo period, blue with gold
decoration. Slavkov, 1839
291 Venus: painted porcelain figure.
Popov factory, Moscow, c. 1850

290

291

MIRRORS

Unlike a glass, a mirror is mainly a luxury article, and for this reason the history of these related objects differed somewhat. The origin of the mirror is undoubtedly more recent, and its development has been subject to interruptions because it was only possible during periods of prosperity and artistic refinement. In addition the mirror — wherever higher artistic standards were involved — was connected with other types of skilled handicrafts, such as wood-carving, goldsmithing, enamelling techniques and carpentry. From Renaissance times the mirror was even more important as one of the most eye-catching features of an interior; it epitomises the cultivation and sense of style of a refined society, and immediately reveals the defective taste of a vulgar or pretentious society.

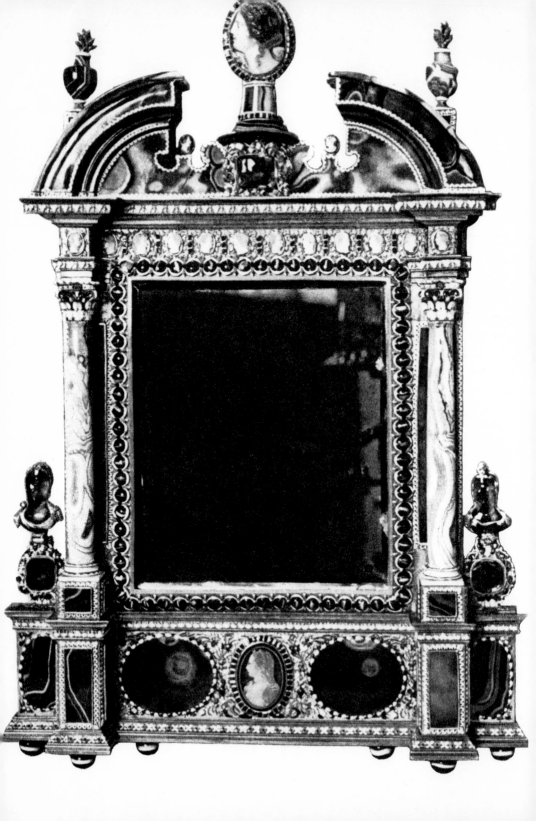

Manufacture

Before the discovery of blown and crystal glass, man experimented with stone and metal, with obsidian, pyrites, gold and silver, with bronze, steel, rock crystal and glass; he tried to grind and polish these materials to a surface so smooth that it would produce a clear reflection.

By the end of the 16th century mirrors made of rare metals, steel and rock crystal (and simpler ones of tin and copper) had already disappeared, thanks to the Venetian discovery of blown and crystal glass. During the 17th and 18th centuries the blowing and casting of glass was practised widely. Holland and Germany were among the first producers of crystal glass: once glass-blowing had been developed in Venice, glasshouses were rapidly established in Germany. In Italy the glass was blown into long bubbles which were slit along one side, laid on a copper plate, polished and silvered. The French method was to spread the molten glass as evenly as possible over a completely smooth bed of metal, then roll it in order to achieve maximum trueness, and finally to let it cool slowly. The glass was then ground and polished with emery. Silvering was effected by placing a sheet of tinfoil on a smooth table, a thin layer of mercury on top and the plate of glass on top of both. The blown glass was not quite white but more translucent and of superior quality.

In the 19th century the development of the mirror was given an unexpected impetus: the Frenchman François Petit-Jean discovered the mirroring of glass with silver instead of copper, and so achieved a clearer image.

Further information about the manufacture of mirrors can be found among the details about the various materials used, in the appropriate chapters of this book.

Historical Survey

Once man had overcome the fear of his own image reflected from a sheet of water, he wanted to retain the illusion. Many thousands of years later he finally succeeded in solving the problem through the discovery of blown, crystal and moulded glass. His creative imagination now had unlimited opportunities to frame this image — and especially that of feminine beauty — in the most attractive way he could devise.

Antiquity

Finds from ancient graves and items from contemporary works of art prove that the round hand mirror was as popular in *Egypt*, where mirrors were manufactured as early as 3000 BC, as in *Greece*, where men knew how to polish mirrors in the 5th century BC, and in *Etruria*. In *China* ornamentation on the backs of bronze mirrors of the 6th century BC was restricted to decorative patterns around a central boss; but in Egypt, Greece and central Italy, robing and marriage scenes were engraved or carved in relief. The handle frequently consisted of a sculpted female or animal figure. The Pompeian frescoes bear witness to the popularity of hand mirrors in *Rome*, the centre of production being Brindisi.

Middle Ages and Renaissance

The fall of the Roman Empire, which had reached a high peak in the production of glass, and the painfully slow development of medieval culture to an equivalent level, adversely affected the manufacture of mirrors. It is very hard to determine exactly how this craft developed, since mirrors made from polished metal and rock crystal on a silver or lead base have only been preserved from the beginning of the 13th century.

In the 14th century court life in Europe became more sophisticated and feminine tastes and preoccupations played and increasingly important part. The patronage of the king of France and his court was responsible for the appearance of masterpieces among the costly trivialities of the time. Women regarded the mirror as an indispensable bibelot, and French ivory carvers produced enchanting miniatures with charming scenes and vows of love on the backs of luxurious mirrors and their cases. There was a superabundance of shapes and materials: mirrors were round, square, rectangular, made from gold, silver, steel, tin and rock crystal; there were pocket mirrors, hanging mirrors, small and large toilet mirrors. And since superstition was by no means dead, we even find, in the 17th century, magic mirrors, distorting mirrors, elliptical, cylindrical, pyramid-shaped and burning mirrors which — as in the Middle Ages — were also used by contemporary magicians.

In the 16th century *Italy* led the field in artistic development. Man became the subject of his own creative efforts and the most important object of artistic activity. The outside world, the beauty of the human body, were portrayed in the most varied gestures, movements and shapes. The senses blossomed with the intellect, and man became hungry for knowledge. Now too began a time of discovery and invention, an expansion of scientific investigation. The mirror grew in popularity thanks to a discovery by the brothers Andrea and Domenico of Murano (already famous in the 15th century for the manufacture of luxury glass). According to records, they produced a perfect mirror of crystal glass in about 1516. Improved technique allowed more attention to be paid to the mirror frame, and interest began to be shown in the aesthetic as well as the purely functional side. The first mirror frames — like those around pictures — were very simple, with hand-finished edges, made of poplar, walnut and chestnut in Italy and from soft wood in northern Europe, where — as can be seen from picture frames which have been preserved — the shape of Gothic windows with pinnacles and gabled hood-mouldings was adopted, a type which became more complicated in the later Middle Ages. The Italian feeling for architecture, which was evident not only in buildings but also in furniture construction, manifested itself in architectural frames which were flanked by pilasters, half-columns and columns. On the cornice which they supported was a three-

cornered or segmental Classical, broken-arch or decorated pediment; in the niches were allegorical, mythological or simply decorative figures; and the empty spaces were covered with finely carved tendrils, shells, beading, egg-and-dart ornament, clusters of fruit and figures, finely chased acanthus leaves and bronze decoration. Octagonal mirrors were of a special type. They had either a broad, bronze frame decorated with small marble plaques or a frame made of *verre églomisé* with coral, white enamel, gilt bronze, or lapis lazuli. The simple basic shape was enriched with sculptured tendrils, shapes attached to the frame, cartouches and mascerons. Since the mirror was a very costly item, its principal collectors were kings (Charles V, Henry VIII, Francis I) and the aristocracy. Among the most famous and beautiful was a mirror belonging to Marie de Médicis, it was shaped like a portal of agate, sardonyx, emerald and gold enamel. There were also frames of stained and gilded wood, some in various colours, others with gold embossing and bone inlays.

One of the most famous collectors of this time was Francis I of *France*, and France boasted several prominent goldsmiths: Allard Plomyer, Jehan Crispin, Loys Poucher. Their specialities were small mirrors in painted Limoges enamel cases. The famous designer of French palaces, Jacques Androuet Ducerceau, and Étienne Delaune, known as Stephanus, produced sketches which clearly exhibit the elegant taste of the French court. Along the edges of the frames or on the silver-inlaid backs of the mirror were attenuated female figures with small heads. In *Germany* the principal designers of mirror frames were goldsmiths from Nuremberg, Augsburg, Munich and Ulm, and ivory carvers, especially those from Munich.

Baroque and Rococo

At the beginning of the 17th century new discoveries resulted in the manufacture of larger sheets of glass, and the mirror ceased to be merely a small accessory. It became an integral part of interior decoration and, as with furnishings, followed the changes in general decorative style. The glass factories of Murano remained the main suppliers of Europe until the end of the 17th century, but mirrors were being manufactured in Sax-

ony and Nuremberg too and the Duke of Buckingham imported Italian glassworkers because mirror production was so very lucrative. In France the first glass factory was built at Faubourg St Antoine in 1665, but as early as 1695 the French glass factories successfully combined to compete against Venice, taking advantage of Bernard Perrot's discovery of glass casting. During the 17th and 18th centuries cast and blown glass were both in use, and everywhere in Europe there were glass factories producing cast glass. Mirrors remained both objects of fashion and works of art, and as such commanded high prices. No longer subject to technical limitations, its makers inspired by new materials and enriched by national and regional specialities, the mirror frame allowed the craftsman to give free rein to his imagination. The result was an astonishing variety of wonderful creations over a period of three hundred years.

France. Here, royal power continued to influence artistic creation; and in the 17th century France supplanted Italy as the artistic centre of Europe. Even criteria of interior decoration were affected. In the 1630s we no longer find the architectural styling of the frames so typical of Italian design. An aristocratic love of ostentation became evident in luxuriant and magnificent decoration with bunches of fruit and flowers, garlands and carved figures, whose sculptured effect was heightened by the application of rich and heavy gilding on a red (and very occasionally yellow) bole foundation. Characteristic of this period were the 'Louis XIV frames', which quickly became popular: carved shells, flowers and foliage were massed in the corners — even in the middle when the frame was a large one — of the profiled borders. A new influence on the manufacture of mirror frames — as on the whole French furniture industry and its European neighbours — came from the work of André Charles Boulle, who devised an exquisite decorative process of interwoven strips, volutes and borders of copper, tin, ebony and tortoiseshell on gold, green, blue or red grounds. Every French architect and designer of this period created his own particular style of furniture: Jean Lepautre, Paul Androuet Ducerceau, F. de Poilly and, best known of all, Jean Bérain and Daniel Marot. Like everybody else in Europe, the French loved exotic imported woods and rich col-

ours. In France there were frames of silver and silver-gilt, of *verre églomisé* with gold arabesques on a red ground, of polished steel, walnut and ebonised pear, ebony and the royal cedar, and, from the end of the 17th century especially, of carved and gilded wood. Frames of exceptional beauty were constructed from flat glass facets, which also formed the cresting and were held together by gilded, undulating borders. Candle arms of chased silver were added to the mirror frames. Mirrors decorated the palaces of Versailles, Fontainebleau, Chambord, Marly and Trianon.

Among the attractions of the most imposing court in Europe were the mirror galleries and rooms, the walls of which were covered with large expanses of mirrored glass. These were made possible by the process of glass casting. The three hundred and six mirrors by Jules-Hardouin Mansart increased the feeling of space in the famous Galerie des Glaces at Versailles, and heightened the luminosity of the candles and chandeliers. It is not therefore surprising that other European monarchs began to imitate this room some decades later. Ballrooms, the walls of studies, salons for conversation and boudoirs in town and country were covered with mirrors. At the end of the 17th century, the severe, plain and massive frames with acanthus leaves and figures gave way to the gay, extravagant designs of Bérain and Marot, with branches, flowers, palmettes and curvilinear outlines, and mirror frames extended to include carved cresting. Paris replaced Versailles as the centre of high society, and in its smaller, more intimate rooms the mirror — like every other object of artistic interest — became more gay and graceful in appearance. During the Regency period (1715-23), sober ebony disappeared and ornamentation became more profuse. Whimsically curved garlands, undulating lines, branches and *amorini* became more spirited, and from the 1720s Rococo decorations appeared ever more frequently. The symmetrically formed frame gave way to a number of asymmetrical shapes. New materials were used: platinum, red, green and lemon gold, and also Strasbourg porcelain. Mirrors were fitted into wall coverings or places above and en suite with console tables. We find large, two-piece overmantel mirrors, and others built into small tables of various shapes — dressing-tables, writing-tables, shaving tables *(barbières)*, and the upper part of bookcases. Goldsmiths designed costly dressing-cases and *nécessaires* for fashionable beauties. France — and indeed the whole of Europe — went mad about Oriental lacquer or imitation painted *chinoiserie* which, with its light-heartedness, exotic charm and nostalgia for the East was very much in keeping with the spirit of the Rococo. All the architects and designers of note displayed some interest in mirrors, as is evident from the designs circulated in contemporary illustrated papers. Such were Robert de Cotte, Nicolas Pineau (both produced decorative mantelpieces with mirrors instead of pictures or reliefs), Jean Mariette, Gilles-Marie Oppenord, J.A. Meissonier, François Cuvilliés, Jacques-François Blondel and others.

Germany and Austria. At the end of the 16th century German craftsmen developed their own form of decoration, which was based on ribbon and auricular ornament. Both of these types of decoration, which originated in Holland (Jan Lutma was doubtless the creator of the auricular ornament, which was further developed in Germany by Unteutsch), spread from the north to the south of Germany. Johann Ulrich Stapf then created complicated designs for frames with rich foliage and *amorini.*

In the 17th and 18th century there was no unifying political and cultural force in Germany. North Germany and Holland had certain artistic links: craftsmen in the Rhineland went their own way; so did those of southern Germany. In both Germany and Austria the basic elements of the Baroque, which later led to Rococo, were being absorbed. The characteristics of the Baroque artist were dynamism and love of strong contrasts of light and shade and vivid colours. A typical feature of mirror frames was decoration with luxuriously sculptured and heavily gilded acanthus leaves, either on their own or with monumental figures. At the end of the 17th century Marot's style also made itself felt in Germany, being adopted by such craftsmen as Decker in Nuremberg. This style was characterised in Germany and Austria by constant movement of form and light: there were frames with continuously curved mouldings and cresting variegated with fretwork, cornices, vases, *amorini* and Rococo motifs; the mirrors were loaded with decoration and

with double, interpolated borders ornamented with small engraved mirrors. A material which proved suitable for mirrors was painted Meissen porcelain. In the second half of the 18th century the contemporary love of asymmetry resulted in the whole frame becoming a restless, weaving stream of light and shade. In Germany, and especially in Bavaria, mirror rooms became popular. About the middle of the century they were filled with gilded and carved wood panelling, alabaster plaques, coloured or dead-white luminescent stucco-work and paintings, all of which were reflected by the mirrored walls. The mirror rooms decorated with costly Chinese porcelain or Delft faience were also imitated in the residences of the German rulers, where Meissen porcelain was most in evidence. Nowhere else, neither in the royal palaces of Italy nor in the Spanish and Portuguese sacristies, was there such magnificence and splendour. In Germany many artists made use of or designed mirror frames: F.X. Habermann and C.A. Grossmann (mirror rooms); J.M. Hoppenhaupt (Frederick the Great's study in Berlin); François Cuvilliés (the Residenz, Munich); Franz Pfleger and Hans Georg Stöhr (La Favorite near Rastatt), and others.

The Low Countries. The Dutch demonstrated their independence even in the manufacture of crystal mirrors, developing their own individual ornamental style. The architect Vredeman de Vries created a band decoration interwoven with birds, animals, bunches of flowers and fruits, and with ribbons and draperies; and, together with Gerbrand van de Eeckhout, Jan Lutma designed the auricular ornament which was interspersed with shells and trophies of war. Particularly beautiful, though simple in style, were the Flemish frames with smooth oak borders. Typical of the Netherlands were the 'flame-border' frames, often with very wide projecting borders and obviously turned. (Many frames with these characteristics were, however, produced in Alpine areas too.) Frames of rosewood with tortoiseshell inlays, flowers and fruit intarsia decoration or marquetry work were very popular, and these were also adopted in Germany and England. One original shape was the Flemish sconce, that is, candle arms on mirrors with chased metal frames. At the end of the 17th century the French style found favour in the Netherlands: in 1685 Marot became architect to the Prince of Orange, and his stately designs influenced the manufacture of mirrors, including overmantel mirrors. As in France, the favourite frames in the Netherlands were made from Oriental lacquer or local imitations.

England. Until the second half of the 17th century, England was still dependent on other European countries as far as technical development and decoration were concerned. Venetian mirrors continued to be imported for quite a long time after the Duke of Buckingham brought Venetian glass-makers to England. England adopted the decorative styles of her neighbours: from Flanders simple frames of ebony, oak, olive and walnut; from the Netherlands decoration with intarsia and marquetry, as well as coloured woods carved with flowers and fruits; and from France frames in the Louis XIV style, made of silver-gilt decorated at the corners and at the centre of each side with sculptured motifs. However, by the second half of the 17th century England had given birth to an original artist in mirror design: Grinling Gibbons. Gibbons specialised in elaborately carved framed which combined flowers, draperies, fruits and trophies of arms, all naturalistically rendered. At the end of the 17th century, frames made of imported or imitation red or black lacquer were preferred in England, and by the beginning of the 18th century Marot's style had arrived. During this period there were simple but extremely elegant mirrors with fine, polished glass facets, and more ornate but no less distinctive mirrors with gently curved cresting on walnut or mahogany frames. English mirrors differed from their French counterparts, however, in that the carving was less carefully executed and the bronze-tinted 'oil-gilding' was applied to the oak carcase with virtually no primer. The craze for *chinoiserie* inspired Thomas Chippendale and his successors to produce an original style of decoration which combined the bizarre shapes of hanging plants with pagodas, waterfalls, flowers and Chinese figurines. Chippendale's elegant designs were imitated by many carvers, so that Chippendale-type frames still appear frequently at European auctions. As in France, English goldsmiths manufactured costly nécessaires of gold, agate and cornelian, of

outstanding quality and furnished with small mirrors. And in England, too, mirror rooms were introduced.

Spain and Portugal. Both of these countries freely admitted foreign styles and designers, but adapted outside stimuli in their own way. As a result, they produced works full of mysterious magnificence. Italian influence was evident in the shape of polygonal mirrors, but the frames, consisting of glass facets, were broader, and the painted flower decorations richer, so that the gilt-bronze frames of the 17th century almost disappeared under a mass of crystal flowers and pearls. This love of glittering splendour was also responsible for gilded wooden frames inset with small mirrors like their earlier Moorish counterparts. Political ties with the Low Countries were evidenced in simple ebony frames with profiled borders or tortoiseshell veneers. An individual Spanish creation was the frame overflowing with carved tendrils and banding in the Churrigueresque style. By the end of the 17th century, French influence could be seen in silvered and gilded frames. An original development in both Spain and Portugal was the mirror for use in sacristies and monastic chapels (cathedrals in Segovia, Avila, Granada, Salamanca and elsewhere). In both countries mirror rooms also existed, the most beautiful being in Queluz palace.

Italy. The shapes and decoration of Venetian glass, which dominated European production from the 15th to the end of the 17th century, were unusually rich and technically superb. Venetian ability in glass production was also evident in their mirrors. Architectural frames were in vogue until the end of the 17th century; then came oblong frames with a cresting and facets of engraved, mostly blue glass, covered with glass tendril ornamentation. In the 18th century there were richly carved frames with bunches of acanthus leaves on the top, decorated with finely carved flowers and female figures, and, surrounding the mirror face, flowers, figures, trophies of arms and animals. These lively frames were ornamented with Rococo shells and rivulets as well as landscapes painted on medallions, which were contained in gilded borders. The Italian Rococo produced charming mirror frames of rose-red, green, blue and black lacquer painted with branches and *chinoiserie*, as well as very high three-piece overmantel mirrors. At the end of the 18th century the Italian master designers produced frames on which there was virtually nothing to be seen but glass: the frames, made from glass facets, were covered with a fine network of engraved tendrils and decorated with flowers and leaves of coloured glass, while the mirror surface was engraved or ornamented with plants or figurative motifs of crystal glass. Strings of coloured glass were also used, as was gaily painted faience from Bassano or Capodimonte. In Naples, corals were combined with gilt-bronze or mother-of-pearl. Like other European countries, Italy had its mirror rooms in palaces (Turin, Bergamo, Milan, Mantua, Venice). In the 18th century, Venetian glass yielded pride of place to Bohemian, which excelled it in both technical quality and beauty.

Neo-Classicism

Neo-Classicism, with its elegant, rectilinear simplicity, introduced gentle, balanced and logical shapes into interior decoration. In France, under Louis XVI, borders of mirror frames were made of gilded, white-painted or natural wood with small, elegant motifs borrowed from Antiquity: beading, egg-and-dart mouldings, meanders, herms, caryatids, garlands, rings and rosettes, trophies of arms and Classical figures.

In the last decade of the 18th century a more Classical type of decor appeared, inspired by ancient Rome: palmettes, laurel wreaths, sphinxes, cornucopias, columns. The gilding was executed very carefully, the craftsman using the thinnest foils of mat, bright or lemon gold. Georges Jacob designed big mirrors for the royal family and, like Biennais, elegant *nécessaires*. Toilet mirrors attached to wardrobes or small tables were popular and so were large 'Psyche' mirrors in the English style. In middle-class homes there were, of course, simpler mirrors with mahogany or walnut frames and metal decoration.

In England, Robert Adam effectively determined the shape of the mirror frame. He worked with clean-cut, classical lines and details, and with specially selected woods painted with trophies, garlands and urns. Hepplewhite and Sheraton interpreted Adam's shapes, but Sheraton, with his simpler, more restrained lines, was the more expressive. From about 1800, mirrors of the Psyche type were popular in England. Known as horse-dressing-tables, these com

prised a framed mirror hung on a stand which could be pivoted to obtain the reflected view required.

The 19th century

The mirrors produced during the French Restoration period were made of *verre églomisé* with gold painting on a white ground. These were superseded by the popular 'Troubadour' style mirrors which reproduced the shape of Gothic windows. Venice produced traditional mirrors with threadwork and flowers of coloured glass. Despite the new process of mirroring glass with silver instead of copper, the creation of original mirrors came to an end in the 19th century. Manufacturers worked in one or more of the styles of the past — Baroque, Rococo, Neo-Classicism. There were gilded frames with coarse chalk or plaster decoration in place of carving, and copies of early Venetian frames. Eclecticism ended in a complete absence of taste, further promoted by cheap mass-produced articles. It was then that groups of artists, theorists and literati reacted to this situation by attempting to develop an original art, untouched by the styles of the past. The new style existed in various countries about 1900 under different names: Jugendstil, Sezession, Art Nouveau, etc. Henri van de Velde, Richard Riemerschmied, Bernhard Pankok and others strove to unify artistic creation and progress in modern techniques. In England the prophet-critic John Ruskin and the prophet-artist William Morris led the new movement. The new art was characterised by its lines, both in silhouette and ornament. The simple lines of the mirror frame were embellished with a rich and flattering decoration derived from Japanese and Chinese prints. If Art Nouveau was not an unqualified success, it nevertheless rendered art a service in banishing hindsight and establishing rules of simplicity, harmony and function. For these qualities alone mirrors of the 1900s period are again much sought after by collectors. The carver also decorated mirror frames with supple flower stems, irises, lotus blossoms and roses — works which are today already part of history.

Advice to Collectors

The chief defect to which the mirror is subject is the clouding of the surface, something which cannot be overlooked because it impairs the value of the mirror.

The care of the frames varies according to the material used, and can be studied in the relevant chapter on the material in question.

Attention must, however, be drawn to the fact that in the 19th century the French company of Baccarat imitated the early Venetian mirrors with carved frames so successfully that they can easily be confused with the originals.

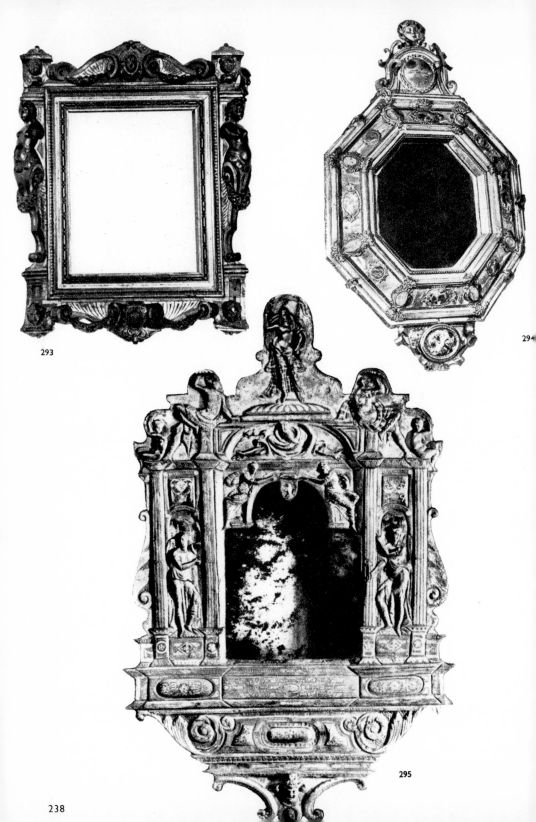

293

29[4]

295

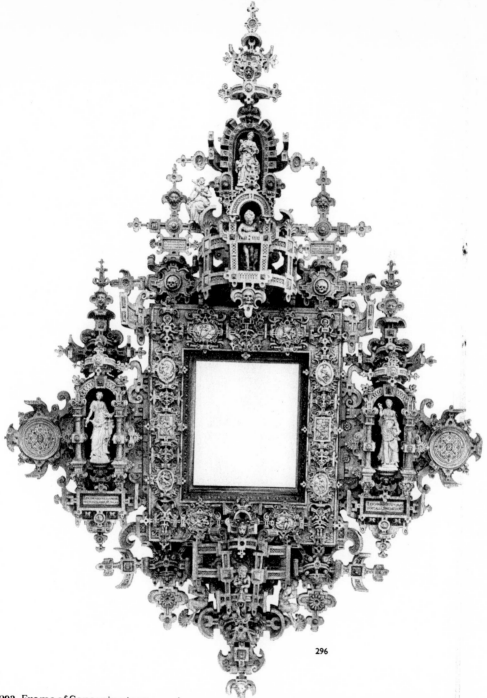

296

293 Frame of Sansovino type, wooden, partly gilded. Venice, first half of the 16th century
294 Octagonal mirror with gilded marble frame. Italy, late 18th century

295 Iron mirror inlaid with gold. Italy, 16th century
296 Wall mirror with carved frame. Holland, 16th century

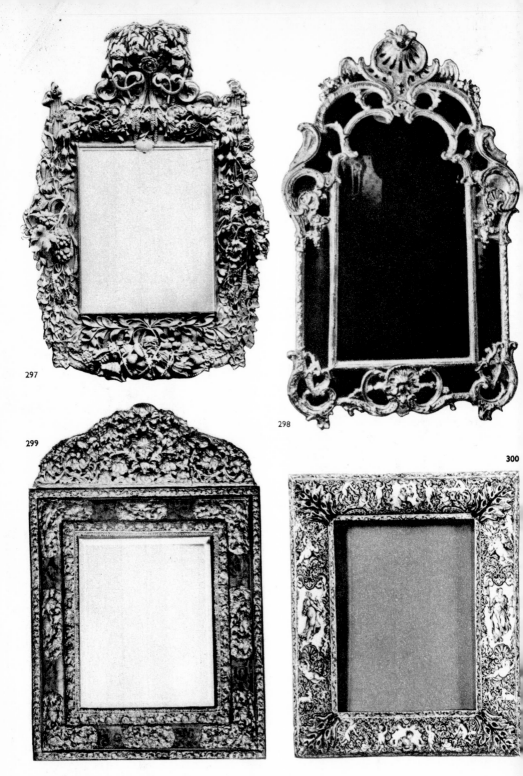

297

298

299

300

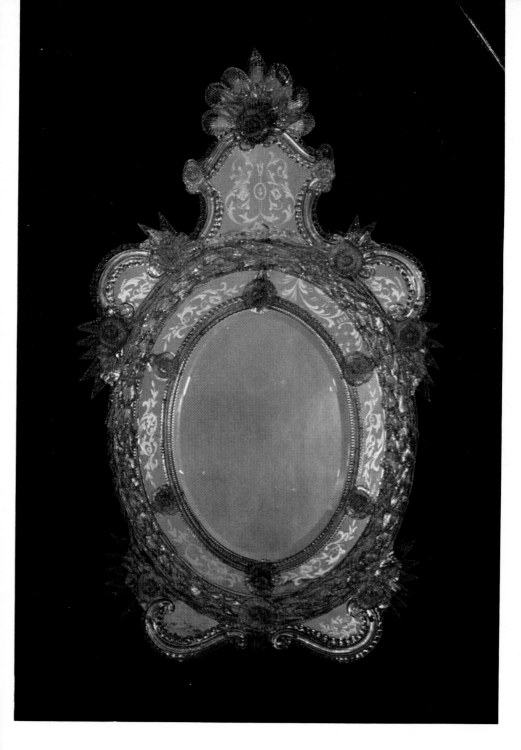

XLIII Wall mirror with polished frame. Bohemia *c.* 1740

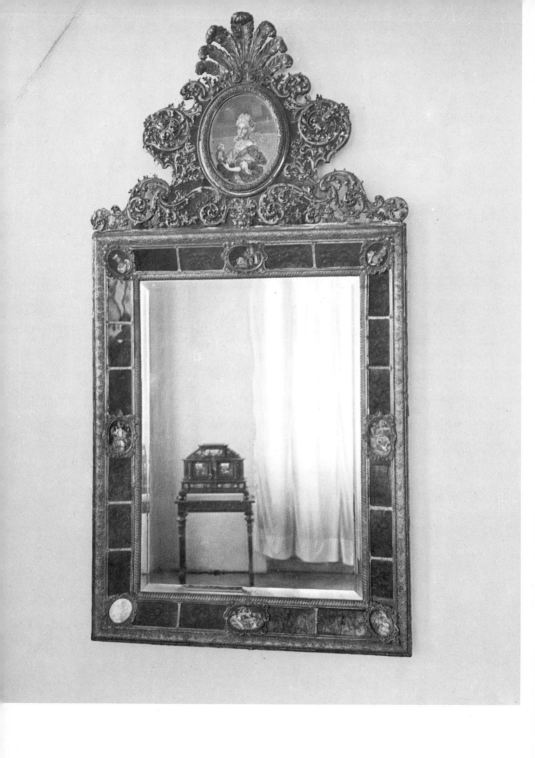

XLIV Wall mirror with silver frame. Southern Germany, *c.* 1680

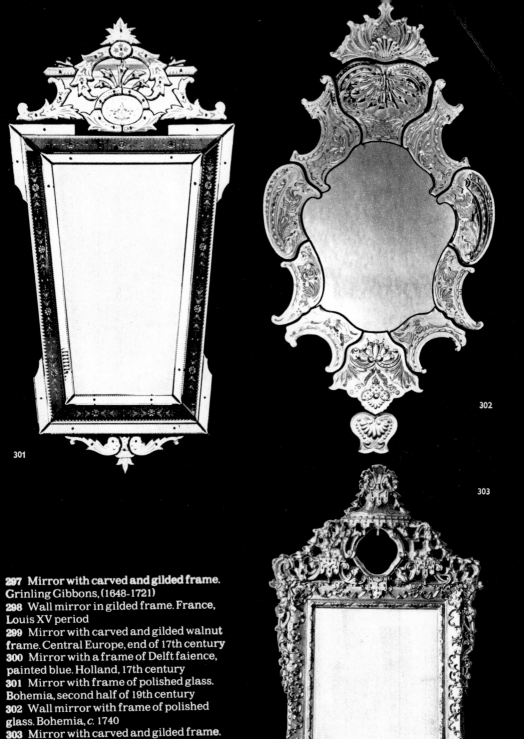

301

302

303

297 Mirror with carved and gilded frame. Grinling Gibbons, (1648-1721)
298 Wall mirror in gilded frame. France, Louis XV period
299 Mirror with carved and gilded walnut frame. Central Europe, end of 17th century
300 Mirror with a frame of Delft faience, painted blue. Holland, 17th century
301 Mirror with frame of polished glass. Bohemia, second half of 19th century
302 Wall mirror with frame of polished glass. Bohemia, c. 1740
303 Mirror with carved and gilded frame. Bohemia, c. 1730

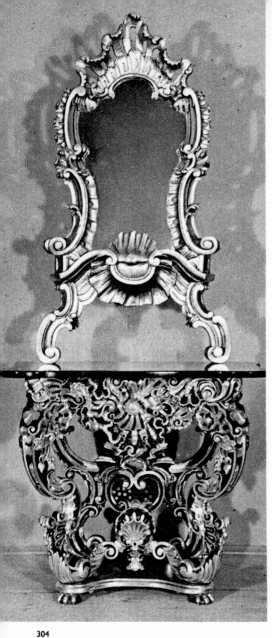

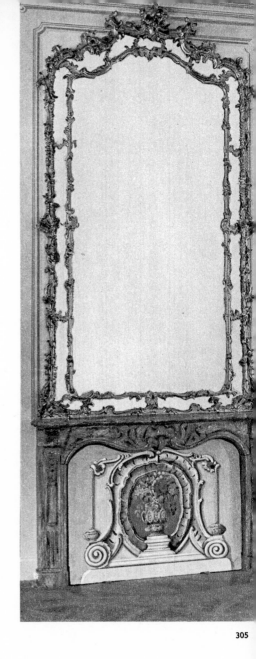

304

305

304 Console mirror with carved and gilded
frame. Bohemia, c. 1750
305 Overmantel mirror with carved and
gilded frame. Bohemia, c. 1750

306 Wall mirror with frame of painted
faience. Italy, Le Nove, second half of 18th
century
307 Design for toilet mirror. France, c. 1770

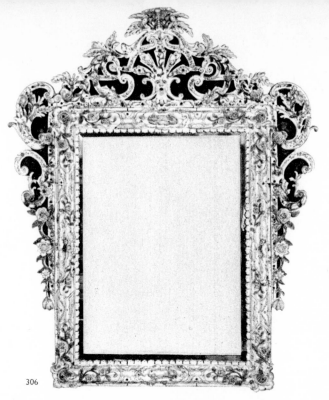

306

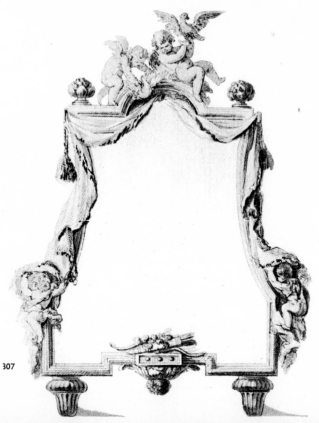

307

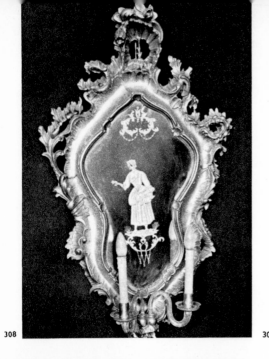

308

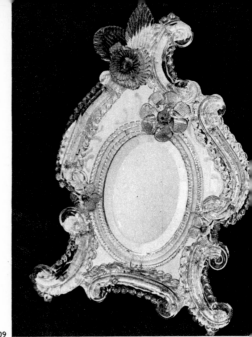

309

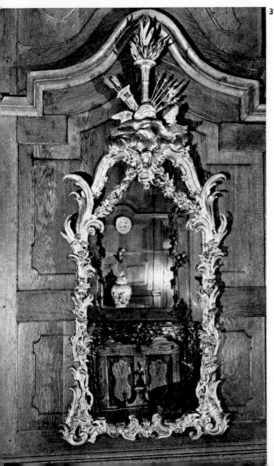

310

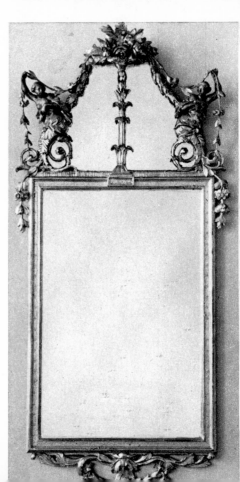

308 Wall mirror with candle arms. Bohemia, *c.* 1760
309 Mirror with frame of clear glass with coloured flowers. Venice, 19th century
310 Wall mirror with carved and gilded frame. France, *c.* 1760
311 Mirror with carved and gilded frame. Bohemia, end of the 18th century
312 Wall mirror with gilded frame. Chippendale, third quarter of 18th century
313 Wall mirror with black lacquered frame and gilded figures. Bohemia, end of 18th century
314 Wall mirror. Robert Adam, end of 18th century

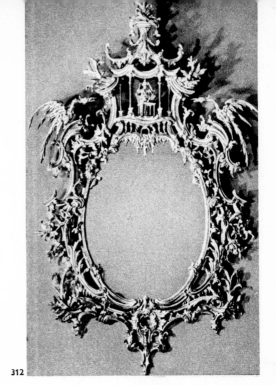

312

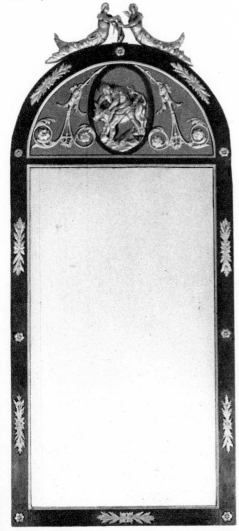

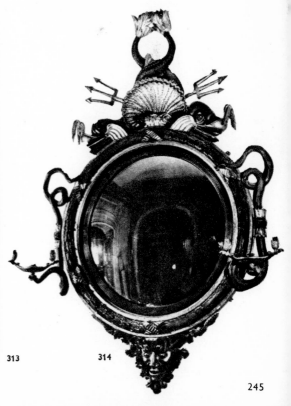

313

314

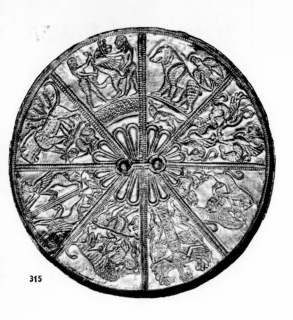

315

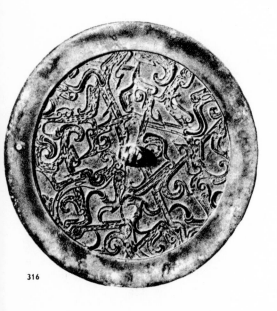

316

315 Back of a Scythian mirror; gilded. 6th
century BC
316 Back of Chinese mirror; bronze. 6th
century BC

GOLD AND SILVER

Gold and silver were already known in remote Antiquity as materials which could be worked artistically, and gold and silver objects serving a wide variety of purposes date back many centuries. The reason is doubtless that no other metal equals them in nobility, durability and beauty of appearance, while they can also be processed by a wide variety of techniques and can, if necessary, also be decorated with additional ornaments, such as precious stones and brightly coloured enamel.

In Antiquity, Hephaestus (Vulcan) was the god of goldsmiths, and later the patron of all craftsmen who worked with fire and metals. In the early Middle Ages, Eloi was elevated to patron saint of goldsmiths. In the first half of the 7th century he lived and worked as a goldsmith at the court of the Frankish kings Clotaire II and Dagobert I. Because of his talent he was appointed Bishop of Noyon and was later canonised for his exemplary life. The reputation of Eloi as a saint and bishop spread throughout the Christian worlds, and numerous monuments and goldsmiths' works represent his legend.

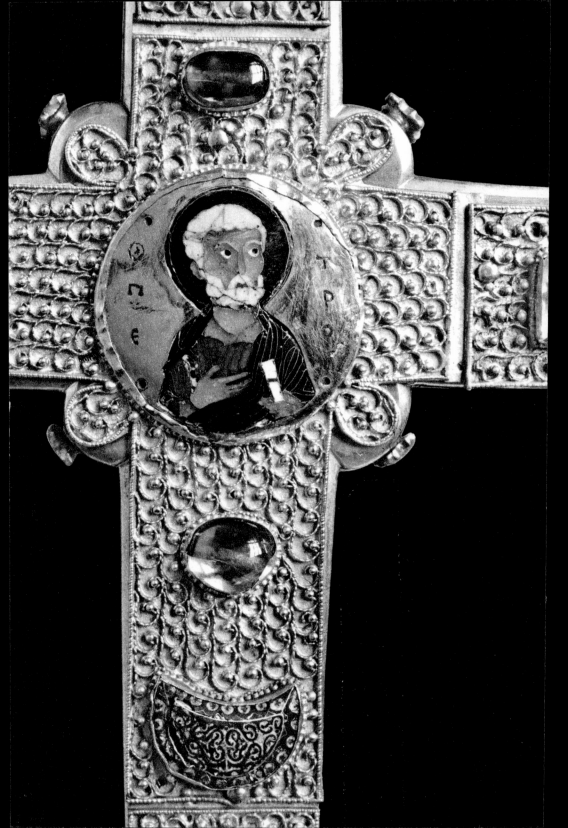

317 Cross of Záviš of Falkenstein: Gold,
filigree work: Meuse region, beginning of
the 13th century; gold cloisonné enamelling,
Byzantine, 11th century

Techniques

The properties of gold and silver. *Gold* (Au),
designated by the alchemists' sign ☉ (sun)
and called 'rex metallorum', has almost al-
ways and everywhere been accounted one of
the most valuable of materials. It is charac-
terised by a beautiful yellow colour, intense
lustre and a high degree of malleability. It
remains resistant to air, even at high temp-
eratures, its melting point being 1064⁰C. It
is resistant to acids, dissolves only in *aqua
regia*, selenious acid, and in calcium or so-
dium cyanide. It occurs in nature principally
in the pure state in small granules or flakes,
in quartz veins or in alluvial deposits which
have resulted from weathering and washing
away of goldbearing earth and from the dis-
integration of masses of rock. The resultant
ore is crushed, washed, amalgamated or
melted. The main places where gold was
found in ancient times were Asia and Egypt;
today it is mainly found in Africa, North
America, Australia and the Soviet Union.

Silver (Ag) was designated by the alchemists
by the sign of the moon ☾ and is a white
metal with a high lustre. It even surpasses
gold in malleability and hardness. It is resis-
tant to pure air, but turns black when ex-
posed to sulphur fumes or hydrogen sul-
phide. It dissolves most easily in nitric acid.
Its melting point is 960° C. It occurs in nature
in silver and lead ore veins, usually as a new
formation that has arisen from sulphur
ores. From the earliest times it has been ob-
tained solely by mining. The Nubian and
Ethiopian silver mines were famous in an-
cient times. The Athenians, who preferred
silver to gold, had their silver mines in Atti-
ca, while those of the Phoenicians, Carthagi-
nians and Romans were in Spain. During the
Middle Ages the best known silver mines
were in the Harz Mountains, Tirol, Saxony
and near Jihlava and Kutná Hora; later in
Příbram, and in Štiavnica and Kremnice in
Slovakia. Today most silver comes from
North America, Mexico, Canada, Peru,
Australia and Spain.
Silver is light and, above all, much cheaper
than gold. In ancient times it was twelve
times cheaper, in the 16th century fourteen

times, and today forty times. Its only disad-
vantage is that it oxidises in the air and be-
comes coated with a dark brown deposit (sil-
ver sulphide). Silver consequently used to be
gilded (mainly up to the 18th century), the
good properties of both precious metals
thus being combined — that is to say, the
lightness and relative cheapness of silver
and the durability and beautiful warm col-
our of gold.

Alloys. Since pure gold and silver are too soft
for practical use, they are alloyed with other
metals: gold with copper and silver, and sil-
ver with copper. The desired hardness and
also the necessary fusibility and malleabili-
ty are obtained in this way. The added metals
also have an influence on the colour of the
alloy, particularly in the case of gold. By ad-
ding a large amount of copper and a smaller
amount of silver, we obtain red gold; if the
proportions are reversed, yellow gold. White
gold is obtained by the addition of nickel and
palladium, and green gold by admixing cad-
mium. The amount of other metals that it is
permissible to add without the depreciation
of the precious metals is determined by
rules, and is designated by stamping with a
mark. The precious metal content in the
casting is expressed in thousandths,
1000/1000 being pure precious metal. In the
case of gold this means 24 carat, in the case
of silver 16/16 fine. Commonest are 18-carat
(750/1000) and 14-carat (580/1000) gold, even
23-carat gold being too soft for processing.
In the case of silver, we find mostly 13/16 fine
(812/1000) or 12/16 fine and 14/16 fine, 15/16
fine being the maximum it is practicable to
use.

Copper is the non-ferrous metal most often
used by goldsmiths because it is very malle-
able. It is used for models for works in pre-
cious metals, and also for decoration. It is
somewhat harder than silver, and its
surface can be plated by gilding.

Methods of working. Gold, silver and copper
are worked in the same way, by hot or cold
processes.

Casting. These metals are fusible and can easily be cast in moulds like bronze. Before casting, the goldsmith prepares a model from wax, lead, copper or even wood. Those parts of the objects which had to be particularly strong, for example the handle, grip or catch of a vessel, or ornaments and figures, were cast in sand moulds. Many moulds had to be made for complicated objects, since the individual parts were cast separately and then assembled by soldering and screwing together. A single mould sufficed for repeated ornaments, being pressed several times successively into the moulding sand. The best castings were formed from copper models, since after chasing they looked like hammered work. Electroplating for producing casts was invented in the 19th century.

Hammering. This is the most original, artistic and difficult technique in goldsmithing. Gold, silver and copper can be beaten into thin sheets of foil, without losing their resistance and elasticity in the process. The shape of the object is created using a beating hammer and the metal in this case does not have to be heated. Objets d'art are often hammered on a base (in most cases a lead or pitch base) which has the same tensile strength as the metal sheet. By means of short blows delivered close to one another, the sheet is hammered with constant turning and pressing on one or both sides until the desired shape has been attained. The decoration is impressed on anvils, using hammering and stamps and punches of various shapes and sizes. Hammered works made from a single sheet represent artistic triumphs of the highest order; it is easier to work with two or more pieces which are then soldered together. Great technical mastery in hammered high reliefs with a three-dimensional effect was achieved by medieval French and German goldsmiths, by 15th-century Italian workers and, at the end of the 16th century by the Nuremberg goldsmiths, particularly Wenzel and Georg Jamnitzer and their school, who specialised in making vessels. They often worked from engraved designs, notably those of Jan Vredeman de Vries. Later, similar decorations were cast and soldered on. The Dutch goldsmiths of the 17th century were great masters of the art of hammering. *Hammering on a solid model* was used even in ancient times, particularly for three-dimensional works involving figures. Gold or silver foil was struck on to a bronze or iron model and then taken off. Very ancient, too, (for flat reliefs) is *hammering into solid forms* and the pressing of the foil between two moulds (punches) made of stone, bronze or iron. In this case, one punch has a relief pattern while the other is hollowed out. This technique, called *punching*, is found on the gold plates from Mycenae, dating from the second millennium BC.

Embossing. This is a related technique in which a relief pattern is raised by hammering on one side of the solid metal to produce all its details. Most coins and medals were stamped in this way, as were ornamental strips (*themata*) and rosettes during the Renaissance; they were then soldered or riveted on to vessels. The Nuremberg goldsmith Wenzel Jamnitzer even possessed an embossing machine, built for him by the Nuremberg mechanic Hans Lobsinger, with the aid of which he made decorative strips which he sold to other goldsmiths. It was not, however, until the later 18th century that machine pressing and embossing were generally used by goldsmiths for their work.

Decorating techniques. *Chasing.* Hammered and cast pieces have to be worked with a chisel and file and rendered smooth with a burnisher. Chasing is consequently a very important technique by which the artist finally gives the surface the finish he wants. The goldsmith places a soft base (sandbag or chasing pitch) under the surface to be treated, and beats in various lines, hatchings or small patterns (rings, stars, etc.) with the chasing or punching hammer. In decorating involving figures, he thereby obtains the correct effect overall and with the individual details (hair, beard, patterns of the draperies, furs). If a smooth ornamental design is desired, then the base is punched.

Engraving. This too forms part of the art of chasing. As with a copper engraving, the drawing is engraved with a sharp graver on to the smooth object. This technique was very widely used in the 13th and 14th centuries and, later, in the 17th and 18th centuries. In order to render the engraved drawing more easily visible, black coloured material is rubbed into the engraving: *niello* (see the section about enamelling). At the

end of the 18th century, machines began to be used for engraving. These covered whole surfaces with regular lines, wavy lines, fine rings or arcs. This technique, *guilloching*, was taken up mechanically at the beginning of the 19th century by turners and led to the disappearance of high-quality art engraving. This method of engraving was used mainly in the case of watch-cases, boxes and similar objects.

Etching. This technique is also related to the graphic arts. As in normal etching, the object is covered with resins or a layer of asphalt mixed with white wax, on which the design is then scratched in. The metal is then immersed in a solution of acid, the acid biting into the etched area. Thus a very shallow and soft-looking relief is achieved. The best work with this technique was done in the 16th century. It had been used earlier for inscriptions on votive objects and sometimes also for goblets.

Filigree and granulation. These are among the most frequently used decorative techniques. Filigree (derived from the Latin *filum* = wire) is a decoration produced with thin wires of gold or silver which are twisted into spirals or tendrils and lattices, and soldered on to the object. Granulation (from the Latin granum = granule) consists of the soldering on of tiny gold or silver particles or granules. Both these techniques were used in Antiquity, particularly by the Etruscans, and were popular during the Middle Ages and the Baroque period.

A jour work. This is done by cutting or filing through the decoration with a file, or by leaving empty spaces on casting. The *cutting* of metal sheets also belongs in this category. These techniques have generally been used to produce interlaced spirals and twisted naturalistic leaves and blossoms. The à jour technique was popular particularly in the late Gothic and Renaissance periods, and cutting was also popular in the late Gothic period.

Enamelling. This is one of the important techniques in goldsmithing. The enamel decoration is a pictorial accompaniment to the work in gold. Enamel is a coloured mass of glass that has been ground to the consistency of dust and dissolved in water and a vege-

table bonding agent (honey, resin). It is applied to the metal plate and fired in a muffle furnace at 700-800°C. At this temperature the metal combines firmly with the enamel, which may be transparent or opaque. Various enamelling techniques were developed in the course of the centuries by which different artistic effects could be obtained. The forerunner of real glass enamel was *niello*. Niello (from the Latin *nigellus* = blackish) is a black mass of silver, copper, lead, sulphur and borax, applied to the engraved or etched drawing and then melted in a weak fire to produce a black background to the design in precious metal. Niello was known in ancient times, and was popular in the 11th and 12th centuries; but an even greater predilection was shown for it during the Renaissance, when copies of Oriental weapons decorated with niello were created. This technique is still used today in India and Thailand.

Cloisonné enamelling. This is the oldest known form of enamelling technique. Thin gold wires are soldered on to the gold surface, forming cells corresponding to the outlines of the drawing. They are then filled with variously coloured masses of glass. After cooling, the surface is ground flat and polished. This technique, known in ancient Egypt, Greece, Rome and the Orient, was used with the greatest mastery of all in the early Middle Ages in Byzantium and a little later in Germany.

Champlevé enamelling has most frequently been carried out on copper and bronze. Shallow cavities, representing the pictorial composition, are hollowed out in the metal with a chisel and graver. These grooves are filled with an opaque mass of glass which is melted in and ground smooth upon cooling. This technique was particularly popular in the 12th and early 13th century. The main centres were in the region of the Meuse and Lower Rhine, and in the French Limoges.

Transparent silver enamelling, also called translucent silver enamelling (*émail en basse taille*), enjoyed special popularity in the 14th and 15th centuries. The drawing is scratched or cut into the silver base surface and covered with a transparent mass of enamel, so that the silver ground reflects the light.

Émail en ronde bosse, described in detail by Benvenuto Cellini, was an admired technique at the Burgundian court in the 15th century and in early 17th-century Bohemia during the reign of the Emperor Rudolph. Cast figures are covered wholly or partly with opaque or translucent glass fluxes, resulting in coloured enamelled sculptures. Reliefs can also be enamelled in this way.

Painted enamel (émail des peintres), also called Limousin enamel, was first used at the Burgundian court in about 1400, and reached its greatest popularity and excellence in Venice and Limoges in the 15th-17th centuries. Metal foil, in most cases copper foil, is covered with a single layer of opaque enamel. The picture is then painted on with variously coloured enamel pastes, each colour being fixed by a separate firing. In many cases the outlines of the design were of gold which added sparkle to the image.

Enamel painting differs from the technique just described. Painting is not carried out with enamel colours on an enamelled ground, but with pure metallic oxide colours on a white enamel ground. Using this technique, which is reminiscent of porcelain painting, miniature paintings were made on boxes, watches and toilet sets, particularly in the 18th century. Often the decoration also includes relief gold work.

Painting with cold colours was used mainly during the Middle Ages and the Renaissance. The lacquers, however, peeled off with time, so that only a few of these objects have been preserved intact.

During the 18th century decoration could be applied to gold boxes, watch-cases and fan handles in various shades of gold (gold à quatre couleurs).

Inlaying is the process whereby precious metal is beaten into a firm iron or bronze base. It is carried out in two different ways: either gold leaf is laid on to the metal surface to be worked, this being burnished down, as a result of which both metals firmly combine, or the drawing is engraved into the harder metal, and gold or silver wire is hammered into the outline. The upper surface is burnished and polished. These works were carried out in a masterly way by the Moors in Spain, the Chinese and Japanese. During the Renaissance this technique was taken over from the famous weapons produced in Damascus; hence also the expression damascening.

Gilding is an important operation in goldsmithing, since less valuable metals are as a result made to look like gold. It is carried out in three different ways: cold, by firing and by liquid means.

The oldest method of gilding, which was known before the Christian era and used during the imperial period in Rome, is the covering of a silver or bronze core with gold leaf (*cold gilding*). Silvering too was carried out in this way after 1743, once it had been discovered in Sheffield that copper cores could be silvered without soldering, that is, merely by pressing on a silver foil. This type of silvering, *silver plating*, was very popular in England in the late 18th century and 19th century.

The noblest method of gilding is *fire gilding*, which has been practised since antiquity. The gold is dissolved in mercury, applied as a thin wash and then fired. The mercury volatilises and the gold combines with the metal base. Since the escaping mercury vapours were, however, injurious to health, other techniques were sought. Today the method of *galvanic gilding* is used.

Historical Survey

Antiquity. The processing of gold extends back to early antiquity, and of course first developed in those regions in which pure gold occurred in substantial amounts. Because of its rarity, beauty, resistance to weathering and ease of manipulation, gold has almost always been the most sought-after material and a standard by which other things are valued. For this reason, many goldsmiths' works have been melted down, so that the material could be used anew - an inestimable artistic and historical loss.

The oldest extant works come from prehistoric graves. They are jewels made from thin gold leaf with a simple stamped geometrical decoration. The peoples of Asia and the early Egyptians were masters in working with

gold. They particularly favoured hammering it into thin plates, from which they cut an ornament, decorating weapons, vessels, garments and furniture with it, as well as whole walls; there are examples of this kind of work in the museums of Cairo and Alexandria. This style, called by Semper *gold leaf style*, predominated in the prehistoric period, in the ancient East, in Greek antiquity, and in Mexico and Peru. It also determined the character of many medieval works.

The Greeks soon mastered the procedures of the Chaldean and Egyptian goldsmiths, most of whose products were hammered and stamped. Chasing and engraving were also developed in Greece, where gold work was executed with great skill. There are many proofs of this in literature as well as archaeological finds. The Etruscans and Romans took over goldsmithing techniques from the Greeks. Its brilliance and luxury culminated in the late republican period and the imperial period: Pompey gave a banquet for a thousand people on gold dishes, Nero had a 'gold house' built for himself. There are works from the Greco-Roman period in many museums. The products of the Cretans and the early Greeks show considerable sophistication both in technique and artistry, for example the hammered gold beakers of Vaphio in the Athens Museum or the Scythian treasures from the graves of the kings in the Crimea (6th-5th century BC) in the Hermitage, Leningrad.

With the fall of the Roman Empire and the period of the barbarian invasions, the centre of artistic activity shifted to the East, to the Byzantine Empire. The use of gold for various objects and garments increased as Eastern influences replaced Classicism, and an Eastern delight in display became apparent. Documents that have survived indicate that Hagia Sophia in Constantinople was completely decorated with gold, and that the imperial court had quite a number of heavy gold vessels. The Turkish occupation of Asia Minor unfortunately destroyed all works made from precious metals in the Byzantine Empire; only those which had been taken to Europe were preserved. While three-dimensional decoration of the pure precious metal predominated in Greek and Roman works, in Byzantium the preference was for strong colour, even in works of the goldsmiths which were decorated with brightly coloured enamel, precious stones and filigree.

The Middle Ages. There were important new developments in goldsmithing during the Ottonian period.

Germany. The centres here were the monastery workshops, which competed with one another in the production of liturgical objects of a high technical and artistic standard; the names of various artists and heads of the workshops have been preserved. Such a monastic workshop was St Michael in Hildesheim, which was directed by Bishop Bernward, who had been educated in Italian schools and had mastered the goldsmith's art. The binding of sections of the Gospels named after him is particularly impressive with its combination of filigree work and ivory. Like the Hildesheim processional cross, it is a masterpiece of this school.

Another important German workshop was in Trier, founded by Archbishop Egbert. It became famous through the Egbert cross in Maastricht, the reliquary with a foot of St Andreas in Trier, and the binding of the Echternach codex. The Lothar cross was produced in Aachen at about the same time, being decorated with filigree work and mounted with a Roman cameo; so were the altar panel on the predella of Otto III and, above all, the famous chancel of the Aachen octagon.

One of the most important monastic workshops was that of St Emmeran in Regensburg. Works produced there include the doors to the sacrament house in Bamberg, the Basle antependium (now in the Musée Cluny, Paris), and the covers of the selections from the Gospels of Abbess Uta (Munich). The Essen workshop, which produced the artist Roger von Helmershausen, and the workshop in Fritzlar also contributed to the fame of German goldsmiths in the early Middle Ages. All the works mentioned are characterised by the purity of the materials used and the care and skill of the workmanship. During the 12th century, secular workshops replaced monastic workshops in the developing towns, above all in Lorraine. The style of the ornament, modelled on that of Antiquity, became schematic. Copper and bronze were used alongside expensive material. Enamel became the main means of decoration, chiefly champlevé, which was more brightly coloured as well as being cheaper than Byzantine cloisonné. The valley of the Meuse

became the main centre for the production of works in gold. Some outstanding goldsmiths came from this region, including Reiner v. Huy and Godefroid de Claire. De Claire created the Alexander reliquary in Brussels, the Heribert shrine in Deutz and the cross of St Omer. Nikolaus von Verdun was responsible for the enamelled Klosterneuburg altar, dating from 1181. A sublime work of that period is the shrine of the Magi in Cologne. Other important goldsmiths of the period were Hugo of Oignies, who worked in the monastery of Oignies in Namur, and Eilbertus in Cologne, the author of the portable altar of the Welf treasure.

France. The blossoming of early medieval French goldsmiths' work was concentrated in the workshop in Rheims, where contemporary Romanesque forms were modelled on ancient vessels. Around 1200 the Limoges workshops produced the best works in champlevé enamel, notably casket-shaped reliquary shrines and processional crosses.

Prague. We owe it to the Emperor Charles IV that in the 14th century the Prague goldsmiths' workshops became famous. They received their guild statutes as early as 1324. Charles IV was a passionate lover of works in gold and jewellery, and had a new Bohemian crown made in 1346. He had the crown of the German kings decorated in Aachen and the bust of Charlemagne, a masterpiece of Gothic goldsmithing, made there. He had the works of the Prague goldsmiths exhibited, together with reliquaries, on the squares of Nuremberg and Prague, and presented the Prague goldsmiths with a mitre by St Eloi, the patron saint of goldsmiths.

During the Gothic period, goldsmiths extended the range of their works by producing reliquary busts in the form of figures, reliquary display vessels and monstrances. Most of these are made from silver- gilt, and are basically architectural in form, as a result of which they create the impression of greater lightness. They have a pierced decoration, usually of translucent enamel. Particularly fine architectural examples are the tower reliquaries (for example, the Maria reliquary and the three-towered reliquary in Aachen) and the monstrances, which were made upon the introduction of the Corpus Christi festival in 1316 for processions and the solemn exhibition of the Host.

The shape of the chalice developed independently, since it was determined by the demands of ritual. The chalice, originally a Roman goblet, appeared in the early Christian liturgy. To begin with, it had a short foot and a wide bowl, so that it should contain sufficient wine for all the faithful, and its whole surface was decorated with hammered or pierced ornamentation and niello. Later on, however, the chalice was intended only for the priest; the bowl therefore became smaller and smoother, and the foot larger. During the Gothic period the foot assumed the form of a decorated capital with entwined plant motifs. Gothic measuring vessels, which in the early Christian era were quite large, now became smaller; water and wine being offered in two separate vessels which were placed on a tray.

The cross-piece of the processional and altar reliquary cross was, int the pre-Romanesque period, finished off with a square, in the 13th century with a lily, and in the 14th century with a quatrefoil. The surface also differed from one period to another.

Reliquaries were made in a very wide variety of shapes. At first they were shrines in the form of a sarcophagus, later they were containers made in the shape of the relic preserved within them — a head, a hand, or a foot. Later in the Gothic period, reliquaries took the form of a crystal shrine which was carried in procession by the faithful. Of the greatest interest are the reliquaries in the shape of busts or statues of saints.

Devotional images — gold and silver figures of Christ, the Virgin Mary and the apostles — were in most cases made of wood, encased in gold and silver sheets or leaf gold. The faces were painted with artists' pigment.

The copes of bishops and clergy were fastened with clasps of precious metal which were usually round or square and ornamented with figures in relief. During the 14th century the clasps were designed to contain the relics of saints and so became small-scale reliquaries.

The formal language of Gothic continued to be used in devotional works in gold down to the 17th century, particularly north of the Alps. During the 16th century Renaissance motifs were being used to decorate gold and silverware, and indeed Georg Seld created in Augsburg in about 1492 a silver Renaissance altar for the court in Munich. But it is nevertheless noteworthy that Gothic forms

were preserved in Italian art as well down to the end of the 15th century, even if the ornament already reflected the awakened interest in Classical decoration.

Very little late medieval secular work has been preserved, although even in the 14th century the church ceased to be the only customer for works in gold. In the 15th century more secular than religious works were produced in gold, while cheaper and more easily available materials — silver and gilded silver — began to be used to make vessels.

The craft workshops, organised into guilds in the towns, increasingly dominated artistic work of all kinds. Natural rather than the idealised forms of the high Gothic characterised the productions of urban society. This is evident in the bossed cup, a cup with a lid on a high foot and with hammered, rounded bossed shapes.

The late Gothic type of embossing, embodying the naturalistic trends of the period, survived alongside the Classical forms of the Renaissance until well into the 18th century. This naturalism led to the creation of goblets in the shape of bunches of grapes and pineapples, the embossing of which reflected the shape of the fruits in question. The most beautiful example of such a cup in the shape of fruit is the apple cup from 1515-20 by the Nuremberg goldsmith Ludwig Krug. It was probably executed after a design by Albrecht Dürer, and is now in the German National Museum in Nuremberg.

During the 15th century and more markedly in the 16th, there appeared alongside expensive cups simpler covered drinking beakers, beakers on bases and also without bases, in a wide variety of shapes: conical, heart-shaped, in the form of a gnarled heart, bossed; and whole sets of beakers were made that fitted into one another, which were called 'piled beakers'. The most popular wedding presents were double cups; that is, two cups joined together at their edges. The salt-cellar and centrepieces for tables in fantastic shapes (towers, animals, ships) formed the main table decoration. Silver tableware was not intended for daily use, serving above all as show-pieces. The council silver was intended to show off the power and richness of the city, though in times of financial difficulty it could be melted down and used for minting coins and the like. Only on ceremonial occasions were the silver beakers used for drinking in the town hall or the guild chambers. Large beakers, guild cups or welcome cups were mainly used for this. Many of them were 28-32 inches high, and they were sometimes made in various bizarre shapes — figures, animals, towers, ships, drinking horns, guild implements, etc.

Germany. Late medieval goldsmithing reached its highest development here, partly because of its connection with German graphic art. The goldsmith worked in close co-operation with the graphic artist. It is known that many copperplate engravers were also goldsmiths, for example Meister ES and his pupil Israel van Meckenen, Martin Schongauer and a good many others. Albrecht Dürer learned goldsmithing from his father. The main centres of German work in gold were Augsburg and, above all, Nuremberg, which retained the leading position from the 15th century to the time of the Thirty Years War. Other important centres were Prague under the Jagellos (reliquary busts in the Cathedral of St Vitus), Vienna, Ulm, Strasbourg, Frankfurt am Main, Cologne, Lüneburg, Lübeck and Breslau. Among the greatest artists who created designs for works in gold were Albrecht Dürer the Elder (the father of the painter), Hans Holbein, Ludwig Krug and Adalbert Jamnitzer in Prague.

The Renaissance. *Italy.* Long before the Middle Ages ended elsewhere, Italian princes, philosophers, poets and artists had developed a new attitude — a delighted contemplation of man and nature as valuable and beautiful in themselves — reinforced by a preoccupation with the culture of Classical Antiquity. The Renaissance Italian displayed a predilection for decidedly luxurious works, such as those created by goldsmiths and jewellers. Goldsmithing was principally concentrated in Florence, Rome and Venice. The shapes of vessels, which were linked to their function, remained largely unchanged, although under the influence of late Renaissance Mannerism they tended to exceed the limits of practically and almost become a branch of sculpture. This was due also to the fact that most goldsmiths were sculptors, and working in gold was considered to be an indispensable preparation for sculpture. Unfortunately very little only of the wealth of Renaissance

gold and silver vessels has been preserved, and of these few, crystal vessels mounted in gold and silver predominate. It is therefore necessary to turn to pictures, drawings, copper engravings and written documents. Michelangelo and Sansovino had a considerable influence on works in gold, these also being designed by leading masters in other arts, Verrocchio, Michelozzo, Pollajuolo, Francia, Ghiberti, Ghirlandaio and Brunelleschi, who were all trained goldsmiths. Devotional works in gold were their main products in their capacity as smiths. The most important goldsmith of the Italian Renaissance was Benvenuto Cellini, the creator of the most famous Italian work in gold in the 16th century, a salt with the allegorical figures of the sea (Neptune) and the earth (Cybele), which Cellini made in 1543 for the French king Francis I; it is now in the Kunsthistorisches Museum, Vienna. Cellini also wrote a famous autobiography and a treatise on goldsmithing in which he lists all contemporary goldsmiths.

Cellini's salt was a typical example of how, in the late Renaissance, the functional shape disappeared under a decoration involving figures. In the second half of the 16th century this led to a synthesis of the work of goldsmith, jeweller and enameller. Agate, jasper and lazulite, as well as crystal and enamel, were used in conjunction with gold and silver to heighten the opulent appearance of vessels. It was certainly not by chance that there was a revival of the art of enamelling (niello enamel) in Venice in about 1500, which also gave rise to a revival in enamelling work in the French Limoges.

Western and central Europe. Hardly any works by French goldsmiths have been preserved, though it is known that they were influenced by Benvenuto Cellini during his two sojourns at the royal court in Paris. The same applies to the works of Dutch goldsmiths, who were the first to assimilate Italian influences, and whose work was of great importance for 16th-century European work in gold. A brightly-coloured, enamelled silver jug and a dish with a representation of the conquest of Tunis (an Antwerp work of 1535) are among the most important pieces in the Louvre. Dutch still-lifes provide most of our information about the luxurious goldsmiths' works of the period. In the North the art of the goldsmith was then entering its

most productive phase in quantitive terms. Vessels and ornaments became excuses for displays of wealth. Vessels of all possible types, hammered and drawn as well as chased in various ways, decorated the sideboards of castles, palaces and citizens' houses. Particularly popular were dishes, the feet of which were decorated with hammered Renaissance patterns and scenes from ancient mythology. Among the greatest Dutch masters who prepared designs for works in gold were Jan Vredeman de Vries, Paul van Vianen, Theodor de Bry and Hendrick Goltzius.

Renaissance influences also reached Nuremberg and Augsburg, and goldsmiths were in fact the first German craftsmen to adopt the new style. It first appeared in strips of scroll ornament with grotesques and moresques, carried out after original copper engravings by the minor masters of Nuremberg from the school of Dürer (Virgil Solis, Albrecht Altdorfer, Henrich Aldegrever, the brothers Barthel and Hans Beham). Presumably through ignorance of Classical Antiquity, the German goldsmith combined Italian ornaments with Biblical motifs. The previously popular legends of saints disappeared, and their place was taken by stories with a mainly human interest: the Prodigal Son, Susanna and the Elders, Judith, Esther, David and Bathsheba. However, representations of the Passion and the four Evangelists also appeared. Along with Classical ornaments (particularly grotesques, winged lions, sphinxes and chimeras) went figures from German fairy-tales (dwarfs and mermaids) and animal heraldry. It was not until about the middle of the 16th century that Renaissance influences also determined the shape of vessels. Typical are lavabos, jugs and dishes for washing the hands after eating, vases, trays, lidded dishes, salts, centrepieces and sets of tankards with lids which, at the end of the 16th century, acquired the shape of a chalice on a high base. Very common and popular were humorous drinking vessels in a very wide variety of shapes — windmill beakers, virgin beakers (for example 'Hansel in the Cellar' by Kaspar Widmann from Nuremberg) and beakers in the shape of animals, birds and the like. Smooth and faceted beer mugs and beakers in the shape of thimbles (such as were made by Elias Lencker of Nuremberg) were especially prevalent.

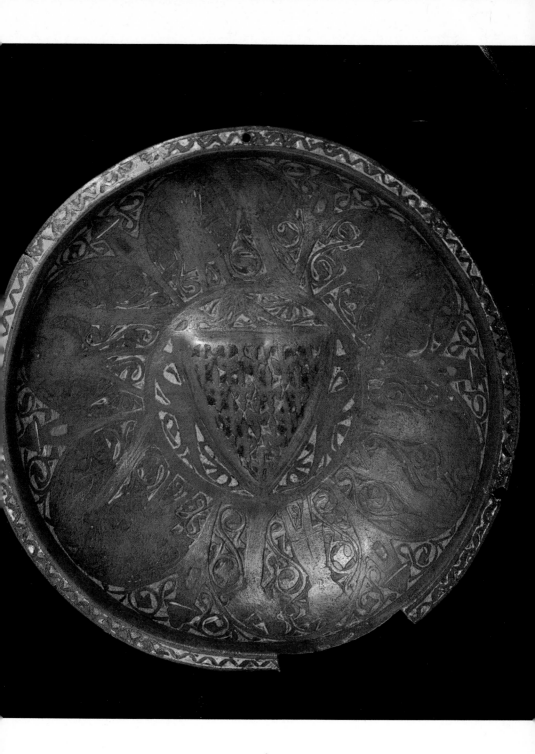

XLV Grape dish; enamelled copper. Limoges, 13th century

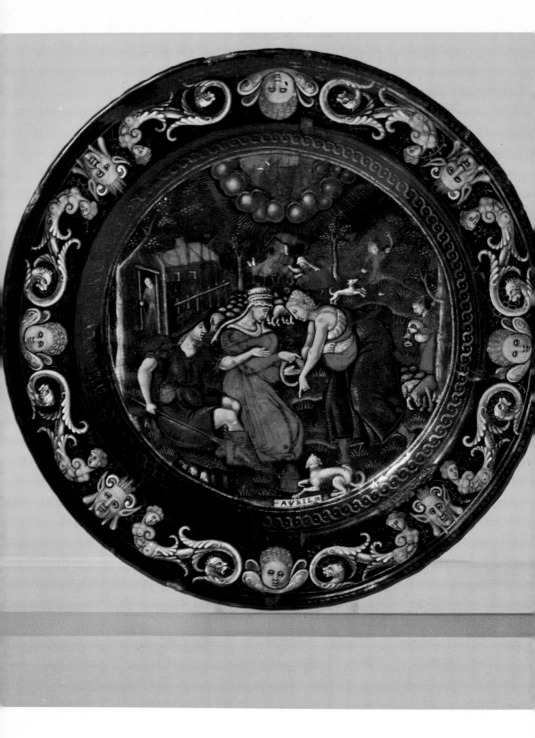

XLVI Enamelled plate with an allegory of April. Pierre Raymond, Limoges, 1580

Towards the middle of the 16th century, the Nuremberg designer Peter Flötner, who collaborated with Melchior Bayer in the design of the house altar in Cracow Cathedral (1538), had a great influence on central European works in gold. Characteristic of his style are Moorish ornamental work and cartouches, as well as allegories and figures of children, which are still found on 17th-century works in gold. Flötner's plaquettes with allegorical and mythological motifs were produced in whole series and were also used for decorating bells. Today 137 types of plaquettes by Flötner are known. These plaquettes were cast from moulds by the goldsmith, or he worked directly on to the metal, in particular for the bottoms of dishes with a base. In addition to ornamental engravings, models made from wood and tallow, and lead castings of details and plaquettes, served to provide the goldsmith with his patterns.

The greatest German goldsmith of the 16th century was Wenzel Jamnitzer, who was born in Vienna in 1508. It was there that he began working, but in 1534 he settled in Nuremberg, where he died in 1584. He founded a large workshop in Nuremberg with a large group of masters working for him, the most important being his brother Adalbert. He was a member of the city council and court goldsmith to the Emperor Rudolph II, the Emperor Ferdinand I and Archduke Ferdinand of Tirol. Jamnitzer was also a master in the art of drawing and an outstanding scholar. He wrote textbooks of physics and mathematics, and made a machine for studying perspective. He dedicated himself to the study of Antiquity and the history of European art, reintroduced enamelling in glass, etched silver and made punches and seals. His knowledge and extraordinary imaginative powers are incorporated in his works, which represent both artistically and technically the high point of German goldsmithing. One of Jamnitzer's creations was the columbine goblet, a bossed goblet the bowl of which is in the shape of a columbine flower. All of his works, of which only 26 are known today (for example the famous table fountains, display jugs and goblets, ornamental cupboards, writing-cases and inkstands) are made with great virtuosity, being brightly coloured and varied in their use of gold and silver, enamel and coloured varnishes, decorated with various ornaments and including motifs from nature, particularly animals and beetles rendered with great mastery. These were without exception objects intended for scholarly collectors such as the famous Ernestin Welcome (now in Gotha), dating from 1540, or the Merkel table centrepiece of 1549 (now in Paris).

The finest collection of works in gold was owned by the Emperor Rudolph II, who housed it in the castle in Prague. In about 1600 his court was the centre of goldsmithing in Europe; the greatest masters, such as Wenzel and Christoph Jamnitzer, Nikolaus Schmidt from Nuremberg and Christoph Lencker from Augsburg, worked for him. Anton Schweinberger was court goldsmith, as was (from 1603) the famous Dutch goldsmith from Utrecht, Paul van Vianen, who had studied in Rome and Florence.

The ideal of this, the late Renaissance or Mannerist period, was 'rare and artificial'; fantastic shapes and decoration replaced the repeated motifs of the Renaissance. This was most fully expressed in goldsmiths' work. Exotic and rare natural objects were mounted in gold and silver: nautilus goblets, goblets made from coconuts and ostrich eggs, vessels made from corals and precious stones, crystal, mother-of-pearl and pearls, as well as ancient cameos, coins and plaquettes. The work of the goldsmith thus met the needs of the cabinets of curiosities and antiquities which were popular at that time.

The famous emperor's crown of Rudolph II, made in Prague in 1602, represents a triumph of German late Renaissance goldsmithing. The viewer is struck not only by its ornamental jewellery work, but also by its fine relief decoration hammered in gold. Another important example is the 'Pomeranian art cabinet' of 1617, which was made under the direction of Philipp Hainhofer in Augsburg.

Baroque and Rococo. The Counter-Reformation period was one of lavish display and magnificent religious ceremonies in Catholic countries. Baroque, the artistic style of Catholicism, was an art of illusion and dynamic movement, extravagant and dramatic.

The new style found full expression in goldsmiths' work. The monstrance, previously made in architectural shapes, took on the shape of the sun, on to which a hammered Baroque ornament — flowers, figures, enamel, and brightly coloured, mainly artifi-

cial stones — was applied. Reliquaries too became radiate in shape. Chalices and ciboria became increasingly lavish objects, in most cases of gilded silver, but also of pure gold and sometimes merely of copper. The bowl remained smooth, but the base and basket of the chalice were richly decorated; on the ciboria the lid was decorated too. The decoration was in hammered open-work or filigree, often supplemented by brightly coloured stones or enamelled medallions. Chalices made at the end of the 17th century in Bohemia were covered with silver filigree work and Bohemian garnets.

As the Baroque style developed, ornamentation became richer and the work of the many goldsmiths' workshops became more and more complicated. The bindings of missals, prayer-books and hymn-books as well as bishops' croziers and the clasps of the copes were also of hammered silver foil or had buckles and corner strips made from precious metal. During the 18th century, silver bindings underlaid with coloured silk with open-work decoration, or velvet bindings with silver applications and clasps, were popular. A new and typical shape was devised for candlesticks on altars: the candlestick rose from a broad, triangulare base standing on three spheres. Candlesticks of various sizes were often set up in rows on altars. Hammered antependia were made from silver, as well as complete altars and tombs with figures, often in life-size — for example, the altar in the pilgrimage church of Heiligenberg near Pribram, and the sarcophagus of St John Nepomuk in the Cathedral of St Vitus in Prague.

In the production of secular works, Dutch craftsmen occupied the leading position in goldsmithing as in painting up to the end of the 17th century. The most famous masters were Adam van Vianen in Utrecht, the creator of the shell ornament, Jan Lutma in Amsterdam, and Gerbrand van de Eeckhout, a pupil of Rembrandt. Their works can be seen in the Rijksmuseum in Amsterdam.

Even in the 17th century the most popular object remained a dish with a base, large numbers being produced in Holland. It was used as a serving dish for pastry, sweets or fruit, and also as an important gift to an individual or corporation. The main works of the goldsmiths were, however, luxurious jugs and basins, which were now made thickish and rounded. There were also hel-

met- and pear-shapes, which were still found in the 18th century. Dutch goblets with very finely engraved decorations in the form of figures are masterpieces.

Mythological and allegorical scenes continued to be popular, often featuring chubby-faced children rendered in the style of Rubens. There were also Biblical scenes and genre pictures inserted into auricular work. The naturalistic floral decoration of the late Renaissance, which spread over the whole of Europe after 1650, was used in the Low Countries at that time as an alternative to abstract decoration.

Germany. Dutch influences penetrated here towards the end of the 16th century, but the goldsmiths' trade suffered during the Thirty Years War. Only after the Peace of Westphalia (1648) did Nuremberg and Augsburg recover. In the north of Germany, Hamburg, which had been untouched by the war, became an important centre; silver was exported from there to the Baltic provinces and to Sweden, where it influenced local production.

Heavy cylindrical or conical tankards with hinged lids became popular, the whole surface being decorated with hammered or cast decoration. During the last quarter of the 17th century the bottom of the tankard, originally flat, was rounded and set on three spheres. Spherical bases also appeared on goblets with engraved decoration. A new form of bottle also appeared at the end of this century, the pilgrim's bottle with a spherical bulge and a high neck. Another new container was a compact bottle with a screw top, which originated as an apothecary's bottle.

The 18th century was the heyday of silver, which exactly met the taste of the elegant and sophisticated society of the age. Dinner services sometimes amounting to 3000 pieces were made of silver. The dinner service consisted of a series of tureens, plates, dishes, trays, sauce-boats, salt cellars, containers for spices, vinegar and oil sets, mustard pots and wine-buckets, together with cutlery of all types, centrepieces for the table, fountains, and so on. Special services were made for travelling and hunting. Also made of silver were candelabra, girandoles, candlesticks, mirror frames, sets of andirons, clocks, writing and toilet sets, tobacco boxes, handles of sticks and sunshades, as

well as furniture. The new beverages, tea, coffee and chocolate, were the excuse for the development of new shapes; a series of jugs and pots, sugar-basins, cake baskets and similar objects appeared.

France. The court of Louis XIV became the model for all other European courts, and France assumed the artistic leadership of Europe. The leading Parisian artists, for example the architect Jean Lepautre and Jean Bérain, produced objects in gold and published engraved designs which were followed throughout Europe. The most famous goldsmith was Claude Ballin. He carried out major works for churches and the court at Versailles, particularly large dishes and vases with reliefs and sculpted decoration in the form of figures, and also silver furniture on the subject of the Peace of Ryswick.

The heavy forms current from the late 17th century until about 1710 were richly decorated with acanthus leaf-work, the edges with beading, egg-and-dart patterns or indentations. The combination of silver with enamel painting was also popular. Particularly large pieces and tableware were cast from clay and wax moulds and chased, the decoration often being stressed by engraving. As in the Middle Ages, silver figures were made by the *au coquille* technique, a process by which silver foil was beaten on to a solid core which had been constructed to the desired shape.

During the early 18th century, between 1715 and 1735, vessels assumed a lighter appearance. The new shape was very elegant, taller and swelling out in a full curve. Decoration instead of covering the whole surface was restricted to bands which contained a floral frieze or perhaps medallions, executed with restraint and discipline. The edges of dishes were scalloped. The most influential artist of the period was Juste Aurèle Meissonier, a goldsmith and architect who created some twelve hundred designs. The leading French goldsmith was Pierre Germain.

The largest number of works in silver was created in the Rococo period, between about 1735 and 1770, during the reign of Louis XV. Thomas Germain and his son François were court goldsmiths. Their works have sinuously curving forms, decorated with C and S scrolls and shell motifs. Jugs and soup tureens have spiral fluting; the edges of dishes are deeply scalloped. During the 1760s the handles of vessels were shaped in the form

of flowers or fruit, and the shell work was also combined with flowers or fruit. Elegant trifles, such as boxes, pots, cane tops, sewing sets, small bottles and so on, were exquisitely made. Great attention was paid to the extravagant tiny boxes which served as presents. The prices of these tiny *bibelots* were enormously high.

The late 18th century. Augsburg became the main centre of goldsmiths' work, though its craftsmen were completely under the influence of France. Many objects in silver were produced and exported to other parts of Europe, particularly Russia. The most famous German masters were called to Augsburg, in which about 190 goldsmiths worked in 1696; even by 1740 the number had risen to 275. These included Elias Adam from Zilchau, Salomon Dreyer from Elbing and Bernard Heinrich Weyhe from Osnabrück. Whole dynasties of goldsmiths settled in Augsburg, for example the families of Thelot, Biller, Busch, Meitnacht and Pfeffenhauser. The most famous was the Drentwett family, which was active from the 17th century up to the beginning of the 19th century.

Other important Baroque centres of goldsmithing were Vienna, Prague, Cheb, Dresden, Graz, Brno, Olmütz and Troppau.

In these centres, objects continued to be made in the Rococo style until the late 1770s, when France had already turned to Neo-Classicism. Under Louis XVI Classical forms dominated the applied arts. The court goldsmith was François Thomas Germain, the last of the important family of Parisian goldsmiths, who was followed by Robert Joseph Auguste, who worked from the etchings of De La Fosse, Lalonde, Forty and Salembier. Roman vessels found in Herculaneum and Pompeii served as models. The Classical shapes of the vessels were decorated with garlands, festoons, lions' heads, mascarons, rosettes and other ornamental motifs taken over from Classical Antiquity.

During the French Revolution much French silver was destroyed. Silver-plated goods from England began to be more popular than the goldsmiths' products: the emphasis was on simplicity and cheapness. The technique of hammering was replaced by pressed or punched work based on the English practice. Also in Germany, where Classicism did not arrive till about 1780, the heyday of German goldsmiths' work was over.

England. Here the art of the goldsmith has an individual history. Old silver has been used and collected for a long time, so that much has been preserved. England's growing wealth attracted foreign goldsmiths, many of whom came from France, particularly after the revocation of the Edict of Nantes (1685). The main centres were London, Birmingham, Sheffield, York, Exeter, Chester and Newcastle, and there were also centres at Edinburgh, Glasgow and Dundee, and at Dublin and Cork.

Queen Anne silver, produced from 1689 to 1727, is justly famous. It impresses through the simplicity and dignity of its shapes. Gadrooned edges usually formed the sole decoration, although acanthus leaves after the style of Lepautre were also used under the influence of immigrant French goldsmiths. The engraved arms or initials of the owner often appeared on the body.

Nearest to Continental silver in style was mid-Georgian silver (1727-1760). A representative of this style was the famous Paul de Lamerie, the 'Jamnitzer of the 18th century', whose works are decorated with Rococo ornamentation. However, the smooth, simple shapes characteristic of English work continued to be produced. Castors, open-work baskets and pastry dishes were popular.

Adam silver (1771-1800) took its name from the architect Robert Adam, who designed slim vases with lids, tea-caddies, ewers, dishes and tureens after the model of ancient urns. Typical are candlesticks on a rectangular base with a vase-like chalice for the candle. These candlesticks were manufactured principally in Sheffield. Neo-Classicism suited the English temperament and had a considerable influence on the work of Continental goldsmiths, particularly in Scandinavia and Portugal.

The 19th century. At the end of the 18th century, Sheffield and Birmingham flooded the European market with cheap, factory-made plated goods. The decline of goldsmithing was halted at the beginning of the 19th century, the period of the French Empire style and English Regency (1800-30). The elaborate court ceremonial of Napoleonic France called for more ambitious goldsmiths' works. This resulted in a rise in standards in France, and in the rest of Europe. Roman imperial art served as a model. Works in gold became more massive and splendid. French excavations in Egypt carried out during Napoleon's expedition likewise produced new inspirations. Leading goldsmiths included Jean-Baptiste Claude Odiot, Martin Guillaume Biennais and Robert Joseph Auguste. Designs for works in gold were prepared mainly by the imperial architects, Percier and Fontaine. Biennais specialised in dressing-cases and toilet sets, Odiot and Auguste in dinner-services. Many goldsmiths' works of the period were inspired by or named after historical events, for example the Trafalgar vases in the Victoria and Albert Museum in London, made as presents for the admirals after the battle of Trafalgar (1805).

The elements derived from Antiquity disappeared with the restoration of the Bourbons, and the first signs of Romanticism appeared; at the same time past styles began to be copied. During the 1830s the 'second Rococo' style emerged. The pictorial art of the 18th-century Rococo served as a model, its forms and decoration being recast in a new, superficially more splendid style which rapidly spread from France to England and Germany. Even at the beginning of the 19th century, Vienna had started to become an important centre of production of works in gold: a beginning had been made even in the 18th century, particularly by the Würth family. Viennese dinner-services in the style of the Rococo revival were to be found throughout central Europe and also in parts of western Europe.

During the second half of the 19th century, markets were flooded with cheap, pretentious products as a result of the introduction of electroplating and pressing. Works of artistic value were produced infrequently, though around 1900, a temporary revival of goldsmithing was brought about by the influence of Art Nouveau; the same influence was felt in silverwork. Characteristic was a naturalism derived from Japanese art, particularly evident in floral decoration.

Advice to Collectors

Gold and silver marks. Works made from gold and silver have the advantage of being provided with a mark which determines almost exactly the time and place at which the object was made. The most important aid for establishing marks is the four-volume work by Mark Rosenberg, *The Marks of Goldsmiths,* which first appeared in Frankfurt in 1889. Since then there have been many handbooks of one sort or another listing marks. However, there are also marks that have not been deciphered or published, and marks that are illegible. There are also objects which are not marked at all, usually because they were manufactured illegally or were products of court or monastery, exempt from guild regulations.

The most important and also the oldest mark, introduced in Paris in 1275 and in London in 1300, is the city sign or city mark, which guarantees the purity of the metal. It was struck in by the inspecting master of the guild to signify that the object had been tested. The test of the purity of precious metals can be carried out in two ways. In the rapid test, the object is rubbed over a black touchstone — siliceous schist is most suitable — and the mark is compared with the mark of touch needles. The whiter the mark, the purer is the silver. In the case of gold, the mark has to be dabbed with acid. Touch needles are small pins of varying purity in fixed grades of 10 grammes to 10 grammes or 5 grammes to 5 grammes. For silver there are, in most cases, 16 pins (160 grammes). There is a larger number of touch needles for gold because measurements are here carried out in steps of ½ a carat up to 24.

The second method, a laboratory test, is the assay of tapped metal or cupellation test. This is much more accurate. A zigzag line, known as the trembling mark, is drawn on the object with a graver, the object being to take up a small amount of precious metal. This is melted in a small dish, called a cupel and is thus freed of added metals. It is possible from the difference in weight before and after melting to establish the exact gold content and then decide whether the object was sound.

The city sign usually shows the arms of the city or its initial letters (see table). From about the 17th century the purity was also indicated, in most cases by the number 13 (for 13/16 fine silver). The year or period of years was indicated by a letter. Each letter represented the period of office of the chief inspector — in France and England from the 15th century and, in Germany, from the 18th century.

Apart from these inspection signs, the master's mark is often also stamped on. By these masters' marks, which were introduced in France, England and Germany in the 14th century and elsewhere in the 15th and 16th centuries, the master guaranteed the quality of his work. Most masters' marks are letters of names or houses marks. To prevent these marks being misused, each master had to stamp his mark with his signature into a metal plate in the town hall and the guild headquarters.

Other signs were sometimes used on an object. There were signs designating imported or subsequently repaired pieces, restamping for articles subject to duty which had already been stamped, receipt stamps as proof that the silver tax had been paid, tax stamps or exemption stamps for older works, import stamps for imported gold and silver works, and so on.

Galvanoplastic castings and copies. The invention of the galvanoplastic techniques rendered possible the casting of gold and silver works from earlier periods. Castings were also made of gold and silver treasures from archaeological finds, for example gold goblets from Vaphia and the Bernay, Boscoreale and Hildesheim finds. These castings were intended for the museums of applied art founded in the second half of the 19th century, and served as documents to sustain the efforts of museums and other bodies to revive first-class quality in applied art.

Copies of works by goldsmiths are very old. Even in the early Middle Ages, copies were made of coronation jewels, usually from cheaper material, these serving as emblems at burials of rulers and often also being

placed in their tombs. Copies were also made for reasons of safety in the case of valuable liturgical vessels which were displayed for prolonged periods in churches or processions. More recently, copies of historical works which are too valuable to be lent have been made for exhibitions.

Fakes and their characteristic features. Every object made from gold or silver has to be examined accurately, both stylistically and technically. The most important aid in establishing old silver is the mark, which rarely agrees in the case of fakes, because the forgers did not pay any attention to marks until 1889, when the first edition of Rosenberg's work appeared. And even after this, many forgers overlooked the marks, or (for example, in German works) the trembling mark. Where the object is not marked, or the marks are copied quite accurately, a thorough examination from the point of view of style must be made. Often the shape of the vessel does not agree with the decoration, or decoration involving figures contains inconsistencies in the subject-matter (for example, scenes with knights in the Baroque period), in the dress of the figures, in the rendering of the landscape or in the general stylistic idiom. In the second place, the execution of the work must be examined. On genuine hammered articles the blows of the hammer can be recognised and the metal is always at its thinnest where it projects furthest. Old cast works are uneven at the bottom, an effect produced by the sand mould. Moreover, they are soldered together from individual pieces, while forgeries are pressed from one piece. Finally, traces of surface wear have to be established, for forgeries lack patina; there is always something hard, sharp and new about them.

Preserving and restoring gold and silver. Objects made from gold and silver should be wiped lightly only with a flannel cloth; metal polishing agents should not be used for cleaning, since these can damage the decoration. It is consequently better to have silver which has become dull cleaned by an expert. This is carried out in baths so that the decoration does not suffer. Objects made from gilded silver or copper must be treated particularly carefully because the thin layer of gold can easily be removed when rubbing them.

318 Book cover with Calvary; silver-gilt with wire enamelling. Slovakia, beginning of 15th century

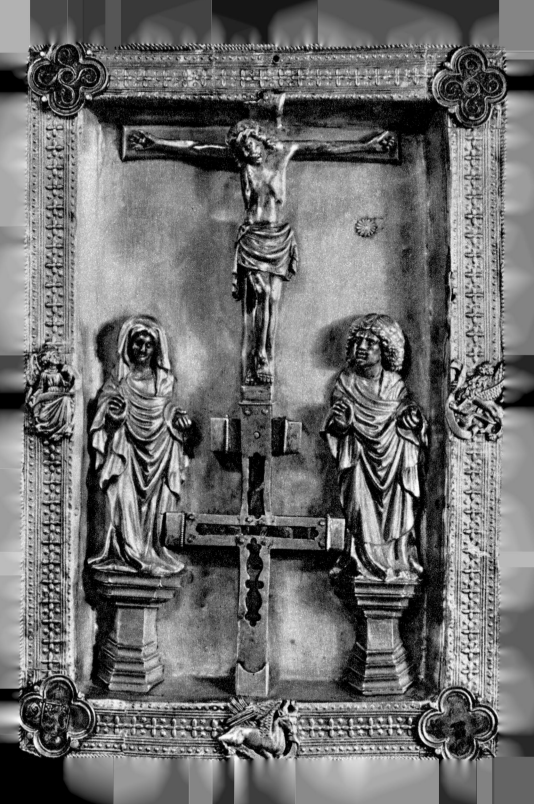

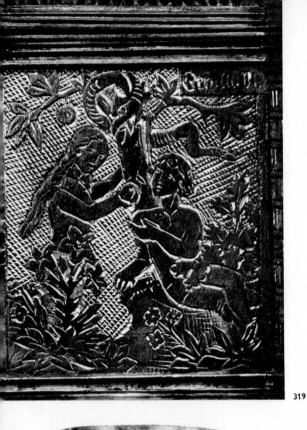

319

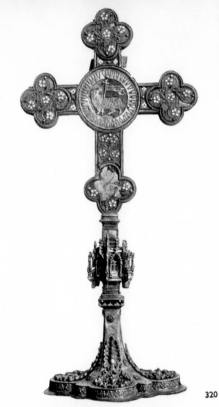

320

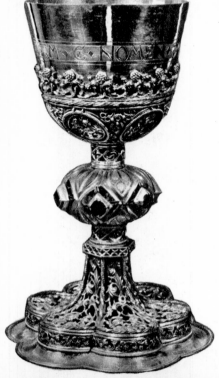

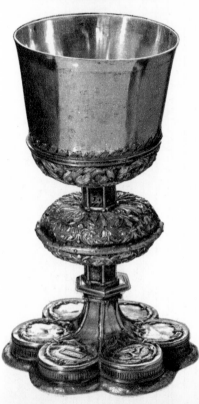

321 322

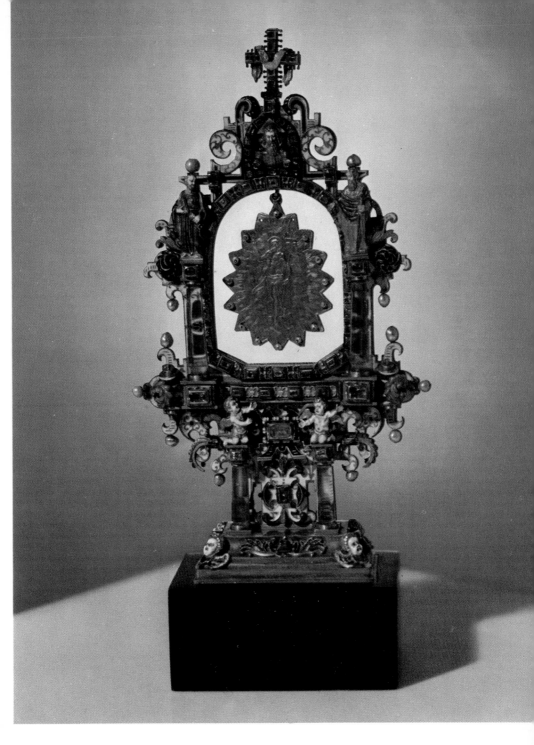

XLVII Gold altarpiece; decorated with enamel, crystal, emeralds, rubies and pearls. Southern Germany, first quarter of 17th century

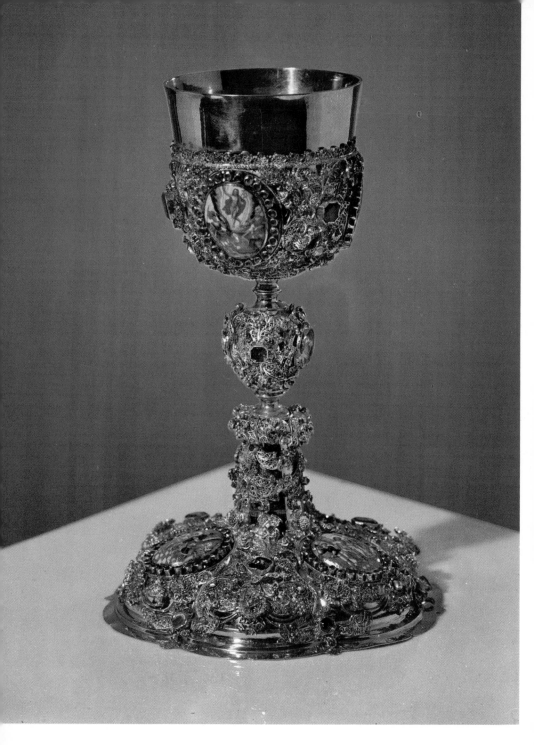

XLVIII Silver-gilt chalice; decorated with filigree, enamel leaves and semi-precious stones.
Johann Zeckel, Augsburg, 1703-5

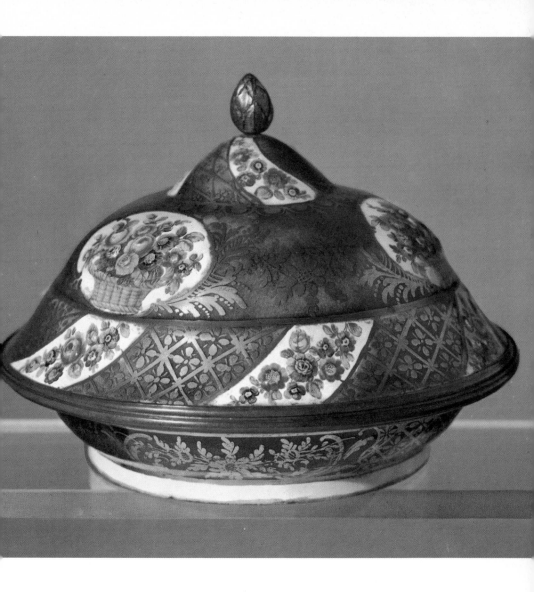

XLIX Enamelled lidded box. Vienna, 1771

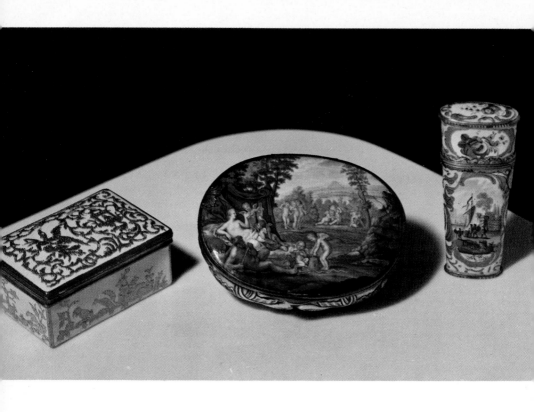

L White enamelled box with gilded Chinese motifs; Saxony, second half of 18th century.
Silver box with enamelled lid, after Francesco Albani; Dresden, 18th-century. Manicure box,
enamelled and gilded; Vienna, second half of 18th century

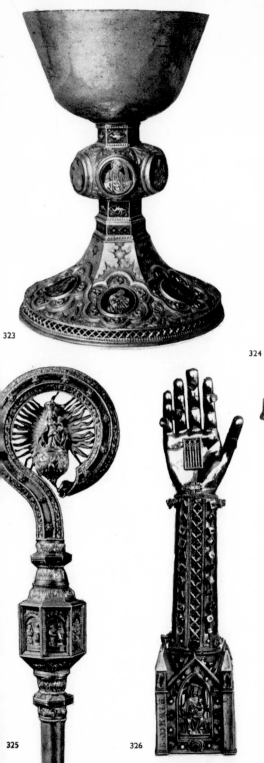

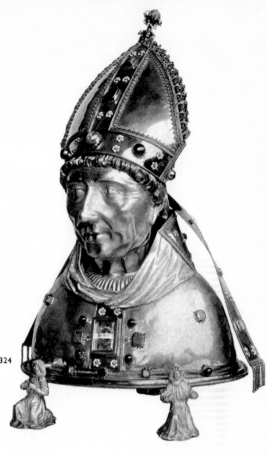

323

324

325

326

319 Ciborium, detail with Adam and Eve; copper, gilded. Slovakia, end of 14th century
320 Pacificale (back); silver-gilt with wire enamel decoration. Bohemia (?), 15th century
321 Chalice; silver-gilt. Slovakia, c. 1482
322 Chalice; silver. Bohemia, 1528
323 Chalice; silver-gilt with niello work. Bohemia, second half of 14th century
324 Reliquary bust of St Adalbert; silver. Meister Wenzel of Budweis, Prague, 1486
325 Crosier of Bishop Perény; silver-gilt. Hungary, 1526
326 Reliquary of St George; silver-gilt. Prague, c. 1350

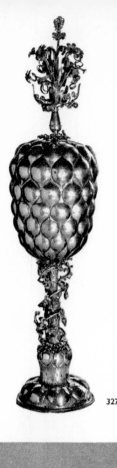

327

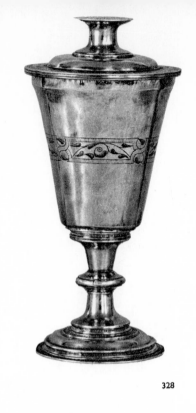

328

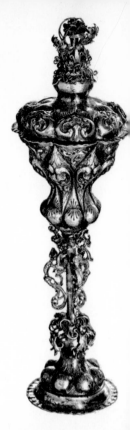

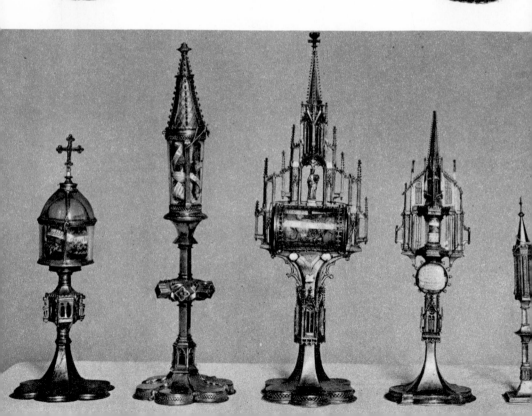

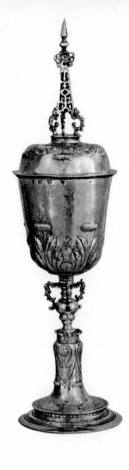

331

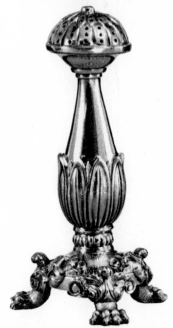

332

327 Grape goblet; silver-gilt. Germany, 16th
century
328 Communion cup with paten cover by
John Ions of Exeter; silver, c. 1570-80
329 Columbine beaker; silver-gilt. Bamberg,
1639
330 Reliquary monstrances of the Prague
Cathedral treasure; silver-gilt. Prague, end
of 14th-15th century
331 Steeple cup, silver-gilt, chased and
repoussé. England, c. 1625-6
332 Nautilus beaker; silver-gilt. Nuremberg,
c. 1580
333 Silver-gilt sugar castor. London hall
mark, c. 1816-7

333

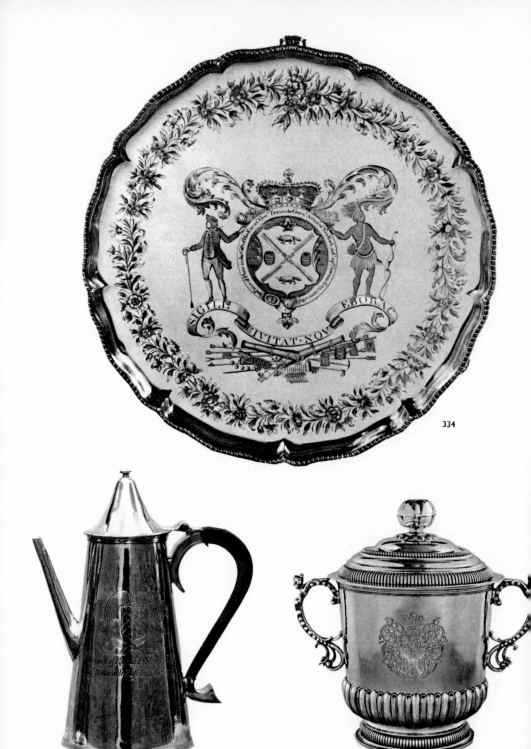

334

335

336

334 Salver by Lewin Fueter. U.S.A., 1773
335 Silver coffee-pot, London hall mark, 1681
336 Loving cup by John Coney. U.S.A., c. 1695
337 Lidded beaker; silver. Germany, second
half of 17th century
338 Tureen by Simon Chaudren. U.S.A.,
c. 1813

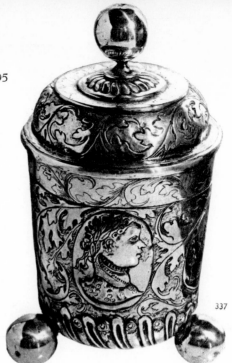

337

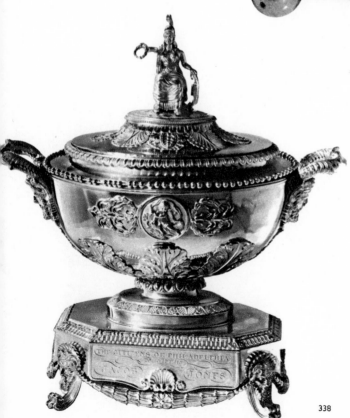

338

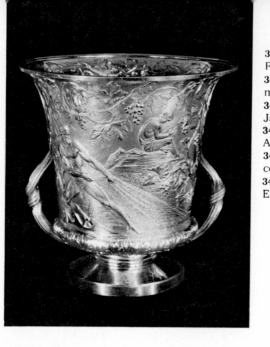

339

339 Theocritus cup designed by John Flaxman; silver-gilt, 1812
340 Chalice; silver-gilt. Southern Germa[ny] middle of 17th century
341 Ciborium; silver-gilt with enamel pla[te] Jan Pakeni, Prague, 1743
342 Crosier of the Abbot of Tepel. Joseph Aycher, Cheb, 1750
343 Sugar bowl; silver. England, end of 18th century
344 Silver salt cellars, mark of Paul Storr England, c. 1816-7

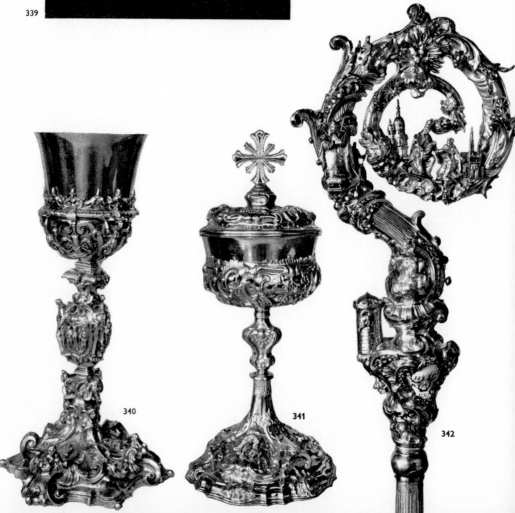

340

341

342

343

344

345

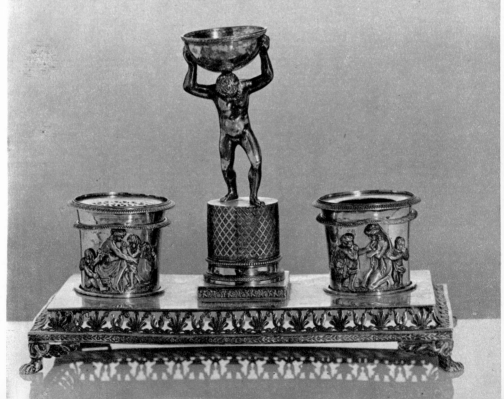

346

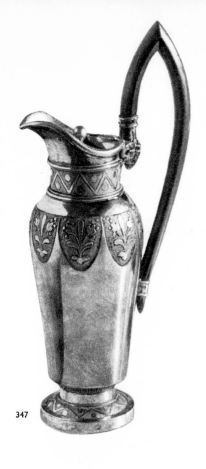

347

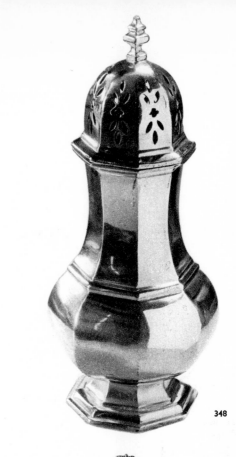

348

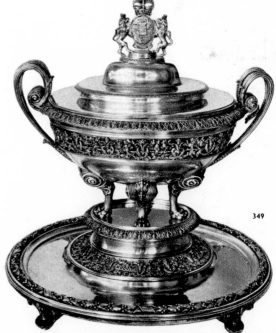

349

345 Sugar basin; silver. Spain, first
quarter of 19th century
346 Writing set; silver. Milan, 1810
347 Milk jug; silver. Vienna, 1807
348 Sugar castor; Birmingham,
1828-9
349 Tureen; silver, with the arms of
the Colloredo-Mannsfeld family.
Vienna, 1819

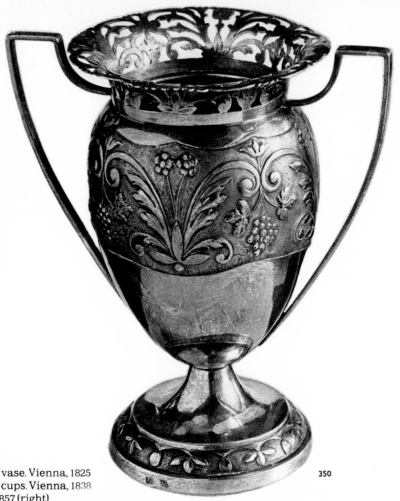

350 Silver vase. Vienna, 1825
351 Silver cups. Vienna, 1838
(left) and 1857 (right)

350

351

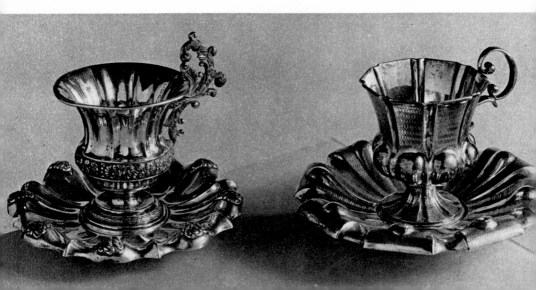

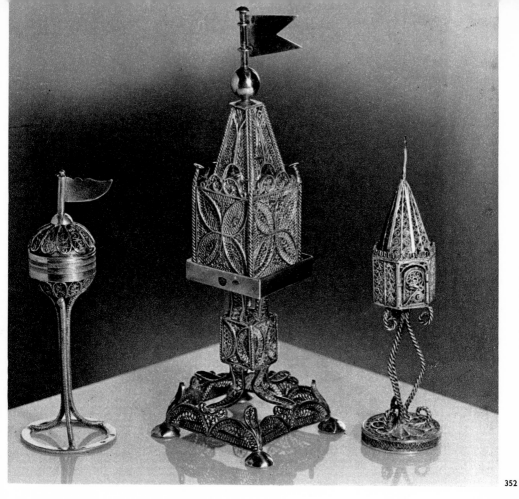

352

352 Three spice boxes made from silver
filigree. Prague, 1814, 1853 and *c.* 1830
353 Tea service; silver. Vienna, after 1838

353

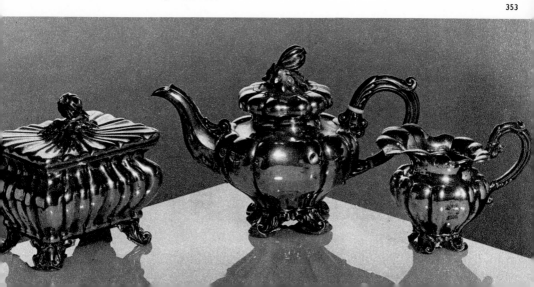

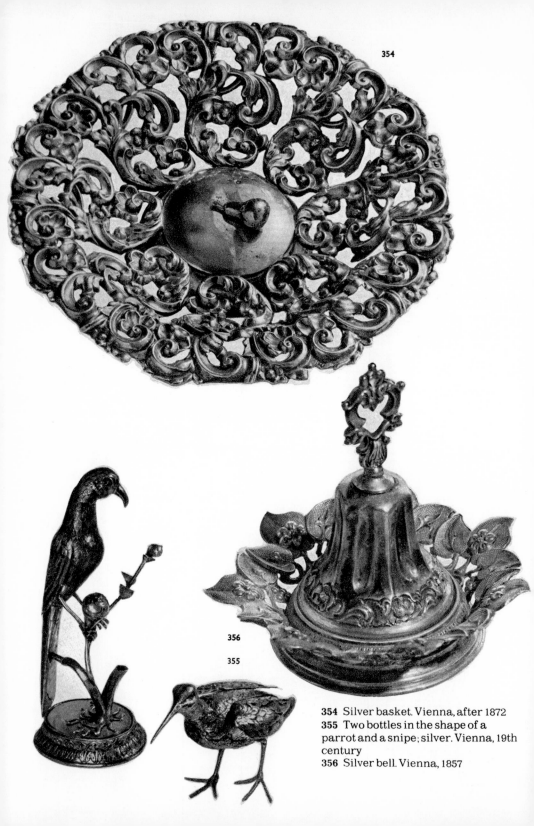

354 Silver basket. Vienna, after 1872
355 Two bottles in the shape of a
parrot and a snipe; silver. Vienna, 19th
century
356 Silver bell. Vienna, 1857

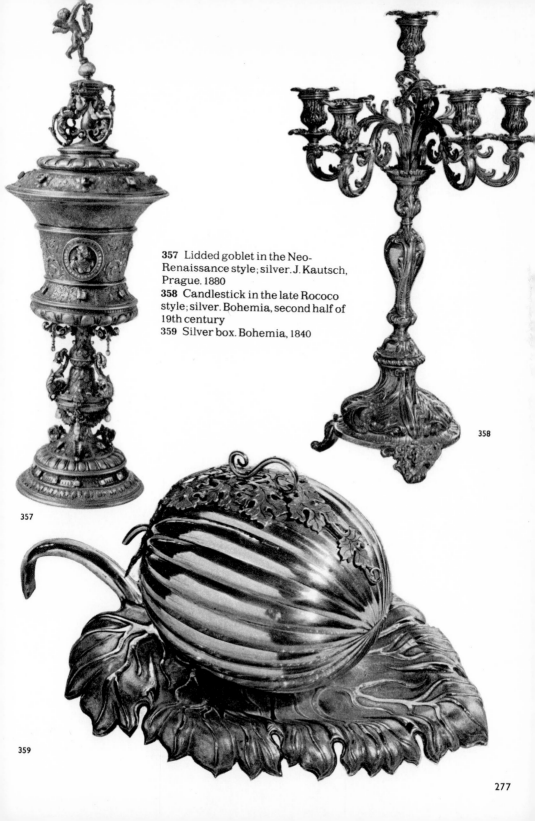

357 Lidded goblet in the Neo-Renaissance style; silver. J. Kautsch, Prague. 1880
358 Candlestick in the late Rococo style; silver. Bohemia, second half of 19th century
359 Silver box. Bohemia, 1840

357

358

359

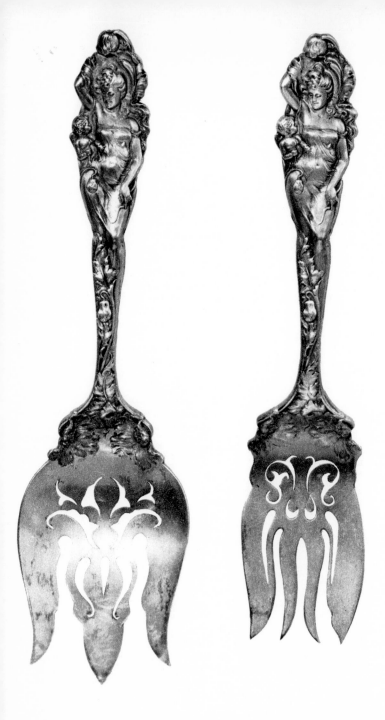

360 Art Nouveau serving set; silver-gilt. England, beginning of 20th century

The history of jewellery is as old as the history of humanity. The need for adornment, as is evident among primitive peoples today, is stronger than the need for clothing. 'Before clothing there existed jewellery' is the opening of one of the fundamental works on the history of jewellery.

Even in early times jewellery fulfilled various important functions, besides that of adornment. At some periods it served as an amulet or talisman; then again it was used to fasten a garment, shoe or belt, or to keep the hair in place. We can accordingly differentiate between symbolical jewellery and jewellery for the garment, the person or the hair.

In Antiquity it was above all in Egypt, Greece and Rome that the most important developments in the art of jewellery took place; their successors were Byzantium, and, in western Europe, the Carolingian Empire. The Carolingian era marks the beginning of the history of jewellery in western Europe. Charlemagne created conditions which enabled a new culture to rise, drawing upon the heritage of Classical culture and Christianity, and upon the creative power of the European peoples. This 'Carolingian Renaissance' greatly influenced jewellery. Earlier jewellery has survived only occasionally, but contemporary illustrations in books, panel paintings and from time to time sculpture provides information on its appearance and its use. The most beautiful examples of jewellery from the early Middle Ages originated in the regions of the Rhine and the Meuse; the most valuable women's jewellery comes from the clothes that the Empress Gisela is supposed to have worn at her marriage to Conrad II in 1027.

In medieval society only a select few could wear valuable jewellery. In Renaissance times it was more widely worn, and the aristocracy and upper clergy adorned themselves more richly than had been the case in the preceding period. Contemporary portraits, especially works by German masters, who faithfully rendered details of dress and jewellery in their pictures, have provided us with information. From these we know, for example, that several rings were often worn on one hand. During the Renaissance, precious stones and coloured enamel were much in vogue, and the pendant, the most favoured form of jewellery in those days, was richly ornamented in this way.

The 17th century was a turning-point for diamond cutting. The brilliant-cut which was devised, revealed the unique beauty of this undisputed king of precious stones. In the 18th century, delicate pieces of jewellery such as brooches, aigrettes and rings, in cluster, spray or bow form, were ornamented with glittering diamonds; in brilliantly-lit ballrooms, at great court receptions and on similar occasions these could be seen sparkling in their full splendour. In France, as well as in other places in Europe, sets of matching jewellery, consisting of necklaces, earrings, brooches, bracelets and occasionally tiaras, were produced, with diamonds taking a prominent place in the design. Cut stones were much in fashion in the Empire period and in the succeeding years; as jewellery became fashionable in ever-wider circles of society, new low-priced materials and new forms and pieces of jewellery were sought, which until that time had been little regarded. In the first half of the 19th century, new principles and newly discovered processes and techniques further enriched the jeweller's art, but the second half of the century brought stagnation and an uncreative preoccupation with the styles of the past. The decline of the old art of jewellery could scarcely be checked. But new tendencies arose, and fashion jewellery superseded the aristocratic jewel.

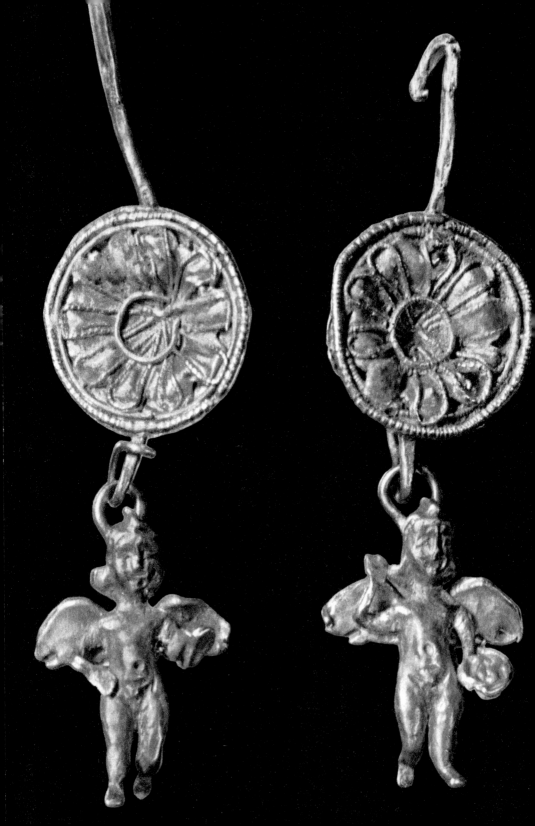

361 Earrings: gold with cupids. Rome, 2nd century BC

Manufacture

From time immemorial, the most varied materials have been used for the making of jewellery: both precious and base metals, precious and semi-precious stones, coloured enamel, pearls, coral, etc. The preference given to particular materials varied according to time and place, and thus can help to establish the provenance of a piece.

Metals. *Gold.* This is the most important metal used in jewellery. This shining, yellow metal, as a chemical element designated by the symbol Au (from the Latin word *aurum*), is the most malleable of all metals and can be beaten into gold leaf to a thickness of 1/800 millimetres or drawn out into a fine wire 3000 metres long and one gramme in weight. Gold is unusually resistant to the effects of exposure to air and acids, and is only soluble in solutions containing chlorine, particularly in *aqua regia* (one part nitric acid to three parts hydrochloric acid). As it is soft in its pure state, it is mostly alloyed with other metals. The metal used as an alloy determines the colour of the gold. With copper, red gold is obtained; if gold is alloyed with silver it is yellow; and if it is mixed with nickel or palladium the result is white gold. Since the 19th century the gold content of the end-product has been stated accurately, and currently it is expressed in thousandths. 1000/1000 signifies pure gold and corresponds to the earlier term '24 carat'; in this connection it must be noted that carat is not here an indication of weight, as with precious stones, but of gold content. As a metal to be processed it is mostly 14 carat gold (585/1000 standard) and 18 carat (750/1000 standard) that are used. In pieces of jewellery which must not be damaged, the approximate standard of the gold is established by assay scraping. A black flint stone is used as a touchstone to scrape the surface of the alloy to be tested. The colour of the scrape is then compared with similar streaks made by metal touch-needles of known composition. To achieve more precise results, time-consuming laboratory investigations are necessary. For the production of cheap jewellery, gold is often replaced by rolled gold, a base metal -

usually a copper alloy - with gold welded on to it.

Silver. This white shining metal, written as Ag in chemistry (Latin *argentum*), is harder than gold and, after it, is the most ductile precious metal. Silver does not oxidise and remains unaltered in pure air; but hydrogen sulphide in the atmosphere, phosphorus and phosphuretted hydrogen discolour its surface.

Silver is also alloyed with other metals for the production of jewellery, in particular with copper (10-20 %), and the standard is currently also quoted in thousandths. Silver testing is based on a principle similar to that already described above for gold, and in practice an alloy of 900/1000 and 800/1000 standard is used.

More recently, cheap jewellery has sometimes been made from Alpaka (plated German silver), a copper-nickel-zinc alloy with the appearance of silver.

Platinum. Since the 19th century this, the most expensive precious metal, which was discovered in the 18th century, has occasionally been used in the production of jewellery. On account of their high price, platinum alloys are chiefly replaced by white silver, which is the metal that most closely resembles them in appearance.

Much use has also been made of base metals in the production of jewellery. This has been so wherever precious metals have been scarce or dear, for instance in prehistory, folk art, etc.

Techniques of ornamentation. In addition to the techniques generally found in metal processing, such as engraving, embossing and chasing, other methods of ornamentation are used in the manufacture of jewellery and are characteristic of it. Filigree and granulation, already known in prehistoric times, are among the oldest of such techniques.

Filigree. This is the use of elaborate work in thin, twisted wire, which is either soldered into designs on a base of the same metal, as

in earlier periods, or worked into an interlaced mesh without any base and with only the points of intersection soldered together. Filigree settings were very popular in some periods. Silver filigree was especially preferred; gold filigree was used less often. In the Middle Ages, for example, church vessels and even valuable bookbindings were very frequently decorated with filigree. In a few regions, filigree jewellery still enjoys great popularity, although there are great differences in the quality of craftsmanship. Even modern mass-produced articles are occasionally decorated with filigree.

Granulation. To heighten the impact of his products, the goldsmith of the past used gold and silver globules soldered on a base of the same metal — thus gold on gold, silver on silver — which often form very effective ornaments. This technique, known today as granulation, increases the interplay of light and shade on the piece of jewellery and brings it to life.

Niello. This technique was practised by skilled goldsmiths for hundreds of years. It consisted of a black metal inlay on a lighter metal base with engraved or etched indentations. As a general rule, silver was used as a base; the inlay was of silver, copper, sulphur, lead and the like, fused together according to specific recipes, and the inlays of different periods and cultures can be distinguished by colour and composition. Thus, according to Pliny, silver, copper and sulphur were used in Classical Antiquity. Lead must therefore have been added in the Middle Ages. Down to modern times, goldsmiths habitually kept secret the mixtures and processes they used. Pieces from the Russian town of Tula, where niello was much used in the 19th century, came to be known as Tulaware; they became popular in central Europe.

Inlay. This technique was imported into Europe from Asia. Objects and jewellery of base metals (iron, steel, bronze), less often of gold and silver, were engraved, and then gold, silver and occasionally fine leaf were inlaid and the decorative metal hammered firm. This method of ornamentation may have originated in Damascus and from there reached Byzantium and central Europe. It was brought to Spain by the

Moors, and Spanish weapons and armou especially were beautiful inlaid. The Japa nese and Chinese made exquisite inlay Gold-inlaid silver jewellery and silver inla on gold products appeared early in Euro pean history; occasionally a show-piece i precious metal would be inlaid with a bas metal filament of another colour.

Precious stones. Prehistoric man used pre cious stones as jewellery, and there has pro bably never been a period in history whe men have not found pleasure in the colou and refulgence of minerals. Of all nature' mineral creations, precious stones are un surpassed for hardness, purity, beauty o colour and manifold refraction of light. The are classified on a scale of hardness; the dia mond alone reaches the highest grade, 1(which the Greeks named the invincible, 'Ad amas'. Stones of the degree of hardness from 9 to 7 were formerly usually described a genuine precious stones, the softer stones a semi-precious or jewellery stones. Indeed i is not always possible to define semi-pre cious stones in exact terms, since not onl beauty and hardness but also rarity value are criteria. Until recently there has been n uniform standard of assessment. In the hardness scale worked out by Friedric Mohs, the diamond is followed by the ruby and the sapphire with a grade of 9, by cat' eye, alexandrite, chrysoberyl, spinel, emer ald, aquamarine and topaz with 8, amethyst hyacinth, tourmaline, garnet, citrine, smoky topaz (cairngorm) and rose diamond with grade 7, and other coloured or transparen stones. In more recent times the carat ha been the unit used as a measure for preciou stones; this, in contrast to the precious meta carat, represents a weight measure of 20(milligrammes, that is, 1/5 gramme.
Before setting, the surfaces of the rough stones - which have been taken from the ground - are treated; and only then is their true beauty revealed. There are two main methods, grinding and cutting, both of which can be performed on one specimen.
Grinding considerably enhances the decor ative effect of the precious stone. Interplay of colour, refraction of light, lustre and shape are only fully brought into being by this means. The lapidary must know the nat ural structure of the crystal, he must res pect the system on which this rests and strive to accentuate the particular charac

er of the stone. In deciding which kind of grinding is the most appropriate, he must also pay special attention to the colour shading of the stone.

Engraving. This was practised by the peoples of all ancient civilisations. The art of engraving gem stones was highly advanced in Greece as early as the 6th century BC, and later also became popular in Rome. Proficiency in this small-scale art reached its zenith during the early Classical period with the gem-intaglios (deep-cut pictures) and with cameos (raised pictures in high or low relief). The Middle Ages succeeded to the inheritance of Antiquity in this as in other branches of art and craft work; but medieval craftsmen soon went their own way, using cut stones for the ornamentation of church vessels and church books, and as show-pieces on the vestments of priests. Aristocratic ladies wore antique jewels and cameos as dress fastenings or, set in precious metal, as medallions and the like. In the Middle Ages, as in Antiquity, men of rank frequently wore a signet ring with their crest cut in intaglio. Glyptic art flourished in the Renaissance period, and numerous well known artists of the period created works of lasting value in precious stones.

Polishing and faceting. While the art of stone-cutting had already reached its zenith in Antiquity, the grinding of precious stones developed more slowly from modest beginnings, and was much inferior to the glyptic of the Classical period. The simplest form of precious-stone grinding, and one already practised in Antiquity, was the cut en cabochon, a process by which the upper side of the stone was domed through polishing and the under side was originally only roughly finished, so that the structure of the stone was recognisable and its size was altered as little as possible. Later, the under side of the stone was mostly smoothed flat, as is still usual today. High-domed stones are called cabochons. In the Middle Ages cutting en cabochon was the only form of cutting; today, generally speaking, it is only the transparent or semi-transparent stones that are finished in this way. In the 14th and 15th centuries the table-cut came to the fore; it is particularly suitable for the octahedron diamond crystal, and allows it to retain its

elliptical form and almost its full size. The faces of the octahedron, the natural form of the split diamond, are polished and the edges are partly rounded. The natural shape of a precious stone is pointed and, in the case of a normal diamond crystal, it is pyramid-shaped. A few rare specimens from the times of the Barbarian migration are so shaped, and this was achieved by the cut en cabochon.

In the 15th and 16th centuries, when water-powered grinding mills were already in use and diamond dust (diamond bort) was used with oil for processing, the facet-cut came into being. It was Louis de Berken of Bruges, the lapidary of Charles the Bold of Burgundy, who first established that finely pounded diamond dust was the best material for cutting, and it was thus he who made possible the real development of the diamond-cut. With the help of his new method, he succeeded in applying the facet-cut (used in the West for rock crystals as early as the 14th century) to the hardest of precious stones, diamonds. In this way he developed to the utmost one of the most important qualities of that stone, its capacity to refract light. (No other gem possesses this quality in equal measure.)

The facet-cut was universally adopted, and different forms developed. Besides the faceted table-cut, used especially on fine stones, and the cone-shaped pointed stone, there is the table thin-stone, with the upper as well as the lower point for the most part ground down and having eight or sixteen facets (with blunted corners). For the table thick-stone, slight cutting of the under side of the octahedron is typical. This led to the development of the step-cut, which was particularly suitable for coloured stones, as the peculiar arrangement of the facets of the under side strengthened the reflection of the light and thus enhanced the whole effect. With the step-cut there were two and sometimes even three steps of facets in the upper side and, in the lower, four to six or indeed even more.

In the 17th century, during which the diamond became the most valued gem, the famous diamond cutters of Amsterdam or Antwerp devised the rose-cut, which probably evolved from the basic shape, the pointed stone. The regular rose, rosette or rhomb is a round stone with a diameter twice its height. In its simple form the rose has six + twelve facets, the 'Dutch or Bra-

bant rose' six + eighteen, and the French 'rose recoupée'twelve + twenty-four.

By 'rose diamonds', which were very popular, particularly in the 18th century, we understand very small rhomboids: it took more than a hundred small stones to make up one carat. The design of the table thick-stone and the encouragement of the chief minister of France, Cardinal Mazarin, to experiments in stone cutting were the starting-points of subsequent trends in diamond cutting. Both the pavilion (the upper side, the crown) and the collet (under side) were richly faceted. Around the year 1700 the Venetian lapidary Vincenzo Peruzzi is supposed to have fashioned a 'treble diamond' for the first time, its crown consisting of 32 facets in 3 rows (besides the table-upper facet) and its lower pavilion of 24 facets (besides the collet-under facet). If the pavilion and the collet are in tha ratio 1 : 2 the refracted light with its myriad reflections gives the stone sparkling brilliance known as *brilliant-cut*. This revealed the unique character of the diamond, and was the forerunner of such modern, highly complicated methods of cutting as the *star-cut*, devised by Caire, which requires a great height of crown and collet and guarantees a maximum use of the raw material. The *scissor-cut* and the American *brilliant-cut*, which enjoy great popularity today, also originated from the standard form of brilliant-cut.

As should now be clear, the brilliant is produced from the rough diamond through a special cutting process, and it is not a special type of natural diamond, as is sometimes erroneously assumed.

The brilliant-cut yields smooth faces (facets) and brings out light refraction, beauty of colour and the brilliance of the precious stone. A different kind of cut, however, is used for opaque gems, which have a beautiful interplay of colours; they are not facet-cut but domed. At times, coloured gems of the first order, particularly rubies and sapphires, are also treated in this way. Such stones are either given a rounded surface on both sides or else the under side is finished with a smooth table-cut. Occasionally the under side is also hollowed - 'beaten out' - which improves the reflection of light, brightens the stone from within and is particularly effective with transparent specimens; sometimes the domed surface is flatly faceted at the rondiste (belt, rim).

Garnet jewellery. Certain types of jewelle can only be developed in special circur stances. Garnet jewellery, made famous Bohemia in the last three centuries, belong to this category. That the fiery blood-red ga net stones were already being systematica ly extracted in the 16th century is know from written sources; moreover, reference to the deep red Bohemian garnet as a stor used in jewellery occur in the Middle Age The actual 'garnet technique' first came in use in the 18th century, and was applied on large scale in the second half of the 19th cel tury. In this method of production the met mostly gold plate on silver, forms only an i visible base, and the cut garnet stones con pletely cover the surface of the piece of jev ellery. Bohemian garnets rarely exceed mm. in diameter, and even specimens of mm. are quite expensive; therefore whe larger stones are required the Bohemia garnets are supplemented with dark red a mandines, imported from India, or with T rolean garnets of violet-red tint, which hav the characteristic brownish black 'plume arising from the process of crystallisatio All methods of cutting are used with garnet from the simple table-cut to the comple brilliant-cut, and the stones are mounted ac cording to need. Sometimes the box settir is used, sometimes riveted claws or sma balls. In the 19th century, Bohemian garne were often combined with pearls.

In earlier times it was particularly the sta or rhomb-shaped brooch and the garne string of several rows which enjoyed gre popularity; in addition, medallions, brac lets, earrings and rings were produced. the 19th century, matching sets of garne were favoured; these included necklace bracelets, brooches, earrings and rings.

The most beautiful Bohemian garnet jewe lery known today was worn by Ulrike von L vetzow, a woman greatly admired by Goeth in his old age. The collection was finished 1820 and had 448 garnets; it consisted of five-stringed rope, earrings, a brooch, tw bracelets and a ring. They are kept in th Trebnice (Trebnitz) museum in Bohemia.

Imitations of precious stones. Even in a cient Egypt and Rome efforts were made t replace the rare and costly precious stone with more moderately priced imitation There are several possible ways of imitatin expensive stones. One lies in the setting an

ounting, whereby a stone of the second or third order can be so presented that it looks like a flawless, valuable piece. Furthermore, skilful 'treatment' of genuine stones can give them a colour and lustre other than their own. The brilliance of the colourless transparent diamond was enhanced in earlier times, for example, through light-reflecting foil, and similar effects were obtained with coloured precious stones. The Renaissance goldsmith and sculptor Benvenuto Cellini boasted that he could produce excellent foil that was capable of significantly enhancing the interplay of colour in gems. Today this type of imitation is less frequently found, as it is just those stones that are dearest and consequently well worth imitating, that is, the specimens 'à jour', that are mounted on the rondiste only, and this practically rules out the use of foil. Attempts to produce imitations of large diamonds, emeralds and rubies, the most expensive of all precious stones, by sticking together two stones, began very early. Three kinds of 'doublets' are known: those which consist of two genuine stones, the one used as the under part being largely of inferior quality; those of which the upper part is a genuine stone but the under part is of a cheaper mineral, such as rock crystal or glass; and those of which both parts are false. Examples of the last type were produced with great skill in the East, with the upper part hollowed out and filled with coloured liquid before being fixed to the base.

We consider as true copies all those stones which are supposed to represent precious gems of fine quality on account of their being of like colour. With some types of stone the colour can be embellished through heating. For example, the yellow topaz becomes light red; and it is especially interesting that dull blue sapphires become crystal clear with heating and are used as false diamonds.

It remains questionable whether it is right to use the word 'imitations' for artificial stones. These have grown and crystallised from the same component as their natural 'brothers', but in a laboratory, under the supervision of a chemist, instead of in the layers of the earth. The artificial are of the same substance and hardness as the natural minerals, and do not differ from them in refraction of light, interplay of colour or brightness. Only rarely can even the scientist recognise whether the ready-cut gem has rested for thousands of years as a rough stone in the earth or has recently left the laboratory. Over many centuries humanity has dreamed of manufacturing precious stones and has sought to probe this secret of nature. Only in the last century has the necessary knowledge been available, and much is a result of work in this field carried out in particular by French chemists. In our century the crystals of many a mineral are factory-made, and serve not only as stones for jewellery but also play an important role in modern technology.

In all periods glass paste has been used as an inexpensive substitute for precious stones. This variety of glass is distinguished by its high capacity for light refraction; and so, when cut it adds sparkle to beautiful colours. It can at times - if coloured with metal oxide - be used in imitation of coloured jewels, and at other times - if colourless - replace diamonds in cheap jewellery. Nowadays imitations of precious stones in glass are mainly of paste, a colourless glass flux or green silica, iron oxide, aluminium oxide, calcium and sodium hydroxide, which were mixed and fused for the first time by the Viennese goldsmith Joseph Strasser in 1758. This substance was so good for cutting that after a cursory inspection the paste stone might be taken for a real diamond. Due to their high refraction of light, artificial brilliants of paste or glass, with the addition of thallium, resemble real brilliants; but they lack other important qualities such as hardness, so that after long wear the signs of use can hardly be concealed and the sparkle is dulled with age. Stones of coloured glass and paste have been very popular in the last two centuries, chiefly as material for fashion jewellery; notable artists in France, Germany and elsewhere have recently devoted themselves to the problems raised by the imitation of precious stones, using glass as a medium on a scale hitherto unimagined.

Determining the genuineness of precious stones. As pointed out above, this is not an easy matter. Even the eye of the most experienced connoisseur may be deceived. Neither colour, nor lustre, nor refraction of light are absolutely certain bases for an assessment of a stone. At first sight it is only possible to establish whether the stone in question is transparent, translucent or o-

paque, and of specific colour or brilliance. A more exact determination nowadays requires complicated instruments, for the availability of synthetic materials renders the magnifying glass of old quite inadequate: a polarisation microscope now has pride of place.

The setting of precious stones. Just as the right frame completes a picture and enhances its general effect as an indivisible whole, so the appropriate setting enhances the beauty of a precious stone. As early as the Classical period, precious stones were set, that is, lastingly joined to metal. And throughout history precious metals have nearly always been used in the setting of jewels; on the rare occasions that base metal has been used, appropriate surface treatment has been employed to give it an appearance of value: copper, for example, was gold plated. Basically we can differentiate two types of setting, of which the older *box setting* was already known and commonly used in the Classical period. The stone cut *en cabochon,* its upper side domed and its under side ground flat, was inserted into the little frame made for the purpose; this consisted of a metal base with a thin strip of the same metal soldered on to it around the edge. The medieval goldsmith adopted this method of setting; he fashioned the metal according to prevailing taste and his own skill, making it sometimes simple, sometimes ingenious, elaborate and original. Thus the upper edge of the metal strip forming the border was ornamented at times by soldering small balls, grains or filigree on to it; at other times it would be artistically cut out in the form of a leaf or ornamented with scroll-work. In the late Gothic period and during the Renaissance, enamelled borders came into fashion, and they remained popular in expensive jewellery until the 18th century. The box setting permitted all kinds of improvements which also enhanced the appearance of the less pure or colourful stones. The most effective way to embellish a stone is to use an appropriate base. The application of a black pigment helps to cover up cloudiness and flaws in the stone. The use of foil has proved even more effective; little metal rods are used which operate as mirrors, reflecting the light. Fragments of brightly coloured silk were also used, giving the coloured

stones more radiance and greater lustre. Even today coloured stones and opaque semi-precious stones are often set in this way.

In addition to the box setting, the *à jour setting* came into fashion at the end of the 10th century; here the base plate was omitted and the stone remained open at both sides. This form of setting was particularly popular after the discovery of the brilliant-cut, as the holding device was confined to a metal ring with grains, which did not detract from the main effect of the stone. The *à jour setting* remains basically unchanged today, as flawless stones of beautiful colour and intense fire really need no additional emphasis.

In the history of jewellery, pre-eminence was given now to the setting, now to the gem itself, depending on the sensibility of a particular period. Down the centuries the basic principles of precious stone setting remained unaltered, and today we are dealing merely with varations of age-old types, some more, some less attractive.

Enamel. Even in prehistory, coloured enamel was used to ornament jewellery made of metal, and many ways were known of making use of the decorative effect of coloured glass flux.

Enamelling is the term applied to the process of coating and annealing metal surfaces either wholly or partly with glass flux. There are three kinds of enamel: the colourless base, called the fondant, and the transparent and the opaque glass frit. In the enamelling itself there are different techniques and methods of processing. With *cell-soldering* (cloisonné enamel), wire or metal strips are soldered on to a metal surface and the cells thus formed are filled with the glass flux. After the firing the whole surface is ground smooth, so that the metal and enamel are flush and the design is accentuated by the metal. This method of enamelling is used especially in the East. The foundation is most frequently of gold, less often of silver or copper; first the fondant (a colourless transparent enamel) is fused on to the base, then the various colours are applied, and finally it is coated with fondant, as a protective and glazing medium. Closely related to cell-soldering is *wire-enamelling,* where the wire projects so that the surface is not flush. This form of enamel is typical of traditional Rus-

sian and Hungarian jewellery. In central Europe preference was given to *champlevé* enamel: cavities are recessed in the metal base with the help of the engraving tool and are then filled with the glass flux. Copper or bronze frequently form the metal base; gold and silver are less usual. The surface of the object thus enamelled is ground smooth and is flush, as with cell-soldering. If the base is of precious metal, preference is given to transparent glass flux, so that the colours may be influenced by the base. To enhance the depth of colour and the effect of the transparent enamel, gold foil is chosen for red and yellow tints and silver foil of high quality for blue and green. If the foundation is of base metal, such as copper or bronze, opaque coloured enamels are more frequently used. The colourless frit is given colour with metallic oxide, and this produces transparent enamel. If it is desired to obtain opaque glass flux, tin-ashes - wholly unfusible - are added and the colourless frit turns white. All transparent coloured enamel is made opaque through blending with the white enamel thus obtained. What is known as *mixed enamel (émail mixte)* - executed with great perfection and artistic sense in the Middle Ages in the Rhineland and the Meuse-Moselle region - entailed the subdivision of large cavities with metal wire. Recently, *à jour enamel,* in which the metal base is omitted and the glass flux completely fills the spaces in a wire filigree, has again enjoyed great popularity, and the *silver solder* is very effective. The design is engraved as flat relief in the silver base, and is then completely coated with transparent glass flux. In the raised parts of the relief the silver shines through more strongly, while the enamel collects in the deeper parts and is darker. With this process the light and shade effects of the relief work come fully into their own. 15th-century Italian goldsmiths were great masters of this technique. With the process called *'basse taille'* - used mainly in France - independently mounted or round parts are fully coated with a layer of enamel.

By *over-laid enamel (émail en ronde bosse)* we understand an object that is cast or embossed, and wholly or partly coated with transparent or opaque glass flux, so that a coloured enamelled moulding results; reliefs, too, may be enamelled in this way. With *painted enamel* - which enjoyed a period of great popularity in 16th-century Limoges - the metal plate is used only as the foundation for painting. The finished plate - frequently of copper, but also of iron, silver or gold - is first completely coated with a transparent flux or an opaque layer of enamel of one colour. Opaque glass flux is used as enamel colouring almost throughout, and this is applied to the base with a sable brush; the colours are fused on, one after the other. But as the colours often differ in shade before and after firing, further painting and firing can hardly be avoided. The reverse side of the plate was also mostly coated with a layer of enamel *(contre-émail)* to prevent the distortion of the metal base in the firing.

The process described above must not be confused with enamel painting, in which use was made of pure metallic oxide colours, chiefly on a white enamel foundation over a ground of gold, silver or copper. This technique also allows the smallest details to be rendered with the greatest accuracy, and it has therefore been found very suitable for the painting of miniatures.

The combination of different enamelling techniques makes it possible to achieve wonderful results in gold and silver work.

Other materials. In addition to metals, precious stones and coloured enamel, other materials which are likewise predominantly of natural origin are used. Among those most frequently encountered are sea and river pearls, coral, ivory, tortoiseshell, mother-of-pearl and amber.

Real pearls. These are the most valuable products of the sea, and their beauty equals that of precious stones. Pearls too were set in precious metals from very early times; they were worn as jewellery and have always enjoyed great popularity. The most beautiful examples are the pearls which are fished near the coasts of Ceylon, which have as special features a light silvery lustre without an iridescent sheen. Oriental pearls are generally held in great esteem, and often have a soft yellowish sheen, while those from America are rather bluish; but there are also rose, reddish and black pearls.

Not only the colour but also the size and shape determine the value of a pearl. Large, perfect, ballshaped pearls are called round pearls and are sold individually. Especially

large, beautifully formed pearls are called paragon pearls, while angular, mis-shapen pearls are called monster pearls. The latter were much used in the Renaissance and later as parts of animal and human shapes in skilled handicraft work on account of their fantastic shapes. Finally the very small seed pearls, which are sometimes no larger than a grain of corn, were used in women's clothing. Pearl embroidery was especially popular in the 16th century. In addition to the pearls mentioned, there are oval, pear-shaped and irregular, angular specimens, which are called Baroque pearls. As nature produces the finished pearl, little remains for man to do. Whole pearls are pierced, threaded one after another on a string or worn as ear pendants. In addition to the real pearl oyster *(Meleagrina margaritifera),* which lives in the sea, river pearl oysters*(Margaritana margaritifera)* also produce pearls, which are mostly smaller than those of the sea oyster and inferior to it in beauty and value. In the 17th and 18th centuries the rivers and streams of central Europe (for example, the Moldavia and the White Elster) still offered a plentiful yield.

Cultured pearls. The generally known fact that the pearl oyster surrounds a foreign particle such as a grain of sand or a small animal with layers of a shell substance (mother-of-pearl), thus forming pearls, has for a long time tempted men to stimulate the pearl oyster to such activity artificially and to obtain cultured pearls. At the end of the 19th century Japanese half-pearls came on the market; the other half, not formed of mother-of-pearl by the pearl oyster, was completed artificially. In the 20th century, Japanese and Chinese cultivators in particular succeeded in obtaining large quantities of pearls by artificial means; these look like natural pearls in every respect and cannot be distinguished from them with the naked eye. As cultured pearls do not realise nearly such high prices as real pearls, the nucleus and substance of a pearl on offer is tested with scientific instruments.

Artificial pearls. By contrast, imitations in glass, produced in various ways, are comparatively easy to distinguish from real pearls. The kind of artificial pearls most frequently found are either blown out of clear glass tubes and coated inside with pearl essence (white fish scales in a thin glue solution), or made of various forms of glass paste. Those known as Roman pearls consist of small alabaster balls which are first soaked in wax and then in pearl essence; however, they lose their beautiful appearance after long wear.

Coral. Another product of the sea that has long been used as jewellery is the rock-hard skeletal ridge of the coral *(Corallium rubrum Lam.).* In its natural state, coral is a type of polyp, up to half a yard high, found in the depths of warm seas, and consists of little trees of red, irregular branch formation firmly attached to rock. There are wide variations of colour, from light pink shades to dark blood-red specimens; here and there even black or white coral may be found. At one time dark red pieces were bleached with peroxide to cope with the whim of fashion.
The raw material is processed in various ways: either it is left as far as possible in its natural, picturesque, branching form, and only lightly polished, or it is shaped into lenticular, spherical or rod-like beads, pierced and threaded into a necklace or left unpierced and mounted like a gem in precious metal. Coral is also used as the raw material for small carvings or relief work. Genuine coral, like real pearls, is often imitated in glass.

Amber. This too, a conifer-resin fossil thousands of years old, comes from the sea, and the waves of the Baltic wash pieces of amber on to the shore with every storm. In early times 'the gold of the sea' was obtained through gleaning on the shore, later through fishing with nets and through what was called stabbing: on clear days the stones on the sea-bed were churned around with long hooks from a boat; the movement of the water made the amber float, and it could then be caught in small nets. That there were dealings in amber as material for jewellery even in ancient times is shown by numerous finds of amber stones in the tombs of Mycenae, which date from about 2000 BC. The Stone Age man of the North used amber for adornment, as the rich finds at Schwarzort from the 15th century BC testify. Amber was very popular in Classical times; it was transported by sea and land routes to Greece and later to Rome and the provinces of her em

pire. Amber jewellery has always been popular, and even healing properties have been ascribed to it in some places. Amber beads, which can vary in shape (olive-shaped, spherical and so on), are rounded on the lathe and then polished. Clear beads were frequently facet-cut, and recently amber necklaces of unworked, merely pierced pieces have been favoured as fashion jewellery.

Ivory. Ivory is one of the oldest jewellery materials, and can be used in many ways. It can be turned, pierced, filed, rasped, sawn and, with a graver and scraper, carved and shaped. The surfaces of the worked piece can, in addition, be ground smooth and polished. Jewellery such as bracelets and earrings, beads and bangles is produced of ivory, and also caskets, boxes and bowls. Combined with gold, it is very effective. In the 16th and 17th centuries, ivory was highly valued in Europe, and European works had no little influence on the African ivory art. Nowadays ivory is frequently imitated in artificial materials.

Tortoiseshell. Tortoiseshell may be dark and light. Light tortoiseshell (also called blonde) is translucent and is therefore particularly well liked. The pattern of the marking and the richness of the colour-play are also important in determining the quality of a particular piece of tortoiseshell. The material is popular for hairslides, combs, boxes, knife rests and inlay work. It can be split, softened through heat, bent in any way, moulded into shape and joined as one piece; in its hard state it can be worked with saw, file and rasp. Finally it is ground and given a final polish with, for example, Viennese chalk.

Open-work tortoiseshell hair ornaments have been highly valued in various periods, for example at the end of the last century and before the First World War, and again in more recent times, effectively revived by high hair-styles. As genuine tortoiseshell is expensive, now as before, it is frequently imitated with horn, galalith and similar cheap synthetic materials.

Historical Survey

In the development of medieval European jewellery, the interaction of Classical, Germanic and Christian elements played an important role. Compared to the jewellery of the ancient civilisations, few pieces of medieval jewellery have survived, because Christian burial practice permitted no burial gifts. What the earth has not protected has been subject to the ravages of time, fashion and vandalism. Pieces of jewellery and contemporary descriptions of ornaments survive today that were preserved only by chance, and it cannot therefore be said with certainty that the history of medieval jewellery is known in all its detail.

Functional jewellery. *Garment brooches.* The *fibula*, used by nearly all European peoples from the Bronze Age, held a key position as late as the Middle Ages. In the course of the centuries it developed from a simple safety pin, designed to hold the garment together, to an object of display. In northern Europe it was the single-pronged brooch that was used; in the Danube regions it was the two-pronged, which - as early as the La Tène period - was frequently made of precious metal with coloured stones and enamel inlay. During the great migrations, when the Germanic races came for the first time into closer contact with the mature Mediterranean civilisation, such wonderful pieces were made as the magnificent fibula of gold with garnet ornamentation, which came to light with the discovery of the Szilagy-Somlyo treasure. Colourful embossed disc-fibulas and animal fibulas of precious metal were also part of Merovingian women's dress; they were mostly worn in pairs, and their influence on Carolingian ornamental art is manifest.

But even from the pieces of jewellery which have survived by chance, it is evident that Carolingian goldsmiths were also influenced by Byzantine work and the legacy of Classical Antiquity. The monumental *cloak clasp*, used on secular dress until the 13th century and worn still longer by the clergy, replaced the golden disc or round or four-pronged fibula. With the cloak clasp the cloak was fastened on the chest or, according to Germanic custom, on the shoulder. If pairs of clasps were connected by a little chain, they were called *tassels*. They were frequently made of thin gold foil and decorated with domed precious stones, jewels, filigree or coloured enamel. As a centrepiece the medieval goldsmith occasionally used a Roman gem or cameo.

In the 13th century the cult of chivalry became increasingly important, emphasising courtliness and service to women. The greater refinement of society was reflected in the goldsmith's art, and the large, magnificent cloak clasp was succeeded by the dainty *agraffe* (a hook and loop fastening). This too is a dress ornament, and fastened the opening in the neckline of a woman's dress. The relationship between donor and recipient is often recorded by inscriptions and mottos appropriate to the age of chivalry: clasped hands, pierced hearts, flowers, keys and similar motifs. In France, the home of the troubadours and trouvères, delicately fashioned agraffes were produced in the 13th century in the form of an *à jour* garland of leaves. Of the ring-shaped agraffes produced in the Baltic area - especially the 13th- and 14th-century agraffes that closed with interlaced pairs of hands - the clasps with ornamental discs and the pins studded with rosettes are typical, and made a real ornament out of dress fastenings; they were fixed to the dress with staples and were called (in the low-German dialect) '*Hant truwebrazen*'. In the 13th century, agraffes made of gold were the most common type of fastening, whereas in the 14th century it was the silver '*Heftlein*', the name originally given to agraffes in Germany. An imposing type of clasp worn on ecclesiastical vestments, which was made in raised relief form and ornamented with cameos in the 13th century, altered its form in the 14th: its flatness was emphasised, and it often bore a design enamelled on silver. Among the most beautiful gems of the Middle Ages were the raised relief agraffes of gold enamel, made by the Burgundian gold

smiths of the early 15th century, which testified to their extraordinary skill and powers of imagination. In addition to figurative motifs taken from the Bible and the history of the Church, they were decorated with fabulous animals, birds, charming figures of women and flowers. This beautiful jewellery was very popular at court. Generally speaking, the finest pieces came from the Rhine-Meuse region. The enamelled high relief agraffe, with predominantly figurative religious motifs, is characteristic of the late Gothic period; but this in no way signifies that such jewellery was only worn by the clergy. The brooch known as the *Magnatenschliesse*, which was produced in Siebenbürgen and exported to many parts of Europe, contradicts such a belief. The most common piece of ecclesiastical jewellery was the *surplice clasp*. The four-prong form of the fibula evolved in the early Middle Ages, was retained for a long time, but was richly adorned with figures. One of the most beautiful examples, preserved in the Aachen Cathedral treasury, is strongly reminiscent of Burgundian jewellery.

As we have seen, the agraffe played an important role in the jewellery production of the Gothic period. Its characteristics were partly regional, and as the chief dress accessory, it expressed the taste of both creator and wearer. During the Renaissance the dress clasp in all its forms (fibula, cloak clasp, agraffe) gave way to the pendant, but then came back in the 17th century as the brooch.

Like its predecessors, the garment fasteners, the *brooch* is not only an ornament of intrinsic value but is often required to fulfil a specific function on the dress. With a brooch, a collar can be fastened to a dress, material can be gathered into soft folds, or an opening can be closed. The forerunner of the modern brooch is ascribed by tradition to Mme de Sévigné, the famous letter-writer. The front of the brooch was first richly ornamented with rubies, sapphires, emeralds and pearls; then, in the second half of the 17th century diamonds in rhombic form were favoured. The back of the brooch, to which the pin was fastened, was often decorated with enamel painting. Just as the elaborate dresses of the ladies at the court of the Sun King were very different from the

modest and refined attire of women in the Gothic period, so the brooch was not just functionally a successor to the garment clasp but an imposing ornament worn to direct attention to a beautiful décolleté or the curves of a woman's bare neck. In the 18th century there was a fashion for brooches set with diamonds. Brooches in the form of loops, small sprays of flowers, artistically interlacing branches and tendrils were favoured; jewellery in the playful Rococo style was similar, but enriched the ornate, severely symmetrical appearance of the Baroque with glittering ornamental detail and asymmetrical effects. At the end of the 18th century the brooch with a miniature portrait, in a gold frame bordered with pearls, became fashionable; the frame was usually a full circle-shape or an oval. The late 18th-century brooch carried a miniature - a silhouette portrait - in a simple frame, or a cameo set in semi-precious stones, or a Wedgwood porcelain plate (two-coloured unglazed reliefs, frequently white on blue) or a mosaic of semi-precious stones. During the Empire period there was a strong preference for cameo-ornamented brooches. The later 19th century was a veritable golden age for the brooch, since it was used to hold together a great number of collars and neckerchiefs. Romanticism also influenced the evolution of brooch styles. Souvenir brooches became popular, their financial value being secondary to their sentimental worth. A lock of hair - of a friend, a loved one or a child that had died prematurely - was worn in the brooch, which was ornamented with emblems of friendship, love or mourning.

In the first decade of the 19th century the age-old techniques of the goldsmith - filigree and granulation in combination with semi-precious stones - came into renewed favour; the Roman jeweller Pio Castellani became famous for work of this sort. Later in the 19th century, stimulus and inspiration were sought in the styles of previous eras. Thus in the 1830s there are Gothic brooches which were occasionally made of fine cast iron. Iron, which had not served as a metal for jewellery since the dawn of history, came into fashion in Germany after the Napoleonic wars. After a Neo-Renaissance style in which 'scrollwork' and motifs on enamelled moulding were preferred, the 'second Rococo' made a triumphal appearance. Brooches of pressed gold foil, with carved relief decor-

ation and multi-coloured cell solder for col-
oured stones and small pearls, became
popular. Often such brooches belonged to a
collection of jewellery (a parure) that con-
sisted of earrings, a bracelet, neck-band
and ring for the finger. In general, however,
the parures of the second Rococo were far
less magnificent and costly than those of the
Baroque and Empire periods, reflecting the
less extravagantly ostentatious outlook of
the 19th century. In the 1860s platinum also
began to be used as a metal for jewellery,
and in particular the open-work setting of
diamond brooches was once again executed
in this metal.
Towards the end of the 19th century crafts-
manship in jewellery, like so many other
kinds of craft work, declined. The carefully
worked individual gem was replaced by
mass-produced fashion jewellery.

Buckles. As early as the Renaissance period,
the pendant was preferred to the agraffe,
and a variant of this type of jewellery was
used as hat ornamentation. The *hat agraffe*
was particularly popular in Italy during the
first half of the 16th century, and both simple
and sophisticated and costly examples were
made. Simple hat agraffes were cast from
bronze and mostly took the form of enamel-
led portraits of a head in a round or oval
frame, while the more ambitious pieces in
chased gold foil often depicted scenes from
mythology, portraits and other motifs, in
high relief and coated with enamel, con-
forming to the taste of the time. About the
middle of the 17th century the *shoe buckle*
became fashionable as an accessory to
traditional dress and an ornament without
any actual function; it was popular for both
adults and children. From the 1830s there
was also the *breeches buckle,* often expen-
sive and studded with diamonds, which was
worn by the noblemen of the day. In addi-
tion to costly buckles there were all kinds
of imitations, such as buckles ornamented
with paste or the steel buckles that were
made in England.
In contrast to the buckles described above,
the *belt buckle* fulfilled an important func-
tion right down the ages; it was made of
bronze or precious metal as early as the La
Tène era, and was ornamented with various
engraved, punched or chased designs. That
the belt buckle was already developed in
prehistoric cultures and early civilisations

is amply proved by finds from ancient
tombs, for these metal buckles - often artisti-
cally decorated with open-work and richly
ornamented - were found waist-high just
where the dead would have worn a belt of
leather or fabric, the material of which
would have perished centuries ago. The
shape of the belt buckle varied little, since it
was determined by the object's function; it
consisted mainly of a prong and a frame
which could be round, square or oval. More
imagination could be used for decorating
the belt clasp, and from the 13th and 14th
centuries shaped and ornamented silver
buckles were most usual; their decorative
effect was further augmented by designs in
niello or enamel. North of the Alps, in the late
Gothic period, buckles richly ornamented
with open-work were favoured; scrolls and
leaves were the most common ornaments.
Cast *silver belts* were very popular in the Re-
naissance period, consisting of individual,
flexible, rectangular links. Botanical and
other contemporary motifs inspired the sil-
versmith in the execution of the open-work
parts of the belt. Renaissance Italians pre-
ferred the flat silver buckle, which was de-
corated with niello, although belt clasps with
shaped relief work were by no means excep-
tional. In the second half of the 16th century
when Spain led European fashion, expen-
sive gold or silver belts with artistic open-
work were much in vogue; in many cases
they had links richly set with enamel, prec-
ious stones and pearls. They were a feast
for the eyes rather than a useful dress acces-
sory. It was only very much later that belt
clasps again began to be objects of artistic
significance - in the Neo-Classical period,
when the 'à la Grecque' fashion of the high-
waisted dress accentuated the belt and its
buckle. The universally popular cameo was
the main ornament of the belt clasp, and also
decorated the sleeve fastenings of the short-
sleeved garment. In the succeeding period,
fashion dictated another silhouette, wom-
en's dress followed a new line, and the vogue
for the buckle came to an end. A few good
examples were still made in the second Ro-
coco and Art Nouveau periods.

The pendant. At the borderline between
dress jewellery and personal jewellery
stands the pendant, which has no direct
function to fulfil on the dress but neverthe-
less contributes effectively to its overall

impression or stresses a particular detail of the costume. It often forms a set with such items of personal jewellery as necklaces, bracelets and earrings.

The pendant is very old indeed: the amulet or talisman to which a magic potency was ascribed belongs to the large pendant family. As people found delight in adorning themselves, the pendant was fashioned in different ways; it was worn on a ribbon or small chain round the neck, on the belt of a dress, on a bracelet or watch strap, or in the hat or cap. Adornment with glittering objects is common to all peoples, and the pendant of precious metal - possibly ornamented with coloured or cut stones, enamel, niello, filigree, granulation, or sculpted or painted portraits - was found in the Classical period as well as among the Germanic races who overran the Roman Empire; this has been proved by objects found in graves. The early medieval jewels known as 'pilgrims' badges' may also be termed pendants - for example, the reliquary in the form of a cross, the crescent ornamented with filigree, granulation or milling, and the miniature relic box in the shape of a bag characteristic of the Slav goldsmiths.

In the Middle Ages, during which exquisite clasps and cloak fastenings were made, far less attention was paid to the pendant. The oldest pendants of this period were circular and flat, ornamented with enamel, coloured stones or pearls, and expressive of religious devotion. Not until the 15th century was the pendant seen more frequently. Then, as well as the circular examples, there were other shapes with relief work, of which the motifs even then generally had a religious flavour. Ivory and mother-of-pearl were popular. The Madonna and Child or a patron saint were often carved in relief.

In the Renaissance the pendant was held in high esteem, and was developed to an extraordinary and scarcely foreseeable extent, putting all other similar kinds of jewellery into the shade. Valuable examples are still in existence, richly set with precious stones and pearls, and ornamented with enamel and in other ways popular in this period. In addition there were also simpler pendants of base metal, which were not nearly so expensively and ambitiously executed. The circular form was no longer retained; the elongated, often pear-shaped form became popular and was further lengthened

with free hanging pearls. Men, women and children all liked to wear splendidly coloured pendants, although it was probably the low-necked woman's dress of the 15th century that gave the first impulse to the extensive development of this form of ornament. In 16th-century Italy, sculpted figures in rich gold enamel, combined with beautifully coloured precious stones, were in vogue. The most beautiful specimens were ascribed to Benvenuto Cellini, probably wrongly, since there were many noteworthy craftsmen at the courts of the Italian princes. The Spanish fashions, which influenced Europe during the middle of the 16th century, were distinguished by magnificent jewellery. Craftsmen who worked in this style likewise preferred the carved figurative motif for the front of the pendant, while covering the back, which was generally flat, with enamelled ornamentation (Moorish, grotesque or corded work). The Renaissance pendant was also frequently ornamented with Christian emblems, figures and scenes, designs from the colourful world of the Classical era, and with the gods, heroes, generals, emperors, and mythological and allegorical characters of Classical Antiquity. Pendants decorated with animals were very popular, and were among the princely gifts customary at the time. Most of all, pendants were found in the form of eagles, cocks, swans, pelicans, ostriches and lizards, and also legendary beasts such as the unicorn and dragon. As has already been mentioned, curiously shaped pearls or stones were used as parts of the body of man or beast, as were other natural materials in grotesque shapes such as mother-of-pearl. It is not possible to ascribe jewellery specially produced in this period to a given place or area, since the best jewellers were summoned to the great courts (for example, that of Rudolph II in Prague) and worked there until their patron died or they were no longer wanted, when they would move on to another court. (There was nothing new about this phenomenon: in the last years of the Roman Empire, goldsmiths had wandered from place to place in the provinces, working indifferently for Roman or barbarian masters).

Pendants with decorative monograms, coats of arms, initials or ornamented designs were also widely found as 'faveurs'. A few pendants of this period were modelled after

the work of famous artists, such as the crescent-shaped medallion of the Virgin Mary, made from a design by Albrecht Dürer, of which several specimens exist. Hans Holbein, Martin Schongauer and other contemporary painters and copperplate engravers influenced the shape of the pendant, as was particularly illustrated in the silver cast pendants of individual figures. One form of pendant, the 'Gnadenpfennig' (grace penny) bearing the head of the ruler and worn on a chain, is particularly characteristic of German work, and belongs in the same way to the group of *faveurs*. Among the most expensive pendants are the *decorations*, which completed the often magnificent costumes of secular and ecclesiastical dignitaries on festive occasions or at court receptions. In the 17th century the unparalleled preference for the pendant gradually diminished, and only the pendant in the form of a cross was still frequently worn; its front was decorated with rhomb-shaped cut diamonds or table-thick stones, while the back was generally enamelled. At the beginning of the 18th century the *necklaces* with diamond pendants in drop or star form were the great fashion. In the Neo-Classical period, when cut stones were preferred, there was a revival of the pendant. Gems and cameos, silhouette and miniature portraits were often worn round the neck on a black velvet ribbon as *medallions*.

Small pendant crosses of fine cast iron were also popular for a time in Germany after the Napoleonic wars. In the 19th century also, inspiration so far as the form of the pendant was concerned was sought in the style of the preceding era, or Eastern motifs were adopted. In the course of time the pendant ceased to have an independent development, but merged with the necklace.

Costume jewellery. The form of jewellery preferred at different times and places was of course profoundly influenced by reigning fashions in dress. For jewellery in the widest sense of the word is a costume accessory. This is perhaps true not only of garment jewellery but also of personal jewellery.

Necklaces. A concrete example to illustrate this point is the necklace: it was already known and widely used in prehistory, and yet was not worn in many later periods because it was not the fashion.

The necklaces worn in the early 15th century are shown in contemporary pictures. The earliest surviving necklaces from western and central Europe date only from the 16th century. Most were heavy, massive necklaces of gold or silver known as *Hobelspanketten*, which were wound once or several times round the neck. In some areas, such necklaces were also worn by women. During the period of Spanish influence richly enamelled, massive necklaces were particularly in vogue. As time went on, the heavy rolled work of the individual links was converted into delicate interlaced scrollwork, with coloured precious stones and pearls increasingly added to the coloured enamel. In the Baroque period, society women particularly preferred Oriental pearls. Gowns with pearl embroidery and *strings of pearls* were very much part of the outfit of the woman of the world. In the 18th century, medallions ornamented with miniature portraits were worn on coloured or black neck-bands. Of the representative women's jewellery of the second half of the 18th century, the *diamond necklace* was the most important, and formed the chief item in jewellery sets of matching design; generally these consisted of rings, earrings, bracelets and, on occasion, jewellery for the hair. That the diamond is most popular when set à jour, has long been known; the *pavé-setting*, mainly used, rested on this principle, so the setting diminished in importance in favour of the stone and detracted in no way from its individuality - indeed, the necklace was a veritable crown of sparkling jewels. At times, beautifully coloured emeralds or rubies also appeared as centrepieces on each link of the necklace, to heighten the effect of the whole. About 1800, 'Grecian' hair styles, dresses and ornaments were in fashion, and the necklace of delicate links often went exceedingly well with the modest knot of hair and the simple dress with its very high-waisted girdle. In necklaces of the Empire period, just as with other forms of jewellery, the great preference for cut stones, especially for cameos, was also noticeable. Such techniques of working precious metals as granulation and filigree, newly revived, were employed on necklaces. In addition, gold of different tints was used and surprising effects were achieved in conjunction with the old tech-

niques. In the second half of the 19th century, the upper classes of the new industrial-commercial society liked to display their increasing wealth in the form of expensive jewellery with diamonds or other costly stones. Unfortunately the material value of the jewellery frequently exceeded its artistic value.

The bracelet also has a history going back thousands of years, in the course of which it has been made in the most diverse forms from the most diverse material, and is found in numerous variations. As with necklaces and garment jewellery, the bracelet is not independent of fashion and was therefore not worn in all periods. In the Middle Ages, when the natural beauty of the human body was of little import, the bare arm was not displayed and the arm ring, so popular in Greece and Rome and among the Germanic tribes, was not found in the Christianised regions north of the Alps. In Italy, where consciousness of the heritage of Antiquity never entirely disappeared, the *arm circlet* was still sometimes found.

With the Renaissance, the predilection for jewellery for the arm returned once more; in northern Europe the golden circlet or *bracelet* in the form of a chain was worn over the sleeve of the dress, whereas in the sunny South, particularly in Italy, preference was given to gold bracelets or pearl-set bracelets worn on the bare arm. About the middle of the 16th century the bracelet enjoyed great popularity: set unsparingly with precious stones and pearls, its decorative effect was further enhanced by the liberal use of enamel.

For the elegant woman of the 17th century, who found pleasure in lace cuffs and ruffed sleeves, jewellery for the arm was of little use; only here and there were *pearl bracelets* to be seen, worn mostly in pairs, or a costly gold bracelet, set with precious stones and ornamented with enamel on the reverse side. Curiously enough, in the Rococo period there was little interest in beautiful jewellery for the arm, although short-sleeved dresses were in fashion; strings of pearls wound several times round the arms or black ribbons with portrait medallions were the only kinds of arm jewellery in use. From the 1790s pleasure was again taken in the simple *gold circlet* which adorned the wrist, up to three being worn, one above the other. The cameo was the dominant element in the

bracelet, as in other Neo-Classical objets d'art, and it was found here mostly combined with gold. For the Romantics, the bracelet of plaited human hair with a miniature portrait was characteristic; also popular was jewellery for the arm made of multi-coloured gold and ornamented with filigree and granulation. Iron jewellery, in its modern form after the Napoleonic wars, also included bracelets of a special kind of particularly delicate workmanship.

In the 1830s and 1840s the custom of wearing bracelets in pairs again became general; the fashion in jewellery was for gay bracelets set with coloured semi-precious stones, and the setting of the stones was often decorated with filigree, twisted wire and similar traditional techniques. The poverty of original ideas in the second half of the 19th century was also clearly recognisable in the general form of the bracelet. Here, too, inspiration was sought in the past or in Oriental art.

Jewellery for the ear. Numerous objects from prehistory later found in graves testify that earrings and ear pendants were worn not only by women and children, but also by men and warriors. In Classical Antiquity, rich jewellery for the ear was popular and was part of Greek as of Roman costume. The motif of the half-moon appeared very early; its basic form was probably of some symbolic significance. To this form further rich decoration was added. Earrings were adopted in imitation of Byzantine jewellery as part of medieval court dress, but were not really accepted in western Europe at any time in the Middle Ages. In central and south-eastern Europe, on the other hand, earrings were very popular, and beautiful examples made of precious metal and decorated with granulation and filigree were discovered during excavations in Mikulčice and in the other centres of the Moravian culture of the 9th and 10th centuries. The earrings belonging to the robes of the Empress Gisela, also decorated with precious stones and filigree, are in the Classical crescent form and are reminiscent of Byzantium in every way (first half of the 11th century).

During the Italian Renaissance, earrings again became popular. In particular the Italians of northern Italy found pleasure in this type of jewellery and used precious stones and large pear-shaped pearls to ornament the ears of their women. The fashion spread

over most of Europe, and finally the earring became exclusively jewellery for women. At the beginning, large pear-shaped pearls were in favour; later, preference was given to rich pendants, set with precious stones in front and enamelled on the back. Earrings formed a part of the uniformly designed sets of jewellery which have been seen increasingly since the Baroque period. Earrings have been worn above all in those periods when hairstyles allowed the ears to show and the dress did not detract from their effect. In addition to the classic materials - which include precious metals, precious stones and pearls, together with other means of ornamentation such as brightly coloured enamel - materials such as ivory, tortoiseshell and expensive woods are found more often with earrings than with other jewellery. In the reign of Louis XIV, French jewellery was the finest in Europe, and fashions in jewellery were dictated by France. The earring too underwent a special development: the pendant of three small precious stones suspended from a main motif under the ear is characteristic of the *girandole*. In the 18th century, delight in the brilliance of a sparkling stone gave the diamond pendant its great vogue; it was mostly worn with a brooch to match on the decolleté. Long ear pendants went best with the low-cut evening dress and the popular *pendeloque* ear drop appeared; it was especially long, with the drop or star-shaped pendant fixed to a bow - the predominant motif - under the ear. In the Rococo period, with its partiality for frivolity, *briolets* were popular on account of their oscillating movement; with them the setting was in certain cases entirely superfluous and the suspension device was sufficient.

The simplicity of Neo-Classicism stands in striking contrast to the light-heartedness of the Rococo. This is evident even in the design of the earring. At the turn of the century a large simple earring appeared; later the enthusiasm for cameos was also reflected in this branch of jewellery design. That jewellery of cast metal was to be taken seriously, and was not merely intended as a cheap substitute, was demonstrated by the fact that all the current forms of jewellery were in fine cast metal, and earrings too were made in this material. In the Biedermeier period (1820-48) ear pendants of multi-coloured gold were worn. The coloured stone, in a filigree or granulated setting, brightened the ap-

pearance of the piece. The further development of earrings resembled that of other jewellery and, for lack of space, will not be described here. Until a new conception of jewellery came into its own in the 20th century, ostentatiously expensive jewellery was most sought after.

The ring. All the forms of jewellery discussed so far were worn from very early times, and chiefly for adornment. Not so the ring. Its primitive function was to serve as a means of differentiation and recognition; it was worn sometimes to establish identity, sometimes to imprint a signature or stamp of ownership. Not surprisingly, then, the ring was unknown to primitive peoples who had otherwise extensively developed jewellery; even Homer's heroes seem not to have worn any. By contrast, rings which were worn to serve as a sign of recognition are mentioned in an Indian epic song of the 11th century BC, and in Egypt the *signet ring* was known from time immemorial; it consisted of a stone, pierced and cut, which was threaded on to a wire band or worn on the finger. Numerous mythological and historical references demonstrate that the ring had earlier been an object that signified position rather than ornamentation. Thus it was Pharaoh's signet ring that Joseph received when he was appointed governor, and on his death-bed Alexander the Great handed over his ring to Perdiccas, whom he nominated as his successor. In Rome the ring was the sign of knighthood. That the original significance and function of the ring has not been entirely forgotten is indicated by the Pope's signet ring, and the amethyst ring which cardinals and bishops receive at their investiture ceremony. The wedding ring too may be regarded as a symbol of unity rather than an object of adornment.

The purely ornamental ring followed the course of European styles during its whole development, right up to the present. Early medieval rings have become available through the excavation of graves and it can be said with certainty that rings were worn by men, women and children alike, and that goldsmithing techniques such as granulation, filigree, enamelling and the cut of the precious stone *en cabochon* were all widely used. Excavations have also demonstrated the extent to which early medieval European goldsmiths were influenced by the Byzan-

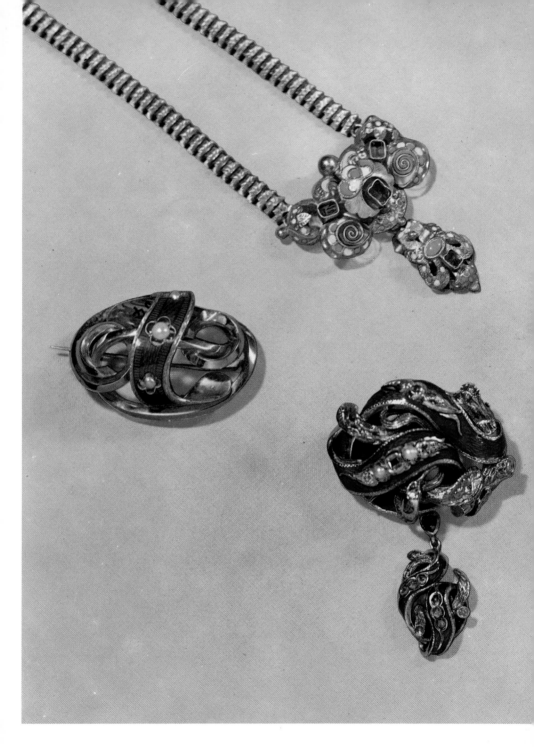

LI Two brooches and a chain of hollow gold, ornamented with coloured enamel. Bohemia, *c.* 1850

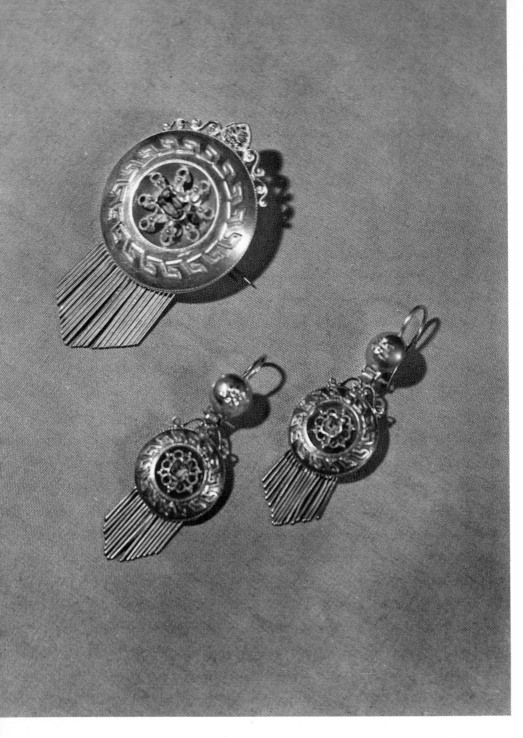

LII Gold brooch and earrings with meander motif of antique design and individually set emeralds. Bohemia, *c.* 1870

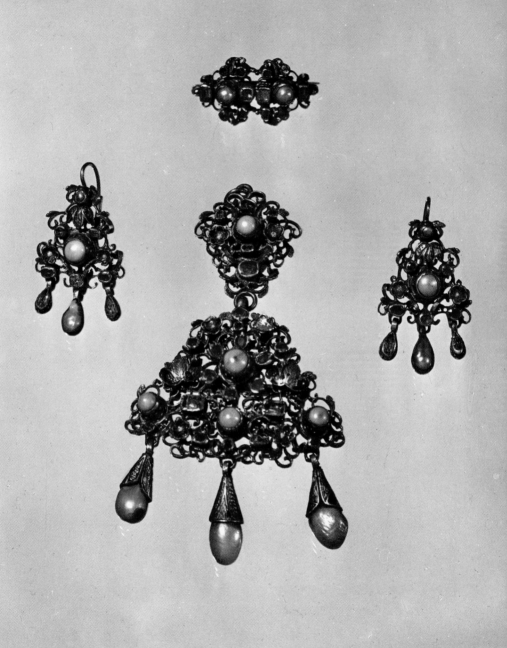

LIII Silver-gilt *parure* ornamented with emeralds, rubies, pearls and enamel. Probably from the property of Ulrike von Levetzow. Central Europe, 17th century

LIV Two gold bracelets of coloured stones set in filigree. Central Europe, first quarter of 19th century ▶

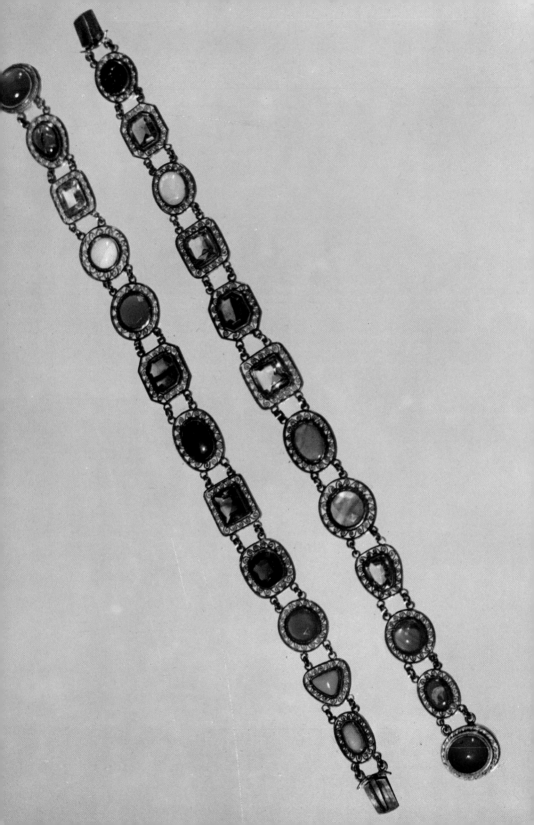

tine art. Rings that have come to light in the great Moravian and Bohemian centres are richly ornamented with granulation or with filigree and polished precious stones or coloured glass flux. That the goldsmiths of the Franks and those of the Ottonian Empire made use of the same techniques in ornamentation may be seen from the *ceremonial ring*, made in the same group of workshops. Characteristic of this ring was the domed stone in a high setting, surrounded by copious filigree and granulation. This ring was worn by secular and ecclesiastical dignitaries as a badge of rank.

In addition, the simple stirrup shape, taken over from the Classical period, continued to be made right through the Middle Ages. Frequently this ring was ornamented with a Roman gem, a cameo or a smooth stone; later a precious stone cut by a contemporary lapidary was also used.

As with garment jewellery, the ring in the medieval period was the symbol of tender relationships; clasped hands and affectionate sayings were found on both. Rings with religious motifs found wide favour, and there is no reason to consider them exclusively ecclesiastical jewellery. Medieval men were deeply religious, and it was only natural that they should ornament their jewellery with emblems which they had known from their youth and which held meaning for them. The church handed over special rings as a badge of office to its higher dignitaries at the time of their investiture. These rings, known as bishop's or 'shepherd' rings, did not necessarily bear a Christian symbol; they were generally worn over the pontifical glove on the fourth finger of the right hand. In the late Middle Ages, as the ornamental ring enjoyed great popularity, nobles, burghers and ecclesiastics alike wore more than one ring. The oldest *bishop's rings* known are from the 10th century, but in many regions they seem to have been in use earlier, as is indicated by written sources (for example in Spain).

From the 12th century, individual abbots were allowed by the pope to wear the *shepherd ring*, and from the 15th century every abbot had this right. Originally there was no distinction as to the appearance of these rings; they were mostly made of gold, only the earliest being of bronze. Right into the late Middle Ages a precious stone, cut *en cabochon*, formed the central piece; in the suc-

ceeding period rings were occasionally set with several stones. The bishop's and shepherd rings have nothing in common with the *'papal ring'* - made of massive, heavily gold-plated bronze, decorated with the symbols of the Evangelists and papal insignia - which appeared in the 15th and 16th centuries and were brought home by pious pilgrims as souvenirs from the 'eternal city'. Special silver rings, decorated with engraved inscriptions and the images of saints, were also worn by the laity, reflecting the strength of religious feeling in Europe. That there were also a great number of *signet rings* should cause no surprise, for coats of arms were widely used.

In the High Middle Ages the simple gold ring, with a round or oval flat top, was much liked as an *ornamental ring*. The flat top carried an engraved ornament and sometimes a motto. Gold rings with modelled decoration were also occasionally found; sometimes there would be engraved and modelled decoration on one piece. Religious subjects and emblems were popular motifs for decoration, as were the symbols of love, reverence, loyalty and affection mentioned above. In the late medieval period, the characteristic leaf and tracery work was also seen on rings.

From the earliest days the precious stone has been surrounded with mystery, superstition and awe. Like the stars, the stones were, medieval men believed, closely linked with a person's destiny. They protected the wearer from illness and accident, from poverty and betrayal; they bestowed strength, tranquillity and happiness. In association with the ring, the age-old symbol of power and magic - here only Solomon's ring and the Oriental fairy tales need be recalled - precious stones were widely used. In the 14th century the simple smooth box setting for the domed ring stone was usual, while in the late medieval period the ring was more ornately treated with enamel and stones. This type of ring could last for a long time, even if it underwent changes in treatment, the setting becoming higher and higher, and the enamelling even richer. In the late 16th and early 17th centuries these tendencies were particularly strong.

At the time of the Renaissance rings became heavier and more massive and were frequently ornamented with a carved stone. As in the Carolingian and Ottonian periods, Ro-

man gems and cameos were used for contemporary rings; in the same way glyptic workers too came into their own, and their work was also set in precious metal. Heavy gold signet rings were also worn. In Italy, silver rings, ornamented with niello and with a portrait or decorative design, came into fashion; some were fitted with a timepiece or mathematical or astronomical instrument, reflecting contemporary interest in the natural sciences. The 'twin ring' for lovers was also conceived: divided, it ornamented the hands of both the betrothed; after the marriage the two interlocking parts were fitted together again. In the 17th century, large cut stones were preferred for the centrepiece; the actual ring was finished with the greatest skill with chasing or engraving. Now and then there was a flower design on the otherwise smooth enamelled ring. A special feature of the times was the *puzzle ring,* which consisted of three small rings which could be worn loose, separated from each other; but when slipped together they comprised a design representing a symbol such as the cross. In the 18th century the brilliant was very popular and the treatment of the ring was not allowed to detract from the pure fire of the stone; enamelling and other kinds of decoration became less popular. The setting appeared unobtrusive and modest; for the pavé-setting, developed from the *à jour* setting, had no intrinsic value of its own and did not detract from the jewel, but supported it admirably. In addition to brilliants, valuable coloured precious stones were worn in rings; they were mostly rectangular or ovalshaped, and were frequently edged with a diamond border. But it was not only the serenely balanced shapes that were found in the 18th-century ring: loops, interlaced tracery and similar animated motifs appeared also on rings again and again. Around 1800 it was above all miniature portraits, framed in pearls or brilliants, that were worn as rings. In some cases paste replaced the costly brilliants in the framing. Black silhouette portraits on gold foil, blue and white Wedgwood porcelain lockets and cut stones were also used on rings. The romantic outlook of the day was reflected in the *memorial rings* and *mourning rings.* An appropriate word, a lock of hair or an artistically elaborate monogram would call to mind the beloved; weeping willows, urns, broken pillars, the figures of mourning women and similar motifs appeared on the mourning ring, which was especially popular in 18th-century England.

Many stones whose beauty had been unappreciated in the past were discovered in this period, in particular, the red carneol and moss agate. The fashion for cameos in the Napoleonic period made the black-and-white and brown-and-white layered onyx and the multi-coloured or finely striped agate very popular for rings well into the 19th century. In addition to the opaque, multi-coloured stones, which were needed for cameos, the transparent rock-crystal, smoky topaz, amethyst and rose quartz, in which intaglios were cut, also experienced a revival. During the Napoleonic wars jewellery was chiefly produced in fine cast iron; even rings were made from this material. In the second Rococo period, light gold rings with coloured enamel, which occasionally concealed a secret hiding place, gave great pleasure. The most beautiful and most expensive ring stone of the 19th century was the 'solitaire', the large brilliant, also set frequently in platinum as an individual stone.

Jewellery for the head and hair. Men adorned their heads from the earliest times and had imitated wreaths of foliage or flowers in precious and base metals. The simple, smooth frontlet - originally probably intended to keep the hair away from the forehead - became a sign of dignity and aristocratic birth; in ancient Egypt specially shaped metal bands were worn by priests and members of the royal house. In the Classical period there was the *diadem,* which in its earliest form was made of chased gold foil. In the course of its development the diadem became richly ornamented and, on festive occasions, would be worn in conjunction with a heavy chain necklet with many motifs and links to the chain. There were in addition an extraordinary number of simpler diadems, which had an eminent place in antique jewellery. The circlet of the Middle Ages and the ruler's *crown* probably derive from the diadem.

Jewellery for the head also played an important part in the East and in Byzantium. A quantity of S-shaped head-bands of silver and bronze were found in the graves of otherwise poor Slavs of the second half of

he 10th century AD in central Europe. As it developed, jewellery for the head became more and more a costume accessory and belonged rather to the realm of dress than to this subject. Perhaps the *bridal crown* should be mentioned here, since in certain regions it really was worn as a piece of jewellery.

Besides the diadem, beautifully decorated hair slides, combs and jewellery in various materials, reproducing natural flowers and tracery, were worn at a very early period in history. In the 18th century the *aigrette* was very popular as jewellery for the hair (it corresponded to the Sévigné brooch worn with a low-necked dress), and glittered and shone with incredible beauty. For, thanks to the pavé-set, the magnificent effect of pearls and precious stones - above all of diamonds - stood out. Plants and animals were a source of inspiration for jewellers; the austere, symmetry-loving Baroque favoured plant motifs, such as sprays of flowers and blossoms, and also bows and waving ribbons, while the Rococo, which stresses asymmetry, also took gay butterflies and slender ornate plumes as models. During the Empire period, with its enthusiasm for Roman antiquity, the diadem came back for a time; it formed the most important item in the contemporary *parures,* sets of pieces of jewellery of uniform design, and was richly ornamented with polished and ·cut precious stones or with coral and similar materials. The diadem consisted of a shining band, tapering into a point at the centre of the forehead; in order to be able to fix it more firmly in the hair, it was occasionally combined with a small tortoiseshell comb. In the 1830s in particular (and on occasions throughout the 19th century), women wore a *tortoiseshell comb* with a high much-bejewelled top in piled-up hair. Quite a few tortoiseshell combs of this period had open-work designs of great beauty; others again had mother-of-pearl or real pearl ornamentation.

Other forms of jewellery. In the development of jewellery in Europe, objects of adornment were devised from time to time which, though certainly worn as jewellery, had in addition a practical function. The *pomander* belongs to this group: a hollow ball in gold or silver, with ornamental open-work sides containing scented spices. Pomanders were generally worn on the belt, next to needle boxes, objects for the toilette, and tiny boxes of ivory or beech-wood, known as *Betnüsse* (literally 'prayer nuts') which had religious motifs engraved on their inner surfaces; other objects for daily use were also worn on the belt. In the 16th century the *amber capsule* replaced the pomander, for in the meantime other, less expensive scents had come to be used. The amber boxes were very beautifully ornamented, so they could also be regarded as adornment. Later the *smelling bottle* took over both functions, for it too was ornamented in keeping with the taste of the day. Phials, ornamented with enamel and precious stones - mainly from the 18th century, but also from the first half of the 19th - were quite often used; they too were worn on the belt or on a chain.

Clocks and watches. When Peter Henlein, the Nuremberg locksmith, succeeded in the first years of the 16th century in making small portable timepieces, a new sphere of activity opened up before the designer of jewellery; for it soon became the fashion to wear these timepieces round the neck in the form of a pendant on an ornamental chain. These watches were equally popular with men and women, and the forms of the oldest types probably developed from the popular grace penny mentioned above. They were shaped like a box and resembled a thick medallion; fitted with loop and ring, they were originally only simply ornamented with engraved arabesques, flat reliefs, open-work geometrical designs and the like. In the second half of the 16th century the watch - frequently oval in shape - was richly decorated with figurative ornamentation in enamel and niello. Now and then it was also built into a pomander. During the Renaissance, buds and blossoms and animal-shaped watch cases were to be seen, and ecclesiastical dignitaries wore watches in the form of a cross, decorated according to the prevailing taste. Specimens of *watch pendants* worn round the neck were commonly found; these were studded with chased reliefs, filigree, granulation and engraving. Later the watch appeared at the belt, and it was soon worn with the highly ornamented châtelaine, which in the main consisted of a shield furnished with a hook, a short, strong chain and a second shield (which often had several small chains), from which the watch was suspend-

ed. Various small objects were hung on the small chains, such as the watch key or the signet, and from about the 1770s it was small trinkets, amulets, commemorative medals, antique jewellery and the like. The craftsman naturally devoted his special attention to the two shields of the châtelaine, which he ornamented with every imaginable form of decoration and material; but even the chain and the trinkets, particularly the signet, did not escape his notice. When the watch was transferred to the pocket it was less attractively designed. In the Baroque period the casing of the *bag watch* (kept in a bag) tended to be enlarged and coarsened until it took on the well-known egg shape, described as 'the little Nuremberg egg', 'Eierlein'). But the *pocket watch* also remained a true piece of jewellery for a long time.

Advice to Collectors

Care. Jewellery of precious metal set with precious stones need not be kept in special conditions: a space with a normal room temperature, cool and dry, is entirely suitable. Where other less durable materials are used, such as wood, hair or pearls, a suitably dry atmosphere must be secured: damp air could be harmful.

To restore old jewellery requires extraordinary skill and technical expertise, including exact knowledge of the physical attributes of the metals, stones or other materials in the piece to be restored. Not less important is a knowledge of the development of jewellery in the different stylistic periods, and the ability to date the piece at least roughly; for the style and technique practised in a given period must be taken into account in the repair.

Before the restoration of the damaged piece is begun, it must be properly cleaned; occasionally defects have been found that were hitherto unimagined. Then it is necessary to consider carefully how the piece can best be restored, in order to limit the operation as far as possible. The temptation to solder with tin should be avoided if possible; badly damaged pieces require the hand of the specialist.

Collections. A piece of jewellery is not only an ornament; it is an object of value. For the modern collector it is far harder than it was for his predecessor to build up a collection, for both the actual value and the notional and scarcity value of old jewellery are constantly rising. The material itself is more expensive and the demand for old jewellery is usually much greater than the supply. Therefore the would-be collector must carefully consider which field of jewellery his collection should embrace: it is essential to have a definite scheme from the outset. To attempt to build a general collection is out of the question for even the wealthy. On the other hand, there are always aspects of the jeweller's art that offer sufficient scope for single-minded activity, and jewellery of less favoured eras or pieces of artistic interest in the less valuable materials can gladden the heart and eye of the enthusiastic collector.

A man is not born a good collector, even if he is very rich. The old saying rightly has it that 'no man is born a master of his craft'. An initial interest in old jewellery must be supplemented by a knowledge of valuable and professionally assessed pieces in museum collections and the collections of private specialists; and in addition it is necessary to compare the knowledge gained from concrete examples with the comments and opinions in the technical literature published on the subject. To be able to declare a piece of jewellery genuine and assign it to a given period, it is necessary to have an exhaustive knowledge of the material used, in order to know the method of treatment and whether it was technically possible at the date proposed for the piece; similarly it is necessary to know of any preference in the given period for a particular kind of jewellery or for any specific design.

Only exact knowledge of all these factors can protect the collector from clever fakes. And when all is said and done, it is good to consult an expert before purchasing a particularly expensive piece.

362 Gold rings a) with almandine; b) with amethyst, with cut decoration; c) with glass imitation of a topaz; d) with precious stone and filigree. Kerch, 3rd century BC
363 Renaissance pendant in the form of an eagle; enamelled, studded with an almandine, diamonds and pearls. Central Europe, 16th century

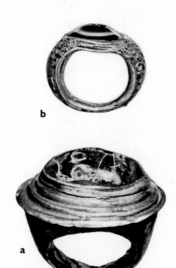

b

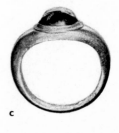

d

a

c

362

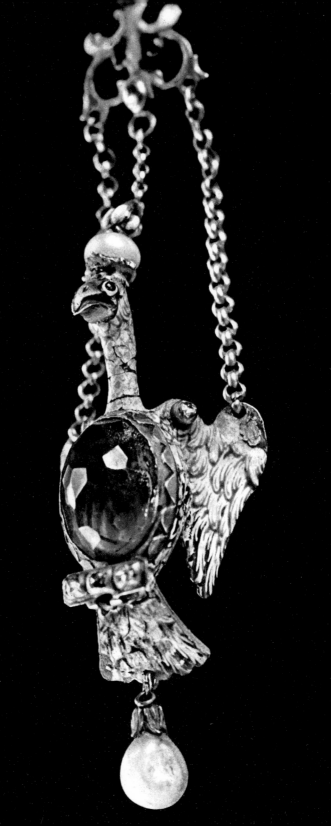

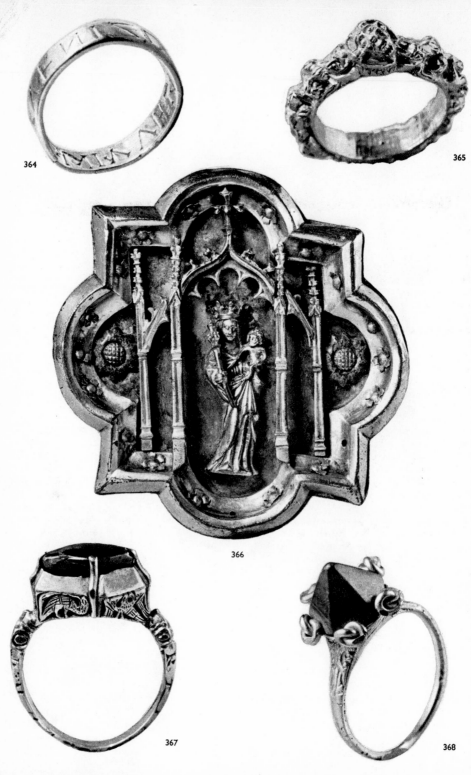

364

365

366

367

368

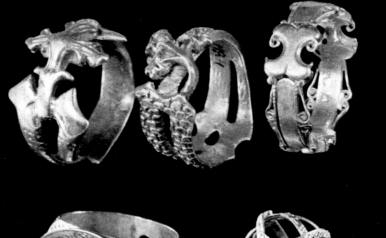

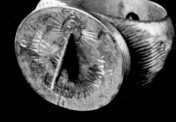

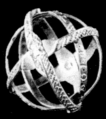

364 Gold ring, with engraved inscription VENIZLAVA. Bohemia, 12th century
365 Roman gold ring with modelled head of Christ and the symbols of the evangelists. Bohemia, 12th century
366 Vestment clasp; copper gilt. Bohemia, end of the 14th century
367 Gold ring, late Gothic. Central Europe, 15th century
368 Gold ring with pyramid shaped malachite. Central Europe, c. 1500

369 Gold rings; Gothic. Central Europe, 15th century
370 a) Brass ring with sundial. End of 16th century; b) Gold ring in the form of a globe which can be taken to pieces. 16th century
371 a) Ring with figure of girl carved in ivory: gold, enamelled. Bohemia, after 1600; b) Silver engagement ring, called a twin ring, 16th century; c) Silver signet ring. Central Europe, 16th century

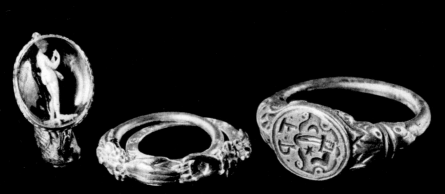

372 Renaissance gold earrings; Italy, 16th century; a) decorated with enamel and pearls and b) ornamented with filigree and enamel
373 Renaissance belt; silver. Bohemia, 16th century
374 a) Medallion, rock crystal, in gold frame decorated with enamel; France, second half of 16th century; b) pendant in cartouche form; silver, rock crystal; Germany, second half of 16th century

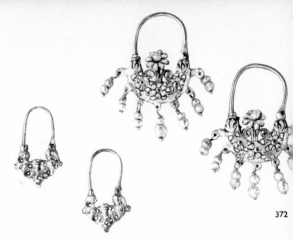

372

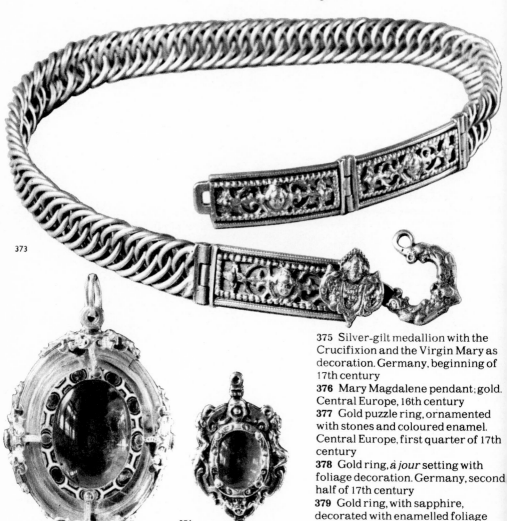

373

374

375 Silver-gilt medallion with the Crucifixion and the Virgin Mary as decoration. Germany, beginning of 17th century
376 Mary Magdalene pendant; gold. Central Europe, 16th century
377 Gold puzzle ring, ornamented with stones and coloured enamel. Central Europe, first quarter of 17th century
378 Gold ring, *à jour* setting with foliage decoration. Germany, second half of 17th century
379 Gold ring, with sapphire, decorated with enamelled foliage motifs. Germany, second half of 17th century

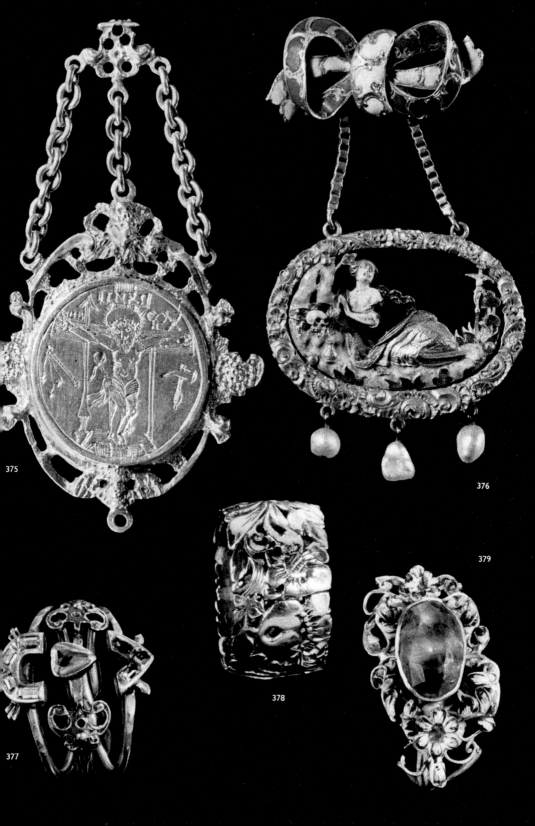

375

376

379

377

378

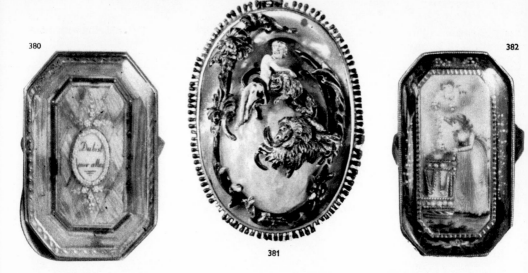

380 Gold ring with hair beneath the
inscription: 'You are everything to me'.
Bohemia, first half of 19th century
381 Pendant with the motif of Daniel in the
lions' den. Central Europe, 17th century
382 Gold ring with miniature painting.
Bohemia, beginning of 19th century

383 Gold ring with diamond initial A on blue
enamel. Bohemia, beginning of 19th century
384 Silver-gilt pendant cross, enamelled
and studded with precious stones. Central
Europe, 16th century
385 Gold ring with diamond initial F on blue
enamel. Bohemia, beginning of 19th century

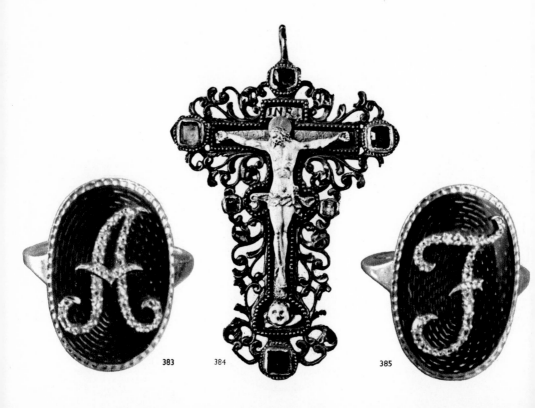

386 Portrait medallion; portrait of the Empress Carolina Augusta of Bavaria, painted on porcelain, with a pearl frame on a pearl chain. Konstantin Abraham, *c.* 1820

387 Gold ring with the inscription 'I live in hope' on green enamel, bordered with diamonds. Central Europe, beginning of 19th century

388 Gold ring with moss agate. Bohemia, beginning of 19th century

389 Gold ring with monogram TV in diamond rhomboids on blue enamel, edged by diamonds. Bohemia, beginning of 19th century

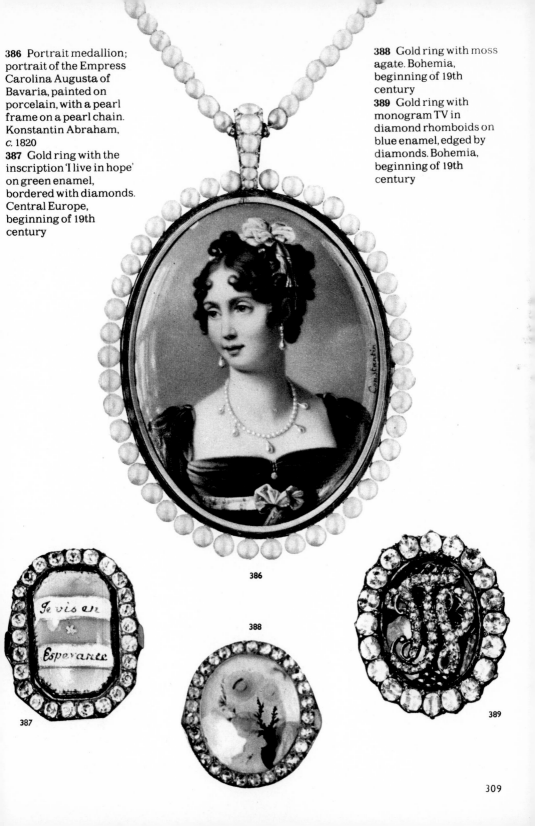

386

388

387

389

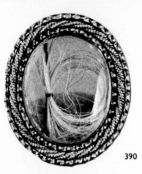

390

391

392

390 Gold ring with lock of hair. Bohemia, first half of 19th century
391 Gold ring with cut rock crystal, gilt engraving. Bohemia, beginning of 19th century
392 Brass ring with black silhouette on gilded glass. Bohemia, c. 1800
393 Bracelet; Fine cast iron. Bohemia, c. 1820

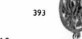

393

394

395

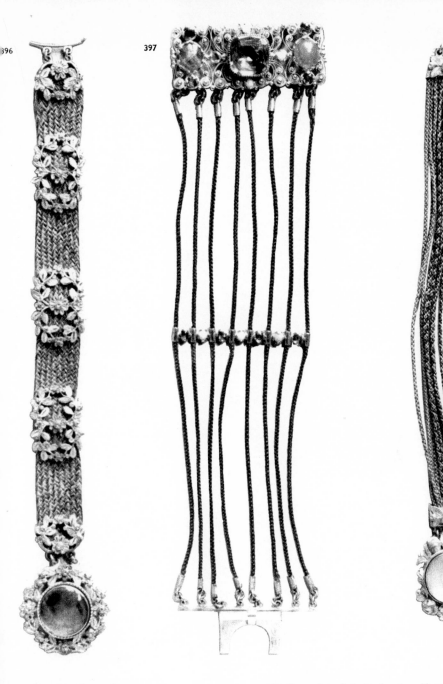

394 Cast iron bracelet.
Bohemia, *c.* 1820
395 Cast iron bracelet. Bohemia, *c.* 1820
396 Bracelet: natural hair, with clasp in gold
decorated with coloured stone. Central
Europe, *c.* 1820

397 Bracelet of plaited natural hair,
ornamented with decoration in gold and
coloured stones. Central Europe, *c.* 1820
398 Bracelet of natural hair with decoration
in gold and a miniature at the clasp. Central
Europe, *c.* 1820

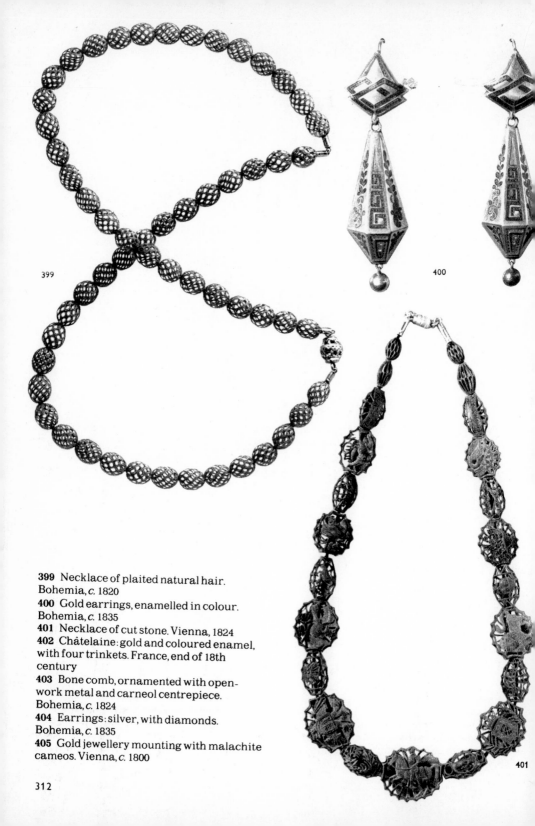

399 Necklace of plaited natural hair.
Bohemia, *c.* 1820
400 Gold earrings, enamelled in colour.
Bohemia, *c.* 1835
401 Necklace of cut stone. Vienna, 1824
402 Châtelaine: gold and coloured enamel,
with four trinkets. France, end of 18th
century
403 Bone comb, ornamented with open-
work metal and carneol centrepiece.
Bohemia, *c.* 1824
404 Earrings: silver, with diamonds.
Bohemia, *c.* 1835
405 Gold jewellery mounting with malachite
cameos. Vienna, *c.* 1800

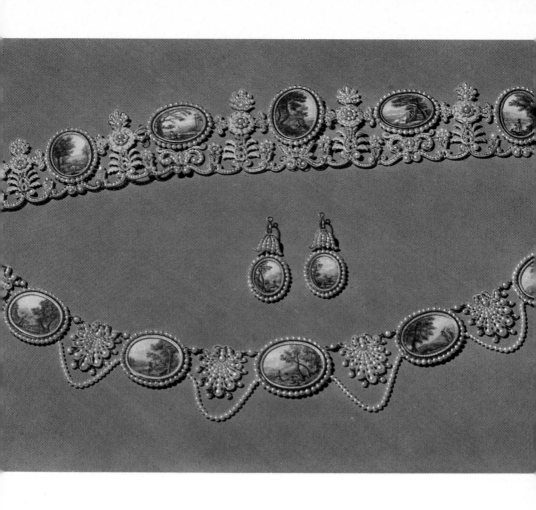

LV Gold *parure* with mosaic and pearls. Italy, after 1800

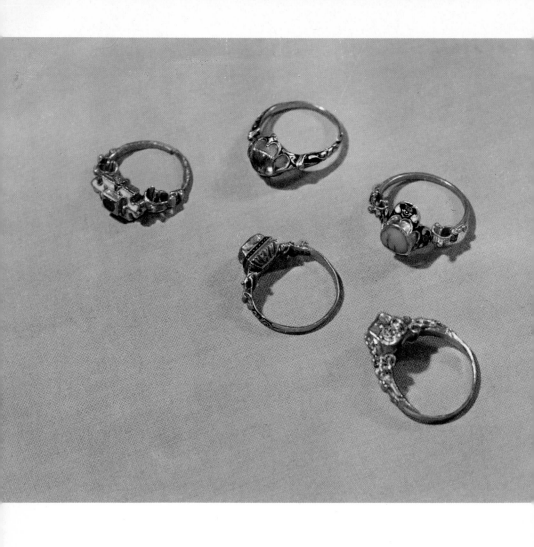

LVI Renaissance rings with stones and coloured enamel. Central Europe, 16th century

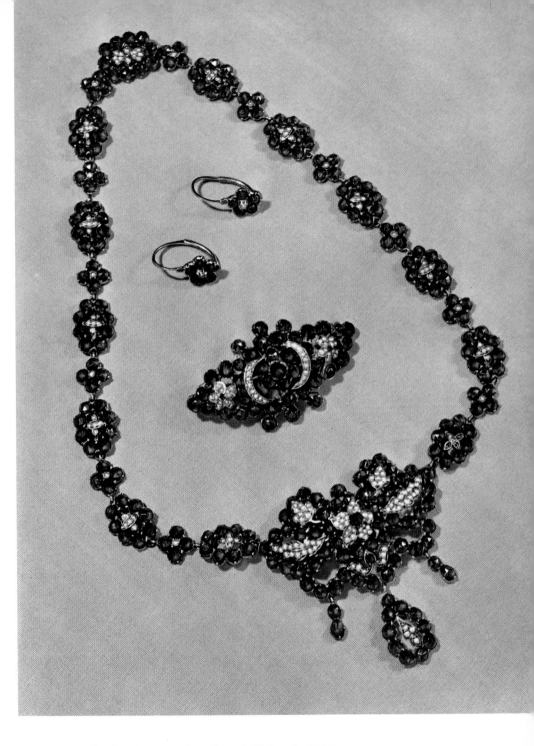

LVII *Parure* of Bohemian garnets and pearls. Bohemia, 1860s

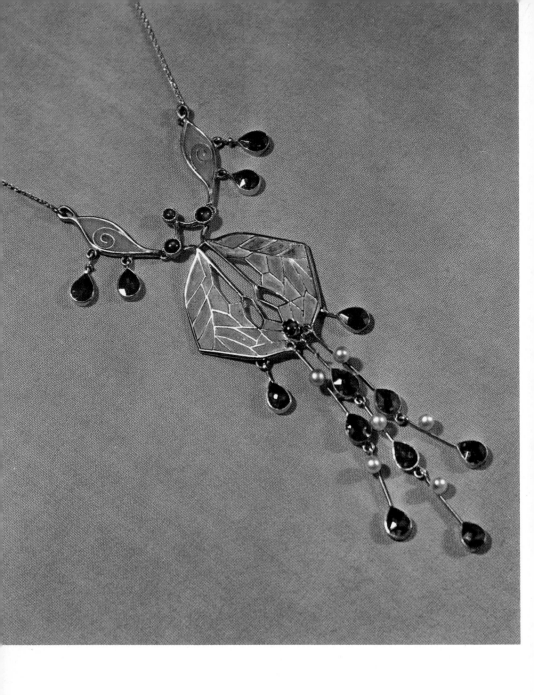

LVIII Gold chain with Bohemian garnets and open-work enamel, *c.* 1900

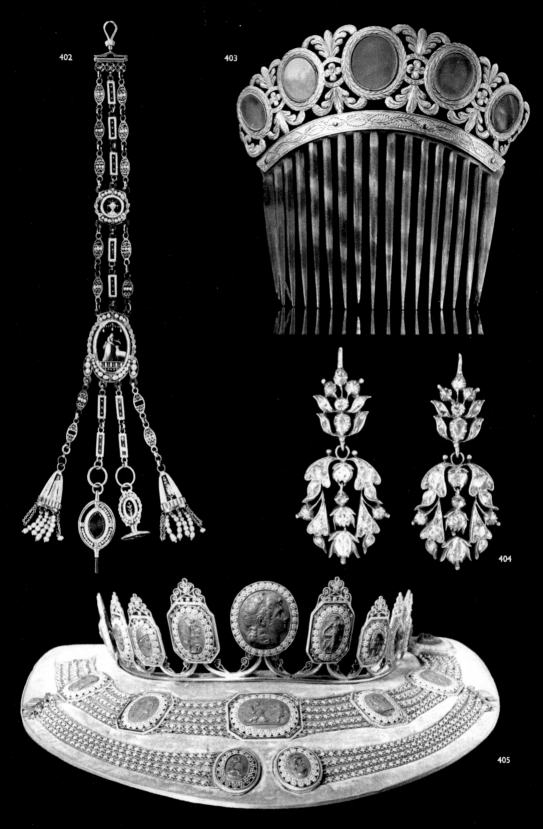

402 403

404

405

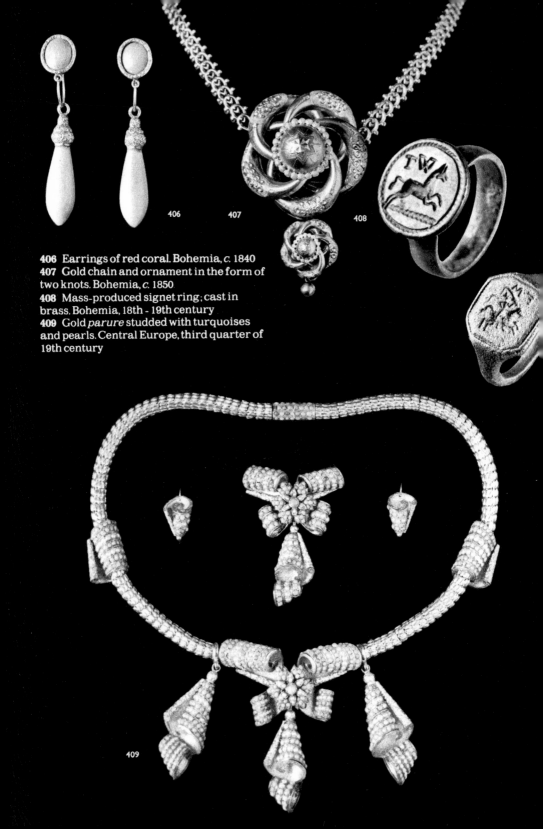

406 Earrings of red coral. Bohemia, *c.* 1840
407 Gold chain and ornament in the form of
two knots. Bohemia, *c.* 1850
408 Mass-produced signet ring; cast in
brass. Bohemia, 18th - 19th century
409 Gold *parure* studded with turquoises
and pearls. Central Europe, third quarter of
19th century

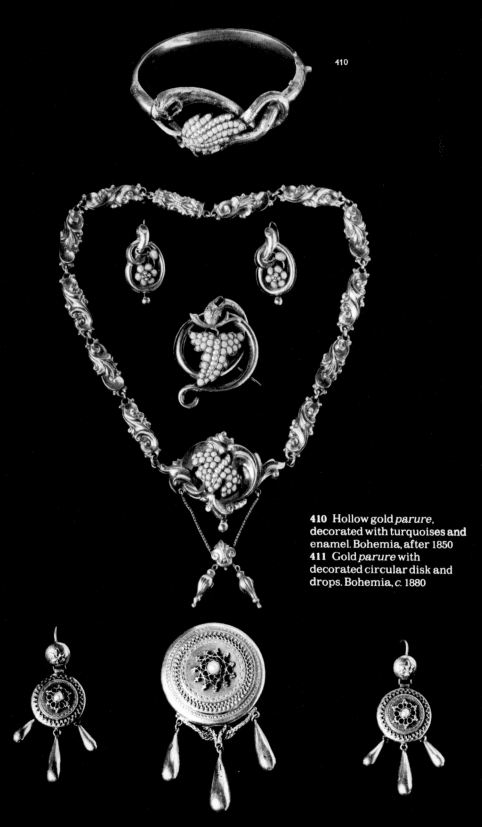

410 Hollow gold *parure*, decorated with turquoises and enamel. Bohemia, after 1850
411 Gold *parure* with decorated circular disk and drops. Bohemia, *c.* 1880

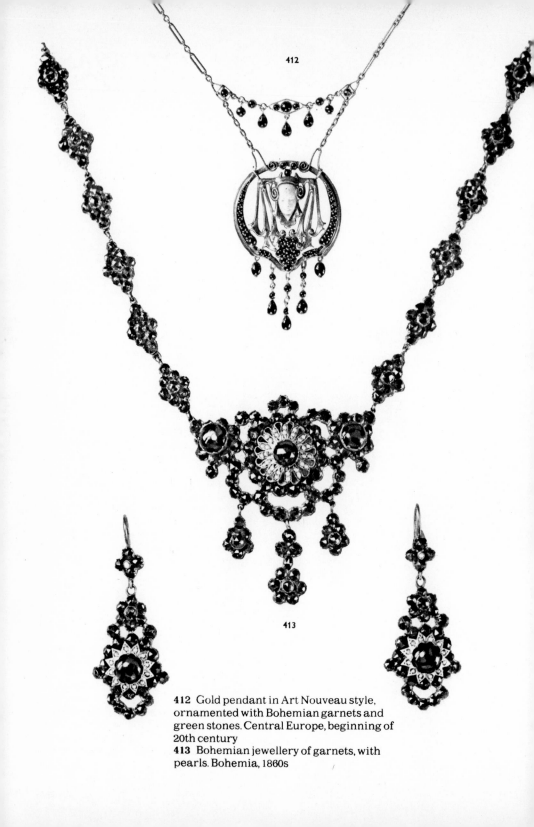

412 Gold pendant in Art Nouveau style, ornamented with Bohemian garnets and green stones. Central Europe, beginning of 20th century
413 Bohemian jewellery of garnets, with pearls. Bohemia, 1860s

CLOCKS AND WATCHES

Man's desire to arrange his own affairs in accordance with the eternal motion of the heavenly bodies can be seen in his various methods of timekeeping throughout history. With the help of all sorts of apparatuses man has been able to measure and divide time. His first step in this direction was with the help of the sun. Its rays divided up the day on the sundial, of which there were two types: fixed and portable. Portable sundials were already known to the ancient Egyptians, and were used throughout Antiquity. They survived for thousands of years, and for a long time were used to correct mechanical clocks, which were extremely unreliable; only with the invention of the spiral balance spring to control the movement (1674), thus making an accurate watch possible, did portable sundials become obsolete. Fixed sundials continued to be important for checking the timekeeping of clocks until the coming of time-signals on the radio. Human ingenuity devised many more instruments for the measurement of time, such as lunar, water and candle clocks, which were used into the 13th century, then sand-glasses, and, from the 16th to 18th centuries, oil clocks. For the first time, the shape and arrangement of the mechanical clock provided a unique combination of timekeeping and aesthetic satisfaction; and hence the fashion for collecting clocks.

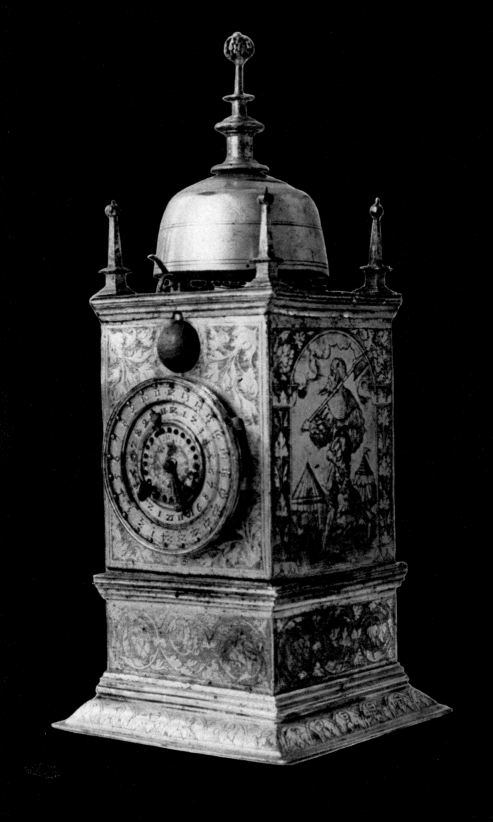

414 Table clock; bronze, Renaissance. Hans Steinmeissel, Prague, 1549

Historical Survey

The mechanical clock — originally made of iron — probably first developed early in the 13th century. It worked through the movement of a wheel driven by weights.

Weight-driven clocks were made for monasteries. (There were liturgical reasons for this). A very early type of clock with weight, foliot, going train, bell and very simple winding mechanism appeared in about the first half of the 14th century. This was the wall clock with twelve figures and a circular dial, with a further twelve figures on a broad toothed wheel inside the dial. Sockets were made in this wheel beside the figures, in which a pin was inserted. A lever lying against the pin and on the cord drum was freed as the wheel turned, allowing the weight to fall and causing the bell to sound. Human intervention was then required to raise the weight again and place the pin in the next socket so that the clock would sound again on the hour. Very soon, either in Germany or Italy, the movement was improved through the use of heavier barrels. In the 14th century, locking plates and a fly (air-brake) were added and (in Germany) the foliot or (in Italy) the wheel balance were introduced to regulate the timekeeping.

With the development of portrait painting towards the end of the Middle Ages, an increasing number of accurately reproduced pictures of clocks were included in the portraits of eminent collectors; among the most famous were Philip the Good, Charles V and Ferdinand I. Weight-driven clocks generally had a casing with dial, side door and sometimes a lunar dial, as well as two bells to indicate the hours and quarter-hours. Most surviving clocks, however, no longer have the hands and front panel with dial. Rare, and therefore all the more valuable, are clocks with dial and bells. Towards the end of the Middle Ages, the biggest European cities could pride themselves on large, astronomical weight-driven clocks (show clocks), many of which also had moving figures or automata of various kinds.

Spring-driven clocks. In the 15th century we find the first indoor weight-driven clock (the exact date of origin is not known). We can also trace spring-driven clocks in which the main wheel was kept in motion by the use of an elastic spring in place of the weight. Portable clocks were already in existence, and when it became possible to manufacture a spring of sufficient length and thinness, small pendant neck watches and, later, pocket watches were produced. However, inadequate records survive from the 15th century for us to be able to follow the exact development of the spring-driven clock. As in the case of the big astronomical clocks, their shape and construction can only be observed from a few examples which have been preserved. Among these is one of incomparable value, the table clock of Philip the Good of Burgundy (1430), contained in a richly gilded Gothic casing shaped like a late-Gothic reliquary (now in the Germanisches Museum in Nuremberg).

Travelling clocks. The first travelling clocks were undoubtedly those made in Paris (1451) by Jean Lieburc, inside a copper casing by J. Moulinet (the casings and covers, which were always gorgeous, were soon to become as valuable as the actual timepieces). These had a dial with a bell above.

The next step in the technical development of clocks came when Peter Paulus Alemann made spring-driven clocks with a fusee, around which catgut was wound, and including a wheel balance and small weights.

Pendant watches. The locksmiths and goldsmiths of the late Gothic and Renaissance periods constructed watches of innumerable shapes, frequently with an incredible variety of ornamentation. Each of these miniatures was a work of art in its own right. There were oval neck watches with convex backs, very light pillbox-shaped striking watches (diameter approximately 1-3 in.), round, costly, richly decorated and gilded musk-apple watches, and the elongated

neck watches designed in France and manufactured mainly in Germany and Italy. Very popular were octagonal watches with rock crystal lids which also include a compass and a sundial (in the 16th century these watches sometimes had even more dials), as were tulip and star-shaped watches, and even some in the form of a cross and a skull. There were, too, watches set into the pommels of swords, writing-cases and rings. All these products were specialities of the goldsmith's art rather than the clockmaker's.

In this period of expanding knowledge and physical discovery, the technical performance of clocks, and particularly of pendant watches, was also improved. The most important innovation, and an alternative to the fusee, was the stackfreed, which was probably first used by its inventor, Peter Henlein of Nuremberg, one of the most famous craftsmen in the clock industry. It was usually accompanied by a verge escapement. The individual parts of the clock were manufactured mainly of iron even in the 16th century, but the possibility cannot be rejected that the most important parts (wheel balance, barrel and fusee) were already being made of brass in 1430, a theory of Ernst Zimmer's. Fifty years later the pin began to be replaced by screws; sometimes it was used together with screws. Screws were only used exclusively in the 17th century, however. They have round, flat heads and are quite easily distinguishable from modern steel screws.

Drum-shaped clocks. This is a special type of clock with a horizontal dial on top of the case. It was about 1 ft. 3 ¾ in. to 2 ft. 7 ¼ in. in diameter and about 1 ft. to 2 ft. 1 ½ in. high. It had twelve figures and one hand, and the works consisted of a verge excapement, spring and fusee which, by means of three arbors, controlled the hour wheel and hand. A further improvement was effected by the addition of an alarm attachment, a drum-shaped piece with a bill over the horizontal dial. The pin in this upper part, which acted upon the hand, caused the bell to ring. The decoration was concentrated on the casing of the big drum in the form of engraved tendrils, hunting and animal scenes, and Classical medallions. These clocks probably originated in France, where F. Valleran constructed them, but they were also known in Germany.

Table clocks. These had replaced the drum-shaped clocks by the end of the 16th century. They were lighter and measured between 3 and 10 in. in diameter and between 2 ½ and 6 in. in height. They also had a bell, and the unbroken surface of their casing allowed plenty of scope for decoration. Apart from simple clocks with dials, bells to strike the hours and alarm discs, more luxurious clocks of gilt-bronze played an ever more important part: among the inevitable arabesque decorations were medallions, the seven planets and dolphins, and sometimes a loose cover protected the casing, with a hunting scene in a landscape. Although during the Middle Ages the smiths, armourers and locksmiths rarely marked their works, the signatures of clockmakers, who played a leading role in their guild, now started to increase. They signed themselves with their initials, for example HG and two crossed spades — Hans Gruber in 1570; MP — Martin Purmann at the end of the 16th century. Deutsch also signed his initials in the second quarter of the 16th century, as did Jakob Zech and Hans Steinmeissel from Prague. From the middle of the century the full name was shown, for example 'J. Marquart'. The next development consisted of square or hexagonal table clocks, which reached the height of their popularity after 1550. Instead of the horizontal dial with astrolabe, the sides were now covered with numerous dials (one for the hours and others for the quarter-hours, the course of the sun and moon, and the date). Although round or angular table clocks were constructed throughout the whole of the 17th century, bracket clocks with springs had begun to replace them.

The bracket clock with a spring. These clocks, which originated in the 15th century, increased in popularity during the 16th century. The demand for improvements in the appearance and design of clocks was soon met, and they became an accepted element in interior decoration. With the solving of technical and other problems a prototype was developed which still exists today in various forms.

In the south German towns of Augsburg and Nuremberg, clocks were made with beautifully designed cases. Pierced ornaments dis-

playing the precision of the goldsmith's art decorated the sides, the hood enclosing the bell, and the sculpted obelisk or small figure above. Finials on the corners, profiled corner pillars, sculpted corner caryatids, sculpted figures on the top, usually made of bronze, were complemented by the arabesques, leaf designs and figurative motifs on the pierced sides which, also made of bronze or brass, were usually gilded or silvered. Of particular value were the splendid square clocks with eight to ten dials on all the sides, showing the hours, the quarter-hours, the course of the moon and its lunar cycle, the course of the sun and a perpetual calendar. Underneath the hour dial, to the front, was a small quarter-hour dial and, to the rear, a dial for the strike indicator and sometimes even an astrolabe. Later it became normal practice to add a pendulum. These clocks were manufactured in Innsbruck, Vienna, Munich and Frankfurt. In France, hexagonal clocks in attractive shapes and with Classical decoration were constructed by Oronce Finé and Bourguignon Cuzin and his sons.

Automata clocks. From the middle of the 16th century these very popular clocks were constructed as curiosities. After 1550 E. Baldwein produced clocks with moving figures to strike the hours. Isaak Habrecht in Strasbourg and W. Pfeffenhauser in Augsburg built multi-tier clocks in the form of towers with figures; Hans Schlottheim produced similar ones. Small clocks with a figure of a man either pointing to or looking up at a revolving globular dial or a clock in a tree-top were popular. Automata clocks remained in use during the whole of the 17th century.

Mirror clocks. A special type of clock appeared in the middle of the 16th century: a round clock in the form of a mirror carried by Hercules. It usually showed the hours and minutes and, on the frontal astrolabe disc, the motion of the heavenly bodies. (In Augsburg huge astronomical clocks were constructed.) These clocks frequently had a small pendulum in front of the dial, a Huygens pendulum behind the clock's works or a Huygens spiral spring.

Monstrance clocks. From the second quarter of the 16th century clocks appeared in Italy which were outstanding by virtue of the

exceptionally imaginative decoration on their cases, their costliness, lively colours and technically advanced movement. There were even clocks in cases which resembled the monstrances of the time.

Crucifix or Calvary clocks. These consisted of a crucifix with a clock, on either side of which stood Mary and John. In these clocks the movement turned a globe around on which there was a band indicating the hours; a hand pointed to the time. These clocks were found throughout Germany during the second half of the 17th century, and were manufactured in Augsburg, Stuttgart and other towns. The name of the clockmaker, the place of manufacture, as well as the name of the contractor or dealer, appeared more and more frequently on the movement in italics. The clocks came to be composed of parts which had been manufactured in different workshops. It had then long been the practice for the clockmaker to sign the case after it had been made by somebody else.

Clocks in wooden cases. The demand for clocks rose steadily, and in order to keep up with it cheaper clocks were made. Their square cases, usually with a bell-top and handle, made with the most varied materials and decorated with every conceivable type of pattern, were made from about the middle of the 17th century. The earliest wooden-case clocks were mainly of German origin. Similar but more attractive clocks were manufactured in France and called *religieuses.* In addition to those of ordinary wood, cases were made increasingly of exotic woods: the sides were ornamented with *intarsia* designs and incrustation, gold borders and straight or twisted corner pillars, while the hood was decorated with figures and vases. The dial, originally made of pewter, silver or gilded copper, was now gilt bronze, richly engraved or etched with reliefs of figures and plants around the enamelled figure plaques (later to be replaced by an enamelled dial). These simple clocks, frequently equipped with metal covers, were brought to England by German clockmakers.

Pendulum clocks. The application by Christiaan Huygens of the pendulum to the clock escapement in 1658, published shortly afterwards, did much to increase the popularity of the clock. Behind the movement, suspend-

ed from cords or a steel band, was a pendulum which was connected to the verge by a crutch, so controlling the movement. Before the end of the 17th century clocks were made in Paris with a pendulum at the side, and in Germany there were very popular clocks with a short pendulum ('Zappler' in front). The date of origin of this type of pendulum is not known, but it appeared among weight-driven clocks before 1700, then among spring-driven clocks, and later was even added to older clocks. Sometimes the pendulum could be seen through a window, behind the dial but in front of the movement. The front position of the pendulum spread from Germany to France, England and Spain. Christiaan Huygens' discovery was followed by Graham's invention of a better escapement.

Repeating clocks. In 1676 Barlow constructed the first rack striking clock. It struck the hours and quarter-hours and, after having struck, could be made to repeat itself. Huygens was also important in securing increased regularity of the movement by means of the short pendulum — within 20 seconds a day — and a long pendulum with anchor escapement — within 10 seconds. His predecessor was Jost Bürgi, who in 1612, by means of the cross beat of two foliots, achieved greater accuracy than the one hour per day which was usual at that time.

Another important discovery by Huygens was the spiral balance spring, which replaced the various balances then in use. This made it possible to convert watches, which until then had been worn round the neck, into *pocket watches.* These too were equipped with compass and sundial. Such timepieces were assembled with particular care, especially in Switzerland (Amiel and Moquin in Geneva) where, in the 17th and 18th centuries, clock production was expanding. The expensive cases made of silvered and gilded chased copper, and of silver, tortoiseshell and Meissen porcelain, many with portraits painted on enamel or inset with pearls and precious stones, allowed goldsmiths to give free reign to their imaginations. Valuable clocks of this kind were also produced in France as well as Switzerland.

Among the curiosities and specialities of the period were numerous clocks which, constructed in different ways, were activated by their own weight. The oldest, the *saw clocks,*

were suspended between two rods with notches cut at regular intervals. In Paris Reynault constructed them as wall clocks, which were inverted when they had run down. Another sort of clock was the *roll (inclined plane) clock.* This descended slowly down an inclined plane over a 24-hour period; when it had finished its descent it was lifted off and placed at the top again. In the 17th century these clocks were made by H. Buschmann and I. Habrecht. *Rolling ball clocks* created by H. Schlottheim in 1600 consisted of a moving track on which a ball ran downwards, and of a mechanism which produced a second ball at the top of the track one minute later: this minute was indicated on the dial. These domestic clocks were produced mainly in Germany but also in Italy, where they were regarded as costly curiosities because they were so richly decorated. Another popular clock was the *display clock,* with its flamboyantly designed casing. From 1600 *musical clocks* were found increasingly inside buildings, like the chiming clocks on towers or the monumental clocks on town-halls. They had an organ, bell or gong, and also moving figures. These clocks remained in favour for more than two hundred years.

Clocks in the 18th and 19th centuries. The golden age of the clockmaker's craft was undoubtedly the 18th century, especially as regards the case and its ornamentation. Architects who were preoccupied with interior decoration — Pineau, Cuvilliés, Meissonier — included clocks in their interiors in conjunction with such articles as console tables, commodes, corner cupboards, writing-desks, dressing-tables and mirrors. France led the field. At the beginning of the 18th century Charles Boulle designed bracket clocks which indicated both hours and minutes, and included an alarm. Their colourful incrustations of tortoiseshell, pewter and brass, the gilded acanthus leaf borders, the gilt figures on the hood and the flat figurative scenes, reflected the magnificence of Louis XIV's court with so much élan that they were imitated throughout the 18th century not only in France but also in Munich. The wall clocks were called *cartel clocks;* their gilded frames decorated with pierced leaf motifs, blossoms and *rocaille* were, towards the middle of the century, asymmetrical, and formed a separate component. In the second

quarter of the 18th century the *pendule en cartel* clock appeared with console and decorated crest. Both types of cartel clock struck the hours and quarter-hours. The importance of the clock case was apparent not only from its size but also from the materials used. As examples of good taste we have the clocks by Voisin, with Chinese figures and peacocks made of Chinese porcelain on a gilded base, and the table clocks of porcelain by J. J. Kändler, with their coloured bocage and foliage, pairs of shepherds, lovers and goddesses accompanied by amorini. At the very top was placed a small clock. A French speciality was the unusually beautiful and deep lustrous blue, green or red lacquerwork, Vernis Martin. The *intarsia* decoration so popular in Austria was much in evidence on cases, which were transformed into complicated works of art with undulating lines and gilded figures. Characteristic because of their flamboyant cases were the German *plate-shaped clocks* set in broad, richly decorated frames which were frequently made of silver. There was usually a short pendulum in front of the dial. Also characteristic were the *picture clocks* made in Vienna at the end of the 17th century, which consisted of a framed rustic or town scene with a painted tower in which the clock was set. These clocks were much sought after in Austrian homes in the Biedermeier period, around 1830. In the 18th century, *long-case clocks* became extremely popular although they had already been manufactured since the end of the 17th century in Germany, England, Holland and Scandinavia. They consisted of a base, a tall case with a pendulum, and a hood containing the clock. In England considerable technical ingenuity was displayed in the manufacture of these clocks with dials showing the phases of the moon as well as weeks, months and years. In the last two decades of the 17th century A. Fromanteel and especially Thomas Tompion discovered a way to indicate mean and sun time together. The contributions of Tompion, Christopher Gould and Daniel Quare are among the major achievements of English clockmaking. The English taste for coloured lacquer and gilded landscapes with buildings, birds and figures was particularly evident in the decoration on the cases of bracket and long-case clocks, which were also ornamented with floral *intarsia* work.

Astronomical clocks were extremely popular in the 18th century. Apart from the hours and minutes they also showed the sun's position at various important points, the day of the month, the seasons, the mean and solar time, and so on. They were manufactured in Paris, Nuremberg, Vienna, Augsburg, Prague and Heidelberg.

In Paris they were still popular in the second half of the 18th century, but the shapes of their cases and cabinets underwent alterations to conform to changes in styles. The predominance of Neo-Classicism led craftsmen to seek inspiration in the temples of Antiquity, in their columns, vases and lamps, as well as in Classical decorative motifs — meander, beading, egg-and-dart ornament and palmettes. The actual function of the clock was increasingly regarded as of secondary importance, and artistic display reached a point at which the clock was almost lost in a mass of detail. The production of clocks, so elegant, charming, graceful and intimate, attracted the attention of such prominent personalities as Falconet, who managed the porcelain factory at Sèvres, Pajou, who produced Sèvres biscuit ware, and the clockmakers Dumont and Lepaute. The level of technical achievement was maintained into the Empire period by such famous artists as Thomire, who specialised in work with gilded bronze. The French *fondeurs, ciseleurs* and *doreurs* belonged to the artistic elite who applied their technical methods to clocks. Pairs of lovers and flower-filled marble vases were succeeded in the Napoleonic period by military themes and motifs inspired by the popular art of Pompeii and conventional Roman motifs. The Napoleonic battlefields also engendered exotic motifs such as Egyptian caryatids, sphinxes and lotus blossoms. Blackamoors of the *type à la négresse* and conversation scenes were much in demand. The sentimental mood of the period was reflected in the Chronos (time) motif, which was later superseded by the Baroque, consisting of maidens studying in Classical or period clothes and girls reading love-letters. There was a reaction against these fanciful and extremely complicated shapes of the second half of the 18th century; hence the table clock shaped like a revolving ball with a ring as a dial, the Empire mantel clock (pendule de cheminée) and the urn clock. With the advent of Neo-Classicism *mantel clocks* appeared with

branched candlesticks or perfume burners as embellishments.

Pillar clocks with wooden or alabaster pillars in front of a mirrored wall were exceptionally popular in central Europe. They appeared in all sorts of forms and their artistic value varied considerably.

In the first half of the 19th century, the revival of interest in the Gothic style led to a renewed use of medieval architectural elements for decoration. Another aspect of Romanticism was the adoption of sentimental figures from contemporary literature as decoration. A pronounced contrast to these theatrical troubadour scenes was embodied in the classical simplicity of *carriage clocks*, in discreet metal-framed glass cases with metal handles, which appeared throughout the 19th century. They were also manufactured by the leading French clock-maker, Breguet, whose main speciality was the *pocket watch* with numerous dials, which he made with incomparable precision and elegance; his technical achievements can still elicit surprise and admiration.

In clock-making, as in other crafts, the second half of the 19th century was a period of sterile eclecticism. At the end of the century a new creative spirit was born, and the tendency towards simplicity and practicality was strengthened by a new emphasis upon high quality of craft work and respect for the materials used. This new style, which erupted in Germany, Austria, England, Scotland and France under various names (Jugendstil, Sezession, Modern Style, Art Nouveau), affected clocks mainly in so far as they were an element in interior decoration.

Advice to Collectors

A complicated procedure was followed in the identification of clocks as early as the 17th century. The contractor signed the finished product and the clockmaker in his turn signed the case, which had been made by another craftsman, at the same time assembling the parts which had been manufactured in various other workshops. The signatures to be found on the clocks are therefore not uniform. In addition, forgeries, which began to be made as soon as clocks began to be collected, made matters more difficult for the collector; and the best were of such competence that even museum experts were sometimes deceived. In particular, the famous Nuremberg clockmaker Peter Henlein inspired forgeries signed with a PH or Petrus Hele (sometimes with a date). Care should also be taken with the long-neck watches signed MK, about 8 × 10 in. in size, which were manufactured at the end of the 1880s.

Clock accessories could also be forged. It is, of course, clear that complicated mechanisms cannot remain in good shape for centuries. When hands, cords and weights, or even the front of the clock, have to be replaced, this involves a new electrotype copy. Forgeries can include clock reconstructions. A characteristic example was the transformation of a clock with big bell into a clock with spherical bells, which was motivated by the discovery of a very old spherical-bell clock from the first half of the 14th century. After this, many old chiming clocks were adapted in this way.

The addition of a pendulum in the 17th or 18th centuries — as long as it was not used for purposes of deception — was as little regarded as fraud as the replacement of an old, worn-out movement with a new one in order not to lose the old, artistically valuable case. The best thing a collector can do in this complicated specialist field is, of course, to seek advice from an expert and to acquire a thorough knowledge of the technical and artistic development of the clock.

Finally, a word about the collecting of accessories, such as balance cocks, hands, keys and weights. In the 16th and the early 17th century, balance cocks were small and usually oval, with narrow supports. After the discovery of the balance spring they became longer and larger because the balance had also been enlarged. Designs were made by quite a number of engravers and designers: H.J. Collaert, Daniel Marot, Etienne Delaune, Michel le Blond, J.M. Hoppenhaupt and others. The decoration of these objects became denser and more complicated until a peak was reached in the 18th century. There were several types: the German and English had only one support (balance cock), the French and Swiss two (balance bridges). The German ones are not decorated at all, but the English ones, which are usually engraved, are lightly pierced; the French are richly decorated and engraved. The cocks with portraits on enamel or figures and coats of arms are very costly. The material most frequently used was gilt brass.

Hands and keys remained plain for a long time: it was not until the late Baroque that intricate, fine ornamentation was applied. The most sought-after keys are those from the 16th and 17th centuries.

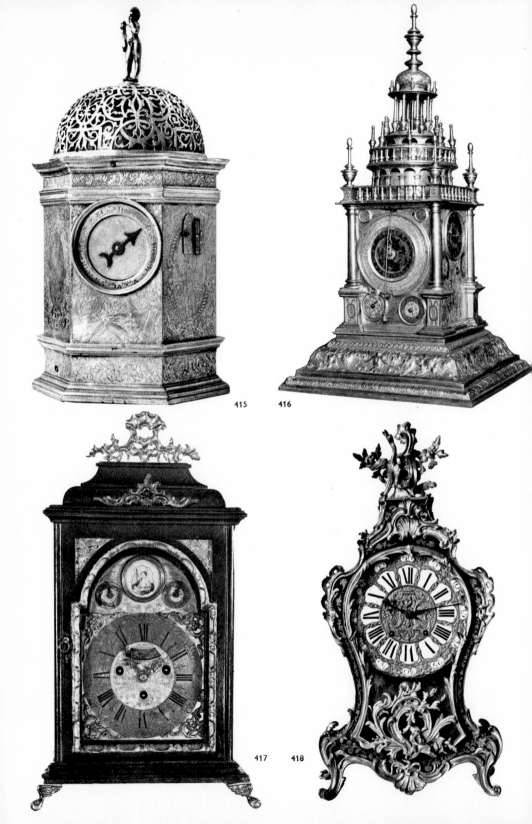

415 416

417 418

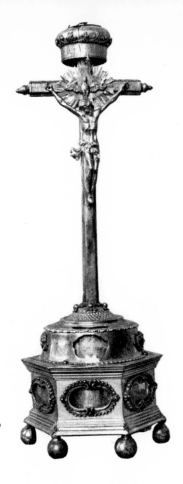

419

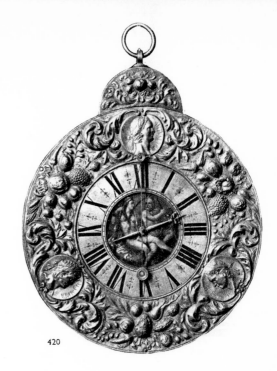

420

421

415 Six-sided table clock; Renaissance. Prague, 1560
416 Table clock; bronze, Renaissance. Germany, first quarter of 17th century
417 Table clock; Baroque. Prague, third quarter of 18th century
418 Bracket clock; Rococo. France, after 1750
419 Crucifix table clock; Baroque. Christoff Leuchner, Prague, first half of 17th century
420 Wall clock with painted dial. Southern Germany, second half of 17th century
421 Table clock; Baroque. France, second half of 18th century

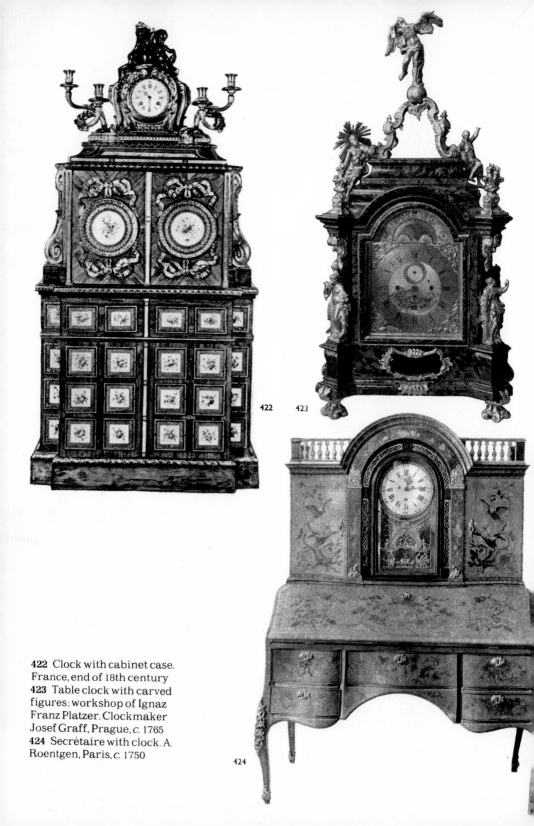

422 Clock with cabinet case.
France, end of 18th century
423 Table clock with carved
figures; workshop of Ignaz
Franz Platzer. Clockmaker
Josef Graff, Prague, *c.* 1765
424 Secrétaire with clock. A.
Roentgen, Paris, *c.* 1750

422 423

424

LIX Table clock. Thomas Fridl, Augsburg (?) Beginning of 17th century

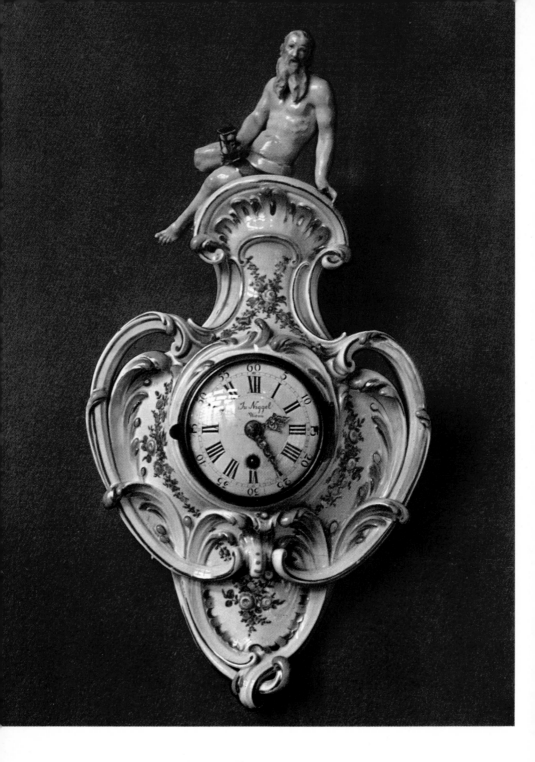

LX Wall clock; porcelain, with Chronos. Vienna, *c.* 1760

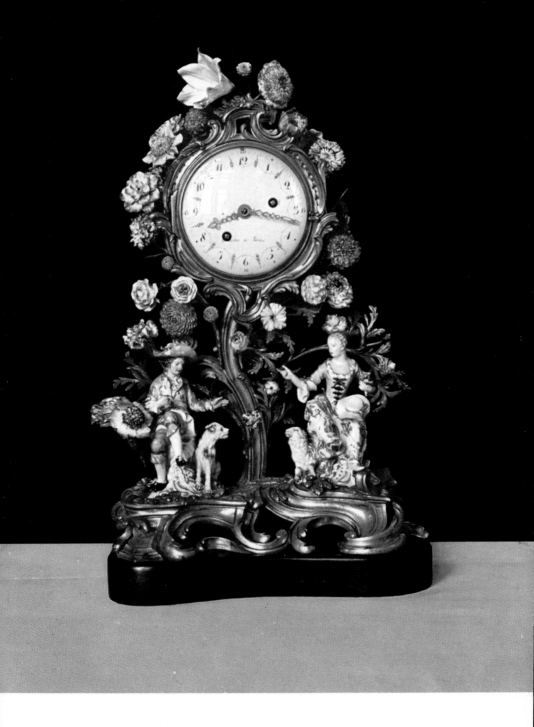

LXI Bronze table clock with flowers and figures of Meissen porcelain. France, *c.* 1750

L XII Candlestick of painted milk glass. Bohemia, 1780-90

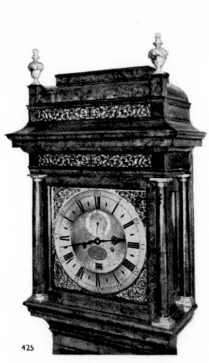

425

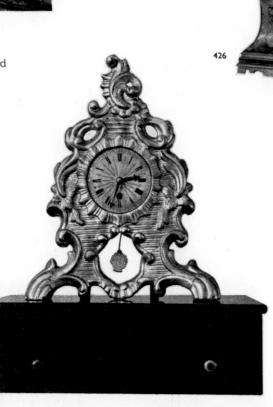

426

427

425 Long-case clock, signed
by Thomas Tompion.
England, end of 17th
century
426 Long-case clock with
carved figures; J.
Winterhalter. Moravia,
c. 1740
427 Table clock (plate-
shaped); Rococo revival.
Austria, c. 1850

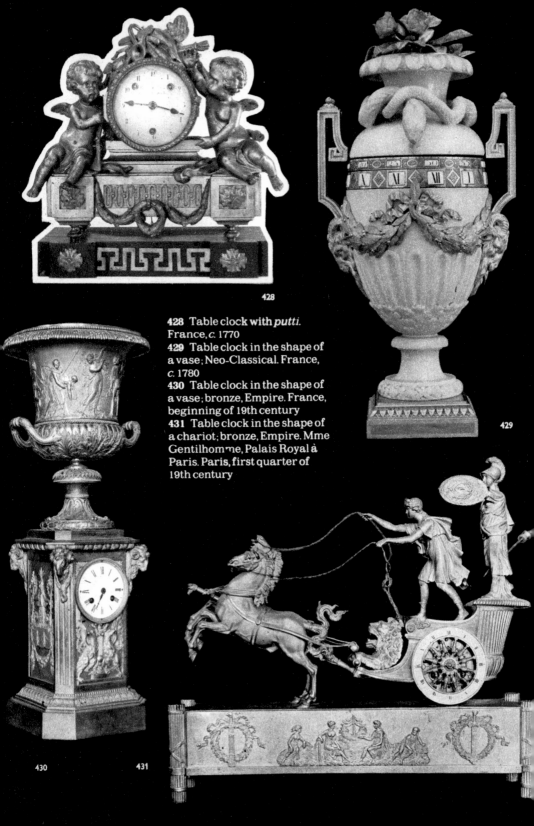

428 Table clock with *putti*. France, *c.* 1770
429 Table clock in the shape of a vase; Neo-Classical. France, *c.* 1780
430 Table clock in the shape of a vase; bronze, Empire. France, beginning of 19th century
431 Table clock in the shape of a chariot; bronze, Empire. Mme Gentilhomme, Palais Royal à Paris. Paris, first quarter of 19th century

428

429

430 431

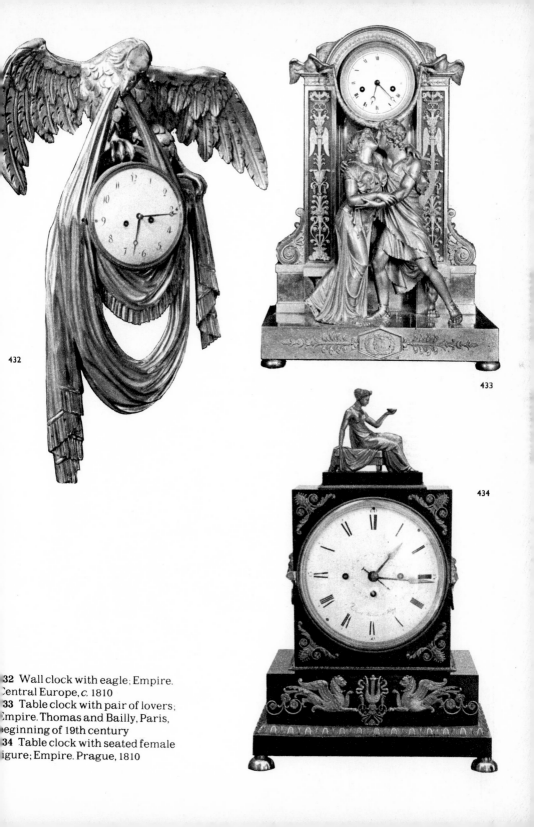

432 Wall clock with eagle; Empire.
Central Europe, c. 1810
433 Table clock with pair of lovers;
Empire. Thomas and Bailly, Paris,
beginning of 19th century
434 Table clock with seated female
figure; Empire. Prague, 1810

435

435 Wall clock ('picture clock'); Prague,
c. 1840
436 Wall clock, gilded; Rococo, Prague,
1840-60
437 Table clock of porcelain with the figure
of an Italian shepherd
Bohemia, *c.* 1850

436

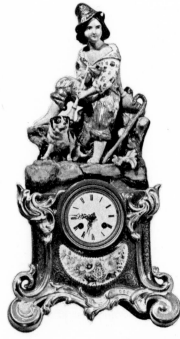

437

LIGHTING

To primitive man, light seemed a magic force: it conquered darkness and, with it, his fears. To conjure it up, he experimented with many different substances, discovered many sources of light and as many ways of using them. He made simple lights, in which the illuminant is the principle element, and complex, sophisticated devices which conceal the source of light with elaborate artistry. Technical progress gave civilised man ever clearer and more powerful illumination, while the actual making of lighting devices gave craftsmen opportunities for creating works of art. Unfortunately art historians have paid insufficient attention to this branch of craftsmanship. Wood-carvers, glass-blowers, enamellers, goldsmiths and other craftsmen made candlesticks and chandeliers in the style of their time. Since the processes used to manufacture these objects were the same as those used to manufacture other objects in the same material, information about such processes is given in the relevant chapter — on glass, ceramics, porcelain, gold and silver, pewter, and so on.

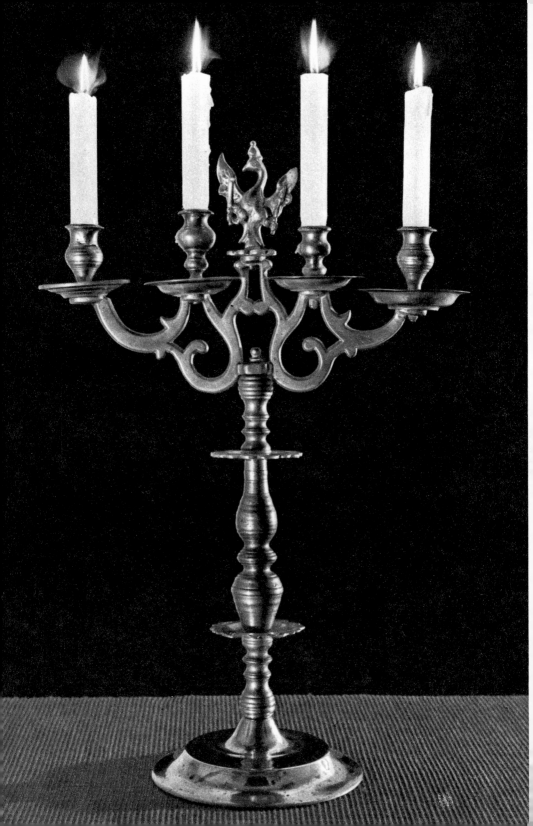

438 Four-branched table candelabrum;
brass, Baroque. Poland, 2nd half of 17th
century

Historical Survey

Antiquity. Early kinds of lighting included
vessels filled with glowing coals or wood-
chips soaked in resin or grease, as described
by Homer, and *torches* in the form of caked
pitch or wax, remains of which have been
identified in Hallstatt and Viking finds.
Primitive lights of this sort gave off fumes
and often caused fires. These defects led to
the invention of *oil-lamps*. The earliest oil-
lamps were used by the Egyptians in the 3rd
millennium BC. They were sandstone col-
umns about three feet high, hollowed out at
the top to hold oil-filled vessels. Decorative
lamps were developed in Crete. They consist-
ed of either small columns with relief decor-
ation or sheaves of stems supporting a chal-
ice-like vessel with handles. By the 6th centu-
ry BC the Greeks were making lamps of
classic, functional beauty. The circular oil-
vessel has one or more openings in its close-
fitting cover, and curves out on one side in a
spout (or several spouts) through which the
wick passes; the opposite side curves into a
handle. Sometimes there are rings beside
the spout for hanging the lamp. Other types
have two spouts set opposite one another
and a central handle. Earlier lamps are
small in diameter; later ones are larger and
richly ornamented by means of a casting
technique invented in the 3rd century BC.
The clay from which the lamps were cast was
pressed into two shallow moulds placed ho-
rizontally; they were joined and the seam
was smoothed off. The surface and spout
could afterwards be ornamented with plant
motifs and grotesque masks; the handle was
also formed to resemble a plant. Later lamps
had no handles and were glazed red or black.
Unglazed grey lamps with handles consti-
tute a special group, the work of rural pot-
ters of the 2nd century BC.
There was a remarkable boom in lamp pro-
duction in ancient Rome. The first lamps
were plain and comparatively crude (3rd-
century remains in the Esquiline). By the
early Christian era, we find simple decora-
tion and elongated spouts. Subsequently
greater decorative fantasy was displayed;
relief ornament, at first confined to the lids,
had spread to the entire surface by the end

of the Roman era. There were also unusual
lampholders representing lively figures:
a Silenus, a half-draped female figure or a
boy on a dolphin would hold the lampstand
within the undulating curve of an out-
stretched arm. During the Roman Empire,
Greco-Roman lamps in the form of animals'
heads were particularly popular in Rome it-
self, whereas those with ornamental covers
were preferred in the Empire and North of
the Alps. More elaborate *bronze lamps* rich-
ly decorated with reliefs constitute a separ-
ate group. By the 1st century, production in
bulk had begun. In Rome lamps were alrea-
dy in use as *wall-sconces* suspended from
hooks by chains. A more sophisticated form
of lighting for the wealthy was the *candela-
brum*, a many-branched stand for candles
or oil-vessels and aromatic woods. The earli-
est known candelabra, found with Etruscan
remains, are 6th- and 7th-century BC. The
base, usually three curved animal feet, sup-
ports a slender shaft, the lower half of which
may be a sculptured figure: an ephebe, a
veiled woman or a Cupid. At the top are
hooks to hold lamps, and either a figure
(dancer, flute-player or discobolus) or a ves-
sel of varying shape. In the 5th century, can-
delabra were still 3 to 4½ feet high;
smaller ones do not appear until the 3rd
century. They all bore an oil, tallow or
aromatic fuel vessel, and stood on table
or altar. Plant motifs soon spread to the
structural parts, which were in the form
of palm or acanthus leaves. The huge
temple candelabra are masterpieces com-
pletely covered with splendid plant
and figural ornamentation.
Lanterns, though finely decorated in the Au-
gustan period, were less imposing, since
they were functional rather than decorative.
Instead of the smoky torches that slaves had
once carried before their masters, the Ro-
mans introduced spherical or polygonal
lamps, the sides of which were made of horn,
skin or oiled linen. The domed or pyramidal
lids were perforated to let out the smoke,
and were attached and controlled by little
chains.
With the decline of Roman civilisation, the

great rooms that had required imposing illumination also disappeared from Europe. For a time the Christian rite was celebrated exclusively in modest consecrated places, and was equally unassuming in its trappings. This simplicity is shown by rare finds from Germanic excavation sites: crudely fashioned *wood candlesticks* intended for resinous wood, tallow and wax, which had again become the only illuminants. But while Western Europe had only modest lighting equipment, we have evidence in the Eastern Empire of a high level of craftsmanship. A splendid candelabra was presented by the Emperor Constantine to Roman churches, and above all a large number of *metal chandeliers* like crowns, constructed of discs, arcs and hoops, whose openings held spherical glass vessels. The later development of Western European candlesticks was influenced by Byzantine and Egyptian and pendant candelabra consisting of a pyramidal base set on three hooves, a stem in a ball-and-ring pattern, and either a shallow pan or a deep vessel. Some delightful metal lamps, in the form of ships steered by a figure of Christ or an apostle, have survived. Equally interesting are the *burial lamps* in the shape of doves.

The Middle Ages. *Romanesque*. The noble, austere beauty of the Romanesque style characterises both form and ornament of its *church candlesticks*, several of which stood behind or in front of the altar from about 1050. At first up to eighteen inches and later about a foot high, they were cast silver or bronze with silver niello decoration. In the 12th and 13th centuries the trend towards richer ornament led to the adoption of new materials: gilt-bronze and chased copper with enamel and, for decoration, rock-crystal and precious stones and metals. The candlesticks from Bishop Bernward's Hildesheim workshop, with their sumptuous ornament of interlaced ribands, of animal and human figures and fabulous beasts, testify to the unsurpassed skill of his metalworkers. Similar work was produced — though in smaller quantities — in the then famous workshops in the Meuse valley, Lorraine and the Rhineland and in others in Westphalia, north Germany and Lower Saxony. The short candlesticks of elaborate pierced design show the current taste for the fantastic. A second type of candlestick, which persisted in Europe for some centuries, has a tripod base on scroll or animal feet, and a widely projecting greasepan with a spike for the candle. Another type takes the form of a human figure supporting the greasepan and candle upon its head or an outstretched hand. Examples survive of a priest figure, sculpted in the round, and of Samson wrestling with the lion.

The custom of lighting candles at Easter Mass, begun in the 4th century, produced the huge Italian marble *Paschal candlesticks* over nine feet high. Their decoration of Easter scenes in relief or geometrical designs was the work of Como craftsmen. The finest extant examples of the huge *seven-branched candelabra*, inspired by the great candelabrum in the Temple at Jerusalem, belong to the 10th and 11th centuries and are now in Milan, Essen and Prague. The 11th century saw the introduction of *church chandeliers* consisting of a copper gilt hoop bearing figures of the apostles set in little niches, the doors of which were surmounted by candles. As they were difficult to tend, the candles were gradually superseded by very beautiful shallow glass or crystal oil-vessels, which were secured by a ring so that they could be drawn up and down by suspension chains.

At this time more elaborate *figure candlesticks* were also in secular demand. The figure was a horseman or a knight fighting a dragon. Two types originating at Limoges became very fashionable in the 12th century. The first had a pyramidal base on three animal feet, a long stem with one or more knops, and was decorated in green, white, blue and yellow enamel; the second — for travelling — had a long stem on a wide base. Several of these copper candlesticks could be fitted together.

High and Late Gothic. During the Gothic period the *altar candlestick* became popular. The tripodal base was either polygonal, circular or a series of convex tiers; its highly elaborate shaft ended in a wide, circular greasepan with a spike. Candlesticks later became less massive, their shafts longer, partly twisted or divided into groups of little columns and pillars with decorative moulding on their capitals. The ornament too was in keeping with the period. *Acolyte candlesticks*, borne by acolytes in processions, in

which the light was held by the kneeling or standing figure of an angel, were very popular in the late Middle Ages. While Rhenish and north German craftsmen were working in brass or yellow-tinged copper, the Catalans introduced wrought-iron candlesticks (13th and 14th centuries) which revealed Moorish influence, notably in the flowers in which the wrought-iron stems terminated. The wrought-iron *chandeliers* produced in France, Belgium and Italy are well known; the squared stem is set on a tripod; round the central stem are three horizontal rings tiered in diminishing diameter, which bear the greasepans or holders. The wrought-iron candelabrum in the form of a triangle with thirteen pans and spikes round its sides, in which candles were lighted for Easter Vespers, was mainly produced in the Rhineland in the 14th and 15th centuries. The *giant candlesticks* which were placed at the bier of exalted personages were also extremely fine.

In emulation of the nobility, burghers furnished their houses with imposing copper, brass, bronze or wrought-iron candlesticks; guilds and town councils commissioned sumptuous silver ones. The production of candlesticks for secular use was also concentrated in several north German and Meuse valley towns. The chief of these was Dinant, whose products inspired the generic term *dinanderie*. The domestic production of *tallow candles*, which were cheaper than wax candles, also created a demand for larger numbers of the more complex types of candlestick. As tallow candles were brittle, the greasepan with a spike was replaced by a deeper holder. Two simple types of *domestic candlestick* of brass or chased copper were evolved. The first consisted of a plate-shaped pan set on three animal feet and a rounded or squared shaft with a bulge surmounted by a long pointed stem; the second type had a deep circular base supporting a large drip-pan below the long cylindrical stem with the socket. The number of rings round the stem indicates the origin of the candlestick: Flemish candlesticks have two only; the German and Italian have four. However, as candles were still costly, earthenware *oil-lamps* remained in use, especially for workrooms, kitchens and studies. This vessel resembled the oil-lamp of Antiquity; there was a dish to catch the drips. Wrought-iron candlesticks with detachable parts were also in use. At the close of the Middle Ages bronze figural candlesticks representing pages or servants in contemporary dress were very popular.

Wrought-iron *wall-sconces* were very common in late medieval times. They were ornamented with pointed arches, complex tracery, etc., and hung over the fireplace. The highly decorative chandeliers with their profusion of candles were unsuitable for daily use. Thus evolved a new type of *chandelier* with six brass or bronze arms set in a circle round a central adjustable stem which hung from the ceiling by a chain. This style was characteristically Flemish: hence the name 'Flemish lustre'. Its use became widespread in north Germany and the northern countries, where iron and brass chandeliers persisted for a long time. Chandeliers made of stag or reindeer antlers were particularly popular in Germany, where they were hung perpendicularly in the North, horizontally in the South. Between the horns stood a polychrome figure (St George and the dragon, Christ or the Virgin), and the light-holders were set between the branches of the antlers. The figure also held a light in its hand. The frontal bones of the animal were usually covered by a carved escutcheon.

In urban Italy, where the streets were still busy in the evenings, householders were required to provide lighting for their own part of the street. The more elegant *lanterns*, ornamental polygonal wrought-iron objects on volute consoles and with spikes to hold the balls of tallow, were provided in streets and piazzas. This late medieval style of street-lamp still survives in northern Italy. More elaborate lanterns were needed by pedestrians; they were either rectangular with decorative iron openwork sides, or circular with light apertures covered with hide or panes of mica.

Renaissance and Early Baroque. In Italy a new, taller type of *altar candlestick* was created. It had either a tripod base with volute supports or a circular base and a complex conical support with architectural or sculptural decoration. The most diverse materials were used: cast or chased precious metals, cast bronze, marble and wood. Venetian and Paduan craftsmen excelled in brasswork.

In the early 16th century, French art was dominated by the Italian masters who

worked at the court of Fontainebleau, and French artists mainly copied their style. But by the end of the 16th century the French had evolved their own style, the chief characteristics of which were elegance, sophistication, and fine harmonious proportions.

The strong Gothic tradition impeded the spread of the new style in central Europe. Here the flamboyant late Gothic style passed — after a short relatively unimportant Renaissance period — almost imperceptibly into the Baroque. Germany had her own Baroque style and also her own techniques of craftsmanship, used particularly in the working of metals into unusually rich and luxuriant forms. German artists excelled above all in chasing precious metals, copper and brass, and in the decorative use of rock-crystal, ivory, mother-of-pearl, glass beads and shells. They applied their inventiveness and their unequalled skill with the chisel to the most diverse materials. This change of taste mitigated the austerity of Lutheran religious precept, which had retained the Gothic type of short brass or bronze candlestick with a bell-shaped base. In the 16th century appeared an original type candlestick consisting of two wide symmetrical goblets of equal size, decorated with radical lobing and united by a base with two convex rings. In Italy new types of candlesticks were gradually introduced into the palazzi of the patricians: the unusually wide and deeply curved base, like that of a chalice, held a wide dish which itself supported a deep vase-like vessel with an outcurved rim. The entire surface was inlaid with silver. This Arab technique was so popular in Venice — and elsewhere — that Paduan craftsmen used it even to cover candlesticks of old type with grotesque masks in relief. The stems and bodies of these candlesticks were decorated with satyrs, sirens and various caryatid figures in high relief. The Venetian love of splendour also found expression in the *glass candlesticks* made at Murano.

Faience superseded precious metals for a time, particularly in France, where the work of such artists as Bernard Palissy and the favourable economic conditions contributed to the development of factories at Moustiers, Rouen and Nevers, who introduced candlesticks with baluster stems, and also the square-based type. These yellow, white, green and reddish-brown faience candle-

sticks with naturalistic decoration in high relief soon gave way to a more austere type made of silver or silver-gilt. These had slender stems and a deep socket with delicate chased figural decoration, cartouches, medallions and masks.

In conservative Germany, *figural candlesticks* (with angels, saints or genre figures) long retained their popularity. German craftsmen imitated the famous Delft pottery in their faience candlesticks with wide rectangular bases and squared stems decorated with painted flowers and leaves. The modest counterparts of these extravagant show pieces for contemporary treasure cabinets were the commonplace but finely executed wrought-iron candlesticks with cornices.

English craftsmen, who had hitherto imitated Flemish and Venetian candlesticks, developed forms of their own in the 17th century in this, as in other applied arts, making tall, wide copper or pewter candlesticks with cylindrical stems and high conical sockets. Both stem and socket of these candlesticks were ringed. At this time Paduan workshops also introduced imitations of Roman lamps. In the middle of the 17th century, Cardan invented a device for regular impregnation of the wick, thus renewing the popularity of the *oil-lamp*, which had previously gone out of favour.

Wall-sconces too, with wall-plates of polished metal to reflect the light and protect the wall or panelling, retained their old form. German wall-sconces had one or two branches. They were used in churches and town and country houses, and soon spread to Holland and England. French sconces, which varied in size from one to five feet were at first simple oval objects, but became progressively more elaborately decorated with religious or mythological scenes. They were made of brass, copper, silver and glass, or wood and porcelain.

Ever-richer figural horn chandeliers, often designed by the best German artists, predominated in German interiors; wedding chandeliers with carved figures of bride and groom were especially popular. A new form of *brass chandelier* was introduced in Holland and Flanders. A central, elaborately turned column, terminating in a large globe with a ring, bears a statuette or heraldic animal; the curved arms, which encircle the axis in one or more tiers, end in wide grease pans with containers. In adapting this form

the Italians blurred its original clarity by their penchant for decoration, adding tendrils, volutes, acanthus leaves and figures. French elegance and sense of form restored the branches to a simple S-form and transformed the central axis into a panier which also held a vase decorated with the currently fashionable woman's or faun's head. The French name *lustre* for any *crystal lighting equipment* had become so firmly established that all ceiling lights were long known by this name. In the 16th century, and particularly in Italy, *lanterns*, whose form remained conditioned by their function, acquired pendant decoration of leaves, flowers and garlanded fruit. Decorative lanterns of this type illuminated corridors, staircases and even reception halls. The superlative art of Murano glass-blowers created the unique, spectacularly decorative glass chandeliers of the second half of the 17th century. They were shaped like lamps, miniature temples or gondolas, their branches almost hidden by festoons of glass beads, garlands of flowers and fruit and — the favourite form of decoration — Cupids. The radiance of these shimmering lights is enhanced by the combination of cut and polished coloured glass with plain and crystal glass.

Baroque and Rococo. New discoveries in the physical sciences, and particularly those of the second half of the 18th century, led to improved lighting techniques. The first step was Johann Joachim Becher's production of gas from coal. Bally, Leroy and Rabiqueau solved the problem of strengthening street-lighting by the invention of the reflector. Leyer invented the flat wick and Argand the lamp with a glass cylinder and a hollow anti-smoke cotton wick. New materials were added to the traditional metals. Symmetry and formal strictness gave place to playful forms: curling tendrils, sprays, flowers and shells with a great variety of little figures. In the middle of the 18th century architectural forms were superseded by plant designs in bizarre and fantastic creations. The swirling and sinuous shapes were emphasised by polychrome overpainting. The pomp and splendour of the French court, and the huge palaces of the nobility with their magnificent ballrooms, mirrored galleries and *salons*, provided the right setting for luxuriant crystal chandeliers, for the great sconces that flanked the vast wall-mirrors,

and for the sumptuous candelabra (girandoles) on their special little tables (guéridons). Logical form and symmetry disappeared even from the structure and decoration of *church candlesticks*. They sometimes look florid and overladen, their individual parts more and more frequently becoming a series of separate little creations.

Even during the lifetime of Louis XIV, the rigid formality of court life was relaxed, and the French example was inevitably followed at the courts of other European princes, who envied and aped French society. As the life of the court withdrew more and more to intimate salons and boudoirs, art too assumed more modest forms and became dominated by architects and decorators, who designed whole interiors down to the smallest detail. Many architects also undertook the design of lighting equipment. The designs of Cuvilliés, Hoppenhaupt, Meissonier Voisin and the Englishman Chippendale reveal the current preference for uninhibited forms and decorations, which gave rise to the most extraordinary creations. New kinds of small *hand candlestick* (bougeoir) evolved. Bedroom candlesticks of precious metals, faience or porcelain consisted of a large circular dish on which stood a deep holder with a short neck for the candle. The scriptomania of the period required new *writing-table candlesticks* with adjustable shades. For the bedroom there were composite pieces, gold or silver candlesticks combined with clocks or scent-bottles.

New, specialised types of candlesticks were evolved in France. The formal counterpart of the modest bougeoir was the *portable candlestick*. On ceremonial occasions many-branched candlesticks were lit. The candelabrum, also used on special occasions, was soon a feature of the French mantelpiece or sideboard; the support was ususally a human figure. The craze for *chinoiserie* in the period 1730-70 inspired bronze candlesticks incorporating chinamen, pagodas, bridges, birds and exotic plants in their structure. The growth of a taste for pastoral life inspired the artists of the Meissen porcelain factory (Kändler in particular) to introduce pairs of figures such as shepherds and shepherdesses, gods and demi-gods, between the branches of their candelabra, which they transformed into graceful flower-

decked balconies, trees and shrubs. A variant of the candelabrum was the girandole, which resembled a tree: the axis and arms were of metal with crystal pendants. Girandoles with arms set in a full circle stood on guéridons; the semicircular type graced the mantelpieces. Twin girandoles were created for ceremonial occasions.

Branched *sconces* of bronze, silver, crystal, porcelain or gilded wood were used in the more important reception rooms, where, with mirrors and wall-panelling, they were integral parts of the decoration. At the climax of Rococo exuberance (about the middle of the 18th century) they came to resemble real branches, covered with leaves, flowers and figures. A profusion of plant decoration, volutes, masks and shells transformed chandeliers, too, into baskets of flowers or fruit, from which emerged C- or S-shaped garlanded branches bearing the lights. In yet another type, voluted arms emerged straight from the centre, bearing clusters of lights. The crystal lustre (chandelier) came into fashion in the reign of Louis XIV. Its long axis, composed of glass cones, bells and vase-forms, ended in a bell (or else a kind of pavilion); the arms, set in several tiered circles, were hung with crystal leaves, rosettes and stars, the edges of which were polished, the upper surfaces faceted to reflect the maximum light. Real crystal, which reflects more softly, was often combined with crystal glass. In Germany, where Baroque attained extremes, original *porcelain chandeliers* were created; their framework was completely obscured by garlands of fruit and flowers and profuse figural ornament. Venetian *glass chandeliers*, though less imposing than crystal ones, were of similar design. But the standard of Venetian glass declined, and Bohemian glass, which had superlative qualities, supplanted it. The Rococo decorative spirit transformed even such workaday lighting equipment as the wrought-iron lantern into a basket of flowers or fruit or a baldachin-shape. The sides of the lantern bore engravings of *scènes galantes* or of flowers and tendrils. Not until after the excavations at Herculaneum and Pompeii did art revert to the calm, logical balance of Classical times and to the simple forms which had been forgotten for almost two hundred years. The shaft once more became smooth and bases simple. Decoration became a secondary element and was also taken from Antiquity: palmettes, laurel garlands, acanthus leaves, targets, panels, bead and egg-and-dart mouldings.

The Nineteenth Century. The Empire style came in with the turn of the century. Changes of style were once more dictated from France, where a new, majestic, grand style, in keeping with the grandiose ideas of the Napoleonic Empire, was created jointly by the imperial architects, Percier and Fontaine. All over Europe, art galleries were founded in expression of the contemporary spirit of rationalism; a series of publications, handbooks and pattern-books enabled craftsmen to reproduce works of art and fashionable designs in large numbers for the benefit of a much wider public. There were also numerous improvements in techniques of lighting apparatus production. However, in the first half of the 19th century the candle remained the principal form of lighting, and was only gradually replaced by Argand's oil-lamp, which gave a brighter light. Both were superseded around 1860 by Silliman's *kerosene lamp*. But the nature of traditional lighting equipment hindered the spread of these inventions. Until the end of the century, craftsmen strove for expression via clumsy imitations of historical styles, which were out of keeping with a radically changed style of life. Only objects made in difficult materials, such as bronze, copper, brass and silver, remained unaffected by the artistic standardisation resulting from mass-production. Outstanding work was produced in these materials, particularly by the French and the English: there were candlesticks in the form of antique columns, of consummate architectural harmony and with sparing ornament, refined in form and execution, consisting of acanthus leaves, lotus flowers, beading and egg-and-dart pattern, meanders and Greek or neo-Egyptian caryatids and sphinxes. There were also candlesticks of porcelain, and of the popular blue-and-white and brown-and-white Wedgwood biscuit.

New types of candlestick evolved: for card-players there were *flambeaux bouillotes*, two or sometimes more circular candlesticks with painted shades set on a wide openwork dish. There were very popular parchment shades with painted decoration which is invisible until the candle

is lit. *Wall-sconces* remained a French speciality. They were made in the form of an eagle, a snake uncoiling itself, or a swan which bore the light-holder on its wings, its beak or its head. The *hand candlesticks* (bougeoirs) were once more simple in form and sparingly decorated. The metal or crystal *chandelier* remained a feature of formal interiors. Two types became established: the lighter and more richly ornate French lustre was baldachin-like in shape, consisting of strings of beads falling from a palmette corona and passing through a ring with decorative curved arms; the German or English type was bell-shaped, consisting of several tiered rings, the smallest at the top, linked by strings of glass or crystal beads and hung with glass pendants. The French also favoured delicately chased bronze chandeliers, whereas the Germans preferred metal or wooden chandeliers, either of the simple dish-shape or consisting of laurel wreaths decorated with eagles, lyres and palmettes.

The oil-lamp came into wider use in the first half of the century, especially in France, where it was improved. Kerosene lamps were just like oil-lamps, consisting of a vase-like holder, two pipes for ventilation, and a wick which went through a pipe and was turned by a key. A circular or bell-shaped glass shade fitted over the glass cylinder. Improvements were made to this type, notably by placing over the pipe a wheel-shaped holder which cast no shade. An adjustable ceiling light composed of several Argand lamps was also used. The decoration of these lamps was confined to their marble or bronze standards. Although pyramid-shaped oil-lamps were installed in the streets of European cities, there was little improvement in streetlighting.

Kerosene lamps remained in use as table-lamps until the end of the century. The French emphasised the artistic form of the vessel: a vase, a bowl or a column supported the burner and the glass cylinder surmounted by the shade. The Germans introduced a new design with a pedestal supporting the vessel, burner, cylinder and shade. The pedestal or podium and the vessel were usually made of china, glass and cast iron, the fittings of brass or cast iron. At the beginning of the century, European scientists began to consider the more extensive use of gas for lighting, but it was not until the second quar-

ter of the 19th century that gas-lamps in the form of candelabra were erected in the streets of European towns.

Art Nouveau. The refined naturalism, with which Art Nouveau stylised the human body, the convolvulus, iris, rose, orchid and other exotic flowers in the complex yet supple lines of table-lamps and chandeliers, successfully balanced and compensated for the austerity and banality of the shape of the electric light bulb.

Appliances. The most frequently used adjuncts of the various types of lighting equipment were wick-snuffers (for trimming), candle-snuffers, light mantles, extinguishers and lighters (tinders). At first purely functional and very elementary in form, from the later 16th century they became steadily more complicated and decorative.

The idea of adding a little box for the wick-ends to the scissors (or snuffers) for trimming the wick was the initial step towards the decoration of snuffers; their 'ears' were cast as balusters or figures, their flat surfaces covered with leaves, scenes with figures or arabesques, either engraved or in relief. In the 17th century, luxuriously designed iron or bronze snuffers had either a case or a little tray with matching decoration. In the 18th century, snuffers, which had hitherto been straight, became curved in various ways; their flat parts were etched and ornamented with chased flowers, Cupids, garlands, leaves, hunting scenes and the owner's arms or monogram. Snuffers became luxury articles; parts of them were even made of silver-gilt. A French speciality was enamel decoration. In the 19th century, simpler snuffers of brass, steel, iron, silver and bronze were supplied with a stand set on little feet. The discovery of paraffin and stearin ended the need for snuffers.

Although we can assume that candle-snuffers, like wick-trimmers, originated in Antiquity, the earliest surviving examples are 17th-century. They are simple and conical, with one handle or 'ear', and are made of brass, pewter, tinware, porcelain and silver. The 18th-century taste for figure and plant ornament transformed candle-snuffers into figures of Chinamen, shepherds, ladies with crinolines, cavaliers or flowers, made of porcelain, faience, or chased or engraved silver. The 18th century also produced au-

tomatic extinguishers worked by means of a sand-glass and a ring and spring. Candle-snuffers in the form of figures were still made in the 19th century, especially in France.

Iron or steel firelighters shaped like knife-blades were provided with handles in the 17th and 18th centuries, and these became objects on which decorative fantasy could be exercised, particularly in the 18th century. They were decorated with filigree, engraving or etching, with incrustation or with scenes in relief. The discovery of sulphur and phosphorus rendered the lighter and tinder superfluous.

439 Ceiling light; late Gothic. Germany, 16th century

Advice to Collectors

The collector of lighting appliances requires just as much specialist knowledge as the collector of any kind of objet d'art, especially since only the costly luxury articles kept in step with contemporary styles, while the average candlestick or other lighting appliance did not change its form or decorative motifs for long periods. A helpful guide is a thorough knowledge of the materials used, the processes of production, the way in which the lamp was used, etc., at any given period. It is also essential to know when the various types first appeared, how they originated and when they became obsolete. Special mention should be made here of modern copies of ancient oil-lamps, and particularly of copies of Roman lamps. These carry patinas so excellent that they are indistinguishable from originals. Every period preferred certain forms, which were either completely imitated or were a combination of traditional parts with new additions. Thus the 19th century copied not only numerous medieval figural candlesticks representing pages, dragons, Samson and the lion, etc., but also ceiling lights made of antlers with polychrome figures and Romanesque altar candlesticks. Only a thorough knowledge of the complex arts and crafts involved enables the collector to know that these are fine copies. And, of course, specialist literature also provides considerable help.

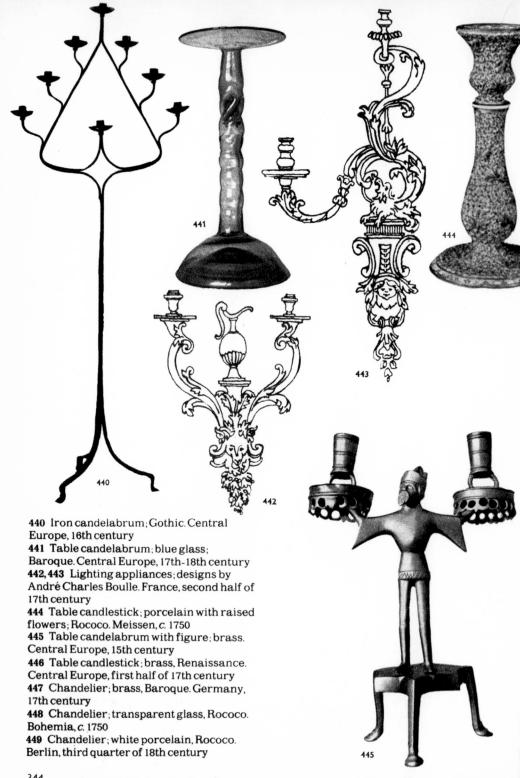

440 Iron candelabrum; Gothic. Central
Europe, 16th century
441 Table candelabrum; blue glass;
Baroque. Central Europe, 17th-18th century
442, 443 Lighting appliances; designs by
André Charles Boulle. France, second half of
17th century
444 Table candlestick; porcelain with raised
flowers; Rococo. Meissen, c. 1750
445 Table candelabrum with figure; brass.
Central Europe, 15th century
446 Table candlestick; brass, Renaissance.
Central Europe, first half of 17th century
447 Chandelier; brass, Baroque. Germany,
17th century
448 Chandelier; transparent glass, Rococo.
Bohemia, c. 1750
449 Chandelier; white porcelain, Rococo.
Berlin, third quarter of 18th century

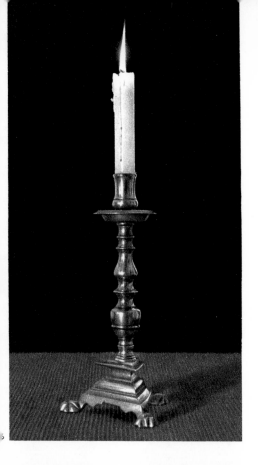

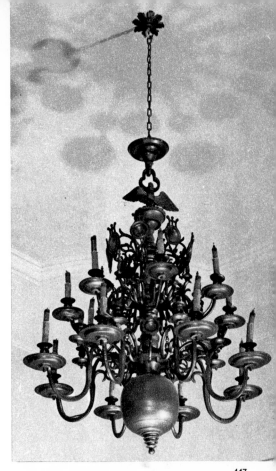

447

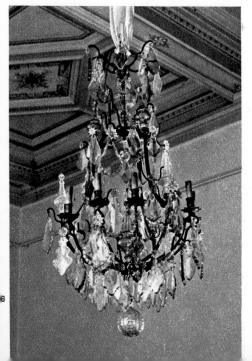

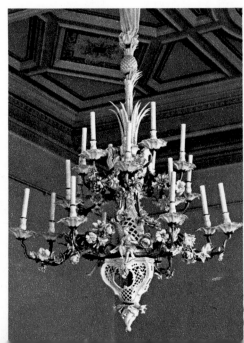

449

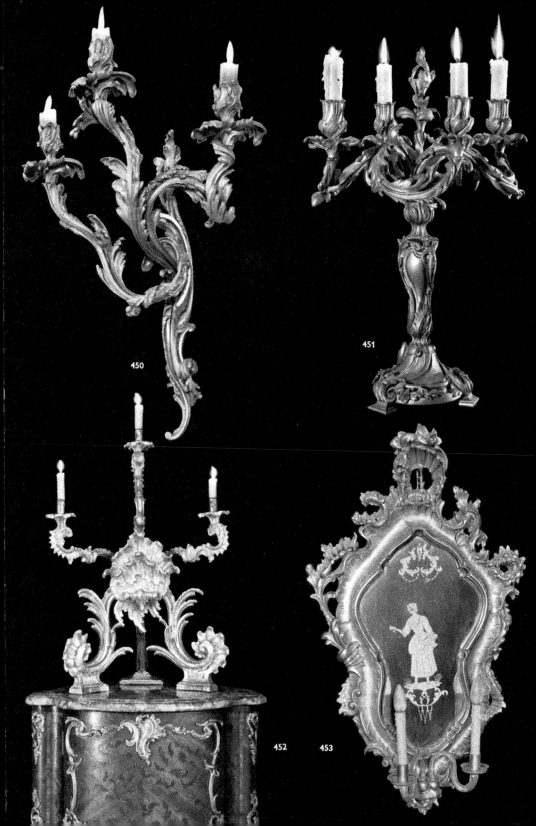

450

451

452 453

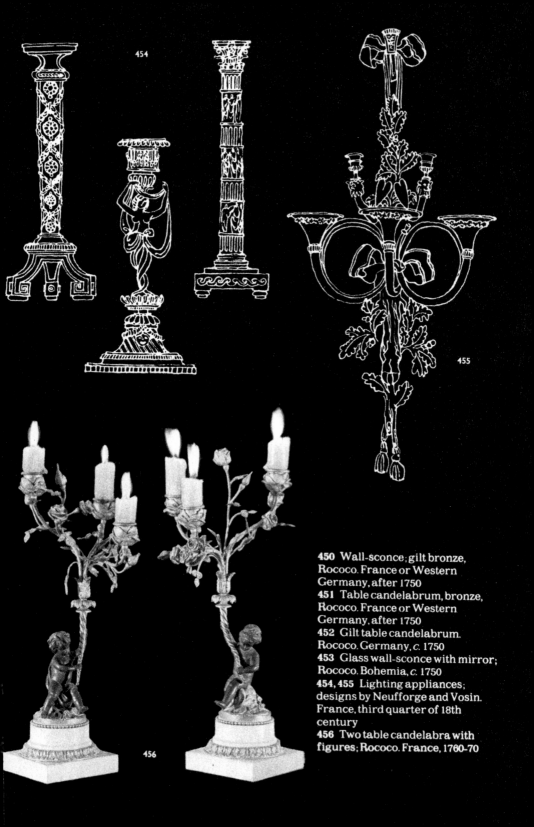

454

455

450 Wall-sconce; gilt bronze,
Rococo. France or Western
Germany, after 1750
451 Table candelabrum, bronze,
Rococo. France or Western
Germany, after 1750
452 Gilt table candelabrum.
Rococo. Germany, c. 1750
453 Glass wall-sconce with mirror;
Rococo. Bohemia, c. 1750
454, 455 Lighting appliances;
designs by Neufforge and Vosin.
France, third quarter of 18th
century
456 Two table candelabra with
figures; Rococo. France, 1760-70

456

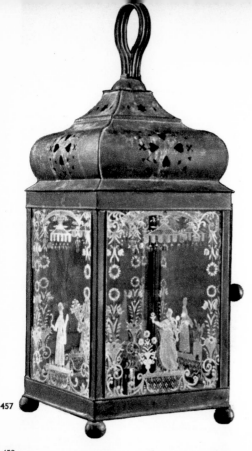

457

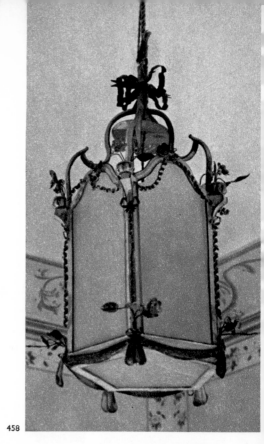

458

459

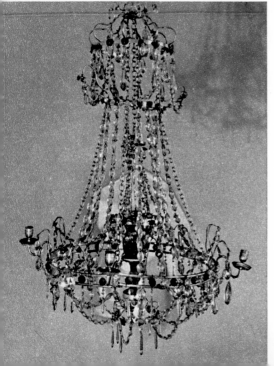

460

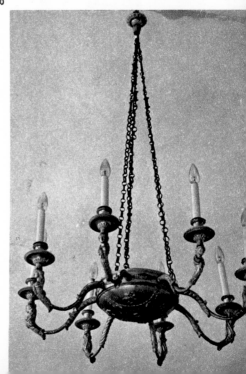

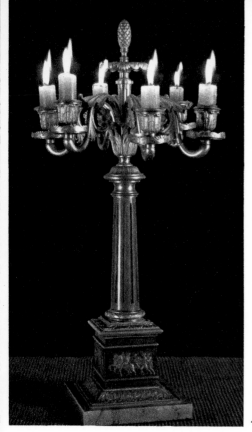

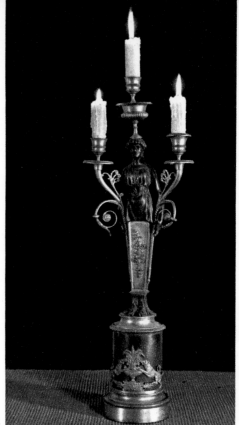

462

463

457 Staircase lantern; glazed, Baroque.
Bohemia, c. 1730
458 Ceiling light with polychrome
decoration; Neo-Classical. Bohemia, c. 1790
459 Chandelier with glass cascades; Empire.
Bohemia, first quarter of 19th century
460 Gilt chandelier; Empire. Bohemia,
c. 1810
461 Table candelabrum; bronze, Empire.
France, c. 1810
462 Table candelabrum with neo-Egyptian
caryatid. France, 1810-20
463 Table candelabrum. Bohemia, c. 1830

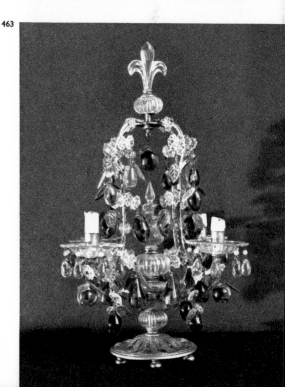

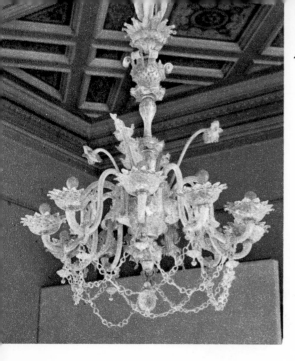

464

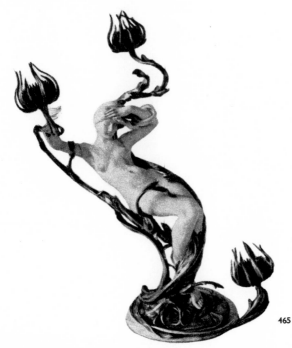

465

464 Chandelier; opalescent glass. Bohemia,
c. 1880
465 Table lamp; Art Nouveau. France,
c. 1900

350

PEWTER

Pewter was very popular throughout the Middle Ages and, indeed, well into the 18th century. Its uses were many and varied, since middle-class households and guild-halls would be richly furnished with pewterware, while at the same time it was used for church plate and quite often for ornamental show-pieces, as well as for the striking-mechanism in clocks, for coffins, conduit-pipes and a large number of everyday utensils. All these articles were made by the skilled hands of craftsmen known as pewterers.

Tin deposits. The oldest known deposits of tin are in Asia. The existence of deposits in Cornwall was discovered in about 1500 BC, and these were more than adequate to meet the requirements of the whole of Europe; in fact Cornwall still yields large quantities. But the first golden age of tin-founding in central Europe did not occur until the 12th century AD, after the mines in the Erzgebirge (which means 'ore-mountains') had been opened. In the 19th century, cheap foreign tin began to flood the European market and tin-mining became so unprofitable that it gradually died out altogether.

The pewter feather. European producers exported various types of pewterware all over the world, the quality of their goods being demonstrated to their clients by means of a sample piece known as the 'pewter feather': a spoonful of molten metal was scooped out and poured on to an iron plate; this set to a flat, ridged, metal strip, generally somewhere between 4 and 24 in. in length, which would be stamped with the coat of arms of the town to which the mine belonged, together with a portrait of its patron-saint.

Guilds. We have documentary evidence of the existence of guilds of pewterers from the 13th century. These were intended both to safeguard the rights and privileges of their members and to compel them to fulfil their duties. Pewterers would either band together to form their own independent guild or else join forces with other craftsmen, preferably with a group practising some allied trade, and create a communal guild; it all depended on how many of them there were and what their status was in the local community. The first set of regulations for the Guild of Pewterers in Lübeck dates from 1360.

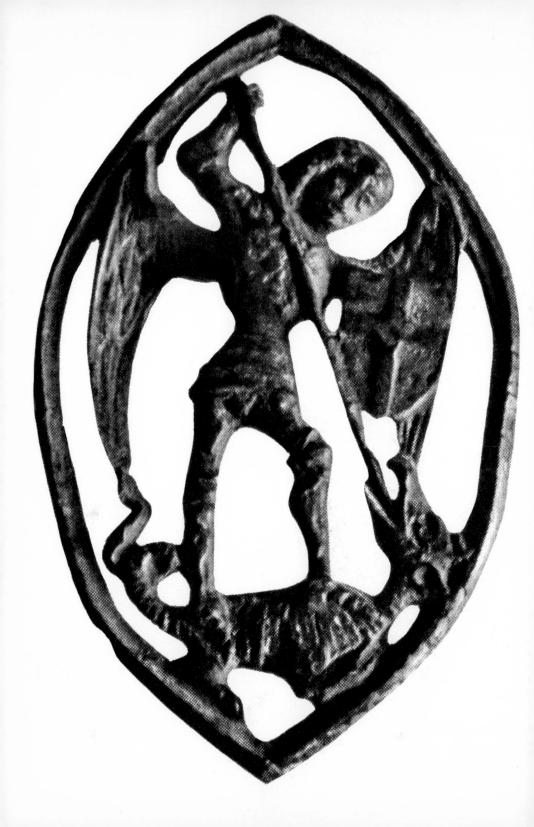

466 Pilgrim's badge with St George and the dragon, c. 1400

Manufacture

Moulds. A good deal of the success of a piece of cast pewter depends on the pewterer's choice of a suitable mould and on his choice of tools. Master pewterers would either make their own moulds or commission professional mould-cutters to do the job for them. Most moulds were made up of several different sections; various materials could be used, the earliest known examples being made of limestone, clay or plaster. But they could only be used a couple of times and even then did not give a very sharp outline. So experiments were conducted at various times with slate, serpentine, lead or bronze to see whether they were capable of producing a harder mould from which a larger number of pieces could be made. In the 15th century, brass moulds began to be used; they were very satisfactory from the technical point of view, but were more expensive. From the 19th century, cast-iron was mainly used, as it still is today. The quality of a piece of pewterware depends on whether the metal has been heated to the correct temperature. This meant that even the business of pouring the metal into the mould was a test of the pewterer's skill and dexterity; if the temperature was either too high or not high enough, this had a detrimental effect on the temper and colour of the metal. When the object had been knocked out of the mould the pewterer worked it either on the lathe or by hand, and if necessary would then assemble the individual parts and give the finished product a final polish.

Types of decoration. *Relief-casting.* Several different methods were used for decorating pewter from an early date. One of the earliest types of ornament was relief-moulding, which was either cast directly in the mould, with the decorative motifs being chiselled out in reverse beforehand, or else cast separately and added later. If the decorative motif was etched out of the side of the vessel in reverse before it was cast, the result was a very flat relief. Any object could, of course, be embellished with etched decoration when completed, but this was a very expensive business and was only used on some plates and bowls made in Nuremberg in the 16th century.

Engraving. This is the most suitable type of decoration for pewterware and is also the most widely used. Pewterers may sometimes have engraved their work themselves, but complicated designs would undoubtedly have been executed by experienced engravers. It was also by no means unusual for the owner to engrave his initials with his own hand, plus his family mark and the date, on to the pieces of pewter which he had commissioned; he would occasionally add figurative or abstract decorative motifs. The technique of engraving can be broken down into several different categories according to the way the line is treated. The earliest involved gouging out a simple, relatively deep, solid line with a burin; the golden age for this type of engraving was the 15th century and the beginning of the 16th, as is demonstrated by the very high quality figurative and abstract patterns on central European pewterware produced in the late Gothic period.

Chased work. This is found only occasionally on pewter utensils. Some pieces made by German craftsmen at the end of the 16th century have chased bosses, arranged in a repeating pattern, which have been beaten out with a wooden hammer.

One technique which is closely related to chasing is repoussé work, which was known as early as the 17th century but was not widely used until the 18th century (and then especially in Germany). The body of the vessel was divided into vertical segments by a series of ribs of various types (melon ribs, gadroons, etc.) which were hammered into the sides of the vessel from inside.

In Germany, Switzerland, the Low Countries, Silesia and elsewhere craftsmen occasionally used the technique of beating; this was generally restricted to flat plates and dishes made of pure pewter, that is, with no lead added, which meant that it was harder. After it had been removed from the mould, the piece was worked with regular hammer blows to strengthen the metal.

Punching. During the Renaissance, punched decoration was in fashion for pewter articles. A rod-shaped iron or steel punch with a stamp cut into the end of it was hammered into the piece to be decorated; the ornaments applied in this way consisted of acanthus leaves, palmettes, lilies and similar motifs, and were generally arranged in strips.

Other decorative techniques. As well as the techniques already mentioned, which were used merely for fashioning and decorating the basic material, attempts were made at an early date to plate pewter with other metals and so increase its value. Occasionally craftsmen would even try to produce imitations of gold pieces.

In England and France pewter began to be painted, and in the Empire and Biedermeier periods in particular, pieces lacquered in one colour or ornamental pieces adorned with multi-coloured paint were popular.

Pewterers frequently combined pewter with other materials in their search for ways of producing particularly attractive pieces. This practice may originally have been given extra impetus by the custom of inlaying pewter with brass strips and circular bands so as to make it stronger. Another idea was to use brass for those parts of the vessel for which pewter was not particularly suitable, for example spouts. It was not long before craftsmen began to appreciate the decorative potential of the contrast between the golden shine of brass and the dull gleam of pewter, and as a result the two metals began to be used together for purely aesthetic reasons. Thin sheets of pewter were often used for marquetry work, particularly in the late 17th century by such famous cabinet-makers as André-Charles Boulle. The two materials appear to their best advantage in wooden vessels decorated with thin and attractively pierced sheets of tinfoil.

Historical Survey

Districts. There were once tin-foundries all over Europe, with each district producing its own individual type of work. There is not space here to discuss the characteristic features of each individual area in detail, but we may refer briefly to *France*, where the production of pewterware flourished from the 15th century, and *England*, where production was not carried out on a large scale until the 17th century, although in fact the English pewter trade has a long history, since the country has such rich deposits of tin that her pewterers were never short of material. As for eastern Europe, a very large number of pewter-foundries were opened in *Russia* in the 17th century, some of which were given over exclusively to supplying the Tsar and his court, while others worked solely for churches and monasteries. The design of Russian domestic utensils closely resembled central European work, whereas ecclesiastical objects were of course made to the requirements of the Orthodox Church. One special feature of Russian pewter is its enamelled decoration, which does not appear elsewhere. The main type of pewterware produced in the Balkans consisted of flasks with moulded decoration.

The Middle Ages. The earliest pieces of pewter to have survived have been found during excavations, most of them having been either dug up from the ground or dredged up from the bottom of lakes, rivers or the sea. As a result, the surface is corroded, sometimes with a different patina from the usual layer of corrosion which tends to be created by the action of the atmosphere on pewter articles. In dating these pieces, experts base their judgments first of all on the circumstances of their burial and only afterwards make comparisons with work which can be dated with certainty. (And in fact there are very few such pieces.) This last point is tied up with the chemical process to which pewter is exposed when buried in the ground; this gradually leads to the material undergoing a chemical change which ultimately results in its total decomposition. So only the occasional piece of prehistoric pewter has survived, and even pieces from the Classical period are exceedingly rare.

Ecclesiastical instruments. Small devotional objects are among the earliest types of memento in Europe, and a large number of them have been found, mainly on the bed of

the Seine. Pilgrims used to toss them in the river as early as the period of the Crusades (11th-13th centuries). These *pilgrims' badges* were worn round the neck and were generally made of a pewter alloy which contained a large proportion of lead. They carried portraits of the favourite saint of the pilgrim's country, which means that the majority of English badges portray St Thomas à Becket, whereas French ones will favour St Dionysius of Paris or St Nicholas, and so on. In 813 the Council of Rheims permitted the use of pewter for *ecclesiastical implements* as well as gold and silver (though all the other base metals were forbidden), but since objects made with the precious metals were far more impressive and were regarded with greater awe by the faithful, pewter articles were still used only in times of scarcity or in the poorer parishes. Excavations of medieval graves have brought to light simple pewter chalices, patens, croziers and crucifixes. Churches in Italy, France, Germany and elsewhere possess wooden *reliquary chests*, dating from the 13th and 14th centuries, which are sheathed with sheets of pewter worked with rich figurative decoration. One of the rarest categories of medieval liturgical implements comprises pewter *ciboria*, which are generally small, compact polygonal boxes with a removable lid and relief decoration on the sides. *Monstrances* were rarely made of pewter, but on the other hand a large number of pewter-lined *fonts*, which are the most monumental items ever to have been made in pewter, survive in Bohemia and Moravia.

In the 14th century, pewterers and bell-founders belonged to the same guild, and this system was also common in later centuries. This meant that one craftsman could practise both trades, a system which affected the design of the earliest fonts. The shape of the earliest known pewter baptismal bucket is rather reminiscent of an upside-down bell mounted on three massive claw-feet. These buckets are often surmounted by three-dimensional human heads wearing beards. The central section of the font is embellished with Gothic arcades framing relief-moulded figures of various saints. Bands of lettering run round the font right up to the rim; these inscriptions are sometimes engraved and sometimes cast, and may be in Latin or in Czech; they supply various details about the piece, generally including the date of pro-

duction. During the Renaissance this type of font underwent various changes: the design lost its original heaviness, the body became slimmer, the arcades on the sides disappeared and the reliefs were adapted to current taste in content and style. Horizontal iron supports were used to strengthen the feet, and iron handles for carrying it were used in all periods. The design remained basically the same from the 16th to the 19th century, although the shape and decoration were naturally affected by the prevailing taste of a given period. About five hundred examples of this type of font have survived down to our own day.

In the neighbouring state of Saxony, articles known as 'baptismal bowls' were being cast in the 15th and 16th centuries; these were large deep dishes with a horizontal rim embellished with an inscription.

Secular pewterware. Apart from the pilgrims' badges mentioned above, numerous different articles were made by pewterers in various parts of Europe. In some cases only a few examples of a design are extant, but others can be found in large numbers and are characteristic of a particular area and a particular period. For instance, along the European North Sea coast, the Baltic coast and in Scandinavia we find a special type of vessel made in the 14th century and known as a *Hanseatic flagon* because of its provenance. This has a flat lid, a relief-decorated handle, and a squat body ending in an enlarged base which ensures that it will stay upright. The sides are either smooth or decorated with a few horizontal flutes. Inside there is often a small plaque with a religious motif — usually the Crucifixion — moulded in high relief. In many parts of central Europe the custom of embedding plaquettes or medallions into the base of the flagon or inside the lid survived into the 17th century, and in Transylvania right down to the 18th. Apart from religious motifs, ornaments such as rosettes and eagles began to be used later, and the top of the lid sometimes carried a coin or a cast of one.

In the 15th and 16th centuries, pewterers in north-eastern Germany and the areas just over the border in Poland cast slender and elegant *baluster jugs*. These generally have smooth sides, though occasionally they are faceted, undoubtedly under the influence of Silesian pewterware. The characteristic

features of baluster jugs — which were used for serving wine — are their flat, circular stands, their slightly domed lids and their handles decorated with relief moulding. Their design is closely related to that of the stoneware jugs made in the Rhineland in the 14th and 15th centuries.

15th- and 16th-century *flat flasks* (a category which comprises pilgrims' flasks and water-bottles) were relatively common in the Rhineland, the Low Countries and northern Germany. They can be recognised by their lens-shaped bodies set on a low circular pedestal, and their short neck with its pair of square lugs through which the straps were passed. The body is generally divided up into sections by a circular line and sometimes by several concentric rings. The circular panel in the middle of the flask generally contains a coat of arms or a portrait of one of the saints, which is either cast in relief or painted. Serving-jugs of the period have similar lenticular bodies, but unlike the pilgrims' flasks they also have lids and handles. An analogous design was used for the jugs with detachable iron handles which were in use down to the 18th century.

Relatively few Silesian *guild-flagons* have survived, but those which have are perfect examples, both in design and execution; the earliest examples date from the end of the 15th century. They were still being made in the early 16th century and were no less fine. They are sometimes as much as 30 in. high. As a rule the body is polygonal, but occasionally cylindrical, tapering into a cone. One characteristic feature of this type of jug is its three-dimensional animal feet, handle and lid. In most cases each flat surface of the faceted body is decorated with richly engraved figurative decoration consisting of religious scenes, portraits of the saints, and so on. The finest examples of this type of flagon are attributed to a master-pewterer called Hans Grofe, who was active around 1400. The flagons belonged to the guilds and were used as serving-jugs for various types of festivities. Large guild-flagons were also made in Bohemia and Moravia at the end of the 15th century, but these were mainly cylindrical, curving in slightly at the top. The chief decoration consisted of inscriptions made up of small Gothic letters arranged in horizontal friezes which divided the body into clearly defined sections. Another type of jug with feet is known to have been made mainly in southern Germany; it appears to have been popular for use during council meetings, which is why such pieces were often supplied to municipal authorities in sets made up of several identical pieces. They can be recognised by their round plate-like stands, which are often completely flat, their cylindrical or conical shafts, squat, spherical bodies and long slender necks. They can be closed by means of a domed lid which is flattened out at the top. The handles are what is known as 'knee-shaped', and branch out from the belly of the jug, ending in a thumbpiece. A shield depicting the arms of the town cast in relief very often appears on the body of the vessel. This type of jug was particularly common in the second half of the 15th and the first half of the 16th century, but it was also popular in the 17th and the same design reappeared in mass-produced jugs manufactured in the second half of the 19th century.

Virtually all the old pewter centres of Europe produced S-shaped *flagons* in various styles from the 14th to the 16th century. They are characterised by their gently domed lids, ending in a slightly raised disc, and their 'knee-handles' (a semi-circular handle which is pinched in at the top and bends sharply to run parallel to the top half of the flagon, joining the body on a level with the belly).

The Renaissance. From the mid-16th to about the mid-17th century, the art of casting pewter was in its heyday, technically and even aesthetically. Mould-cutters and pewterers worked together to produce some superb works, and frequently one craftsman would do both jobs. This period saw the beginning of what is known as 'display pewter'. This was defined by Hans Demiani, one of the most important pewter experts and collectors of the 19th century, in the following terms: 'The term "display pewter" refers to pewter articles whose makers have gone beyond the purely functional aspect and have given them an artistic form; they should generally be considered as show-pieces, in contrast to ordinary everyday pewterware.'

France. The Mannerist style, which appeared in the 16th century, swept through the courts of Europe. Inevitably it also influenced the pewter trade, being heralded by elegantly designed *plates, dishes and flag-*

ons which were richly decorated with Renaissance arabesques in flat relief. These were produced in the pewter workshops of France from about 1550 to 1575 and had a considerable influence on the work of master-craftsmen in Nuremberg, of whom the most outstanding were Nicolaus Horchaimer and Albrecht Preissensin. Their method of working was characterised by the use of figurative or purely ornamental decoration in low relief with particularly sharp outlines which were etched in the mould. They chose themes from the Bible and from Classical mythology, allegories being extremely popular. Plates and dishes were usually plain as far as the broad, smooth rim, which was again richly decorated. Etching continued to be used down to the beginning of the 17th century.

François Briot, an engraver and medallist born in Demblain in Lorraine, was an outstanding artist who was particularly skilled in the art of making *relief pewter*. From 1585 he worked at the court, of Frederick, later duke of Württemberg, where Briot produced his most famous work; his pewterware had a strong influence on pewter production throughout Europe for many decades. Several copies of his masterpiece, the huge 'Temperantia' Dish with its companion ewer, have survived. The name is taken from the allegorical figure which appears in the centre. The relief decoration was added actually during the casting process, the image being cut in reverse into the mould. The base of the ewer fits exactly into the raised centre of the dish, which is surrounded by a decorative frieze of figures personifying the four elements — earth, air, fire and water — each of which is framed in an oval cartouche; the cartouches are separated by herms and grotesques. Allegorical figures representing the seven liberal arts plus the goddess Minerva adorn the rim of the dish, and the spaces between them are filled with grotesques and masks. The ewer is oval and is also decorated with allegorical figures in relief. The 'Temperantia' set was undoubtedly used at banquets for the guests to wash their hands after eating. Both pieces bear the initials FB, and there is also a medallion, set in the centre of the underside of the dish, containing a portrait of the artist cast in relief plus the inscription FRANCISCUS BRIOT SCULPEBAT. Apart from these signed pieces, va-

rious other unsigned items are also generally attributed to Briot on stylistic grounds, examples being the Mars Dish with its matching ewer and the set depicting Susannah and the Elders. Briot was active from 1580 to 1616. Relief pewter of a very high aesthetic and technical standard was produced in the last twenty-five years of the 16th century, but in most cases the artist is unknown; examples are the Pyramus and Thisbe dish, the Hercules dish and the Adam and Eve dish.

Briot's influence did not reach Strasbourg, which was a particularly important pewter centre, until after 1630. It can be seen above all in the work of Isaac Faust, a pewterer who acquired Briot's original moulds after the latter's death. Relief pewter was very popular in Strasbourg until well into the 18th century, and relief decoration was especially common on the type of dish known as a maternity bowl which became widely popular. This was a deep round porringer with relief-decorated horizontal handles at the side and a lid with rich relief decoration which could also be used as an extra dish. Various similar types of porringer with handles were made elsewhere, though these were less elaborate and sometimes did not have a lid.

Germany. A high standard was attained in the production of relief pewter in Nuremberg, the old centre of the German pewter trade. The most famous maker of relief pewter in Germany was Caspar Enderlein, who was born in Basle in 1560 but settled in Nuremberg. His greatest fame came from pieces modelled on the work of Briot, but adapted freely and cast in moulds which he cut himself. He made, among other objects, two copies of the Temperantia dish, adding his own master's mark (CE) during casting. As with Briot's dish, one of Enderlein's had a medallion on the bottom containing his portrait and the inscription SCULPEBAT CASPAR ENDERLEIN. Just as he had used Briot's moulds, so his own moulds continued to be used by other pewterers after his death; in those days it was perfectly normal for one craftsman to copy another's designs, and this was in no way considered damaging to the reputation of either. There are other pieces which bear Enderlein's signature, one of which is a dish depicting Lot and his daughters, another with the Creation of Eve, and a dish known as the 'double eagle dish'. There were several important pewterers doing re-

lief work among Enderlein's contemporaries and successors in Nuremberg, including Jacob Koch II, Veit Zipfel, Melchior Horchhaimer and Hans Zatzer.

The gradual disappearance of the Mannerist style certainly did not spell the end of relief pewter, and indeed pewterware decorated with reliefs continued to enjoy great popularity for many years, with Nuremberg still the main German production centre for this type of work. The next development concerned what are known as 'disc-plates' which are flat plates roughly 8 in. in diameter with relief cast decoration in the central panel and round the rim. As in the previous period, the decoration consisted of scenes from the Bible plus ornamental motifs such as interlaced flowers and various types of scrolls or volutes. One feature which was completely new was a relief portrait of the local ruler or the imperial electors. Various designs of disc-plates were created for the coronation of the Emperor Ferdinand III in 1637, and these depict the emperor in the central panel with six imperial electors round the broad rim.

Swiss craftsmen began to make relief pewter in the 17th century, presumably modelling their work on the pewterware being made in Nuremberg at the time. *Heraldic plates* with the coats of arms of the thirteen old towns depicted round the edge were very popular in Switzerland, and in fact they are still made today.

Unlike Nuremberg, whose craftsmen concentrated on plates and bowls, the Erzgebirge district produced mainly *drinking vessels*, that is, jugs and tankards. The production methods used there were also different, for whereas the pewterers of Nuremberg either copied from a model or used a design of their own invention when engraving their copper-moulds, a method which enabled them to make a large number of clear-cut casts, in the Erzgebirge district they used small modelling-plates, most of which came from Nuremberg workshops; they would be arranged in a row and then a clay or sand mould was made over them. The pewter was cast in these moulds, and the resulting individual strips of casting were put together to form the outer shell of the vessel. A certain number of flaws were unavoidable, so the surface of relief pewter made by this method has a rather coarse and dull look about it.

It is possible that the relief-decorated pieces made in Eger (Hungary) and Prague and Iglau (Czechoslovakia) from the second half of the 16th century were influenced by the work produced in the Erzgebirge area.

Miners' candlesticks were a speciality of the Erzgebirge pewter trade; they were pewter figures dressed as miners and holding a candle-socket in one hand; they generally came in pairs. The earliest were made in the 17th century, but they were not widely used until the 19th, by which time their aesthetic quality had declined sharply and in many cases they were merely imitations of earlier work.

The Baroque Period. *Domestic utensils.* Alongside the elaborate pieces made for show, everyday utensils were being made in pewter which afford a glimpse into the way households were equipped. Evidence can be found in contemporary wills (the total weight of pewter is mentioned), and also in pieces which were hidden. The 17th century was a period of upheaval, and pewterware, along with articles of many other types, was often stored in a safe place, remaining there untouched until brought to light in our own day. In the 17th century the average bourgeois household required at least ten items of pewterware. The most common were bowls and plates; there were also several jugs and tankards, plus at least one of each of the following: salt-cellars, wash-basins, candlesticks and flasks. All the utensils would have been made within about thirty years of each other, since that was the average life-span of articles in everyday use. When they became too worn they would be returned to the pewterer to be melted down to make new pieces; all the owner had to do was to pay for the work involved. This is one of the main reasons why so little old pewter has survived; if we want to obtain a complete picture we must turn to contemporary paintings and book-illustrations. Ordinary household utensils might be plain, or decorated with engraved or punched ornaments, or a combination of both. Individual pieces of pewter often carried both the usual maker's mark and a family mark, which might be engraved or stamped or chiselled; the purpose of the family mark was to prevent theft or the deliberate exchange of one piece for another.

During the 16th century, the rims of *plates*

and bowls, which had initially been narrow, were made wider. Even in the first half of the 17th century, dishes with engraved concentric circles, or at any rate with decorated rims, were still made, as well as plain ones and others with nothing but family marks and coats of arms. In the second half of the 17th century *'cardinal's hat' dishes* were very popular; they can be recognised by their rims, which are exceptionally broad in proportion to their bases. The decoration on this type of dish, if any, consists of engraved pomegranates and interlaced foliage covering the whole surface, often accompanied by the date framed in an oval cartouche. Particularly sumptuous examples of this type of work were made in the pewter workshops of Germany, Austria, Bohemia and Transylvania. The master's mark appears either on the rim, which was the normal place at that time, or alternatively in the centre of the inside of the bowl; this last position became virtually standard practice in the 18th century. As well as the types of vessel which had been in use in the earlier periods — and which were still being made in a variety of different styles — the 17th century saw the appearance of new designs which varied according to local traditions. One of the items most in demand was a *jug*; it might be cylindrical or conical or faceted, and was often embellished with engraved decoration, though the quality is very uneven. Height and width, general appearance, the shape of the lid, the thumb-piece and the handle, the design of the inside of the body or the way a stand or foot projects beyond the base were all largely governed by the requirements of the market and the possibilities offered by local production.

Among the most distinctive jugs are those known as *Röhrken* or *Krönken,* which were made in northern Germany and were still very popular in the 18th century. They were slender vessels roughly 8 to 12 in. high, widening towards the aperture, and had a handle and usually a simple lid as well.

Pichets, or small drinking tankards, were made in France from the 15th century, reaching the peak of their popularity in the 17th and 18th centuries. Their design and decoration did not change, apart from a few regional variations. They were generally between 6 and 8 in. high, with a base which was sometimes not very prominent and some-times strongly accentuated, a gently bellied body, a slender neck and a funnel-shaped lip covered by a lid which was at first round and flat but later became heart-shaped. Sometimes it was even domed. A simple bar of metal led from the middle of the lid or sometimes from a third of the way along to the thumb-piece, while the ribbon-like handle rested on the belly of the vessel.

The Dutch jug known as a 'Jan Steen', because it so often appeared in still-lifes by that painter, was closely related to other types of pewter jug made in the Low Countries which also had pot-bellies; in fact the only difference lay in its spout, which slopes sharply and is generally rectangular in cross-section.

Swiss pewterware was made in a wide variety of designs and has an individual stamp, with a fairly marked difference between the work produced in the different cantons. The most typical items are two different types of flagons. Both of these were known quite early, but they did not become really popular until the 17th century, and they are still well represented today. As its name suggests, the design known as a *bell-flagon* was bell-shaped with a short spout set near the lip, generally with a lid to close it. The flat lid of the flagon was usually unscrewable and had a ring handle. There were two variants on the other basic type, which had an ornamental chain handle. One variant had a strong belly with an exceptionally slender neck and a heart-shaped aperture covered by a flat lid, which was also heart-shaped. The simple ribbon-like handle was surmounted by a hinged thumb-piece, often designed in the shape of a pair of acorns. This type of article is known as a *'Valais flagon'* after its place of origin. The second variant had a prismatic body, but was otherwise very like the other type; it was made mainly in the pewter-foundries of Geneva, Vevey and Lausanne.

The 17th century saw the appearance of the *flask*, a new style of jug which was in general use down to the 19th century. Most flasks had a detachable handle and were used as containers for water, wine or oil. The bodies were of various types — round, square, hexagonal or occasionally lobulate — and the sides either smooth or richly engraved, or possibly decorated with three-dimensional motifs.

Guild articles. 17th-century *guild flagons*

look rather different from their counterparts in earlier centuries. By this period they were in general use, having supplanted the extremely fragile ceramic vessels formerly used in guildhalls. What is more, pewterware, although inexpensive, looked very much like costly silver articles. Compared to earlier, more solid pieces, the guild flagons now being made had slender, bolder-looking bodies, though their appearance varied considerably from district to district according to local styles. New decorative motifs were also used. The flagons were generally mounted on spherical, disc-shaped or zoomorphic bases, or sometimes with angel heads or similar themes. The various designs were often engraved with the guild symbol, which was sometimes contained within a special shield. The names of the guildmaster also often appeared on guild-flagons, as did occasionally those of the journeymen as well.

One special item made in pewter was a vessel known as a 'welcome', which was extremely common in the 17th and 18th centuries, though particularly in the 17th. The earliest known examples date from the second half of the 16th century. They were used for drinking toasts on festive occasions. The welcome had a shaft mounted on a circular base and surmounted by a body which might follow any one of a number of different types of design. An evenly spaced row — possibly two rows — of three-dimensional lions' heads or other masks ran round the sides; each creature held in its mouth a coin or a silver cartouche fastened by a chain, with the names of the guild-masters inscribed inside them, plus on occasions the date and the guild symbol. Sometimes the lid also carried a shield held by a human figure in contemporary dress.

Occasionally the individual guild commissioned a pewterer to make some sort of *drinking-vessel* in a design to symbolise the calling of the members. Examples which have survived are in the shape of a cooper's mallet, an axe, a thimble, a shoe, a Pretzel and a bull. Apart from the large guild-flagons and drinking-vessels, guild signs were also made in pewter; pewter was in fact particularly suitable for this purpose because it was both unaffected by the atmosphere and also relatively cheap.

Ecclesiastical pewter. Although pewter began to be used more often for ecclesiastical vessels, this did not result in a whole new series of designs, for pewterers leant heavily on already existing designs that were intended to be executed in some other material such as gold or silver. Their products did, however, look different because they were compelled to simplify both their design and their decoration.

Many Protestant churches used simple undecorated Communion chalices and simple Communion jugs, both in pewter; the Catholic Church also allowed pewter to be used and this practice was now more common than before. Other items made in pewter were small Communion flagons and chrismatories for holding Holy Oil; the latter were often made in the shape of a cloverleaf, with three compartments for the consecrated oil; the lid of each was marked with the letters S, C or I (for *oleum sanctum, chrisma* and *oleum informum*). Other pewter objects used in churches were censers, which were very occasionally made in the shape of a nautilus shell, holy-water buckets and basins, altar-vases, and a large number of altar candlesticks and bigger candlesticks for the rest of the church.

The Rococo Period. In the 18th century the pewter trade flourished as never before, though the seeds of the social and economic changes which were to lead to the decline of the craft in the following century were already present. The main reasons for this decline were the arrival of attractive and functional materials such as earthenware and porcelain, and the decline of the actual craft of pewter-casting, which was now changing over from individual craftsmanship to mass-production methods. In previous centuries each individual district had produced its own original designs which were quite different from those produced elsewhere. By contrast, the principal aim of 18th-century pewterers was to make their work as much like silver as possible, so that pewterware made in this period has a uniform look about it, although certain differences are still noticeable. Nevertheless this did not prevent a whole series of new designs from being invented.

Tableware. Tableware was enriched by the addition of a large number of new designs for a variety of uses. Plates and bowls were

made in the graceful, airy style of the Rococo period, with three-dimensional decoration on their rims. They were joined by sumptuous soup tureens, sausage-dishes from Nuremberg, which were in great demand, a new type of decorative table-set including spice-containers and dishes, together with elaborate centrepieces and glass-and-pewter cruets for oil and vinegar, and so on.

As well as salt-cellars, both town and country households also used the following items of pewterware at table: cruets, sugar-basins, spoons and dippers. The graceful lines of the Rococo vessels enhanced the effect of light and shade created by the treatment of the surface, which was either covered with rich decoration or divided into segments by a series of gadrooned ribs. The pewter-workshops in Karlsbad were particularly famous for this type of work.

Everyday objects. Although the Rococo spirit is most noticeable in tableware, it also influenced other pieces such as inkstands, ornamental boxes, vases and candlesticks, objects which were both functional and decorative. Even *liturgical objects* were adapted to the prevailing taste, so that quite a number of Communion cups, sanctuary lamps, baptismal bowls and flagons, holy-water buckets and candlesticks were made in the airy Rococo style.

Christening plates were large dishes or plates in the style of the period, sometimes decorated with naïve engravings on some religious theme such as the *agnus dei* or a portrait of one of the saints. The christening plate carried an engraved dedication which gave details of the plate itself, of the child concerned and the date of his christening. Ceremonial dishes and plates with similar decoration were used as gifts for special occasions such as anniversaries. Articles known as *shooting-plates* were popular as prizes for shooting-matches; they were made from the end of the 18th century in Saxony, particularly in Zittau, but soon spread far beyond their place of origin. One most unusual type of pewterware was the vessel known as a *Trenck beaker*, which is a favourite with forgers. It was a slender drinking-vessel of the type which was in general use from the Middle Ages onwards but has rarely survived because its design was unpretentious and it was used every day

(two factors which, as we have seen, are not conducive to survival). In the 18th century these beakers were now adorned with all sorts of engraved figurative scenes, decorative motifs and long-winded sayings by Baron Friedrich von der Trenck during his imprisonment in the fortress of Sternschanze near Magdeburg from 1754 to 1763.

In the second half of the 18th century, when many great pewter centres began to decline, craftsmen in the town of Eger, one of the traditional centres of the trade, invented a new type of jug known as a *Lirlkrug*. The body was shaped like an upside-down pear, the spout was tubular, and there was a simple ribbon-like handle and a screw-top with a ring-handle. Shallow drinking vessels known as *Pitschen* or *Petschen* were popular in the same area and at roughly the same time. They had a cylindrical body, tapering slightly inwards towards the top, a richly curving spout, an equally curving lid, which covered the whole of the top of the vessel, and a simple ribbon handle.

Lichtenhain beer-tankards were very popular in Thuringia and the surrounding districts in the 18th century, their name coming from the beer of the same name, which was made in Jena. The sides were made of wooden staves coated with pitch, and were decorated with figurative and abstract motifs cut out of thin tin-foil. The rim and the inside of the base, the lid, handle and spout generally had pewter mounts. One regional product typical of Bohemia, Moravia and Silesia in the 18th century was an item known as a 'pear-jug', which had a lid, a handle and generally a moulded spout.

Everyday utensils made in the 18th century were much less strongly influenced by the Rococo style than more expensive tableware. Pewterers continued to use the old styles which had been tried and tested, merely adapting them to current requirements.

Apart from the articles already mentioned, a whole range of functional and delightful objects were made in pewter, including *toys*. Here I shall only mention the toys which were faithful copies in miniature of contemporary kitchenware, tableware and objects for ecclesiastical use, and the tin-soldiers which are still popular today.

Pewter *measures* were made in various parts of Europe, and their design varied in accordance with local customs, so that conical and cylindrical measures were made,

and also bellied ones. Some had a handle and no lid, some a lid and no handle, and some had both. The design alone does not prove whether or not a vessel of this type is a measure, and it is more important to look at the official mark, any indication of contents, or at any rate the date when it was passed as accurate; all these details are normally stamped on the neck or handle of the vessel.

As pewter is not harmful to the health and is also easy to clean, it was popular for *sanitary equipment* such as screw-top containers, boxes and flasks for apothecaries, and bedwarmers. Many households were equipped with *oil-lamps and candlesticks*, both small ones for holding in the hand and larger ones which stood on their own. The oil-lamp had a fairly long shaft branching upwards from a circular base and was surmounted by a cupshaped body. This design was closely related to that of *oil-clocks*, which were made mainly in the 18th century but were still in use in the 19th; the small lamp on the shaft was accompanied by a bellied glass container set in a pewter mount with the scale marking the hours as the oil was consumed; the sinking level of the liquid showed what time it was.

From the 1770s the design of *tableware* began to be more strongly influenced by Neo-Classicism, although the Rococo style still influenced the style of certain pieces. The designs and methods of decoration which are typical of the Rococo style survived or were revived in the 19th century, since their decorative effect was highly prized. The designs characteristic of Neo-Classicism, with their echo of the spirit of Classical Antiquity, came into their own in showpieces. The dominant motifs in the decorative repertoire of Neo-Classicism were beading, interlaced acanthus scrolls, festoons and rosettes. Colouring was now more popular than it had been before, and we occasionally find the black and gold or multi-coloured decoration against a background of red, green, gold or brown which was typical of current styles.

The 19th Century. In the first half of the 19th century, attractive new materials — which were sometimes cheaper as well — began to oust pewter. The production of pewterware declined sharply, with many items going out of production altogether, and pewterers were compelled to search for new ways of making use of their material. One idea was to reawaken interest in pewter by combining it with light blue or ultramarine glass, while another was to rely even more heavily than before on imitating silver. But the decline of this trade which had once been so prosperous was inevitable, and even the 19th-century penchant for imitating the styles of the past could do nothing to halt the process; the quantities of mass-produced imitations of earlier styles which were made were of little aesthetic value.

However, the Art Nouveau style at the turn of the century and the renewal of interest in craft work even led to the resuscitation of the old craft of pewter-casting. The German firm of Kayser in Oppum, near Krefeld, was in the forefront of attempts to create a new and modern type of pewter, and their product soon had a world-wide reputation.

Advice to Collectors

Ordinary dirt can be removed from pewter by means of hot water, soapsuds, a soft brush and a piece of flannel. The pewter must then be carefully rinsed in clean water, dried and polished with the piece of flannel. Pewter should be kept in a warm, dry place at a temperature which never goes much below normal room temperature.

Restoration should be left to experts wherever possible, and it is always well to remember that good pewterers are far from being automatically good restorers.

Diseases of pewter. Pewter can be attacked by two different chemical processes. The first produces black, rough-looking or ulcer-like patches on the surface of the article, and represents corrosion resulting from an electro-chemical process caused by the irregular action of violent substances on the surface. These patches are extremely difficult to remove, even by mechanical methods. The best results are achieved by using electrolysis.

The second process is caused by the transformation of the tetragonal metal modification of pewter (tin α) to a grey modification (tin β) with the tetrahedric diamond structure. The visible sign of this type of corrosion is a series of swellings of varying sizes which disintegrate into a blackish-grey crystalline powder when touched. As chemists think that this type of corrosion can be transferred to unaffected pieces of pewter, care should be taken that such pieces do not come into direct contact with corroded articles. This corrosion sometimes acts very slowly, but it can also destroy an affected object extraordinarily quickly; it can only be checked by the radical treatment of cutting away the diseased areas and replacing them with pieces of new metal.

This type of restoration should not, however, be thought of as the definitive answer to the problem, so before taking such a step it is advisable to study carefully the latest experiments as they are set down in technical books and journals.

Fakes. It is not easy for the inexperienced collector to define and classify pewter, and there is no general recipe for learning how to do so. Even the interested layman will gain a certain amount of practice as he builds up his collection if he is prepared to compare the pieces in his own collection with the fine pieces in museums and follow up everything published on the subject.

It is important for every collector to know what types of forgeries can be made. They can be grouped into three main categories. It is very difficult to detect fakes when they have been made by an experienced forger who has gone to great trouble and expense to get his pieces labelled as 'antique pewter' in the salerooms. Forgers use old moulds and tools, and are thoroughly versed in old casting techniques and methods of decoration. They make their work seem even more credible by using old stamps, which means that there is absolutely no difference between the 'touches' or makers' marks on their pieces and the originals. But perfect forgeries of this type are not common, and will only be found among attractive pieces which will raise large sums of money. Even the experienced collector should consult a specialist before buying a particularly expensive piece. Laborious forgeries of this kind would be uneconomical for cheaper pieces, and it is therefore easier to detect fakes in this category because they will show clear evidence of the forger's imperfect technical knowledge or carelessness. The most numerous fakes are also the easiest to make: they have various modern 'improvements' which are supposed to make the object more 'artistic' and hence more attractive to the buyer. The majority of the fakes of this type are simple plates and jugs which have been embellished with additional decoration. Even the best forger will sometimes make a mistake and stamp his piece with a touch which is older than the method of decoration or the actual motif he uses.

If the collector has a detailed knowledge of the different types of decoration, the different patterns, and the dates of the best-known pewterers, he can detect such forgeries. Even the layman and the private collector will build up enough experience to enable

him to recognise forgeries and pick them out from genuine pieces.

Touches. These can be helpful in one sense. Guild regulations stipulated that all pewterware must be marked with a 'touch' as a guarantee of its quality and as a form of control. Pewter touches in the form of coats of arms, circles, rectangles and squares are all known. Initially they were scarcely more than half a centimetre square, but later on they became bigger; as a rule they would be stamped somewhere unobtrusive such as on the handle, on the bottom of the inside of the article or inside the lid. In many cases it is possible to decide roughly where a piece comes from by looking at the type of touch on it and studying its shape and the symbol used.

The touch might consist of the pewterer's initials or his personal master-mark, plus the year when he passed the master's examination, or the date of some important new guild regulation; there might also be the heraldic device (in many cases merely a simplified version) of the town where the pewterer worked or where the guild was of which he was a member. Sometimes the touch consisted of the master's mark plus the town's coat of arms. From the 18th century, certain quality marks were also often stamped on pewter. For example in Germany we find SW — FEINZINN (fine pewter) PROBEZINN (testpewter), CL — CLAR and LAUTERZINN (pure pewter, unalloyed) and so on. In England a statute of 1503 required that all pewterers should put maker's marks on their products; these consisted of a maker's device or initials. In addition there was a quality mark in the form of an X with a crown, or of a crowned rose.

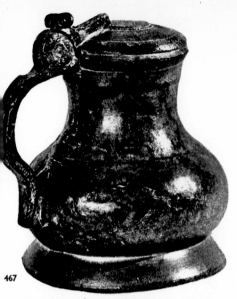

467

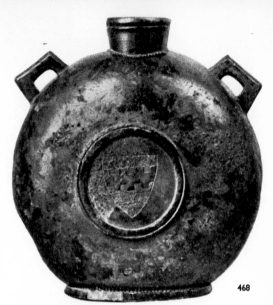

468

467 'Hanseatic flagon'. The Low Countries, 14th century
468 Pilgrim's bottle with the coat of arms of the Overstolz family. Cologne, 14th century
469 Guild flagon with engraved coat of arms and portraits of the saints. Silesia, early 16th century

470 Flagon used at council meetings. Master Cuncz Has, Regensburg, 1453
471 Guild tankard belonging to the Guild of Millers, Gingerbread-Makers and Pretzel-Bakers. Bohemia, 1557

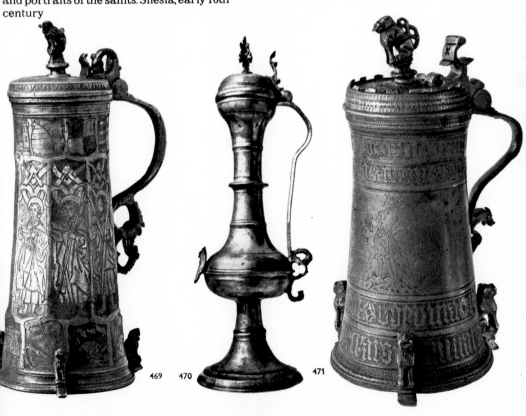

469 470 471

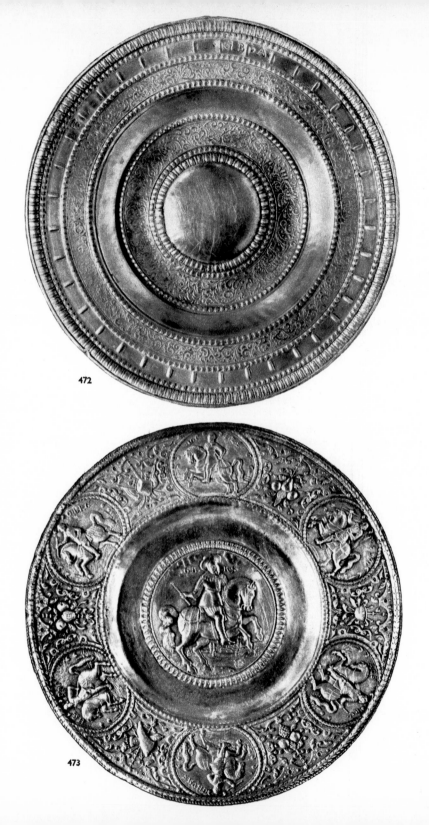

472

473

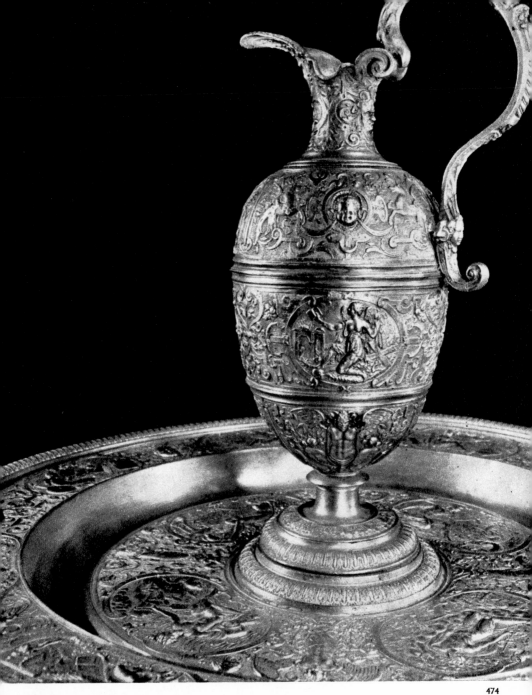

472 Embossed bowl with decoration in low relief. Master Hans Zatzer, Nuremberg, 1560-1618
473 'Gustavus Adolphus' plate. Master Paulus Öham the Younger, Nuremberg, 17th century

474 The 'Temperantia' dish with its ewer. François Briot, Montbéliard, Lorraine, c. 1585-90

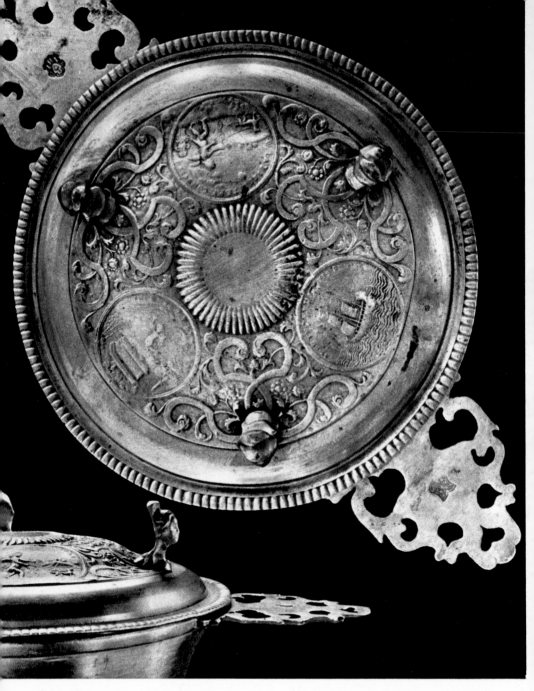

475 *Maternity* bowl with relief cast
decoration. Master Isenheim III. Strasbourg,
first half of 18th century
476 Swiss heraldic plate. Master Joachim
Schirmer the Elder, St Gallen, 1613-97

477 Tankard with relief cast decoration
from plates prepared by Peter Flötner.
Erzgebirge, second half of 16 century
478 Pewter tankard with brass handle;
richly engraved. Saxony (?), after 1600

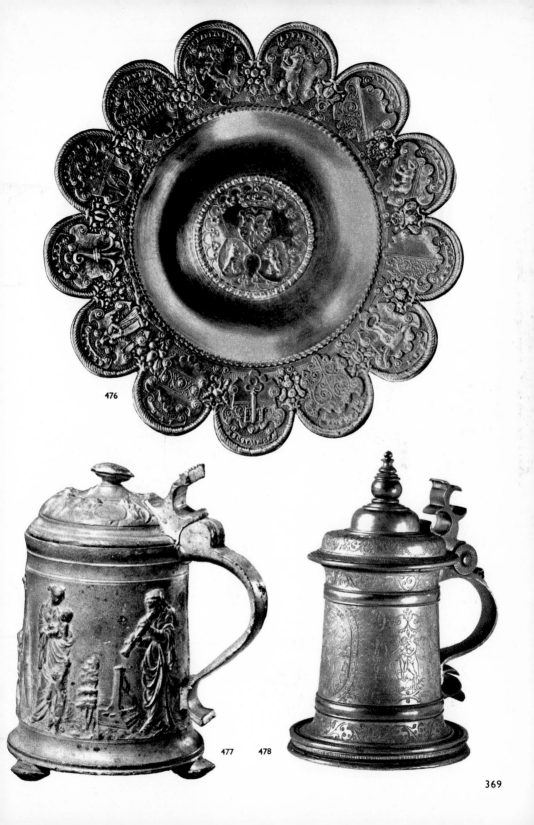

476

477 478

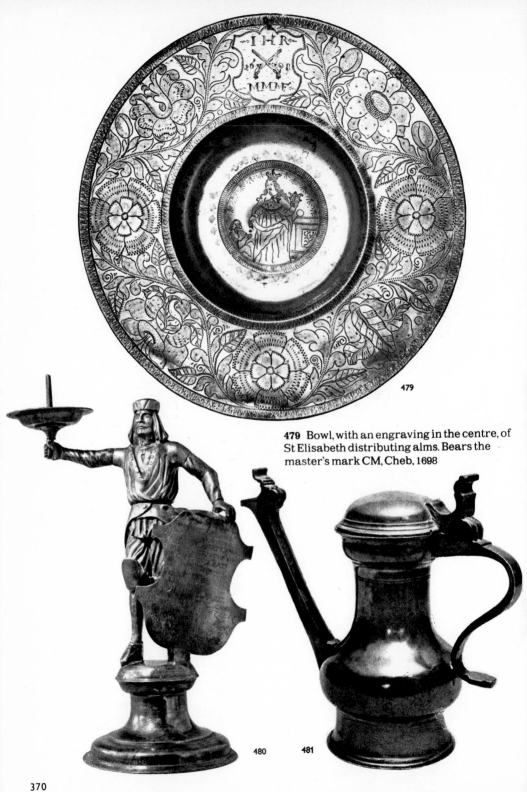

479 Bowl, with an engraving in the centre, of St Elisabeth distributing alms. Bears the master's mark CM, Cheb, 1698

480

481

480 Miner's candlestick. Erzgebirge, 1685

481 'Jan Steen' jug, for pouring. Low Countries, 1670

482 Tankard with lid: known as a *Röhrken*. Made by Hans Conrad Gottespfennig, Rostock, 1737

483 Screw-top flask with engraved decoration on the sides. By Nicolaus Harsch, Villingen, Swabia, 1666

484 Square flask with engraved decoration. Bears the master's mark CS, Chemnitz, 1703

483

482

485-7 Swiss jugs. Switzerland. 17th and 18th centuries

484

485

486

487

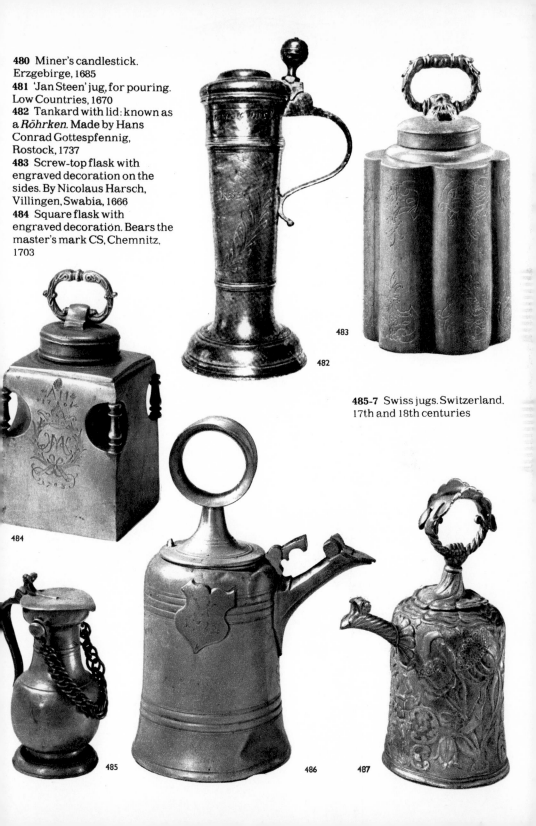

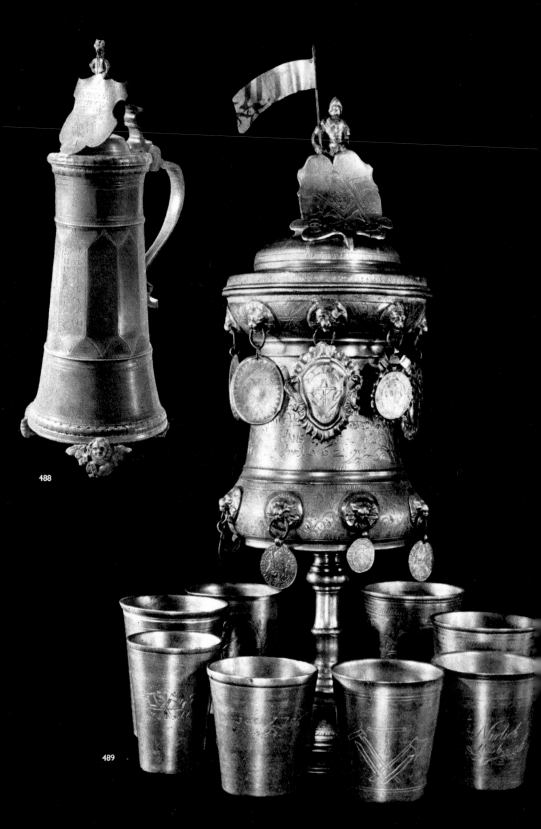

488

489

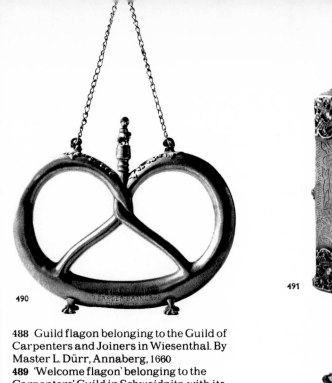

490

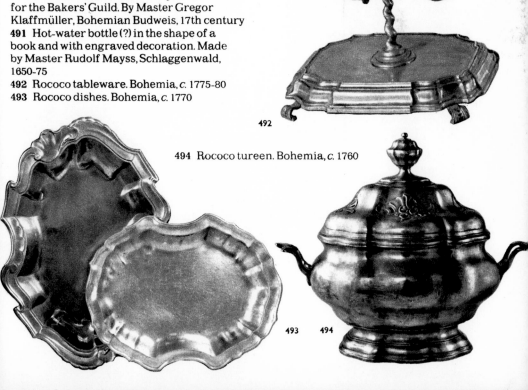

491

488 Guild flagon belonging to the Guild of Carpenters and Joiners in Wiesenthal. By Master L. Dürr, Annaberg, 1660
489 'Welcome flagon' belonging to the Carpenters' Guild in Schweidnitz, with its beakers. Made by Melchior Heinrich, Schweidnitz, 1662
490 Guild container in the shape of a Pretzel for the Bakers' Guild. By Master Gregor Klaffmüller, Bohemian Budweis, 17th century
491 Hot-water bottle (?) in the shape of a book and with engraved decoration. Made by Master Rudolf Mayss, Schlaggenwald, 1650–75
492 Rococo tableware. Bohemia, c. 1775-80
493 Rococo dishes. Bohemia, c. 1770

492

494 Rococo tureen. Bohemia, c. 1760

493 494

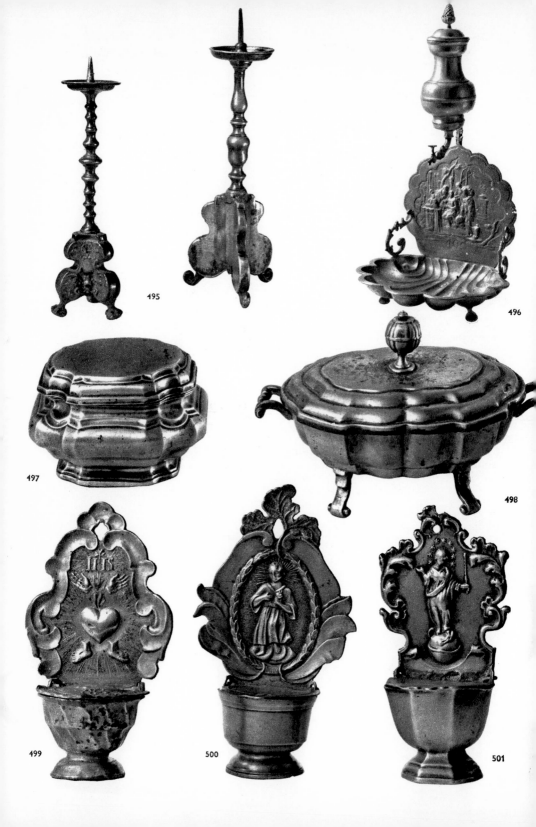

495

496

497

498

499

500

501

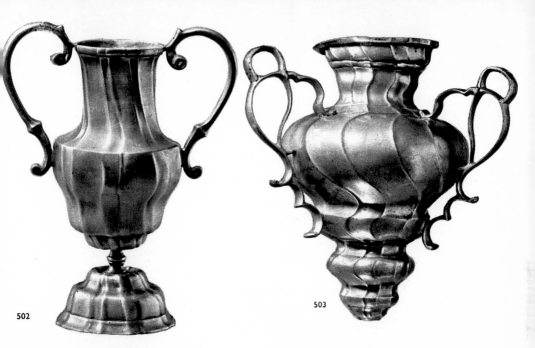

502

503

495 Two altar candlesticks, Bohemia, 17th and 18th centuries
496 Lavabo by Master Gallus David Apeller the Younger. Innsbruck, second half of 18th century
497-8 Rococo containers. Bohemia, c. 1750-60

499-501 Three wall stoups with figurative relief decoration. Bohemia, 18th and 19th centuries
502 Altar vessel, Rococo style. Bohemia, c. 1750-75
503 Sanctuary lamp, Rococo style. Bohemia, c. 1750
504-6 Lichtenhain tankards. Thuringia, 18th century

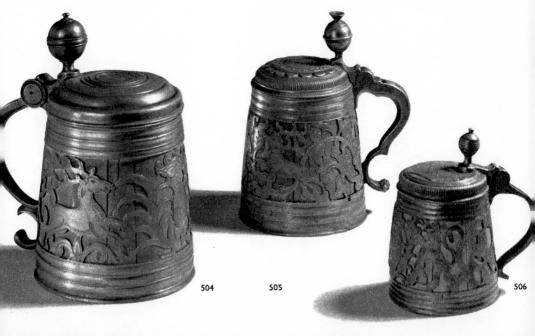

504 505 506

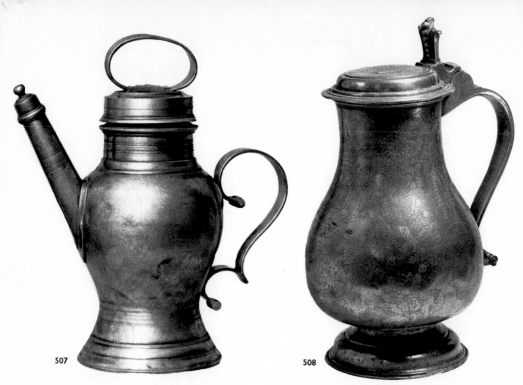

507

508

507 *Lirl* jug. Cheb, 18th century
508 Pear-shaped jug with engraved portraits of St Wenceslas and St John Nepomuk. By Master Karl Korb, Prague, 1731
509 Lamp and oil-clock. Erzgebirge, 19th century
510 Art Nouveau bowl. Made by the firm of Kayser at Oppum, near Krefeld

511 Art Nouveau lamp. *Kayser-Zinn*
512 Jewish *Seder* bowl decorated with figures and inscriptions in Hebrew. Prague, 18th century
513 Jug with Hebrew inscription. By Master J. A. Rispler, Prague, c. 1750-75
514 Jug, cup and saucer with decoration in relief. By Master Joseph Neidhart, Slavkov, c. 1825

509

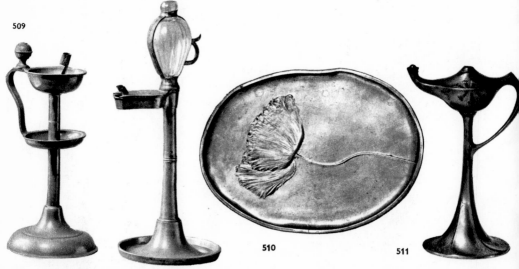

510

511

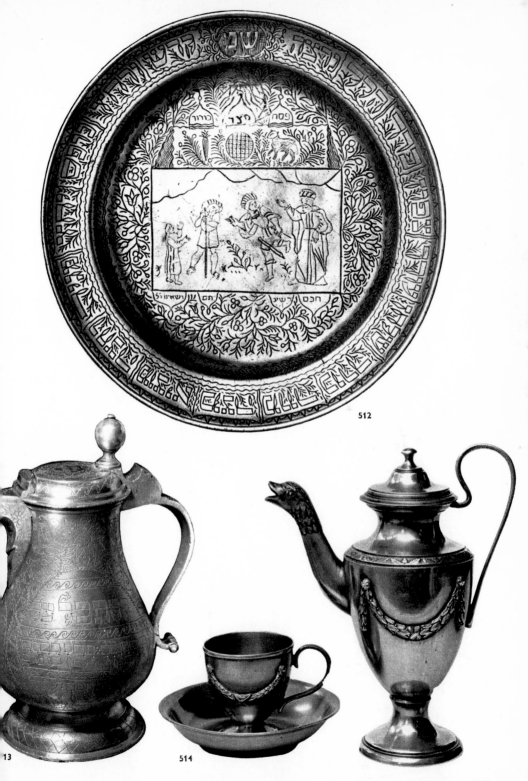

512

13 514

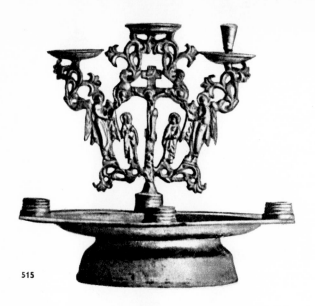

515

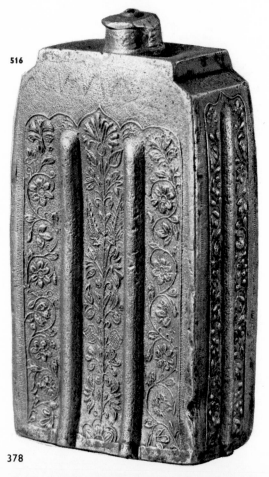

516

515 Consecration dish by Master Wassi
Makiov, Moscow, *c.* 1735
516 Flask with relief cast decoration.
Balkans, 18th-19th century

IRON

Antiques made of iron, wrought ironwork and locksmiths' work are often much less attractive to the collector than other antiques. Even today there are only a few connoisseurs who devote themselves exclusively to collecting ironwork. There are two main reasons for this: first, iron is less immediately pleasing in appearance than other metals, and therefore not attractive enough for the layman; second, many pieces of wrought ironwork often occupy so much space that it is impossible for the average collector to house them.

Iron (chemical symbol Fe, from the Latin *ferrum*) is the most important of all metals from the technical point of view. It is obtained from iron-ore, which occurs naturally in large amounts. It is not used in a pure state but always in combination with other elements such as carbon, sulphur, phosphorus and silicon. After being processed in various stages, a firm, solid but malleable material is obtained.

Examples of ironwork are discussed here from the collector's point of view. 'Iron' refers to all objects made of this metal, whatever form of iron is used. 'Steel' refers to hardened iron, and 'grey cast iron' to cast iron.

379

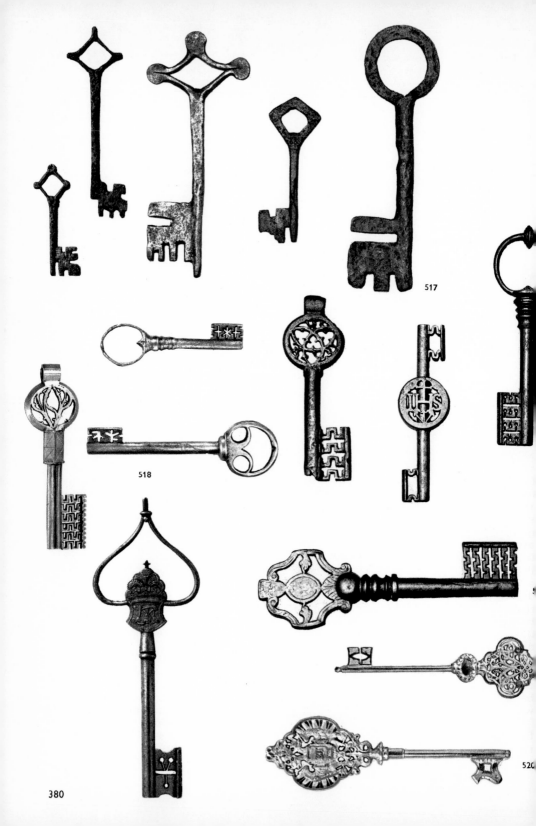

517

518

380

520

517 Five Gothic keys. Bohemia, 15th century
518 Four Renaissance keys. Bohemia, second half of 15th century and 16th century
519 Three Baroque keys: a) double key with covering, elaborate filigree, IHS on one side, MARIA on the other. Bohemia, 1711; b) chest key. Bohemia, 17th century; c) key with ornamental filigree handle. Bohemia, first half of 18th century

520 Three chamberlain's keys: a) with heart-shaped handle. Austria, 18th century; b) elaborate filigree handle, with MARIA. Austria, 18th century; c) elaborate filigree handle in the form of a heart-shaped double eagle shield with FJI; gilded brass. Austria, reign of Francis Joseph I.

Manufacture

Techniques used in wrought ironwork. The date at which the Iron Age began varied greatly from one area to another. Iron came into use in the Mediterranean area about 1500 BC, whereas it was only from the 8th-10th century AD that the knowledge of how to obtain and use iron spread over central Europe. The oldest known example of wrought ironwork was made by smiths during the first part of the second millennium AD. Specialised branches of the smith's craft developed during the following centuries: written sources refer to blacksmiths, armourers, sword-makers, cutlers, platers, farriers, nailsmiths, locksmiths, tinsmiths, tool-makers and gunsmiths.

The work of the blacksmith and the locksmith will be discussed in detail. Then as now they required a hammer and anvil, fire and water. Their material was iron in the form of bars and rods of various shapes. It is only possible to date many examples of old ironwork because of the fact that in different periods bars and rods with distinctive cross-sections were used. Circular bars were used in Roman times and during the Renaissance period; Gothic ironwork is distinguished by square bars, but Baroque ironwork has many different types of bar. Old specimens of wrought ironwork are characterised by the marks of the hammer-blows. Even the most delicate ornamental work was done with a hammer.

Decorative techniques. Craftsmen used various techniques to give the cast ironwork a more pleasing appearance:

Swaging. This process has been used since the 14th century. The upper and lower swages or dies consist of a hollow steel mould whose inside surface corresponds to the outside of the surface to be cast.

Chasing. A sheet of iron was placed on a softer base (clay, chasing-pitch, wood, etc.) and worked with a hammer so that the required design or figurative picture was produced by carefully directed hammer-blows. Moulds were used for several pieces with identical patterns, such as door-panels.

Etching. This form of decoration was carried out chemically. The smoothly polished upper surface of the forged piece was partly covered with an etching-ground, asphalt, wax or pitch, to protect it from the action of the acid; the design was then applied with an etching needle, making grooves in the unprotected areas. Occasionally these grooves were enhanced by colouring or by plating with a contrasting metal

Engraving. This was especially popular among the German, Italian and French craftsmen of the 16th and 17th centuries. Graving-tools, augers and files were used to decorate the iron.

Blueing. This occurs when iron has been heated to a high temperature and cooled rapidly. It becomes hard and takes on a bluish colour, as a result of the formation of a thin anti-corrosive oxide film.

Historical Survey

Mounts. *Door mounts.* The earliest pieces of wrought ironwork which have survived from historical times are door mounts, designed to make the wooden doors stronger and more solid. Although only a small number have survived from the 11th-14th centuries, even these are sufficient to demonstrate that efforts have been made to produce pieces which were decorative and not merely serviceable. Some of the most beautiful old wrought ironwork in existence is to be found in France, for example the 13th-century mounting on the west portal of the cathedral of Notre Dame in Paris. Functionalism is the characteristic of these early pieces, and their decoration, in the form of attractively worked iron bars, is determined by their purpose. Stylised patterns of plant designs, volutes and animal and legendary figures were popular motifs. Rings or bands were often used to join the individual pieces, and sometimes these were welded together.

Wrought ironwork developed somewhat later in Germany than in France, but even here a great variety of skilful work was produced over a relatively short period. Simple door mounts composed of flat bands set in various ways were fixed to the wooden parts of the door with rivets, and during the 12th century C-shaped mounts began to be used as well as the main band: this practice continued until the end of the 14th century. In Germany interlaced leaf patterns and other plant motifs were very popular. The main horizontal band survived as a functional element of the mounting, and the decoration began to spread out on both sides, often extending over the whole panel. The aim of the smiths became to create work as light and delicate as possible. From the 15th century, wooden doors were often completely covered with iron, the square or diamond-shaped panels between the flat diagonal bars being decorated with interlaced patterns, tracery or heraldic devices such as eagles, lions or fleurs-de-lis. Rivets and nails, their surfaces hammered out into rosettes, fleurs-de-lis and other tiny flowers, projected from the bands of iron and, as well as fulfilling their basic function, became a standard element of the decoration. The iron mounts were often painted, both to give them a more striking appearance and to prevent the material from rusting. The diagonal bands were gilded and the diamond-shaped panels painted blue and red. The door mounts described above should not be confused with the metal doors and gates which were particularly popular in the 17th and 18th centuries: these were made by placing iron plates in an iron framework with diagonal supports and then covering it with decorative work. After the 16th century, striving for decorative effect replaced the older functional approach towards door mounts: wrought-iron grilles began to be used more frequently, and their form was often influenced by the shape of the mounts. In the 17th, and even more so in the 18th century, door mounts became purely decorative elements which were altered to conform to the prevailing style of the period.

Furniture mounts. The goods and chattels of our ancestors were stored in chests, caskets and cases; it is not therefore surprising that these often had artistic iron mounts. As wealth increased, decorative metals such as silver or brass were also used for furniture mounts, which were cast, chased or engraved; sometimes they had inlays of different metals or of enamel. To enhance the effect, the top of the case or chest was often covered with brightly coloured material or leather, and then artistically worked mounts were added. The popularity of the various types of mounts reached its peak in the 18th century.

Door-knockers. Beautifully worked door-knockers were also used to decorate doors and gates. The oldest knockers in existence are in the form of an animal's head with a huge ring in its mouth. The characteristics of the Gothic style can be seen in the knockers of that period. Renaissance door-knockers were made from circular bosses in the form of animal masks with a ring in their mouths. In addition, craftsmen began to use the flat iron rods supplied by the foundries:

ron in this form offered ample opportunity to shape the surface and apply current decorative techniques.

Door latches and handles. These too were carefully made, and during the 17th and 18th centuries in particular, an abundance of artistically worked examples appeared.

Locks. In Egypt the oldest locks were made of wood, but the Romans preferred bronze and iron. North of the Alps, locks from the 5th century are the earliest ones which are perfectly preserved; wooden locks were also used, and still are in some mountain areas. Basically each lock consists of a catch and a bolt, whose function has remained unchanged over the centuries. To avoid going into too much detail, locks will be discussed from the point of view of their use, and differences between mechanisms will not be dealt with. The categories considered will be door locks, chest locks and padlocks. In door locks, the bolt is pushed horizontally into its catch; in chest locks it slides vertically into the catch in the lid of the chest. When the chest lock is opened, a toothed locking device separates and releases the catch; when the lid is closed, the lock clicks shut without the help of the key.

Gothic locks. At first these were simple in construction; it was only in the 15th century that catches with spring and lever mechanisms began to be used. About the same time, craftsmen began to produce locks with more than one catch. Frequently the only part of the original lock which remains is the plate which covered the mechanism inside the door. At first this had a moulded, interlaced decoration, often set on a coloured base of leather, cloth or parchment. The decorative ironwork overlay often took the shape of spreading branches or interlaced flower stalks, so designed as to facilitate the insertion of the key in the dark. In the later Gothic period, lock plates were particularly richly decorated, the motifs being taken from contemporary ornament and architecture. They included spires, crockets, gables, buttresses, trefoils, quatrefoils, tracery and sometimes figural motifs. In the 16th century the development of the lock and its mechanism underwent an important change when various ingenious locking devices began to be used, all carefully and accurately worked.

The Renaissance door lock was nearly always composed of several horizontal catches and bolts, and these could be opened, without using the key, by means of a lever-device on the inside of the door. Keys could now be more easily removed from the open locks. Methods of fixing the lock to the door changed, along with the mechanism of the lock itself: whereas in Gothic times the actual mechanism was concealed in a special hollow in the door, in the Renaissance period it was visible on the inside of the door. As a result, efforts were made to render this part of the lock as attractive as possible to look at. The lock plate, until this time the only visible, and consequently the most important part of the lock lost its important functional character and either became very much smaller or was left out completely; gradually richly decorated and functional cover plates developed.

The decoration of the lock was extended to the solid forged base plate, which was often engraved around the edges. It usually had nail holes to fasten the lock to the door. Later, even the actual locking mechanism was decorated with interwoven flower and leaf work, grotesques, masks, dolphins and figures: in short, all the popular decorative motifs of the Renaissance. Often the ornamentation was copied from the works of Renaissance artists and sculptors such as Peter Flötner, Heinrich Aldegrever and Virgil Solis. The most varied decorative techniques were used, for example chasing, etching, engraving and chiselling. Some locks were tinplated, partly for decorative purposes and partly to protect them from rust. A thin blue iron plate came into fashion as a base plate, replacing the previous type made of brightly coloured leather.

Baroque locks. Unlike Renaissance locks, these did not undergo any great change as far as the mechanism was concerned; the cover plates became larger and more care was taken with the decoration. They were made of cast brass with artistic filigree work, and as in previous styles, the base often consisted of a blue iron plate. Craftsmen turned for inspiration to the design books of France and Germany, which had become famous. The art of the locksmith passed its zenith at the end of the 18th century, although many worked examples were still being made in the first half of the 19th century.

Padlocks. The development of the padlock can be traced from Gothic times, like the locks described previously. The simple, purely functional padlock, completely plain and undecorated, was used basically unaltered from the 15th to the 19th centuries. The dating of such padlocks is often a difficult problem for the layman: they could be heart-shaped, spherical or cylindrical. In addition to these simple locks, decorated ones were soon produced, and the decoration can be used as an aid to dating. The Renaissance witnessed great changes in the padlock, and many perfectly fashioned and artistically made padlocks have survived from this period. Various examples have been preserved from the 17th and 18th centuries: some have a combination of letters, others have double locks with different keys, and others springbolts.

In general there was not much difference between the keys of the various sorts of padlocks and those for other locks. One exception was, however, the screw-key. This generally consisted of a long screw with a ring-shaped handle which fitted into the spiral key-hole: the key had to be screwed right out or in to open or close the lock.

Complicated anti-theft devices, such as hidden key-holes, were often incorporated in locks. The method of opening the lock was known only to the owner or to the initiated, and it sometimes involved a whole series of special manipulations. Many examples of this type of lock have survived from the beginning of the 19th century, when they were quite popular.

Chest locks. Beautifully worked and decorated locks were made for the heavy metal chests in which monasteries, guilds, nobles and well-to-do burgesses kept their possessions. Complicated mechanisms with numerous catches often extended over the whole of the inside of the lid and were usually concealed under filigree work and etched or engraved plates. Stout, portable caskets, similar to chests, were either made entirely of metal or lined with wood; secret drawers and hidden key-holes were used to protect the contents, and cover plates were fixed in the wrong places to mislead intending thieves. Safes were often brightly painted on the outside or decorated with filigree ornaments. Smaller caskets were engraved or etched.

Keys. *Gothic.* The keys of the 14th and 15t centuries were still relatively plain and so lid: characteristic of the period were th slender, solid stems, the flat rectangular bit and variously shaped steps. The handle wa larger and easier to hold than in former pe iods, and was mostly circular or diamonc shaped: sometimes it was left open at the to and sometimes the edges of the diamon were forged smoothly together. From th technical point of view the greatest care wa taken with the bit, while artistically the har dle was the centre of interest. In the late Gothic keys this was often covered with tra cery and other Gothic ornaments, mad from strips of iron.

Renaissance. Keys with hollow stems sur vive from the late 15th and early 16th centu ries. Their handles were decorated with in terlaced leaves and other patterns, and the fitted similarly ornamented locks an wards. Trefoils and quatrefoils were ofter used as decorations, and the handle itsel could be in the shape of a circle, a diamond, three- or four-leafed clover, etc. The figura tive decoration in the filigree handles wa added to the plant designs, and the handle were often engraved or etched. The stems o the Renaissance keys were thicker tha those of previous periods, the bits were mor solid and the steps, shaped with a file, mor complicated.

Baroque. The effort to make locks and key as decorative as possible reached its peak i the 18th century. Keys were made of bras and silver as well as iron, and sometimes th parts were cast separately. In many case the locksmith made only the bit which woul fit the lock, and the making of the stem anc the handle was left to the founder. In the 18t century there were many double keys wit beautifully decorated covers. Ornamenta keys were often made of silver, but thes were only symbolic and never put to practi cal use. They appeared first in the 16th cen tury, and continued to be produced in va rious forms up to the 20th century.

Grilles. These comprise some of the most im posing examples of the blacksmith's craft all the constructive and decorative element of wrought ironwork could be incorporate imaginatively and artistically into the grille The main function of the grille was to form a

screen, through which people could see, to shut off a separate room such as a chapel or vault. As well as huge protective grilles, there were also beautifully decorated iron doors and gates; and chancel screens were often placed in churches to enclose the sanctuary. In secular architecture, wrought-iron grids were used quite early on for sky-lights and chimneys, wells and windows. In palaces and large houses there were magnificent wrought iron balustrades, façades and balconies. Courts of honour and gardens were often screened off by means of wrought-iron gates.

The Middle Ages. The Roman grille was made from perpendicular bars, and the spaces between them were filled with flat symmetrical spirals, four-leafed clovers and similar motifs, which were always kept within the grille itself. Flat square bars were used, usually pinned together by means of bands.

In Gothic churches there were massive iron gratings, and also delicate grilles to protect the altar. Characteristic of the Gothic grilles were the profusion and variety of brightly gilded plant motifs.

Renaissance. The finest of all wrought-iron grilles were made during the Renaissance. Smiths began to sign their works; it was customary in many places for the craftsman to incorporate his initials into the grille. Many more examples have survived from this period than from previous ones. Square and circular bars were most frequently used, but flat bars or strips were also employed. Grilles were used at every opportunity, both in secular and in ecclesiastical buildings, and their working and decoration was of a hitherto unknown diversity. The decorative motifs most frequently employed during the early Renaissance were spirals, volutes, interlacing and curvilinear patterns, and sword-shaped leaves. The end of the bars were usually decorated with variously shaped leaves. The grilles were finished on both sides and did not have a front and a back; the crown piece was usually moulded. In the course of the Renaissance, grilles, previously built flat, began to be decorated with moulded flowers, leaves, herms, busts and figures which were sometimes forged and sometimes pre-cast. The separate parts of the grille were, as previously, pinned together with bands, and craftsmen also began to weld them together. Often interwoven elements such as leaves were used to contrast with the main motifs — spirals, for example. Renaissance grilles were brightly painted, although this can no longer be seen on surviving examples. This custom continued until the Neo-Classical period, when the painted coat disappeared, only to reappear to a limited extent in the black, white and gold of the Empire style.

Baroque. In this period iron in various forms was used for grilles: bands, square or circular bars and flat pieces of iron are often all used on the same grille. The characteristic vitality of the Baroque liberated the grille from the stiffness of the previous periods, and the ornamentation began to run riot. The Renaissance treasury of ornaments seemed almost inexhaustible: acanthus branches, palmettes, cartouches, volutes, flowers and foliage in bright succession formed a pageantry of confused splendour. An innovation was the perspective grille, which created a most unusual effect: the grille was made in such a way that it seemed to the person standing before it that he was at one end of a long gallery with a portal in the distance.

Rococo grille ornaments became more delicate and filigree-like, and the few remaining traces of a symmetrical pattern disappeared. Flowing, moulded, interlaced patterns, *rocaille* and garlands spread over the grilles.

Neo-Classicism. At the end of the 18th century the horizontal and vertical look came into fashion again, and once again grilles became straight and plain. A regular structure was also characteristic of the subsequent Empire style. The main decorative motifs were meanders, acanthus branches and garlands. Grilles went out of fashion in the 19th century, when artistic feeling and craftsmanship in any case largely disappeared from wrought ironwork and historical styles were imitated.

Miscellaneous articles. In addition to the examples already mentioned, a whole range of iron objects was made in past centuries which are either no longer used and have been forgotten, or which are now made of other materials.

Signs. These were often beautifully worked and hung outside inns and workshops.

Crosses for graves. If it is not carefully looked after, iron, exposed to the open air, rusts and crumbles; and for this reason not many iron crosses from before the 17th century have survived. These too, however, are enduring proof of the skill of the craftsmen.

Votive offerings. These charming iron figures of common domestic animals pose many problems for the collector: even today, any efforts to classify them chronologically, or to explain their function, inevitably meet with difficulties.

Tools and household objects. The most common archaeological findings are iron tools, such as scissors, knives, tongs, hammers, axes, hatchets, etc., and their simple but functional form is still a source of surprise and pleasure. Iron chandeliers, wall brackets, candle-holders and similar objects popular in the Middle Ages were also made in the Gothic style, and clearly reflect the tastes of the period. The few remaining examples of the various type of iron lamps and candleholders mainly date from the 18th century. It was then that the craft of the smith reached its peak. During the 19th century, with industrialisation and mass-production, it gradually disappeared. Now only the expert appreciates the beauty and value of handwrought ironwork.

Cast ironwork. At the same time as wrought ironwork was going out of favour, cast ironwork came into fashion again. This rough, hard material, rich in carbon, revealed a grey colour when broken, and so was called 'grey cast iron'. Unlike wrought iron, it does not become soft and malleable, but melts at 1100-1300°C. Cast iron has been known for a long time, but it first came into common use in Europe after the 15th century AD. It was used for cannons, cannon balls, pots, vessels, piping and grates, but in the course of the following centuries it began to be used for decorative purposes.

Bas-reliefs. Of all the methods of decoration which were technically possible, bas-reliefs were the most suited to grey cast iron. They were obtained from wooden motifs cut by a pattern-maker These were placed next to or on top of one another in a bed of damp sand previously prepared in the blast furnace, and the molten iron was run off directly from the furnace into this bed. The decorated plates thus obtained were often joined to form ovens, with the help of grooved pieces of joining metal. These pieces of metal were moulded in various ways, and the moulded oven bases were often made in the same way. Sometimes the name or sign of the pattern-maker and the casting-overseer, and possibly that of the foundry master also, appeared on cast ironwork.

Ovens. Cast iron gives out heat quickly without itself being affected — that is, without melting. This makes it a suitable metal for ovens. The sides of the oven were usually decorated with reliefs, showing single figures, and well known scenes from mythology and the Scriptures. Ovens bearing a coat of arms or similar motifs were very popular: the surfaces of the plates were usually painted. During the Renaissance period, decorative cast iron oven plates from Germany were particularly well made, and they continued to be produced over the following centuries.

Miscellaneous articles. Andirons and chimney plates were often decorated with relief patterns similar to those found on oven plates. The foundries of Germany, the Netherlands and France, where the art of iron casting developed in the 17th and (even more markedly) in the 18th centuries, were famous for this kind of work. Cast iron plaques and crosses for graves have survived that date back as far as the 16th century; only a few door mounts, grilles and well-poles are still in existence. Waffle irons from the late 18th and the 19th century, much sought-after by the collector, are often decorated with religious or popular motifs.

The 18th and 19th centuries. The development of technology in the 18th century encouraged a renewed interest in cast ironwork; great progress was made in this field, in particular in England. Towards the end of the 18th century the Englishman John Wilkinson produced a spherical oven in cast iron. Technical progress, together with the Empire and Neo-Classical styles, helped in the development of ornamental cast ironwork.

Cast iron statues, monuments for tombs and

portraits in relief were popular, and various articles in daily use were also made of cast iron, such as writing instruments, boxes, vases, candlesticks and, during the first twenty years of the 19th century, even jewellery (Berlin iron jewellery). Cast iron was of importance in architecture, though only as a structural element. Improved techniques allowed it to be used even in sculpture, which had not been possible prior to the technical developments of the last part of the 18th century. From this period there are many sculptures cast in one piece, which previously would have had to be cast in parts, a process which imposed considerable limitations on the artist. Ornamental cast ironwork reached its peak in the first half of the 19th century in Germany, and the fame of German foundries, particularly those of Berlin, spread throughout Europe.

Advice to Collectors

Oxidation is the inexorable enemy of iron and ironwork; it manifests itself as rust on the surface of the iron. If this process is left unchecked for a long period, the inevitable result is the complete disintegration of the iron. The methods which may be used to remove rust from an object which has been attacked vary according to its condition. The preservation of articles which are completely corroded and covered with rust, such as archaeological finds, should be left to experts; this is usually done by means of what is known as a stabilisation process. If the iron is only partly affected, and if traces of old paint still remain on its surface, both the rust and the paint can be removed chemically. It must first be cleaned with acetone, trichlorethylene or a similar degreasing agent, and then left in a phosphoric acid bath with an inhibitor for as long as it is necessary. The rust can then be removed mechanically, using a wire brush in running water. These two processes, the bath and the brushing, should be repeated alternately until all the rust has been removed. When the piece is completely clean it should be washed in a 3-5 % phosphorus solution, wiped well with a cloth and dried in hot air. As an aid to preservation it may be dipped, while it is still hot, in a silicone oil bath or painted with a coat of varnish. Recently, successful results have been obtained by using specially prepared wax of various sorts. However, care must be taken to avoid a hard gloss which would spoil the characteristic surface of the iron.

Large objects which cannot be placed in a bath can be cleaned with a phosphoric acid paste. In cases where hardened iron is to be cleaned, in lock springs, for example, or where the iron is alloyed with other metals, this method of cleaning should be avoided and the tannin method should be used. The object is degreased as above, and then a thick horse-hair or wire brush, dipped in a tannin solution (tannin, distilled water and alcohol), is used to rub off the rust. Due to oxidation the surface becomes black. The above-mentioned aids to preservation can then be used.

If there are only a few spots of rust on a smooth or polished iron surface, these can be removed by using refined petroleum or methylcyclohexanol and rubbing the object with a piece of felt or flannel. It can then be degreased and treated as above.

The collector should keep his pieces at normal room temperature, or even slightly lower, at about 50-53°C. Care should be taken that the humidity of the room does not fall below 55 % of the relative humidity.

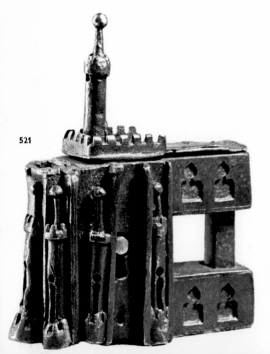

521

521 Padlock in the form of a Gothic castle with tower and battlements. Zvikov castle, Bohemia, 15th century
522 Two padlocks. Bohemia, 16th century

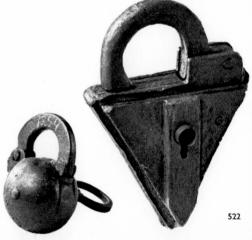

522

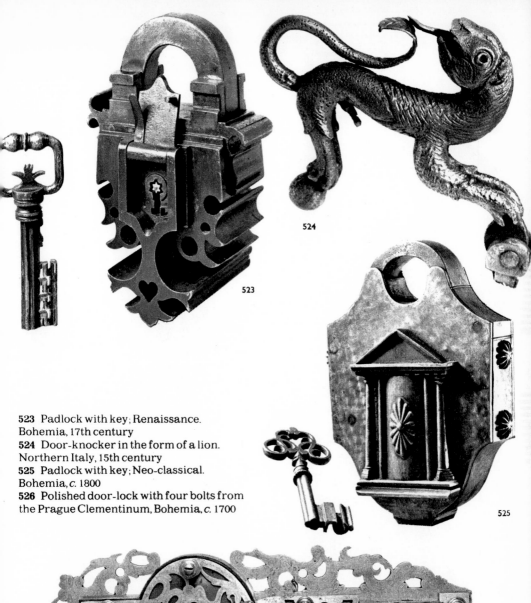

523 Padlock with key; Renaissance. Bohemia, 17th century
524 Door-knocker in the form of a lion. Northern Italy, 15th century
525 Padlock with key; Neo-classical. Bohemia, c. 1800
526 Polished door-lock with four bolts from the Prague Clementinum, Bohemia, c. 1700

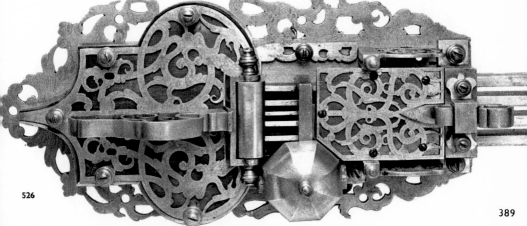

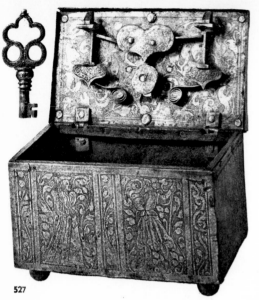

527 Casket with etched figures and ornaments. Southern Germany, 16th century
528-530 Iron chests with gilt decorations; Rococo. Bohemia, c. 1750
531 Protective grille for tabernacle with forged, chased and engraved flower patterns. Austria, 15th century
532 Miner's lamp. Bohemia, 17th century
533 Bell-pull decorated with forged interlaced flower work. Bohemia, 17th century

527

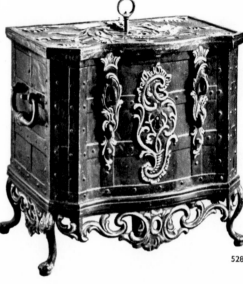

528

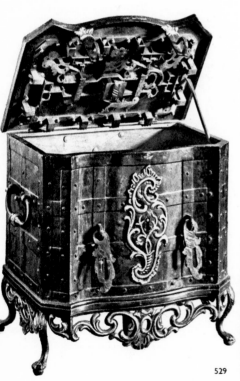

529

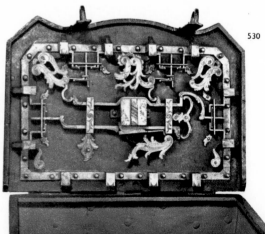

530

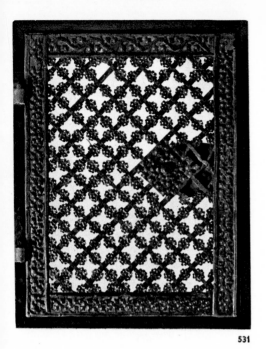

531

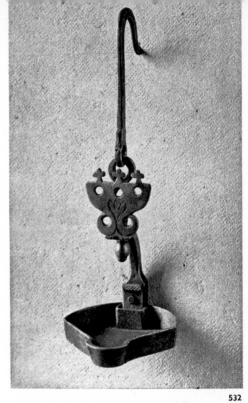

532

533

391

534 Wrought-iron Renaissance grille. Bohemia *c.* 1600

535 Waffle irons; decorated on the inside with cast ironwork and double-eagle shields. Bohemia, beginning of 19th century

536 Torch and candle-holders. Bohemia, 18th and 19th centuries

537 Geometrical instruments with etched decoration. Salzburg and Central Europe, 16th century

538 Perspective grille in the Italian chapel in the Prague Clementinum. Bohemia, 1715

534

536

537

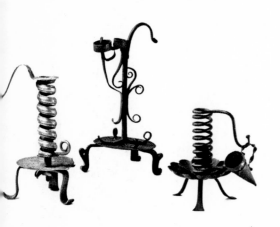

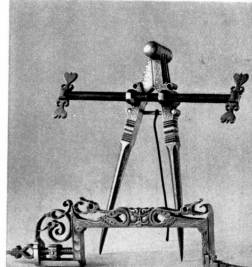

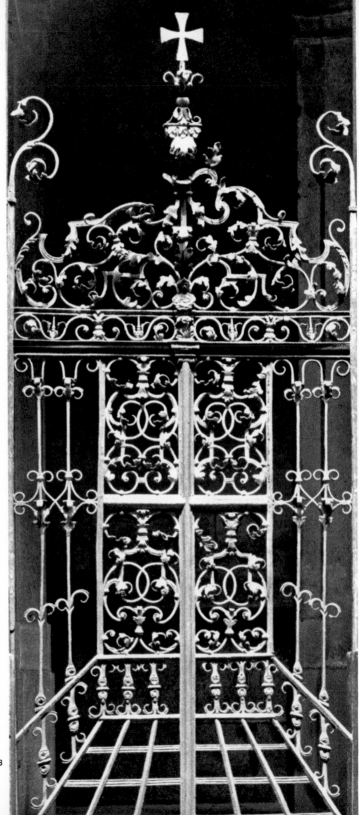

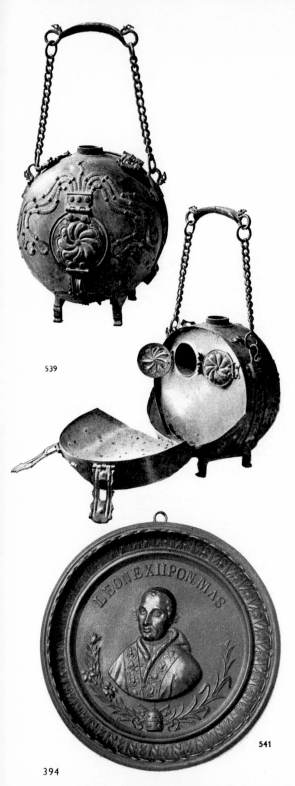

539

540

541

539 Two views of a vessel with handle; chased. Bohemia (?), 17th century
540 Cast iron plaque in three parts: above, two monks with courtesan and four stars; below, stag and dog. Hans Rabe foundry, c. 1525
541 Cast iron medallion with bust of Pope Leo XII. Bohemia, 1823
542 Cast iron plaque in three parts: above, crucifix, woman praying, miner and nine stars; below, two Turkish knights. Hans Rabe foundry, c. 1525

542

543 St Wenceslas; cast iron statuette.
Bohemia, second quarter of 19th century

COPPER

Copper (chemical symbol Cu, from the Latin *cuprum*) was one of the first non-precious metals to be discovered and was being used at a very early date. References in the Old Testament and accounts given by Classical writers often do not differentiate between pure copper and copper alloys, the same word being used for both. This remained standard practice in the following centuries and indeed right down to the 16th century AD, which was when the term 'bronze' first began to be used; the word 'brass' (popularly known as 'yellow metal') did not make its appearance until somewhat later. It is interesting to note that in almost all the European languages the word for copper is derived from the Mediterranean island of Cyprus, where large quantities of copper were mined from very early times. (Exceptions to this general rule are the Slav languages and, amazingly enough, Italian.)

There are only a few places on the earth's surface which have large deposits of copper, Europe having relatively little copper-ore compared to America, which nowadays meets the greater part of the European demand.

Manufacture

Deposits and Production. Copper is extracted from copper-ores. Pure copper is also quite common, and can be found here and there, being used either virtually unalloyed, with just a very small addition of other metals to make it easier to smelt, or alternatively as the basic component of various alloys, of which the most important from the point of view of the art historian are bronze (copper + tin) and brass (copper + zinc).

Properties. The characteristic features of copper are its strange reddish colour and the fact that it is fairly hard, extremely strong, highly malleable and can stand up to atmospheric effects. Apart from all this, it i also an excellent conductor of heat and is ea sy to work with both in its molten state an when it has solidified.

Three different methods of processing an working copper have been used since ver early times. It can be either cast, forged, o chased. The surface of copper articles can b embellished with engraved, chased c punched decoration.

Copper — or one of the alloys of copper - was the first type of metal to be cast, an there is evidence to suggest that copper casting was in progress in Mesopotamia a early as the 3rd millennium BC.

Historical Survey

Northern Europe. Because it is both malleable and hard-wearing, copper was used in northern Europe from the Middle Ages onwards for roofs for towers and palaces, for gutters and for various types of pipe. The coppersmiths' workshops also supplied chemists and doctors with their crucibles, mortars, flasks and screw-top boxes and other receptacles, plus various complicated instruments and other apparatus with the component parts soldered together or alternatively rabbet-jointed. The soap-boilers, chandlers, wax-chandlers and dyers all commissioned the equipment they needed from the coppersmiths, the most important item being a copper cauldron, which was virtually indispensable for all of them. Pieces of delicate scientific apparatus such as astrolabes or sundials were also generally made of copper. Most of the richly engraved copper and brass measuring instruments and chronometers made in the 16th and 17th centuries were extremely accurate, and were made by brilliant mechanics; but at the same time some instruments were made to be decorative rather than functional.

Copper was also highly prized by craftsmen involved in the applied arts, who used it to make objects of aesthetic value.

Ecclesiastical objects. Crucifixes, commu nion chalices, monstrances and the lik were frequently made of copper from th medieval period onwards; such items woul subsequently be gilded, partly because th regulations of the Catholic Church forbad the use of non-precious metal (with the ex ception of pewter) for liturgical purpose and also because it made them look mor sumptuous. From the point of view of techni que, this type of article was modelled on th work of contemporary goldsmiths, and wa therefore close to it in style, design and de coration. This also applies to the bust shaped copper reliquaries which were pro duced in large numbers in various places i Europe in the 13th and 14th centuries (Italy France, Belgium, Bohemia and elsewhere Limoges was a particularly well-know centre for this type of reliquary in the 13t century.

Household utensils. Copper and brass wer already being used for ordinary utensils i the Middle Ages, and here the special advan tages of copper and the various copper al loys came well and truly into their own Brass and copper articles took the place o honour, especially in the kitchen, along wit bronze and later on, cast-iron.

Coppersmiths generally produced everything that was needed by their local clientele, but as early as the 12th century production centres were growing up to supply the requirements of consumers over wider areas. The medieval chased brass and copper articles known as *Dinanteries* were made in the small town of Dinant in present-day Belgium; from the 12th century the famous coppersmiths of Dinant exported their vessels and implements and even some monumental pieces such as fonts to distant lands. In Germany there was initially much less interest in brass and copper than in bronze, and hence these materials were only occasionally used even for making ecclesiastical objects and household equipment, let alone for decorative articles. But in the 15th century, and even more in the 16th, the Germans began to acquire a taste for hammered *brass dishes and basins,* large quantities of which were made, chiefly in Nuremberg. The centre of such a showpiece would generally be decorated with chased motifs or scenes taken from Classical mythology or the Bible; stencils were generally used for this type of decoration. The whole surface could also be divided up into a series of punched concentric circles.

The use of copper utensils reached its peak in the countries north of the Alps in the 17th and 18th centuries, and a number of beautifully made pieces have survived from this period; examples from Holland, Germany, Austria and Switzerland were clearly made by craftsmen who possessed both a well-developed sense of design and brilliant technical ability. High-quality copper articles were still being made in the 19th century, for although output was now much smaller, the attractive new materials which were being introduced did not completely oust copperware from the table and the hearth. Towards the end of the 19th century, cheaper mass-production methods superseded individual craftsmanship and also led to the decline of the copper-casting, copper-forging and copper-chasing trades.

Copper kitchenware. Copper utensils are lighter than their counterparts in pewter, bronze or cast-iron, and are therefore more manageable and eminently suited to kitchen use. Copper can also, like bronze and iron but unlike pewter, stand up to high temperatures, and so can be placed over an open fire without any ill-effects; this means that it was largely used for cooking utensils. Copper cauldrons, pots and pans were easy to clean and scour until they shone because their surface was hard and resistant; their warm reddish glow looked splendid when set against whitewashed walls. Cooking utensils made of copper were lined with tin to guard against the damaging effects of the metal on human health, and to prevent the unpleasant after-taste left by food which has come into contact with copper. A large number of copper pots of various shapes and sizes were part of the normal range of kitchen utensils; for instance, among other types we can find pots with a single handle, others with two handles, yet others with a spout and some bowl-shaped pots with handles. The *salt-cellar* hanging on the kitchen wall would often carry rich geometrical or vegetal decorations or popular animal motifs.

An extraordinarily wide variety of *jugs* was available. Here it is possible to detect regional variations in design and decoration, each different style being typical of one specific production area. The most common type of smaller vessel is a jug with a broad body in the shape of a flattened sphere, plus a handle and spout and sometimes small legs as well. This type of jug spread from northern Germany, where many examples were also being made in brass, to some neighbouring areas. They were primarily used as water-jugs and tea-kettles. Highly individual conical tea-pots and coffee-pots were produced in northern Germany; their lines were strong and elegant, and the body and high-domed lid combined to form a single powerful and compact unit. The only other place which produced a similar design was Holland, except that there the spouts and handles were different. One particularly unusual piece, found only in northern Germany, was what is known as a 'tapering jug', which consisted of a body shaped like an inverted cone set on a broad flat foot. Large water-jugs were generally designed on the lines of staved wooden jugs modelled like pilasters. They were mostly found in southern Germany but were not restricted to that area, being found with various modifications wherever copperware was produced. They can be recognised by the gentle lines of the conical body, and by the fact that the spouts, handles and lids are carefully designed to blend in with the characteristic outline of the whole

jug. A similar design can be seen in some jugs with lids which have a ring for carrying them plus an ordinary handle. In central and southern Germany both S-shaped curved jugs and pear-shaped ones were common, whereas those made in western Germany were designed on particularly bold lines; the inhabitants of south-western and central southern Germany preferred a very ancient beak-shaped design which was being used for bronze jugs made in this area as early as the Hallstatt period (c. 700 – c. 450 BC).

The wooden ancestor of the type of jug known as a *Röhrken* is to be found in the far North; it clearly originated as a beaker but was then given a plate-shaped pedestal, a spout, a lid and a handle. Copper and brass jugs varied from one district to another, some being pear-shaped, others like a double cone, and yet others barrel-shaped or egg-shaped. The bulge sometimes came in the top part of the body, sometimes in the middle and sometimes at the bottom.

In the 17th and 18th centuries, when a wide range of household utensils was in use, two new factors began to affect the design of copperware: the different districts wanted to give their wares an individual regional stamp, and at the same time coppersmiths were attempting to produce articles which would closely resemble pieces made in other metals and yet retain their individuality. So it is not surprising to find one particular type of design, a special shape of handle or spout, or an unusual lid, cropping up in various places.

Another type of container for liquids which was produced in copper and brass was the *flask*. Its design scarcely ever varied, and a cylindrical shape with a screw cap made of pewter seems to have been the most popular type. The ring for carrying it was generally modelled and shaped, and the walls were either completely plain or covered with engraved or chased decoration. One frequent decorative motif was the coat of arms of the owner's family or their initials, plus the date when the flask was made; these were often accompanied by plant ornaments covering the rest of the surface.

Virtually every household had a series of copper *pastry-moulds* in varying sizes. There was a wide range of different shapes, from the traditional moulds for making *Gugelhupfe*, or pound-cakes, to shapes such as garlands, lilies, melons, snails, shells, bunch-es of grapes, fish, crabs and lambs. Bigger pastry-moulds had a ring by which they could be hung up on the kitchen wall, where they provided a type of sculptural decoration. It is difficult for us to realise the amount of work which went into forging a mould by hand; it involved hammering the sheet-copper over and over again to give it the shape requested by the client. The traditional moulds for pound-cakes, for instance, were made in whatever size was required from a sheet of metal a fraction of an inch thick. This was placed on a small anvil and worked as follows: first of all the coppersmith hammered out a flat shell and filled it with pitch; when this had hardened he would rotate the dish, then, working outwards from the centre, mark in the flutes and finally hammer them out; then he removed the pitch, cleaned out the shell, shaped the rim and put the finishing touches to the decoration.

The typical centrepiece is missing from the earliest pound-cake moulds. The first ones to have a hollow cylinder in the middle were made from a single piece of sheet-copper, but later on this laborious method was abandoned, and the mould and cylinder were made separately and soldered together afterwards.

In some districts, instead of the usual bread-bin, housewives used a bread container up to about 40 in. tall, with a lid that could be lifted off and a pair of handles with which to carry it. These were particularly common in Saxony, and had either smooth undecorated sides or chased decoration.

Large copper *apothecary's jars* were rather similar in shape to these bread containers; as with copper apothecary's stands, a number of different designs were to be found in central Germany. The copper vats which were used in places such as breweries were not unlike modern coal-bins; they were lined with tin, and so were presumably used mainly for storing perishable goods. The straight part of the walls was often embellished with figurative chased decoration. Large copper basins were also popular for cooling wine, and these were again not much different from their contemporary counterparts in bronze.

Of the various types of *warming-pan* available, the large ones in the shape of a double pan with a handle are still used today, though admittedly only for decoration. The

circular surfaces were generally covered with chased decoration, and figurative motifs were often employed. Holes were punched at the top and possibly also at the sides to regulate the air-supply so that the charcoal inside could burn properly. To warm the bedclothes the warming-pan would be run up and down over them just as if it were a large iron. Pots containing food would also occasionally be placed on top of them.

The Balkans. A large amount of copperware was used here from an early date, and copper utensils are still extremely popular today. Their makers follow formulas several centuries old, and modern copper workshops produce the same type of ecclesiastical and domestic articles as their ancestors: dishes, bowls big and small, hanging kettles, jugs of all sizes, the vessels known as *dschesva* which are indispensable for making genuine Turkish coffee, pots, censers with ornamental pierced sides, warming-pans, braziers, engraved table-tops and so on.

As in other areas where copperware was produced, Balkan craftsmen mostly embellished their work with fine engraved or chased decoration, or with punched motifs. A large number of designs were executed with stencils. The predominant motifs were geometrical patterns and vegetal elements, all of which clearly show that local methods of decoration had been strongly influenced by Oriental art. Lettering was one of the main decorative devices, as it was in all work produced in the Islamic sphere of influence. Human or animal figures were exceedingly rare. Unlike copper articles produced elsewhere in Europe, Balkan wares were in many cases plated with tin as well as being lined with it. The design of domestic utensils produced in this part of the world was also different from the work we are familiar with, since once again it was strongly influenced by Oriental craftsmanship. The commonest design was a jug with a strikingly curved body and a tall and comparatively narrow neck rising from the wide lower section; it had a domed lid, a handle and a straight spout which was generally long and branched stiffly out from the bulging lower part of the body, finishing with a bold sweep on a level with the lid. A second type which was widely used had a considerably wider neck, plus in most cases a lid and a handle. The chased copper bowls made in the Balkans were deeper than usual, and were set on a base which was often given extra emphasis by being made to project sharply beyond the body. More or less flat dishes with high domed lids were among the favourite pieces of copperware in the Balkans. Craftsmanship and the applied arts were able to hold their own for many years in this part of Europe, and even the mass-produced copper articles made today remain faithful to the old traditional designs, which means that their style is quite different from that of copperware in the rest of Europe.

Advice to Collectors

Articles made of copper or copper alloys are generally covered with a layer of corrosion caused either by water or carbon, or by a number of other substances, some of which have an extremely violent effect; as a rule the damage caused by the action of the soil is greater than that caused by the atmosphere. It is easy to distinguish between the different types of corrosion found on copper and alloys of copper because their effects are completely different. The surface can be coated with an authentic patina, or with an unsightly looking layer called verdigris, or with a thick, blackish crust which corrodes the metal.

As a rule no special precautions are needed for cleaning and preserving pieces which are not coated with verdigris or the blackish crust; it is enough to use one of the standard liquid cleaners or a special paste. In exceptional cases, pieces which are in particular danger from their surroundings should be given a film of transparent lacquer. Before setting about preserving a corroded object, you must be absolutely sure what type of corrosion you are dealing with — it is easy to find out by using a strong magnifying glass — and then select the appropriate method. In all cases where there is no danger of the damage becoming progressively worse, an attempt should be made to retain the patina, since it enhances rather than detracts from the aesthetic effect.

Objects coated with a genuine patina must be cleaned with great care so as not to damage them; the patina is often as smooth as glass and may be a brilliant green or else blueish or an attractive brownish shade. Ordinary dirt is cleaned off with a soft brush under running water, though the most obstinate particles will have to be removed with a sharp instrument of some kind. The article should then be thoroughly washed in distilled water (the water should be changed several times if possible), dried with a hairdryer or some similar instrument, and then coated with a layer of transparent lacquer as soon as it has cooled down to a temperature of between 80°F and 95°F. If this results in a harsh glitter which spoils the effect, the article should be painted with a wax and carbon tetrachloride solution and polished with a soft cloth. Pieces which have been dug up tend to be heavily corroded, as may be seen from their incrusted and very uneven surface; these are best left to the care of experienced and properly trained experts who can use chemical and electro-chemical methods.

Objects made of copper, bronze or brass need little looking after, and the average room — not too dry or too damp, not too hot or cold — is perfectly adequate for keeping them in. They should not come into contact with iron, since this may result in a chemical interaction that will produce unsightly spots which are difficult to remove, or will turn the whole object an unattractive colour.

544 Copper flask with screw-top made of pewter and chased decoration on the sides. Leipzig, early 18th century

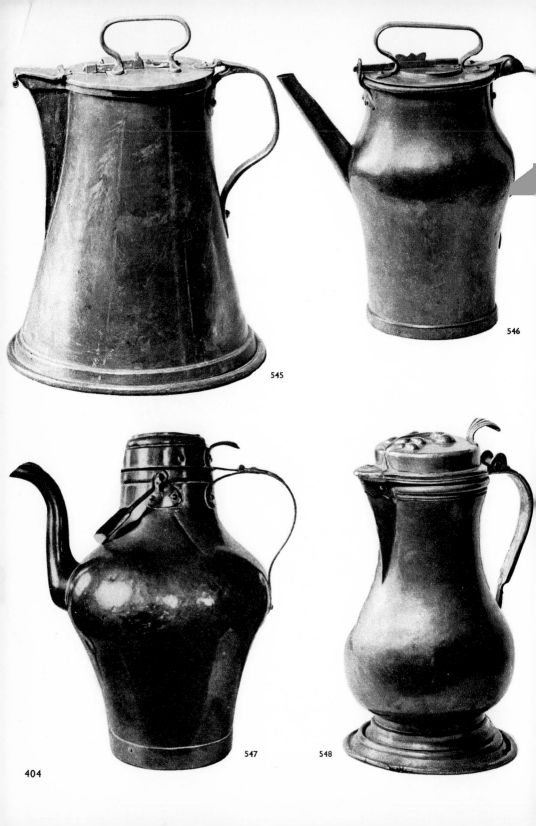

545

546

547 548

404

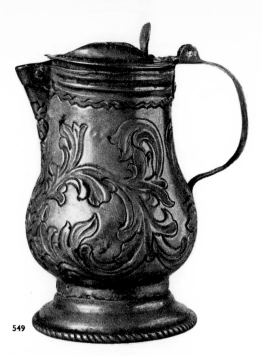

549

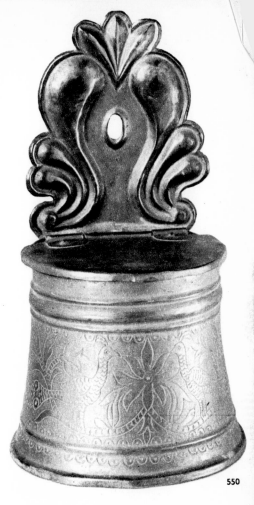

550

545 Jug with bolt-fastening on the lid.
Bohemia, 18th-19th century
546 Tubular jug with high-shouldered body
and bolt-fastening on the lid. Bohemia, 18th
century
547 Milk jug. Saxony, 18th century
548 Copper jug with chased decoration on
the lid. Bohemia, 18th century
549 Copper jug with chased decoration on
the body. Bohemia, 18th century
550 Wall salt-cellar with chased and
engraved decoration. Bohemia 18th century
551 Copper vessels. Bohemia, 18th century

551

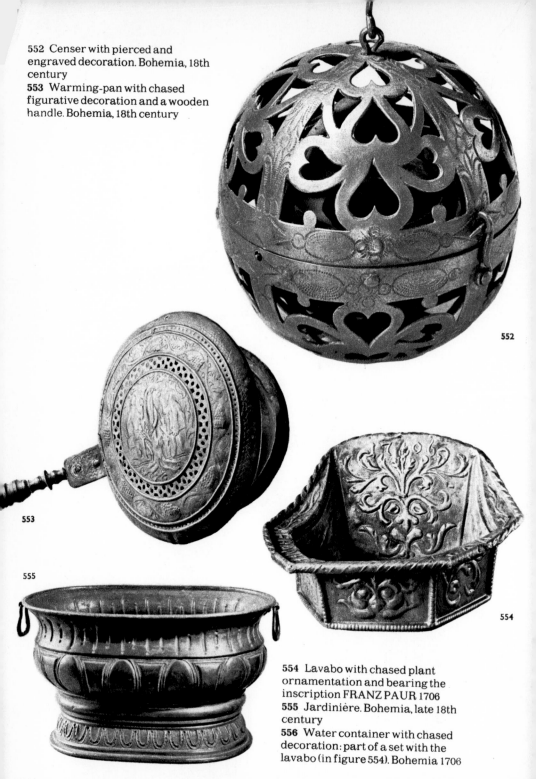

552 Censer with pierced and engraved decoration. Bohemia, 18th century
553 Warming-pan with chased figurative decoration and a wooden handle. Bohemia, 18th century

552

553

555

554

554 Lavabo with chased plant ornamentation and bearing the inscription FRANZ PAUR 1706
555 Jardinière. Bohemia, late 18th century
556 Water container with chased decoration: part of a set with the lavabo (in figure 554). Bohemia 1706

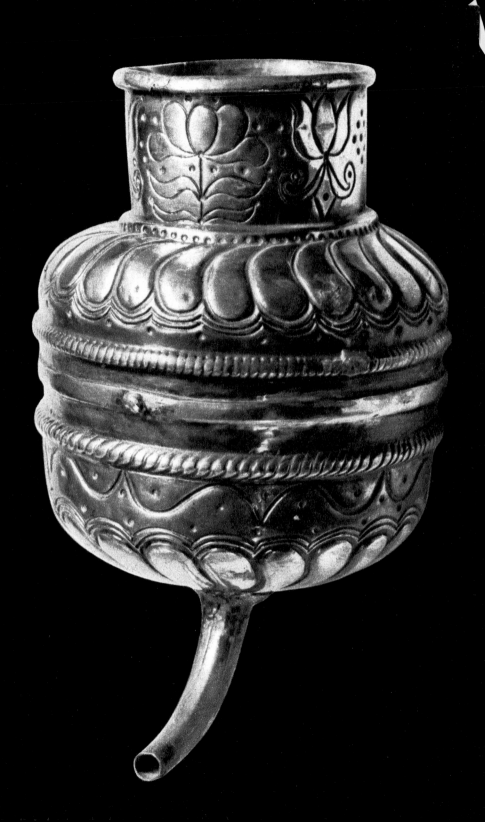

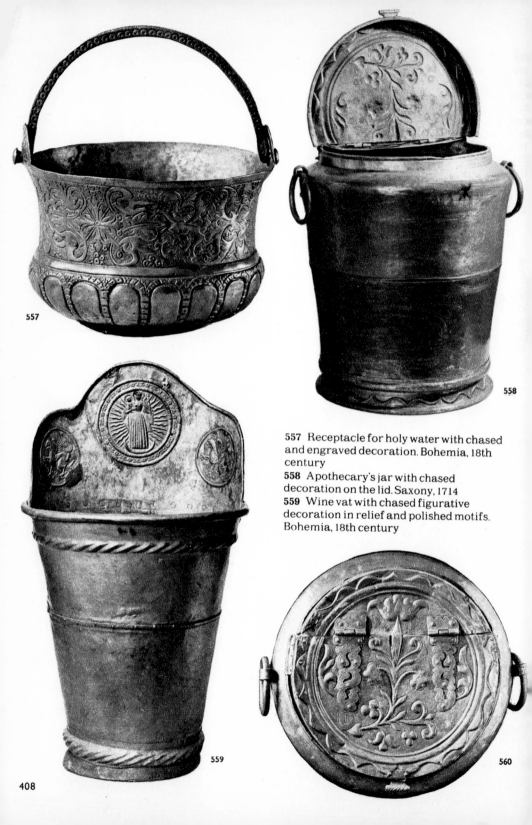

557 Receptacle for holy water with chased and engraved decoration. Bohemia, 18th century

558 Apothecary's jar with chased decoration on the lid. Saxony, 1714

559 Wine vat with chased figurative decoration in relief and polished motifs. Bohemia, 18th century

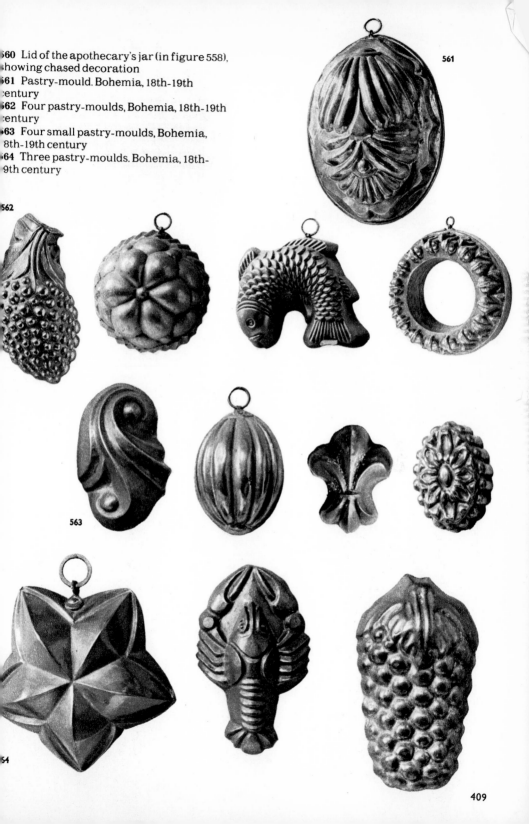

560 Lid of the apothecary's jar (in figure 558),
showing chased decoration
561 Pastry-mould. Bohemia, 18th-19th
century
562 Four pastry-moulds, Bohemia, 18th-19th
century
563 Four small pastry-moulds, Bohemia,
18th-19th century
564 Three pastry-moulds. Bohemia, 18th-
19th century

561

562

563

564

565

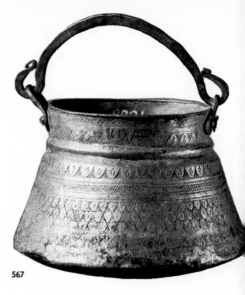

567

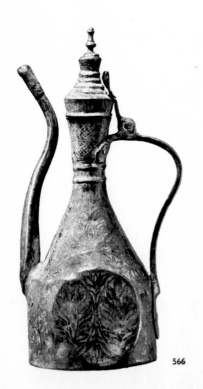

566

565 Dish with a lid and engraved decoration.
Bulgaria, 20th century
566 Copper jug lined with tin; engraved
decoration. Balkans, 19th century
567 Copper water-jug lined with tin:
engraved decoration and iron handle.
Bulgaria, second half of the 19th century

BRONZE

ronze is an alloy of copper and tin which
an also contain some zinc, lead or silver.
he colour of this alloy depends on the pro-
ortion of tin: if the proportion is small, the
eddish colour of the copper predominates;
 it is considerable, the bronze will have a
haracteristic golden tint. When the tin con-
nt exceeds 10%, the bronze is a yellowish
olour; when it is more than 33%, it gleams
lvery-white. The proportions of copper and
n also govern the working potential of

bronze. Three of the special classes of
bronze can be mentioned here: bronze coins
containing 5% tin, gun metal with about 10%
and bell metal with 20-23%.
Bronze is a firm, strong, durable metal, re-
sistant to weather conditions and technical-
ly easy to work. It is suitable for both detailed
and smooth casting and, in addition, the sur-
face can be worked after this (by chiselling,
for example).

Manufacture

om ancient times, craftsmen have em-
oyed two basic methods of working in
onze:-

hasing. The bronze sheet is placed on a spe-
al block made of wood, lead or pitch, and
e desired decoration is obtained with the
d of hammers (or punches).

asting. This process is much more fre-
ently used, and can be carried out in two
ays. The 'solid cast' method is to pour the
olten metal into a simple stone, plaster or
nd mould. For a free-standing object the
ould will have to be made in two or more
ctions. Casts produced in this way are
mewhat complicated, and also expensive,
ce they require a lot of material. For this
ason, preference was early given to the
llow cast' method, which nevertheless re-
ired a complicated mould and a perma-
nt core. In order to produce thin-shelled
rks of art, the *cire perdue* process was
olved and remained widely in use, almost

unchanged, from ancient times until the 19th
century. The core was covered with a layer of
wax the same thickness as the future metal
cast. The wax was then modelled in all details
to correspond with the artist's model, and an
outer covering of clay applied which en-
closed the gates and vents. The mould was
then heated and became hard, the wax melt-
ed and ran out, and the molten bronze was
poured into the space so created. When cold,
the plaster outer casing was broken and the
gates, vents and core removed. The cast
could then be further finished by chiselling,
and perhaps decorated with engraving.
In the course of time, the desire to obtain
more than one cast from a mould led to im-
provements being made to this process, and
ultimately it became possible to obtain
many casts from a single mould. In essence,
however, the process survived unchanged
until the 19th century. In recent times the
piece-mould process, in which founder's
sand is used, has largely taken the place of
cire perdue.

Historical Survey

Antiquity. The second of the three great prehistoric ages is called the 'Bronze Age'. In Crete, traces of bronze culture have been found which date from about 2100 BC, while in Scandinavia archaeologists discovered Bronze Age coins from the 6th century BC. In Mesopotamia the technique of metal casting was known as early as 3000 BC. It was here, also, that bronze was used for the first time in history side by side with copper for casting. In Egypt too, this alloy quickly replaced pure copper as the preferred material for sacred, decorative and functional objects. In China, bronze casts existed from the first millennium BC. The Greeks learned the art of bronze casting from the peoples of the Near East, and developed it to such a degree that only the very best modern pieces can equal them. So we can thank the ancient Greeks, among others, for the technique of casting monumental statues, busts and statuettes in bronze, for it is from Greece that the art has spread throughout the Western world.

The Middle Ages. In the Middle Ages, many uses were made of bronze (called 'red cast' by the guilds) on account of its excellent qualities. Bronze utensils for ecclesiastical and domestic use, reliefs, statues in the round, statuettes and monumental works (which were often placed out-of-doors), all enjoyed great popularity at one time or another. Bronze was especially suited to the open air, being resistant to weather.

In medieval Germany, and particularly in the 11th and 12th centuries, the art of bronze casting flourished to such an extent that art historians might be tempted to call this period another 'bronze age'. At first the alloy was worked exclusively in monastery foundries, where cooking utensils and objects for ecclesiastical use were cast. Bronze was used as both a basic and a supplementary element in the adornment of religious buildings, and a profusion of bronzes of all kinds decorated the interiors of churches and monasteries. Bernward von Hildesheim was one of the foremost figures of his time in the art of bronze casting. A bronze pillar (the Bernwardsäule) almost four metres high, with reliefs depicting scenes from the life of Christ, was cast in his famous foundry. To Bernward we owe many other valuable bronzes including the world-famous cathedral doors at Hildesheim with the sixteen sculptured Biblical panels. Many other German towns followed the example of Hildesheim. Magdeburg, Augsburg and Brunswick, for example, became famous for their bronze doors, fonts and other similar features. A renewed interest in the art of bronze casting also appeared outside Germany, especially in Holland, where works of considerable importance were created.

For a time, bronze work was executed by goldsmiths, but later, as the craft was more widely practised, the red casters (as bronze casters were called in contrast to yellow or brass casters) frequently formed their own guilds, and craftsmen began to specialise in various types of work in bronze.

Bronze for ecclesiastical use. Crosses comprise the greater number of small bronzes of a religious nature that have survived. These often contained a relic and were worn as pendants by the pious. The oldest are in the form of a simple Latin cross, either without decoration or bearing the figure of Christ in relief or engraved. These crosses were sometimes inlaid with coloured enamel and became very popular, particularly in the Rhineland and in Limoges, between the 12th and 14th centuries.

Among the most beautiful of all Christian ceremonial bronzes of the period are the *baptismal fonts*, many examples of which can be seen in parish churches today. A few of the most richly decorated in relief can be mentioned here: the bronze fonts in the cathedrals of Hildesheim (12th century), Würzburg and Brandenburg; the famous font in the Sebalduskirche in Nuremberg; and, perhaps the most beautiful of the period, the remarkable font made for the Marienkirche in Wittenberg by Hermann Vischer, father of the great German bronze sculptor Peter Vischer.

ncense burners for use in Roman Catholic churches were frequently made in bronze. These were fashioned in two bowl-shaped parts, the top one upturned to act as a lid; the lower part usually stood on a base. The pierced sides were elegantly ornamented with designs borrowed from contemporary architecture, plant motifs, tracery and so on. *Holy water vessels* and *sprinklers* of the period were similarly decorated.

Ewers in the shape of animals, with a bowl for washing the hands (aquamanile), were originally intended for liturgical use but later found their way into the homes of the upper and middle classes. So it was that, in the course of time, ecclesiastical objects acquired a domestic use. The earliest examples of these ewers, in the form of lions, dogs, dragons and so on, were made in the 12th century. The water was poured through the mouth of the animal and the opening for filling was on the back. The handle curved across the back and was either an extension of the animal's tail, or was made in the form of a dragon, a snake or a similar creature. Only in exceptional cases were they not fashioned in animal shapes.

Similar types of bronze work can be found in both ecclesiastical and domestic buildings of the period, for example, beautifully carved *doorhandles, latches, doorknockers* and *gargoyles* in the form of animal masks or fabulous beasts.

Domestic utensils. In the 12th century, bronze was also widely used for domestic purposes. Chased bronze dishes, known as *Hansesschüsseln,* were produced in Lorraine and the Rhineland and exported all over the world. These beautiful dishes were often further decorated on the inside with engravings or chiselling. Bronze became increasingly the most popular metal for kitchen and table ware, and we can still admire these articles today. Bronze was heat-resistant, decorative and almost indestructible. These utensils remained almost unchanged in form until the 16th century. Among the earliest were the multi-purpose solid bronze *cauldrons,* which stood on three legs over the open fire. In contrast to the Gothic style of the day, these cauldrons were made with a rounded line, suggestive of wooden pails with their customary triple horizontal hoops. North Germany, Lower Saxony and the Lower Rhineland can be considered the area in which the tripod bronze cauldron originated. In the 13th and 14th centuries mortars with one or two handles (often placed at different heights) showed the same horizontal line, reminiscent of the older wooden shapes. However, the Gothic influence in mortar design had made itself felt by the 15th century, and the vertical movement of the ribs and bold outline had replaced the older, purely functional shape. Two handles of the same height were now normal. In the 16th century, however, emphasis on the horizontal line recurred and, as time went on, mortars were made lower and wider, with inscriptions surrounding the whole, either directly under the rim or round the centre, thus emphasising the utensil's breadth. Sometimes mortars were decorated in relief with weapons, flowers or figures.

The tripod cooking pot or *skillet,* with a handle or chain device to suspend it above a fire, was particularly suited to the medieval kitchen with its open hearth. These skillets appeared in various forms in different parts of Europe. Some especially fine examples survive from North Germany, where they were called *Grapen,* and their manufacturers, who enjoyed considerable prestige, were known as *Grapengeter.* The earliest skillets, from the 14th century, were round in shape and stood on long legs. The shape changed over the centuries to a bag-shape, and was later flattened and widened still further, so that it resembled a dish. In the 18th century, the pure round shape became popular again. In North and Northwest Germany and in Holland, pear-shaped bronze skillets were used; this flattened form was prevalent in Holland from the 16th to the 18th century, and was also characteristic of the Dutch *Bügel* pots. Flat, low *dishes* on three squat feet were also characteristic features of the bronzeware of this area. In North Germany in particular, massive, beautifully decorated, shallow, open *buckets,* usually on three stocky feet, were used as charcoal burners, serving to warm otherwise unheated rooms. In South Germany (especially in Swabia, Upper Austria and the Tyrol), tall two-handled bronze pots with rich relief were produced: they were characteristic of this region and apparently not found elsewhere. Among the most valuable of the bronze uten-

sils in middle-class homes were the *ewers* with twin spouts and a hanging device. They were used to display the wealth and taste of the owner, though they were functional objects as well. The spouts were often artistically designed in animal shapes, a popular taste in the 15th century. Bronze *jugs* occupied a place of honour beside the bronze *plates* and *dishes* in middle-class and more prosperous peasant homes. Here and there, beautifully made bronze *spoons* were used for soup and porridge.

Bronze *candlesticks* were much in favour in both churches and private homes. In essence, there was very little difference between the simple church candlestick and those that were placed in a niche or on a commode in the home. Few examples survive of the ornate, richly decorated church candelabra of the Romanesque and Gothic periods. In the course of time the single candlestick as we know it today was evolved. Out of the normally circular base (the Renaissance base was also triangular) came a short, and later a somewhat longer stem, on top of which was the pricket and drip pan. The stem would be fluted according to the taste of the time.

Standard measures. As the units of weight and size varied from one medieval town to the next, the measures used were of different shapes and sizes, each characteristic of the trading area of origin. The sides of the containers were often smooth or inscribed; sometimes they carried the coat of arms of the town, the date of issue and volumetric capacity. As they were in essence purely functional objects, these measures remained practically unchanged in form from the 15th to the 19th century, and were made in the appropriate traditional local style.

Bronze sculpture. Sculptors of the early Middle Ages executed their works in wood or stone. Even in the 13th and 14th centuries, monumental sculpture in bronze was rare, although this period was not lacking in bronze works of art; for the bas-reliefs and full round figures which decorated the fonts and the high-relief or engraved protraits of the dead on memorial tablets must be considered 'sculpture' in the widest sense of the word. The memorial tablets originated for the most part in German or Dutch foundries, as did the enormous brass lecterns with their sculptured Biblical birds, eagles or pelicans. Fine works of art were created in bronze doors with relief decoration. Here it is obvious that metal was the most suitable material for the sculptor.

The Renaissance. *Italy.* Side by side with the famous German metal doors already mentioned, we must consider the masterpieces of the Florentine sculptor, Andrea Pisano, in particular the famous doors of the Baptistry in Florence, which were made in the 1430s. The twenty framed upper panels of the two doors represent in high relief the life of John the Baptist; the eight lower panels carry figures of the eight cardinal virtues. These works served to introduce bronze into Italian arts and Pisano's doors demonstrated its admirable qualities as a medium for sculpture. Famous artists of the early Italian Renaissance such as Lorenzo Ghiberti, Donatello and Andrea Verrochio created their major works in bronze. Italy, in place of Germany, led the whole of Europe in the art of metal casting for many centuries. It was in northern Italy, during the Renaissance, that bronze sculpture reached its zenith. There wealthy patrons, paying homage to the new ideals, gave generous commissions to artists in general and sculptors in particular, which enabled them to produce delightful and hitherto undreamed-of works.

Enormous *equestrian statues*, magnificent bronze *doors* and elaborate *fountains* were prominent features of northern Italian towns during the Renaissance. Free-standing statues of single figures or groups representing Biblical or mythological subjects, portrait busts and magnificent tombs put the works of other European sculptors in the shade. No other country could compare with Italy in the field of artistic bronze work.

In the 15th and particularly in the 16th century, small bronze statues became fashionable; as soon as they appeared, these *statuettes* were in great demand as embellishments for the richly-appointed rooms in which the brilliant society of the Renaissance moved. In contrast to the scarcity of bronze survivals from Gothic times, there are many examples of the work of Renaissance craftsmen. The prosperity of Renaissance society was reflected not only in statuettes but also in household utensils and other objects.

The art of Antiquity provided models and

motifs for the sculptors of statuettes, as for all Renaissance artists and craftsmen, though these of course applied their own inventive genius to the Classical heritage. Figures and scenes from mythology and the Bible were represented in statuettes, and animal forms, especially lions, wolves, horses, bulls and goats, were very frequently rendered. Portrait busts and allegorical figures were also popular. In many cases sculpture formed an integral part in the production of household objects; for example, the bronze *chandeliers* and tall *candelabra*, which played such an important role in ecclesiastical and domestic architecture; the *candlesticks* and small bronze *oil lamps*, which were closely modelled on Roman lamps. These were not only functional objects but also works of art. Writing equipment was imposing and richly decorated in relief; not only the inkwells but also the writing-paper boxes were of cast bronze and embellished with figures and ornamental motifs. To all these beautifully made objects in common use must be added the *andirons* in the hearth and the tall, usually slender *vases*, which stood either on a shelf or on some costly piece of furniture. Mention must also be made of the richly decorated, massive *bowls*, which stood on pedestals in the living-rooms and were probably used as wine coolers. A new piece of equipment in large Renaissance houses, soon to become indispensible, was the metal *hand-bell*, used for summoning the servants. These bells were produced in great numbers, and many examples have survived. The alloy which was used for casting the hand-bells contained a larger proportion of tin than usual, which resulted in a pure and charming ring. As we have seen, the colour of bronze depends on the percentage of tin in the alloy, so it is not surprising that hand-bells were lighter in colour than statuettes and other objects. Sometimes the handle was in the form of a carved figure, and the mantle was often decorated in relief. The coat of arms of the family to whom it belonged was often displayed under an ornamental frieze.

Renaissance *mortars* were decorated in similar taste, often with a frieze running under the upper rim, the sides carved in relief and an ornamental strip surrounding the suggested or actual base. The horizontal line was strongly emphasised by the shape of the vessel, which was broad and shallow. Other characteristics of Renaissance mortars were the sculptured feet and protruding lip. Bands with inscriptions under the rim are found less frequently on Italian mortars than on those from north of the Alps.

The bronze foundries of Venice produced chandeliers, small boxes and dishes which betrayed a strong Moslem influence. The fine, mostly engraved decoration was often enriched with silver inlay. Large bronze ewers and basins are also examples of this work.

Simple kitchen and household articles, which were produced in Italy, differed little in form and decoration from those in current use north of the Alps.

More than other countries, Renaissance Italy used bronze for furniture *mounts*, which were highly decorative as well as functional. The *doorknocker* changed very little from Roman times until the 19th century; it was used on gates and doors of ecclesiastical and domestic buildings and took the form of an animal mask with a ring in its mouth, often made in wrought iron. A new design for a doorknocker was introduced in Renaissance Italy and soon spread to other parts of Europe. This was in the form of a lyre supported by putti or confronted animals, with dolphins, foliage, cornucopias forming the decoration. These doorknockers were a special feature of the towns of northern Italy.

Germany. The bronze foundries of Nuremberg, founded by Hermann Vischer in 1453, were of considerable importance in the development of bronze casting, and continued to be so over a long period. Hermann was succeeded by his son Peter, the foremost German bronze caster, and by his grandsons Hermann, Peter and Hans. Innumerable works of all kinds were produced in this foundry: bronze tablets, tombs, reliefs, free-standing statues, fountains, statuettes, medals, plaquettes, *genre* works, inkwells, etc. The number and variety of small bronzes produced in Germany did not, however, match those of Italy.

The most powerful of all bronze monuments is the unfinished tomb of the Emperor Maximilian in the Hofkirche at Innsbruck, to which many German artists contributed. Work on this magnificent project stopped at the beginning of the 16th century, owing to the early death of the emperor, but we can still admire the over-life-size statues of an-

cestors, saints and busts of the emperor, which all testify to the ambitious plan.

Baroque. In the 17th and 18th centuries, France assumed the leading role in Europe in the art of bronze casting. Many important artists worked in bronze. Their patrons were usually members of the Bourbon ruling family or great court nobles. The brothers David and Antoine Chaligny were unable to complete the equestrian statue of the Duke of Lorraine on account of the war in Europe; David died in 1621 and Antoine lived to achieve a great reputation under the patronage of Louis XIII. An example of the bronze monuments made for the brilliant French court is the portrait bust of Louis XIII by Pierre Biard the younger, commissioned by Richelieu. One of the most famous bronze-smiths of France was the Swiss-born Johann Balthasar Keller who was appointed commissioner general for the fountains of France in 1683. In that capacity he cast a large number of bronze statues which embellish the palace and park of Versailles. During Louis XIV's reign, many magnificent tombs, equestrian monuments, statues and portrait busts, groups of children and mythological figures were produced. The beautifully appointed apartments in the homes of the French nobility set a standard for the upper classes everywhere in Europe. Leading artists such as J.A. Houdon were at one and the same time sculptors and bronze-smiths. The statuettes which, in the 17th and even more markedly in the 18th century, formed part of the splendid interior decoration of aristocratic houses, were often the work of famous artists. In this connection the names of Boulle, Cuavet, P. Caffieri the younger, Gouthière, Torestier, Gobert and Thomire must be mentioned. From the 17th century, France produced wonderful works in *gilt-bronze;* only rarely could comparable works in this medium be found elsewhere. The best, purely sculpturesque examples of the gilt-bronze finish are those which were made from models by Falconet and Claude Michel (called Clodion). Chiselling, which had formerly been used only to finish the cast, now played an important and sometimes the most exacting part in the whole process of production. This new development can be observed most easily in bronzes, for they were produced in great quantities and in hitherto undreamed-of varieties of form and design as show-pieces for interior decoration.

Candelabra and other lighting appliances aroused the special interest of artists, and today we can still admire the many-candled chandeliers, whose warm glow illuminated the luxury and splendour of magnificent apartments. Candelabra, table lamps and chandeliers were artistically designed and decorated with vegetal and figure motifs of the time. Heroes of Antiquity, ancient gods and playful figures of children were very popular as candle-holders. It was the fashion to combine wall *sconces* with a polished metal plate or mirror which reflected the light and enhanced its brilliance. As companion-pieces to the sconces, bronze *consoles* were hung on the walls purely for their decorative effect. Bronze *vases* with their stylised scroll design, frequently combined with French or Chinese porcelain or marble, were also pure show-pieces. In the 18th century, the elaborate *andirons* produced an original and powerful effect in the red glow of the hearth. In the 17th as well as in the 18th century, bronze was the metal preferred for both simple and ornate door and window fittings. The luxurious and imposing furniture of the time also carried richly decorated and often heavy bronze mounts.

In many a Baroque palace, in addition to the magnificent marquetry furniture, there were long-case and bracket clocks in richly decorated cases which are eloquent witnesses to the ornate style of the period. The structure of long-case clocks was modelled in imitation of Classical architecture and its ornament, with symbolic figures and decorative motifs, reflecting the prevailing taste until the mid-19th century.

At the end of the 18th century, under the impetus of Neo-Classicism, darkly patinated bronze became fashionable. Snuff boxes, sugar bowls, small caskets, walking-cane knobs, inkwells and writing equipment were still made in bronze, although the cheaper cast-iron was becoming popular and beginning to supplant bronze as the prevailing metal. In the 18th century, copper also rivalled bronze, and was widely used for domestic utensils; in particular, copper kitchenware was very popular. Stone and chinaware took the place of bronze on the tables of the upper classes and earthenware in the kitchens. Utensils were made of cheaper metals.

Advice to Collectors

When judging iron, copper, bronze and brass objets d'art, it is necessary to pay due attention to the material used and to observe the design, technique employed and style of decoration. The order in which we do this is not important. It is, however, absolutely necessary to establish whether the above factors are in keeping with the taste, style and technical capacity of the period to which the object is said to belong. All information about it should be investigated with this in mind. It is not impossible to determine the date if only one of the factors is known to belong to a given period and the others are not actually inconsistent with it. It is difficult to get the requisite knowledge from specialist literature alone. Theoretical knowledge thus gained must be tested by reference to fully authenticated objects in museums and private collections run by experts. In time, the collector will gain, through application of his theoretical and practical knowledge, so much experience that he will be able to rely on his own judgment. But even when extensive knowledge and years of experience have facilitated the task of judging and dating, it is advisable for the collector, before acquiring each new piece, to look round museums and well-run private collections for other authenticated objects of a similar nature, and where possible to examine them closely; for imitations can deceive even the most expert, and great caution is always necessary.

Alongside his knowledge of genuine works, the collector must also have a knowledge of modern methods of 'faking', in order to protect himself against wrong assertions and false conclusions. Fakes are designed to deceive by giving an impression of antiquity. There are many factories in different parts of the world, set up in the middle of the last century, which specialise in imitating earlier works of art in metal. It would be of advantage to the collector to visit one of these factories and study the processes used. Particular attention should be paid to the technique of decoration. The counterfeiter lays great stress on decoration, as it is this element which catches the eye of the purchaser. The more perfect and sharply defined the detail, the more caution is required. In order to produce a credibly antique appearance, some fakers artificially corrode or patinate the surface of their imitations.

With some experience of collector's pieces in metal, it should not be difficult to recognise the mass-produced, crude imitations, because evidence of hand finishing — such as hammer marks on wrought iron, copper and other metals — is usually lacking. Electrotyped imitations of old bronzes can also be singled out without much difficulty. At the same time, it should not be hard to identify modern 'improvements', for example, the replacement of the original date by an earlier one. When all is said and done, should the collector be offered a 'unique piece' by a clever and experienced forger who is exactly informed about the historical and technical background of the object, the fake is very hard to detect. However, one small hint of suspicion is enough for it to be recognised and exposed. Of course it is usually only the valuable and expensive pieces that are copied.

When buying a bronze, it is always advisable to establish its origin — who owned it before it came on to the market, and so on. If a large sum of money is involved, it is best to seek the advice of an expert, who would probably be able to recommend more searching methods of establishing authenticity.

568 Reliquary in the form of a cross. Opočnice, near Podiebrad (Bohemia), 13th century

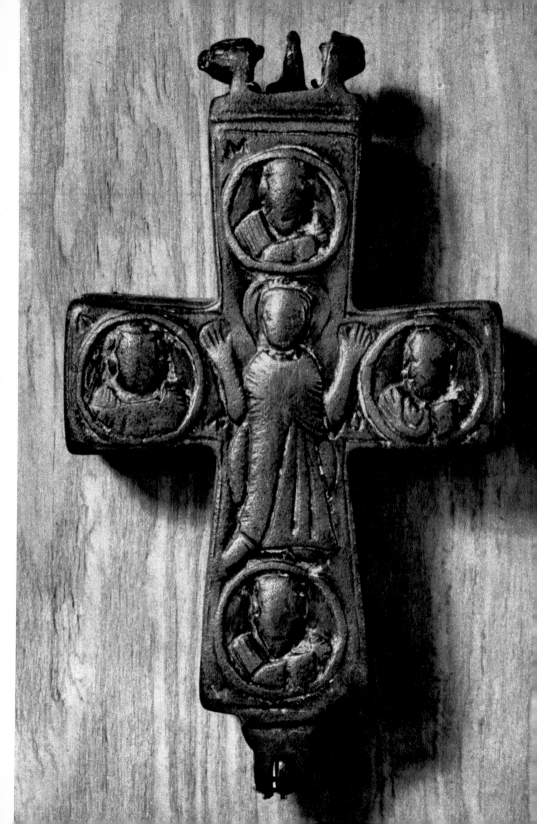

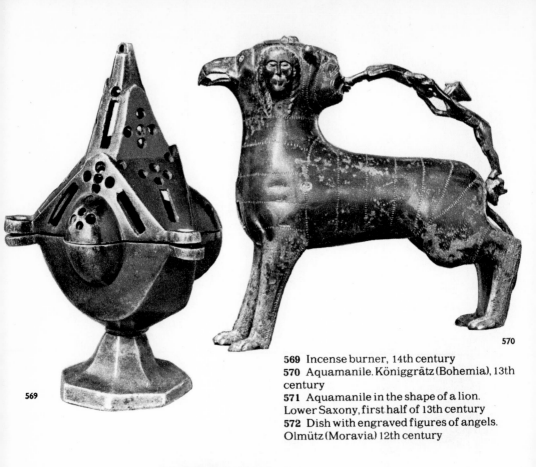

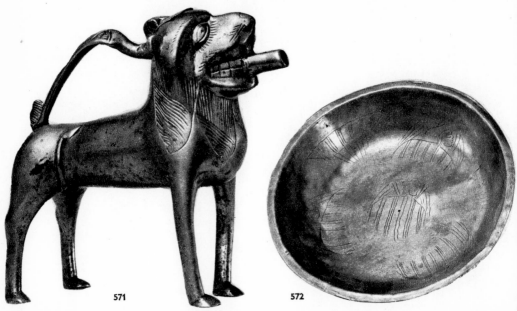

569 Incense burner, 14th century
570 Aquamanile. Königgrätz (Bohemia), 13th century
571 Aquamanile in the shape of a lion. Lower Saxony, first half of 13th century
572 Dish with engraved figures of angels. Olmütz (Moravia) 12th century

569

570

571

572

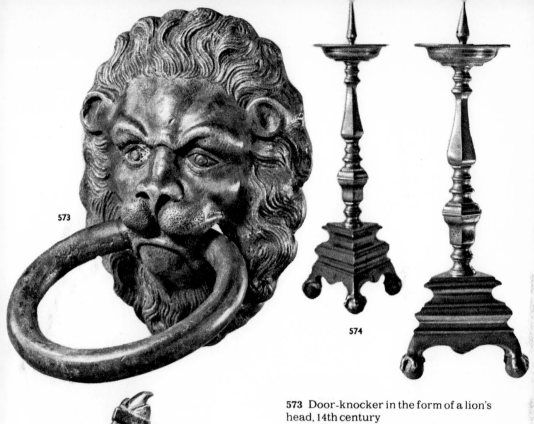

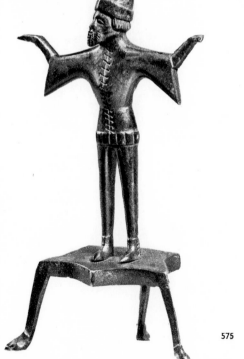

573 Door-knocker in the form of a lion's head, 14th century
574 Two candlesticks. Central Europe, 16th century
575 Candleholder with figure of a man. Flanders (?), 15th century

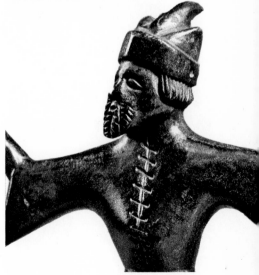

573

574

575

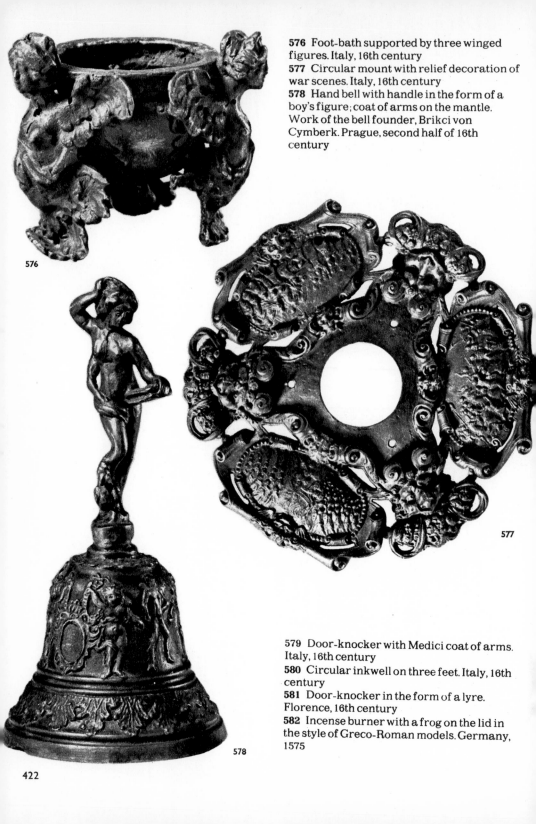

576 Foot-bath supported by three winged figures. Italy, 16th century
577 Circular mount with relief decoration of war scenes. Italy, 16th century
578 Hand bell with handle in the form of a boy's figure; coat of arms on the mantle. Work of the bell founder, Brikci von Cymberk. Prague, second half of 16th century

576

577

579 Door-knocker with Medici coat of arms. Italy, 16th century
580 Circular inkwell on three feet. Italy, 16th century
581 Door-knocker in the form of a lyre. Florence, 16th century
582 Incense burner with a frog on the lid in the style of Greco-Roman models. Germany, 1575

578

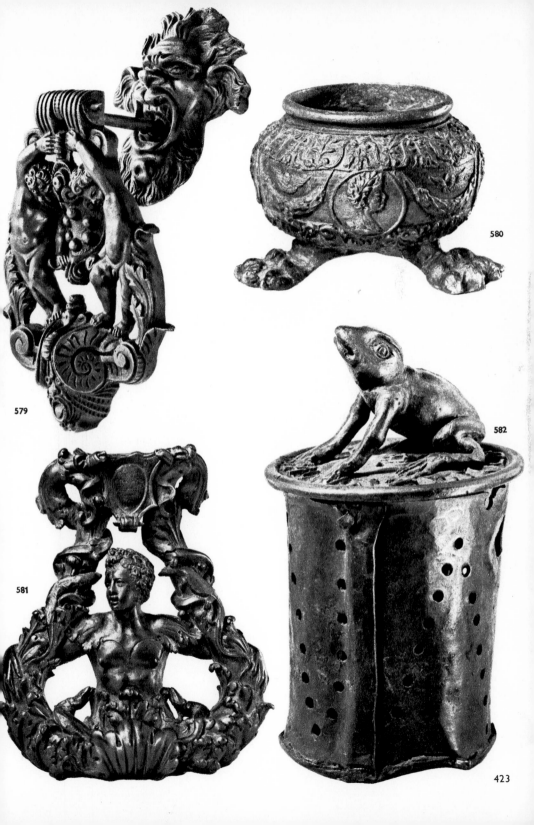

579

580

581

582

423

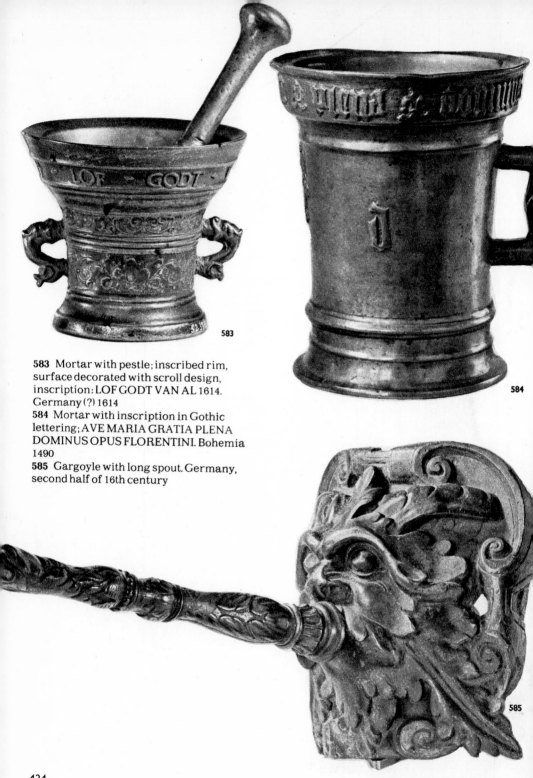

583 Mortar with pestle; inscribed rim, surface decorated with scroll design, inscription: LOF GODT VAN AL 1614. Germany (?) 1614

584 Mortar with inscription in Gothic lettering; AVE MARIA GRATIA PLENA DOMINUS OPUS FLORENTINI. Bohemia 1490

585 Gargoyle with long spout. Germany, second half of 16th century

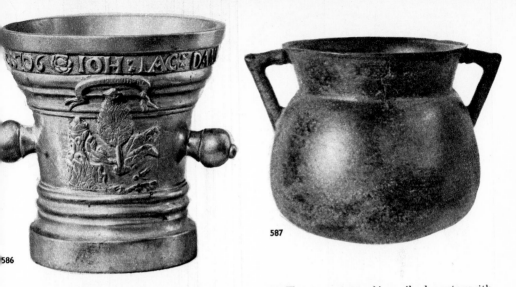

586 Mortar with decoration in relief and inscription: IOH IAC DANNBACH NOTRS CAES. Central Europe, 1706
587 Hanging pot. Flemish, 16th-17th century
588 Bronze saucepan with handle. 17th century

589 Three mortars: a) inscribed mortar with leaf decoration. Florence, 1500: b) mortar with foliage decoration. Italy, 16th century; c) mortar with skittle motif. Central Europe, 15th-16th century

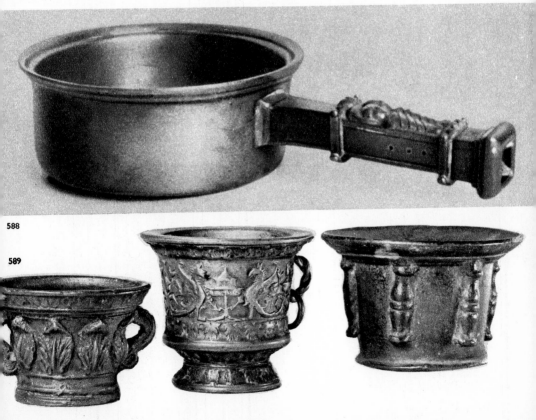

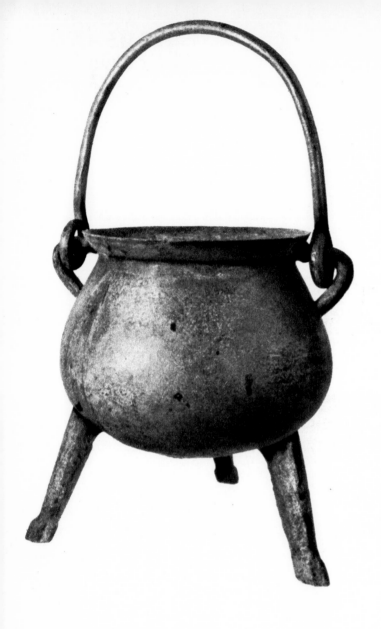

590 Tripod cooking pot; cast-iron. Germany,
17th-18th century

ARMS AND ARMOUR

In the Stone Age, the stone hammer and axe, and later the pike or dart fitted with a stone or a bone point, were the basic tools by means of which man contrived to feed himself, in particular by hunting. From the very earliest times, primitive man also directed these instruments against other members of his own species, in battles between tribes. But only the further development of human society in the Bronze Age led to actual 'weapons', specially fashioned for combat between man and man: the dagger and the sword.

For a long period of history, mankind's arms can be divided into the two main sections which concern us here — arms and armour. Besides hunting and combat weapons, there grew up in the medieval period another type of weapon which we nowadays call a 'sporting' weapon. Progress in the use of weapons led to specialisation and consequent classification according to type. We therefore distinguish between cut and thrust weapons, intended for direct combat between man and man, or for a direct attack on another living creature from close quarters, and shooting weapons and firearms, which are used at a distance.

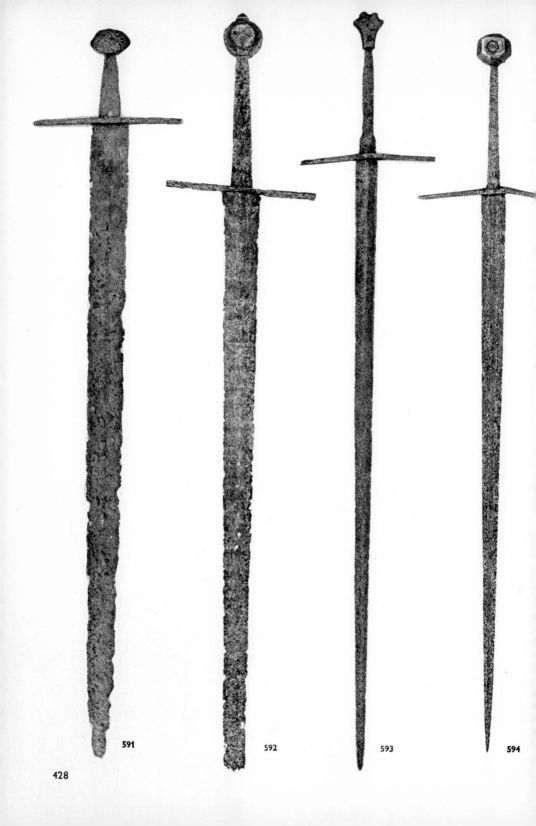

591 592 593 594

1 Romanesque sword with pommel in the shape of a brazil-nut. 11th-12th century
2 Gothic sword with round double-coniform pommel. 14th century
3 Rapier sword with flat pommel. 15th century
4 Gothic rapier sword with octagonal pommel. 14th-15th century

Cut and thrust weapons

To this category belong those weapons which are made from various materials (but specially bronze. iron and steel), used for hunting or in battle, which achieve their object by the cut. stab or thrust.

Within these three groups there is a sub-division into 'handle weapons' which can be wielded with one hand, and in view of the way they are carried are sometimes also known as 'side-arms', and 'staff weapons' in the use of which two hands are needed.

In order that we may proceed in the further examination of these types of weapon with a clear understanding of the terminology, a short account of the individual types of weapons follows:-

1. *Cutting and stabbing weapons*. Short weapons (side-arms, handle weapons), weapons consisting of a blade. cross-piece (mostly basket-shaped), hilt and pommel. The sword, the dussak, the pallash and the sabre are cutting weapons. the poniard and the dagger are stabbing weapons.

Staff weapons — that is, weapons in which the part used for cutting or stabbing is attached to a wooden pole of varying length — mostly intended to be wielded with both hands. An example of a cutting weapon is the axe, and examples of stabbing weapons include the pike or spear. Combined functions — that is, cutting and stabbing — are possible with the halberd, the partisan, the glaive, the runca and other varieties.

2. *Striking and thrusting weapons*. Combat weapons, with which the desired effect is achieved by thrusting or striking can also be divided into short and staff weapons. Short weapons of this type are the club, the bludgeon and the pole-axe. Staff weapons resemble those previously referred to, differing from them only in their length of stock. To these also belong other, mostly national, types such as the flail and the morning star.

The history of cut and thrust weapons.

The earliest cut and thrust weapons were made in the Bronze Age, for only with the advent of metal was it possible for weapons to assume their characteristic form. The bronze sword with a straight or tongue-shaped blade and a simple or shaped handle was cast all in one piece. Only a connoisseur can distinguish the details and characteristic forms which indicate the origin and age of individual examples. As with all ancient weapons, the collector cannot get by without the aid of specialist writings.

In the early Iron Age (known as the Hallstatt period) bronze swords remained in use. It was not until the second half of the 1st century BC that iron swords appeared; but thereafter iron rapidly superseded bronze as the material for weapons of all kinds.

Somewhat older than the sword is the dagger, which in the Bronze Age had quite a broad triangular blade. Even in Antiquity there were weapons with a curved blade, such as the ancient Greek machaira and the Roman curved sword (*ensis falcatus*). The relative ease with which bronze could be worked made it possible for craftsmen to produce quite advanced forms of the axe. The equipment of Greek and Roman soldiers also included the lance and the javelin, the bronze heads of which were also even-

tually replaced by iron ones. The lance and spear of this period, and the first few centuries AD, can be recognised by the narrow socket and long, leaf-shaped point with a central rib.

The Middle Ages. There are three basic types of cut and thrust weapon which are characteristic of the early Middle Ages in Europe: the sword, the battle-axe and the pike or spear. The oldest forms of medieval side-arms vary a great deal. The Sax, of very ancient origin, is often shaped like a short sword with a two-edged, tongue-shaped blade. Other examples have a one-edged blade with quite a marked curve, and the most important form, known as the scrama-sax, is straight but one-edged. In the 7th century, what were known as Viking swords appeared; from the 8th to the 10th century they were used almost everywhere in Europe, from England to Russia.

There was a great variety of types. The pommel and the cross-guard, and even the hilt on a few exceptional examples, are richly decorated with inlaid and applied gold, silver, copper and brass, often in most varies and beautiful colour combinations. The swords of this period were valuable cavalry weapons, whereas the battle-axe was the typical infantry weapon. Lance heads are relatively narrow, but are of considerable length, and often, before inserting into the socket, have a horizontal spur that projects at right angles. The cavalry of the Avars, and later the Magyars, carried the curved sabre into central Europe; finds have been made on a number of sites. But curved sabres quickly disappeared again, and in the following two centuries (11th and 12th), the commonest type of sword had a pommel shaped like a Brazil nut. The cross-guard mostly took the form of a narrow rectangle which varied between 7 to 9 in. (18 to 23 cm.) long. On these swords, the old type of ornamentation still appears, in the form of a covering of silver and coloured metals in beautiful combinations. On the blade there are inscriptions, mostly religious in meaning, often abbreviated or rendered by symbols. In the course of the 11th century the old pointed type of pike with wings disappeared, although the basic shape of the pike did not change greatly. As early as the 12th century a difference appeared between the short cavalry lance and the infantry pike. Battle-axes were made in a

great variety of shapes. In addition to the ancient types which were still in existence, the axe with a bow-shaped blade emerged. This owed its characteristic shape to an incision in the leaf, behind the cutting edge. There were other axes which resembled the broad axe of the carpenter.

Throughout the Middle Ages the sword remained the principal weapon for close combat. However, in the 13th and 14th centuries changes in function as well as shape were made. In the 13th century there were a few individual examples, and in ensuing centuries ever-increasing numbers, of swords which were made without their distinguishing cutting characteristic. The blade remained two-edged and of a considerable width narrowing into a slim sharp point, and was thus designed to thrust rather than to cut. Thus the rapier was evolved. The hilt, which up till then had been very short, was lengthened considerably from the end of the 13th century, so that the 'hand-and-a-half' appeared. Even the shape of the pommel altered noticeably. Up to the middle of the 13th century it still retained the familiar Brazil nut shape, but then quite new shapes appeared. The most important was the round pommel, which became the basis for nearly all further developments in shape during the 14th and the first half of the 15th century. Finally, a flat pommel was evolved which, in rare examples, has a coloured metal inlay, a symbol or an inscription generally of a religious nature. In the 14th century the sword cutler (sword smith) began to evolve new shapes, first by introducing flutings along the edge, and later by thickening the spine of the blade on both sides so that eventually a double coniform shape emerged. The surface of the pommel was then decorated with ornament in relief, which often bore a symbol either impressed or inlaid in coloured metal. From the round pommel it was only a step to the elliptical form; and from this, at the end of the 14th century, the octagonal form developed. There were also, however, quite new shapes: a double-pyramid-shaped stump attached vertically to the end of the angle, a pommel of polygonal form, and many others.

In the cross-guard the hitherto rectangular form changed; it was usually curved in a bow shape from the blade outwards. Not infrequently, the end of the bow-shaped cross-guard broadened out into a flat form.

Among side-arms, the dagger in particular was more widely used. Extant Gothic daggers are valuable decorative pieces which have found homes in the most famous collections in the world, but we can get a better idea of their great variety of form from paintings. The medieval dussak with a straight one-edged blade, in various lenghts (14 to 28 in., 35 to 70 cm.) occasionally appears on the market and can be acquired by the collector. These weapons generally had a cylindrical hilt ending in a bow-shaped iron guard. The cross-guard was mostly absent or was barely suggested, so that it only slightly exceeded the width of the blade.

Lance tips, too, were made with different forms in the 13th and 14th centuries. As well as the old leaf-shaped type with a rib, there also appeared cavalry lances with narrow four-cornered tips which went straight into the socket, and pikes with very short points resembling two pyramids joined together. At this time many staff weapons began to be made (halberds, glaives, etc.). Original 14th-century examples are very rare, and the essential development of these weapons did not occur until the following centuries.

The thrusting sword acquired a special character at the end of the 15th century, when what is now known as the rapier, with a three- or four-sided blade, appeared. A major change was in the form of the cross-guard, which was now S-shaped, curving gracefully out from the shaft. It was also flatter. Besides the previous types there now appeared the pear-shaped pommel, the shallow form of pommel opening out like the upper half of the ball-shaped pommel. Other new types of cutting weapons date from the middle of the 15th century. Among the side-arms is the sabre, which developed in central Europe, obviously under eastern European influence (Hungary, Poland). It is distinguishable from previous swords only by its curved blade. Another cutting weapon, the two-handed sword, was intended for the infantry. As a foot-soldier's weapon this two-handed sword was mainly used around 1600. The oldest examples, which date from the Gothic period, have a straight blade, lozenge-shaped in section; on later pieces there is a two-edged hook below the cross-guard, designed to intercept the opponent's blade. In the 16th century there also appeared watered (damascened) blades and a few examples of rapier. In the oldest examples of

these, the cross-guard is generally straight, with a round or rectangular cross-section, and often has balls or acorns on the end. Later the shapes became more complicated; they are bow-shaped, and are often finished with figure-of-eight guard rings.

In the way in which they were wielded, two handlers resembled staff weapons, the importance of which increased with that of the infantry on the battlefields of the 15th century. The halberd, which had previously developed away from the axe shape into a point (the Swabian-Swiss type), now acquired its typical form: The point was separated from the axe. This form was already distinctive, in the 14th century, in a few varieties of the Czech halberd.

In the 15th century, striking weapons became particularly important. In combat clubs, six or more trapezoid blades are attached in a circle around the cylindrical socket, into which, in the late 14th and early 15th centuries, a wooden handle was inserted. Later the socket was lengthened into a cylindrical iron helve, often decorated with relief work, most frequently with ornamental hoops. In about 1500 the blades were shaped in section. Another type is the fist combat hammer, the handle of which is shaped like a human hand holding a hammer in the clenched fist.

Another staff weapon was the combat hammer, usually topped with a spike. There were many interesting military developments in 15th-century Europe, especially central and eastern Europe, and most notably in the organisation and weapons of the Hussite armies. Thus combat flails, clubs and different varieties of the morning star were found to be effective. The combat flail became part of the equipment of the armies of some German states, especially those near Bohemia, as did the morning star, which in German literature is often referred to as 'the star of Zizka' (the great Hussite general). This consisted of a spherical or knobbed head mounted with sharp spikes.

The 16th and 17th centuries. Gradually the heavy cutting sword proper ceased to be the most important weapon, although some of the new forms of this weapon were developed. To these, for example, belongs the short sword (skirmisher) of the foot-soldier. Among the cutting weapons, the curved sabre acquired great importance in central

Europe. However, in this period the leading role was played by stabbing weapons, principally the rapier, which then assumed its most distinctive form. Another development was the use of the basket to protect the hand. Around 1600 the cross-guard assumed at first a simple curve and later an elegant combination of curves. These extended, spiralling up to the base of the basket. Immediately below the cross-guard, a short flat piece of metal (ricasso) covered the blade. The basket was a kind of cage around the handle to protect the hand. It could be formed by an extension of the cross-guard which curved upwards in an arc; the basket arose from a pair of clasps around the blade above the cross-guard. The classical form of the basket in the Renaissance period was achieved by the addition of a further pair of clasps above the cross-guard. The 'basket' then consisted basically of an S-shape, joined at the top to the pommel, at the centre to the ring clasps and at the base to the cross-guard. Modern collectors call this a 'swept hilt'. In these cases the outer side of the basket is as a rule more lavishly worked than the inner side. Complete protection of the hand was achieved by a sword or falchion of northern Italian origin, known as the schiavona, which quickly spread to central Europe. The basket of the schiavona was always fashioned from diagonally crossing straps, mostly shaped rather than flat in section, protecting the hand from both sides. Campanulate swords, which originated in Spain and spread to Italy, are fitted under the simple knuckle-guard with round bowl-shaped or bell-shaped plates, mostly with ornamental perforations known as cup or dish-hilts. Generally only a simple hoop actually shield the hand. In show-pieces the makers increased the artistic effect by covering the bowl and pommel with elaborate carved decoration. Often we find reliefs of plant or animal motifs and medallions showing scenes with figures. Often the iron is inlaid with a plant ornament in silver wire, or some parts are gilded.

In weapons of Spanish origin there are often engravings or reliefs of mauresques or arabesques. Spanish sword cutlers achieved a special effect by perforating the upper part of the blade. On Italian and central European blades engraved or chased and gilded ornamental decoration appeared, and towards the end of the period figure compositions were also employed.

Simple forms occured, on the other hand, in military weapons, in which ornament was entirely lacking and efficacy in actual use was all that mattered. A few surviving Hungarian and Polish types of sabre had a simple straight cross-guard with a hilt ending in a plain iron cap. In many central European types of sabre, baskets were constructed from parallel strips, which are very similar to the schiavona. On weapons from the Eastern, frontier area of Austria and Hungary baskets were in the form of a leaf which extended out from the cross-guard and stretched in an arc inwards again towards the flat, rectangular pommel.

During the Renaissance there were a particularly large number of daggers. The blades are mostly lozenge-shaped in section, but can also be flat and wide. The short cross-guard usually curves towards the blade in an arc, in order to trap the opponent's blade. Cross-guards and pommels carry similar ornamentation to that of the rapier. Two types of dagger differ from the rest in shape. The most important is the fencing dagger (known as the 'left-hander' because it was held in the left hand, with the rapier in the right). This had a three-cornered curved basket developing from a straight and longish cross-guard; this basket is often decorated with incised ornament. The broad Italian dagger, known as the cinquedea (ox-tongue), has a flat, double-edged triangular blade. The faces are elaborately etched and gilded with narrative scenes, medallions and coats of arms. The typical handle of the cinquedea recalls a violin in shape, and is often made of ivory. Short clubs and hammers no longer played an important part in the 17th century. Here and there, indeed, combat clubs and combat hammers were still used, but as symbols of authority rather than effective weapons. On the other hand, this was the heyday of staff weapons. A characteristic feature in the development of the halberd was more than anything else the lengthening of the points, which in the second half of the 17th century grew to up to 20 in. (50 cm.) long. The shape of the axe, simple until now, changed. At the beginning of the 16th century the cutting edge acquired a slanting direction; later it went inwards in an arc. The blade was often perforated, and blade and hook were elaborately shaped. Partisans (long-handled spears) became more elaborate too, their tongue-shaped point being curved in sec-

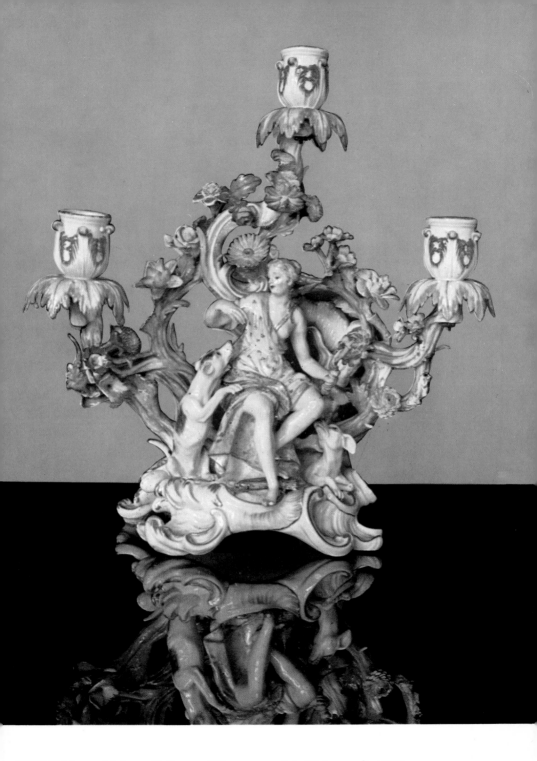

LXIII Table candelabra with figure of Diana: porcelain, Meissen, after 1750

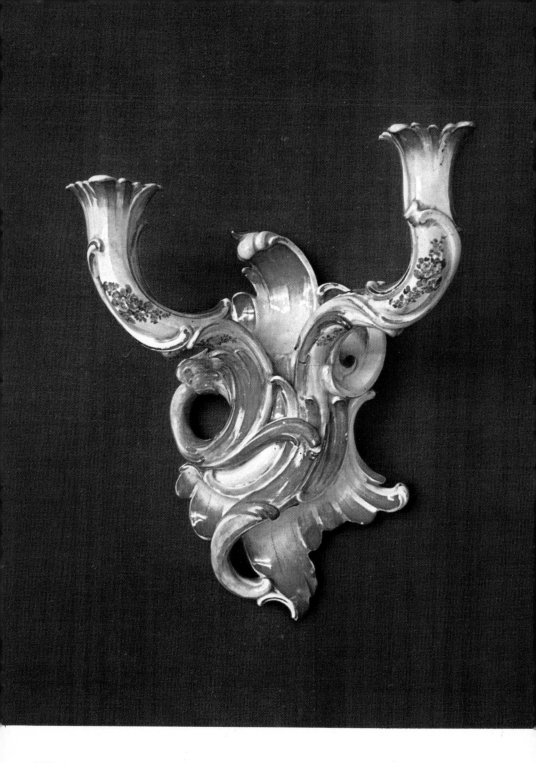

LXIV Wall candelabra: porcelain. Vienna, *c.* 1755

tion. Similar alterations in form also occurred in other types of staff weapons used for cutting and thrusting. The weapons of guards at the European courts were of course different from the usual army equipment. They were richly decorated with ornamental and figure motifs and with the monarchs' initials or mottoes.

Arms makers. In the course of the 17th century, cut and thrust weapons largely ceased to be the products of individual craftsmen. Military weapons of each European state became standardised and were produced in large quantities.

The makers of late medieval weapons were in most cases anonymous. It is even questionable whether the names which often occur in the inscriptions on the blades of swords (for example, ULFBERT) should be interpreted as the makers'. In any case, marks are often found here and there on weapons which obviously represent a certain provenance. To these belongs, for example, the 'Wolf of Passau'. This sign, in the form of a linear, stylised running beast, is generally inlaid with brass or copper wire, and indicates the soutern German centre of blade production. Later examples are combined with other identifying signs, such as those of Solingen.

In the Renaissance period, arms makers emerged from their anonymity. Italian, Spanish and later also German craft masters signed their products, at first with monograms or pictorial signs, but later with their full names. Thus as well as production centres, families and individuals became known. One centre of this type was Toledo, where the most important families worked: Aguirro, Hernandez, Martinez, Ruiz, Sahagun and others. In northern Italy a similar centre was Milan, where the Piccinino family was especially well known, though there were also numerous individual makers of some importance. Well known sword cutlers also worked in other Italian centres, especially in and around Brescia. The Genoese mark — a jagged half-moon — was even copied by sword cutlers in other parts of Europe. In Germany, Passau and Solingen were the principal centres of sword manufacture.

18th- and 19th-century weapons. In the second half of the 17th century — when armies became the most important single state body — particular types of arms were produced identically and in large numbers. From the beginning of the 18th century it is possible to distinguish two types of army sword, the falchion, a broad, curved convex-edged sword and the sabre. A characteristic civilian weapon down to the 19th century was the relatively light nobleman's sword which had remained unaltered in form from the 17th century; such swords can be differentiated only by their ornamentation. The shape of the basket is very simple, with the typical round pommel and the bow-shaped knuckle-guard; the transition from blade to hilt is made by a cross piece which has downward-curving scrolls on both sides. The basket is separated from the blade by an oval, round or double kidney-shaped curved protective sheet.

Ornamental and figure motifs are engraved on the blade, which is two-edged lozenge-shaped, or triangular in section. The Rococo sword differs from the Baroque example only in its decoration. Towards the end of the 18th century both basket and pommel were lengthened greatly; and in the 1770s side by side with brass baskets, baskets made of beaten steel appeared. These could either be very simple or lavishly ornamented with metal rivets with facetted heads like polished diamonds.

Handles of painted porcelain have also survived from this period. During the Empire, along with the classical swords, the light Empire sabres were made. They had a metal basket and a flat wooden handle. By the beginning of the 19th century the period of individually designed side-arms came to an end, even in civil life.

Military models (18th-20th centuries). Military side-arms can be roughly divided into three groups according to the nature of the blade: the sword, carried by officers, army officials, technicians and doctors; the pallash, the principal weapon of the heavy cavalry units, which by the middle of the 19th century had disappeared from the army equipment and was used thereafter only in the French cavalry; and the sabre, used by light cavalry units and also, with a much shorter blade, by the infantry. Pioneer units and the infantry of a few states were equipped with short knives of the hedging-bill type, with broad straight blades. Even staff

weapons continued to be used. There were then two varieties of these — spontoons and halberds, which in the first half of the 18th century were still used by officers and non-commissioned officers of nearly all armies, and the lances of the Uhlans, which along with Cossack pikes were still in use in World War I. In Poland, the country of the Uhlans, lances were still in use at the beginning of World War II, and were part of cavalry equipment. Bayonets form an independent group. The most ancient type, from the late 17th century, has a characteristic round wooden handle (the plug bayonet). Later the bayonet was used for a long time with a cylindrical end piece on the barrel (the socket bayonet). The last phase of development was the bayonet with a normal handle attached at the side or below the rifle barrel (the sword bayonet). This last type appeared at the beginning of the 19th century, but it was not properly developed until the middle of the century.

A thorough acquaintance with bare side-arms of the 18th to the 20th centuries necessitates:

1. Making oneself familiar with the different types of sabre, sword, pallash and hedging-bill knife in the equipment of individual armies, and studying the development of every one.

2. Investigating reciprocal influences in the construction of cut and thrust weapons from one country to another.

3. Realising that the pallash was part of the equipment of heavy cavalry units of all countries; that short weapons with saw teeth on the backs of the blades belonged to pioneer units; that the hussar sabre, which was principally used by hussar units of the Habsburg armies, appeared in many forms in other armies, with a characteristically simple basket with a strikingly long, guard-plate... and so on...

Abundant help in judging the origin and age of weapons can be obtained by studying the signs they carry.

These are: the monogram of the craft master, which is either engraved on the blade or included directly in the ornamentation of the basket; various inscriptions on the surfaces of the blade; manufacturer's marks; and augmentation signs. (Old Prussian weapons, for example, bear on the blade the inscription POTSDAM, and on newer ones the name of one of the blade manufacturers of Solingen appears regularly.) Prussian weapons, especially those of the second half of the 19th century, also bore imprinted initials and figures which give the number and troop attachment of the regiment as well as the unit's command and the number of the weapon itself. On English weapons we find the trademark of the well known firm of Wilkinson, and on Russian weapons, as well as Cyrillic letters indicating the destination, we also find the marks of the great Russian production centre at Slatoust.

Germany. The basic type of German side arm is the sabre, with the characteristic S-shaped knuckle guard. The first weapon of this type was known as the Blücher sabre, officially designated as Prussian cavalry sabre M 1811. It was derived from the English light cavalry sabre of 1796, the weapon which became famous in the battles fought by the English armies against Napoleon. Immediately after the Blücher sabre came the Prussian artillery sabre M 1848, which was still used in 1864-6, as well as the Uhlen's sabre M 1873. The Prussian officer's sabre M 1889 and others had a similar form of basket. A similar type was used for a short time also in the equipment of the Austrian army in the years 1837-54.

Three of the best known types from the middle of the 18th century must be mentioned here. The first is the pallash of the Prussian cuirassiers M 1732 with a basket richly ornamented with the Prussian eagle in relief. Similar to it is the Prussian dragoon pallash M 1735 which remained in use in the Prussian cavalry right down to the Napoleonic wars; the pommel is in the form of an eagle's hand. The third weapon, used by the Prussian infantry for almost the whole of the 18th century, is a sabre with a brass basket with a heart-shaped guard. On Prussian sabres the monogram FR is mostly inscribed, and on similar Russian ones, E. II (Ekaterina II). Further examples which should be mentioned are the Prussian cavalry sabre M 1852 and the infantry officer's sword 89.

France. Collectors mainly concentrate on the sabres and pallashes from the Napoleonic period. These are the cuirassier pallash M AN XI (1802-3) with three branches on the back, which served as a model for the M 1854 pallash of ther German officers of

cuirassier units, and also the French light cavalry sabre M AN XI (1800), on which was based the Russian cavalry units' sabre produced by the well known Russian manufactory at Slatoust. No less famous are the carabinier sabres of 1794, 1810 and 1815, and the heavy cavalry pallash M 1854, both types having a three-branched basket of brass. Basic and characteristic features of the French sabre are the arc-shaped guard-plates and the brass basket. On the back of the blade there is usually engraved not only the year of production but also the sign of the production centre (Klingenthal), and later also the regiment to whose armoury the sabre or pallash belonged.

Austria. A characteristic cavalry weapon of the Austrian army of the 18th century was a pallash with a simple brass basket for officers, and a pallash with an iron basket with a shell-shaped guard plate for other ranks.

For the period 1769-1945 typical weapons were a pallash with a flat guard-plate perforated round the edges, and a short infantry sabre with a simple brass basket. The high-ranking officer's sabre has a stylised lion's head on the top of the hilt. The Austrian infantry sabre has a hand-guard with an undulating rather than simple curve. This type was introduced for the first time in 1862 and remained in use, with a few small alterations, up to the end of World War I.

In the arms and armour collections we find a very large number of cavalry sabres among the Austrian weapons with a characteristic leaf basket manufactured from various sorts of perforated and incised sheet metal. The different types can be distinguished according to the nature of these perforations. This series introduces the Austrian cavalry sabre M 1845. In the Danish war of 1864 and in the Austro-Prussian war of 1866 the Austrian cavalry was armed with the M 1861 sabre, which is distinguished from the above-mentioned type by the geometrical cuts in the basket. The final example of this type is the cavalry sabre M 1904 which has an asymmetrical, leaf-shaped basket which is perforated for rank and file, and lavishly pierced for officers.

Russia. The development of side-arms in Russia has no independent significance, fashion, practical good sense or diplomacy determining which foreign weapons the Russians should imitate. Certain elements of Prussian weapons were taken over, later the influence of French and Austrian designs made itself felt. One exception is the characteristic Cossack sabre type 1851, 1898 and 1918.

Shooting weapons and firearms

Mechanical shooting weapons. For many centuries men have striven to invent means by which to strike targets — in hunting or battle — from a greater distance. Thus developed shooting weapons, which derived the energy necessary to impell an offensive object from either the action of the human hand (the sling) or the stretching of an elastic substance (the bow). Both types of weapon were in fact used until recent centuries, but very few indeed have survived.

The development of the cross-bow began in the 11th century, from which time it gradually came into use all over Europe. For most of its history the cross-bow was made of layers of wood, horn or fish bones stuck together; the upper surface was also covered with bone. Steel bows appeared shortly before the middle of the 15th century. The bow of the cross-bow was attached to the end of the stock, in the centre of which was what is known as a nut, with an incision: the string, made of twist from fine hempen thread, was placed in this for stretching. In shooting, a simple lever mechanism released the nut which turned, and the string thus set the bolt in motion. The oldest surviving cross-bows date from the 15th century, and have a long, relatively narrow, simple carved stock inlaid with bone. In cross-bows of the Renaissance period the stock was usually shorter and tougher, and strengthened in the middle. It was lavishly decorated with bone inlays representing hunting and mythological scenes. In hunting and sporting cross-bows of a later date, the stock made accurate shooting possible; it resembled the butt of the contemporary hand-gun. The oldest cross-bows were stretched by a movement of the whole body, the foot holding the frame

which was joined to the middle of the bow. But soon mechanical devices were invented for stretching the string: among the best known is the German windas. Renaissance windas were richly ornamented with engraving or chasing. Another type used especially with large cross-bows was the English windas, which used a block and pulley system to stretch the string.

Hand fire-arms. Fire-arms, by means of which a projectile can be shot from a metal barrel through the energy resulting from the combustion of gunpowder, were first used in the early 14th century. Although gunpowder was known much earlier — in Europe at latest in the 13th century — the oldest incontestable evidence of the existence of fire-arms is a miniature dated 1326, in the Bodleian Library in Oxford in the manuscript *De Officiis Regum*. What however is still open to question is whether artillery or hand-guns developed first. Evidence from the middle of the 14th century indicates that a differentiation between these two categories already existed, and reliable documents somewhat later point to the existence of hand fire-arms.

Medieval artillery weapons are extremely rare, and only the latest examples should be collected, whatever their size.

Production and development. The majority of medieval hand fire-arms were made of bronze. Technological expertise in the gun manufacturing foundries of central Europe was considerable. Medieval gunsmiths, who were able to cast cannon weighing several tons, could work with equal success on small objects, though with a somewhat different casting method. For the smelting of large quantities of metal for cannon barrels, pit furnaces were used, but for the manufacture of hand fire-arms — for example in Bratislava in the 1440s — crucible furnaces were satisfactory. Iron weapons were forged; cast iron cannon barrels from the 15th century are extremely rare.

Construction of the barrel of hand fire-arms was simple. An iron piece of appropriate size and strength was twisted around a mandrel, and the join was then soldered with a hammer. The polygonal or cylindrical shape of the exterior was achieved by drop-forging in an appropriate form. Both of these techniques in weapon manufacture existed side-by-side throughout the 15th century. From the second half of the 15th century the manufacture of iron cannon barrels gradually ceased, but iron ousted other metals for hand fire-arms. At this same time a distinction began to be made between the producers of cannon barrels, the gun master craftsmen, and the manufacturers of hand fire-arms, gun manufacturers. The production of fire-arms was not, from the beginning, an organised craft; individual gun craftsmen entered into the service of organisations (such as the cities) or individuals. Craftsmen working alone, dependent neither on the cities nor on one master, were not found until the 15th century. In the middle of this century there was also a large trade in fire-arms, especially hand fire-arms. In the second half of the 15th century in Nuremberg, the beginnings of mass-production of hand fire-arms for the open market began. The development of other production centres, such as Suhl, only started in the following centuries.

In Germany outstanding gunsmiths were already working from the 16th century onwards, especially in Augsburg, Nuremberg, Suhl and Solingen. Although their names are for the most part unknown, we still recognise the products of these centres by their well-known proof marks, which are mostly stylised representations of the city arms. There was already mass-production of hand fire-arms from the 16th century in Essen (lasting until the end of the Napoleonic wars) and also in Suhl and Nuremberg. In Prussia, army weapons were produced in Potsdam; in Saxe-Gotha in the towns of Zella-Mehlis and Olbernhau. Hanover produced military weapons in Herzberg; Hessen in Schmalkalden; Bavaria in Amberg; and Württenberg in Olbersdorf.

A country famous for its arms smiths was Italy, where arms were produced principally in the neighbourhood of Brescia. The products of the Cominazzo family of gunsmiths established in Gardone were to be found throughout Europe for two centuries, and can nowadays be seen in many museums and private collections. First-rate gunsmiths also worked in Milan and Florence.

A very high standard was also reached by the products of the gunsmiths of Amsterdam, Rotterdam, Utrecht and Maastricht in the Netherlands, and of Moscow and Tula in Russia. In France, gunsmiths operated in Paris and other cities; military weapons

were produced in the manufactories at St Étienne, Charleville, Maubeuge, and later Versailles and Metz. On of the largest production centres, especially of barrels, was Liège.

In England, military and sporting weapons were manufactured in London and Birmingham. In Bohemia the production of shooting weapons was at first concentrated in Beroun and Cheb, and later in Prague, Karlovy Vary and in north-eastern Bohemia. In Austria these weapons were produced mainly in Ferlach, Wiener Neustadt, Vienna and Steyr.

The history of hand fire-arms. The oldest surviving hand fire-arms can be dated to around 1350. From this period, for example, comes a bronze weapon (from the collection of Pobezovice Castle, Western Bohemia), which is at present in the fortress at Helfstejn in northern Moravia. It is a simple cylindrical barrel, reinforced with three shaped hoops, which is provided with a socket at the back to receive the stock. Almost exactly the same, even to the details, is a gun from the old Berlin Zeughaus collection, which dates from the same period. The famous example of a bronze hand gun, found in 1849 buried in the ruins of the Tannenberg fortress, dates from the late 14th century. Tannenberg fortress was taken and destroyed in 1399, so the gun must have been made before then. The octagonal barrel, with a narrow powder chamber considerably reinforced on the outer side, also has a socket to receive the stock. In European arms collections there are numerous bronze hand-guns which are identical in shape with the Tannenberg one. Iron weapons, with short, generally polygonal (sexagonal or octagonal) barrels, are to be found in the Historical Museum at Berne, the National Museum in Prague, and elsewhere. These were placed in butts and fastened with iron hoops, most examples of which turned into a projecting hook on the underside, thus anticipating the transformation of this type of weapon into the hooked arquebus.

The Hussite wars provided conditions for regular and relatively lengthy tactical use of hand fire-arms. As well as the division of fire-arms into hand and artillery weapons, which was at that time already well-established, there also grew up a specialisation within the basic types of hand fire-arms. A light hand gun was made that could for the first time be wielded by a single person (in Czech, the pišťala = pipe). In the Hussite town of Tabor an example of this type was found which had a short, mainly cylindrical butt with a socket for the stock. From the hand gun equipped with a hook there developed a further heavy type, the hook arquebus, which was intended for shooting from a static position. The hook became an essential part of the butted weapon, either with a stock in the socket or with a shaft which gradually changed into a much divided butt.

This then made precise aiming possible, and so there then developed the crude aiming sight and later the visier. A first attempt to develop fire-arms for cavalry as well was the petronel, a short gun with an iron shaft.

In the development of the shape of these weapons, late Gothic influence was felt in the second half of the 15th century, lending elegance to what had hitherto been quite primitive pieces. In the middle of the 15th century success was first achieved in attempts to fire the projectiles mechanically. Tinder-locks and match-locks were made, at first with a simple lever cock (illustrated for the first time on a miniature probably made in 1411). This mechanism allowed the gunner, who could handle the weapon alone, to aim when shooting. An intermediate type from the end of the 15th century is a lock with a button trigger on a lightweight hooked arquebus (a 'half-hook') in the collections at the Plzeň Museum. Around 1500 the lock was completed by a spring which transferred to the cock the pressure on the trigger, and in the match lock the mechanism had already (between 1510 and 1520) been attached to the inner side of the lock plate.

The match lock. The first mechanical shooting device for fire-arms, the match lock, was made in the second half of the 15th century, and was used in Europe until the end of the 17th century.

During this time a whole series of developments took place affecting the form of the mechanism, the character of the butt, and (very markedly) the qualities of the barrel. The very primitive lock which released the tinder holder by pressure on an outer spring, and the heavy, clumsy, straight butt, were characteristic infantry weapons around 1500. By the second half of the 16th

century there were already muskets whose butts allowed the weapon to be leant firmly on the shoulder. Characteristic of the central European type was a flat shaft tip, broadening at the end, and in the neck of the butt there was also a piece on which the thumb was supported. The trigger was like a long lever. In order to be able to handle muskets more easily in the field, the gunner carried with him a fourquette, a long stick with a fork at the end in which he rested the gun before firing. During the Thirty Years' War the large trigger lever was replaced by a small lever which the trigger guard bow protected from damage and accidental manipulation. This improved type of musket was used until the end of the 17th century. Asian weapons, especially those of Chinese and Japanese origin, had tinder locks in the middle of the 16th century.

The wheel lock. This is a somewhat later type and was used throughout the 16th and 17th centuries side by side with the match lock, and in the first half of the 18th century even side by side with the flint lock.

It did service, therefore, for two centuries. In determining the date of the weapon, generally the only clue — if it is not marked by a known manufacturer — is the decoration of the butt, the mounting and the lock plate. An independent type of wheel lock is found in the lightweight hunting guns known as Tschinkes (or Teschinger or Teschner guns, after Cieszyn, the place of production in Silesia). These resemble the Italian wheel lock, which is distinguishable by the covered, external mechanism, but differs from it in the divided shape of the lock plate, which is fitted to the typically short, bent butt shaft. These Tschinkes are very rare and are always among the show-pieces of an exhibition.

The place of manufacture of a gun can be identified from its type and shape. French and Spanish butts, with their shoulder supports, have a characteristic appearance. The most widely distributed form is the 'German butt', straight in shape, with shaft cheek pieces and a latticed trigger bow, mostly with a bullet box in the shaft.

A characteristic decoration on hunting weapons of the 16th and 17th centuries consists of rich bone and mother-of-pearl inlays in the butts, and rich engravings and carvings on the mounts and lock plates.

The wheel lock made possible the development of the cavalry pistol. In the oldest pistols the handle of the butt is heavily hollowed out, whereas in the 16th century a ball was added to the butt end. In the late 16th and early 17th centuries, the butts gradually became somewhat flatter and the balls became smaller until they had changed to a sort of enlarged butt end which prevented the pistol from slipping from the hand.

The flint lock. In the second half of the 17th century a new type of lock appeared which later became the basic characteristic feature of hand fire-arms in the 18th and early 19th centuries. Flint locks are classified into numerous types according to the methods of construction, which exhibit great differences.

The most ancient type is the Scandinavian (end of the 16th century), remarkable for its long cheek pieces of the cock and for the firing steel, attached to a long holder, which at that time still did not cover the touch pan. This lock influenced a number of later designs. Items dating from the 17th century are known as Baltic, English and Italian locks. An independent and frequently found form of the flint lock was the Italian and Spanish miquelet, of which the rectangular cheek pieces, attached to the snaphaunce, were a characteristic feature. The cock is activated by a spring of unusual action at the lower end of this snaphaunce. In the Italian lock the spring pressed the front part of the lower end downward; in the Spanish lock the rear part was lifted. There was also a difference in the form of the fire flash. Both the above-mentioned types of lock, of which the Spanish is authenticated as early as around 1600, were particularly characteristic of the late 17th and early 18th centuries. In this period they reached the Balkans and north Africa, where they were still being used during World War I.

The basic 18th- and early 19th-century form of gun and pistol lock was the classic French flint lock. The oldest documentary evidence of this lock comes from the 17th century: it was drawn in an illustration by the gunsmith and author D'Aubigny in 1654. But further development and distribution of this French lock did not get under way until the beginning of the 18th century.

The basic shape of this weapon hardly altered at all for a hundred and thirty years,

and slight alterations in the inner construction and shape of the barrel are scarcely perceptible. For this reason the character of the ornamentation must serve as a distinguishing feature. A further aid in identification is provided by our knowledge of when individual weapon manufacturers were active. Even in the flint lock we find designs such as the built-in flint lock, which is placed in a container made by lengthening the barrel, and which operates in this container: weapons of this kind are of 18th-century Bohemian manufacture. The only exceptions — as far as dating the weapon is concerned — are army guns, which were already produced serially according to prescribed specification. In these, influenced by the French AB IX gun, further alterations were effected in the form of the lock: the pan was of brass and the cock was reinforced, and an incision was made under its cheek pieces.

The percussion lock. At the beginning of the 19th century a new form of lock design appeared which remained characteristic of weapons produced right up to the 1870s. Chemical locks mark the beginning of this new type. The oldest and best known was patented by a Scotsman, Forsyth, in 1807. From this lock, which worked with an explosive compound, the classic percussion lock later developed. At the beginning the cap was made in the form of a small cylinder; later, about 1816, several inventors independently arrived at the percussion lock with a percussion cap.

Here again there is no rule which makes it possible to date weapons with percussion locks. It is quite different with army guns, which show numerous variations in construction, and corcerning which, with the aid of specialist literature, one can determine with relative accuracy not only the period of their use but also the army and regiment to which they belonged.

Breech-loading guns. At the end of the percussion lock era a new type of sporting gun and pistol for bullets slowly evolved. They were made on the Lefaucheux system, named after their inventor, a Paris gunsmith.

Lefaucheux's design (1832) was based on a forgotten project of the Swiss gun maker Pauly, who tried to achieve a homogeneous cartridge. The principal element of this weapon is a metal cartridge with a characteristic pin-like attachment at the side which was placed in the barrel (in which there was a notch) from the breech.

In firing, the gun cock struck the protruding pin, this hit the explosive charge within the cartridge and the charge ignited the gunpowder.

The spread of the new system was ensured by the Prussian victories of the 1860s. A great part was played in these successes by the Dreyse system army guns, which were called needle guns, after their characteristic long striking-pin. Immediately after 1866 a feverish conversion of muzzle-loading into breech-loading guns began, and later there was independent construction of breechloaders.

In analysing weapons of this period one should examine locks of various types. One of these was the flap lock, in which, after the lock was lifted, the cartridge could be placed in the chamber. The main examples of this type were the Krnka models, which were used by the Russian army in the Russo-Turkish war; the Snider 1865 model; Berdan I — also used from 1867 by the Russian army; Albini-Brändlein (1867 — Belgium); the one known as *à la tabatière* (1867 — France); and Wänzl (1867 — Austria). Another type was the falling block lock. In this the lock was pushed downwards by means of a trigger and the chamber thereby opened. Important examples were the Ballard 1861, a famous American gun, and Sharps (USA) and its variants, of 1835-69. A lock of this type was used by Aydt, a famous gun maker of Suhl, in his sporting weapons (target shooting guns). The falling block lock, in which the barrel chamber was opened by lifting the front part of the lock, was used in the Martini-Henry system (England 1871), and also in the famous guns of the Turkish and Italian armies. In Germany a whole series of sporting guns was equipped with this lock. Among other military guns, the Stahl (1869) and Werder (1868) models should also be mentioned.

In any description of military gun systems, mention should be made of the lock which was the forerunner of present-day military hunting and sporting weapons. This was a cylindrical lock with two basic varieties, the revolving lock and the straight-firing lock. It was first used in the Dreyse design mentioned above. Other important examples of

this lock system were the Mauser-Noris 1867-9, the Veterli 1868, the Russian Berdan II 1871, Mauser 1871, and Grass 1874.

In sporting weapons the Lefaucheux system was replaced at the end of the 19the century by the Lancaster system, which was set in motion by a small hammer striking a percussion cap set in the centre of the catridge. This technique was later abandoned and a switch-over made to the hammerless lock.

Revolvers. Revolvers form a separate collector's field. As with modern weapons, the collection of revolvers is mostly restricted by law, since most revolvers — the Smith/Wesson system, Colt and its European imitators, the Adams system, Grass, etc. — were made after 1891, though of course the law varies from country to country.

Very occasionally, military guns or pistols are found with strikingly enlarged muzzles. These are blunderbusses, which were used in the army mainly by the cavalry, and in particular by the navy, and fired lead at short range. However, the blunderbuss was very much more widely used by the civilian population. Around 1800 it was extremely popular in England, where it was used by travellers to protect them from highwaymen, and by householders against thieves.

Sporting weapons. Here the barrel is the basic identifying feature, distinguished by the various types of bore. If it is smooth, then it is a smooth-bore gun; if it has grooves we call it a rifle.

Sporting weapons are a separate class of hand fire-arm, and include the target rifle and sporting pistol. They are distinguished by the strong, heavy barrel, the weight of which is intended to prevent the weapon from wobbling while it is being aimed; by the shape of the well-worked butt, which allows a firm hold on the weapon; and by the far superior aiming device, the sight being set on the neck of the butt. Weapons used at the end of the last century which are breech-loaded will mostly be found to have either a Martini or an Aydt lock.

Pistols. Duelling pistols are the most sought-after 19th-century pistols. They can be recognised at first glance because there are always two absolutely identical pieces with smooth-bored barrels, fully finished and housed in a case. In the case with the

pistols all the equipment necessary for cleaning and loading them should be found, and sometimes if it is a very special set, a few hints on first-aid for the wounded man may still be there.

Air guns. The first extant documentation of air rifles dated from the 16th century: in about 1556 Hans Lobsinger offered his invention to the town council of Nuremberg. Further development of this weapon, however, did not begin until the late 18th century. The chief example was the Austrian army air and repeater gun, of Girardoni's system, of 1780. The manufacturers of these weapons were, among others, Contriner in Vienna, Bater and Jover in London, Bosler in Darmstadt, and Jacobi in Dresden. At the end of the 19th century this type was principally used for indoor target practice.

Unusual forms. Up to now we have concerned ourselves with the normal types of hand weapon, which appear in large quantities at auctions and are to be found in the main collections. In addition to these types there are rarities of interesting designs which were in many respects ahead of their time; inevitably, they are among the pieces most sought after by collectors. In particular there are breech loaders dating from the period of match, wheel and flint locks.

Pistols and guns with more than one barrel are also in a class of their own, single examples appearing even in the Middle Ages. Weapons with several differently arranged barrels, each with its own lock, or with revolving barrels and a common lock, are generally to be found among the flint and percussion systems. For the most part they occur in the form of pistols, known as Mariettes, named after a Belgian gunsmith who was making them in 1837. Typical of this weapon is the cylindrical arrangement of the barrels, each of which is provided with an independent piston for the percussion cap.

The first attempt to devise a revolver system, characterised by a cylinder attached to the end of the barrel, was made as early as the late 16th century. At that time they were actually cylindrical in shape, not differing greatly from the present system. In hunting weapons with a flint lock these designs were usually in the form of three chambers joined together, which were furnished with an indi-

vidual fire-steel and fire-steel spring. Typical of a later period, both for guns and pistols, was the compact cylinder with hollowed-out chambers for powder charge and bullet. In the rear section of the barrel, in recesses, were pins for the percussion cap.

Another interesting and very rare design is the Espignole. In weapons of this type several individual charges of powder and bullets were housed in the barrel, one behind the other. Firing was either automatic, so that after the first bullet was fired a continuous wick ignited the next charge, or the design was so contrived that one shot after another could be fired. Weapons of the Espignole type can be recognised at first glance either by their three or four locks placed one behind the other, or, where there is only one lock, by it being located remarkably far forward.

Finally, there are the combinations of hand fire-arms, mostly pistols, with other objects. These either combine spontoons and pistols, or daggers, axes, swords or falcions — even cross-bows — with a short barrel which has a simple flint or wheel lock. These combinations date from the 16th to the mid-18th century.

Distinguishing marks. Every weapon bearing a proof-mark is a valuable collector's object. This mark serves to date the object exactly, and sometimes to verify whether it is an original or a later model. The proof-mark is to be found on the barrel or the lock plate. It is usually an impressed mark — a symbol, or simply the name of the manufacturer. Often, too, one finds an incrustation with the manufactuere's name, or the name and possibly also the place of manufacture are engraved on the barrel or the lock plate. There are also combinations of impressed marks and inscription. In weapons of particular artistic value, the lock plate or some important part of the bone inlay usually carries the name of the artist responsible for the ornamentation.

In the 19th century it was by no means unusual for a gunsmith to order the barrel from a factory. Such barrels were mostly supplied from Liège and can be recognised by their characteristic marking: a star within an oval above the letters ELG. In serially produced weapons for army and civilian use which were manufactured at the end of the last century, it is very easy to establish the type. On the barrel, the bullet chamber, or possibly the lock of the barrel, not only the type itself but also the firm of the manufacturer and sometimes — as in Winchester guns — the patent number are marked.

Collections. Hand fire-arm collections usually also contain accessories, above all powder horns — large for the coarser barrel powder, smaller for the finer priming powder. Powder horns are mostly richly ornamented, and these ornaments make it possible to establish when the object itself was made. Powder horns made of horn, sometimes wood, were characteristic of the 16th and 17th centuries. Such a horn was covered by a skin and decorated with sheet brass chasings, and included a simple dispensing device. In the 19th century, powder horns were made of lavishly chased sheet copper, or decorated with skin and equipped with a better dispensing device which allowed the quantity dispensed to be altered.

Other accessories in collections include wheel lock keys, tools for taking the weapon apart and repairing it, pincers for casting bullets, measuring devices, containers for ignition caps, shot, and so on.

Armour

By armour we mean protective clothing which defends the body of the warrior, and possibly also of his horse, from the impact of enemy arms and missiles.

Like other kinds of military equipment, armour has undergone many complicated developments over the centuries.

Antiquity. In the early 1st millennium BC, pieces of armour made of bronze were being used in Mesopotamia and the Mediterranean. Of particular importance for the whole future development was the armour worn by the Greeks and Romans. Bronze cuirasses (thoraces), often moulded to the figure, were completed by greaves (knemides) and helmets of different shapes. The Greek type of helmet, appearing in the middle of

the 1st century, protected not only the head but also the neck and the sides of the face, and had a long nose guard; it was imitated during the Italian Renaissance (in the 15th century) in what is known as the Venetian helmet. Probably the commonest type was an open helmet surmounted by a large plume, such as is often seen on ancient Greek pottery. Besides plate armour there was also armour made of bronze aglets and armour scales.

Roman armour was composed of similar types. In the last centuries before Christ, bronze armour was partly replaced by iron armour, especially in tace armour. Roman helmets were mostly open, only occasionally with a movable visor. The round helmet often bore a plume. The most widely used material was bronze, but it was not uncommon for iron to be used side by side with bronze.

The Middle Ages. The most important means of defence for a warrior at the beginning of the Middle Ages was tace armour, which was in fact nothing but a coat of leather or cloth which was covered with small iron plates arranged regularly like roof tiles one above the other. However, from archaeological discoveries it can be seen that as early as the 7th or 8th century there appeared chain mail hauberks, which consisted of small iron rings linked together. The oldest form of head protection in metal was the simple casque, shaped like a skull-cap or slightly conical. The wooden shield, covered with skin, was round, and reinforced at the centre and edges with casings. From the 10th century until the height of the Middle Ages the most important body protection was chain mail, which at first consisted of a long hauberk with sleeves. In the 11th century chain leg coverings also appeared. In the 12th century the cavalryman's body was almost entirely covered: the sleeves ended in chain gloves, and head and neck were covered to the chin by a chain hood. The warrior wore his helmet on top of this hood. The basic form of the helmet was conical until around 1200, and until the middle of the 14th century the cavalry wore the heavy type of bascinet which covered the soldier's face and had only narrow slits for the eyes. In the 11th century the shape of the shield changed as well; it became a long almond-shape, rounded at the top and pointed at the lower end. This Norman shield became

gradually smaller, and in the first half of the 13th century it acquired the form of a triangle with rounded sides; it was used in this form until late in the 14th century.

It can thus be seen that there were considerable alterations in cavalry armour in the 13th century. The expansion of medieval towns, the growth of commerce and craft specialisation made possible the development of new techniques and forms. In the 13th century the first pieces of iron-plated armour appeared. Plate armour consisted of square plates attached to a leather or cloth base, and later also a large breast-plate (cuirass) and a back-piece. Shoulder-plates, knee-pieces and greaves also appeared. In the first half of the 14th century the old mailed mittens were replaced by plated gauntlets. This tendency in the development of cavalry armour led by the end of the 14th century to the emergence of the complete suit of armour. The helmet, too, changed. The heavy type of bascinet with immovable eye-slits no longer corresponded to the requirements of battle, and it was retained, with a few adaptions, only for jousting. One new type was the helmet open at the front which, however, covered the nape of the soldier's neck and also had a mail curtain (camail) to protect the neck. In western and central Europe a markedly conical shape, with a shallow crest sloping slightly backwards, was common. Italian helmets were oval in shape and had a long nose piece (barbuta). The open shape lasted for a whole century, although these helmets were soon — as early as the last quarter of the 14th century — equipped with a protruding visor which could be raised or lowered according to necessity.

What has so far been said about armour applies, of course, only to battle cavalry armour. The armour worn by the light cavalry, marksmen and infantry developed quite differently. Generally such armour covered only part of the body. A mailed hauberk down to the knees mostly served to protect the body, and to this were later added a breast-plate and a back-piece. Mailed sleeves were sometimes worn, though very rarely before the 15th century. Another type of armour used by marksmen and infantry was the brigandine, a cloth or leather coat (jerkin) strengthened on the inside by small iron plates sewn on. Very common, too, was the tabard, a tunic

strengthened by vertical or horizontal quilting of thick double cloth with a cotton padding or an interlining of some other material. To protect the head there was usually a hood of mail or cloth over which a helmet was worn. The most usual type of helmet was the iron hat and the bowl-shaped helmet. Whereas shields became obsolete for the cavalry, they became more important for the infantry. These shields, which earlier had been oval or drop-shaped, became rectangular in the late 14th century, and the shield for the whole body (pavise), which played an especially important role in 15th-century warfare, came into use.

For the cavalryman the survival of his horse in battle was essential, so horses too wore armour — at any rate those of the wealthier horsemen. An armour of mail sewn on to a cloth lining protected the head and chest, and often the whole body, of the horse. In the 14th century this was replaced by plate armour, especially to protect the animal's head.

The structural development of plate armour came to an end in about 1400, and in the course of the 15th century attention was concentrated on the surface decoration which was mainly influenced by the Gothic style. Italian armour had relatively simple lines with prominently rounded surfaces. The breast-piece was often divided, its lower portion rising to a point in the middle of the chest and fixed to the upper case by a clasp decorated with pierced ornament. The upper part of the body was often covered with a costly cloth. Also typical were the elaborately shaped and widely extending additions to the elbow-guards (coudieres) and the knee-guards. The chain mail curtain ceased to be used to protect the head: helmets, which took many different forms, now extended to cover the neck and shoulders. A new type of helmet was the casque, which included a plated chin-strap to protect chin and neck. Late Gothic shapes also appeared in the special jousting armour.

The makers of a few pieces from this period are known, particularly the northern Italian plate-armour makers. The Missaglia family of Milan is the most highly reputed of these.

The Renaissance. The full panoply of armour was distinguished by great richness and by a great variety of forms. The armour of various types of troops differed markedly from one another. The infantry of the first half of the 16th century had demi-suits of plate in which the plate covering reached at most only to the middle of the calves. The open helmet was soon replaced by a metal hat. From the mid-16th century the number of pieces of armour diminished even for the infantry, and finally there only remained the pike-man's breast and back plates with flaps, and a helmet of the storm-helmet type, or a morion. The musketeers dispensed with even these remnants of armour. In the heavy cavalry the shin guards and foot coverings were soon omitted, armour reaching only to the knee, and even shoulder-guards became simplified. Thus emerged a type of armour known as display armour. Its helmet, which in the first half of the 16th century was still closed (the burgonet) was replaced in the second half of the century by an open helmet with movable face and neck coverings, which in the 17th century gradually changed into the well known Pappenheimer helmet. The breast and back plates of the light cavalry disappeared around 1600, and the cavalryman wore a hat with his leather jerkin.

At the same time as this development, which led to the gradual abandonment of armour for practical purposes, increasingly ostentatious parade armour and jousting armour was made. The divided Gothic cuirass was first replaced by an undivided, rounded, bulging shape which was later embellished by a tapering rib in the middle which ended in a point (tapul). The gradual downward extension of the tapul led to the development of 'pigeon-breasted' armour in the late 16th century. The Gothic casque with a separate chin-strap was replaced by a closed helmet of which the chin-strap formed an integral part, and which was attached to the edge of the armour collar with lacings. A type of armour impressive in its fluted decoration was the central European armour of the early 16th century, known as Maximillian armour. On later pieces the surfaces of individual parts are no longer moulded, but are decorated with chased and engraved decoration, with abstract ornament or figural motifs. Thus a dazzling effect was created, since each of the individual parts of simple armour could in turn be polished and blackened or blued. In southern European armour, especially Italian and south German, Classical influences became marked. Full display uniforms were wholly

or partly decorated on the surface with figural ornamentation in relief. Some armour parts are also painted, with a black ground. Plate armour craftsmen also achieved a beautiful colour effect by blackening deeply chased strips and gilding the raised surfaces. Often, too, they used a combination of metal and coloured enamel.

Special jousting armour differed from ordinary armour mainly in that it afforded the jouster the greatest possible guarantee of safety. The difference is not only in the strength of the plate, but also in the protection given the shoulders and in the shape of the helmet.

During this period the old production centres, already famous in the Middle Ages, expanded further. These were mainly in northern Italy, especially Milan, and southern Germany (Nuremberg, Augsburg, etc.). From the end of the 16th century an English school, known for its individual style and special forms, grew up in Greenwich.

In the following centuries the increased use and effectiveness of fire-arms made armour superfluous.

The cuirass continued to be worn by the heavy cavalry (cuirassiers) until the middle of the 19th century, but by then it had lost its individual character and had become incorporated in the uniform. Armour has continued to be worn, even in our own times, by a few special guard units.

Advice to Collectors

By no means all weapons which the collector finds on the market nowadays are originals from the period which their form and ornamentation suggest. Specialist periodicals supply abundant information about the modern manufacture of replicas of weapons of all kinds. It is somewhat different with items manufactured as imitations in the past. The romantic nostalgia for the past which was prevalent in the 19th century led wealty people to decorate their houses with 'historical' objects, but many were content with good imitations. At this same time, great changes came about in army equipment and weapons manufacture, so that a previously flourishing craft declined; and whole enterprises attempted to survive by manufacturing imitations of old weapons and armour for use as decoration. It is not always easy to distinguish items of this sort from the originals.

The age of an item is often immediately obvious: the maker has attempted to give only a general impression of antiquity and has not paid attention to quality and detail. It is more difficult to recognise imitations in which appearance, craftsmanship, decorative techniques and even the proof-marks tally with the original. In such cases only highly specialised knowledge can help, and even today there are cases in which specialists disagree. The only really exact method of determining the age of pieces of this sort is metallurgical analysis.

Some clues are offered by the purpose which the piece was intended to serve. Most manufacturers of imitations concerned themselves above all with the outer form of the object, but little if at all with its real function.

If, for example, a thoroughly well-fashioned armour, the character, type and decorative technique of which would lead one to believe it was made in the late 16th century, hinders or prevents movements of the hand or foot, it can safely be concluded that it is not an original but a decorative piece manufactured at a later date.

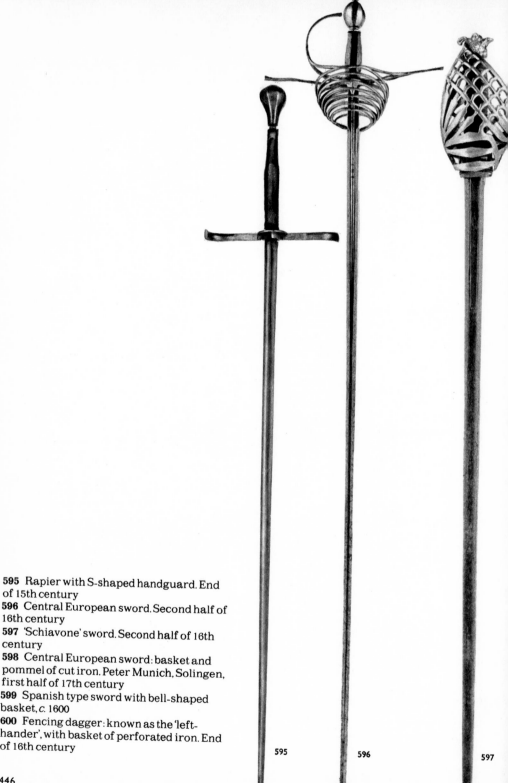

595 Rapier with S-shaped handguard. End
of 15th century
596 Central European sword. Second half of
16th century
597 'Schiavone' sword. Second half of 16th
century
598 Central European sword: basket and
pommel of cut iron. Peter Munich, Solingen,
first half of 17th century
599 Spanish type sword with bell-shaped
basket, c. 1600
600 Fencing dagger: known as the 'left-
hander', with basket of perforated iron. End
of 16th century

595

596

597

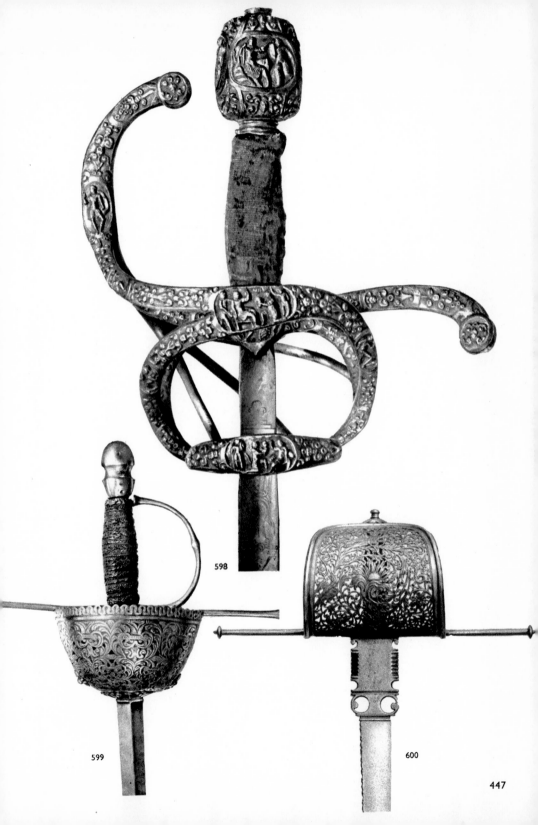

598

599

600

601 Octagonal combat club. Second half of 15th century

602 Halberd. 17th century

603 Stave weapons: a) Italian couso (dual purpose); end of 15th century; b) Italian halberd; second half of 15th century; c) 'long-eared' halberd; Bohemia, 15th century; d) spiked club; 15th-century type (imitation); e) halberd with a hook; end of 15th century

604 Baroque sword. First half of 18th century

605 Prussian infantry sabre. 1712-86

606 Russian cossack sabre; Don type; 1914-18

607 Austrian hussar sabre M 1803

608 German sabre. Blücher type M 1811

609 Officer's sabre of the Austrian infantry M 1861

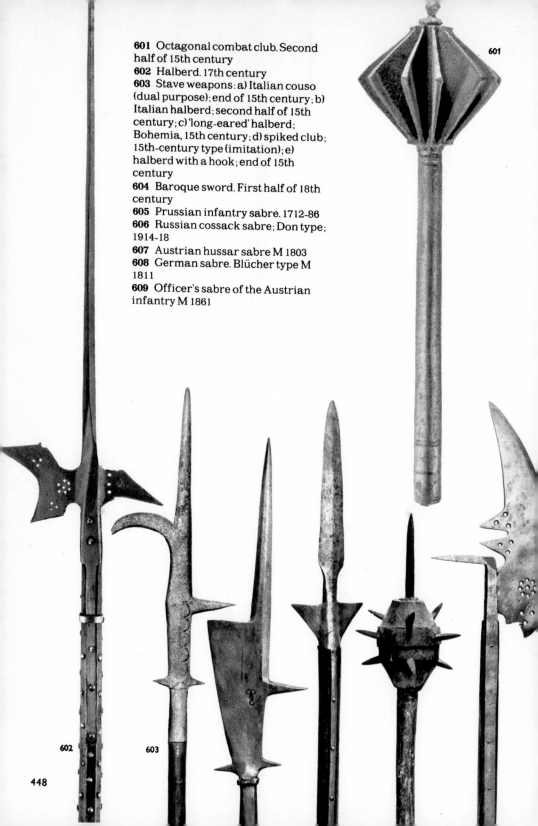

601

602

603

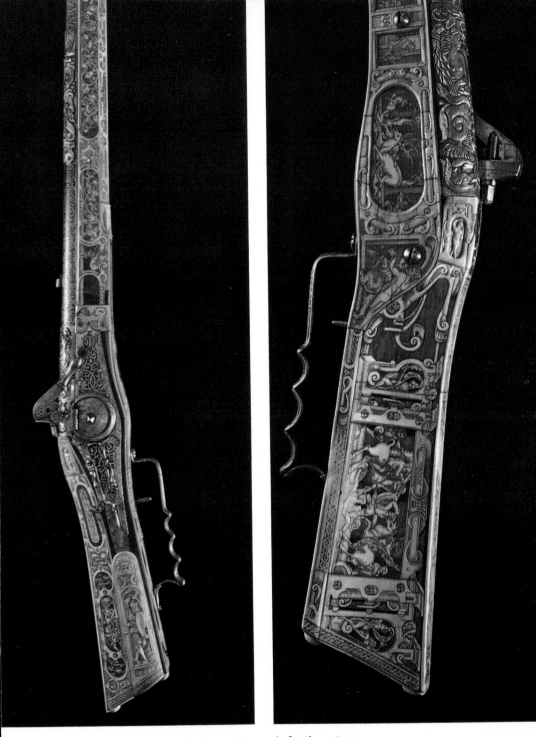

LXV Flint gun with wheel lock. Northern Italy, end of 16th century

LXVI Detail of a butt with ivory inlays and gilded relief on the barrel

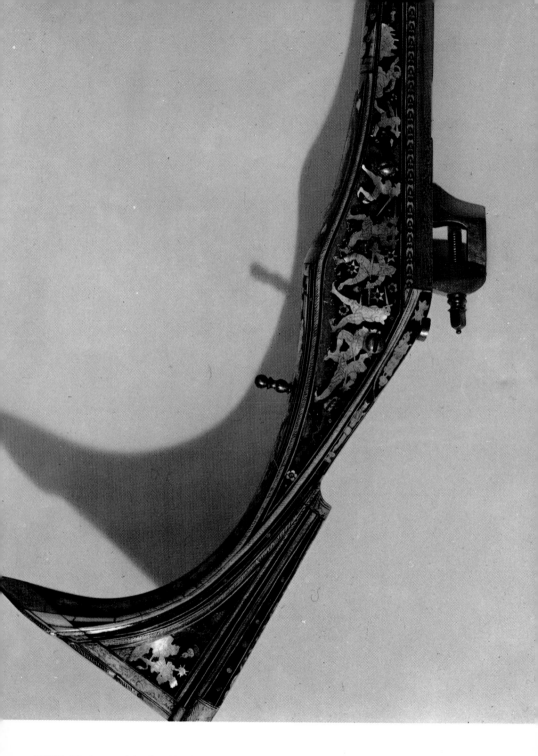

LXVII Flint gun with wheel lock; mother-of-pearl inlays. Italy, middle of 16th century

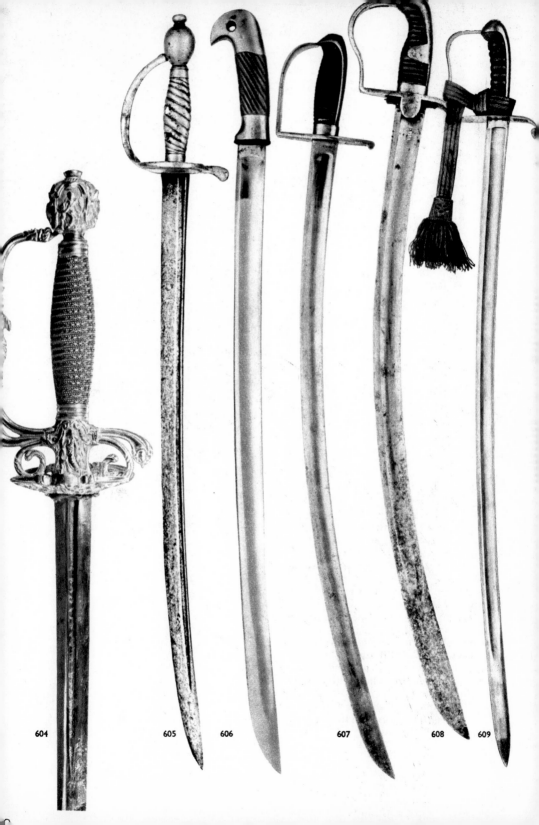

604 605 606 607 608 609

610

611

610 Forged iron gun; *c.* 1375
611 Forged iron hand gun with a socket.
Beginning of 15th century
612 Arquebus. After 1464
613 Arquebus (half-hook) with a simple
tinder lock (match lock?) with button trigger;
c. 1500
614 Match lock musket with an English type
butt. End of 16th century
615 Bullet gun with wheel lock; German type
of butt. First half of 17th century
616 Bullet gun with wheel lock; French type
of butt. First half of 17th century
617 Short bullet gun with external Italian
type of wheel lock, combined with a match
lock. End of 16th century
618 Bullet gun with wheel lock; German type
of butt with rich bone incrustation. 17th
century

450

612 613

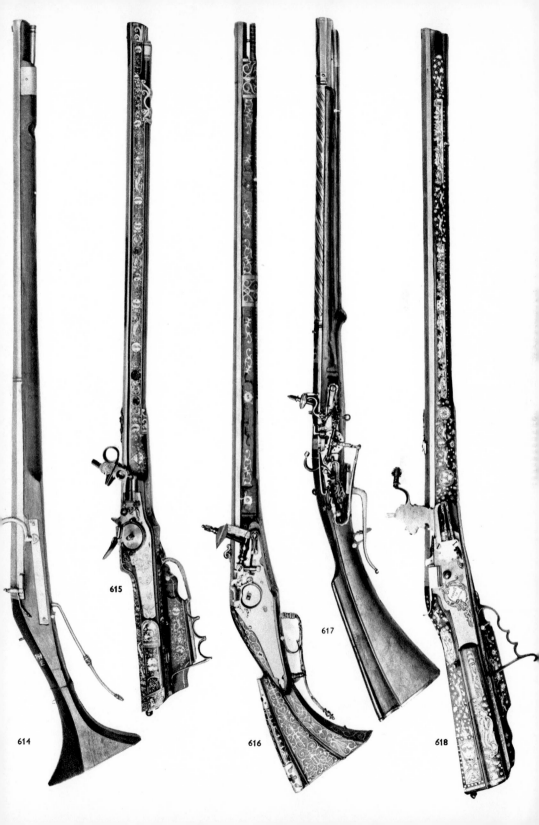

614

615

616

617

618

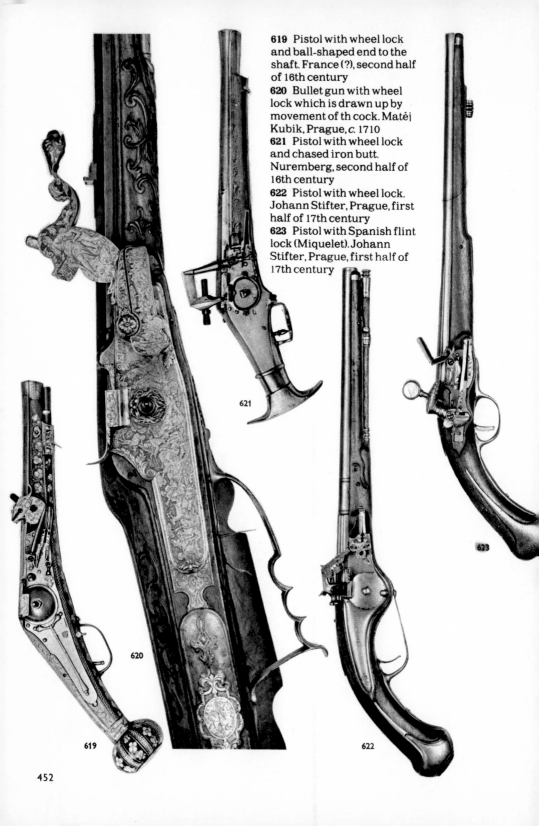

619 Pistol with wheel lock and ball-shaped end to the shaft. France (?), second half of 16th century
620 Bullet gun with wheel lock which is drawn up by movement of th cock. Matěj Kubik, Prague, c. 1710
621 Pistol with wheel lock and chased iron butt. Nuremberg, second half of 16th century
622 Pistol with wheel lock. Johann Stifter, Prague, first half of 17th century
623 Pistol with Spanish flint lock (Miquelet). Johann Stifter, Prague, first half of 17th century

621

623

620

619

622

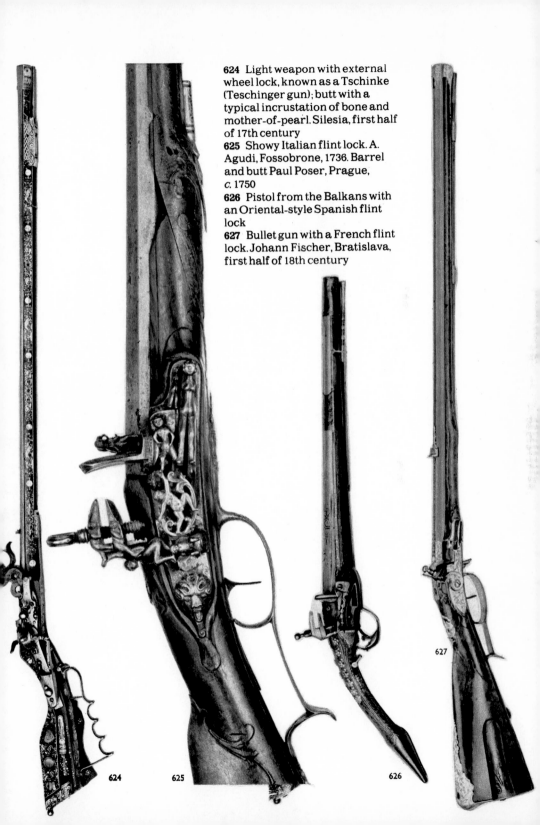

624 Light weapon with external wheel lock, known as a Tschinke (Teschinger gun); butt with a typical incrustation of bone and mother-of-pearl. Silesia, first half of 17th century
625 Showy Italian flint lock. A. Agudi, Fossobrone, 1736. Barrel and butt Paul Poser, Prague, *c.* 1750
626 Pistol from the Balkans with an Oriental-style Spanish flint lock
627 Bullet gun with a French flint lock. Johann Fischer, Bratislava, first half of 18th century

624

625

626

627

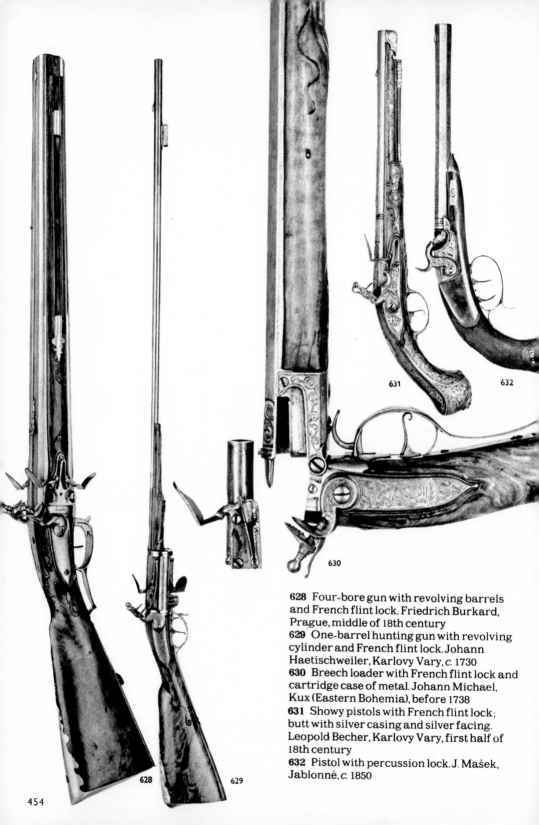

628 Four-bore gun with revolving barrels and French flint lock. Friedrich Burkard, Prague, middle of 18th century
629 One-barrel hunting gun with revolving cylinder and French flint lock. Johann Haetischweiler, Karlovy Vary, c. 1730
630 Breech loader with French flint lock and cartridge case of metal. Johann Michael, Kux (Eastern Bohemia), before 1738
631 Showy pistols with French flint lock; butt with silver casing and silver facing. Leopold Becher, Karlovy Vary, first half of 18th century
632 Pistol with percussion lock. J. Mašek, Jablonné, c. 1850

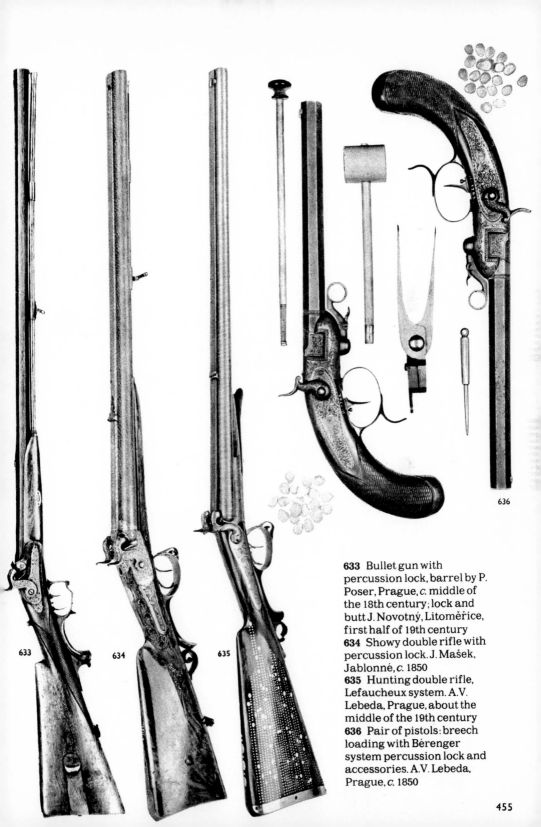

633 Bullet gun with percussion lock, barrel by P. Poser, Prague, *c.* middle of the 18th century; lock and butt J. Novotný, Litoměřice, first half of 19th century
634 Showy double rifle with percussion lock. J. Mašek, Jablonné, *c.* 1850
635 Hunting double rifle, Lefaucheux system. A.V. Lebeda, Prague, about the middle of the 19th century
636 Pair of pistols: breech loading with Bérenger system percussion lock and accessories. A.V. Lebeda, Prague, *c.* 1850

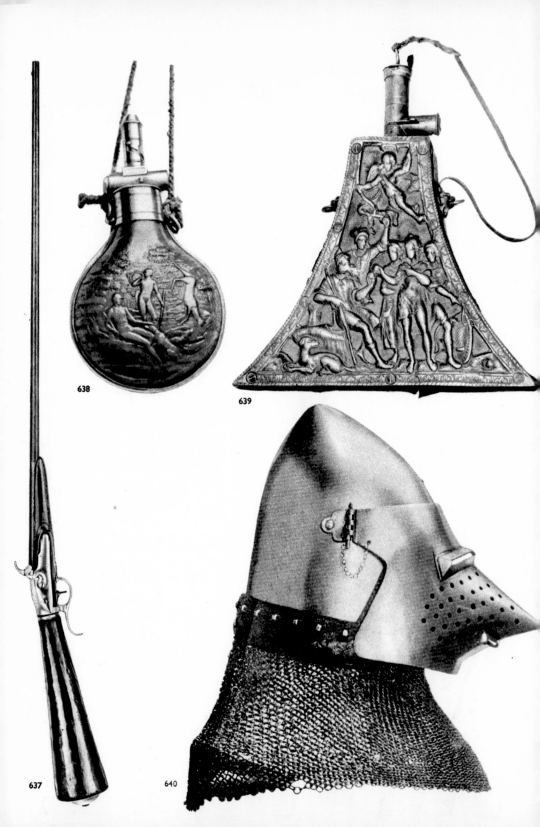

637

638

639

640

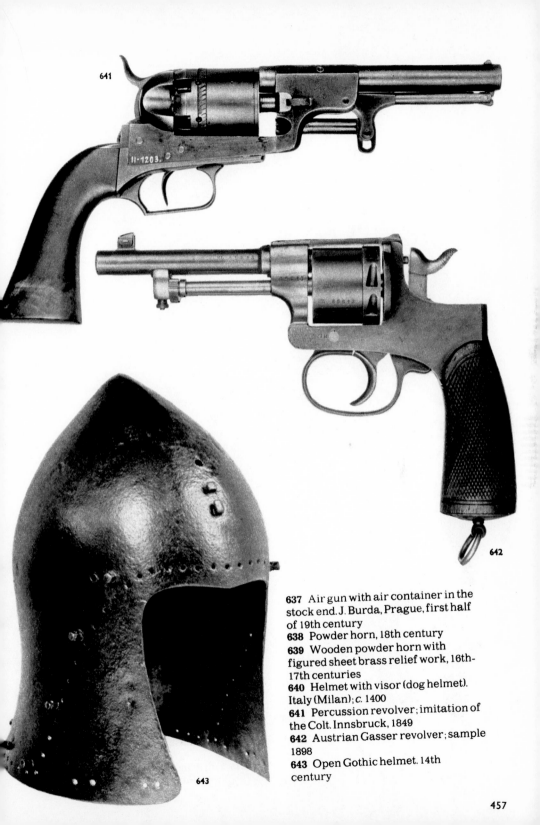

637 Air gun with air container in the stock end. J. Burda, Prague, first half of 19th century
638 Powder horn, 18th century
639 Wooden powder horn with figured sheet brass relief work, 16th-17th centuries
640 Helmet with visor (dog helmet). Italy (Milan); c. 1400
641 Percussion revolver; imitation of the Colt. Innsbruck, 1849
642 Austrian Gasser revolver; sample 1898
643 Open Gothic helmet. 14th century

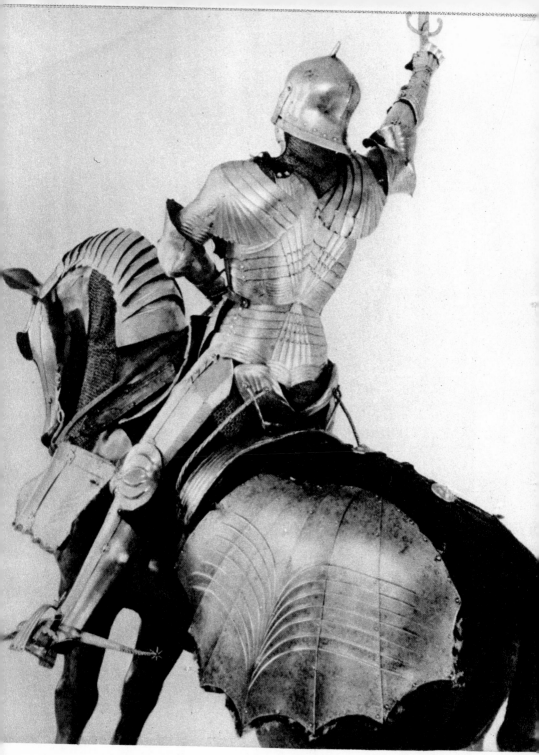

644 Full panoply of armour, late
Gothic. Southern Germany, 1475-85

645 Full armour, known as ribbed
armour. Nuremberg, c. 1540

644

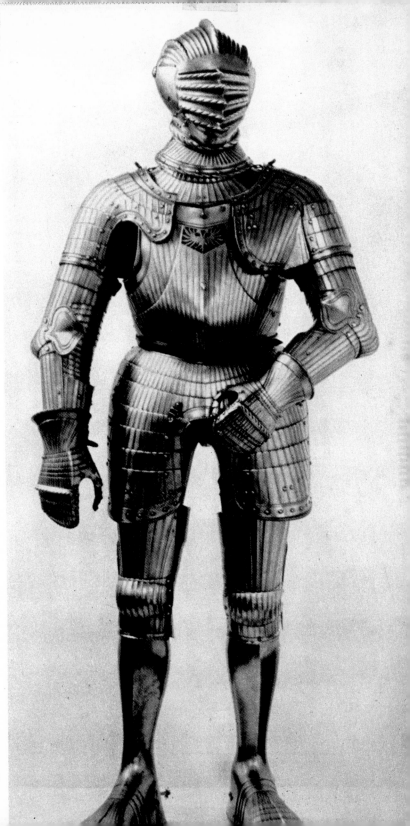

645

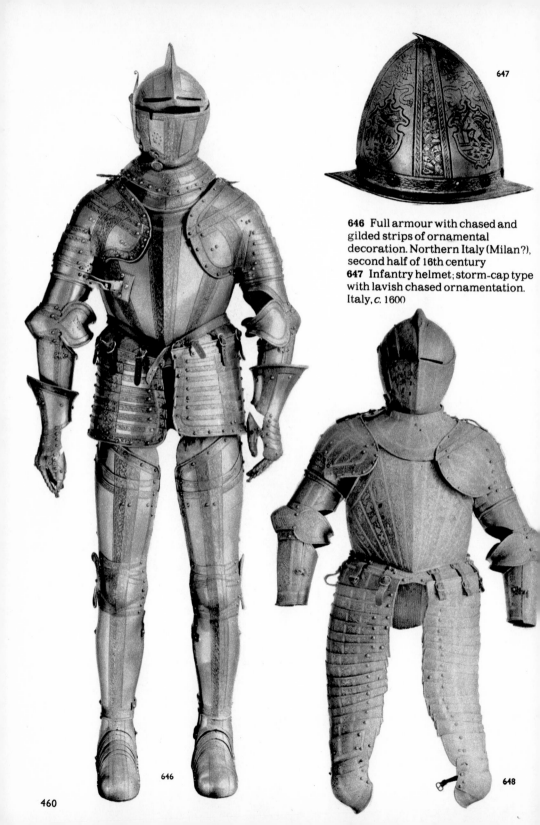

647

646 Full armour with chased and gilded strips of ornamental decoration. Northern Italy (Milan?), second half of 16th century
647 Infantry helmet; storm-cap type with lavish chased ornamentation. Italy, c. 1600

646

648

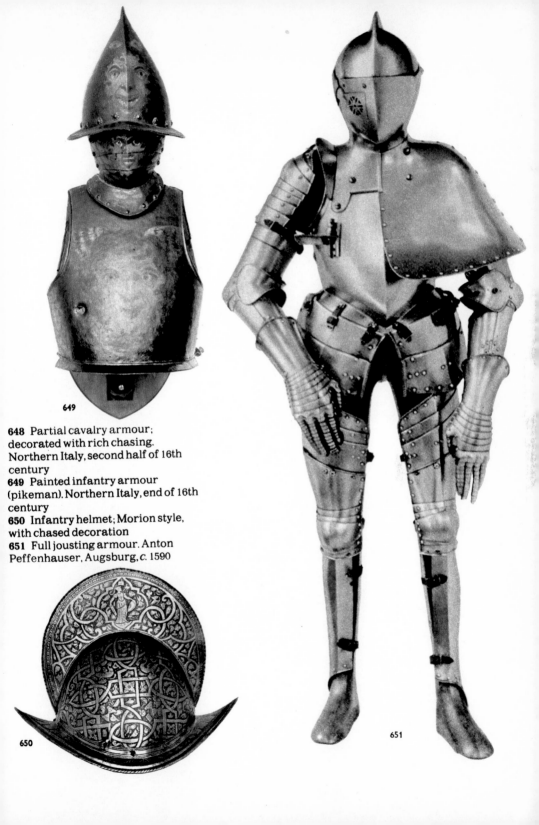

648 Partial cavalry armour;
decorated with rich chasing.
Northern Italy, second half of 16th
century
649 Painted infantry armour
(pikeman). Northern Italy, end of 16th
century
650 Infantry helmet; Morion style,
with chased decoration
651 Full jousting armour. Anton
Peffenhauser, Augsburg, *c.* 1590

649

650

651

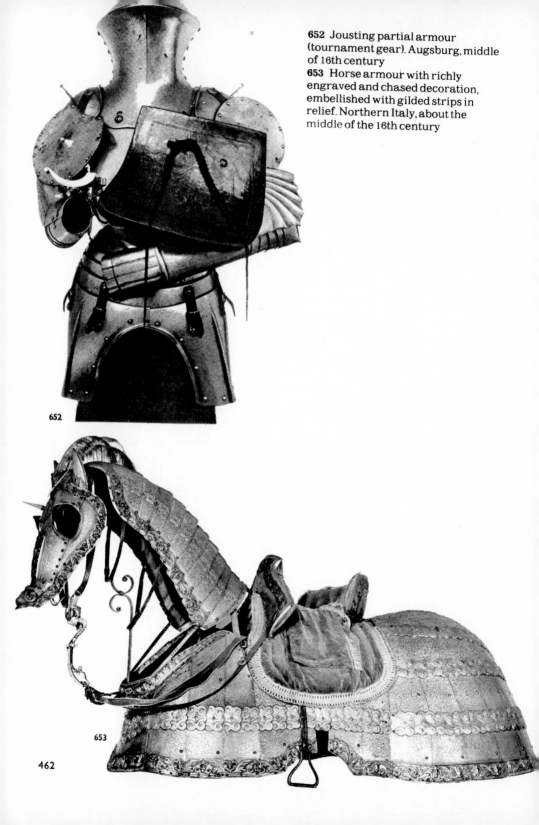

652 Jousting partial armour (tournament gear). Augsburg, middle of 16th century

653 Horse armour with richly engraved and chased decoration, embellished with gilded strips in relief. Northern Italy, about the middle of the 16th century

652

653

Bibliography

FURNITURE

Aronson, J. *The Encyclopaedia of Furniture*, London 1966.

Boger, L. A. *The Complete Guide to Furniture Styles*, London 1961.

Bracket, Oliver *English Furniture Illustrated*, London 1950.

Burr, G. H. *Hispanic Furniture*, New York 1964.

Edwards, Ralph and P. Macquoid *The Dictionary of English Furniture*, London 1954.

Edwards, Ralph *The Shorter Dictionary of English Furniture*, London 1964.

Fastnedge, Ralph *English Furniture Styles, 1500 to 1830*, London 1955.

Gloag, John *A Social History of Furniture Design from BC 1300 to AD 1960*, London 1966.

Gordon, H. *Old English Furniture: A Simple Guide*, London 1948.

Harris, E. *The Furniture of Robert Adam*, London 1963.

Hayward, H. *World Furniture*, London 1965.

Hepplewhite, George *The Cabinet Maker's and Upholsterer's Guide*, London 1788.

Hughes, Therle *Old English Furniture*, London 1963. *Cottage Antiques*, London 1967. *The Pocket Book of Furniture*, London 1968.

Hughes, Bernard and Therle *Small Antique Furniture*, London 1958.

Janneau, G. *Les Meubles, (Vols 1 - 3)*, Paris 1929.

Joy, E.T. *The Country Life Book of Chairs*, London 1967. *English Furniture*, London 1962.

Kreisel, H. *Die Kunst des deutschen Möbels*, Munich 1968.

Laking, Sir Guy *The Furniture at Windsor Castle*, London 1905.

Loukomski, G. *Mobiliers et décorations des ançiens palais Russes*, Paris 1928.

Ramsay, L. G. G. *Connoisseur Guide to Furniture*, London 1961.

Reeves, D. *Furniture: an Explanatory History*, London 1948.

Schmitz, Dr. H. *The Encyclopaedia of Furniture*, London 1926. *Deutsche Möbel des Barock und Rokoko*, Stuttgart 1923. *Deutsche Möbel des Klassizismus*, Stuttgart 1923.

Schottmüller, F. *Wohnungskultur und Möbel der italienischen Renaissance*, Stuttgart 1926.

Singleton, E. *Dutch and Flemish Furniture*, London 1907.

Symonds, R. W. *Veneered Walnut Furniture*, London 1946.

Toller, Jane *Antique Miniature Furniture*, London 1966.

Verlet, P. *Les Meubles du XVIIIe siècle*, Paris 1955.

Watson, F. J. B. *Louis XVI Furniture*, London 1960.

Wenham, Edward *Old Furniture*, London 1964. *The Collector's Guide to Furniture Design*, London 1928.

Wernitz, G. *Historische Möbel und Innenräume*, Berlin 1956.

TAPESTRY

Badin, J. *La manufacture de tapisseries de Beauvais*, Paris 1909.

Baldass, L. *Die Wiener Gobelinsammlung*, Vienna 1920.

Blažková, J. A. *Book of Tapestries*, London n.d.

Goebel, H. *Die Wandteppiche*, (3 vols.) Leipzig, 1923-4.

Guiffrey, J. *Histoire de la tapisserie*, Tours 1886.

Janneau, G. and J. Niclausse *Le Musée des Gobelins*, Paris 1938.

Léjard, André *La tapisserie, La tradition française*, Paris 1942.

Leland Hunter, G. *Tapestries, their Origin, History and Renaissance*, New York 1906.

Müntz, E. *La tapisserie*, Paris 1884.

Niclausse, J. *Tapisseries et tapis de la ville de Paris*, Arts, Paris 1946. (Special number).

Schmitz, H. *Bildteppiche*, Berlin 1922. *Les Tapisseries de la Cour Impériale de Vienne*, Paris 1922.

Stenton, Sir F. *The Bayeux Tapestry*, London 1957.

Thomson, G. W. *A History of Tapestry*, London 1906.

Valencia, Conde de *Tapices de la corona de España*, Madrid 1903.

Wauters, A. *Les tapisseries histoiriées à l'Exposition nationale belge de 1880*, Brussels, 1881. *Le Grand Livre de la Tapisserie, VIIIe siècle de la tapisserie*, Paris 1965.

CARPETS

Bode, Wilhelm von and E. Kühnel *Antique Rugs from the Near East* (trans.), Brunswick 1958.

Dilly, A. U. (revised by Maurice S. Dimand) *Oriental Rugs and Carpets*, New York 1959.

Dimand, Maurice S. *Peasant and Nomad Rugs of Asia*, New York 1961.

Dreczko, W. *Teppiche Europas*, Recklinghausen 1962.

Edwards, A. C. *The Persian Carpet*, London 1953.

Erdmann, Kurt *Oriental Carpets, An Account of their History*, London 1960.

Heinz, D. *Alte Orientteppiche*, Darmstadt 1956.

Jacobsen, C. W. *Oriental Rugs: A Complete Guide*, London n.d.

Jacoby, Heinrich *How to Know Oriental Carpets and Rugs*, London 1963.

Kendrick, A. F. and C. E. C. Tattersall *Hand-woven Carpets, Oriental and European*, London 1922.

Kybalova, Ludmila *Carpets of the Orient*, London 1969.

McMullan, Joseph V. *Islamic Carpets*, New York 1965.

Neugebauer-Troll *Handbuch der Orientalischen Teppichkunde*, Leipzig 1930.

Ropers, H. *Morgenländische Teppiche*, Brunswick 1955.

Schlosser, Ignaz *European and Oriental Rugs and Carpets*, London and New York 1963.

Schürmann, Ulrich *Caucasian Rugs*, Brunswick and London 1965.

Oriental Carpets, London 1966.

Tattersall, C. E. C. *Notes on Carpet-knotting and Weaving*, Victoria and Albert Museum, London 1961.

GLASS

Barrington Haynes, E. *Glass Through the Ages*, London 1948.

Bergstrom, E. H. *Old Glass Paper-Weights*, Chicago 1940.

Bernt, W. *Altes Glas*, Munich 1950.

Blancourt, H. *Art of Glass*, London 1699.

Bles, Joseph *Rare English Glasses of the Seventeenth and Eighteenth Centuries* London 1926.

Buckley, Francis *History of Old English Glass*, London 1925.

The Art of Glass, London 1939.

Davis, D. C. *English and Irish Antique Glass*, London 1964.

Davis, Frank *The Country Life Book of Glass*, London 1966.

Dudley Westropp, M. S. *Irish Glass*, Dublin 1920.

Elville, E. M. *The Collector's Dictionary of Glass*, London 1961.

English Table Glass, London 1951.

English and Irish Cut Glass, London 1953.

Fleming, A. *Scottish and Jacobite Glass*, London 1938.

Frothingham, Alice *Spanish Glass*, London 1964.

Gasparetto, A. *Il Vetro di Murano*, Venice 1959.

Hartshorne, A *Old English Glasses*, London 1897.

Heinemeier, E. *Das Glas*, Düsseldorf 1966.

Hettes, K. *Bohemian Glass*, Prague 1954.

Honey, W. B. *Glass. A Handbook and a Guide to the Museum Collection. Victoria and Albert Museum*, London 1946.

Hudig, Ferrand *Dutch Glass Engravers*, 1926. (Privately printed).

Hughes, G. Bernard *English, Irish and Scottish Table Glass*, London 1956.

English Glass for the Collector: 1600-1860, London 1958.

Klesse, B. *Glas, Kunstgewerbemuseum*, Cologne 1963.

Mariacher, Giovanni *Italian Blown Glass*, London 1961.

Mosel, C. *Glass Collection. Pictorial Catalogue of the Kestner Museum*, Hanover 1957.

Neuberg, F. *Glass in Antiquity* (Trans.) London 1949.

Pellat, Apsley *Memoir on the Origin, Progress and Improvement of Glass Manufacturers*, London 1821.

Poche, E. *Le verre de Bohême*. Paris (UNESCO), 1959.

Polak, Ada *Modern Glass*, London 1962.

Four Pioneers in Modern French Glass, Oslo 195

Rademacher, F. *Die deutschen Gläser des Mitte ters*, Berlin 1933.

Saldern, A. von *Enamelled Glass*, Corning 1966.

Thorpe, W. A. *English Glass*, London 1935.

Vavra, J. R. *Das Glas und die Jahrhunderte*, Prag 1954.

Wakefield, H. *Nineteenth Century British Glass*, L don 1961.

Wills, Geoffrey *The Country Life Pocket Book Glass*, London 1966.

POTTERY

Ballardini, G. *Corpus della Maiolica italiana*, (2 v Rome 1933-8.

Ballot, M. J. *La faience française*, (2 vols.), Paris 1924-

Bedford, John *Wedgwood Jasper Ware*, London 196

Burton, W. *A History and Description of English E thenware and Stoneware*, London 1904.

Buten, H. M. *Wedgwood A B C*, London 1964.

Chaffers, W. M. *Marks and Monograms on Europe and Oriental pottery and porcelain*, Los Angel 1946.

Clarke, H. G. *Colour Pictures on Pot-lids*, London 192

Cook, R. M. *Greek Painted Pottery*, London 1960.

Evans, Lady M. M. *Lustre Pottery*, London 1920.

Falke, O. von *Das Rheinische Steinzeug*, (2 vols.), Ber 1908.

Forrer, R. *Geschichte der europäischen Fliesenker mik*, Strasbourg, 1901.

Frothingham, A. *Lustreware of Spain*, New York 195

Garner, F. H. *English delftware*, London 1948.

Haggar, R. G. *The Concise Encyclopedia of Continen Pottery*, New York and London 1960.

Hannover, E. *Pottery and Porcelain. A Handbook f Collectors*, London 1925.

Hernmarck, V. *Marieberg*, Stockholm 1962.

Honey, W. B. *English Pottery and Porcelain*, Lond 1962.

European Ceramic Art, (2 vols.), London 1949-52.

Wedgwood ware, London 1948.

Hüsler, K. *Deutsche Fayencen*, (3 vols.), Stuttga 1956-8.

Hudig, F. W. *Delfter Fayence*, Berlin 1929.

Kelly, A. *The Story of Wedgwood*, London 1962.

Korf, D. *Dutch Tiles*, London 1963.

Lane, Arthur *Greek Pottery*, London 1963.

French Faience, London and New York, 1948.

Lane, E. A. *Guide to the Collection of Tiles*, Victoria ar Albert Museum, 1960.

Mackintosh, Sir H. *Early English Figure Pottery*, Lor don 1938.

Price, R. K. *Astbury and Whieldon Figure and Tob Jugs collected by the Author*, London 1922.

Rackham, B. *Catalogue of Italian maiolica*, (2 vols London 1940.

Early Netherlands maiolica, London 1926.

English Pottery, London 1924.

Rada, P. *A Book of Ceramics*, London 1962.

Rice, D. Talbot *Byzantine Glazed Pottery*. Oxford 1930.

Savage, G. *Pottery through the Ages*, London 1959.

naw, Simon *History of the Staffordshire Potters,* London 1829.

oehr, A. *Deutsche Fayencen und deutsches Steingut,* Berlin 1920.

horne, A. *Pink Lustre Pottery,* London 1926.

ilmans, E. *Faiences de France,* Paris 1954.

owner, D. C. *English Cream-Coloured Earthenware,* London 1957.
Leeds Pottery, London 1963.

ydra, J. and L. Kunz *Painting on Folk Ceramics,* London, n.d.

ydrova, J. and J. Ehm *Italienische Majolika,* Prague 1955.

ORCELAIN

ldridge, E. *Porcelain,* London 1969.

acci, Mina *European Porcelain,* London 1969.

arbantini, N. *Le porcellane di Venezia e delle Nove,* Venice 1936.

erling, K. *Das Meissner Porzellan und seine Geschichte,* Leipzig 1900.
Festschrift zur 200-jährigen Jubelfeier der ältesten europäischen Porzellanmanufaktur, Meissen 1911.

ourgeois, E. *Le biscuit de Sèvres du XVIIIe siècle,* Paris 1909.

Chavagne, Comte X. de *Histoire des manufactures françaises de porcelaine,* Paris 1906.

Daydi, M. O. *Das europäische Porzellan von den Anfängen bis zum Beginn des 19 Jahrhunderts* (2vols.) Berne 1955-57.

Ducret, S. *German Porcelain and Faience,* London 1962.

Grandjean, B. L. *Kongelik Dansk Porcelain,* Copenhagen 1962.

Hayden, A. *Kopenhagener Porzellan,* Leipzig 1913.

Hayward, J. F. *Viennese Porcelain of the Du Paquier Period,* London 1952.

Hobson, R. L. *Chinese Porcelain and Wedgwood Pottery,* Lady Lever Art Gallery, 1928.

Hofmann, F. H. *Frankenthaler Porzellan.* Munich 1911.

Honey, W. B. *French Porcelain of the XVIII century,* London 1950.
German Porcelain, London 1947.
Dresden China, London 1954.
Old English Porcelain, London 1948.

Hughes, G. B. *The Country Life Book of China.* London 1967.

Lane, Arthur *Italian Porcelain,* London 1954.

Lisci, L. G. *La Porcellana di Doccia,* Florence 1963.

Lukomsky, G. *Russisches Porzellan,* Berlin 1924.

Meyer, H. *Böhmisches Porzellan und Steingut,* Leipzig 1927.

Morazzoni, G. and S. Levi *Le porcellane italiane,* Milan 1960.

Poche, E. *Böhmisches Porzellan,* Prague 1956.

Rava, C. E. *Les porcelaines de Venise,* Milan 1922.

Rollo, Charles *Continental Porcelain.* London 1964.

Sauerlandt, M. *Deutsche Porzellanfiguren des 18 Jahrhunderts,* Cologne 1923.

Savage, G. *Porcelain Through the Ages,* London 1954.
18th Century German Porcelain, London 1958.

Schnorr v. Carolsfeld, L. *Porzellan der europäischen Fabriken,* Braunschweig 1956.

Schrijver, E. *Hollands Porcelein.* Bussum 1966.

Watney, B. *English Blue and White Porcelain of the 18th Century.* London 1963.

Wills, Geoffrey *The Country Life Pocket Book of English China,* London 1965.

Zimmerman, E. *Meissner Porzellan,* Leipzig 1926.

MIRRORS

Berndt, W. *Bilder und Rahmen.* Kaysers Kunst- und Antiquitätenbuch, Heidelberg-Munich, 1957.

Fuchs, F. L. *Die Glaskunst im Wandel der Jahrhunderte,* Darmstadt 1956.

Roche, S. *Miroirs,* Paris 1956.
Mirrors, London 1957.

Rose, T. *Gläser,* Kaysers Kunst- und Antiquitätenbuch, Heidelberg-Munich, 1957.

Schmidt, R. *Das Glas,* Berlin 1922.

Wills, G. *English Looking Glasses,* London 1965.

GOLD AND SILVER

GENERAL

Douglas, Jane *Collectable Silver,* London 1963.

Hughes, G. B. *Small Antique Silver,* London 1957.

Jones, E. A. *Old Silver of Europe and America,* London 1928.

Steingräber, E. *Der Goldschmied,* Munich 1966.

Taylor, G. *Art in Silver and Gold,* London 1964.
Silver, (3 vols.), London 1965.

Victoria and Albert Museum *Small picture books on Silver* (12 in the series).

Wenham, Edward *Old Silver,* London 1965.

GREAT BRITAIN AND IRELAND

Banister, J. *An Introduction to Old English Silver,* London 1965.
English Silver, London 1965.

Bradbury, F. *Guide to Marks of Origin on British and Irish Silver Plate.* London 1959.

Cripps, W. J. *Old English Plate.* London 1906.

Hayward, J. F. *Huguenot Silver in England 1688-1727,* London 1959.

Heal, A. *The London Goldsmiths 1200-1800,* London 1935.

Jackson, Sir C. J. *An Illustrated History of English Plate* (2 vols.), London 1911.
English Goldsmiths and Their Marks, London 1949.

Oman, C. C. *English Domestic Silver,* London 1962.
English Silversmiths' Work, Civil and Domestic. London 1965.

Philips, P. A. S. *Paul de Lamérie: a Study of his Life and Work,* London 1935.

Rowe, R. *Adam Silver,* London 1965.

Watts, W. W. *Old English Silver,* London 1924.

Wenham, Edward *Domestic Silver of Great Britain and Ireland*, London 1931.

AUSTRIA

Kris, E. *Kunsthistorische Sammlungen in Wien*, Vol. V. Part 1. *Arbeiten in Gold und Silber*, Vienna 1932.

BELGIUM

Crooy, L. A. F. *L'Orfévrerie religieuse en Belgique*. Paris 1911.

DENMARK

Boesen, G. and Bøje, C. A. *Old Danish Silver*, Copenhagen 1948.

FRANCE

Beuque, E. and M. Frapsauce *Dictionnaire des Poinçons de Maitres-Orfèvres Français*, Paris 1929.
Taralon, J. *Les Trésors des Églises de France*, Paris 1966.

GERMANY

Leitermann, H. *Deutsche Goldschmiedekunst*. Stuttgart 1953.
Lessing, J. *Gold und Silber. Handbook of the Berlin Museums*. Berlin 1907.
Rosenberg, M. *Der Goldschmiede Merkzeichen*, (3 vols.), Frankfurt 1961.

HOLLAND

Frederiks, J. W. *Dutch Silver, Embossed Plaquettes, Tazze and Dishes*, Amsterdam 1952.
Voet, E. and Voet, P. W. *Nederlandsche Goud- en Zilvermerken* 1445-1951, The Hague 1951.

ITALY

Bulgari, G. C. *Argentieri Gemmari e Orafi D'Italia*, Rome 1959.
Gregorietti, G. *Argenti Italiani*, Milan 1959.

NORWAY

Penzer, N. M. *Bergen Silver of the Guild Period*, The Connoisseur, London, April 1958.

RUSSIA

Porfiridov, N. *Russian Silver and Enamel*, Leningrad 1956.

JEWELLERY

Bainbridge, H. C. *The Life and Work of Carl Fabergé*. London 1950.
Bassermann-Jordan, E. *Der Schmuck*, Leipzig 1909.

Battke, H. *Geschichte des Ringes*, Baden-Baden, 1953.
The Ring Collection in the Schlossmuseum, Berlin 1938.
Bauer, J. A. *A Book of Jewels*. London 1966.
Blanc, C. *L'art dans la Parure et dans le Vêtement*. Paris 1874.
Bradford, E. *Contemporary Jewellery and Silverware*, London 1950.
Four Centuries of European Jewellery, London 1953.
English Victorian Jewellery, London 1967.
Castellani, A. *Antique Jewellery and its Revival*, London 1862.
Clifford Smith, H. *Jewellery*, London 1908.
Evans, Joan *A History of Jewellery 1100-1870*, London 1953.
Flower, M. *Victorian Jewellery*, London 1951.
Havard, H. *Histoire de l'Orfévrerie Française*, Paris 1896.
Higgins, R. A. *Greek and Roman Jewellery*, London 1962.
Hinks, P. *Jewellery*, London 1969.
Jessup, R. *Anglo-Saxon Jewellery*, London 1950.
Oman, C. C. *Catalogue of Rings*, Victoria and Albert Museum, London 1930.
Pugin, A. W. N. *Glossary of Ecclesiastical Ornament*, London 1844.
Schondorff, E. *Schmuck und Edelsteine*. Munich 1958.
Selwyn, A. *Retail Jewellers' Handbook*, London 1951.
Smith, C. H. *Jewellery*, London 1908.
Smith, G. F. *Gemstones*, London 1958.
Steingräber, E. *Alter Schmuck*, Munich 1956.
Webster, R. *Practical Gemmology*, London 1941.
Gemmologist's Compendium, London 1964.
Williamson, G. C. *Catalogue of the Collection of Jewels and Precious Works of Art, the Property of J. Pierpont Morgan*. London 1910.
Wright, J. S. *The Jewellery and Gilt Toy Trades*, London 1866.

CLOCKS AND WATCHES

Baillie, G. H. *Watchmakers and Clockmakers of the World*, London 1947.
Clocks and Watches: an Historical Bibliography, London, 1951.
Beevers, S. B. *Time measurement instruments*. London 1958.
Britten, F. J. *Old Clocks and Watches and their Makers*, London 1956.
The Watch and Clock Maker's Handbook, Dictionary and Guide, (15th edit.), London 1955.
Camerer Cuss, T. P. *The Country Life Book of Watches*, London 1967.
Carle D. de *Watch and Clock Encyclopedia*, London 1959.
Denison, E. B. (Baron Grimthorpe). *Clocks, Watches and Bells*, London 1883.
Edwardes, E. L. *The Grandfather Clock*, Altrincham 1952.
Gelis, E. *L'horlogerie ancienne*, Paris 1949.
Hayward, J. F. *English Watches*, Victoria and Albert Museum, London 1956.

Joy, E. T. *The Country Life Book of Clocks*, London 1967.

Lloyd, H. Alan *The Collector's Dictionary of Clocks*, London 1964.
Some Outstanding Clocks Over 700 Years, 1250-1950, London 1958.
Chats on Old Clocks, London 1938.
The English Domestic Clock, London 1938.
Old Clocks, London 1962.

Milham, W. L. *Time and Timekeepers*, New York 1947.

Morpurgo, E. *L'orologio e il pendolo*, Rome 1957.

Scherer, J. O. *Antike Pendulen*, Berne 1957.

Symonds, R. W. *A Book of English Clocks*, London 1950.
Thomas Tompion, his Life and Work, London 1951.

Tardy, P. *La Pendule française des origines à nos jours*, Paris 1961-3.

Ward, F. A. B. *Time Measurements, Part I: Historical Review*, London 1961.

Wiget, F. *Montres anciennes*, Paris 1951.

Zinner, E. *Alte Uhren*, Heidelberg-München 1959.

LIGHTING

d'Allemagne, H. *Histoire du luminaire depuis l'époche romaine jusqu'au XIXe siècle*, Paris, 1891.

Encyclopedia Italiana An article on 'Candelabro e Lampada'.

Henriot, Gabriel *Encyclopédie du Luminaire depuis l'Antiquité jusqu'à 1870.* (2 vols.) Paris 1933-4.

Hessling, Egon *Le style Empire; I. Le Luminaire du premier Empire*, Paris 1911.

Janneau, Guillaume *Le luminaire de l'antiquité au XIX siècle*, Paris 1934.

Mackey, T. W. G. *Old English Candlesticks and their Venetian Prototypes.* Burlington Magazine, Vol. 80, London 1942.

O'Dea, William *The Social History of Lighting*, London 1958.

Rebske, Ernst *Leuchter, Lampen und Laternen*, Stuttgart 1922.

Reifenberg, A. *Jewish Lamps.* Journal of the Palestine Oriental Society. Vol. 16, 1936.

Walter, H. B. *Catalogue of the Greek and Roman Lamps in the British Museum*, London 1914.

Wechsler-Kümmel, Sigrid *Schöne Lampen, Leuchter und Laternen*, Munich 1962.
Chandeliers, lampes et appliques de style, Fribourg 1963.

PEWTER

Bapst, G. *L'étain*, Paris 1884.

Bedford, John *Pewter*, London 1965.

Bell, Malcolm *Old Pewter: its history and development*, London 1923.

Bertram, F. *Begegungen mit Zinn*, Prague 1968.

Boucaud, C. *Les pichets d'étain*, Paris 1958.

Cotterell, H. H. *Old Pewter: its makers and marks in England, Scotland and Ireland*, London 1963.
Pewter Down the Ages: from mediaeval times to the present, London 1932.
National Types of Old Pewter, London 1925.

Cotterell, H. H. and M. Westropp *Irish Pewterers*, London 1917.

Douroff, B. A. *Les étains parisiens*, Paris 1963.
Étain Français de XVIIe et XVIIIe siècles, Paris 1959.

Englefield, Elsie *A Treatise on Pewter and its Manufacture*, London 1933.

Gale, Edward J. *Pewter and the Amateur Collector*, London 1910.

Haedecke, H. U. *Altes Zinn*, Leipzig 1964.
Zinn. Ein Handbuch für Sammler und Liebhaber, Braunschweig, 1963.

Markham, C. A. *Pewter Marks and Old Pewter Ware*, London 1928.

Masse, H. J. L. *The Pewter Collector: a guide to English pewter*, London 1921.
Old Pewter, London 1911.
Pewter Plate, London 1910.
Chats on Old Pewter, London 1928.

Michaelis, R. F. *Antique Pewter of the British Isles*, London 1955.

Moore, H. N. *Old Pewter and Sheffield Plate*, London 1905.

Mory, L. *Schönes Zinn, Meister, Formen, Stile*, Munich 1964.

Reinheckel, G. *Zinnsammlung im Zwinger*, Dresden 1966.

Ruhmann, K. *Edelzinn aus der Sammlung Dr. Karl Ruhmann*, Innsbruck, 1960.

Sutherland-Graeme, A. V. *Old British Pewter, 1500-1800*, London 1951.

Tardy, P. *Les Étains Français*, Paris 1959.

Verster, A. J. G. and R. M. Vetter *Das Buch vom Zinn*, Hanover 1963.

IRON, COPPER AND BRASS, AND BRONZE

Barton, D. B. *A History of Copper Mining in Cornwall and Devon*, Truro 1961.

Brown, R. A. *The History and Origin of Horse Brasses*, London 1952.

Dickinson, H. W. *Matthew Boulton*, London 1937.

Donald, M. B. *Elizabethan Copper*, London 1964.

Gardner, J. S. *English Ironwork of the XVII and XVIII Centuries*, London 1911.

Hamilton, H. *The English Brass and Copper Industries to 1800*, London 1926.

Hughes, G. B. *Horse Brasses and Other Small Items for the Collector*, London 1956.

Larkin, James *The Practical Brass and Iron Founders' Guide*, Philadelphia, 1853.

Liefchild, J. R. *Cornwall: Its Mines and Miners*, London 1860.

Lindsay, J. Seymour *Iron and Brass Implements of the English House*, London 1965.

Mann, James *Monumental Brasses*, London, 1957.

Peck, E. Saville *Notes Upon a Cambridge Collection of Bell Metal Mortars.* Cambridge Antiquarian Society's Communications, vol. 32, 1932.

Smith, B. W. *Sixty Centuries of Copper*, London 1965.

Verster, A. J. G. *Brons in den Tijd*, Amsterdam 1956.
Schönes Schmiedeeisen, Hanover 1960.

Victoria and Albert Museum *Old English Pattern*

Books of the Metal Trades, London 1913.
Weaver, L. *English Leadware,* London 1909.
Weihrauch, H. R. *Bronze,* Braunschweig-Berlin 1967.
Wills, G. *Collecting Copper and Brass,* London 1964.
 The Book of Copper and Brass, London 1968.
Zimelli, U. and Vergerio, Giovanni *Wrought Iron,*
 London 1969.

ARMS AND ARMOUR

Blackmore, L. *Guns and Rifles of the World,* New York
 1965.
Blair, C. *European and American Arms,* London 1962.
Boeheim, W. *Handbuch der Waffenkunde,* Vienna
 1966.
Gohike, W. *Die Blanken Waffen und die Schutzwaffen,*
 Leipzig 1912.
Grancsay, S. V. *Treasures of Arms and Armour,* Lon-
 don and New York 1968.
Hayward, J. F. *European Armour,* Victoria and Albert
 Museum, London 1961.
 Firearms, Victoria and Albert Museum, London
 1961.
 Swords and Daggers, Victoria and Albert Museum,
 London, 1961.
Hewitt, J. *Ancient Armour and Weapons in Europe,* (3
 vols.), New York 1967.
Kelly, F. and R. Schwabe *A Short History of Costume
 and Armour* 1066-1800, New York 1967.
Laking, G. F. *A Record of European Armour and
 Arms,* (5 vols.), London 1920-2.
Lugs, J. *Handfeuerwaffen,* Berlin 1962.
Malatesta, E. *Armi ed Armaioli,* Milan 1939.
Müller, H. *Historische Waffen,* Berlin 1957.
Paul, Martin *Arms and Armour from the 9th to the
 17th Century,* Rutland 1968.
Peterson, H. L. *Encyclopedia of Firearms,* London and
 New York 1964.
Seifert, G. *Schwert - Degen - Säbel,* Hamburg 1966.
Seitz, H. *Svärder och Värjan som Arme vapen,* Stock-
 holm 1955.
Stone, G. B. *A Glossary of the Construction, Decoration
 and Use of Arms and Armor,* Portland 1934.
Tunis, E. *A Pictorial History of Weapons,* Cleveland,
 1954.
Wagner, E. *Hieb- und Stichwaffen,* Prague 1966.

GENERAL

MAGAZINES:

Pantheon — International Arts Magazine, appears
 times yearly, Munich.
Die Weltkunst — Illustrated Art Journal, appears for
 nightly, Munich.
Artis — Journal for old and new art, appears month
 Constanz.
Alte und Moderne Kunst — appears 6 times year
 Vienna.
Connaissance des Arts — appears monthly, Paris.
Réalités — published in French and English, appea
 monthly, London and Paris.
The Connoisseur — edited by L. G. G. Ramsay, appea
 monthly, London.
Apollo — edited by Denys Sutton, appears month
 London.
Antique Dealer and Collector's Guide, appears mont
 ly, London.
Antique Collector — appears 6 times yearly, London.
Burlington Magazine — appears monthly, London.

BOOKS:

Ramsay, L. G. G. *The Consise Encyclopedia of Ant
 ques,* (5 vols.), New York and London 1959-61.
Bond, H. L. *An Encyclopedia of Antiques,* London 1961.
Reynolds, E. *The Plain Man's Guide to Antique Colle
 ting,* London 1963.
Hayward, H. *The Connoisseur's Handbook of Antiqu
 Collecting,* New York and London 1960.
Hughes, G. B. *Collecting Antiques,* London 1960.
 The Country Life Collector's Pocket Book, Londo
 1968.
Reitlinger, J. D. *The Economics of Taste,* Vol. III, Lor
 don 1963.
Bradford, E. *Antique Collecting,* London and Ne
 York 1963.
 Dictionary of Antiques, London and New Yor
 1963.
McClinton, K. *Complete Book of Small Antiques Co
 lecting,* New York 1965.

canthus — antique ornamental motif derived from a plant of the thistle family. Innumerable variants of this motif are found in works of art dating from all periods, ranging from realistic to highly stylised forms.

edicula — architectural feature, consisting of columns or pilasters, entablature and pediments, which breaks up a wall, surrounds doors and windows or frames shrines, sometimes containing statues.

igrette — a spray of gems worn on the head.

lbarello — a cylindrical faience vessel with a low wide neck. Vessels of this type were produced in Italy during the 15th and 16th centuries, after Oriental models. They were used chiefly as jars by apothecaries.

lexandrite — a variety of chrysoberyl found in the Ural mountains.

morini — in antique art, representations of winged, naked boys accompanying the god Amor (Eros). In the Middle Ages angels take their place, and naked boys without wings — *putti* — are later found in secular pictures.

Antependium — covering or plate placed on the front of the altar, since early Christian times, made of fabric, wood, metal or leather, decorated with embroidery, painting or plastic relief-work.

Aquamanile — medieval pouring-vessel used since the 12th century by priests for hand washing. Usually made of bronze or brass in the shape of a lion, dog or deer.

Arabesque — ornamental motif consisting of intertwined leaves or scrollwork. Of Hellenistic origin, it was introduced into Europe through Hispano-Moresque art. Frequently used during the Renaissance, Classical and Neo-Classical periods.

Arcade — curved row of columns or pillars or covered way. Blind arcades are made up of half-pillars for wall decoration or the same material as the wall.

Arcanists — craftsmen professing knowledge of the secret of porcelain-making and other pottery processes. Some, but not all of them, were notoriously impostors.

Arched Frieze — moulded element of Romanesque architecture. A regularly repeated cornice arch motif of varying cross-section.

Arrow-head — motif found predominantly in Turkoman and Caucasian carpets and used in repeat-designs in borders. Resembles arrow-heads or cuneiform script.

Astragal — decorative element principally of Classical but also of later architecture. Circular in section, like a string or circlet of beads, it was used to outline part of the building.

Auricular Ornament — q.v. **Shell Work**

Baldachin — 1. Originally a canopy of costly material supported on four poles and carried in processions above the Most Holy or over the Pope or Bishop. 2. Fixed baldachin over a throne or altar. 3. Since the 12th century, a stone baldachin or *ciborium* has been placed above the altar; later, figures were given a baldachin-like cover. 4. Motif in Baroque ornamentation.

Baluster, Balustrade — 1. Architectonic ornament. Railings of a row of short spherical-shaped columns. 2. Part of the stem of Baroque glasses.

Barber's Pole — European term for an ornamental motif found in oriental carpets reminiscent of the diagonally-striped poles hung by barbers in front of their establishments.

Basketwork — geometrical ornamentation made up of regularly interwoven bands covering either the whole surface or the edges only. It was known in antiquity.

Bead and Reel q.v. **Astragal**

Bezoar Stones — concretions in ball-shape found in the stomachs of some animals, usually ruminants, and formed of layers of animal matter.

Biblia Pauperum — Bible of the poor. A medieval selection of pictures illustrating Bible stories which placed those of the New and Old Testaments in relation to each other. Provided with the minimum text, they were intended for illiterate believers, the so-called 'poor in spirit'.

Bole — yellow or red-brown clay from which pottery was made in the Middle Ages *(terra sigillata)*. Bole was used as a first coat in 17th-century painting. Yellow and white bole was also used from the Middle Ages onwards as priming before gilding, and in the manufacture of water-colours.

Border — decorated edge of material, carpet or tapestry forming part of the weave. Also used to

denote ornamental frames of miniature paintings.

Bust — painted or sculptured head and shoulders.

Cabochon — a precious stone merely polished, without being cut into facets or shaped.

Cameo — cut stone or semi-precious stone with a raised pattern.

Carneol — form of cornelian semi-precious stone; now obsolete.

Cartouche — ornamental motif. Consists of a shield-type centre-piece and frame with contemporary ornamentation. Found principally in Renaissance and Baroque painting, graphic art and sculpture.

Caryatid — Grecian female figure which replaced the pillar as support in Ionic architecture. Also found in Renaissance architecture and, reduced in size, on furniture.

Cheval-glass (Psyché) — full-length mirror mounted on a stand with legs in the form of animals' feet. These mirrors were typical of the English and French periods.

Chi - q.v. **Cloud-band**

Chimera — fire-breathing monster of Greek mythology with a lion's head, a goat's body and a serpent's tail.

Chinoiseries — a Baroque trend which was several times revived in European art. These pseudo-Chinese figures and scenes are frequently found in Rococo ornamentation and more especially in the applied arts and in decorative painting. Derived from Chinese and Japanese models.

Chintamani — decorative motif of three balls in triangular arrangement found in Near-Eastern carpets. Originally symbolic of Buddha.

Churrigurism — a type of Spanish art named after the Spanish ar-

chitect, José Churriguera (1665-1725). This style is characterised by rich architectural sculpturing. The decorative profusion pushed the structural features right into the background.

Ciborium q.v. **Baldaquin**

Citrine — a glassy wine-yellow variety of quartz.

Cloud-band — decorative motif on oriental carpets based upon the Chinese *chi* motif elongated into stylised curves. Particularly evident in 15th-century Persian carpets.

Column — architectural element; an upright support consisting of base, circular shaft and capital.

Console — a richly decorated supporting or carrying architectural feature in S-form or voluted. In Gothic architecture consoles carried roofing ribs, later also balconies and statues.

Corinthian Capital — ornate top of Corinthian column or pilaster decorated with volutes and acanthus leaves.

Cornice — architectural feature. A horizontal strip projecting from the wall, with both decorative and structural value.

Cornucopia — ornamental motif. Curved, S-shaped horn with wide mouth filled with flowers and fruit. Belonged to the goddess Demeter in Greek legend. Mainly found among Renaissance and Baroque ornamentation.

Crocket — sculptured, Gothic, decorated shape on pediments, pinnacles, spires and so on. In the form of a rolled leaf.

Cupids - q.v. **Amorini**

Dagger — short stabbing weapon with various types of blade (flat, rhomboidal, three-edged).

Dionysus (Bacchus) — in Greek and Roman mythology the god of wine, shown surrounded by satyrs and nymphs.

Dossal — long, narrow tapestry placed over the back-rest of an ecclesiastical armchair.

Drapery — decoratively draped curtains or clothing in pictures or sculptures.

Dussak — (knife, peasant weapon) cutting weapon with a short straight, one-edged blade.

Egg-and-Dart Motif — decorative element of Greek architecture. Continuous ornamentation consisting of alternated ovolo and angular dart-like motifs. Usually a band of beading (q.v. Astragal) joined it from both sides. Adopted in the Renaissance period from Classical art and also used in modern times.

Ephebe — Greek word for a youth

Espagnolettes — 18th-century name given to bronze ornaments including female figures at angles of tables, especially on *Cressent* tables.

Faun — Roman fertility god, protector of crops and herds; the Pan of Greek mythology, depicted as a man with horns and a tail; often clad in a goatskin.

Festoon — sculptured or painted ornamental motif. Hanging garlands of foliage and flowers interwoven with banding, etc. Appeared in classical ornamentation, the Renaissance, Baroque and Classical periods.

Finial — sculptured, Gothic, decorative shape on the top of pinnacles, in the form of flowers and leaves.

Frieze — part of entablature of Classical architecture between cornice and architrave.

Gabled Hood-Moulding — Gothic ornamental pediment above doors or windows, decorated with crockets and finials.

Galalith — celluloid-like substance obtained by the action of formaldehyde on the casein of milk.

Gem — Cut stone or semi-precious stone with incised design. Gems were also designated as intaglio.

Girandole — large many-branched candelabrum placed either on the table or against a wall.

Girlande, Guirlande - Garlands — ornamental motif of regularly alternated segmental pendant features of flowers, leaves, fruit and ribbons.

Gul — decorative element in oriental carpets (particularly Turkoman). It is a patterned octagonal medallion, the colours and design of which vary from tribe to tribe.

Halberd — cutting and stabbing weapon which in its most fully developed form consists of a combined lance and axe.

Half-column — architectural feature which, apart from its functional value as a support, is principally of artistic value. Projects only partially from the wall. Base and capital are semi-circular in shape.

Heracles (Hercules) — in Greek and Roman mythology the son of Zeus and Alcmena, endowed with unusual strength and talents. Usually represented clad in a lion's skin and with a club in his hand.

Heraldic Figures — figures appearing on the various quarterings of coats-of-arms and representing living creatures and inanimate objects.

Heraldry — the art of armorial bearings concerned with the origin, history and symbolism of emblazonment. The oldest armorial bearings go back to the Crusades of the 12th century.

Herms — three-dimensional busts ending in a prismoidal or rectangular conical base or a scroll. In Classical antiquity they initially depicted the head of the God Hermes, but later other figures were also used. They reap-

pear in Renaissance and Baroque architecture.

Hour-glass — decorative motifs frequently found in the borders of oriental carpets. Repeated triangles, point-to-point, recall hour-glasses.

Imari — Japanese seaport which gave its name to an 18th-century type of decoration on Japanese porcelain.

Incrustation, (Encrustation) — Inlays of stone in stone or of metal and other materials in metal. This technique was always known in ancient times, when walls in particular were decorated with incrustation. It was also popular in Byzantium, but especially in Italy.

Intarsia — inlay in wood of other woods, ivory, bone, metal or mother-of-pearl, etc. Renaissance and particularly Baroque furniture was decorated with intarsia.

Khilin — a Chinese animal motif representing either a lion or a doe which appeared on Persian and other oriental carpets.

Lambrequin — originally a cover with scalloped edges and usually tasselled. In the high Baroque and early Rococo periods its was used as a decorative motif in carving, painting and architecture.

Lavabo — wash-basin with spout which can be stopped up. Was installed in church vestries where the priest used it to wash his hands. Originally also used in the home.

Leaf-work — low relief decoration of broad leaf forms used mainly on South German furniture.

Linenfold — delicately carved low-relief ornamentation on furniture reminiscent of folded linen and common during the late Gothic period, especially in countries making oak furniture.

Lisena - q.v. **Pilaster**

Lotus Blossoms — derived from flowers of the lotus plant which appeared in various forms in Near Eastern art. Used to decorate friezes in classical art, together with palmettes.

Meander — ancient ornamentation named after the meanderings of the winding river Meander in Asia Minor. It consists of a right-angular broken line or spiral.

Marquetry — very fine furniture inlay (q.v. Intarsia).

Mascaron — ornamentation derived from ancient theatrical masks in the form of natural or stylised human heads.

Medallion — 1. Picture or relief of oval shape. 2. In gold and silver work an oval pendant with a picture in it. 3. Ornamental motif of oval shape, variously profiled on the edges.

Metope — part of Doric architecture. The square blocks usually carved in relief alternating with triglyphs in a Doric frieze.

Mihrab — prayer niche in a mosque. It is represented on oriental prayer carpets.

Minne — term for chivalrous love in medieval times.

Mir-i-bota — design element said to be derived from a clenched fist that served oriental rulers as a seal. It is shaped rather like a pine cone and is frequently referred to as such. Appears on many oriental carpets in both field and border.

Monstrance — liturgical vessel for the dedicated host or reliquaries. The casing is made of crystal or glass, often in the shape of a half-moon. The monstrance alters in shape at various periods, but always rests on a shank with a base.

Niche — a bay let into a wall, usually with an arched roof and framed

by pilasters. Statues are often placed in niches.

Niello − decorative process used in metalwork. A black alloy of silver, tin, copper, borax and sulphur used for filling designs incised on metals. The technique was used by silversmiths already in ancient times.

Pallash (type of broadsword) − cutting weapon with a long straight one-edged blade.

Palmette − ornamental motif consisting of stylised palm-leaves arranged fanwise. Already found in antique art.

Partisan − ancient thrusting weapon with a long and fairly broad tongue-shaped head; in the 18th century it became a symbol of rank for non-commissioned officers of infantry and grenadiers.

Parure − a set of jewels or other ornaments intended to be worn together.

Pavillion − the part of a brilliant-cut diamond between the girdle and the collar.

Pediment − feature over the upper cornice. Appeared in various shapes at various times (often triangular or segmental), and can be broken up by windows, or decorated.

Pendeloque − ornamental drop hanging loose from an earring, brooch or other piece of jewellery; hanging glass drops of chandeliers or other lights.

Phoenix − mythical bird of the Middle Ages which burnt itself to death and emerged rejuvenated from its ashes. It has become symbolic of Christianity and Christ's resurrection and immortality.

Pilaster − architectural feature of support. A flat-faced pillar with base and capital which, for the most part, is built half into the wall.

Pillar − architectural feature. Vertical support consisting of a base, cylindrical shaft and capital, but not a Classical column.

Pinnacle − feature of Gothic architecture. Pointed turret on a buttress or at both sides of a gabled hood-moulding. The pyramid-shaped apex is ornamented with crockets, and ends in a finial. A miniature version of the pinnacle also appears in Gothic handicrafts.

Plaited Ribbon-work − decoration of plaited ribbon motifs which first appeared in France *c* 1700 and spread throughout Europe. Since 1750, mainly a decorative element in painting and stucco-work.

Pluvial − ceremonial vestment of the Catholic priests, worn above all in processions. It consisted of a type of rain-cape and had a semi-circular cut. The pluvial was held together by a clasp on the chest. Of the hood there only remained an ornamental peak at the back.

Pole Medallions − decorative motif composed of medallions with a pole down the centre. In oriental carpets, used to fill in the field.

Pomegranate − motif based on this fruit which since the late Middle Ages has figured in textile design, notably in brocade and velvet.

Putti - q.v. **Amorini**

Rapier − piercing sword with a long narrow blade, generally rhomboidally shaped cross-sectionally.

Rocaille − Rococo ornamental motif. An asymmetrical, mussel-shaped ornament usually accompanied by strange shell-like forms.

Rosette − ornamental motif of classical origin. A centrepiece composed of a rose which later reappeared principally in the Renaissance and Classical periods. Also the description given to

round windows in Gothic churches.

S-Ornament − geometric S-shaped decoration which has appeared in various forms since earliest times.

Saracen Trefoil − plant ornament appearing in Saracen art, mainly in the borders of carpets.

Sarcophagus − coffin decorated with reliefs or paintings, originally of stone but later of other materials. Its development can be traced from Antiquity; it reached its peak in early Christian times.

Schiavone − ancient sword used by Dalmation cavalry in the service of the Venetian Republic.

Sconce − light holder with curving branches; could be attached to the wall, panelling or to individual pieces of furniture. It was already in use in secular interiors in the 15th century and became an important feature of Rococo furnishing.

Scroll Ornament − ornamental motif of tendrils of acanthus leaves. Appears in the ornamentation of all eras.

Shah Abbas Palmettes − palmette motifs composed of lines and to be found in nearly all oriental carpets.

Shell Work − early Baroque ornament of Dutch origin, used principally in wood-carving. The name is based on the shape of the ornament which is composed of coiled, protruding, shell-like volutes.

Silenus − companion of Dionysus and father of the Satyrs in Greek mythology; depicted as a fat old satyr.

Sirens − mythical creatures of Classical Antiquity reported to lure with their enchanting singing all sea-farers venturing near their island.

Sphinx − mythological figure, ori-

ginally from Central Asian culture. In Egypt it has a lion's body and a human (male or king's) head, and in Greece it has a lion's body with a female head.

trapwork — q.v. **Plaited Ribbonwork**

word (early type) — cutting weapon with long, straight, rather broad two-edged blade.

word (later type) — piercing weapon with a long, narrow blade, mostly with rhomboidal cross-section.

ree of Life — ancient Syrian decorative motif. A tree-trunk-like shape crowned with a palmette. The branches are also represented by palmettes. It has many variations in oriental art and also on oriental carpets. In Europe it is usually confined to folk art.

Tendril Ornament — ornamental motif consisting of tendrils of acanthus leaves. Appears in the decoration of various periods.

Triglyph — element of Doric architecture alternating with metopes in the frieze and consisting of a block with repeated vertical grooves or glyphs.

Trophy — originally ancient war symbol from captured weapons, but later ornamental motif in which weapons and pieces of armour are grouped together.

Urns — vessels of various shapes in which the ashes of the dead were stored, originally discovered in archaeological expeditions. Mostly made of pottery, glass or metal.

Veduta — (ital. = view) applied to painting representing a place, usually a town e.g. Canaletto's paintings of Venice.

Verdures — tapestries featuring plants and landscapes without figures but sometimes including heraldic designs. Mainly 17th-century.

Verre Églomisé — glass decorated at back with designs in colour and gold and silver foils, named after an art-collector, J.B. Glomy, who died in France in 1786. Borders of *verre églomisé* in arabesque patterns and with coats-of-arms were used to frame mirrors c. 1695.

Volute — a spiral scroll; a classical motif still used today.

Wall Candelabra - q.v. **Sconce**

Wineglass Border — decorative motif on oriental carpets in which stemmed wine-glasses in conical form are repeated in rows to form a border.

Index of Major
Museum Collections

Aachen	Domschatzkammer of Aachen Cathedral (goldsmith's and silversmith's work)
Aix-en-Provence	Musée des Tapisseries et d'Ameublement Ancien (tapestry)
Amsterdam	Gemeentemusea Amsterdam (clocks and watches); Rijksmuseum Amsterdam (carpets, tapestry, glass, ceramics, porcelain, mirrors, goldsmith's and silversmith's work, pewter, copper, arms and armour); A.J.G. Verster (private collection of pewter)
Angers	Musée des Tapisseries d'Angers (tapestry)
Augsburg	Maximilianmuseum (clocks and watches)
Bad Homburg	Jantzen (private collection of mortars)
Bedford	Cecil Higgins Gallerys (ceramics, porcelain)
Belgrade	Vojni Muzej (arms and armour)
Berlin	Museum für Deutsche Volkskunde (arms and armour); Kunstgewerbemuseum (decorative arts); Schloss Köpenick (ceramics, porcelain, goldsmith's and silversmith's work, clocks and watches, pewter); Schloss Charlottenburg (ceramics, porcelain, jewellery, pewter, bronze)
Berne	Bernisches Historisches Museum (pewter, copper, arms and armour)
Bielefeld	Heinrich Gläntzer (private collection of pewter)
Breslau (Poland)	Muzeum Śląskie w Wrocławiu (pewter)
Brunswick	Herzog-Anton-Ulrich-Museum, (ceramics, porcelain)
Brussels	Musée Royal d'Armes et d'Armures (ceramics, porcelain, arms and armour); Musée Royal de l'Armée et d'Histoire Militaire, (ceramics, porcelain, arms and armour)
Budapest	Hadtörténelmi Múzeum és Levéltár (arms and armour); Magyar Nemzeti Múzeum (goldsmith's and silversmith's work, pewter, arms and armour)
Cambridge	Fitzwilliam Museum (ceramics, porcelain)
Cleveland	Cleveland Museum of Art (goldsmith's and silversmith's work, arms and armour)
Coburg	Kunstsammlungen der Veste Coburg (glass)
Cologne	Kunstgewerbemuseum der Stadt Köln (furniture, glass, ceramics, porcelain, mirrors, pewter); Domschatzkammer of Cologne Cathedral (goldsmith's and silversmith's work)
Copenhagen	Det Danske Kundindustrimuseum (ceramics, porcelain); Nationalmuseet (carpets, tapestry, clocks and watches, etc.); De Danske Kongers Kronologiske Samling paa Rosenborg (goldsmith's and silversmith's work, arms and armour); Tøjhusmuseet (arms and armour)
Corning (New York)	The Corning Museum of Glass (glass)
Cracow	Muzeum Narodowe w Krakowie (arms and armour); Panstwowe Zbiory Sztuki na Wawelu (goldsmith's and silversmith's work)
Darmstadt	Hessisches Landesmuseum (ceramics, porcelain)
Dresden	Grünes Gewölbe, (Albertinum) (goldsmith's and silversmith's work); Museum für Kunsthandwerk, (glass,

	pewter, copper); Historisches Museum (arms and armour); Staatlicher Mathematisch-Physikalischer Salon, (clocks and watches); Porzellansammlung, (Zwinger) (porcelain)
Düsseldorf	Kunstmuseum der Stadt Düsseldorf (ceramics, porcelain)
Esztergom (Hungary)	Keresztény Múzeum (goldsmith's and silversmith's work)
Faenza (Ravenna)	Museo Internazionale delle Ceramiche (ceramics)
Florence	Museo degli Argenti, (goldsmith's and silversmith's work); Museo dell'Opera del Duomo (goldsmith's and silversmith's work); Museo di Storia della Scienza (clocks and watches); Museo Nazionale, (Bargello) (goldsmith's and silversmith's work); Museo Stibbert (arms and armour); Galleria degli Uffizi (furniture)
Frankfurt-on-Main	Museum für Kunsthandwerk (furniture, ceramics, porcelain, pewter)
Geneva	Musée d'Art et d'Histoire (arms and armour)
Genoa	Museo del Tesoro di San Lorenzo (Cathedral Museum) (goldsmith's and silversmith's work)
Graz	Kulturhistorisches and Kunstgewerbemuseum (pewter, ironwork); Landeszeughaus (arms and armour)
Hague (The)	Haags Gemeentemuseum (ceramics, porcelain)
Hamburg	Museum für Kunst und Gewerbe (furniture, tapestry, carpets, glass, ceramics, porcelain, mirrors, lamps, pewter)
Innsbruck	Schlossverwaltung zu Innsbruck und Ambras (arms and armour)
Klášterec nad Ohři	Muzeum Porcelánu (porcelain)
Karlovy Vary	Městske Muzeum (arms and armour)
Leipzig	Museum des Kunsthandwerks, (Grassi-Museum) (ceramics, porcelain, pewter)
Leningrad	State Hermitage Museum (carpets, tapestry, ceramics, porcelain, goldsmith's and silversmith's work, pewter, bronze, arms and armour); Artillary Museum (arms and armour); Russian Museum (pewter)
Liberec (Czechoslovakia)	Severočeské Muzeum (carpets, tapestry, ceramics, porcelain, pewter)
Lichtenwalde	Fritz Bertrams Erben (private collection of pewter)
Liège	Musée Curtius (glass); Musée d'Armes de Liège (arms and armour)
London	Tower of London (arms and armour); British Museum (glass, ceramics, china, mirrors, clocks and watches, lamps, jewellery, bronze, etc); Clockmakers' Company Museum (clocks and watches); R. M. Michaelis (private collection of pewter); Science Museum (clocks and watches); Victoria and Albert Museum (furniture, carpets, tapestry, glass, ceramics, porcelain, mirrors, goldsmith's and silversmith's work, clocks and watches, lamps, pewter, bronze, arms and armour, etc.); Wallace Collection (furniture, bronze, arms and armour)
Lyon	Musée Lyonnais des Arts Décoratifs (ceramics, porcelain)
Madrid	Museo de la Real Armeria (arms and armour)
Milan	Castello Sforzesco (ceramics, porcelain, goldsmith's and silversmith's work); Tesoro del Duomo (Treasury of the Cathedral) (goldsmith's and silversmith's work)
Moscow	State History Museum (pewter); State Kremlin Museum (goldsmith's and silversmith's work, arms and armour)
Munich	Bayerisches Nationalmuseum (glass, ceramics, porcelain, goldsmith's and silversmith's work, clocks and watches, lamps, pewter); Deutsches Museum von Meis-

	terwerken der Naturwissenschaft und Technik (clocks and watches); Die Neue Sammlung (Staatliches Museum für angewandte Kunst) (ceramics, porcelain); Ludwig Morry (private collection of pewter); Residenz-museum (furniture); Schatzkammer der Residenz (goldsmith's and silversmith's work)
Naples	Museo e Gallerie Nazionali di Capodimonte (lamps, bronze, arms and armour, etc.)
New York	Metropolitan Museum of Art (mirrors, goldsmith's and silversmith's work, clocks and watches, pewter, arms and armour); Morgan Collection (jewellery)
Nuremberg	Germanisches Nationalmuseum (furniture, glass, ceramics, porcelain, goldsmith's and silversmith's work, clocks and watches, lamps, pewter, arms and armour)
Opava (Czechoslovakia)	Slezské Muzeum (ceramics, porcelain)
Oslo	Haermuseet (arms and armour)
Oxford	Museum of the History of Science (clocks and watches)
Paris	Musée de l'Armée (arms and armour); Musée des Arts Décoratifs (furniture, tapestry, ceramics, porcelain, mirrors, jewellery, clocks and watches, lamps, pewter, bronze); Musée Carnavalet (lamps); Musée de Cluny (furniture, tapestry, ceramics, porcelain, lamps, pewter, bronze); Collection Baron Edmond de Rothschild (jewellery); Musée du Conservatoire National des Arts et Métiers (clocks and watches); Musée des Gobelins (tapestry); Musée National du Louvre (furniture, tapestry, carpets, ceramics, porcelain, mirrors, goldsmith's and silversmith's work, lamps, bronze)
Pforzheim	Schmuckmuseum (jewellery)
Prague	Umélecká Beseda (tapestry, glass, ceramics, porcelain, goldsmith's and silversmith's work, pewter); Vojenské muzeum (arms and armour); Muzeum Hlavniho Mèsta Prahy (pewter); Poklad Svatovitského Dómu v Praze (goldsmith's and silversmith's work); Loretánský poklad v Praze (goldsmith's and silversmith's work)
Regensburg	E. Wiedemann (private collection of pewter)
Rome (Vatican)	Tesoro della Basilica di S. Pietro (goldsmith's and silversmith's work)
Rotterdam	Museum Boymans-van-Beuningen (pewter)
Sèvres	Musée National de Céramique (ceramics, porcelain)
Schleswig	Schleswig-Holsteinisches Landesmuseum (ceramics, porcelain)
Schwerin	Staatliches Museum (ceramics, porcelain)
Skokloster (Sweden)	Slott-och Motormuseum (arms and armour)
Solingen	Deutsches Klingenmuseum (arms and armour)
Solothurn (Switzerland)	Waffensammlung im Alten Zeughaus (arms and armour)
Stockholm	Kungl. Armémuseum (arms and armour); Kungl. Livrustkammaren (arms and armour); Nationalmuseum (ceramics, porcelain, goldsmith's and silversmith's work)
Strasbourg	Musée des Arts décoratifs (ceramics, porcelain, pewter); Musée Historique de la Ville de Strasbourg (arms and armour)
Stuttgart	Landesgewerbeamt Baden-Württemberg (ceramics, porcelain, pewter)
Turin	Armeria Reale (arms and armour); Museo Civico di Torino (ceramics, porcelain)
Velbert (Rheinland)	Deutsches Schloss und Beschläge Museum (iron, bronze)
Venice	Galleria Giorgio Franchetti (furniture); Museo Civico del Risorgimento (mirrors); Museo del Settecento Ve-

	neziano (furniture); Museo Vetrario di Murano (glass, lamps); Tesoro di San Marco (goldsmith's and silversmith's work)
Vienna	Heeresgeschichtliches Museum (arms and armour); Kunsthistorisches Museum (tapestry, carpets, mirrors, goldsmith's and silversmith's work, clocks and watches, lamps, bronze, arms and armour); Österreichisches Museum für angewandte Kunst (glass, ceramics, porcelain, pewter); Technisches Museum für Industrie und Gewerbe (clocks and watches); R. M. Vetter (private collection of pewter)
Warsaw	Muzeum Narodowe (pewter); Muzeum Wojska Polskiego (arms and armour)
Wildon b. Graz	Karl Ruhmann (private collection of pewter)
Würzburg	Mainfränkisches Museum (ceramics, porcelain)
Zurich	Schweizerisches Landesmuseum (ceramics, porcelain, pewter, copper, arms and armour)

PHOTOGRAPHIC ACKNOWLEDGEMENTS

The photographs of the individual items are reproduced by the kind permission of the following museums, institutes, etc:

By Gracious Permission of H.M. the Queen 339
Aix-en-Provence: Archévé d'Aix 84
Musée d'Aix 94
Musée des Tapisseries 92
Amsterdam: Rijksmuseum, Amsterdam 300
Angers: Musée des Tapisseries d'Angers 59, 65
Arles: Musée Réattu 80
Bayeux: La Ville de Bayeux 60
Berlin: F. Bertrams Erben, private collection 472-476, 489
Boston: Museum of Fine Arts, Gift of Denman W. Ross 27
Bratislava: Slovenské Národné Múzeum 627
Slovenský památkový ústav, Bratislava 318, 319, 321, 325
Brunswick: Formsammlung der Stadt Braunschweig 587, 590
Cologne: Römisch-Germanisches Museum 131, 132
Copenhagen: Det Danske Kundindustri-museum 424
Deerfield: Pocumtuck Valley Memorial Association of Deerfield, Mass. U.S.A. 36
Delaware: Henry Francis Du Pont Winterthur Museum, U.S.A. 16, 35
Dobříš: State Castle Dobříš 95
Frýdlant v Čechách: State Castle Frýdlant in Bohemia 622, 623
Harvard: Harvard University, U.S.A. 336
Hluboká: State Castle Hluboká 75, 76, 82, 90
Horšovský Týn: 625
Kabul: Private Collection 117, 118, 119. XI
Konopiště: State Castle Konopiště 614-619, 624, 647, 648, 653, LXV-LXVII
Kozel: State Castle Kozel 50, 427, 429, 457, 458, 460
Kynžvart: State Castle Kynžvart 63
Lemberk: State Castle Lemberk 1, 7, 8, 9, 11, 15, 19, 22, 30, 87. 299, 301, 304, 313, 417, 438, 440, 446, 447, 450, 451, 456, 461, 462
Leningrad: State Hermitage Museum 61, 62, 66, 71, 73, 74, 96, 315, VII-X
Liberec: Severočeské Muzeum VI
London: Victoria & Albert Museum 33, 39, 43, 44, 46, 297, 328, 331, 333, 335. 344
Wallace Collection 422, 640, 643, 644, 645, 651, 652
British Museum 222

Country Life 24
Moravská Třebová: City Museum 72
Munich: Bayerisches Nationalmuseum 296
Münchner Stadtmuseum 588
Náchod: State Castle Náchod 88
Náměšt n. Osl: State Castle Náměšt n. Osl. 64, 91
New York: Fountain Elms, Munson-Williams-Proctor Institute, Utica 20
Museum of the City of New York 37
New York Historical Society 334, 338
Opava: Slezské Muzeum 77
Paris: Musée du Petit Palais 295
Musée National du Louvre 292
Musée des Arts Décoratifs 86, 307
Galerie Persane 112, 114
La Faculté de Médecine 85
Mobilier National 68
Musée de Cluny 67, 294
Musée des Gobelins 81
Private Collection, Paris 109, 111, 113
Plzeň: Západočeské Muzeum 361, 362, 612, 613
Prague: Vojenské Muzeum 591-609, 620, 621, 628-639, 641, 642, 646, 649, 650
Hrad, Míčovna 78, 93
Clementinum, Vlašská kaple 533
Uměleckoprůmyslové Muzeum 3-6, 10, 12-14, 17, 18, 21, 23, 28, 29, 45, 47, 48, 51, 52, 54-58, 89, 128-130, 133-174, 176-178, 180-188, 190-221, 223-228, 230-291, 293, 303, 306, 308, 311, 317, 320, 322, 323, 327, 329, 332, 337, 340-343, 345-360, 366, 368, 370-372, 375, 377-380, 382, 383, 385-395, 399-405, 407, 409, 410, 412, 414-416, 418-420, 423, 426, 428, 430-433, 435-437, 441, 444, 448, 449, 453, 459, 463, 464, 478, 480, 485-487, 490, 492, 493, 496, 504-507, 510, 511, 518, 526, 528-532, 534, 535, 558-560, 574-581, 583, 584, XVII-XLI, XLIV-L, LIX-LXIV
Národní Muzeum 49, 175, 363-365, 367, 369, 373, 374, 376, 381, 384, 396-398, 406, 408, 411, 413, 469, 471, 479, 483, 488, 491, 494, 495, 497-503, 509, 514, 516, 517, 519-525, 527, 536-546, 548-555, 557, 561-573, 582, 585, 586, LI-LVIII
Národní Galerie I-IV
Private Collection, Prague 302, 309, 421, 445
Státní Židovské Muzeum 512, 513, 556
Městské Muzeum 26, 41, 53, 434, 484
Svatovítský poklad 324, 326, 330
Rheims: Musée des Beaux-Arts 69, 70
Tehran: Golestan Museum 120
Private Collection, Tehran 97-108, 115, 116, 121-123, XII, XIV-XVI

PHOTOGRAPHIC CREDITS

FROM THE COLLECTIONS OF THE AUTHORS:

INDEX OF NAMES

Böttger, Johann Friedrich, b. 1682, d. 1719, inventor of hard-paste porcelain, director of the first European porcelain factory in Meissen, 1710–19, 193, 194, 195, 197, *230, 231*

Botticelli, Sandro, b. 1444 or 1445, d. 1510, Florentine painter and engraver, 22

Bouchardon, Edmé, b. 1698, d. 1762, French sculptor, creator of the drawings, 'Cris de Paris', 204

Boucher, J. François, b. 1703 Paris, d. 1770 *ibid.* French painter during reign of Louis XV, 63, 64, 65, 206, 207

Boudová, Anna. b. 1870, d. 1940, painter and ceramist in Prague, 169

Boulle, André Charles, b. 1642, d. 1732 Paris, French painter, architect and ornamentalist, cabinet-maker to Louis XIV, 26, 233, 322, 354, 416, *21, 442, 443*

Briot, François, b. 1550 Lothringen (Lorraine), d. *c.* 1616, medallist and coin-maker, engraver, pewterer, 158, 357, *474*

Brogniart, Alexandre, b. 1770, d. 1847, geologist, director of Sèvres Porcelain Factory 1800–47, 204

Bronzino, Agnolo, b. 1503 near Florence, d. 1572, Italian painter, 61

Brueghel, Pieter, the Elder, b. 1525 near Breda, d. 1569 Brussels, Flemish painter, 66

Brunelleschi, Filippo, b. 1377, d. 1446, Florentine architect, sculptor and draughtsman, 22, 256

Bry, Theodor de, b. 1528, d. 1598, Flemish engraver 256

Buchwald, Johann, arcanist in Höchst, Fulda, Holíče and eastern Faience factories 1748–85, 166

Buckingham, George Villiers, Duke of, 1592–1628, Minister of James I of England, 233, 235

Bürgi, Jost, b. 1552, d. 1632, astronomer, instrument and clock-maker, 322

Buquoy, Georg, Count, b. 1781, d. 1851, owner of glass-works in Nový Hrady, 135, 136

Burgkmair, Hans the Elder, b. 1473, d. 1531, German painter in Augsburg, 24

Burkard, Friedrich, b. 1730, d. 1812 Prague, gunsmith in Prague, *628*

Busch, Christian Daniel, d. 1790, porcelain-painter in Meissen up to 1745, in Vienna up to 1748, in Nymphenburg and elsewhere, 198

Busch, Esaias the Elder and the Younger, goldsmiths in Augsburg 17th century, 259

Buschmann, Johannes, German clock-maker and mechanic, Master from 1620, 322

Bustelli, Franz Anton, b. 1723, d. 1763, Master modeller in Nymphenburg, 201, *253*

Caffieri, Jacques, b. 1678, d. 1755, goldsmith, 204

Caffieri, Philippe the Younger, b. 1714 Paris, d. 1774 *ibid.*, bronze-founder, 416

Calemelli, Virgiliotto, d. before 1570, ceramist and painter in Faenza, 157

Cardan, English technician, 338

Carl Eugen, Duke of Württemberg, 201

Carlin, Martin, French cabinet-maker, 28

Carl, Theodor, Elector Palatine, 201

Carriés, Jean, b. 1855, d. 1894, French sculptor and ceramist, 169

Castellani, Pio Fortunato, b. 1793 Rome, d. 1865 *ibid.*, goldsmith, 291

Cazin, Jean-Charles, b. 1841, d. 1901, French painter, etcher and ceramist, 169

Cellini, Benvenuto, b. 1500 Florence, d. 1571 *ibid.*, goldsmith, sculptor, die-sinker and medallist, 252, 256, 285, 293

Chaligny, Antoine, d. 1651, member of the Lorraine bronze-founders' family, 416

Chamberlain, Robert, ceramist in Worcester from 1783, 206

Champagne, Philippe de, 62

Chaplet, Ernest, b. 1835, d. 1909, French ceramist, 169

Catherine II (the Great), b. 1729, d. 1796, Czarina of Russia 1762–96, 207

Charles the Bold, b. 1433, d. 1477 Nancy, Duke of Burgundy, son of Philip the Good, 61, 283

Charles I, Duke of Brunswick, 200

Charles the Great, b. 742, d. 814, King of France from 768 and Holy Roman Emperor from 800 A.D., 254, 279

Charles III, b. 1716, d. 1788, King of Spain 1759–88, 205

Charles IV, b. 1316 Prague, d. 1378 *ibid.*, Emperor of Germany and King of Bohemia, 254

Charles V, b. 1500, d. 1558, Holy Roman Emperor and King of Spain, 60, 62, 63, 233, 319

Carl Theodor, b. 1724, d. 1799, Elector Palatine of Bavaria, 201

Chicaneau, Pierre, died before 1678, ceramist in St Cloud, 202

Chippendale, Thomas, b. 1709 or 1718, d. 1779, English cabinet-maker, 30, 235, 339, *312*

Clair, Adam, b. 1763, d. 1829, modeller in Frankenthal and Nymphenburg, 201, *256*

Claire, Godefroid de, goldsmith and enameller of the 12th century in Huy, 254

Clauce, Isaak Jacob, b. 1728, d. 1803, miniaturist and porcelain-painter in Berlin manufacture from 1753, 199

Cleffius, Lambertus, d. 1619, owner of faience workshops in Delft, 162

Clement VII, Pope, 62

Clérissy, Pierre, b. 1651, d. 1728, founder of Moustiers faience factory, 163

Clodion, Claude Michel (called Clodion), b. 1738, d. 1814 Paris, French sculptor, 204, 416

Colbert, Jean-Baptiste, b. 1619 Rheims, d. 1683 Paris, French statesman, 65

Collaert, J. J., engraver, decorator, 325

Colt, Samuel, b. 1814, d. 1862, credited with the invention of the modern revolver, 440

Comans, Marc de, weaver from Brussels, beginning of 17th century, 62

Cominazzo, gunsmith family in Gardone and Brescia, 436

Conrad II, b. *c.* 990, d. 1039, Holy Roman Emperor, m. Gisela 1016, 279

Constantine, Emperor, 336

Contriner, Joseph, gunsmith in Vienna, *c.* 1800, 440

Corneille, Pierre, b. 1606 Rouen, d. 1684 Paris, French playwright, 62

Corplet, Charles Alfred, b. 1827, d. 1894, French enameller and restorer, 158

Cortona, Pietro da, b. 1596 Cortona, d. 1669 Rome, Italian painter and architect, 64

Cosimo I de Medici, b. 1519, d. 1574, Duke of Tuscany, 66

Cosway, Maria Louisa, b. 1759 Florence, d. 1838 Lodi, painter and etcher, 206

Cotte, Robert de, b. 1656, d. 1735, French architect and decorator, 27, 234

Coypel, Charles, b. 1694 Paris, d. 1752 *ibid.*, painter and engraver, 64

Cozzi, Geminiano, ceramist in Venice, 1764–1812, 205

Cranach, Lucas, b. 1472 Kronbach, d. 1553 Weimar, painter, 63

Crell, Hans, German draughtsman, pupil of Lucas Cranach, mid-16th century, 63

Cressent (Crescent), Charles, b. 1685, d. 1768, French cabinet-maker and sculptor, 28

Crispin, Jehan, French goldsmith, 233

Cuvilliés, François the Elder, b. 1695, d. 1768, French architect, decorator and ornamentalist, 29, 234, 235, 322, 339

Cuzin, Bourguignon and sons, French clock-makers, 321

Daffinger, Johann, porcelain-painter in Vienna from 1760, 198

Dagobert I, d. 638, last powerful French ruler of the Merovingian dynasty, reigned 628–38 A.D., 247

Dalpayrat, Adrien, ceramist in Paris, end of 19th century, 169

Dangel, Joseph, modeller in Vienna, active 1750–87, 198

Dannhauser, Leopold, d. 1786, modeller in Vienna,

active 1762–86, 198

Dannhofer, Joseph Philipp, b. 1712, d. 1790, porcelain-painter in Vienna and other manufactories, 165, 198

Daum, Auguste, b. 1854, d. 1909, glass-maker in Nancy, 137

David, Gérard, b. c. 1450 Oudewater, d. 1523 Bruges, Flemish painter, 62

David, Jacques Louis, b. 1748 Paris, d. 1825 Brussels, French painter, 64

Deck, Joseph Theodor, b. 1823, d. 1891, ceramist, director of the National Porcelain Factory in Sèvres, 169

Decker, Paul the Elder, architect and engraver, active 1677–95, 204

De La Fosse, Jean Charles, b. 1734, d. 1789, architect and decorative engraver in Paris, 259

Delaherche, Auguste, b. 1857, French ceramist, 169

Delaune, Étienne (called Stephanus), b. 1518/19, d. c. 1583, French engraver, medallist and draughtsman, 233, 325

Demiani, Hans, d. 1911, collector and author of publications on pewter, 356

Desmalter, Honoré Georges (called Jacob-Desmalter), b. 1770, d. 1841, French cabinet-maker, 31

Desoches, French modeller in Fürstenberg, active 1769–1774, 200

Donatello, b. c. 1386 Florence, d. 1466 ibid., Italian sculptor, 414

Dorsch, Christian, glass-grinder in Nuremberg c. 1700, 133

Dossi, Battista, b. c. 1474, d. 1546, Italian painter in Ferrara, esp. landscape, 66

Dourdin, Jacques, Paris weaver, 2nd half of 14th century, 60

Drentwett, Augsburg goldsmiths' family 17th–19th centuries, 259

Dreyer, Salomon, d. 1762, goldsmith in Augsburg, 259

Dreyse, Nikolaus, b. 1787 Sömmerda, d. 1867 ibid., inventor of famous needle-gun, 439

Ducerceau, Jacques Androuet, b. 1510 Paris, d. c. 1584, Annecy, architect and engraver, 61, 233

Duesbury, William, b. 1725, d. 1786, owner of porcelain factory in Derby from 1756, and from 1770 in Chelsea, 205

Dumont, Jean Joseph, d. 1755, French tapestry-designer, clock-maker, 65, 323

Duplessis, Jean Claude-Thomas, d. 1774, French goldsmith, modeller in Vincennes-Sèvres, 203, 204

Dupont, Pierre, b. c. 1560–70 Paris, d. 1640 ibid., French carpet-maker and illustrator, 101

Durantino, Francesco, and Guido da Castel Durante (also known as Guido Durantino) d. 1576; the latter founder of the Maiolica Workshop in Urbino 1520, 157

Dürer, Albrecht the Elder, b. 1427, d. 1502, goldsmith in Nuremberg, 255

Dürer, Albrecht the Younger, b. 1471 Nuremberg, d. 1528 ibid., painter, wood and copper engraver and draughtsman, active in Nuremberg, 63, 293

Dwight, John, English porcelain researcher, 17th century, 167, 194

Dyck, Sir Anthony van, b. 1599 Antwerp, d. 1641 London, Flemish painter and etcher, 67, 92

Eberlein, Johann-Friedrich, d. 1749, modeller in Meissen, 196

Eder, Paul, glass-grinder in Nuremberg, 2nd half of 17th century, 133

Eenhoorn, Samuel van, faience ceramist in Delft, son of Wouter van Eenhoorn, 162, 199, 200

Eenhoorn, Wouter van, faience ceramist in Delft, owner of workshops, 162, 167

Eeckhout, Gerbrand van de, b. 1621 Amsterdam, d. 1674 ibid., Dutch portraitist and historical painter, etcher, 235, 258

Effner (Oefner), Joseph, b. 1687, d. 1745, architect and interior decorator, 29

Egbert, Archbishop of Trier, 978–93 A.D., 253

Egermann, Friedrich, b. 1777 Novy Bor, d. 1864, painter on glass, and glass technician in Blottendorf and Nový Bor, 127, 136

Egmont, Joost van, b. 1602 Leiden, d. 1674 Antwerp, Flemish painter, 65

Eilbertus, monk in the Monastery of St Pantaleon, Cologne, goldsmith and enameller, 12th century, 254

Elers, John Philip and David, potters in red stoneware in Fulham, London, before 1693, 167

Emanuel, Max, founder of a Munich tapestry workshop, 66

Emens, Jan, stoneware potter in Raeren, active 1566–94, 159

Enderlein, Caspar, b. 1560 Basle, d. 1633, Master pewterer in Nuremberg, 357

Erhart, family of Hafner ceramists in Winterthur (Switzerland), 17th century, 159

Eyck, Jan van, b. c. 1390, d. 1441 Bruges, Flemish painter, 61

Faber, Johann Ludwig, painter on glass and faience in Nuremberg, 1678–93, 164

Falconet, Étienne-Maurice, b. 1711, d. 1791, sculptor, manager of modelling department in Sèvres; from 1766 in St Petersburg, 203, 204, 207, 323, 416

Faust, Isaac, b. 1606, d. 1669, Master pewterer in Strasbourg, 357

Fawkener, Everard, b. 1684, d. 1758, owner of porcelain factory in Chelsea, 1749–58, 206

Feilner, Simon, b. 1789, painter and modeller in Höchst, Fürstenberg, and Frankenthal, where he became manager, 199, 200

Ferdinand I of Habsburg, b. 1503, d. 1564, Archduke of Austria, King of Bohemia and Hungary and Holy Roman Emperor, 257, 319

Ferdinand of Tyrol, b. 1529, d. 1595, son of Ferdinand I, Archduke of Austria, 257

Ferdinand III, b. 1608, d. 1657, Holy Roman Emperor, 358

Ferdinand IV, b. 1751, d. 1825, King of Naples and Sicily, 205

Fischer, Johann, gunsmith in Bratislava, first half of 18th century, 627

Fischer, J. S., porcelain-painter, 198

Flight, Thomas and sons, owners of porcelain factory in Worcester, from 1783, 206

Flötner, Peter, b. c. 1485 Thurgau, d. 1546 Nuremberg, designer, goldsmith, cabinet-maker, miniaturist, wood-engraver; from 1522 active in Nuremberg, 24, 257, 383, 477

Fontaine, Pierre-François-Léonard, b. 1762, d. 1853, French architect and theorist, 31, 65, 260, 340

Fontana, Orazio, d. 1571, son of Guido Durantino (Fontana), maiolica ceramist in Urbino, 157

Forsyth, Alexander, b. 1768 Scotland, d. 1843, priest of Anglican Church, inventor of the first percussion-lock for explosives, 439

Forty, Jean-François, draughtsman and engraver in Paris c. 1775–90, 259

Francesco I de Medici, b. 1541, d. 1587, Grand Duke of Tuscany, 194

Francia, Francesco, b. 1450 Bologna, d. 1517, goldsmith and painter, 256

Francis I, King of France 1515–47, 61, 233, 256, 79

Frederick, Duke of Württemberg, 357

Frederick I, King of Prussia 1701–13, 195

Frederick the Great, b. 1712 Berlin, d. 1786 Sans Souci, King of Prussia 1740–86, 29, 235

Frijtom, Frederik van, painter in Delft, active 1658–73, 161

Fromanteel, A., English clock-maker of the 17th century, 323

Frye, Thomas, b. 1710, d. 1762, co-founder of the porcelain factory in Bow and its director from 1759, 193, 205

Gabriel, Jacques-Ange, b. 1710, d. 1782, French architect, 27

Gallé, Émile, b. 1846, d. 1904, craftsman in Nancy, 124,

founder of the porcelain factory at Vincennes, 203

Otto III, King of Germany and Holy Roman Emperor, 991–1002, 253

Oudry, Jean-Baptiste, b. 1686 Paris, d. 1755 Beauvais, painter, book-illustrator, etcher, pattern-designer, 64, 65

Owidzka, Jolanta, b. 1927, Polish textile-designer, 68

Pajou, Augustin, b. 1730 Paris, d. 1809 *ibid.*, French sculptor, also active in Sèvres as a modeller. 204, 323

Palissy, Bernard, b. *c.* 1510, d. *c.* 1590, alchemist and ceramist in Saintes, Paris and elsewhere, 157, 158, 338

Pannemaker, Flemish family of weavers 16th–18th centuries, 62

Paquier, Claudius Innocentius du, d. 1751, founder of the porcelain factory in Vienna, 132, 197, XXXVIII

Parisot, Peter, one time Capucine friar called Norbert von Lothringen, 102

Passavant, Claude, carpet-weaver, 102

Paul I, b. 1754, d. 1801, Tsar of Russia 1796–1801, 207

Payer, Anton, modeller in Vienna, second half of 18th century, 198

Peche, Dagobert, b. 1887 Salzburg, d. 1923 Vienna, Austrian painter, craftsman and architect, 169

Peffenhauser, Anton, b. *c.* 1525, d. 1603, armourer in Augsburg *651*

Pellipario, Niccolo (also Niccolo da Urbino), painter of maiolica in Castel Durante *c.* 1510–15, 157

Percier, Charles, b. 1764, d. 1833, architect in Paris, 31, 65, 260, 340

Perkin, Sir William Henry, English chemist, 89

Perrot, Bernard, French ceramist, 1662–88, 233

Peruzzi, Vincenzo, lapidary in Venice, end of 17th century, 284

Peter I of Russia (the Great), b. 1672, d. 1725, Tsar from 1682, 67

Petit-Jean, François, discovered use of silver on glass for mirror-making, 231

Pfau, family of pottery and stove painters in Switzerland, 17th century, 159

Pfeffenhauser (also Peffenhauer), Augsburg goldsmiths' family of 16th–18th centuries, 259

Pfeffenhauser, Wilhelm, German clock-maker of 16th century, 321

Pfleger, Franz, d. 1737, German Court painter, 235

Pfohl, Karl, b. 1826, d. 1894, north Bohemian glass-grinder in Steinschönau, 136

Philip II, King of Spain, *190*

Philip II (the Bold), b. 1342, d. 1404, Duke of Burgundy, 60

Philip III (the Good) b. 1396, d. 1467, Duke of Burgundy, 61, 319

Philip IV (the Fair), b. 1268, d. 1314, King of France from 1285, 61

Picart Le Doux, Jean, b. 1902 Paris, 68

Picasso, Pablo, b. 1881 Malaga, contemporary Franco-Spanish painter, 68

Piccinino, gunsmiths' family in Milan, 16th century, 433

Piero (di Cosimo), b. 1462, d. 1531, Florentine painter, 22

Pigalle, Jean-Pierre, b. 1725 Paris, d. 1796 *ibid.*, sculptor, 204

Pijnacker, Adriaen and Jacobus, faience ceramists in Delft, owners of workshops 1680–1707, 162

Pineau, Nicolas, b. 1684, d. 1754, French ornamental sculptor, interior decorator, draughtsman and orna-mentalist, 28, 234, 322

Pirot, Andreas, b. Frankfurt, d. 1763 Würzburg, Court carpet and tapestry-weaver in Würzburg, 66

Pirotti, family of maiolica ceramists in Faenza 1505–1632, 156, *185*

Pisano, Andrea, b. 1270 Pontedera, d. 1348–49 Orvieto, Italian sculptor, goldsmith and Master builder, 414

Planche, François de la (van den Planken), 62

Planche, Raffael de la, 62

Pleydenwurff, Hans, d. 1472, Nuremberg painter, 61

Plomyer, Allard, French goldsmith, 233

Pocetti, Bernardino, Italian decorator, 66

Poilly, François de, the Younger, b. 1671 Paris, d. 1741

ibid., French engraver and draughtsman, 233

Pollajuolo, Antonio del, b. 1433 Florence, d. 1498 Rome, goldsmith, painter, engraver, draughtsman, sculptor in bronze and marble, modeller in clay, 22, 256

Pollion, Dionys, modeller in Vienna Porcelain Works 1750–60, d. *c.* 1783, 198, *244*, XXXIX

Pöppelmann, Matthes Daniel, b. 1662 Herford, d. 1736 Dresden, architect, 196

Poser, Paul, gunsmith in Prague *625, 633*

Poterat, Louis, b. 1641, d. 1696, ceramist in faience and soft-paste porcelain in Rouen, 202

Poucher, Loys, French goldsmith, 233

Poussin, Nicolas, b. 1594 Villers, d. 1665 Rome, French painter, 62

Powolny, Michael, b. 1871, d. 1954, sculptor and ceramist in Vienna 169

Preissensin, Albrecht, Master pewterer in Nuremberg *c.* 1564, 357

Preissler, Daniel and Ignaz, b. 1636–76, d. 1733–41, painters on porcelain and glass in Bratislava and Kunštát, 126, 132, 196, 199, *150, 248*

Preuning, Paul, Hafner ceramist in Nuremberg, mid-16th century, 159, XXIX

Prutscher, Otto, b. 1880, d. 1949, architect and craftsman in Vienna, 169

Purmann, Martin, German clock- and compass-maker *c.* 1600, 320

Quare, Daniel, b. 1648, d. 1724, English clock-maker, 323

Rabiqueau, maker of street-lamps in 18th century in Paris, 339

Rachette, Dominique, b. 1744 Copenhagen, d. 1809 St Petersburg, modeller in the St Petersburg Porcelain Factory 1779–1804, 207

Raes, Jan, Brussels weaver, active 1610–31, 65

Raphael (originally Santi), b. 1483 Urbino, d. 1520 Rome, Italian painter, sculptor and architect, 62–67, 204

Rath, Stephan, b. 1875, d. 1960, owner of glass factory Lobmeyr in Vienna, 1919–51; manager of glass refinery in Steinschönau, 138

Recum, Peter and Johann Nepomuk van, lessees of the porcelain factory in Frankenthal from 1795–9, 201

Reichard, Ernst Heinrich, d. 1764, modeller and arcanist in Wegely's, later Gotzkowsky's Porcelain Factory in Berlin, 199

Reinhard, Oswald, Hafner ceramist in Nuremberg, 16th century 159

Reinicke, Peter, b. 1715 Danzig, d. 1768 Metz, modeller in Meissen 1743–68, 196

Richelieu, Armand Jean du Plessis de, b. 1585 Paris, d. 1642, Cardinal from 1622, French statesman, 416

Riedl, Johann W., owner of glass factory in Palubný, introduced manufacture of glass jewellery 1742, 134, 136

Riesener, Jean Henry, b. 1734, d. 1806, French cabinet-maker and worker in bronze, 28, 30

Ringler, Joseph Jakob, b. 1730, d. 1804, arcanist in Vienna, Höchst and Strasbourg, from 1753 in Nym-phenburg and 1759–1802 director of the porcelain factory in Ludwigsburg, 201

Risenburgh, Bernard van, cabinet-maker, 28

Robbia, della, family of sculptors and maiolica ceramists, 15th and 16th centuries, 156, 158

Roentgen, Abraham and David, b. 1711–43, d. 1793–1807, German cabinet-makers, 28, 30, 32, 43, *424, 46*

Roger von Helmershausen, goldsmith of Essen, 253

Romano, Giulio, b. 1499 Rome, d. 1546, Italian painter and architect, 66

Rombrich, Johann Christoph, d. 1794, modeller in Fürstenburg from 1770–94, 200

Rosbach, Elias, d. 1765, glass-cutter and grinder in Zechlin, 134

Rosenberg, Marc, author of the work: *The Marks of Goldsmiths*, 261

Rouault, Georges, b. 1871 Paris, d. 1958, painter and graphic artist in Paris, 68

painter, craftsman in Belgium and Switzerland, 169, 208, 237

Venezia, Domenico da, ceramist in Venice c. 1560–80, 157

Verdun, Nikolaus von, goldsmith and enamelist of 12th–13th century, 254

Verrocchio, Andrea del, b. 1433 Florence, d. 1488 Venice, Italian sculptor, painter, bronze-founder and goldsmith, 256, 414

Veterli, Friedrich, maker of the first repeating rifle with self-actuating cocking device, director of the Swiss small-arms factory in Neuhausen, 440

Vezzi, Giuseppe and Francesco, ceramists in Venice, c. 1719–40, 205

Vianen, Paul van, b. c. 1570 Utrecht, d. 1613 Prague, goldsmith, metal-chaser and medallist, 256, 257

Vigne, Charles de, d. 1751, French weaver in Berlin, 66

Vischer, brass-founders' family in Nuremberg, 15th and 16th centuries, 412, 415, 416

Vlaminck, Maurice de, b. 1876 Paris, d. 1958, painter and graphic artist, 169

Vogt, Adam, Hafner ceramist in Augsburg c. 1621, 159

Voháňka, Jindřich, b. 1922, Czechoslovakian textile-designer, 68

Voisin, François, French draughtsman c. 1790, 339

Vos, Josse de, weaver in Brussels from 1705, 66

Vouet, Simon, b. 1590 Paris, d. 1649 ibid., French painter, 62

Vries, Paul Vredeman de, b. 1567 Antwerp, d. post 1630, architect and painter, 235, 250, 256

Wachenfeld, Johann Heinrich, b. 1694, d. 1725, German ceramist and painter, 165

Wall, John, b. 1708, d. 1766, partner in the porcelain factory in Worcester, 206

Walle, Jacob van de, co-founder of the Hanau Faience Factory, 1661, 164

Wänzl, Franz, b. 1810, d. 1881, Viennese gunsmith, 439

Watteau, Antoine, b. 1684 Valenciennes, d. 1721 Nogent-sur-Marne, French painter and etcher, 64, 65, 196, 198, 206

Wedgwood, Josiah, b. 1730, d. 1795, founder of the Etruria Stoneware Works in Staffordshire, 153, 166-168, *223, 224, 226*

Wegely, Wilhelm Kaspar, founder of the Berlin Porcelain Factory 1752–57, 199, 200, *250*

Weinmüller, Josef, b. 1746 Aitrang, d. 1812, pupil of Straub in Munich, modeller in Ludwigsburg, 202

Weisweiler, Adam, German cabinet-maker, end of the 18th century, 30, *45*

Werder, Johann Ludwig, b. 1808, d. 1885 Nuremberg,

versatile inventor, 439

Wesson, Daniel B., gunsmith, co-founder of the small-arms factory in Norwich and small-arms factory 'Smith and Wesson' in Springfield, 440

Weyhe, Bernard Heinrich, b. 1701, d. 1782, goldsmith in Augsburg, 259

Whieldon, Thomas, b. 1719, d. 1795, ceramist, partner of J. Wedgwood 1754–59, 167

William III (of Orange), King of England 1682–1702, 67, 235

Wilkinson, John, English inventor of the round furnace, 386

Willumsen, Jens Ferdinand, b. 1863 Copenhagen, d. 1958, painter, graphic artist, sculptor, ceramist, architect in Copenhagen, 169

Winck, Christian, b. 1738 Eichstätt, d. 1797 Munich, German etcher and painter, 66

Winter, Friedrich, Silesian glass-cutter, c. 1685–90, 134, *153*

Winter, Johann Georg, b. 1707 Groningen, d. 1770 Munich, German painter, 66

Winter, Martin, d. 1702, Silesian glass-cutter, active in Potsdam, 134

Witz, Konrad, b. 1400–10 Rottweil, d. 1444–6 Basle, German painter, 61

Wolff, David, b. 1732, d. 1798, stipple-engraver on glass in the Hague, 127, 135, 136

Wolfsburg, Karl Ferdinand, b. 1692, d. 1764, porcelain-painter in Breslau and Vienna, 198, 199

Wolgemut, Michel, b. 1434 Nuremberg, d. 1519 ibid., German painter and designer for woodcuts, 61

Wouwermans, Philip, b. 1619 Haarlem, d. 1668 ibid., Dutch painter, 67, 196

Würth, goldsmiths' family in Vienna, 18th and 19th centuries, 260

Xanto Avelli, Francesco, painter of maiolica in Urbino, active 1530–42, 157, *186*

Zatzer, Hans, Master pewterer in Nuremberg 1560–1618, 358, *472*

Zech, Jakob, Bohemian clock-maker of the 16th century, 320

Zick, Januarius, b. 1730 Munich, d. 1797 Ehrenbreitstein, German painter and architect, 30

Ziegler, Jules Claude, b. 1804 Langres, d. 1856 Paris, painter, graphic artist and ceramist in Paris, 169

Zipfel, Veit, Master pewterer in Nuremberg c. 1582, 358

Zsolnay, Vilmos, b. 1828, d. 1900, Hungarian ceramist, 169

INDEX OF OBJECTS

A berrettino technique 156, *185*
Acanthus foliage 20, 22, 25, 26, 27, 31, 62, 101, 156, 157, 204, 233, 234, 236, 259, 260, 322, 335, 339, 340, 354, 362, 385, *188*
Acolyte candlestick 336
Adam style 260, *44, 314*
Afghanistan carpet 97
A fiori ornament 156
A fleurette decoration 61
A foglie ornament 156
Afshari carpet 92
Agate 256, 298, *388*
Agate glass 138
Agraffe 290, 291, 292
Aigrette 279, 299
Air gun 440, *637*
A jour technique 251, 285, 286, 287, 290, 294, 298,

378
Alabastron *172*
A la Grecque fashion 292, 294
Albarello 156, *184, 187*
Alexandrite 282
Alla porcellana ornament 156
Alligator motif 95
Alloy 249, 281, 355, 397, 398, 402, 411, 412
Almandine 284, *362, 363*
Altar 254, 257, 258, 335
Altar candlestick 336, 337, 342, *495*
Altar cloth 60, 61
Altar candlestick 336, 337, 342, *495*
Amber 287, 288-289, 299
Amethyst 282, 298, *362*
Amorini 234, 323
Amphora *173, 174*
Amulet 279, 293, 300
Anabaptists 160

Andiron 415, 416
Angster bottle 131
Animal carpet 92
Animal feet 20, 22, 23, 336, 337
Animal heads 23, 29, 98, 155, 259, 382
Annagelb 136
Annagrün 136
Antepedium 68, 258
Antikenzierat 200
Apocalypse 59, 65, *60*
Apostle tankard *194*
Apostle tapestry 60, 62, *152*
Apothecary's jar 400, *184, 558, 560*
Applewood 34
Aquamanile 413, *570, 571*
Aquamarine 282
Arabesque 22, 23, 24, 26, 62, 91, 92, 94, 129, 156,

158, 165, 196, 234, 299, 320, 321, 341, 357, 432
Armchair 22, 37, 47, *95*
Arm circlet 295
Armour 282, 441-445, *640, 643-653*
Arms 427-441, *591-642*, LXV, LXVI, LXVII
Arms makers 433
Arquebus 437, *612, 613*
Arras 57
Art Nouveau 33, 95, 102, 137, 169, 208, 237, 260, 292, 324, 341, 362, *58, 360, 412, 465, 510, 511*
Art pottery 169
Arte del perlaio 137
Arts and Crafts Movement 169
Ashwood 24, 27, 32
Astragal decoration 20
Astrolabe 320 398

494

INDEX OF PLACES